TIME
The Illustrated
History of
the World's
Most Influential
Magazine

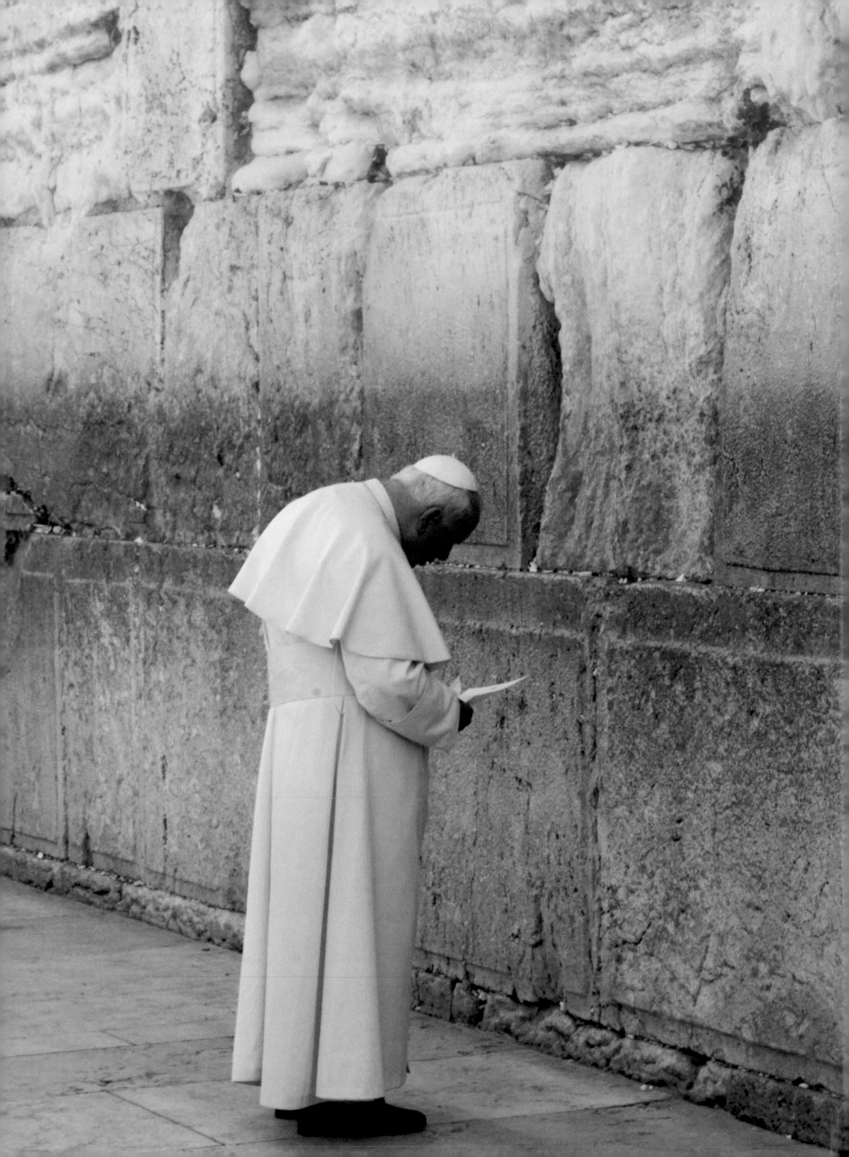

Norberto Angeletti
Alberto Oliva

TIME
The Illustrated History of the World's Most Influential Magazine

RIZZOLI NEW YORK

New York · Paris · London · Milan

First published in the United States
of America in 2010 by
Rizzoli International Publications, Inc.
300 Park Avenue South
New York, NY 10010
www.rizzoliusa.com

*Time: The Illustrated History of
the World's Most Influential Magazine*
© 2010 Norberto Angeletti and
Alberto Oliva

Distributed in the U.S. trade by Random
House, New York

Designed by: Pentagram

Printed and bound in China

ISBN: 978-0-8478-3358-0

Library of Congress Catalog Control
Number: 2009925152

Powerful messenger. Pope John Paul II in March 2000 at the Western Wall in Jerusalem (page 2), one of the holiest sites in Judaism, where, following tradition, he left a prayer committing the Catholic Church to a "genuine brotherhood with the people of the covenant." Improving relations with people of different faiths was only one of his accomplishments. *Time* devoted fifteen covers to John Paul II and named him 1994 "Man of the Year."

Part I:
The Birth of a News Style

1923–1967

Part II:
From the Turbulent 1960s to the Transformation of Journalism

1968–1995

Part III:
The Magazine for the New Century

1996–2010

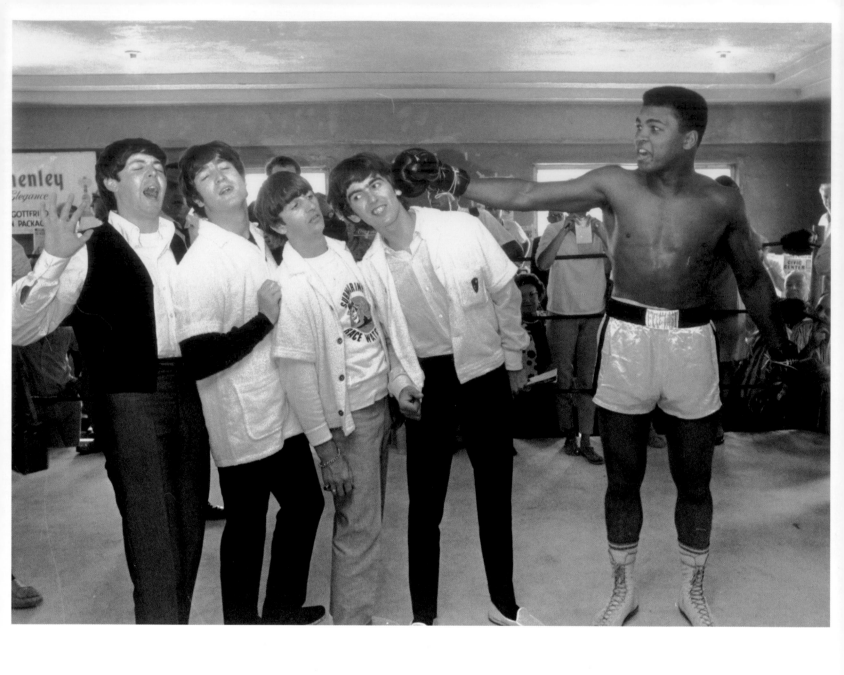

Rising stars. Beatles Paul McCartney, John Lennon, Ringo Starr and George Harrison pretending to be toppled by a punch from boxer Muhammad Ali during a break in the filming of the February 16, 1964, *The Ed Sullivan Show*, where the British rock group made its American debut (above). *Time* waited until September 1967 to devote a cover to the new look of the "Unbarbershopped Quartet." After its first cover story on the dreams of the young Cassius Clay in 1963, *Time* devoted two more covers to Clay— renamed Muhammad Ali in 1964—in 1971 and 1978.

Preface

Henry R. Luce and Briton Hadden didn't come up with the iconic red border until four years after they started publishing *Time*, but it ratified an idea that was present at the creation: everything within *Time*, that is, within those red borders is worth knowing— and anything outside of it, well, not so much. It was a bold idea, even an arrogant one, but it symbolized something that is as true today as it was eighty-seven years ago: data requires editing, voices need moderating, information must have a human hand to turn it into knowledge. The idea that we separate the wheat from the chaff, the trifling from the essential, is the value proposition that has animated *Time* from the beginning and still does today.

When Luce and Hadden started *Time* in 1923, there were fourteen daily newspapers in New York City. Not quite the fire hose of information we get today, but it was more information than any one person could process. *Time* was designed to synthesize, edit and make sense of all that information for readers who had other things to worry about. "Aggregation" is a trendy term current in today's media, but Luce and Hadden were the original aggregators, editing and refining information from around the world to put within their red borders.

Time was the original newsmagazine. Indeed, it created the genre itself. It gave you a taxonomy of information that allowed you to make sense of it all. There was a place for everything—and everything was in its place. The magazine had sections and a beginning, a middle and an end. In that sense, it was a way of looking at the world, a way of sorting through the chaos and coming up with something that was clear and meaningful. Another idea that is still true today.

Luce once said, "I became a journalist to come as close as possible to the heart of the world." That is *Time*'s mission—to take readers as close to the heart of the world as possible. We aim to give you a front row seat. Our mission is not and never has been about the *what* of news, it is about the *how* and *why*. Anyone can tell you that the president signed a particular bill, but why he needed to, what

it meant to him and to all of us is what *Time* has always brought to the table. We don't give you the news—that's a commodity—we put it in context.

One reason for that is another Luce mantra: names make news. From the start, *Time* wrote about the news through personalities—events were not abstract and impersonal, people made news, and *Time* helped you understand those people. It's an old notion: men and women make history as much as history makes men and women.

And very often, those men and women made history for the better. *Time* is and always has been optimistic and a believer in American exceptionalism. Luce wrote that the twentieth century was the American century and I heartily agree. *Time* mirrors a great many American virtues: openness, diligence, a reverence for facts, the importance of innovation and ingenuity. Those values are enduring ones to both *Time* and America.

Every editor of *Time* channels Luce in his own way. I want our writers, editors, correspondents and photographers to have a point of view, but we must always be fair-minded and explore every side of an argument. We undermine prejudice, we don't preach it.

This handsome book examines *Time*'s indelible contribution to international journalism and culture. The twentieth century—and now the twenty-first—would not be the same without *Time*. The authors conducted more than thirty interviews with some of the writers, editors and art directors who have made *Time* great. They spent many hours immersed in the *Time* archives. The book is not only a visual history of *Time*, but also an intimate cultural one. For that reason, it is also a rich resource for historians and academics. *Time: The Illustrated History of the World's Most Influential Magazine* meticulously documents how *Time* mirrored and shaped events, and shows, once again, that we not only mark history, we make it too.

Richard Stengel
Managing Editor, *Time*

Introduction

Time magazine, now in its eighth decade, ushered in the era of the modern newsmagazine. This book pays tribute to the editors, photographers, journalists, designers and artists who have built *Time* and continue to build it today—the men and women who are invisible to readers but who are behind every page. This book conveys the magazine's history, as well as its editorial and design contributions.

The magazine, which started out as a rewritten digest of the news for busy people to read within an hour, soon groomed its own reporting and writing staff. By the late 1950s, to keep up with the ever-increasing global news, the staff had grown to 436 correspondents, contributors and writers working out of thirty-three bureaus throughout the world. Under the stewardship of co-founder Briton Hadden, a unique writing style, called *Timestyle*, was developed, which would later be imitated by other journalists. Other *Time* editorial innovations include reporting the news through newsmakers, following Carlyle's dictum that history is "but the biography of great men" and the development of the "Man of the Year" brand.

Time witnessed and interpreted world political, social and cultural changes at the same time it faced historic competition from *Newsweek* and *U.S. News and World Report*, the advent of color TV, the internet and the emergence of cable TV—particularly CNN. These challenges compelled *Time*'s managing editors to reinvent the magazine's formula, whether through redesigns— three major ones in 1977, 1989 and 2007—or innovations needed to keep the magazine current and reader-friendly.

The Kennedy legacy. Brothers John Kennedy, Robert Kennedy and Ted Kennedy in an undated photograph taken at the family compound in Hyannis Port, Massachusetts (opposite). The Kennedy name has been significant in American history. Head-of-the-clan Joseph P. Kennedy was the first Kennedy to make the cover of *Time* on July 22, 1935. Thirty-one *Time* covers with Kennedys followed.

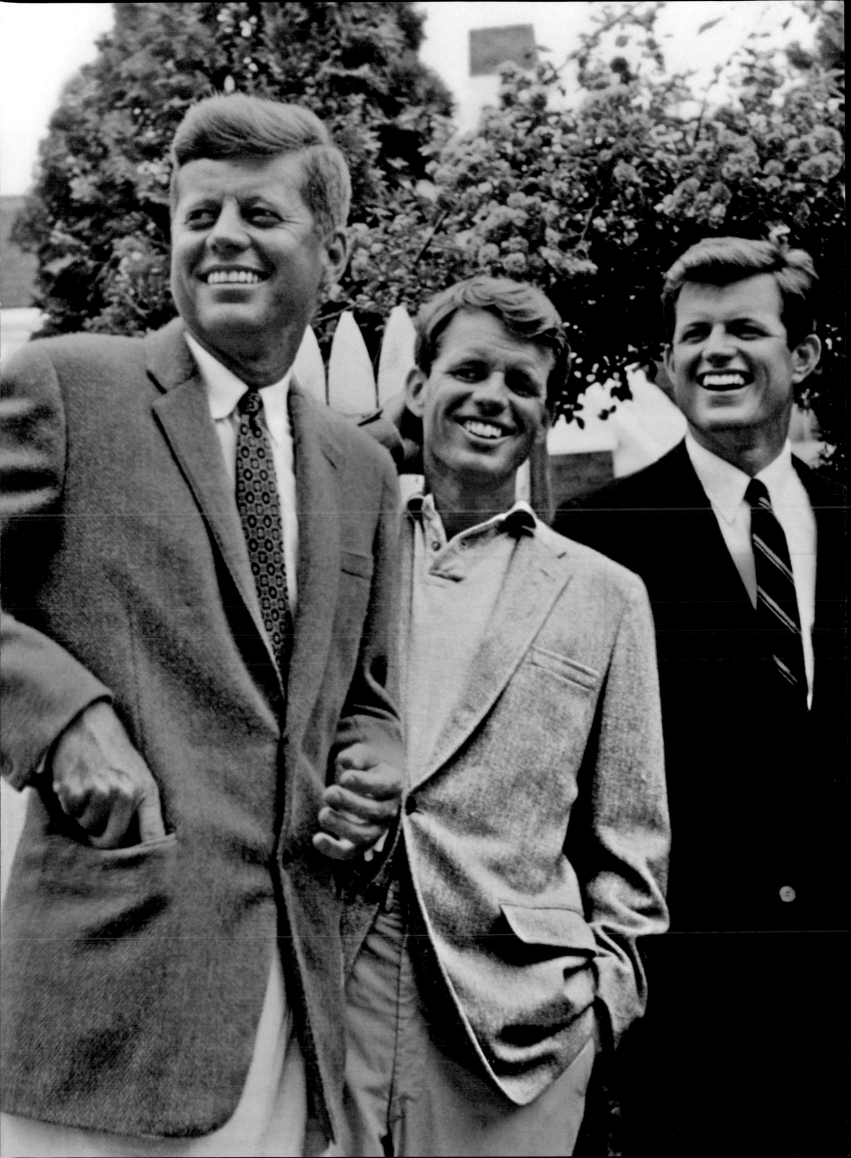

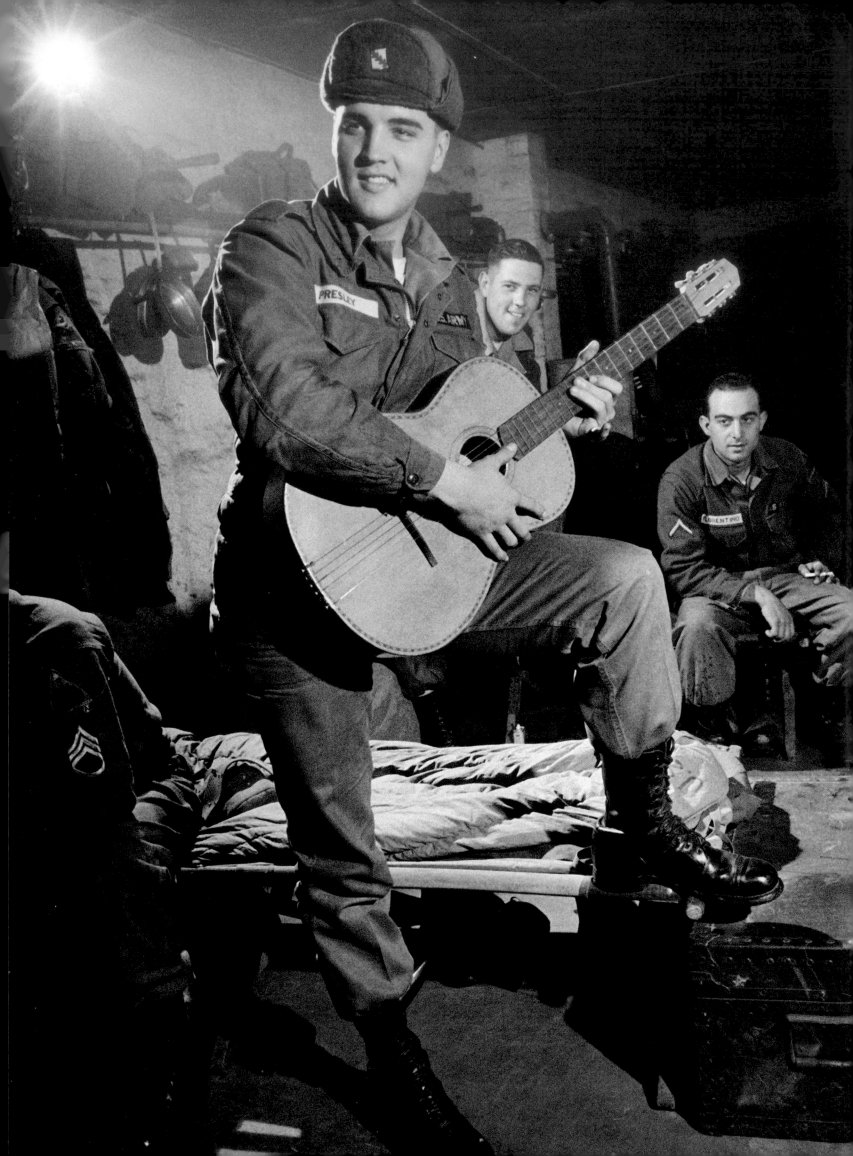

1923. Benito Mussolini

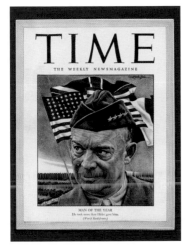

1945. General Dwight Eisenhower

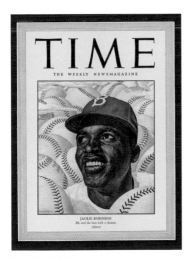

1947. Jackie Robinson

In addition to acknowledging the magazine's contributions to international journalism, we hope this book is a resource for historians, professionals, academics and journalists, as well as the general public. We hope that the readers of this book will become as captivated as the authors were by the behind-the-scenes anecdotes and the various editorial approaches that the magazine's sixteen managing editors used to report the news through the years.

We tell the story of *Time* through the most important events that happened in the nation and the world. Our examination is a chronological look at what was taking place within *Time* and how it changed with each editor's tenure, and how *Time* portrayed history every seven days to its readers.

Over six years, we conducted more than thirty interviews with *Time* editors, writers and designers from the magazine's past and present. This book includes nearly 600 illustrations and photos, through which we examine *Time*'s remarkably successful visual formula. This formula has evolved throughout the years. Design milestones include the creation of the cover's emblematic red frame and *Time*'s world-renowned school of covers, headed by the revolutionary trio of Boris Artzybasheff, Ernest Hamlin Baker and Boris Chaliapin. *Time* also opened its doors to some of the past century's most innovative artists, including Bernard Buffet, Ben Shahn, Gerald Scarfe, Marisol, Frank Gallo and Robert Vickrey, and some of the masters of contemporary painting, such as Roy Lichtenstein, Robert Rauschenberg and Andy Warhol.

The book also explores the fact that *Time* was the first newsweekly at the end of the 1970s to be produced in full color, making it one of the biggest proponents of photojournalism in the 1980s and 1990s.

On its pages, *Time* displayed the work of talented photographers, such as Eddie Adams, Neil Leifer, Dirck Halstead, David Hume Kennerly, David Burnett, James Nachtwey, Diana Walker, Gregory Heisler and Matt Mahurin, among many others. Through the years these photographers won major photo awards for the magazine.

This book does not overlook *Time*'s controversial decisons and mistakes, including the magazine's political subjectivity, which initially led *Time* to openly back Republicans, often to the detriment of its credibility and authority. We also do not ignore the length of time the magazine took to give women access to the top echelons of its editorial offices or the very limited number of writers of color on staff.

Part I of this book covers the birth of the magazine up until *Time* co-founder Henry Luce's death. This section tells the story of how Luce, with Briton Hadden, established a niche and a market for *Time*. Part II covers the turbulent 1960s to the transformation of journalism, caused by the Internet revolution in the mid-1990s, and relates how, through successive editorships with differing editorial philosophies, the magazine evolved with the changing culture in the United States and the world. Through the lens of *Time*'s editorial evolution, this book covers historical events, such as the Vietnam War, the Watergate scandal, the Gulf War, the moon landing and the fall of the Berlin Wall. Part III covers the decadence of the 1980s, the tragedy and grief of 9/11 and the economic decline of the first decade of the new century. For *Time,* this period marked a boom in advertising revenues, which in turn paved the way for the magazine's golden era of the photo essay. For the nation, this period also marked another milestone with the election of Barack Obama, the first African-American president.

Newsmakers. *Time* told history every seven days through the newsmakers it portrayed. Pictured is Elvis Presley, the King of rock 'n' roll, entertaining the troops in an army barracks in Germany in 1958 (opposite). Fascist dictator Benito Mussolini's first *Time* cover was August 6, 1923 (top). After D-Day, General Dwight Eisenhower was named 1944 "Man of the Year" (middle). The September 22, 1947, cover featured baseball's first black player, Jackie Robinson, as Rookie of the Year (bottom).

For this book, we commissioned four distinguished newsmakers to write essays that examine their particular relationship with the magazine. Walter Isaacson, former *Time* managing editor and best-selling author of biographies on Albert Einstein and Benjamin Franklin, writes an essay on the legacy of founder Henry Luce; distinguished filmmaker Steven Spielberg recalls when *E.T. The Extra-Terrestrial* was featured in an article in *Time* and how the movie business has changed since then; renowned diplomat and presidential advisor Henry Kissinger reminisces on his relationship with *Time* during the turbulence of Vietnam and Watergate; and Bill Gates, the digital revolution's godfather, writes about how *Time* covered the era of information technology and explains why he believes in *Time*'s survival. Also included are sections titled "My days at *Time*" that include archival text and new interviews with former and current *Time* staffers and shed new light on the publication.

Time began as a mirror of the world, and now, eighty-seven years after its inception, *Time* has also become the lamp of history, offering clarity in a confusing world and explaining not only what happened but also why, turning information into knowledge and giving it significance. Today's *Time* continues to evolve in continuous movement to the rhythm of the history it follows and interprets, true to its well-known slogan—"*Time* will tell."

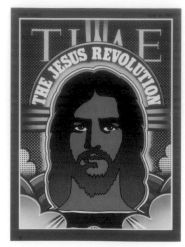

1971. The Jesus Revolution

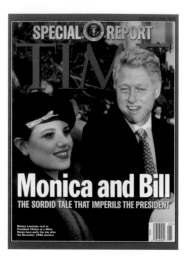

1998. Monica Lewinsky and Bill Clinton

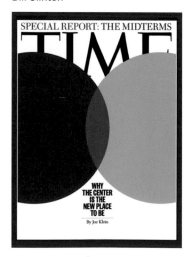

2006. Why the Center is the New Place to Be

Trends and social issues. On June 21, 1971, the magazine devoted its cover to the surge in religion among the young (top). In February 2, 1998, it covered the scandal that imperiled the presidency of Bill Clinton (middle). The November 20, 2006, cover illustrates the changes that took place after the 2006 midterm elections (bottom). This page from the January 16, 1939, issue was part of a series of self-promotional ads profiling the readers of *Time*. It focused on women, stressing their key role in the community (opposite).

YOU

are a good citizen

You do about a million hours a week of unselfish work —that hard personal work that is impersonally called "Civic Welfare." And *that's* a restrained phrase to describe your deep concern for better housing and more playgrounds, for ward patients or underfed children.

What a lot of people must have a warm respect for you women in TIME's 700,000 families. For nearly half of you—307,300—are active in helping others.

It may be specific help or help for the community you live in. School boards improve ventilating and heating systems at your insistence, level grade crossings give way to overhead passes, the city dump may even become a public park if you demand it.

Individually you may be a little embarrassed when TIME tells you how fine—and how important—you are —but aren't you proud of the other 307,299 of you?

TIME ★ THE WEEKLY NEWSMAGAZINE

A SERIES TO LET TIME READERS—SO WELL-INFORMED ABOUT THE NEWS—BE WELL-INFORMED ABOUT TIME READERS

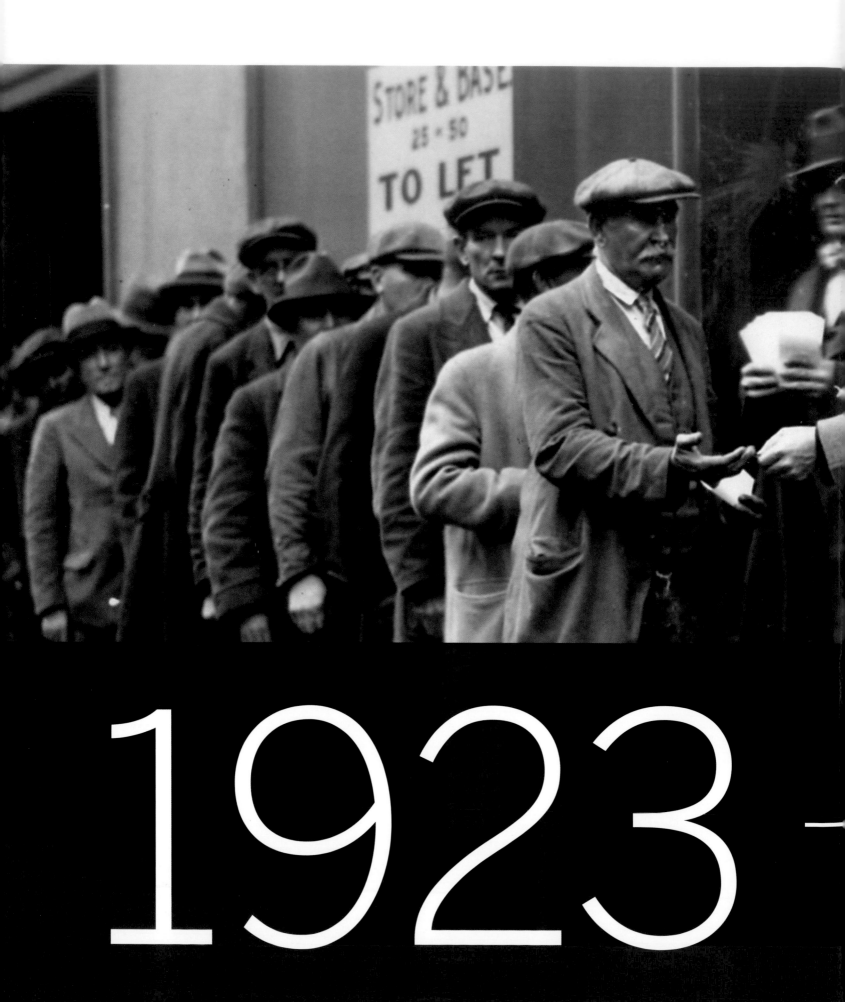

1923

MR. GLAD

will be at this corner this after-
noon at 4 o'clock to distribute
ONE THOUSAND NICKELS
to One Thousand needy Men

GLAD

AND NICKELS

needs Men

APPLES

-1967

1

Writing History Every Seven Days

The two were born a few months apart in 1898, but thousands of miles away: Briton Hadden on February 18 in Brooklyn, New York; Henry Luce on April 3 in Tengchow, China.

Their year of birth was the first of many coincidences between the two men who, twenty-five years later, would change the history of journalism with their brainchild: *Time, The Weekly News-Magazine*, which launched on March 3, 1923. The publication started the era of the modern newsweekly and would become, through the years, one of the most innovative and influential magazines in the world.

Their lives were full of coincidences, even though their origins were very different. Luce was born in China, the son of a Presbyterian minister who had settled in that distant country to carry out missionary work. He helped run a small school for Chinese who had converted to Christianity. In China, little "Harry," as he was called, attended a British school that placed great emphasis on a moral and religious upbringing. At the age of seven, Henry Luce first traveled to the United States, and from then on he hoped to live in that country. Little Harry's dream came true when he received a scholarship to the Hotchkiss School in Connecticut. There he met Briton Hadden, who had grown up in residential Brooklyn Heights. When Hadden was seven, his young father, a stockbroker, died. His mother later married a successful physician. Hadden attended private schools and summered in places like Quogue and Westhampton, Long Island, as was common among the members of the prosperous American middle class.

Luce and Hadden had little in common: they had different upbringings, different temperaments

Depression. After the "Roaring Twenties" came a period of shortages and hardship. Images of people forming long lines outside of soup kitchens became emblematic of the economic crisis of the 1930s. (Previous spread)

Meeting. Henry Luce (opposite, left) and Briton Hadden met at the Hotchkiss School in Connecticut. The two went on to Yale University and military training together at Camp Jackson South Carolina. They were both hired to work as reporters at the *Baltimore News*. In March 1923, they launched *Time*—Luce was twenty-four, Hadden was twenty-five.

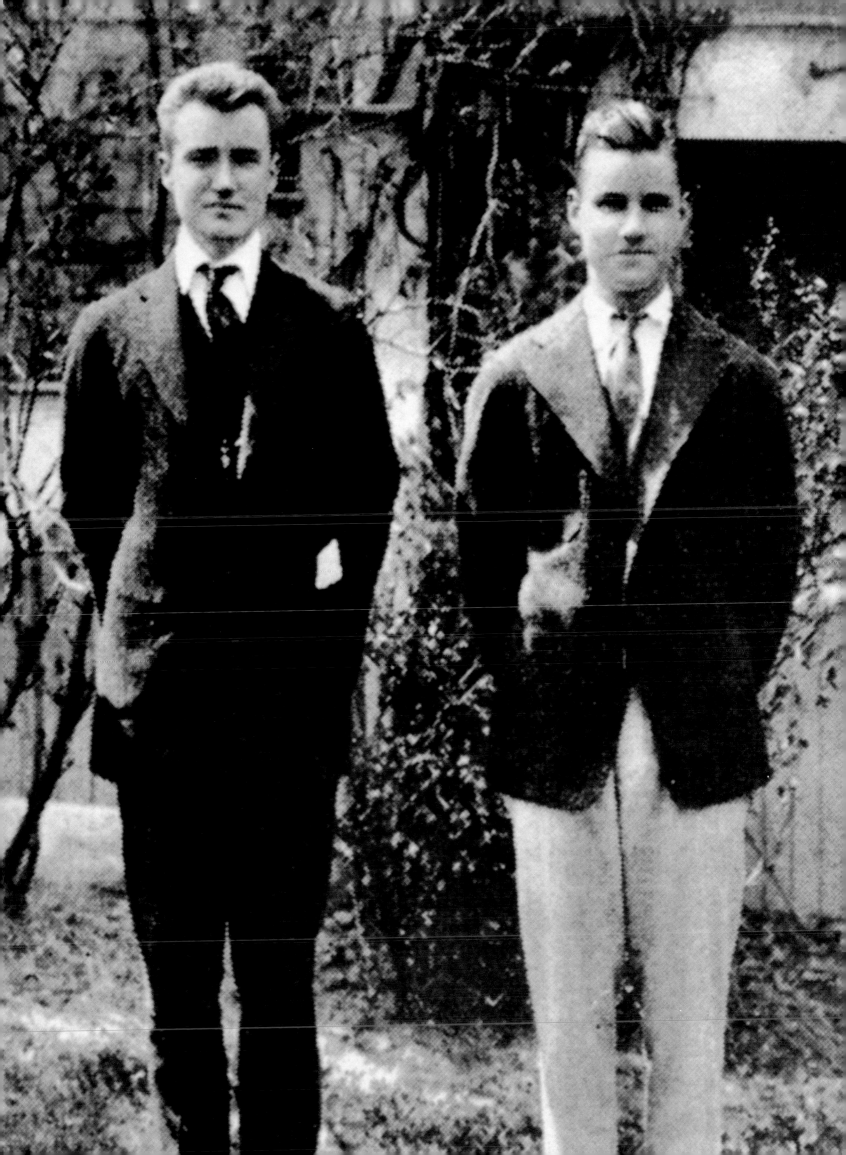

and few shared experiences. Only one thing brought them together: their mutual passion for journalism. At Hotchkiss, Luce and Hadden edited rival student publications. Hadden's publication, the *Hotchkiss Record*, featured international news on the cover along with school news inside, plus a current affairs column devised to—as he explained then—create a condensed record of the most important events for Hotchkiss students who didn't have time to read the newspaper. (A preview of what would become *Time* and its news summary style.) Luce's publication, the *Literary Monthly*, featured an illustrated fourteen-page section with stories on the most prominent personalities of the day. (A preview of what would become *Time* and its newsmaker features.)

They both ended up at Yale University in the fall of 1916, and in August 1918, they both attended Camp Jackson, the South Carolina military camp where *Time* was born. At Camp Jackson, the two young men started training in anticipation of being called to serve as U.S. Army officers during World War I. Luce made reference on several occasions to the close relationship he and Hadden developed in military camp, and mentioned Camp Jackson as *Time*'s birthplace. In *Time Inc., The Intimate History of a Publishing Enterprise, 1923–1941*, commissioned by *Time*, Robert T. Elson quotes Luce as saying, during a dinner celebrating the magazine's twentieth anniversary:

> "There's a picture in my mind ... of an army camp in the last war; of two underaged second lieutenants, Brit Hadden and Harry Luce—two shavetails, two second loonies doing training duty down in Camp Jackson, South Carolina. It was sickeningly hot that summer, but it cooled off a little at night. One night Brit and I were walking back to our

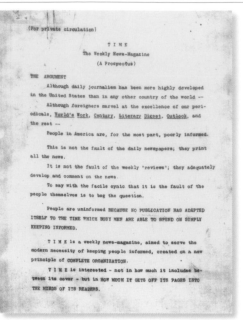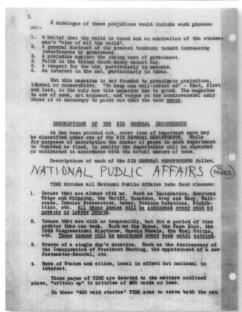

Brief. After working for several months on fine-tuning their concept for the magazine, Luce and Hadden showed the project to Samuel Everitt, treasurer of Doubleday, Page & Company. Their typewritten pages (above) explained the content of the new publication, section by section. Everitt advised, among other things, that Luce and Hadden learn about distribution before undertaking the venture.

barracks through the vast, sprawling camp. At each step, our feet sank ankle-deep into the sand. But we ploughed on for hours—and talked and talked.

For many months we hadn't either of us talked about anything except artillery, mess, inspection—and Saturday night when we went to town and smoked a cigar. Here we were talking about 'that paper'—about something we would do—cross our hearts—some day ... I think it was in that talk that *Time* began ... Why do I say that *Time* was born during that long talk, of which I cannot remember a single phrase or sentence? On that night there was formed an organization. Two boys decided to work together. Actually that had probably been decided long before then. But that night seemed to settle it. Somehow, despite the greatest difference in temperaments and even interests—

somehow we had to work together. We were an organization. At the center of our lives—our job, our function—at that point everything we had belonged to each other...."

Once their military training was over, Hadden and Luce returned to Yale, graduated and followed different paths, but always with the idea of someday fulfilling the commitment they had made under the name of "that paper."

Luce headed to England, to attend Oxford, and then to Chicago, where he joined the *Chicago Daily News* as a reporter. Hadden, on the other hand, settled in New York and began his journalistic career at the *World*. But soon after, in 1921, their paths would cross once again, this time in Baltimore, where they were asked to work for the *Baltimore News*. Luce and Hadden spent all their free time developing

Birth certificate. The two young men presented the ideas for the publication they were about to launch to advertisers. This is the cover of the document they printed (opposite). To test the waters, Everitt provided a list of subscribers. From the 7,000 copies sent, 6.5 percent of the responses were positive, which was actually quite good.

TIME

The WEEKLY NEWS-MAGAZINE

Announcing

the publication of

a brief, readable

chronicle of

significant events

TAKE
TIME
IT'S
BRIEF

DE OMNI RE SCIBILI ET QUIBUSDAM ALIIS

After frantic thought we have come to the conclusion that a name which explains the mag like "Review" or "The Weekly News Budget" (as one advertiser proposes) will have no distinction.

TIME does not explain, but there is a connection which sub-consciously people ought to catch on to easily. What do you think?

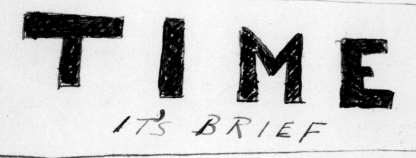

TIME
IT'S BRIEF

Another Slogan

TIME IS INTERESTING
Because ———————— It's Brief.

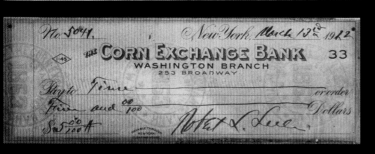

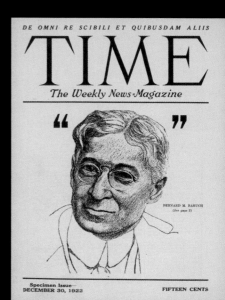

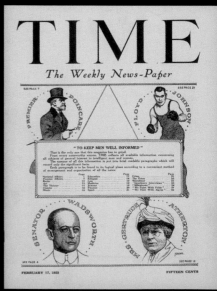

their idea. On February 6, 1922, they quit their jobs in Baltimore and moved to New York, where they devoted themselves to settling three fundamental issues regarding the future of the new magazine, which they initially called *Facts*: proving that there was room for another weekly publication; clearly defining it to show how it was different from existing publications; and obtaining the money to publish. And so a new story began.

As soon as they arrived in New York, the two young men looked for a place to set up shop. Resources were scarce; both lived at home with their families and neither had much money to invest. With Hadden's savings, they were able to rent a house at 141 East Seventeenth Street for $55 a month and buy some used furniture for $48.70. They both smoked heavily and to save money they shared one ashtray—an old iron container once used to make soap—which they placed between their desks. Hadden was about to turn twenty-four and Luce was six weeks his junior. They had very limited experience and limited funds, not exactly the best formula for launching a magazine.

But Luce and Hadden's biggest asset was their brainchild: a typewritten prototype showcasing their project. They first took the project to Samuel Everitt, treasurer of Doubleday, Page & Company, which published magazines and books. Everitt liked the project but wasn't interested in buying it. Luce and Hadden then sought the advice of their former writing professor at Yale, Henry Seidel Canby, now editor of the *New York Evening Post*'s literary review. Canby's advice was fundamental for the future of the magazine—it was essential for Luce and Hadden to develop a writing style for the magazine to set it apart from the rest and give it a tone of its own.

Luce and Hadden decided to better define the magazine's identity before

setting out to find financial backers. At that time, there were 2,033 newspapers in the United States, fourteen of them in New York City. General-interest magazines covering a wide range of topics were very popular. The *Saturday Evening Post* with 2.2 million subscribers headed the list. *Literary Digest*, *Atlantic*, *Harper's*, *Scribner's* and the *Century* were also very popular.

The main goal now became to clearly state that the new magazine would be very different from the rest, that it would have its own place and create its own space. The magazine's basic principles were included in a prospectus introducing the publication, which was already called *Time*. On his way home one night after working on the magazine's prospectus, Luce saw an ad reading something like: "Time to retire" or "Time for a change." The word "Time" had such an impact on him that he didn't pay attention to the rest. "Time" immediately became the future magazine's name. Their prospectus, now considered a historical document on the magazine's origins, begins:

"Although daily journalism has been more highly developed in the United States than in any other country of the world—

Although foreigners marvel at the excellence of our periodicals ... people in American are, for the most part, poorly informed.

This is not the fault of the daily newspapers; they print all the news.

It is not the fault of the weekly 'reviews'; they adequately develop and comment on the news.

To say with the facile cynic that it is the fault of the people themselves is to beg the question.

People are uninformed BECAUSE NO PUBLICATION HAS ADAPTED ITSELF TO THE TIME WHICH BUSY MEN ARE ABLE TO SPEND ON SIMPLY KEEPING INFORMED."

After laying the groundwork and establishing that lack of time was a problem for those who enjoyed reading, Luce and Hadden described their product in detail and explained what would set *Time* apart from all other publications:

"*Time* is a weekly news-magazine, aimed to serve the modern necessity of keeping the people informed...

Time is interested—not in how much it includes between its covers—but in HOW MUCH IT GETS OFF ITS PAGES INTO THE MINDS OF ITS READER...

From virtually every magazine and newspaper of note in the world, *Time* collects all available information on all subjects of importance and general interest. The essence of all this information is reduced to approximately 100 short articles, none of which are over 400 words in length (seven inches of type). Each of these articles will be found in its logical place in the magazine, according to a FIXED METHOD OF ARRANGEMENT which constitutes a complete ORGANIZATION of all the news..."

While writing the prospectus, the enterprising young men got in touch with friends and Yale classmates, who ended up being their main partners and project backers. By October 1922, Luce and Hadden had raised $85,675—$15,000 short of the goal they had set for the launching. Robert L. Luce, a cousin of Henry's, a judge and Yale alumnus, wrote the company's articles of incorporation, dated November 28, 1922. *Time* made its debut almost one hundred days later, on March 3, 1923.

Historical letters. Both Luce and Hadden were very fond of writing to relatives to offer details of their plans for the new magazine. In 1922, Luce sent a long, handwritten letter to his father (opposite, top left). In it, in block letters, he drew the word "TIME"—a preview of the magazine's name and logo.

Prototypes and first subscriber. Before the magazine's debut, Luce and Hadden created two sample editions: one with a lighter font for the logo (opposite, top right), and the other a heavier font (opposite, bottom right). In the end, an intermediate font was chosen. Judge Robert L. Luce, a distant cousin of Henry Luce, who drew up the incorporation papers, sent in his check a year before publication, when Luce and Hadden were fine-tuning their ideas (opposite, bottom left). He was the first of 6,000 initial subscribers.

The First Issue

When the young men showed their prototype around, everyone was impressed by the unique way they planned to display the news every week. But the big question to most was how the stories would be written and how the publication's distribution would be set up. To deal with those challenges, Luce and Hadden decided to split up the tasks: Luce, who was better at numbers, would handle circulation and product management, while Hadden would devote himself exclusively to editorial. The two also agreed that they would alternate the editing role yearly. Luce started out by learning mail distribution techniques, while Hadden focused on setting up the newsroom. Before the launch, they produced two dummy issues and tried out writers. The staff was made up of several novices: Manfred Gottfried, a recent Yale graduate; Thomas John Cardell Martyn, in charge of the "Foreign News" section; Louis Bromfield, who would receive a Pulitzer Prize in 1927 for his novel, *Early Autumn*; and John Thomas, who would later gain notoriety with his successful book, *Dry Martini*.

After several weeks of intense work, just past midnight on the last Tuesday of February 1923, Brit, Harry and practically the entire newsroom went by cab to a small print shop, Williams Printing Company, to take care of the last few details of the magazine. They wrote, cut and pasted, edited phrases, sized articles and closed. When Luce finally saw the galleys he remarked:

> "I picked it up and began to turn through its meager 32 pages (including cover). Half an hour later, I woke up to a surprise: what I had been reading wasn't bad at all. In fact, it was quite good. Somehow it all held together—it made sense, it was interesting."

And so on March 3, 1923, with 9,000 plus copies at fifteen cents a copy, *Time, The Weekly News-Magazine* hit the streets of the United States, starting the era of the newsmagazine now known worldwide. Its cover featured a charcoal drawing, without a headline, of the tough-looking Joseph Gurney Cannon, a veteran eighty-six-year-old congressman, who had just announced he was retiring from the U.S. House of Representatives after a then-record twenty-three terms. Inside, the story, under the headline "Uncle Joe," took up fifty lines, little less than a column. The article, one of 119 that *Time* published in its first issue, was featured in the "National Affairs" section.

In short, in its thirty-two pages (including the cover) and twenty-two sections—National Affairs, Foreign News, Books, Art, The Theatre, Cinema, Music, Education, Religion, Medicine, Law, Science, Finance, Sport, Aeronautics, Crime, The Press, Milestones, Miscellany, Imaginary Interviews, Point With Pride and View With Alarm—*Time* offered an abundance of news from all continents, and summarized just about every aspect of the political scene and American life.

But what innovations did Hadden and Luce introduce into the magazine world? The first and most prominent was the way their magazine organized the news. They divided pages into sections of short articles, which were arranged according to importance. In addition to this way of presenting the news, *Time* made another great contribution: the interpretation of the news. It transported the reader to each event, and it drew connections to others and to the history of the place where the events happened. It put news into context. *Time* summarized in a few lines what had happened during the week regarding a particular event, interpreted the event, assessed its importance and

First cover. With the image of Senator Joseph Cannon, Speaker of the House of Representatives, on the cover, *Time* was launched on March 3, 1923 (opposite). The thirty-two-page first issue contained 119 articles. The cover story, part of the "National Affairs" section, one of twenty-two sections in the publication, barely took up fifty lines. The issue had a 9,000-plus circulation—thus began the modern newsmagazine era.

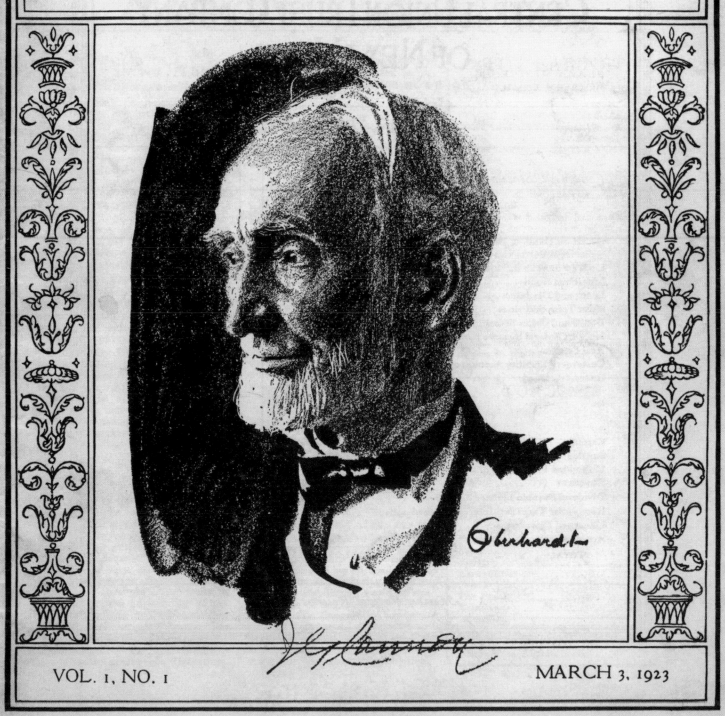

FIFTEEN CENTS

TIME

The Weekly News-Magazine

VOL. 1, NO. 1 MARCH 3, 1923

TIME
The Weekly News-Magazine

Published by TIME, Incorporated, at 9 East 4th St., New York, N. Y. Subscription, $5 per year. Application for entry as second-class matter is pending.

Vol. I, No. 1 March 3, 1923

NATIONAL AFFAIRS

PRESIDENCY

Mr. Harding's Defeat

Seeking only the nation's welfare, Mr. Harding has suffered defeat at the hands of Congress. Not only that, but the man who was elected President by the largest plurality in history has been reproved by a Congress controlled by his own party.

The Ship Subsidy Bill, never popular, and never made so by the President, was politely strangled to death.

The wisdom of some of the most important of the President's appointments has been questioned. For example, Daugherty, Butler, Reily.

The Bonus almost is not laid.

Nothing which has recently emanated from the White House which could be called a foreign policy has secured the united support of the President's party.

Today Mr. Harding is prepared to draw a deep breath, for Congressional politics will soon cover the horizon. After a short holiday in Florida he will gather about him the business men of his cabinet and counsel to manage the affairs of the nation, untrammeled until a new Congress rises—from the West.

In 1924

Who will be the Democratic Presidential nominee in 1924?

Before Senator Oscar Underwood sailed for Egypt last week he wrote the following sentence in a letter to a fellow Alabaman: "When I return I shall give very careful and thorough consideration to the friendly suggestions that are being made in reference to the advisability of my entering the fight for the Presidential nomination of our party."

Mr. Underwood's candidacy is being advanced by the more conservative element among the Democrats.

Mr. Ford and Mr. McAdoo, both of whom may fairly be classed as progressives, have received most of the boom advertising this far.

Democrats who do not take kindly to either Mr. Ford or Mr. McAdoo extol Oscar W. Underwood as a "second Grover Cleveland." And Mark Sullivan, dean of Washington critics, adds: "Underwood's relation to his party and public life generally is not unlike the relation of the new British Premier, Bonar Law, to British public life. Underwood, indeed, might claim not unreasonably that he is probably, on the whole, a somewhat abler man than Bonar Law. Certainly he has a greater experience in public life and in party leadership."

A New World Court

Mr. Harding and Mr. Hughes proposed that the United States join The Hague Permanent Court of International Justice. The suggestion gained the support of two men as far apart politically as former President Wilson and Ambassador Harvey.

The Court acts independently of the League of Nations. It is composed of 15 judges, chosen by the League, who serve nine-year terms. They will build up a body of law upon which to base their decisions, which will not be reviewed by the League. The decisions will not be put into effect by force, but by prestige and public opinion.

"Such action," Mr. Harding said, "would add to our own consciousness of participation in the fortunate advancement of international relationship and remind the world anew that we are ready for our proper part in furthering peace and adding to stability in world affairs."

Whether or not the plan is put into effect by this Congress or another or not at all, the multiplication of such proposals coming from our own government shows a growing sense of American discontent with isolation.

THE CABINET

Postmaster-General New

The name of Mr. Harry S. New, retiring Senator from Indiana, will be presented to the Senate for confirmation of his appointment as Postmaster General some time before that body disperses.

At the same time the nomination of Postmaster General Hubert Work as Secretary of the Interior will go to the Capitol.

President Harding has a Cabinet again. The resignation of Secretary Fall for announced reasons of ill health left a vacancy difficult to fill. When Secretary Hoover and Mr. John Hays Hammond, obvious first choices, rejected the position, the President found himself in a difficulty.

Mr. New is 64. Included in his qualifications is experience as a big game hunter, an editor, and as a soldier in the war against Spain.

CONTENTS

IMAGINARY INTERVIEWS

(During the Past Week the Daily Press Gave Extensive Publicity to the Following Men and Women. Let Each Explain to You Why His Name Appeared in the Headlines.)

Jack Dempsey: "When newspaper reporters mentioned my name to General Degoutte commanding the French in the Ruhr, he asked: 'Who is Jack Dempsey?' For that matter, I never heard of General Degoutte!"

The Prince of Wales: "Propagandists maintain that all factions in England and Ireland would unite if only I should marry Mrs. MacSwiney."

Prince George, youngest son of King George V: "I consented to have my two little toes removed. I had been afflicted with 'hammer-toe'—a shortening of the tendons which causes the little toe to curl up and is very painful in walking and dancing, of which I am very fond."

Prince Bernardes of Brazil: "I sent a message of congratulation to *The New York World,* which promoted the New York-to-Rio flight of Pilot Hinton. I referred to aviation as 'that enterprise in which the Americans are unsurpassed—having given wings to man.'"

The boy Emperor of China: "I have adopted the name of 'Henry' for myself and of 'Elizabeth' for my recent bride, Princess Kuo Chia Si. I did so in admiration of Henry VIII and Queen Elizabeth."

Prince Bullawa Cetewayo of Zululand: "I arrived in Chicago and inspected the flappers. Then I issued this statement: 'We do not have flappers in Zululand. I think American standards are far too loose.'"

Lady Elizabeth Bowes-Lyon, fiancee of the Duke of York: "My future mother-in-law, Queen Mary, presented me with a diamond brooch, formed like a rising sun."

Edward Young Clark, Imperial Giant of the Ku Klux Klan: "The Propagation Department of the Klan was taken from my control. People say this means the severance of my official relations with the Invisible Empire."

Mary MacSwiney, widow of the Mayor of Cork: "Since her arrest by Free State soldiers on Feb. 13, Annie MacSwiney has been on a hunger strike and is getting very weak. So I cabled my brother-in-law in New York: 'Notify friends in United States to protest.'"

Governor Alfred E. Smith of New York: "I attended a dinner of 400 newsboys in Manhattan and told them: 'Each of you can be the President of the United States, if you want to.'"

General Charles G. ("Hell and Maria") **Dawes:** "I told the Union League Club of Chicago that in the last ten years there have been more demagogues in Congress than ever before. So *The New York Times* said I was 'inclined to take too bilious a view of things.'"

Henry Ford: "Both branches of the Nebraska Legislature invited me to come to their State and indicate its waterpower. I am usually ready to respond to the call of the people."

John D. Rockefeller: "When I recovered from my recent illness, I went out and played golf. Motion picture men photographed me hitting a 14-foot putt. Arthur Brisbane, Hearst Editor, commented: 'Alexander, advancing his dissatisfied generals, held up his purple cloak, saying that was all that he had got out of it. My Rockefeller might hold up his little golf ball and putter, saying: "This is about all I got out of it!"'"

Edith Rockefeller McCormick: "*The Chicago Herald-Examiner* quoted me as saying: 'I was the first wife of King Tutankhamen. I married him when I was only 16 years old, and died two years later.' My interest in re-incarnation is of many years' standing."

Princess Yolanda of Italy: "I visited in Turin the parents of my fiancé, Count Calvi di Bergolo. Together we inspected several villas in order to chose one to live in after our wedding in April."

Harry K. Thaw: "Having received a ten day furlough from the Pennsylvania Hospital for the Insane, I went home to Pittsburgh to visit my mother."

Admiral Von Tirpitz: "I published an article in one of Hugo Stinnes' papers, *Die Allgemeine Zeitung,* in which I said that although it would be difficult to forget the 'barbarous methods of war employed by the English,' Germany must strike out on paths that will make serious antagonism to the Anglo-Saxon impossible."

Mayor John F. Hylan: "My hotel room at Palm Beach costs $12 a day. I told a reporter that Mrs. Hylan and I have a room and bath, but no maid, no secretary, no animals."

Benito Mussolini: "When I act as notary of the Crown at the marriage of Princess Yolanda and Count Calvi in April, the King will confer on me the Order of the Annunziata. That means I shall rank as a cousin of the King."

POINT with PRIDE

After a cursory view of TIME's summary of events, the Generous Citizen points with pride to:

Uncle Joe Cannon, retiring after weathering the Congressional storms of 50 years. (P. 2.)

Female efficiency, with Mrs. Mabel Willebrandt as acting head of the Attorney-General's office. (P. 4.)

The new touch of dignity added to Supreme Court procedure by Chief Justice Taft. (P. 4.)

Uninvited guests whose departure was requested by their hosts—our army returned from Germany. (P. 4.)

The efficiency of the Chilean Department of Health, which demands that our delegates to the Pan-American Conference be vaccinated. (P. 6.)

Annual taxes of $90 per capita which England bears like a great nation, without grumbling. (P. 8.)

The S. S. *Majestic,* on which an eminent British statesman, Lord Robert Cecil, arrives—not on a mission; no, nor lecture tour. (P. 8.)

Czecho-Slovakia, the only nation of Central Europe ready to pay her debts. (P. 10.)

A night's sleep, on a soft bed, in mid-air, and a thousand miles traveled between sunset and sunrise. (P. 19.)

The first successful helicopter. (P. 21.)

The harems of the Turk, from which a new womanhood is to walk into a larger destiny. (P. 10.)

The four hundred (not society people) whom Governor Smith of New York picks as possible future Presidents. (P. 26.)

Hanihara's determination to avoid questions likely to cause disagreement with the United States. (P. 11.)

Castor oil, a cure for popular indifference to the polls. (P. 9.)

The cause of the classics. (P. 17.)

offered an opinion about it. In addition, *Time* made another significant innovation: *a description of the personalities behind the news*. It made newsmakers' personalities central to each article, allowing readers to get to know them. Aside from all this, *Time* offered a revolutionary writing style that gave the publication relevance and personality, and even brought new words into everyday use.

Time's determination to set itself apart from other publications, and above all, to show its own personality and character, reached levels seldom seen before. For instance, unlike other publications, the magazine did not include a table of contents in its first few pages. Instead, *Time* featured a summary of the news in its last few pages in an unusual way: ranking the news. On page twenty-seven of the first issue, in a column under the heading "Point With Pride," the magazine made up an imaginary character that it called the "Generous Citizen." This "Generous Citizen" selected the items that the magazine considered to be positive and organized them "with pride," indicating the page number where readers could locate them. On page twenty-eight, another imaginary character, the "Vigilant Patriot," apprehensively listed some fifteen news items in its content that were not to his liking. The section was entitled "View with Alarm." Regardless of the fact that its pages didn't include an editorial section, this trait—the magazine's opinion—was permanently present in each published item. *Time* provided the news viewed from different angles and offered its own point of view. And it did so in all its sections.

In the "National Affairs" section of the first issue, in an article on a monument that was planned in homage to black nannies, *Time* reported:

"In dignified and quiet language, two thousand Negro women ... protested against a proposal to erect at the Capitol a statue to 'The Black Mammy of the South' ... (seeing it as) 'the reminder that we come from a race of slaves.' This, of course, will rebuke forever the sentimentalist who thought they were doing honor to a character whom they loved ... But that person's educated granddaughters snuffed out the impulse by showing that they are ashamed of her."

The "Books" section was likewise marked by *Time*'s opinion, and not only in the reviews. In an aggressively antimodernist article, the magazine defended readers' rights:

"There is a new kind of literature abroad on the land, whose only obvious fault is that no one can understand it. Last year there appeared a gigantic volume entitled *Ulysses*, by James Joyce. To the uninitiated, it appeared that Mr. Joyce had taken some half million assorted words—many such as are not ordinarily heard in reputable circles—shaken them up in a colossal hat, laid them end to end. To those in on the secret the result represented the greatest achievement of modern letters—a new idea in novels ... the admirers of Messrs. Eliot, Joyce, et al., (contend): Literature is self-expression. It is up to the reader to extract the meaning, not up to the writer to offer it. If the author writes everything that pops into his head ... that is all that should be asked. Lucidity is no part of the auctorial task."

The same order, rigor and meticulousness that Luce and Hadden used to lay the foundation of the magazine they had just created were applied to its everyday journalistic approach. Before publication, the issue went through countless filters. Consequently, *Time* is credited for being the magazine that created fact-checking, a strict and thorough verification system that contributed to the accuracy of information.

This editing process was carried out by the "fact-checkers," a team made up entirely of women—initially there were four—"[m]ore or less, depending on how many had recently quit," according to Isaiah Wilner's book, *The Man Time Forgot*. The fact-checkers acted as a newsroom within a newsroom and offered assistance, support and control of writers' copy. They were versed in history, grammar and geography, and their work began as soon as the stories to be published were selected. Initially, they set out to search for any additional information that would add to the story. Later, as press time approached, their task became obsessive, punctilious and even unpleasant for writers. They worked alongside them and, before a story reached the editor, it had to pass through the fact-checkers' strict filters. They checked off every piece of information in the copy—every historical event, name, place and date—and marked each fact with a dot: a black dot for facts from newspapers, a red dot for facts from books and a green dot for an unconfirmed fact for the staff editor to go back and correct. And the editor had to adhere to the fact-checkers' instructions, because if the slightest error slipped through to the final text, it was the fact-checker, not the writer, who was held responsible. Any adjective used inaccurately by the writer, any quote out of context, any physical description that didn't jibe with the picture exposed the fact-checker to a trial of sorts during the weekly errors report, in which the entire newsroom participated.

Front and back. The magazine was organized in sections. The first and longest (six pages) was "National Affairs" (opposite, top). The plan was for each page to feature ten to twelve stories. There was no editorial page, but *Time* offered its point of view in each of its articles and also in two columns, "Point with Pride" (opposite, bottom) and "View with Alarm." The founders' premise was that in just one hour, the time it took to read the entire magazine, readers could be informed about the most important national and international events.

From Good Magazine to Good Business

The press didn't seem too impressed with the launching of *Time*. The *World* devoted just a few lines to it, while *The New York Times* published four paragraphs related to the magazine's debut, saying that 100 prominent men were part of the original subscriber list. In addition, many copies in the first edition didn't reach their destination. Due to the inexperience of the young people hired to label the mailings, some subscribers received several copies while other subscribers received none. Despite all the effort that went into the first issues, they had many editorial and commercial lows and highs. Finances were a big concern. The business plan had little to do with reality: subscriptions were being dropped and newsstands returned more and more copies. Hard times soon followed; money was short and sporadic—Time Inc. often ran out of funds and the partners at times resorted to financial stunts to keep afloat. Sometimes, Hadden issued checks without signatures. By the time the checks were reissued with the signature of both partners, the necessary funds were in the account.

Today, more than eighty-five years after the publication's birth, it's worth remembering the foundations of the magazine's financial success. The young journalists, aided by advertising, subscription and circulation experts, were also forced to be creative and resourceful to keep their brilliant ship afloat.

First, Luce and Hadden discovered that their magazine was very popular with young people. It was they who most appreciated the new style used to publish the news. But of most impact, undoubtedly, were *Time*'s language, irreverence, character descriptions and made-up words. So the founders set out to go directly after young people by distributing and promoting *Time* on college campuses on both the East and West coasts. They promoted *Time* as an innovative, modern and indispensable product for young people with high aspirations. As a result, with carefully placed ads, circulation showed signs of recovering after the first month. In 1924, the guaranteed circulation was 30,000, which grew to 63,468 in October 1925 and to 69,876 by year's end. *Time*'s readers were not only college students but also now included young and progressive businessmen. Half of the subscribers were in New York and elsewhere on the East Coast, followed by the Midwest, the West Coast, the Mountain States and almost 600 subscribers from Alaska, Puerto Rico and Hawaii.

Second, the rapid increase in subscriptions was a result of *Time*'s innovative subscription campaigns. The most impressive and effective among them was the offer to pay the mailing cost of the subscription request. Roy Edward Larsen, the circulation manager, came up with the idea. He sent potential subscribers a sales letter with a stamped postcard. Along with Larsen, Hadden also thought of an original way to promote the magazine. He and Larsen used a new medium, the radio, which was becoming increasingly popular. They came up with a question-and-answer game that was very successful. The game was based on eleven questions about news items published in *Time*. Listeners had ten seconds to answer them at home. This challenge to the audience's knowledge was officially called "The Pop Question Game," but due to Hadden's constant reference to the magazine, many people called the game the "Time Questionnaire." The game was broadcast by WJZ, one of New York's top stations, and it was such a hit that stations in other states started carrying it.

At the same time, the magazine started to be associated with several slogans. The

Future president. Franklin Delano Roosevelt was featured on the cover for the first time on May 28, 1923 (opposite), ten years before his first term as president. He was also one of the magazine's first subscribers. Subscriptions increased by 1925, as did advertising revenues, due to a unique promotional system created by Roy Larsen and Robert Livingston Johnson, "circulation guarantee," in which ad rates were based upon circulation.

TIME

The Weekly News-Magazine

© Underwood

VOL. I, NO. 13

FRANKLIN D. ROOSEVELT
"The way to save is to stop"—See Page 26

MAY 28, 1923

most frequently used was "curt, clear & complete," to define its writing style. Just as popular was the phrase "from cover to cover" to identify the short time—an hour—it took to read the entire magazine. "Time marches on," a play on words using the publication's name, also came into use in 1924 to support the idea of reading and becoming informed in a short time.

Just as important, the magazine started to appeal to advertisers. *Time* was also forced to be innovative in the pricing of advertisements. The increase in circulation brought with it an increase in printing and distribution costs but not an increase in advertising revenue. Fourteen companies that had bought space in advance advertised in the new magazine. At that time, it was common

practice in the publishing industry for advertisers to pay the same price for each ad, regardless of the number of times they bought it. Also, they paid more according to the amount of space bought: a whole page cost exactly twice that of a half page. Advertising manager Robert Livingston Johnson considerably increased the price of smaller ads under the rationale that since the ads ran next to news stories, they were more visible to readers. In addition, Johnson offered discounts according to the number of times ads ran.

Without a doubt, Johnson's most revolutionary change, which would make history in the publishing world, was the creation of the so-called "circulation guarantee." In 1923, *Time* had a circulation

of just less than 19,000. The Johnson-Larsen duo promised advertisers to increase circulation to 30,000 subscribers by September 1924, to 35,000 by October 1924 and to 70,000 by December 1925. The numbers were verified by the postal service, which delivered the magazine to subscribers. In exchange, advertisers paid an increased ad rate, as long as circulation reached the targeted numbers. Otherwise, their money would be refunded. It was a good move for *Time*, and the "circulation guarantee" or "rate base" system was soon adopted throughout the publishing industry and became the norm used then and now by American magazines.

First newsmakers. Below are some of the noted figures featured on the cover of *Time*'s first ten issues: President Warren G. Harding was on the cover of the second edition; writer Joseph Conrad, on the sixth edition; and seven days later, on April 14, Winston Churchill appeared for the first time on the cover.

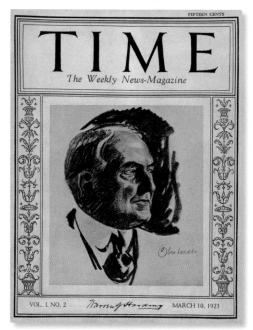

1923. Warren G. Harding

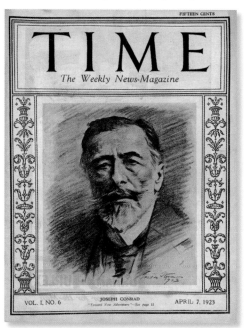

1923. Joseph Conrad

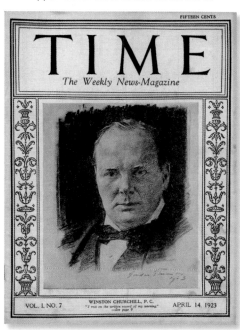

1923. Winston Churchill

Two years old. By 1925, its second anniversary, *Time*'s circulation had risen to over 70,000, as this in-house ad boasts (opposite), with a goal of 110,000 "guaranteed by January 4, 1926." To solicit more advertisers, the magazine boasted of its rapid increase in circulation and promised a "circulation guarantee."

Self-promotion and in-house ads. *Time* ran these in-house ads to tout the reasons for its success. The first ad, from 1928, highlighted *Time*'s uniqueness. The second ad, from 1933, noted the recent addition of Campbell's soup to the other well-known brands advertised in *Time*, among them Budweiser, Ovaltine and Heinz. (Following spread)

BORN MARCH 3rd 1923

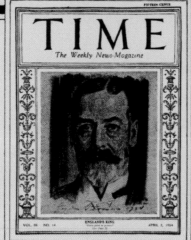

2 Years !

Just Look at the Husky Youngster NOW

No other magazine in the quality field has ever equalled TIME'S circulation growth. No other magazine in the past two years has delivered 110% more circulation than was promised.

TIME sells on its personality alone, without premiums and without "stunts." TIME'S readers are the cream of the country's most astute readers.

Keyed advertisements show TIME'S readers unusually responsive. Every advertising dollar spent in TIME buys the maximum of reader interest in a clientele unsurpassed by any other weekly or monthly in the U. S.—and TIME offers

OVER 70,000

QUALITY CIRCULATION AT MASS RATES

AND 110,000

GUARANTEED BY JAN. 4th, 1926

From every standpoint by which QUALITY Circulation is measured, TIME rightfully deserves the earnest consideration of every buyer of advertising space.

ROBERT L. JOHNSON, Advertising Manager

TIME
The Weekly News-Magazine

236 East 39th Street **New York City**

Send for Our Booklet

REPRESENTATIVES

WESTERN
Powers and Stone,
38 South Dearborn Street,
Chicago, Ill.

NEW ENGLAND
Sweeney & Price,
127 Federal Street,
Boston, Mass.

SOUTHERN
F. J. Dusossoit,
1502 Land Title Building,
Philadelphia, Pa.

There is Just *ONE* Newsmagazine!

There are thousands of Periodicals.
There are hundreds of Magazines.
There are dozens of Journals of Opinion.
There are several Weekly Reviews.
There is just one Newsmagazine.

It is TIME. TIME is not a journal of opinion, it is not a digest of opinion—it is all news, all fact.

There is one, and only one, complete record of the swift-changing civilization in which and through which you live.

It is TIME, the weekly newsmagazine, the first and only complete summary of all the news. TIME makes it possible for the busiest man to read the story of his life-time as he lives the story of his life.

For newsstand buyers the coupon below will effect a saving of $2.80 over the newsstand price — will ensure regular and prompt receipt of your weekly copy of TIME.

TIME
The Weekly Newsmagazine
NEW YORK · CLEVELAND · CHICAGO

TIME, Circulation Dept., Penton Building, Cleveland
Enter my subscription for TIME for one year ($5), and send me a bill.

Name...................................... Address..................................

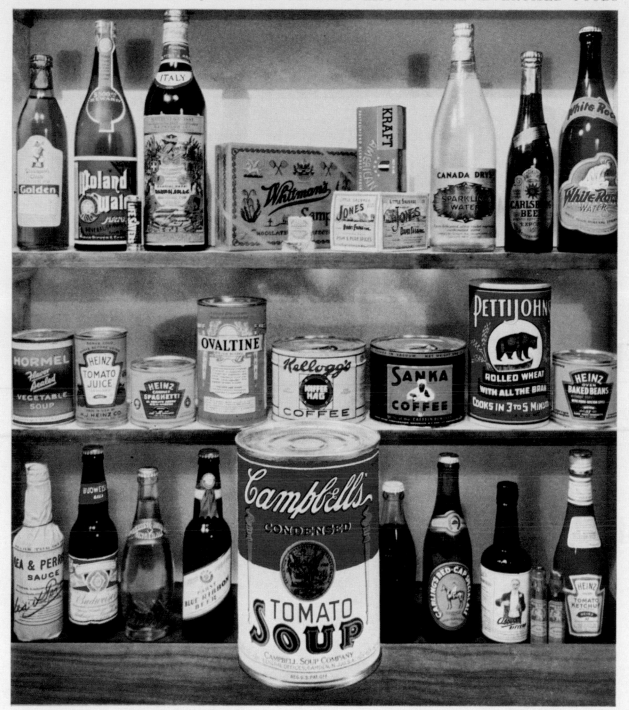

"**THE** time is ripe for aggressive, energetic action by the leaders of American business."—From a statement by A. C. Dorrance, President of the Campbell Soup Company, announcing the additions of TIME, Collier's, Liberty, New Yorker and True Story, to the extensive list of magazines already carrying Campbell Soup advertising. ● TIME, the Weekly Newsmagazine, has been selected for the new program because TIME is the favorite magazine of the Best Customers of the best stores ... The most profitable outlets for Campbell Soups and for all the foods and beverages advertised in TIME.

TIME is now second among all magazines in pages of national advertising. The most impressive gain in recent years has been in food and beverage advertising.

TIME
The Weekly Newsmagazine

The Writing Style, the Key to Success

Now, it is generally agreed that *Time*'s subscription increases and economic success were due to the way in which the magazine displayed and wrote the news. Although when the magazine initially appeared, some felt the writing style was shocking and aggressive.

Henry Grunwald, a writer in the 1940s and the magazine's managing editor in the 1970s, noted in his book *One Man's America: A Journalist's Search for the Heart of His Country*:

> "The early issues of *Time* were quite un-American, if measured by the pieties of Oskaloosa. It was irreverent and occasionally cynical. It was blunt, even graceless, in the way it pushed facts at the reader. A *Time* specialty was the more or less colorful detail often omitted from standard newspaper reports: the menu at a state dinner, the vintage of the wine with which the food (in the inevitable phrase) was 'washed down,' the color of the president's necktie.... People didn't simply die; instead 'Death, as it must to all men, came to So-and-So.' For obscure reasons, sentences were inverted to the point of self-parody.... *Time* insisted on printing middle names in full, which did not please everybody. Walter P. Chrysler, who prided himself on being a rugged, ex-mechanic, was furious when *Time* revealed that the middle initial stood for Percy. In a face-saving deal, *Time* agreed to omit the Percy, except once a year."

Under Hadden's leadership, *Time*'s editorial style, which has since become known as *Timestyle*, was forged. *Timestyle* was Homeric. There was a protagonist behind every news item, and a man behind every protagonist, with virtues and defects, distinguishing quirks, mannerisms, a way of acting, a style of dress and physical attributes—long legs, wide waistline or round face. Writers spared no effort to adapt to this style, in which newsmakers were powerful demigods or villains. From the very first issue, *Time* writers worked diligently to describe personalities. In the first cover article, *Time* made reference to Congressman Cannon's success by writing:

> "... On March 4 Uncle Joe will be gone and Henry Cabot Lodge alone will remain to carry on the banner of the ideal. To the American people, however, the senior Senator from Massachusetts must perforce seem a little too genteel, too cold, too Back Bay to serve as an adequate trustee for the Old Guard tradition. They will long for the homely democracy of Mr. Cannon, so often expressed by those homely democratic symbols—Uncle Joe's black cigar and thumping quid."

Also, in that issue, *Time* described Senator Joseph Robinson as "a fighting Southerner who talks with his fists. Born with a red-headed temper, he soon acquired freckles. But years of law and politics have induced a certain amiability, so that he now enjoys fishing."

In its early years, *Time*'s novel way of describing newsmakers became an obsession with the writers. Accordingly, Mexican President Francisco Madero was "wild-eyed," Minnesota Senator Henrik Shipstead was invariably "the duck-hunting dentist," George Bernard Shaw was "mocking, mordant, misanthropic" and General Erich von Ludendorff was "flagitious, inscrutable, unrelenting."

This characteristic that distinguished *Time* from the other magazines of the day did not arise by chance. The idea was analyzed, discussed and put into practice

Physics and personality. Physicist Albert Einstein is shown here in his house, circa 1925 (opposite). In the February 18, 1929, issue, before his fiftieth birthday, his wife Elsa described him: "Professor Einstein is not eccentric. He wears stiff collars when the occasion demands it without protest. He hardly ever mislays things. At least, not more than most men. He knows when it's time for lunch and dinner."

by the magazine's creators for a reason. Robert T. Elson, in his book *Time Inc., The Intimate History of a Publishing Enterprise, 1923—1941*, noted that Luce never got tired of repeating to his writers:

"No idea exists outside a human skull—and no human skull exists without hair and a face and a voice—in fact the flesh and blood attributes of a human personality. *Time* journalism began by being deeply interested in people, as individuals who were making history, or a small part of it, from week to week. We tried to make our readers see and hear and even smell these people as part of a better understanding of their ideas—or lack of them."

The work week began on Thursday. On this day, the writers in charge of each section met with the managing editor to offer their story ideas, which were drawn from the world's major newspapers. Once the proposals were approved, the arduous task of seeking additional information for each item began. The fact-checkers researched books, encyclopedias and clipping files to provide all the data that would enrich the basic story.

The main articles were written on Fridays, but often were later tossed out. The articles had to be condensed as much as possible. The process of selecting, eliminating and rewriting stories continued on Saturday. The writers worked from morning to midnight to ready the next issue for submission to the editor in chief first thing on Sunday. Until then, the writers struggled over every article, every sentence and every word. They looked for the exact synonym, the word that shortened the phrase as much as possible without losing meaning, strength or appeal.

This was the style and the objective that the magazine's creators firmly enforced:

Summarized style
John Martin, Hadden's cousin, managing editor from 1929–33 and 1936–37, is quoted by Lance Morrow:

"Brit would edit copy to eliminate unnecessary verbiage ... If you wrote something like 'in the nick of time,' five words, he might change it to 'in time's nick,' three words.... At all times he had by him a carefully annotated translation of the Iliad. In the back cover he had listed hundreds of words, especially verbs and the compound adjectives, which had seemed to him fresh and forceful." ("The Time of Our Lives" by Lance Morrow, in *Time, 1923–1998, 75 Years: An Anniversary Celebration*)

Short and concise
In the same book, Elson related a memo from Luce to the writers:

"The other day a fairly interesting item was written in 50 lines. I got fussing with it. Fuss. Fuss. Fuss. I fussed for an hour. At the hour's end I had in 30 lines every single fact which was in the 50 lines—plus one or two extra facts ... This particular story was interesting enough for 30 lines; in 50 lines it was dull ... [Writers] are supposed to have time enough and to be just as willing as the M.E. to sweat and swink until they have reduced 50 lines to 30—without losing a single fact..."

Taglines
Isaiah Wilner, in *The Man Time Forgot: A Tale of Genius, Betrayal, and the Creation of* Time *Magazine* explained *Timestyle*:

"Hadden had another purpose for Homeric style besides making *Time*

easy to read. He wanted his readers to grasp the importance of the people they read about and commit the facts to memory. Since he lacked the space to get too deeply into history and context, Hadden used the Homeric epithet to tell readers what they needed to know about newsmakers in just a few words. Every figure discussed in *Time* had his own tagline, even the 'famed poet William Shakespeare.' A frustrated reader wrote in to ask what was next—'onetime evangelist Jesus Christ'?"

Captions
Wilner related a variety of details about the magazine's emerging editorial style:

"Having placed public figures on a pedestal, Hadden found new narrative possibilities. He could, for instance, knock them down. *Time* published items about politicians fighting on the golf course, losing their swimming trunks in the ocean, and singing lewd songs to their children. While the newspapers printed posed photographs, Hadden realized that a candid picture could be more revealing. For years a startling image of the fascist dictator Benito Mussolini glared at readers from *Time*'s pages. 'His eyes rolled with fury,' the caption cracked. Even a reader who knew nothing of Mussolini could grasp that Hadden thought he was a no-good guy. If a public figure phoned *Time* to protest, Hadden would chirp. 'Cameras cannot lie.'"

Provocative voice
There were three guidelines for the magazine's voice, according to its

"Cinemactor." Charlie Chaplin was featured on *Time*'s cover for the first time in July 1925, the year *The Gold Rush* was released. The magazine wrote: "His hat, feet, waddle and harassed, insouciant smirk were familiar to South Sea Islanders." Chaplin (opposite) was referred to as a "cinemactor"—a term used for actor. "Cinemactor" and "cinemactress" were examples of the many words *Time* coined as part of its writing style.

1923. George Bernard Shaw

1924. Sigmund Freud

1925. John D. Rockefeller, Jr.

1925. Henry Ford

Influential. The magazine's founders believed that history was shaped by and could only be changed by key players and decision makers. *Time*, therefore, should inform its readers about these people. Above, some of the most influential thinkers and personalities in business, science and the arts featured on *Time*'s early covers.

1923. Eleanora Duse

1924. Mrs. Herbert Hoover

1924. Queen Marie of Romania

1924. Ethel Barrymore

First women. Few women were featured on the cover during the magazine's early days. As seen in the covers above, the first was Italian actress Eleanora Duse in July 1923. The following year, four women were featured, including future First Lady Louise Henry Hoover, Queen Marie of Romania and actress Ethel Barrymore, grandmother of the actress Drew Barrymore.

founders: Everything in *Time* had to be provocative, extremely concise and based on facts. The provocative voice spoke of "cinemactresses" or "cinemactors," "radiators" or said people were "great and good friends" if the purpose was to indicate they were lovers.

New words

Robert E. Herz Stein, in *Henry R. Luce: A Political Portrait of the Man Who Created the American Century*, explained:

"Brit turned nouns into adjectives, so a man who was a teacher became 'teacher Jones' ... An enthusiastic classicist, Hadden parodied Homer, describing people as 'wild-eyed' or 'long-whiskered.' He invented new words, like 'kudos' (for honorary degrees) and 'tycoon' for men of wealth."

Time created popular terms such as "socialite" (to define aristocrats who enjoyed socializing). Even the word newsmagazine, whose era began with the creation of *Time*, was shortened and its spelling changed in the same publication. Wilner wrote:

"Hadden and his writers also invented words in order to save space. The term *news-magazine* had begun as a compound noun. In 1927, when Hadden eliminated the hyphen, he coined a new word for a new type of news medium." (Isaiah Wilner, *The Man Time Forgot: A Tale of Genius, Betrayal, and the Creation of Time Magazine*)

Inverted syntax

English syntax rules establish a set structure for writing sentences:

subject, plus verb and predicate. *Time* disregarded this and moved sentence elements around as it pleased. For example, Wilner noted, its stories included such sentences as: "To Versailles (150 years ago) swarmed empurpled princelings, intent on an implicit mission of state," when the traditional structure would have been: "150 years ago, a swarm of princelings dressed in purple went to Versailles intent on an implicit mission of state." Or, as Robert Elson noted, *Time*'s writers turned the sentence structure around:

"A ghastly ghoul prowled around a cemetery not far from Paris. Into family chapels went he, robbery of the dead intent upon."

The creation of nontraditional writing techniques reached its maximum expression in the "Milestones" section, which announced births, weddings and obituaries in a unique way. For instance, the following item came out on September 14, 1925:

"Engaged. Monica Borglum, niece of Sculptor Gutzon Borglum and daughter of the late Sculptor Solon H. Borglum, to A.M. Davies of London, onetime officer in the Royal Air Force, son of Sir A.T. Davies, permanent Secretary for Welsh Education."

The following month, in the October 19 issue, *Time* ran this engagement announcement:

"Engaged. Georgette Cohan, 25, actress, daughter of famed comedian George M. Cohan, nine months-widow of J.W. Souther, to one H. Rowse, 'rich perfumer.'"

In the same issue, *Time* made note of a birth:

"Born. To Mrs. Ruth von Phul, so-called 'crossword puzzle champion,' a daughter, in Manhattan."

Among the researchers who have examined the *Timestyle* and its structure, Wilner best described the parts in which stories were divided and "hooks" used to grab readers' attention. Wilner exalted Hadden's work and placed him on a pedestal. Hadden's editorial style has an immense value in the magazine's history and its writing style. In the following excerpts, Wilner explains that:

Story structure

"Having invented a new writing style that made each sentence entertaining and easy to grasp, Hadden and his writers began to toy with the structure of the entire story. Most newspaper writers tried to tell everything in the first one or two paragraphs. By printing the most important facts first, they destroyed the natural narrative of news. Hadden trained his writers to act as if they were novelists. He viewed the whole story, including the headline and caption, as an information package. Some parts of the package provided little information; they grabbed readers, teased them, and encouraged them to move on."

Plot line

"The *Time* story followed a plot line. It opened with a bit of tension: the criminal marking time in his cell on the last day of his life; the teenage sensation waiting in the wings of the Metropolitan Opera as the crowd began to buzz; the swimmer coating her body with grease as she prepared to leap into the ocean. Crisis arose: the

Glamour. French fashion designer Gabrielle (Coco) Chanel (opposite), creator of the "poor chic" trend in the 1920s, was known for the simple elegance of her clothes, and became very popular in the United States. Between 1928 and 1938, *Time* mentioned her nine times, mostly in reference to the fashion scene in France and the United States, except for the November 27, 1933, issue, where *Time* announced in the "Milestones" section her engagement to painter, decorator and designer Paul Iribe.

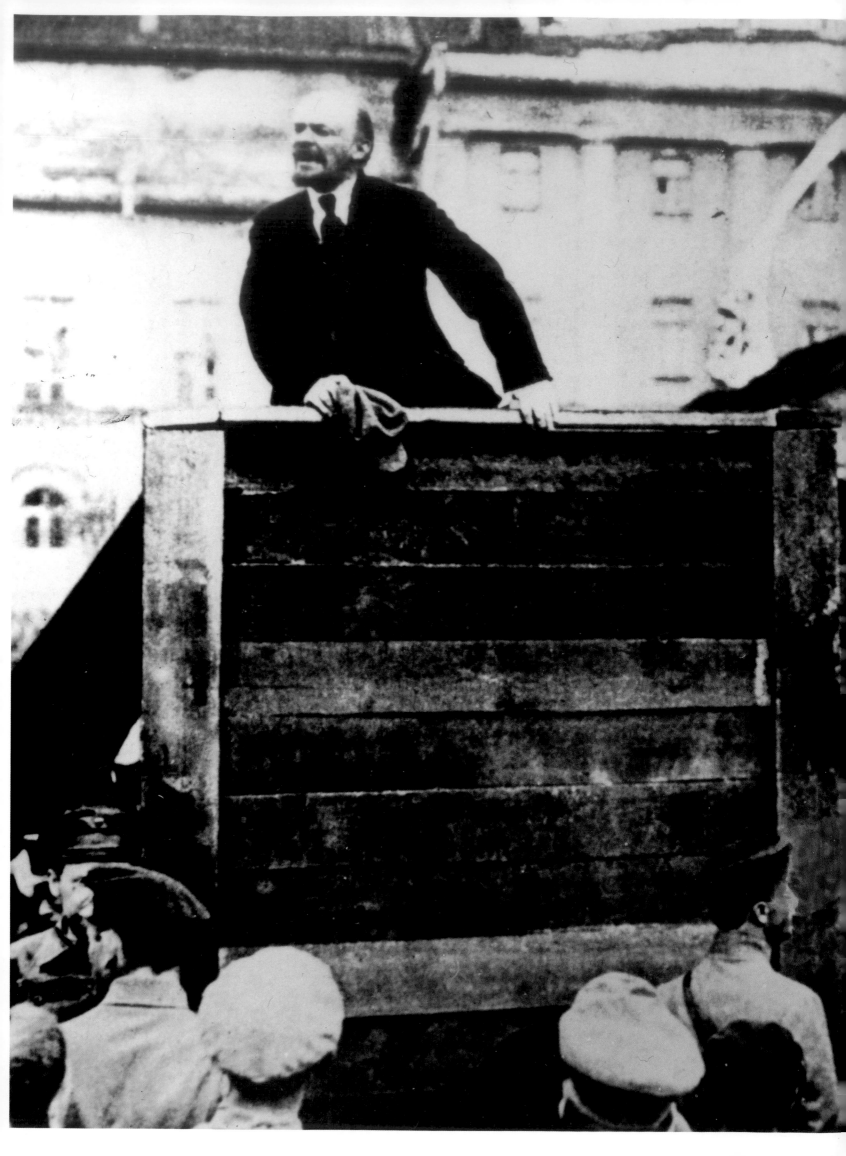

appeal was denied; the singer stepped into the spotlight; the swimmer grew faint, buffeted by angry waves. And then, resolution: mounting the gallows, the criminal confessed; romancing the spotlight, the singer burst into an aria; reaching the shore, the swimmer became the first woman to cross the English Channel."

Headlines and lead
"Hadden edited the entire magazine to create a sense of suspense. His headlines never gave up the story; instead they tantalized readers with titles like 'Sea of Revolt,' 'Place of Prodigies,' 'Flowers Wilt.' Opening sentences began at a cosmic level: 'Stars twinkle, the moon beams.' Or they began at the most minute: 'The long Presidential forefinger extended itself.' Often the start of a story took the tone of a tale told around a campfire: 'Out of Russia, weird and mystic land...' A story on Italy would coyly begin with the image of a dog howling and scratching at a spot in the forest floor. Carabinieri would prance by, capes flowing and swords rattling, to discover the object of the dog's intrigue—a murdered government minister. *Time* writers called this style of introduction the 'blind lead.'"

Front-row seat to history
"Hadden entranced his readers by giving them a front-row seat at history's stage. Sitting in their cubbyhole of an office, *Time*'s three staff writers dug through *The New York Times* to find the details buried deep within that symbolized the story. When Winston Churchill lost a close election, *Time* described the cigar dropping from his mouth and falling to the floor. When Lenin died, *Time*'s story, 'Cold Death,' showed the mourners

shuffling past his tomb in air so cold that sparrows fell dead from the trees. By skillfully employing such narrative detail, Hadden and his writers managed to paint a word-picture in their readers' heads. In the era before television, no news organization gave people a better feeling of how history looked and sounded."

Middle names
"... Middle names, like nicknames and epithets, provided Hadden a coy method of demeaning unsavory characters. Once a writer, confused, asked Hadden what angle to take on a piece about the hated owner of the *Saturday Evening Post*. 'Listen,' Hadden said. 'Do you happen to know what Cyrus Curtis' full name is? It's Cyrus Hermann Kotzschmar Curtis, by God! We can't leave a name like Kotzchmar lying around, can we? Let's find some damned excuse to get it in the magazine.'"

The magic of news
"The writing style Hadden developed came to be known as *Timestyle*. Hadden inspired his readers with the magic of the news. He captivated them with the personalities behind the news. He hooked them by building suspense and weaving the news into a story line. Taken together, the many stories Hadden told formed an epic tale that brought Americans closer to events than ever before. Hadden helped the nation envision each event as part of a grand and ongoing drama—tragic and comic, momentous and farcical, painful and inspirational. It all added up to a true tale about the way people lived."

Lenin. In the February 4, 1924, issue, the magazine reported his death. To describe the weather conditions endured by thousands who wanted to bid farewell, the writer used the following words: "All of them had stood in line in the streets of Moscow for 10, 20, 30 hours, in inhuman cold ... a blizzard raged. Sparrows fell frozen in the street." Here, at left, Lenin addresses the troops heading to Poland in May 1920.

From Charcoals to the Historic Red Border

From the beginning, *Time*'s founders gave the cover design particular attention. Both Luce and Hadden considered it their weekly calling card for readers, and so they argued that it had to be impeccable and attractive, and it had to convey the magazine's personality. The focus of the design was always a newsmaker's face, usually drawn using charcoal. At the time, photographs provided by agencies were technically mediocre, while charcoal portraits achieved eye-catching, livelier compositions. A wide variety of artists were devoted to making celebrity sketches. One of them, illustrator William Oberhardt, created the first portrait featured on the cover of *Time*.

Oberhardt had sketched Congressman Joe Cannon in the fall of 1921 in his Capitol office and, by request of Luce and Hadden, gave the magazine permission to publish it once. Oberhardt, who specialized in portraits of politicians, also drew the portrait published on the second issue cover: President Warren G. Harding.

But it was in 1924, with the hiring of Samuel J. Woolf, that *Time*'s covers began to have a more defined profile. Eventually, Woolf's work for *Time* became known as "Woolf's head-and-shoulders style." This New York illustrator, trained at the Art Students League, started as a portrait artist in 1920, with drawings of celebrities published in *The New York Times Sunday Magazine*. His cover portraits, most of them in charcoal, were characterized by their focus on the face and included the shoulders, which usually faded away near the bottom of the frame to emphasize the newsmaker's features even further. His first job for *Time*, a portrait of Pope Pius XI, was published in June 1924, and during the decade he spent at the magazine he drew almost 200 cover illustrations. Woolf was also the artist behind one of *Time*'s earliest color illustrations, a head-and-shoulders portrait of automotive industry entrepreneur Walter P. Chrysler, published in January 1929.

In addition to the portraits, *Time* placed special emphasis on the cover's design. The word "Time" took up the majority of a rectangular frame at the top of the magazine, the remainder of the frame contained the phrase "The Weekly News Magazine" in small type. Underneath this frame was another of greater importance, with wide side strips that looked like columns, and with filigree drawings that highlighted the newsmaker's image. Finally, a third smaller frame located at the bottom of the image provided space for the illustration's caption, issue date and number.

This cover design remained unchanged until March 1926, that is, for more than 150 issues. Having attained 70,000 subscribers, Hadden and Luce considered redesigning the cover to make the magazine more attractive and therefore increase circulation. According to Isaiah Wilner, for all of *Time*'s success in attracting subscribers and advertisers, the magazine had yet to gain widespread attention because of its anemic newsstand sales. Only 3,500 of America's 60,000 news dealers carried the magazine. Hadden and Luce started by adding one color to the cover. They also took out one of the filigree columns, the one nearer to the "T" of the logo, replacing it with an orange or green banner, which contained a news index.

However, the changes to the cover did not improve newsstand sales. Finally, Robert Johnson, according to Wilner, asked a news dealer for his thoughts:

> "'What you need on the cover,' the dealer responded, 'is pretty girls, babies, or red and yellow.' Pretty girls and babies seemed out of the

Historic framework. The well-known red frame that is emblematic of *Time* was first used on the January 3, 1927, cover, surrounding the image of British writer, journalist and politician Leopold Charles Maurice Stennett Amery (opposite). Studies show that red is the most eye-catching color. Used on the magazine's cover, the frame is similar to a billboard that signifies importance, urgency or caution. From this issue forward, the frame became a fixture on the magazine's cover.

TIME

The Weekly Newsmagazine

LEOPOLD CHARLES MAURICE STENNETT AMERY

Least popular, most potent
(See Page 10)

Volume IX

Number 1

January 7, 1929

TIME

The Weekly Newsmagazine

Volume XIII

A MAN OF THE YEAR
Big game stays in the deep forest.
(See Business)

Number 1

question and yellow seemed a little gauche. But a splash of red would be feasible and quite in keeping with the appearance of the magazine. In the New York office, where Johnson related his story to the advertising team, Hadden's friend, Philip Kobbé, grabbed a crayon and a copy of *Time*. He drew a bright red border around the outside. 'That's it,' Hadden said. '*Time* was about to go color.'"

Wilner concluded:

"The red-bordered cover of January 3, 1927 represented a visual improvement over its black-and-white predecessors. It also brought in $1,400—in the form of a bold yellow advertisement...."

The improvement had visual impact because it framed the newsmaker's image and attracted the reader's eye to it. Since then, the red-bordered frame has epitomized *Time*'s identity and it never disappeared from the cover (except on a few occasions). In addition, many other newsweeklies around the world imitated it. Focus groups have concluded that the red-bordered frame is a sign that the magazine contains important information.

At first, the rococo-style vertical filigrees shared space with the red frame as a second lateral border. But in 1940, artist Ernest Hamlin Baker replaced the filigrees with delicate graduated lines that framed all four sides of the main image. This caught the reader's eye and drew it toward the image; the lines worked as a frame within a frame. This method was used for more than a decade and later was replaced with different-shaped frames. The second frame was white, black or sometimes alternating. What never changed and is still in place was the red frame that characterizes *Time* magazine. Without a doubt, the frame became a trademark.

Proofs. Before settling on the color for the magazine's frame in 1926, seven editions were published with a red vertical column and five with a green vertical column. These columns contained an index of the stories included in the issue. Above are two such covers: a red one with Oliver Wendell Holmes and a green one with Raquel Meller.

1926. Oliver Wendell Holmes

1926. Senorita Raquel Meller

Color illustration. Covers in the 1920s were characterized by S. J. Woolf's head-and-shoulders style portraits, featuring only those portions of a newsmaker's figure. The January 7, 1929, cover (opposite) used this style, plus an addition: the image of Walter P. Chrysler, who had been selected as "Man of the Year," was printed in four colors, a first in the magazine's history.

The Birth of a Milestone: Man of the Year

Height: 6 ft. 2 in.
Age: 25.
Eyes: Blue.
Cheeks: Pink.
Hair: Sandy.
Feet: Large. When he arrived at the embassy in France no shoes big enough were handy.
Habits: Smokes not; drinks not. Does not gamble. Eats a thorough-going breakfast. Prefers light luncheon and dinner when permitted. Avoids rich dishes. Likes sweets.
Calligraphy: From examination of his handwriting, Dr. Camille Streletski, secretary of the French Graphological Society, concluded: superiority, intellectualism, cerebration, idealism, even mysticism.
Characteristics: Modesty, taciturnity, diffidence (women make him blush), singleness of purpose, courage, occasional curtness, phlegm. Elinor Glyn avers he lacks "It."

This summary description introduced *Time*'s January 2, 1928, article on Colonel Charles Augustus Lindbergh, who had recently piloted his small plane, the *Spirit of St. Louis*, solo across the Atlantic. On *Time*'s cover, under a portrait of Lindbergh, a caption read: "The Man of the Year." That caption was the start of a journalistic phenomenon that over time would become a milestone, followed throughout the world by those publications that once a year highlight human achievement in several categories—"Woman of the Year," "Scientist of the Year," "Athlete of the Year."

With the innovation of "The Man of the Year," and the way in which people started incorporating it, buying into it and participating in it, *Time*'s founders achieved another objective: Luce and Hadden proved that they were gradually reaching the goal they had set for themselves when they said that the magazine should be judged according to "how much it gets off its pages into the minds of its readers." *Time* had incorporated into its stories the United States, the world and their protagonists. And it had brought the news from the outside, wherever events took place, to inside the reader's mind, where the news took on the shape of thought, entertainment, admiration, anger or excitement. Now it was impacting readers with another novelty that also managed to seep into "the mind of its readers." Starting in 1928, *Time*'s "Man of the Year" became an American institution whose selection generated expectation, bets and controversy. Guessing who would be chosen was not only a national pastime, but also an intellectual challenge that forced people to reflect on the year's events and those who had been at the center of them.

However, few knew that "The Man of the Year" idea originated almost by chance, as a means to justify a previous omission. It was during a late-in-the-year newsroom meeting in which unappealing cover proposals were ruled out one after the other that the idea originated. Usually, the last few weeks of the year are a headache for magazine editors—sales drop as readers are preoccupied with holiday gift giving and family gatherings. Cover stories with strong appeal are hard to find since very little news of interest is generated during those weeks.

In addition to Lindbergh being an interesting story, "The Man of the Year" also emerged as a way to rectify a mistake in judgment by the magazine earlier that year, in May, when it failed to portray Charles Lindbergh on the cover. *Time* had only reported Lindbergh's feat of crossing the Atlantic solo aboard the *Spirit of St.*

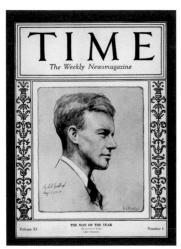

1928. Charles Lindbergh

1931. Mahatma Gandhi

The first one. With this January 2, 1928, cover (left, top), the magazine created the "Man of the Year" designation. The illustration of Charles Lindbergh, the twenty-five-year-old 1st lieutenant who crossed the Atlantic Ocean solo in a small plane, the *Spirit of St. Louis* was drawn by S. J. Woolf. Mahatma Gandhi was designated 1930 "Man of the Year" (left, bottom). Lindbergh in his plane (opposite).

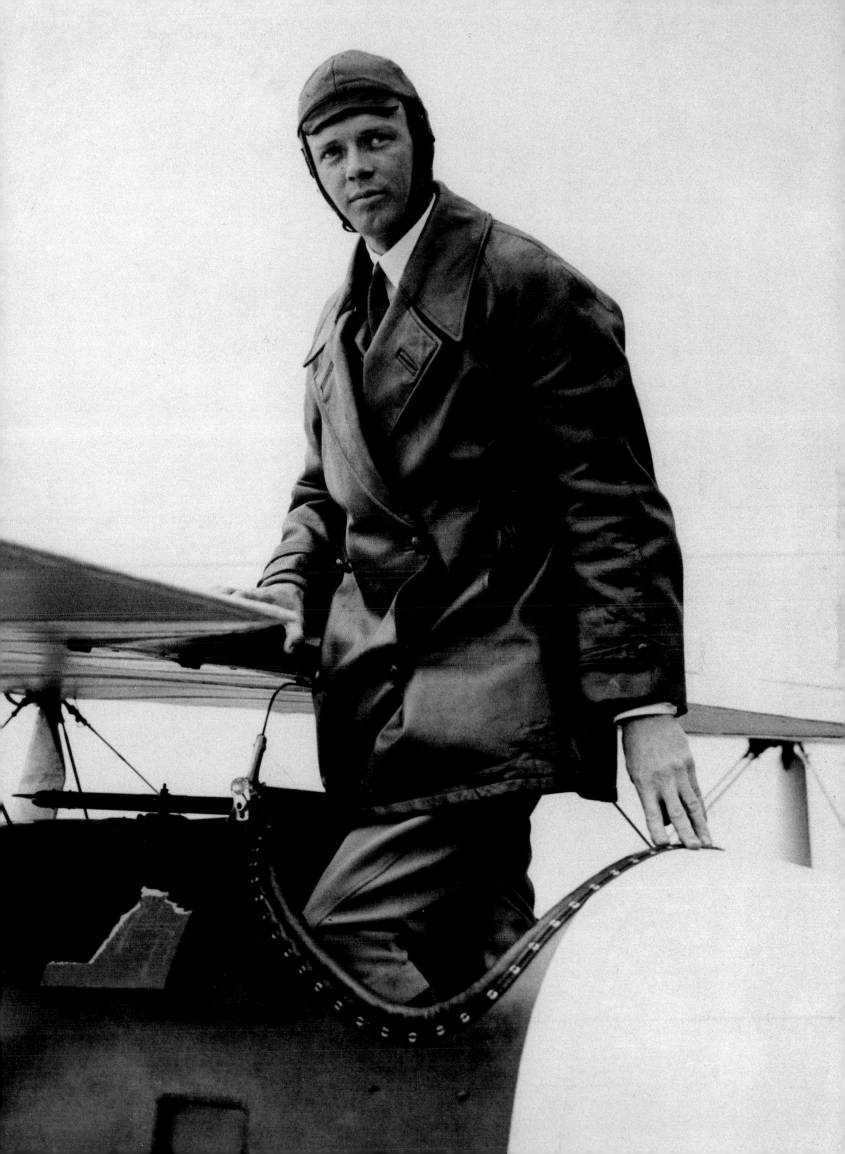

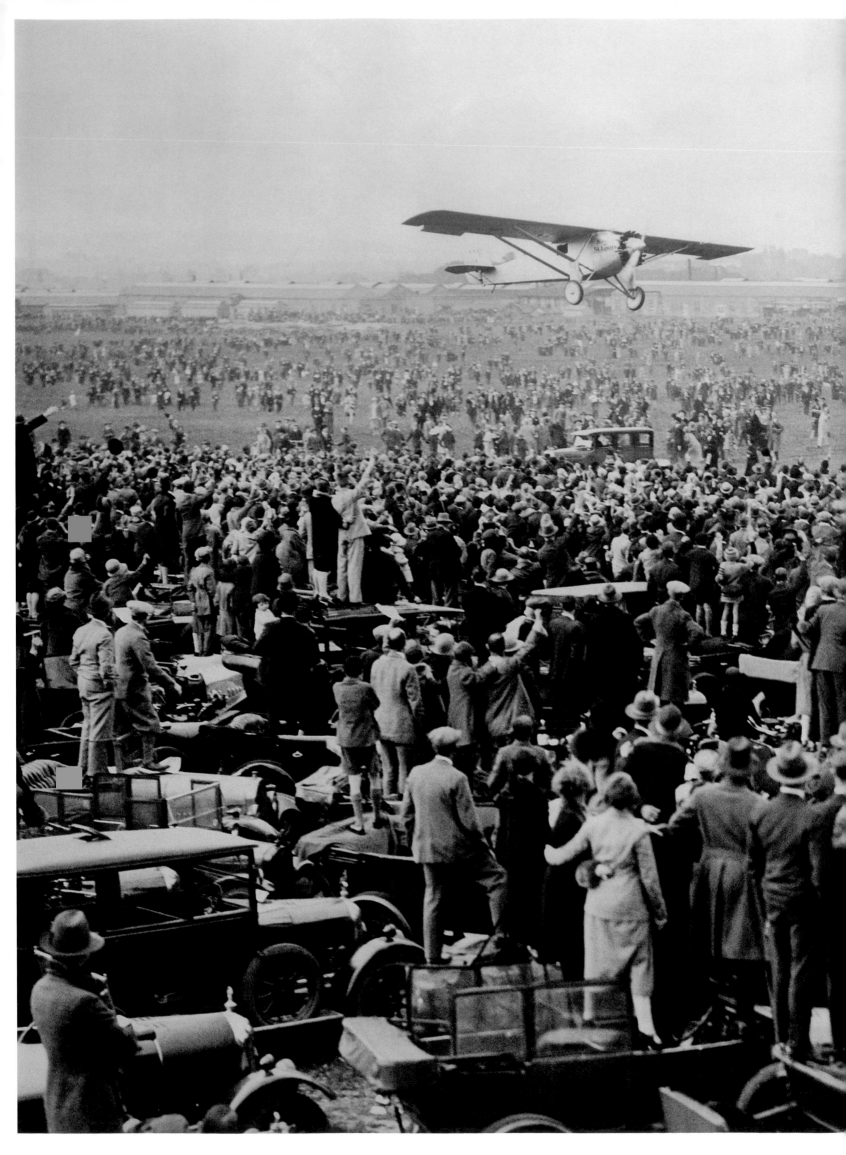

Louis. Over the next few months, Lindbergh had become a national hero, with massive turnouts in every city to pay him tribute, with confetti, parties and all sorts of honors. The tall, blue-eyed Minnesotan had a shy smile and pinkish skin, and was daring and optimistic. He had risked his life to carry a message of peace and bring together countries on two continents. For Americans and their national spirit, his image undoubtedly represented what they aspired to for themselves and their country. But despite his popularity and being considered a model citizen, Lindbergh had never been on the cover of *Time*.

Months after his heroic deed someone at the news meeting proposed crowning him as the man who starred in the most important news event of the year. Most were enthused with the proposal. Only Luce had objections, pointing out that not every year would a hero of Lindbergh's proportions be available for the cover. Editors came up with two solid arguments to persuade Luce. The first one dealt with how morally important it was for the country that his magazine pick a celebrity of note every year. Luce accepted only if it was made clear to readers that "The Man of the Year" nomination wasn't a reward for good deeds, but simply an editorial acknowledgement of influence or impact. The second argument was an illustration by S.J. Woolf (*Time*'s usual cover artist), which was used as the Lindbergh cover illustration. Woolf had depicted Lindbergh at the American embassy in Paris just six days after his heroic feat. Not only was the illustration timely, but Lindbergh had also agreed to sign the drawing, which gave it a commemorative tone that was very appropriate for the year's last issue.

So Lindbergh was on the January 2, 1928, cover—in the United States, the cover date is always later than the publication date—and either by chance, creativity or to amend an editorial error, one of the most enduring and imitated milestones in the publishing world was born.

The following year, "The Man of the Year" continued with Walter Chrysler, selected because in 1928 he shook up Detroit's automotive industry with the purchase of Dodge and the launching of Plymouth. In 1930, it was Owen D. Young, the entrepreneur that led the Second Industrial Conference following the war; in 1931, it was Mahatma Gandhi, who had been jailed by the British in India and brought attention to the situation and to the demands of his people. Gandhi was followed in 1932 by French Prime Minister Pierre Laval, who put his country at the center of world affairs, and in 1933, it was Franklin D. Roosevelt, the president elect who was about to lead the United States during its greatest economic crisis ever.

Until 1933, "The Man of the Year" was nominated solely by the editors, who were not aware of the impact their choice had on the public. Only in late 1933 did the editors actually understand the expectation generated by their decision, when they learned that the residents of Hiram, Ohio, which had been brought to a standstill by a snowstorm, were betting on who would be *Time*'s 1934 "Man of the Year." It was then that Luce and his staff—who that year chose 1933 New Deal Administrator Hugh Johnson—grasped the impact of their editorial decision. For that reason, the following year the editors decided to share the decision with subscribers, who began to submit their opinions, beginning what over the years would become one of the most entrenched practices among news media and readers.

Arrival! This photo (left) was taken just as Lindbergh landed in England at Croydon Airport in May 1927. When he returned to the United States, the aviator was welcomed as a hero wherever he went. *Time* featured Lindbergh on the cover seven months after his heroic feat, creating a milestone in journalism: the "Man of the Year" designation.

The Decade of *Time*'s Birth

"When *Time* started, the atom was still unsplit. So were most marriages. Movies were silent, and a 'byte,' however you spelled it, had to do with food, not information. In headlines, 'holocaust' was only a word for a large fire. The juxtaposition of 'man' and 'moon' was strictly fantasy."

This observation by Henry Grunwald, in his book *One Man's America: A Journalist's search for the Heart of His Country*, helps describe the times in which a small thirty-two-page magazine appeared in the editorial market. World War I, now over, had done away with Europe's old order and turned the democratic and industrial United States into a superpower. Obviously, problems abounded in both regions of the world. The fall of the old imperial powers shook Europe. In Russia, Nikolai Lenin died on January 24, 1924, and was succeeded by another iron hand, Joseph Stalin. In the Middle East, the fall of the Ottoman Empire led to territorial struggles. France had occupied German regions along the border under the Treaty of Versailles, and Europe was still suffering the consequences of the misery and hunger left behind by the war.

The situation wasn't as chaotic in the United States, but tough issues deeply hurt morale, justice and freedom. In the South, the Ku Klux Klan openly displayed racial hatred, as its members paraded down the streets of Georgia, Louisiana, Alabama, Tennessee and South Carolina. Prohibition had led to the emergence of the Mafia and gang warfare in major cities, as well as a culture of disregard for the law.

Despite these burdens, the decade of the 1920s produced one of the most important and transcendental changes for the future of the United States: the popular culture boom. It was the era of jazz, the blues, the Charleston, and The Harlem Renaissance. It was also the birth of the Hollywood studio system, which eventually became history's most powerful industry devoted to conceiving and promoting dreams and fantasy. Personalities, such as Eugene O'Neill, Virginia Woolf, Charles Chaplin, the Marx Brothers, Buster Keaton, Ethel Barrymore and Amy Lowell, among others, were celebrated in literature, theater and film, and a little mouse called Mickey, created by Walt Disney's genius, in time would become a giant. Frank Lloyd Wright, one of the century's most important architects, left his mark in design. In New York City, huge towers, such as the Empire State Building that began construction in 1930, emerged. The Museum of Modern Art opened in 1929. Manhattan was becoming a cultural center of international reach; New York began to be called the world's "shock city." In addition, it was in the 1920s that Americans discovered their insatiable appetite for electronics, through radio: 60,000 homes owned a transistor in 1922, and by 1929, 10 million people purchased the latest models offered by the industry.

As keen observers of reality, Luce and Hadden were among the first to notice that the country had changed considerably after the Great War. Basically, a new cultural center of gravity had emerged, with a new up-and-coming urban middle class that was more intellectual, more socially secure. This new class started to climb the corporate ladder, to join the business world, to have comfort needs and to buy products. In short, the consumer society had been born. It gave way to the birth of a new society, with new information needs.

In this new era of the automobile, the arts, mega construction, film and radio, Hadden and Luce detected a consumer appetite for activity, excitement, variety and novelty. Traditional sources of information were no longer adequate. The newspapers were local and regional and, at best, offered fragments of

Charleston. The 1920s were marked by an American popular-culture boom, in music, the arts and Hollywood. New York became the world's "shock-city." The Charleston became a symbol of the "Roaring Twenties," giving rise to dance contests, which were all the rage (opposite).

national information. Magazines tended to specialize, to offer more opinions than information, and seldom provided the news as such. No one besides Hadden and Luce had come up with an editorial product that covered national and world news.

They did so by publishing the news in their particular short and concise style, mainly influenced by Hadden's personality and news curiosity. "Brit Hadden wanted to amuse and inform; Harry Luce, perhaps reflecting another of his father's traits, wished to educate and *uplift* his readers," wrote Robert Herzstein. In the confluence of those two purposes, *Timestyle* was nourished and grew, with clearly defined positions that gave the magazine a unique tone. While *Time* defended principles (it was against Prohibition, a law that in its opinion encouraged crime, and also

opposed the South's racial segregation), *Time* also wrote the news in a brief and entertaining way, providing historical and anecdotal data as did no other publication.

In *Time*, advances in medicine, science, archeology, art and technology were news. The coverage of local and international politics was detailed by intertwining information, humor and opinion, but above all, by describing images in a way that would make them pop into the reader's mind. The July 12, 1926, issue, for instance, featured Benito Mussolini and Italia Bella under the headline "Barely a scratch":

"When a group of admirers presented him with a lioness cub, they supposed he would scarcely venture to play with her after a few months. To the despair of his guards Signor Mussolini has become so

attached to the now full-grown lioness that he insists on entering her cage for an occasional frolic. When he calls: 'Italia! Italia Bella!' the lithe tawny beast bounds up to him. To date *Il Duce* has suffered barely a scratch or two from her claws. Like her namesake, 'Fair Italy,' she appears to adore him."

The editors also paid particular attention to describing situations, even if at times they exaggerated reality. Note an example of exaggeration when Winston Churchill narrowly lost the parliamentary election to Otho Nicholson, *Time* published the following in its March 31, 1924, issue:

"Otho Nicholson had won by a majority of 43 votes ... Churchill turned ashen pale. His cigar dropped from his mouth

Wall Street collapse. The collapse of the New York stock market on "Black Tuesday," October 29, 1929, started the world's worst economic depression in history. Pictured (below) is a bustling Wall Street scene. The November 4, 1929, "Bankers v. Panic" story described the mood: "Wild were the rumors of ruin and suicide."

and rolled unnoticed to the floor. His wife buried her face in her hands. 'Demand a recount,' whispered Churchill's campaign manager. 'I demand a recount!' cried Winnie. The result was the same."

"National affairs" articles also contained the descriptions and painstaking details that created figures, images and context to help readers formulate strong images. For example, in the February 25, 1929, issue, a section titled "Crime," under the headline "Chicago's Record," reported:

"It was 10:20 o'clock on St. Valentine's morning. Chicago brimmed with sentiment and sunshine. Peaceful was even the George ('Bugs') Moran booze-peddling depot on North Clark Street,

masked as a garage ... where lolled six underworldlings.... Through the office door strode four men. Two, in police uniforms, swung sub-machine guns. Two, in plain clothes, carried stubby shotguns.... Tin coffee cups clattered to the stone floor. Snarled orders lined the six gangsters up along the north wall.... The garage became a thunder-box of explosions."

Although *Time* was criticized on several occasions throughout its long history for its sometimes ultraconservative political positions, during these first few years, *Time* received countless accolades for its criticism of the South's fundamentalist racism. In the "Letters" section the magazine addressed readers' objections to references to African-Americans as

"Mr."—a discussion that enraged many white segregationists—and also published chilling accounts of lynchings. On April 26, 1937, in a story titled "Lynch & Anti-Lynch," *Time* wrote:

"In Winona, Miss., ... Roosevelt Townes and Bootjack McDaniels, 26-year-old Negroes, were pleading not guilty to a charge of murdering a crossroads country grocer.... But when they stepped out of a side door of the courthouse, they found themselves face to face with what so often handles cases like theirs in the South. An angry mob surged forward, took them from the custody of their guardians without a struggle.... [H]eavy chains clink as the two blackamoors were made fast to trees. Bootjack McDaniels was asked

The birth of skyscrapers. The Empire State Building exemplified the technological progress of the decade in which *Time* was born. It was built in 1930, and has become an iconic part of New York's architectural landscape. The building became famous throughout the world with the 1933 release of the film *King Kong*. It is pictured below in 1936 with the German Hindenburg zeppelin.

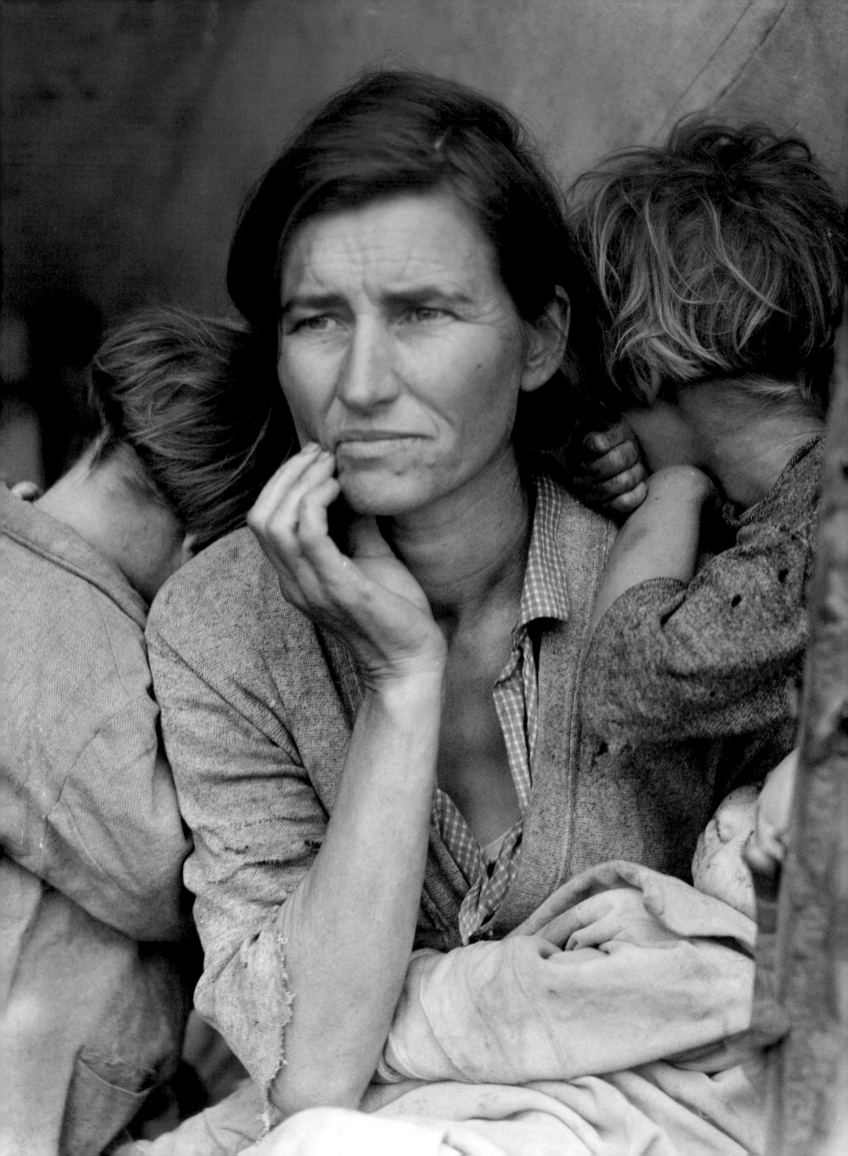

to confess first. He gibbered that he was innocent. A mobster stepped forward with a plumber's blow torch, lighted it....

Again he refused to confess. Then the blue-white flame of the torch stabbed into his black chest..."

This particular style of conveying the full dimension of news events in a few lines, and the success of this approach (by the end of its second year, *Time* had a paid circulation of 70,000), confirmed to the magazine's founders that the country was enormously thirsty for knowledge about events both within its borders and around the world. Americans had started to notice the decisive international role their country played. They felt pride, and increasingly wanted to know how their country's supremacy was regarded in world economics, industrial development, and technological, artistic and cultural sectors.

But the charm, exuberance and explosion of the "Roaring Twenties" suddenly were shaken up by the 1929 stock market collapse. The Great Depression, the country's longest and toughest economic crisis, rippled throughout the world. That same year, a crisis of its own, caused by a totally unexpected event, made *Time* shake: the death of one of its founders, Briton Hadden, at barely thirty-one. According to Isaiah Wilner's account, Hadden was passionate about animals. In a well-known anecdote at the time when newspapers began to publish news about American millionaires who participated in African safaris, Hadden ordered a reporter to write from the animal's standpoint. "We're for the lions every time!" he shouted. "We're for the lions!"

Many believed—as did Hadden—that a feral cat he found on the street and brought home to feed milk caused the infection. At one point, the kitty scratched him, possibly infecting him with streptococcus, which spread through his bloodstream until it reached his heart. In the absence of penicillin, doctors were unable to save him, and Hadden slowly lost strength until he died on February 27, 1929, six years after the first issue of the magazine hit the streets.

Hadden left behind a great legacy, the *Timestyle* and an important contribution: the creation of a formula that turned the news into a national pastime. *Time* didn't have journalists, it had storytellers, Hadden used to say. He told his writers that *Time* should be a Roman circus of sorts: five fights should be taking place at all times. According to Wilner:

"Within a few years of founding the magazine, Hadden began to codify his innovations in a stylebook. Toward the end of the stylebook, he wrote two lists, 'Forbidden Phrases' and 'Famed Phrases,' which commanded writers to use certain words often and others never. Under the heading 'Unpardonable Offenses,' Hadden listed the failure to print a person's nickname. Middle names, he advised, must be included if 'little-known,' 'comical,' or otherwise significant. Hadden redrafted the stylebook every few years.... A few rules never changed. Toward the end of his life, Hadden listed them on the front of his stylebook: 'Be specific.' 'Be impersonal.' 'Appear to be fair.' 'Be not redundant.' 'Reduce to lowest terms.' Hadden wrote his favorite last: 'You cannot be too obvious.'"

John Martin, Hadden's cousin and one of the bastions in the creation of the writing style, was named managing editor of the magazine. Luce took charge of the business side, but ended up having greater control of the newsroom. His intention was to publish a "more complete" magazine; that is, more serious, responsible and informative. It would take him a while to reach that goal.

In the meantime, the world struggled to recover from the Depression, not always successfully. In 1933, just as *Time* was about to celebrate its tenth anniversary, two individuals who would dominate and play leading roles in the news of the decade reached power almost simultaneously: Adolf Hitler on January 30, and Franklin D. Roosevelt thirty-three days later. Unemployment in the United States reached 25 percent. "Hoovervilles," illegal encampments set up by the homeless but tolerated by the government and public, emerged. People rummaging through garbage cans in search of food became a common sight. In Europe, hunger became sadly notorious with the death of millions.

To pull the United States out of the situation, Roosevelt created the New Deal, a plan that put the unemployed to work in the construction of dams, bridges, highways and airports. Hitler, on the other hand, set out to put an end to unemployment in Germany with its weapon factories, which built, to a large degree, a war machinery that years later would go into high gear.

The world gave way to a new story. And *Time* continued to tell it, every seven days.

The face of the Depression. This photograph (opposite), now known as *Migrant Mother,* is one of a series that Dorothea Lange took of Florence Owens Thompson and her children in early 1936 in Nipomo Mesa, California. The photo was shot at the end of Lange's assignment for the Farm Security Administration to photograph migrant farmworkers around the state.

My Days at *Time*
Letters to Mom and Dad

Extracted from Briton Hadden letters, dated February 7, 1922, written on Baltimore News *stationery*

Dearest Mother:
I tendered my resignation to Editor in C[h]ief Harwood this afternoon ... Luce and I are to leave *Baltimore News* Wednesday night.

...

I am confident that in the 7 weeks prior to April 1 we shall be able to determine whether or not the paper FACTS is going to be brought into existence. We propose to devote our time in New York to working out our ideas and having them criticised by able journalists ... This process of criticism is bound to result in either one of two ways. Either our plans will meet with such approval that we shall feel justified in going out and "getting the money." Or our plans will receive such universal condemnation as will warrant our immediate and prodigal return to Baltimore. At any rate, we intend to prove this paper FACTS either a potential success or a potential failure sometime before April 1.

...

You will note that all through the above I have spoken of the paper FACTS as a "potential" success or a "potential" failure. It won't be, of course, a real success or a real failure until I ask somebody to put some money into it. I don't intend to invite anybody to invest one copper penny until I have thoroughly explored every fraction-of-an-inch of the way. I'm not in a hurry. If necessary, I'll spend a year in planning this thing—provided I am financially able to pay myself $10 per week and provided I continue to receive encouragement from able journalists ... In order to defray expenses and eliminate the necessity of paying myself $10 per week, it is quite possible that I shall write a bit of "Sunday stuff" for *The World* at $8 per column ... I shan't allow it to interfere with my vital work on FACTS, however.

...

I feel sure that you and Bill will read this letter calmly and will make a sincere endeavor to see things through my point of view.

Also I am gratefully cognizant of the fact that (even though you may not agree with a single statement that I have here made) you will give me your moral and material support in the venture and will not bawl out: "We told you so!" if the scheme (during the 7 weeks) crashes.

...

Several bushel baskets full of love and regards and apologies from Brit

Fact-checkers. Accuracy was one of the features that distinguished *Time* from other magazines. Charged with this task was a group of women, versed in history, grammar and geography. They verified every historical event, name, place and date in each story. This strict and thorough verification system followed Luce's premise that journalism should both inform and educate through the presentation of accurate information.

Extracted from Luce Letters-581, *a letter he sent to his father in 1922 written on stationery from the Yale Club, New York*

Dear Father:

I have relied upon Mother to tell you all about what's going on, but here's just a word about the general situation as far as the paper is concerned.

We are more and more convinced that there is a big place for the kind of journalistic stunt we are trying to put over.

Our ideas have grown considerably since last November, and it is quite possible that the thing is too big for us.

What we are planning now is a real magazine of a really superior character. As such I believe it is a fundamentally sound proposition. There are two basic questions, granted the idea is good: 1. Can we produce the magazine we intend. 2. Having produced it, can we float it.

1. The answer to the first question we will have definitely and unequivocably settled before we start publishing
... I do not mean to say we will know whether our magazine will appeal to all the people we hope, but we will know whether or not we have manufactured the product which we propose. In other words we will not think of publishing anything that is not thoroughly professional. We are making progress in this line with as much rapidity as could be expected.

2. The answer to this question naturally depends a great deal on the answer to the first question, hence I say "having produced it" can we float it? Can we raise enough capital? Frankly, I do not know. I can't say we will raise so much here and so much there.

... In the meantime what goes on? Expenses to September 1, including sample copies, office, travel, circulars [will] come to about $1000 for each of the three of us. Certainly no more. And that, together with our time and brains is our total investment in the enterprise because it is all we've got and perhaps we haven't got that!
...

Mother also said that you had said there was something like $280 which was the accumulation of your birthday gifts, etc., which we could have any time. If possible, I should like to take that + $200 from Harper's + ask you for $500.
...

Our magazine will probably cost 10¢. If there is not $1 worth of information in it, I myself will be totally unsatisfied. If we put that $1 worth into every issue, I cannot but feel it will be a service of the highest order.
...

Love
H.R.L

PS[:] We have all but decided on a name: TIME.
 Slogans: "Take TIME—It's a brief"
 "TIME Will Tell"
 "Time Is Valuable"
...

TIME does not explain, but there is a connection which sub-consciously people ought to catch onto easily. What do you think?

2

Time's Evolution in a World at War

Luce and Hadden created *Time*'s prototype while working at the East Seventeenth Street office in Manhattan. Soon after, when they had thirty-three employees, they moved the office to the old Hupfel brewery building on Thirty-ninth Street. *Time*'s founders were so different that few understood how their partnership worked so well. Sometimes, to avoid dealing with the issues that they knew they would disagree on, they waited until one of them was absent to make a decision, which the other accepted without complaint. Such was the case when Luce opted to move the office to Cleveland, Ohio, in 1925, a decision he made while Hadden was on vacation in Europe. Luce held that a national magazine should be located in the center of the country. So he seized the chance while his partner was away. Hadden, a cosmopolitan man who frequented pubs and enjoyed New York's nightlife, wasn't happy with the decision. He went along reluctantly but quietly. Two years went by before he could take "revenge"— while Luce was overseas. Upon his return, Luce found everybody set up in the new office Hadden had rented in New York.

After Hadden's death, his cousin, John Martin took over the editorship. Luce, who was busy launching a new magazine, *Fortune*, took over the business side. He read the magazine, made comments, but tried to keep his distance. Martin led *Time* from 1929 to 1933 and later, for a brief period, between 1936 and 1937. John Shaw Billings was in charge in the interim. It was a time of few changes, but many controversies.

During his years as a writer, Martin had written for all the sections of the magazine and excelled in the art of condensed writing and the use of sharp phrases and humor. He was considered to be the

Winds of war. Nuremberg, 1937. Hitler reviewing his troops (opposite). Two years later he signed a nonaggression treaty with Russia, which divided Poland between the two countries and enabled the führer to attack Poland without fearing intervention from Russia.

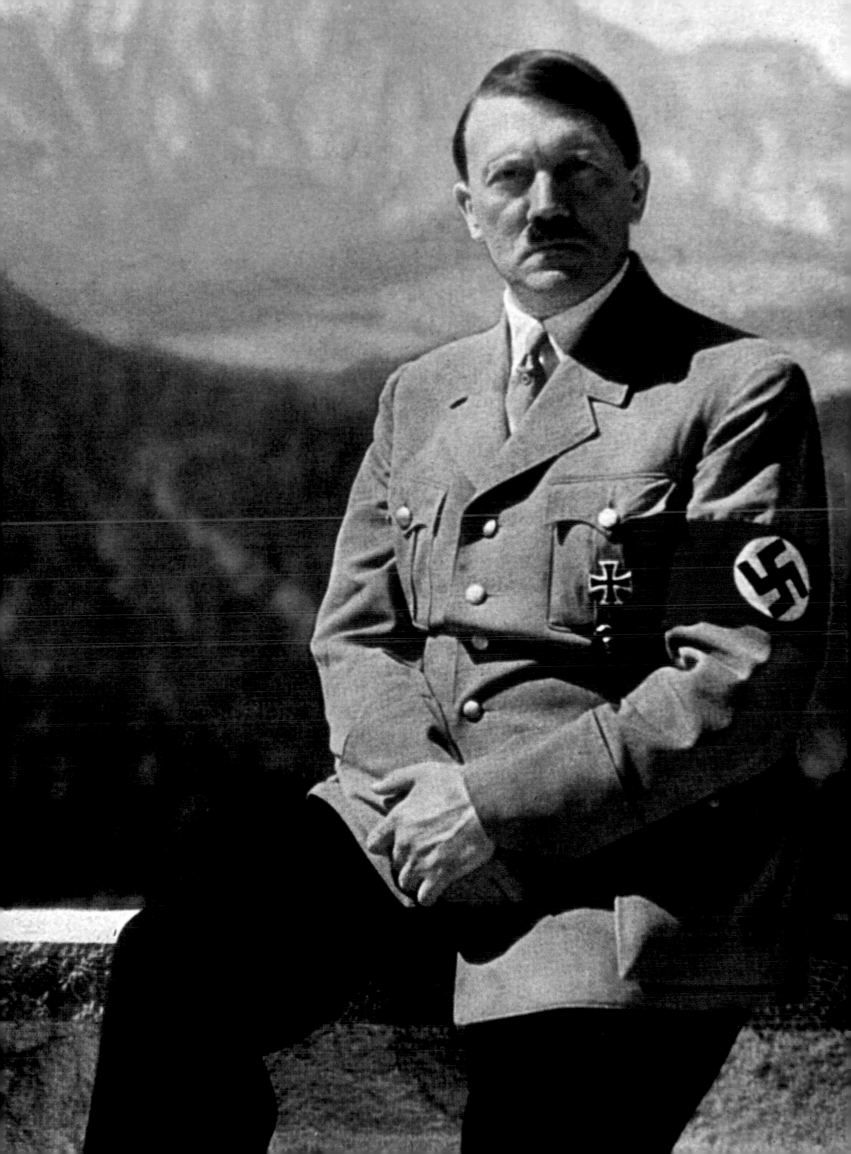

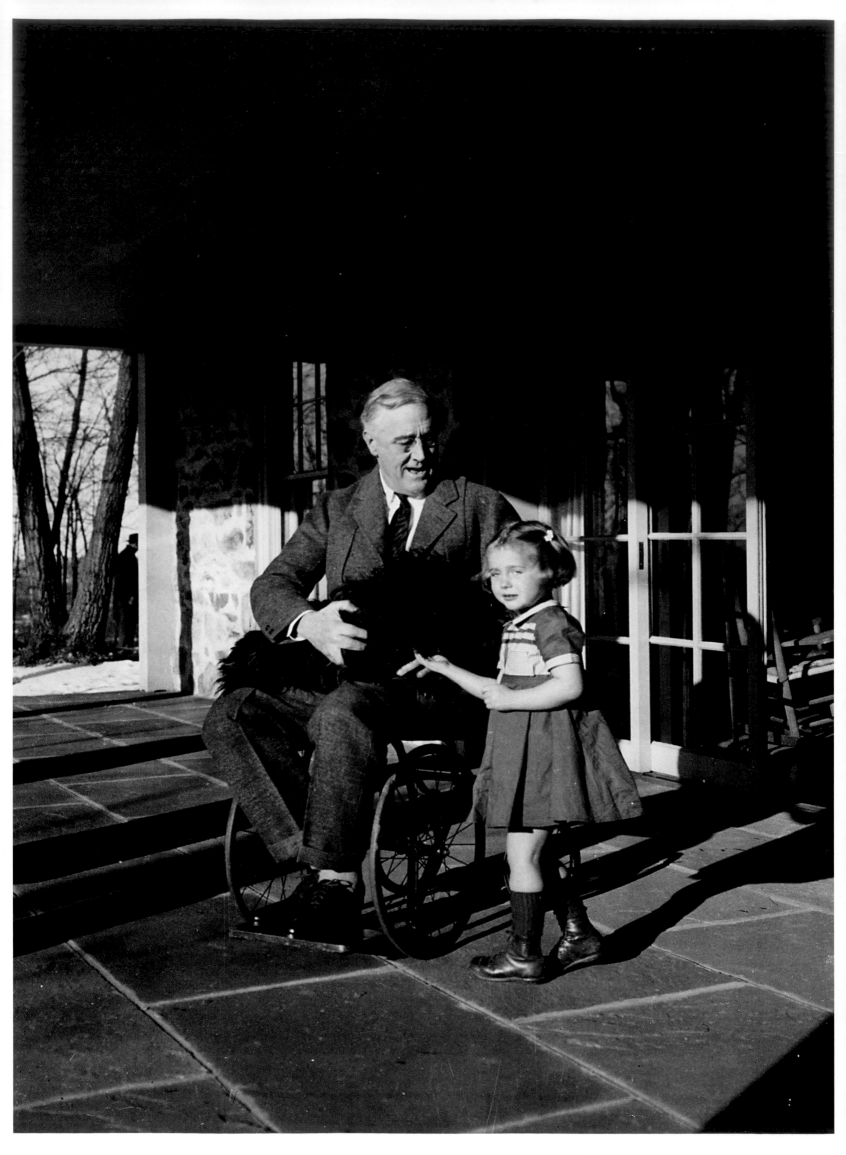

greatest exponent of the "Hadden style," particularly in his use of the Homeric epithet. While he was at the helm of the magazine, *Time* changed very little. Martin, who was a fervent admirer of Hadden, set out to take the writing style created by his cousin a step further and increasingly demanded that writers include settings, profiles and anecdotes in their texts.

But there were some issues with that magical style of writing, particularly when writers tackled newsmaker descriptions. It was not always welcomed, and it generated plenty of controversy and countless letters of complaint. *Time* called New Orleans Mayor Thomas Semmes Walmsley "buzzard-bald" and Senator James Eli Watson "long-legged, large-paunched, small-eyed"; Senator David Walsh of Massachusetts was "tall and stout. A double chin tends to get out over his tight-fitting collar. His stomach bulges over his belt."

The provocative photo captions—which *Time*'s editors considered one of the strongest hooks to draw the reader into a story—also tended toward disrespectful descriptions. For example, under a photo of the queen mother of Spain, who had just died, it said: *They took her to the Dump.*" The article explained that she was buried at El Escorial—the monastery outside Madrid that is the burial place of Spanish monarchs. The word "escorias," the article continued, means "refuse" and refers, in this instance, to the "slag dumpings of an abandoned medieval iron mine."

But the fiercest criticism of the magazine came when it made reference to the ailments that afflicted President Franklin Delano Roosevelt, who was unable to walk normally after a bout with poliomyelitis. On page nine of the December 5, 1932, issue, under the headline "Debts Week," the magazine wrote that "President-elect Roosevelt hobbled

out of the White House elevator..." But that wasn't all. On the following page, in a story titled "Roosevelt's Rest," *Time* reported: "At Warm Springs, Ga., last week President-elect Roosevelt ... [b]egan daily two-hour swims in the Foundation's indoor pool, followed by a massage of his shriveled legs by physiotherapist Helen Lauer."

This phrase, "shriveled legs," set off a firestorm. Until then the newspapers had never referred to the president's illness nor had they shown him in a wheelchair. Indeed, there was an unspoken agreement among them not to do so. *Time*'s phrase thus elicited a double reaction: surprise and displeasure. Some readers were indignant. "How can you justify the utter cruelty?" Asked one, while another demanded, "Who is your editorial writer so completely lacking in a sense of common decency and good taste?"

The scandal reached such proportions that the editors were forced to respond to their readers. They did so with a letters column in which they tried to justify the expression "shriveled legs," arguing that it was important not to ignore the illness:

"*Time* conveys the full significance of a man, paralyzed in the prime of life, rising above what to another man might have been an insuperable hindrance and going on to high national destiny ... Without stressing the subject, and certainly never with malice or disrespect, *Time* will continue to regard Mr. Roosevelt's legs as mentionable—unless a great majority of *Time* readers commands otherwise."

The controversy continued for some weeks, until the magazine itself put an end to it with an explanatory note: "No clear majority of readers 'commands otherwise.' [S]core of letters through last week: 238 con, 252 pro. This *Time* construes as a firm

mandate to continue mirroring Nature."

But the scandal left its mark. Luce realized that, in their zeal to set their publication apart from the others, his writers and editors had gone too far in their descriptions, at times pushing the limits of personal offense. And this was doing his magazine no good.

Luce addressed the issue in a memo to his writers. According to Robert T. Elson in *Time Inc., The Intimate History of a Publishing Enterprise, 1923–1941*, Luce's memo read:

"No more cracks, please, about Mr. Gielgud's nose. (John Gielgud had been described as 'a sensitive and intelligent Englishman of 32 with a nose the size of a hockey puck.') Long experience has taught us that what hurts people most is a reference to some physical characteristic—and this is also what readers most resent our saying about people in whom they have no personal interest ... [a]ny reference to any characteristic is peculiarly the responsibility of the Managing Editor. This means that any writer who says a man has a nose as big as a hockey puck is putting the M.E. on a spot—because if the M.E. doesn't catch it, it is the M.E. who is peculiarly at fault—and the M.E. is apt to become annoyed with a writer who pitches him too many sour balls. Obviously this does not mean a ban on physical characterizations. What it does mean is that physical characterizations are to be given the first call on our best journalistic skill, sensitivity and sense of responsibility. Hereafter if a king is to look like a dentist or if anybody is to have a nose as big as a hockey puck, he will have it for *Time*'s best considered reasons."

Roosevelt and a *Timestyle* scandal. *Time*'s physical descriptions of newsmakers sometimes surprised and displeased readers. The magazine's description of President Franklin D. Roosevelt as a man with "shriveled legs," as well as the publication of this picture of Roosevelt (with his Hyde Park caretaker's granddaughter, Ruthie Bie) (opposite), caused much controversy. *Time* was criticized for making reference to Roosevelt's ailments by showing him in a wheelchair.

Hitler and
Hymn of Hate

John Martin's last term as *Time* managing editor ended in 1937. He was appointed temporarily to replace John Shaw Billings, who in 1936 had moved on to take over the same position in the company's successful new magazine: *Life*. Billings had joined the magazine in 1929. He was the first journalist with newspaper experience on staff. Before replacing him as managing editor, Shaw was Martin's protégé and head of "National Affairs."

For the six years between 1937 and 1943, the magazine was under Managing Editor Manfred Gottfried. Since Hadden's death, Henry Luce had distanced himself from the magazine's day-to-day operation. As the company's president, he oversaw the business operations. Luce named Ralph Ingersoll, from *Fortune* magazine, which the group had launched in February 1930, as *Time*'s editor. One of the biggest scandals in the magazine's history took place in 1939, while Ingersoll was in charge and Luce was away on a trip.

Although no one within *Time* liked the idea, the decision had been made months earlier: Adolf Hitler would be the 1938 "Man of the Year." The magazine itself offered the following explanation for the choice to devote the January 2, 1939, cover to him:

> "Greatest single news event of 1938 took place on September 29, when four statesmen met at the Führerhaus, in Munich, to redraw the map of Europe. The three visiting statesmen at that historic conference were Prime Minister Neville Chamberlain of Great Britain, Premier Edouard Daladier of France, and Dictator Benito Mussolini of Italy. But by all odds the dominating figure at Munich was the German host, Adolf Hitler. Führer of the German people, Commander-in-Chief of the German Army, Navy & Air Force, Chancellor of

the Third Reich Herr Hitler reaped on that day at Munich the harvest of an audacious, defiant, ruthless foreign policy he had pursued for five and a half years. He had torn the Treaty of Versailles to shreds. He had rearmed Germany to the teeth—or as close to the teeth as he was able. He had stolen Austria before the eyes of a horrified and apparently impotent world. All these events were shocking to nations which had defeated Germany on the battlefield nearly 20 years before, but nothing so terrified the world as the ruthless, methodical, Nazi-directed events which during late summer and early autumn threatened a world war over Czechoslovakia. When without loss of blood he reduced Czechoslovakia to a German puppet state, forced a drastic revision of Europe's defensive alliances, and won a free hand for himself in Eastern Europe by getting a "hands-off" promise from powerful Britain (and later France), Adolf Hitler without doubt became 1938's Man of the Year."

Although the choice was very controversial and generated much negative reaction from readers, it fell short of the upheaval that took place within *Time*. Ingersoll, who like Hadden and Luce came from Hotchkiss but had graduated several years later, had been *The New Yorker*'s managing editor and had joined Time Inc. to become *Fortune*'s associate editor. He reported directly to Luce, who was in Europe, while Gottfried was under him. The ultimate responsibility for important decisions fell on Ingersoll.

The primary problem that Ingersoll had to deal with was the Hitler issue's cover image. It could not be victorious or exultant; otherwise its placement in such a prominent spot might convey the impression that *Time* favored Hitler

Nazi Party's power increases. A meeting of the National Socialist Party in 1934. As the leader and chancellor of the Third Reich, and later as commander in chief of the army, Hitler began an unprecedented arms buildup. (Previous spread)

Hitler: "Man of the Year." *Time*'s designation in 1938 was perhaps the most controversial choice in the magazine's history. In order not to show support of Hitler, the editors, unlike usual practice, did not use his face on the cover, rather, they used a drawing by Rudolph Charles von Ripper, titled *Hymn of Hate* (opposite). The illustration depicted naked cadavers hanging from a wheel of torture, while a tiny figure, resembling Hitler, is playing a pipe organ.

FIFTEEN CENTS — JANUARY 2, 1939 — NUMBER 1

TIME

THE WEEKLY NEWSMAGAZINE

Rudolph Charles von Ripper

MAN OF 1938

From the unholy organist, a hymn of hate.

(Foreign News)

VOLUME XXXIII — NUMBER 1

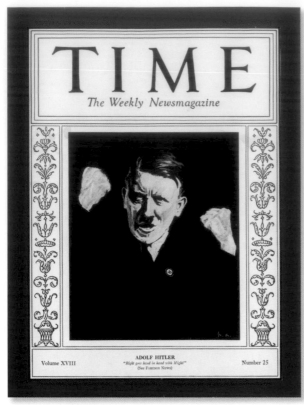

1931. Adolph Hitler

Hitler covers. The first was published in the December 21, 1931, issue (above). Before being designated "Man of the Year" in 1938, Hitler occupied the cover four more times before the end of WWII.

or his ideas. But all available photos showed Hitler relaxed, at ease, as if he were a uniformed statesman. Several cover proofs were made, all of which were too flattering. Finally, a consensus was reached on a photo of Hitler in a khaki uniform and almost expressionless. Although the photo portrayed Hitler as strong, clean and respectable, it was chosen simply because it was the one photo in which Hitler appeared least triumphant.

According to an account years later by Roy Hoopes, his biographer, Ingersoll was so worried about publishing a cover that gave Nazism a positive image and— about Luce's reaction—that he brought

up the issue with his psychiatrist. In fact, it was his psychiatrist who recommended that, if there was still time to change the cover, Ingersoll check out the work of Rudolph Charles von Ripper, an artist who had exhibited his work in New York that spring. Ripper was an Austrian refugee who had been imprisoned in Germany years earlier precisely because of his work, which was critical of the Nazi Party. Ripper created a pen-and-ink drawing, which showed a small man, easily recognizable as Hitler, playing an organ. Hanging from a turning wheel, similar to the one used to torture the first Christians, were the bare bodies of his victims. The illustration showed, in addition to military men, a

religious figure, symbol of the support that the German clergy had offered Hitler.

Ingersoll immediately ordered its publication, sure that there would be no doubt that the magazine rejected Nazism. In addition, under the illustration and the title "Man of 1938" he added the following epigraph: "From the unholy organist, a hymn of hate." The text that accompanied *Time*'s description of Hitler had a disparaging tone:

"The man most responsible for this world tragedy is a moody, brooding, unprepossessing, 49-year-old Austrian-born ascetic with a Charlie Chaplin mustache. The son of an Austrian petty customs official, Adolf Hitler was raised as a spoiled child by a doting mother. Consistently failing to pass even the most elementary studies, he grew up a half-educated young man, untrained for any trade or profession, seemingly doomed to failure..."

Ingersoll made the decision to change the cover illustration without consulting anyone, not even Gottfried, the managing editor, who, after closing and sending the cover to press, had taken the weekend off. Gottfried later remembered that when he found out about the change, he was furious. He agreed that running an expressionless image of someone who readers disliked was not the right thing to do, but his main complaint was that never before had the magazine used the cover as a deliberate tool for propaganda. Gottfried was not the only one that Ingersoll had ignored. He had also failed to consult with Luce, who was notified of the change when he returned to New York and the presses were running with *Hymn of Hate* on the cover.

Luce was furious when he saw the "Man of the Year" cover, because the illustration

My days at *Time*

Where the Hell Did They Get Such a Portrait?

Extracted from Ralph Ingersoll: A Biography *by Roy Hoopes, published by Atheneum in 1985.*

The Man [of the Year] for 1938 had, of course, to be Adolph Hitler, who was threatening to overrun Europe. But what arrived on [my] desk was a glamorized portrait of *der Fürher*, right arm raised in a *"Sieg heil"* salute that made him look the embodiment of leadership. "Where the hell did they get such a portrait?" I fumed. "That afternoon on Gregory Zilboorg's couch [his psychiatrist] [I] could talk of nothing else. Zilboorg had a suggestion. If there was time to replace the offensive cover, he knew just the man to draw a new one—a fine artist, anti-Nazi, but not a German. He was an Austrian, both an aristocrat and a Catholic, and no man to be called a red. His name was Rudolph Charles von Ripper. Overnight von Ripper drew a portrait of Hitler in pen and ink ... but in this version the setting left no doubt about how he had made the news that led *Time* to choose him. The background was a Catherine wheel on which naked bodies were bound, tortured and broken. Down in front, accompanying the torture on an organ, was *Time*'s Man of the Year. [I] did not hold a conference about this cover. [I] simply scrapped thousands of dollars worth of four-color printed covers and put

through his black-and-white substitute. Luce played no part in the decision, but when he saw the cover, after the issue was already on its way to the newsstands, his secretary ... was on the phone, fast: "Get up here pronto, Mr. I—pronto." When [I] arrived at Luce's office, the offending issue lay at the center of his desk, everything else pushed impatiently to one side. "He was standing over it," I recall.

Who did this?
I did.
You did?
Have you any idea what you've done?
A basic tradition destroyed ... everything I've built ... in one gesture.

Then Luce paused, actually trembling with rage. "It was beyond any words that could be exchanged between us. I said nothing, he said no more; we simply stood there, eyes fixed on each other. Then, abruptly, Luce said: 'Spilt milk,' and it was over. I left the room and me and Luce never discussed editorial matters again. Harry was right to have been so shaken, by my taking an open editorial position on the cover of *Time*.... But on that spilt milk morning in 1938, the world was still young and neither Harry nor I ever brought up the issue again. I doubt if either of us understood them, then—I know I didn't."

Visual pioneer. Luce launched *Life* in 1936. He is pictured below with two of *Life*'s editors, John Shaw Billings (left) and Daniel Longwell (right). Luce always selected the image of the newsmaker on the cover—the allegorical illustration of Hitler for the 1938 "Man of the Year" cover infuriated him.

fell totally outside the canons the magazine had established for the cover. He was particularly upset over two matters: that the image had editorialized the "Man of the Year" and that, at the same time, it broke with the tradition of using the face of the newsmaker of the year on the cover. In mid-1939, Ingersoll retired from the company to devote himself to a newspaper prototype, the *New York Daily PM*. In recognition for his service, Time Inc. decided to pay his salary through the end of the year. It was the epilogue to one of history's most controversial "Man of the Year" episodes—internal struggles had claimed none other than the magazine's editor.

After Ingersoll's departure, Luce immediately announced that he would once again take over as managing editor of the magazine. He also appointed himself as editorial director to establish the "general character, tone, direction, ambition and ideals" of the publication. Manfred Gottfried was appointed executive editor, to ensure that "creative, aggressive, knowledgeable journalism shall be represented in every issue ... in short, that each issue shall pack a punch—meaning at least three punches."

Among his many duties, Luce made Gottfried responsible for "all the news of all the world that can be put into two hours' reading is put there ... cause stupidities to vanish, realities to abound."

Luce was displeased with some writers and editors who complained that they didn't know who *Time*'s readers were. A memo, published in Elson's book, reads:

"... The editors and writers are not sufficiently eager to please *Time*'s 700,000 customers. *Time* did not invent its most famous slogan: 'cover to cover.' That was given to us by hundreds and thousands of readers who unselfconsciously used that phrase....

The conception of *Time*'s reader is hard, very hard, to put into words, but terribly simple for anyone to grasp if he wills to grasp it. *Time* is edited for the Gentleman of Indiana. At this point I cannot say what I want to say without indulging in a little Americanism. America, for example, is not New York. New York is in the bloodstream of America and America flows hot through New York. But New

York is not America. Perhaps we should seriously consider moving *Time* to Chicago. For Wall Street is not America. Broadway is not America. Café Society is not America. Park Avenue is not America. The Intelligentsia are not America. Columbia University is not America. New York is the fascination of America—where vices easily become virtues and virtues vices...

I have heard much muttering and some loud talk about the new conditions facing *Time* competitively—the radio, the commentators, the more serious attitudes of readers and *Life* ... All that talk bothers me not one bit. If I had to make my fortune over again, and there were no *Time*, you wouldn't catch me wandering off looking for gold mines—you'd find me peddling stock right now in a real genuine newsmagazine. Good grief, in 1923 the basic premise of *Time* was that the newspapers were excellent and the magazines were excellent BUT. The more means of communication there are, the bigger that BUT...."

Time's design remained unchanged until 1938. The first design change came in the March cover that year, in the fifteenth anniversary edition. To mark the event, the covers of some issues were published with "Time's Fifteenth Anniversary 1923–1938" written on a red and black band, which partially overlapped the logo. It was the year's first innovation, but it would not be the last one. Months later, Luce ordered additional modifications, basically to change the title type inside the magazine and update the cover design. Before then, *Time* was considered a "thin unimpressive little magazine" in terms of visuals. Its thirty-two pages were in black and white, it had no art director and the editors laid out the pages in a style similar to a

Anniversary. The magazine celebrated its fifteenth anniversary by putting James Roosevelt on the February 28, 1938, cover (below). This was the first special anniversary edition of *Time*.

1938. James Roosevelt

newspaper, with one story following another in columns.

In 1938, Luce recruited designer Eleanor Treacy to revamp the magazine. She modified the original logo created by Gordon Aymar (art director from the J. Walter Thompson advertising agency, who charged $500 for the job), picked a bolder typeface, and substituted small black triangles for the ornate marks that preceded some paragraphs. She also eliminated the fancily scrolled cover border, which she said looked like spinach. The "spinach" designs, which

had appeared on the cover for 811 issues, finally disappeared in the October 3 issue that year, featuring a photo of William Bragg.

Treacy's visual changes were minimal, as Luce had requested, since his belief was "not tamper with success." He believed that in a magazine with as much reader loyalty as *Time*, the "evolutionary" approach was more appropriate than the "revolutionary" one, especially in visual changes and redesigns.

In July 1939, just a few weeks before Germany put its ruthless war machinery

into motion by invading Poland, Sigmund Freud appeared on the cover of *Time*. His psychoanalytical theories would fall short of explaining the atrocities that would upset the world over the following years. *Time* would continue to convey the news to readers each week, as it happened. *Time* told stories and functioned as both an observer and a participant in history.

Cover design change. After fifteen years of being on the cover, *Time* replaced the "spinach leaves," the in-house term given to the flowery patterned border framing the newsmaker (below, left), with a less ornate design. The cover of the October 3, 1938, was the first to use the new design (below, right).

1938. Richard Rodgers and Lorenz Hart

1938. William L. Bragg

"Man of the Year": The First Woman, the First Controversy

Working for *Time* was a matter of pride and prestige for its staffers. They belonged to a magazine that had revolutionized journalism, with original and innovative contributions. However, in the early 1930s, some of the senior editors and section chiefs felt that *Time* needed to go further in its editorial strategy, that it should be more daring, that is wasn't enough to tell yesterday's news. *Time*, they argued, was in a position not only to gather the news from the world's leading periodicals but also to generate its own news stories. It should no longer be—and this was one of its competitors' main criticisms— a "re-write sheet."

Luce had predicted the self-criticism that the style he and Hadden had invented might produce in its writers. For this reason, in 1933, when the magazine was ten years old, he sent a memo—which was published in Elson's book—to congratulate the writers, explaining:

> "*Time* is a re-write sheet. *Time* does get most of its news and information from the newspapers. *Time* is not only proud of the fact, but, in fact, the genius of *Time* lies in that fact...
>
> It takes brains and work to master all the facts dug up by the world's 10,000 journalists and to put them together in a little magazine."

However, early in 1937, the magazine found itself involved in another controversy, due to the selection of Wallis Simpson as the 1936 "Man of the Year," making her the first woman the magazine chose for the honor. Following the tradition set by Hadden of including the newsmaker's middle name, the title read: "Mrs. Wallis Warfield Simpson," the reason for selecting her was explained in the article's deck:

"In the entire history of Great Britain there has been only one voluntary royal abdication and it came about in 1936 solely because of one woman, Mrs. Simpson."

Wallis Simpson was an American divorcée who had captured the heart of a British monarch, Edward VIII, who, after a well-publicized romance, opted to abdicate the throne to marry her. During the formalities—the abdication and its acceptance by royalty—Simpson waited patiently for the outcome and ensuing preparations for a wedding at a French castle, while her name took up headlines in newspapers throughout the world.

In the United States, defenders of women's rights—which was a very popular issue during the previous decade— welcomed the news of a European monarch abdicating his throne because of his love for an American divorcée. However, for the conservative majority—which included many *Time* readers—it wasn't a welcome event, particularly when the magazine chose Simpson above other deserving candidates as the most prominent person of the year: President Franklin D. Roosevelt; black sprinter Jesse Owens, who had defeated German athletes in the Berlin Olympics; Margaret Mitchell, author of *Gone with the Wind*, the first novel to sell more than a million books in six months; or playwright Eugene O'Neill, who had received the Nobel Prize for his works that year.

Time had to offer an explanation—as it did on many other occasions and for other newsmakers—that the designation wasn't an award for the year's best deed. It was, in fact, an editorial acknowledgment of the central figure in that year's news, and not a moral commentary on that figure's character.

1937. Wallis Warfield Simpson

First "Woman of the Year." In 1936, *Time* selected Wallis Warfield Simpson, the divorcée who led Edward VIII to abdicate the throne and whose marriage to him rocked the British crown, as 1937 "Woman of the Year" (left). Many readers felt that the event was not newsworthy enough to merit the designation. The Duke of Windsor is pictured with Simpson in their house in Portugal in 1940 (opposite).

The Birth of the Cover School and the "Infographic" Maps

In 1937, five years before the United States fully joined World War II, an editor who would be key in developing the *Time*'s cover school joined the magazine. His name was Dana Tasker, a professional who had studied literature and English at Amherst College with poet Robert Frost. He came from teaching art history at Deerfield Academy and working as visual and text editor at *Reader's Digest* and *Newsweek*.

Tasker's first job at *Time* was as editor of the "Business & Finance" section, but he then devoted himself specifically to reorganizing the art department in general, and covers, illustrations and graphics in particular.

The first challenge Tasker faced during his tenure was finding cover illustrations that were less predictable. (At the time, the images on the magazine's main page—photos or charcoal drawings—were usually black and white, which diminished their impact. In 1940, for instance, only nine of the fifty-three covers published were four-color images). He also lost sleep over the question of whether the selected newsmakers should be portrayed as they were physically, or interpreted by the magazine's illustrators and editors?

To solve all these issues, during his tenure, Tasker hired a group of illustrators who were fundamental in the development of *Time*'s cover school. With them, Tasker was able to move forward with what is considered to be one of his big contributions to magazine covers: the creation of the "news illustration" or "news portrait." Those were the designations given to the art that included the newsmaker's face, with a background that complemented, clarified and contributed to the facts that had led to featuring the personality on the magazine's cover. The basis of the formula was to portray a "meticulously realistic painted

likeness [to the newsmaker] complemented by background[s] and symbols alluding to the reason for the subject['s] newsworthiness," according to Frederick S. Voss, in his book *Faces of Time: 75 Years of Time Magazine Cover Portraits*.

Among the images that started to characterize this new cover style in 1939 and 1940 were those Ernest Hamlin Baker made of Polish pianist Ignace Paderewski, American journalism magnate William Hearst and German pastor Martin Niemoller. However, Tasker's style first made a splash with the November 10, 1941, issue, when the magazine cover featured Rita Hayworth's full body. At the time, she was Hollywood's best-known sex symbol. Illustrator George Petty's depiction of Hayworth, wrapped in a black diaphanous dress with a slit revealing her beautiful and curvaceous leg, graced the cover, provoking both positive and negative comments. But more than anything, it made clear that new changes were taking place on the magazine's covers. They would become even more prominent in the following years when a trio of illustrators would give *Time*'s covers center stage.

Those days would also witness a fundamental change in the maps that illustrated a story. American cartographer Robert M. Chapin, Jr. revolutionized journalistic cartography with his innovative technique of adding visual information to the maps. Chapin, as well as Tasker, started working at *Time* in 1937. Curiously, cartography wasn't his original career, he had studied to be an architect. But when he graduated from the University of Pennsylvania in 1933, during the worst point of the Depression, most architects were jobless. By chance, Chapin found work retouching photos at *Newsweek*, and he learned to draw maps during the two years he worked there. By 1937, the rival's newsmagazine maps had caught the eye of

1939. Ignace J. Paderewski

1941. Rita Hayworth

Interpretive covers and "infographic" maps. Starting in 1939, covers became more interpretive. In one, Ernest Hamlin Baker painted the highly expressive face of Polish pianist Ignace Paderewski (left, top). In another, George Petty depicted Hollywood sex symbol Rita Hayworth in a full body pose, wearing a gossamer dress that revealed her legs (left, bottom). Chief cartographer Robert M. Chapin's infographic maps followed the war step-by-step (opposite).

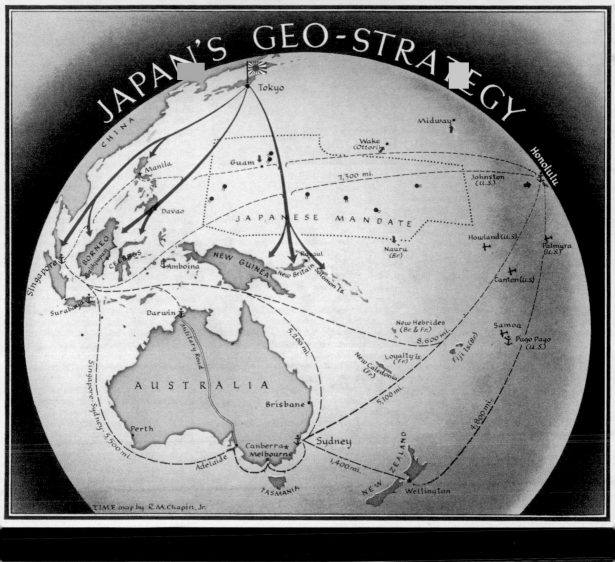

JAPAN'S GEO-STRATEGY

CHINA · Tokyo · Manila · Guam · Davao · BORNEO · Balikpapan · CELEBES · Singapore · Surabaya · Amboina · NEW GUINEA · Rabaul · New Britain · Solomon Is. · Darwin · Military Road · Singapore-Sydney 5,500 mi. · AUSTRALIA · Perth · Adelaide · Brisbane · Canberra · Melbourne · Sydney · TASMANIA · NEW ZEALAND · Wellington · 1,400 mi. · 5,100 mi. · 5,200 mi. · New Caledonia (Fr.) · Loyalty Is. (Fr.) · New Hebrides (Br. & Fr.) · 8,600 mi. · Fiji Is.(Br.) · Samoa · Pago Pago (U.S.) · 4,800 mi. · JAPANESE MANDATE · 7,300 mi. · Nauru (Br.) · Wake (Ottori) · Midway · Honolulu · Johnston (U.S.) · Howland (U.S.) · Palmyra (U.S.) · Canton (U.S.)

TIME map by R.M.Chapin, Jr.

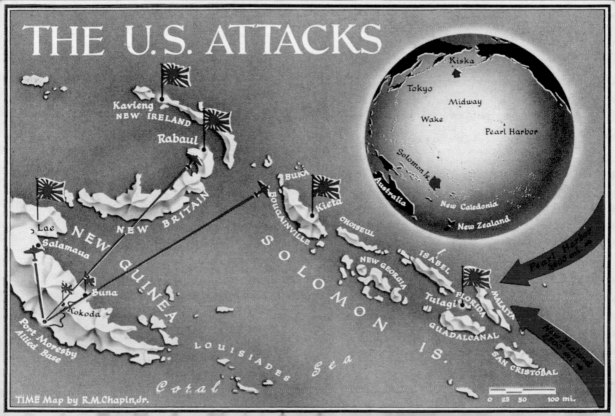

THE U.S. ATTACKS

Kavieng · NEW IRELAND · Rabaul · Lae · Salamaua · NEW BRITAIN · NEW GUINEA · Buna · Kokoda · Port Moresby Allied Base · BUKA · BOUGAINVILLE · Kieta · CHOISEUL · SOLOMON · NEW GEORGIA · ISABEL · Tulagi · FLORIDA · MALAITA · GUADALCANAL · SOLOMON IS. · SAN CRISTÓBAL · LOUISIADES · Coral Sea

Kiska · Tokyo · Midway · Wake · Pearl Harbor · Solomon Is. · Australia · New Caledonia · New Zealand

0 25 50 100 mi.

TIME Map by R.M.Chapin,Jr.

Time's Managing Editor Manfred Gottfried, and less than a month later Chapin was installed in the old *Time* offices in the Chrysler Building.

Chapin would remain at *Time* for thirty-three years, during which he turned himself into the first and greatest "infographic" cartographer in the world. His technique revolutionized journalistic cartography with three historical innovations. First, Chapin used an airbrush, a sort of high-power atomizer, with which he sprayed paint over his maps in an infinite number of shadings that gave mountains and valleys, plateaus and riverbeds their three-dimensional height and depth. Second, he suspended two large floating globes—one political, one physical—from the ceiling by pulleys and counterweights in such a way that they could be turned, lowered and photographed from any angle or perspective. Third, he created a library of celluloid symbols, which included bomb explosions, flags, camels, ships, soldiers and moving battalions. "I try to dramatize the news of the week," Elson quotes Chapin as having said, "not just to produce a reference map like those in an atlas."

Sometimes, he had to be as much a cryptographer as a cartographer. Chapin started drawing between two and three maps a week, but at the beginning of the Second World War, he had to double the amount, compelling him to work overnight to make deadlines, especially with breaking news from the war front. He set up a team to help him. Alone or with their help, Chapin would produce some of the most inventive cartographical "infographies," such as the Ethiopian invasion by Mussolini's troops and the Paris liberation. One day in August 1942, a correspondent cabled from Hawaii: "If Chapin is a wise man, he will know

Robert Chapin in action. Chapin (above), hired by *Time* in 1937, worked for the magazines for thirty-three years. With his airbrush technique and his use of celluloid symbols, he added information and context to his maps, which revolutionized the use of cartography in journalism.

what to map in the Pacific." After some thought, having realized that this was a coded message owing to national security restrictions, Chapin put his finger on a little-known chain of islands named after Solomon in the Bible. The map was drawn and ready to be filled in with last-minute detail, when the navy finally released news of the Guadalcanal invasion four days later.

Chapin's journalistic cartography became world renowned because of the rigorous geographical details of his maps, and it was (and still is) regularly used as reference material by the American National Library, NASA, the army and the navy, as well as by foreign governments, American and international schools and history book publishers.

My days at *Time*
My Fights with Luce

Extracted from the book Name and Address: an Autobiography *by T. S. Matthews, published by Simon and Schuster in 1960.*

This anecdote recounts a fight, which came as a result of Luce's telephone call to Matthews's house to question some points in the lead story in The Nation. *Luce called him on a Wednesday, Matthews's day off, which he devoted to his family. Matthews hated to be bothered at home on his day off and Luce was furious because Matthews refused to talk to him. The following day, Matthews found a memo from Luce on his desk, which prompted his response.*

Luce's notes and memos to his editors, which he scribbled off at great speed, often had a sting in them. His irony was sometimes amusing and effective, but his occasional sarcasms were apt to be more wounding than I think he realized. Was I too ready to take offense? Or was I too watchful for signs that power was making him tyrannical? Perhaps both. But once I did something worse, in terms of office politics: I wrote an answer to his memo and took it to him myself and stayed while he read it. That was worse than a crime, it was a blunder, for it left him no way out. This was my note: "There are several possible answers to your memo of yesterday ... 1) tear it up and throw it in the wastebasket ... 2) remonstrate with you ... 3) say nothing; 4) tell you to go to hell—as I have been very strongly tempted to.

I honestly think I have listed all the possible answers. No decent human being would answer your memo by accepting it.... You have written it as if to dogs, not human beings. And you thus make a great mistake. If you're really degenerating into a barking boss, you'll soon have behind you only the anxious, stupid, dishonest subservience that kind of boss can command. But you will no longer command either my respect or my services."

No apology wrested by force is worth getting, and this cornering demand for one was, I am sure, both wrong and foolish. I got the apology, but I don't suppose he could ever quite forgive me for insisting on it. I wouldn't have, in his shoes. In fact, as I look back on those days, I can see now that Luce must have put up with a good deal from me. I've found another of my notes to him, dated six months later, that begins: "Well! Your memo amply proves that you are not only 1) a busy man but 2) a rude one and 3) an unclear one ... I can't imagine ... any press lord you can mention, tolerating that kind of talk from one of his subordinates."

When I returned to New York to wind up my twenty-four-year affair with *Time*, Luce and I had a farewell dinner together ... We reminisced, and then I said "Harry, now that you've got America, how do you like it?" ... He said (or words to this effect), "By what right do you put me on the moral defensive?"

...

I thought that might have been our final meeting but it wasn't. Five years later chance brought us face to face in New York. I asked him to dinner; he turned the tables on me as usual by having me instead, and we spent a pleasant evening in his apartment talking over old times, like two ex-cronies who weren't saying all they knew but who shared some deep memories. I felt again some of my old fondness for this grizzled tycoon whose hard-shell opinions hadn't become any softer. He was a little put out because I hadn't reached sixty yet, as he had, but I mollified him by promising that I soon would. And though we raised our voices, it was not from temper but because we had both become rather hard of hearing.

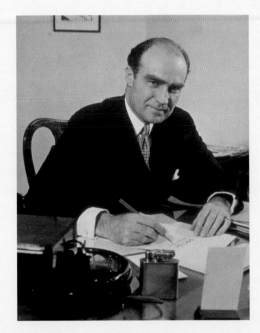

Memos and reviews. During the period in which he was managing editor, Luce, after reading the magazine, wrote memos to *Time*'s editors and reporters, expressing his impressions and thoughts (left). Some of the memos were didactic, others ironic, but most were forceful. The journalists feared them.

The ABC Trio That Changed *Time*'s Cover

The world got to know them by their nickname, "*Time*'s ABC cover trio." But their fame largely superseded the moniker that identified them, made up by the initials of their last names. Boris Artzybasheff and Boris Chaliapin were Russian. Ernest Hamlin Baker was American. Together, the three produced more than 900 covers and dictated a style that gave the publication character, strength, personality and impact.

The three were hired for the magazine by Dana Tasker. The first to join was Baker, who made his debut in the magazine with a painting of musician Ignace Paderewski in February 1939.

Throughout his seventeen years at *Time*, Baker produced more than 300 covers for the magazine, many of them memorable. His method was a long, meticulous and laborious process to come up with what he called the "facial map" of newsmakers. Using photographs and a powerful magnifying glass, he examined every feature for hours on end. Then he made a preliminary sketch that emphasized the subject's every wrinkle, blemish and pore—a cross between an anatomic study and an orographic map. He then started working on the final portrait, using as a guide sketch lines that he patiently painted in color. "The result was a crisp image that occasionally seemed brutal in its factuality, such as the one he did with aging Italian dictator Benito Mussolini for a February 1941 edition," explained Voss.

In a letter to readers published on August 18, 1947, Baker explained the fundamentals of his editorial technique and why he focused on certain artistic details:

"A good cover should not only help sell the magazine but also reflect its character. Therefore, in the same sense that *Time* tries to bring out the true significance of world events in terms of personalities through its use of complete news coverage, it would be my job to bring out the subject's true character through a complete coverage of his facial forms—forms that tell of minor Munichs, Dunkirks, heedings of integrity, yieldings to expediency, forms that have been stamped into his face by numberless deeds and intentions, good, bad and indifferent. These untold tales will emerge automatically and add up to the subject's total character, provided only that I do two things: first, report unflinchingly every perceptible form, second, weave and integrate these forms into a living unity. If it works, I will be telling *Time* readers not only what the man LOOKS like but what he IS like—a really good reporting job."

The news illustration is born

Baker's first cover illustrations had impact, with results that at times seemed more real than reality itself. A good case in point was the William R. Hearst cover in March 1939, in which the press magnate was shown aging, wrinkled and haggard due to the hard economic times his editorial empire was undergoing. Another example was Baker's portrayal of Franklin D. Roosevelt, the 1941 "Man of the Year," which revealed details of the president's face that his closest friends probably hadn't even noticed.

Baker's illustrations, however, lacked context. The faces he depicted were loaded with expression, but there were no images surrounding the face to place readers in the news scene.

This way of displaying news personalities on the cover seemed inadequate to Tasker and Baker, particularly in a magazine in which the news content, as well as its interpretation, was a priority. "This was how they both began to conceptualize a cover portrait that provided readers with a shorthand and somewhat

1940. Martin Neimoller

1942. Franklin D. Roosevelt

Illustrations with context. The Neimoller (left, top) and Roosevelt (left, bottom) covers are examples of newsmakers portraits with context illustrations. The cover, of the February 15, 1943, issue, is one of artist Boris Artzybasheff's masterpieces (opposite). Chief of Japan's Naval Staff, Osami Nagano's smug expression portrays his confidence in his fleet's readiness to fight—and the animated battleship's trigger finger is poised to fire its pistol.

TIME

THE WEEKLY NEWSMAGAZINE

Artzybasheff

NAGANO OF JAPAN
He, too, has just begun to fight.
(*World Battlefronts*)

subliminal explanation of its news context," wrote Voss.

Tasker and Baker created what is known in the history of covers as the "news illustration." One example of this important advance could be seen in Baker's cover featuring Martin Niemoller for the December 23, 1940, edition of *Time*, in which the Lutheran pastor was shown flanked by a cross and a swastika, which suggested his and other clergymens' opposition to the Nazi regime. Another example features an illustration of entrepreneur Henry Ford in March 1941, with a backdrop of the new routes under construction in the United States after the era's automotive boom.

Artzybasheff fuses men and machines

Each cover took Baker between ten and twelve days of work. It was precisely to ease the illustrator's workload and deadline pressure that Dana Tasker decided in 1941 to hire Boris Artzybasheff, the second member of the trio, who remained at the magazine until his death in 1965.

Artzybasheff was born in Russia in 1899. The son of celebrated novelist Mikhail Artzybasheff, Boris had to stop going to law school when he was drafted, but instead of enlisting, he decided to elude authorities in 1919 as a stowaway on a ship to New York. There, with the help of an American immigration officer, he obtained work at an engraving shop. But Boris soon gave up his job and law school to devote himself to his true passion, drawing and illustration, which he later put to use in set design and eventually, illustrating a book of fairy tales, published by E.P. Dutton in the mid-1920s.

Fame, however, came with the more than 200 *Time* covers he created over twenty-four years. "I was so profoundly impressed when I saw the Russian Red Army armaments"—he wrote in a draft of his memoirs, now in the archives of New York's Syracuse University—"that I decided to humanize them and transform the modern technology machinery and weapons into recognizable human forms but with a whimsical and surrealist touch." Among the best examples of this type of illustration,

based on modern machinery and weapon technology, were his 1943 covers of Admirals Karl Doenitz (in charge of the Third Reich's feared submarines) and Osami Nagano (the brains behind the Japanese navy). Artzybasheff portrayed Doenitz as a submarine periscope leading his attack fleet, and Nagano on a warship deck, in front of one of his battleships that resembled a fighter about to pull the trigger.

The Russian illustrator was in this way bringing full circle the original head-and-shoulders formula started by Woolf and later complemented by Baker's visual context. His ironic fusion of weapons and human beings brought a level of unprecedented artistry to the magazine's design.

Chaliapin's lyrical realism

The frequent cover image changes spurred by last-minute news and newsmakers often forced Tasker to dramatically shorten the time illustrators had to turn in their work. For example, Baker had forty-eight hours to deliver the Paderewski cover, and Artzybasheff was forced to submit

Two Chaliapin masterpieces. The Russian artist painted the silhouette of Gandhi behind Indian Prime Minister Nehru to show that Nehru was captivated by his ideas (below, left). He portrayed the Yugoslavian Second World War hero, Marshal Tito, with his partisans who helped him to fight the Nazis (below, right).

1942. Jawaharlal Nehru

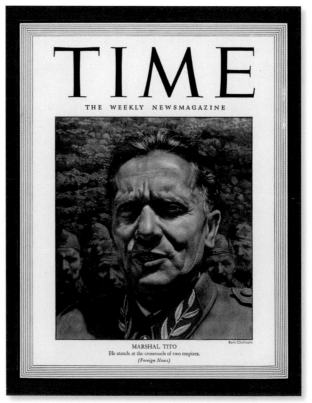

1944. Marshal Tito

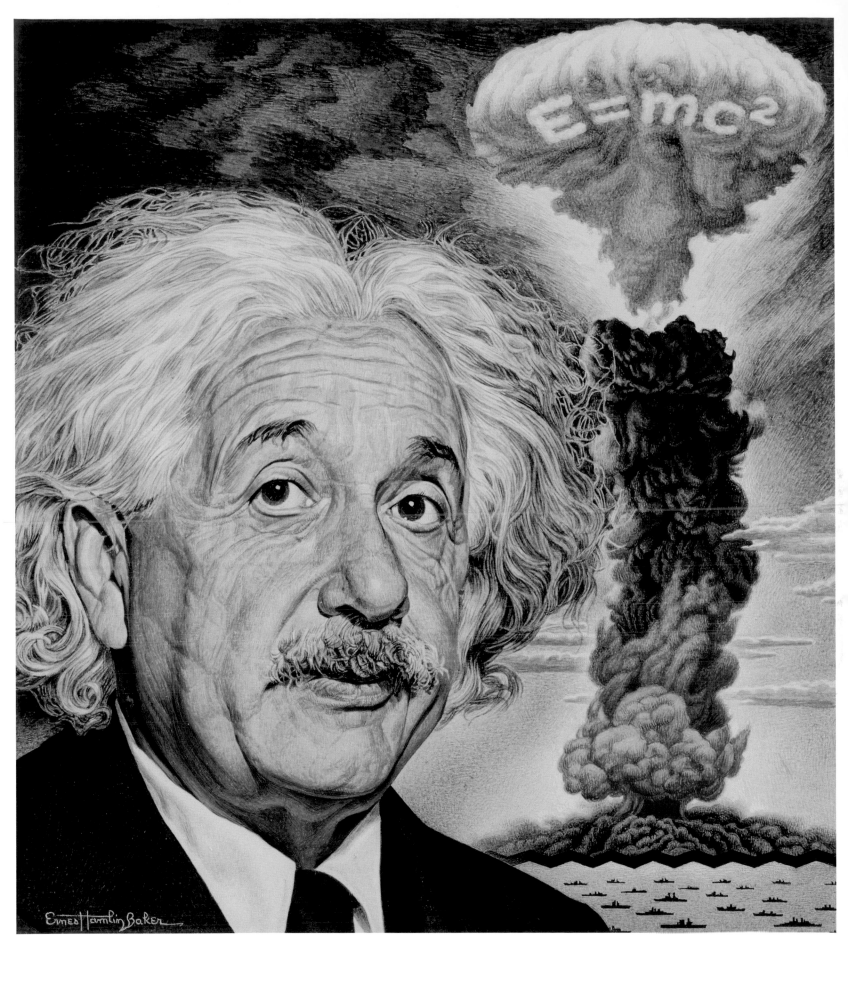

Einstein by Baker. The July 1, 1946, cover illustration of Albert Einstein (above) with the "soft brown eyes and dropping facial lines of a world-weary hound," was published after the atomic bombs were detonated over Hiroshima and Nagasaki. The story dealt with the direct and indirect influence that Einstein's scientific discoveries had on the atomic arms buildup.

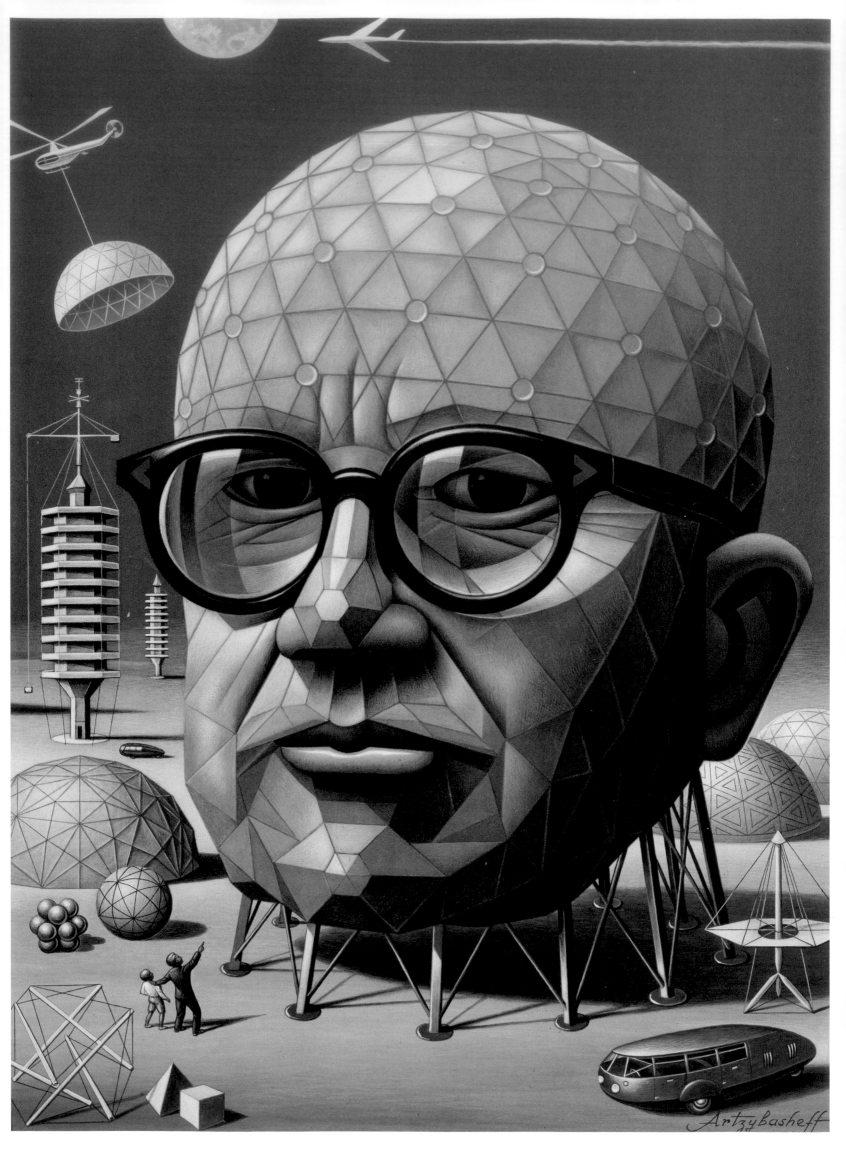

Artzybasheff

his portrait of General Kong Le of Laos within four days. All this provoked strong protest from the illustrators and generated constant tension between the editorial and visual staffs. Hoping to neutralize this tension and to speed up portrait submissions, Tasker hired Russian Boris Chaliapin (son of noted opera singer Feodor), the third member of the trio, who remained with the magazine as an illustrator for twenty-eight years.

Like his fellow countryman Artzybasheff, Chaliapin witnessed the Russian Revolution during his adolescence, but unlike Artzybasheff, he decided to remain in the USSR to study painting. His parents' and his own disillusionment with the Russian totalitarian regime forced them to emigrate to Paris. Boris then moved to New York in 1935, mainly because he knew that in New York he would find figurative art trends better aligned with his realistic style than the vanguard art that prevailed in France.

Tasker hired him in 1942, on the recommendation of *Time*'s international politics editor, who, like the illustrator, was an opera fan. His first job for the magazine was a portrait of Indian Prime Minister Jawaharlal Nehru, published in the August 1942 issue. What is striking about the illustration is that behind Nehru's face, in the shadows, is the silhouette of Mahatma Gandhi, which gives the cover a subliminal context and expresses what was a well-known secret: the prime minister responded to the ideas and orders of the pro-independence leader, who had been his mentor. "His major visual contribution to the *Time* school of covers was his staunch lyrical realism," Voss explained. A clear example of his artistic touch and the drama he accomplished in his work were the 1944 covers portraying Marshal Tito and, behind him, his Yugoslav followers, and one of famous jazzman Thelonious Monk. In it, he drew the black

piano player and civil rights defender over a red background that made the anger in his face and eyes stand out. When published in February 1964, the cover, although previously slotted to be published the week John Kennedy was assassinated, was nonetheless an appropriate expression of the anguish and hopelessness that the assassination had provoked in the black community.

In addition to the realism in his work, however, Chaliapin also became known for how quickly he could create portraits without sacrificing quality, at times producing them overnight in an incredible record-breaking seven hours.

War covers

The strength, penetration and impact of these covers as the war evolved were remarkable. Voss mentioned in his book an anecdote that illustrates the universal impact of these *Time* covers.

"While being the subject of a *Time* cover story is often good for the ego, there can be a downside, as Robert Woods learned in the fall of 1945. The recent West Point graduate had been featured on the cover the previous June in tandem with a story on West Point. Woods recalled that being a cover subject was a pleasantly exciting experience until he reported for duty to a battle-scarred company captain in occupied Japan. After exchanging salutes with Woods and verifying that he was talking to the Robert Woods of *Time* cover fame, the captain launched into a story of some particularly grueling combat he and his men had endured the previous June in the Philippines. Just as the fighting ended, he said, a mail orderly brought him a copy of the issue of *Time* bearing Woods's likeness. The thought that *Time* was holding up the untested Woods

as an emblem of America's soldiering capabilities while seasoned fighters such as himself sat unheralded in a Pacific jungle was too much to bear. At that moment, said the captain, he swore that if he ever ran into West Point Group First Captain Woods in the flesh, he would shoot him. With that, he pulled from his desk a .45-caliber revolver and grimly pointed it at Woods. Fifty years or so later, Woods could not remember just how he managed to escape unscathed. On one point, however, he had no doubt: the captain was in earnest, and for a few tense moments Woods thought that he was about to die, the victim of *Time* cover fame. The next day the captain, clearly suffering from battle fatigue, was sent home."

The trio was responsible for most of the cover illustrations during the war. In their hands, were generals, soldiers and captains; Japanese, German, Italian and British; and allies and their opponents. Artzybasheff, Baker and Chaliapin illustrated the faces of the war for *Time*. Their influence and work would set the bar for many years. Voss noted:

"What's most curious about these three excellent illustrators, is that despite their artistic differences, their covers adhered pretty much to the same formula, and in doing so, they set the stylistic rules and standards for years to come for most of the other artists who were brought into *Time*'s stable."

Fuller by Artzybasheff. The creator of the geodesic dome, R. Buckminster Fuller was called "the first poet of technology." He became an ecological activist in the fields of architecture, engineering and design. Artzybasheff depicted Fuller's head on the January 10, 1964, cover in the shape of his geodesic dome, surrounded by his other architectural designs and inventions (opposite).

Time Responds to the Second World War

It was the twentieth century's most devastating war, spanning from 1939 to 1945. It divided most of the world's nations into opposing factions: the Allies and the Axis powers.

In power since 1933, Adolph Hitler established the Third Reich, intensifying nationalist sentiment. In 1939, Germany invaded Poland, leading the United Kingdom and France to declare war on Germany. Hitler then attacked and occupied Denmark, Norway, Holland, Belgium and France and bombed London but was unable to advance into Great Britain. In 1941, Japan attacked the American fleet in Pearl Harbor and the United States joined the war.

In 1944, the Allies orchestrated the decisive invasion of Normandy, and in July of that year, liberated Paris. Early in 1945, the Soviets reached the German border. In February, at the Yalta Conference, Roosevelt, Stalin and Churchill laid out in post war plans.

The conflict had claimed the lives of 27 million troops and 11 million civilians—6 million of them perished in Nazi German concentration camps.

During the war, *Time* underwent significant changes in its structure, as well as in the way it treated the news.

Correspondents

As Europe became the main battlefield, an army of journalists was deployed by *Time* to cover events. During the 1930s, the magazine broadened its news network and went from having a single correspondent in 1929—David Hulburd in Chicago—to having no fewer than 435 correspondents in 1958. They covered the news, always breaking and international, from thirty-three regions in the world. *Time* thus created the most thorough information network a magazine has ever had, which became the *Time-Life News Service*. At a time when television had not yet been born and the photographs in newspapers were inadequate, magazines, through the use of powerful and poignant images, became the best medium to follow the war.

The first to travel to cover the war were photographer Carl Mydans and his wife Shelly, a journalist. They did so in 1939, two weeks after the Germans attacked Poland. Another reporting couple that stood out in *Time*'s coverage was Melville Jacoby and his wife Annalee, who were authorized by General MacArthur to cover his Australian campaign. Melville Jacoby was killed when a military transport plane went out of control on takeoff and crashed into the group he was waiting with to board the next plane en route to the Australian front. He became *Time*'s first journalist to die in action. The magazine's correspondents were present in all battlefields, from Tarawa to Sicily, from the fall of Paris to the Normandy invasion, from Guadalcanal to Salerno. And more than once their work was recognized by the public and by critics. John Hersey, for instance, received the Pulitzer Prize in 1945 for his novel, *A Bell for Adano*, one of three he wrote about frontline events that he covered for *Time*.

Group journalism

With the massive hiring of correspondents, the old complaints by writers and editors who wanted the magazine to create its own news instead of being a rewrite sheet were put to rest. At the same time, a characteristic *Time* working style was born—or, rather, became international. This was group journalism. The term simply denoted a well-oiled and polished editorial process that precisely regulated the efforts of the correspondents, researchers, writers and editors who worked on the magazine week after week.

Group journalism had its origin in one fundamental, key element: the

Churchill and ruins. This May 1941 image (opposite) shows Winston Churchill among the ruins of the House of Commons after it was bombed by the Nazis—exactly where on May 13, 1940, Churchill delivered his famous speech in which he said, "I have nothing to offer you but blood, toil, tears, and sweat."

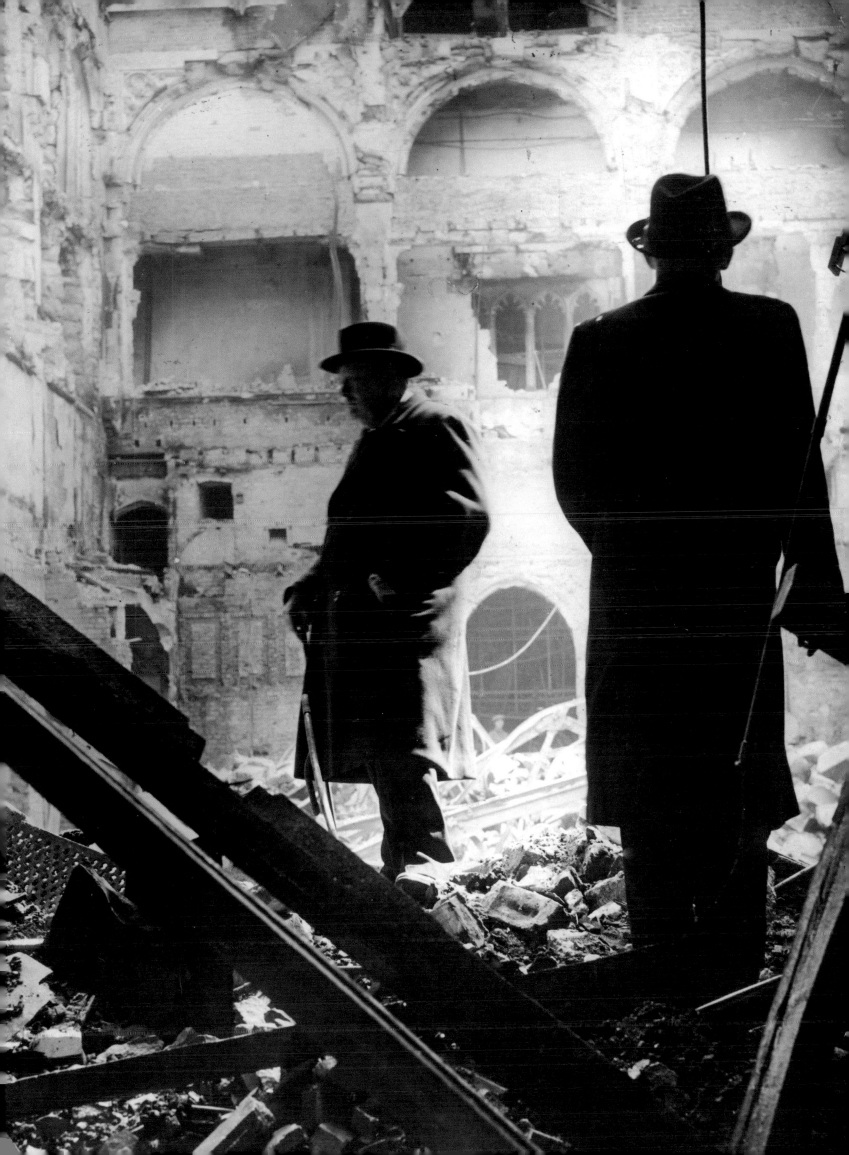

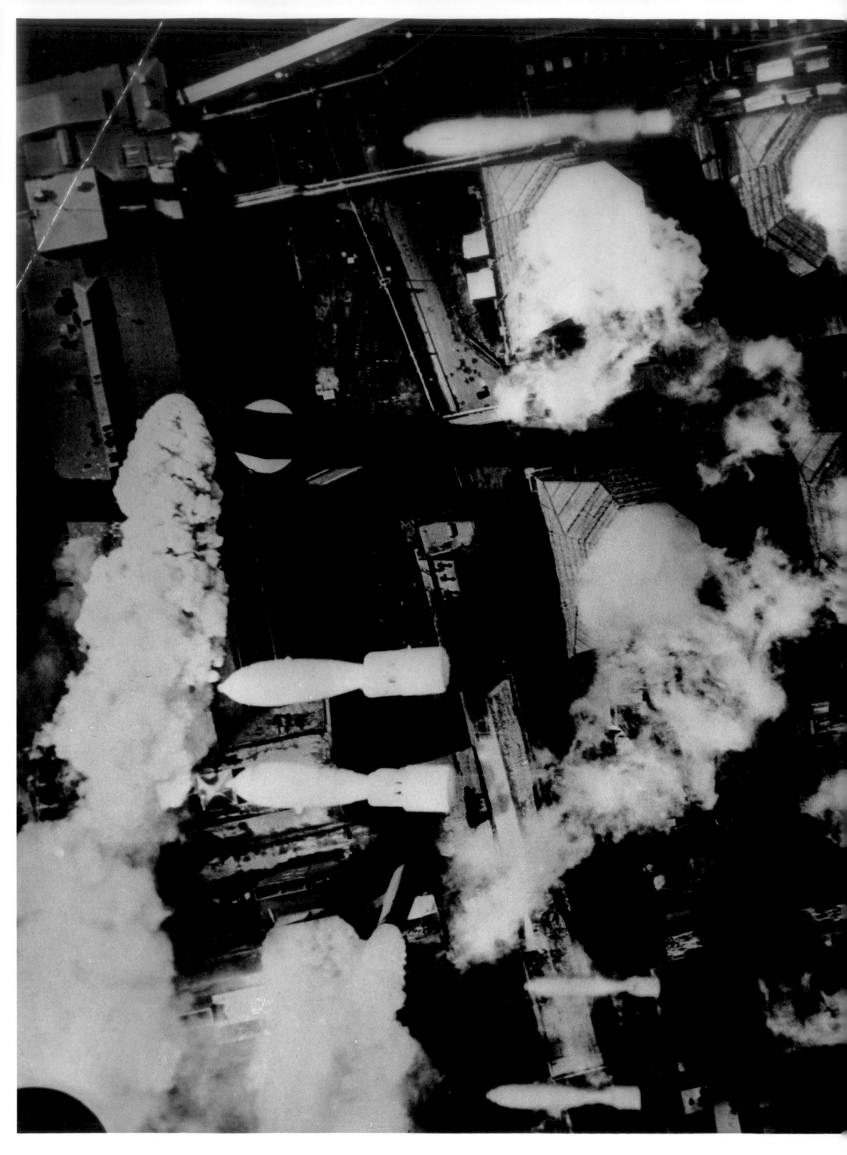

correspondents. They wrote directly, often knowing that their stories would not be printed as filed, but rather to be used to inform the editors. They wrote copious reports often with scant attention to length limitations or literary style. Their copy was usually rewritten and cut. For this reason, the dispatches contained reams of detail, color and quotes that would later be used by other writers to give *Time* articles their characteristic vitality.

The cycle of this journalistic method continued in New York. There, group journalism reached its maximum expression, since the magazine's editorial production system required that each article be edited at least twice as it changed hands along the line: from the writer, it went to the senior editor, who after rigorous editing sent the article to the managing editor. After the managing editor's approval, the same article went back to the researcher to corroborate facts, then it went to the copyeditor, who reconciled all the editorial comments and factual and stylistic corrections and finally to the senior editor for review. The senior editor sent the article to production for typesetting and fitting and was responsible for cutting or expanding the article as necessary.

This tedious and meticulous work method, with someone who was ultimately responsible for the work and unified writing style—the managing editor—remained unchanged for decades and gave the magazine character and personality.

The American Century
Both criticized by and backed by many, Henry Luce and his company had an active role supporting the United States joining World War II. The pro-war inclination was generally reflected in his magazines, more so in *Life* than in *Time*. In the February 17, 1941, issue of *Life,* he published an

article in which he came to the conclusion that the U.S. had to go to war. Luce had developed a proposition that as far as he was concerned, gave direction to his country's history. It evolved in three speeches that he made early in the year in colleges in Pasadena, Tulsa and Pittsburgh, in which he said:

"... We are, for a fact, in a war ... The irony is that Hitler knows it—and most of the American people don't ... Of course, we are not technically at war, we are not painfully at war, and we may never have to experience the full hell that war can be. Nevertheless the simple statement stands: We are in the war ... Perhaps the best way to show ourselves that we are in the war is to consider how we can get out of it. Practically, there's only one way to get out of it and that is by a German victory over England ... We say we don't want to be in the war. We also say we want England to win ... As America enters dynamically upon the world scene, we need most of all to seek and to bring forth a vision of America as a world power which is authentically American and which can inspire us to live and work and fight with vigor and enthusiasm. As we come now to the great test, it may yet turn out that in all our trials and tribulations of spirit during the first part of this century we as a people have been painfully apprehending the meaning of our time and now is the moment of testing here may come clear at last the vision which will guide us to the authentic creation of the 20th Century—our Century."

Luce saw "four areas of life and thought" in which Americans might realize such a vision:

Lethal response. This image (left), taken from an English plane, shows the moment when bombs fell on the German city of Cologne. The British bombing was a reprisal against an earlier German attack that left in ruins many London streets and damaged the emblematic buildings of Parliament, Westminster Abbey and the House of Commons.

<... >

WORLD BATTLEFRONTS

WORLD BATTLEFRONTS

type of Chinese transport drivers who carried on throughout the blitz, evoking the remark from an Australian officer supervising them: 'If I want the most efficiency in Singapore I will go first to the Scotsmen and then to the Chinese.'

As everywhere, the Chinese in Singapore were stoical under bombing. Some 1,000 were mobilized, given weapons and put under twelve leaders sent from Chungking. Truckloads of khaki-clad Chinese Communists rode to battle singing and saluting with clenched fists—a salute which on one occasion was answered by a grinning policeman, whose main job for several years had been the rounding up of Communists. Generalissimo Chiang Kai-shek sent his countrymen in Singapore a message: "Victory of the Allies means our victory."

Battle for Time. General Sir Archibald Wavell, Supreme Commander of Allied Forces in the Southwestern Pacific had a clear sense of the importance of Singapore's battle. Said he last week to the men on Singapore:

Our part is to gain time for great reinforcements. . . . We are in a similar position to the original British Expeditionary Force which stopped the Germans and saved Europe in the first Battle of Ypres [on Nov. 9, 1914]. We must be worthy successors to them and save Asia by fighting these Japanese.

The Golden Isle. The brown, lean men gazed down the barrels of their Dutch and American rifles at the yellow visitors. The brown men fired. The yellow men fell. Dutch officers urged on the Amboinese: the best native troops in The Netherlands East Indian Army. Japanese aircraft appeared again & again with bombs for Amboina. There were very few Dutch, U.S. or Australian planes to meet them. Soon more yellow men came than the brown men could kill. The brown men's green uniforms melted back into the green jungles. So fell Amboina, the Indies' second naval base, a key to Java.

Japanese bombers ravaged the hot and busy streets of Surabaya in eastern Java, heralding a sea-borne drive at the Indies' No. 1 naval base. The U.S. Asiatic Fleet was based at Surabaya, and before the bombs came U.S. sailors strolling among the stucco shops, the bright roadways, the bungalowed suburbs thought it was all remarkably like home.

At the northern approaches to Java the Jap strengthened his footholds in Borneo and Celebes. From ruined Balikpapan Jap patrols fought southward toward Banjermasin on Borneo's south coast, 300 miles from Java.

Japanese planes dropped their first bombs on Batavia, the capital. Slowly Nazi lines tightened about Java. The Dutch bombed back, claimed the sinking of a Japanese cruiser and a transport. A few U.S. P-40 fighters joined a few U.S. Flying

Fortresses in the Indies air. A few hundred more could save Java.

When & if Jap wins Java, he wins the Indies with their riches and mastery of seaways which link the Western Hemisphere, Australia, Africa, India, Suez and their imperial routes.

Crocodiles & Cannon. This week a new book about Java and all Oceania appears: Australian Paul McGuire's *Westward the Course!* (Morrow; $3.75). Author McGuire is a professional traveler, lecturer, writer of mystery stories. His book was written before the Jap struck, but *Westward the Course!* is a timely introduction to the coming Battle for Java.

In Batavia, doves cluster at dusk on the crocodile cages, supple natives bathe in the filthy canals ("They are a very clean people, but they like their water dirty"). An ancient cannon, sacred but now annoyingly useless, stands at Batavia's Amsterdam Gate. The native women pray to it for fertility and have so many babies that Java has 817 people per square mile. According to native superstition, the cannon has a wife at Bantam on the western end of the island. When the two meet, Dutch rule in Java will end.

High in the western interior lies Bandung, the Indies Army's main citadel and headquarters. From its suburban gardens, its well-guarded bastions, civilians and soldiers can see the great, three-cratered volcano of Tangkoeban Prahu ("The Overturned Boat"). (Volcanoes—some dangerously alive, some long dead—rib the narrow island from end to end.) The city of Bandung lies in a flat-bottomed bowl in the hills. And "the thunderstorms roll about the hills all the afternoons, re-though Dutch officers roll about the golf courses all the mornings, tanks and machine-gun carriers roll across the fields . . . and practice jungle war on the higher slopes."

The Dutch Indies Army in late 1941 had been upped from 50,000 to 151,000 internalized Europeans, Javanese and natives of the Indies' outer islands like the hardy Amboinese. Hidden in the interior jungles are many airdromes, and a prime Dutch defense task is to guard their approaches from the flat, vulnerable coastlands on the north. Says Author McGuire: "The Dutch Army, like all Navy, needs heavy stuff to back it; but in a campaign fought through jungles, across mountains and splashing in the sawahs [irrigated rice fields], it could probably match in Java anything likely to come against it."

This week the Jap bombs plopping into Batavia and Surabaya confirmed some of Author McGuire's best ironies. The Indies' natives, like all Asiatics, is a subtle fellow. He appreciates quality, when & if he finds it in his European masters. "When the Dutch took Malacca, one said to a Portuguese captain, mocking him: 'When will you return to govern here again?' The Portuguese answered: 'When your sins be greater than ours.'"

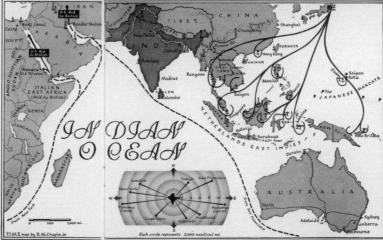

"It is for America and America alone to determine whether a system of free economic enterprise—an economic order compatible with freedom and progress—shall or shall not prevail in this century....

[T]here is the picture of an America which will send out through the world its technical and artistic skills ... Engineers, scientists, doctors, movie men, makers of entertainment, developers of airlines, builders of roads, teachers, educators...

A third thing which our vision must immediately be concerned with ... we must undertake now to be the Good Samaritan of the entire world. It is the manifest duty of this country to undertake to feed all the people of the world who as a result of this worldwide collapse of civilization are hungry and destitute...

But all this is not enough. All this will fail and none of it will happen unless our vision of America as a world power includes a passionate devotion to great American ideals. We have some things in this country which are infinitely precious and especially American—a love of freedom, a feeling for the equality of opportunity, a tradition of self-reliance and independence and cooperation.... In addition, we are the inheritors of all the great principles of Western civilization—above all Justice, the love of Truth, the ideal of Charity.... It now becomes our time to be the powerhouse from which the ideals spread throughout the world ... It is in this spirit that all of us are called, each to his own measure of capacity, and each in the widest horizon of his vision, to create the first great American Century."

A visionary? An imperialist? Luce's proposition provoked considerable discussion, criticism and controversy; his 1941 vision and the historical events that followed are still debated. His "American Century" is a crucial document that anticipated the American role on the international stage.

The writing style
The war was clearly reflected in the magazine's writing style. The gravity of the times and the tragedy of the news displaced from articles phrases that ridiculed personalities, the "fat noses," "jowls" or "wasp-waisted." *Time* covered the various theaters of the war in a more restrained, sober manner:

France: "Armistice and After"
"Roles changed quickly in Europe last week. Patriots became traitors and exiles, and conquerors became sightseers. Foremost sightseer was a little man in a light brown duster ... Adolf Hitler gazed down at the tomb of Napoleon Bonaparte, whose star had soared to a zenith equaled only by his own before it sputtered and plunged.

Accompanied by a staff of art historians and architectural experts, the Führer visited the Opera, strolled through the galleries of the half-emptied Louvre, went to the top of the Eiffel Tower where a swastika waved."
(Published in the July 8, 1940, issue.)

Great Britain: "The Landmarks Fall"
"History received its most mortal wounds in London last week. The Mother of Parliaments, Westminster Abbey, the British Museum were all hit in one night of explosion even more desecrating than the City bombing of last December. The House of Commons Chamber, where Disraeli argued with Gladstone in the days when the Empire was being completed, where Prime Minister Herbert Asquith told the members of Parliament that World War I had begun, was gutted by seven high-explosive bombs just 72 hours after Winston Churchill had there spun one of his finest fabrics of oratory."
(Published in the May 19, 1941, issue.)

D-Day: "June Night"
"Twenty-four hours were left to bid the battle teams a last Godspeed. In the morning "Ike" Eisenhower stood at an English quayside, chinning in his friendly Kansas way with embarking Tommies. In the afternoon he called newsmen into his trailer tent, told them of the great decision. He slouched in his chair, grinned lopsidedly, chain-smoked cigarettes, wisecracked a bit, once leaped like an uncoiled spring to exclaim: 'The sun is out!' All evening his khaki staff car, marked with the four red stars, rolled across the sleeping landscape ... Night cloaked the countryside and the airdromes were humming with preparation when he gave his last "good luck."
(Published in the June 12, 1944, issue.)

Italy: "The End of Il Duce"
"This Sunday morning in a sun-drenched square not far from Milan's center, where 22 years ago Editor Benito Mussolini launched the Black Shirt March on Rome, his battered, bullet-riddled corpse sprawled in public display. His head rested on the breast of his mistress, comely Clara Petacci, who had died with him. A howling mob was struggling for a place beside the heap of cadavers. The bodies lay on the ground for many hours. Then, to give the mob a better view, the partisans hanged them by their feet from a scaffold on the Piazza."
(Published in the May 7, 1945, issue.)

Live: the war. During the Second World War, *Time* published the section "World Battlefronts" in which Chapin's infographic maps were often used to follow the course of the military actions. On the maps, Chapin used symbols from the large library he created to make the maps more comprehensible and visually appealing. The top map was published in the December 15, 1941, issue, and the bottom one in the February 16, 1942, issue.

Buchenwald: "Back from the Grave"
"In the terrible barracks of the Small Camp, the starving men lay packed like rotting cargo on bare wooden shelves reaching from the floor to the ceiling ... it was all I could do to stand the sight and smell of the parodies of human beings who inhabited them. They were alive by instinct only, and by instinct they almost knocked me down when I produced from my pocket one pitiful chocolate bar in answer to a plea of a prisoner for food. At the sight of that morsel of food these filthy, spidery human beings were galvanized by a single impulse: to get a crumb, just a crumb of something to put into their stomachs."
(Published in the May 14, 1945, issue.)

From subjectivity to the two faces of Stalin

In addition to the changes to the magazine's writing during the war, a controversy arose in the office at the time that put Luce in the spotlight. The controversy was promoted by several editors led by Gottfried, who noted with concern the increasing lack of objectivity in the magazine, due to the influence of its founder's opinions. During the war, a weekly section, "Time at War," expressed ideas that had more to do with Luce's thoughts than with the events themselves. Luce's opinions even led the publication to a face-off with Churchill, since Luce didn't agree with his war objectives or the political handling of the situation in India. Churchill's positions were so harshly criticized by *Time* that the British prime minister even accused the publication of being anti-United Kingdom, making it necessary to dispatch emissaries to London to straighten out the situation and produce a reconciliation.

But undoubtedly, the most noted case involving subjectivity at the time involved Russian dictator Joseph Stalin, named "Man of the Year" in 1939 and again in 1942. The first time he was featured on the cover in an Ernest Hamlin Baker depiction

One war, seven fronts. *Time* published weekly stories on the war. This spread (below), from 1944, helps readers to understand the various theaters in which the war took place. Chapin's maps were so accurate and thorough that government officials used them in their work.

1944. "World Battlefronts"

The Siegfried Line. This map (opposite) shows how Chapin illustrated the series of antitank fortifications, pillboxes and artillery that ran along the western border of Germany. The line held back the Allied advance. On March 5, 1945, Cologne became the first major German city to be captured.

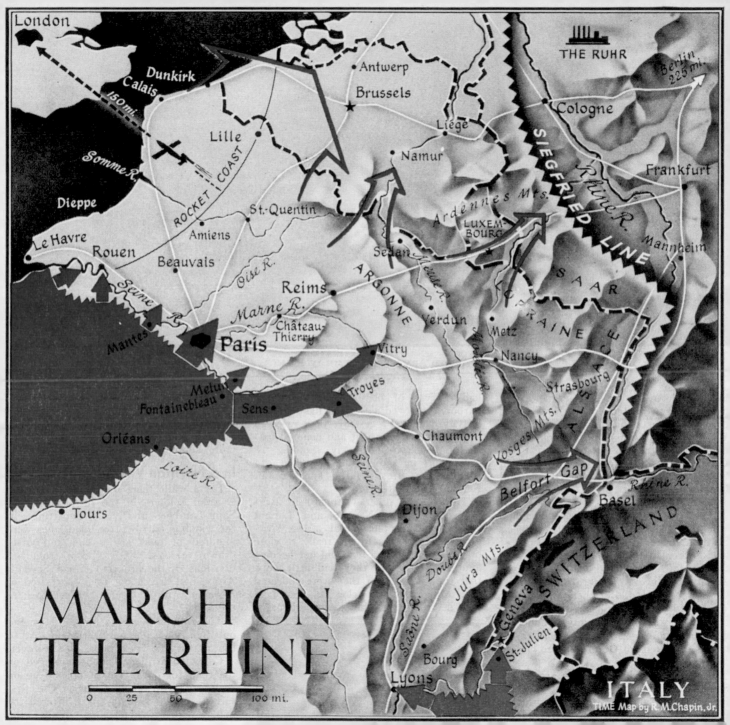

London

Dunkirk
Calais
150 mi.
Somme R.
Dieppe
Le Havre
Rouen
Lille
ROCKET COAST
St. Quentin
Amiens
Beauvais
Oise R.
Seine
Mantes
Paris
Melun
Fontainebleau
Sens
Orléans
Loire R.
Tours

Antwerp
Brussels
Liège
Namur
Ardennes Mts.
LUXEM-BOURG
Sedan
Meuse R.
ARGONNE
Reims
Marne R.
Château-Thierry
Vitry
Troyes
Chaumont
Seine R.
Dijon

THE RUHR
Berlin 225 mi.
Cologne
Rhine R.
SIEGFRIED LINE
Frankfurt
Mannheim
SAAR
LORRAINE
Verdun
Metz
Nancy
Moselle R.
Strasbourg
Vosges Mts.
ALSACE
Belfort Gap
Rhine R.
Basel
Doubs R.
Jura Mts.
Saône R.
Geneva
SWITZERLAND
Bourg
St. Julien
Lyons
ITALY

MARCH ON THE RHINE

0 25 50 100 mi.

TIME Map by R.M.Chapin, Jr.

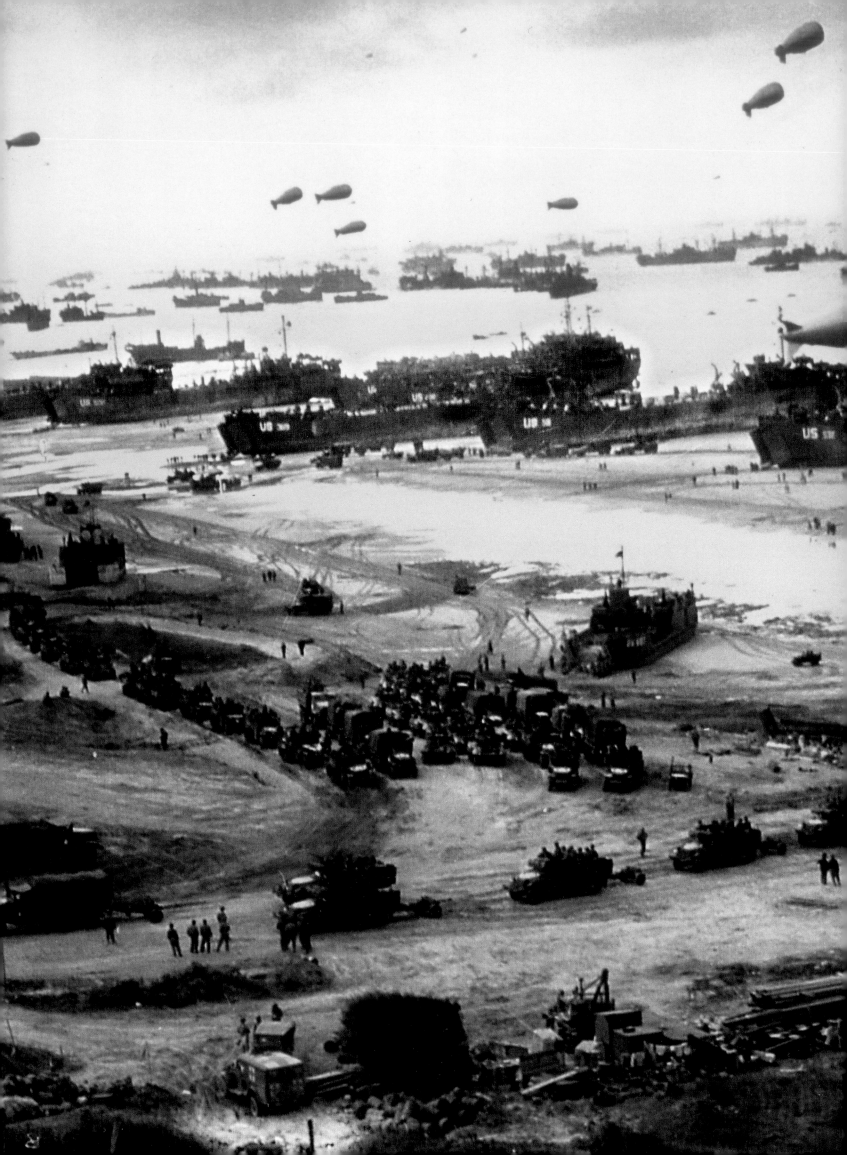

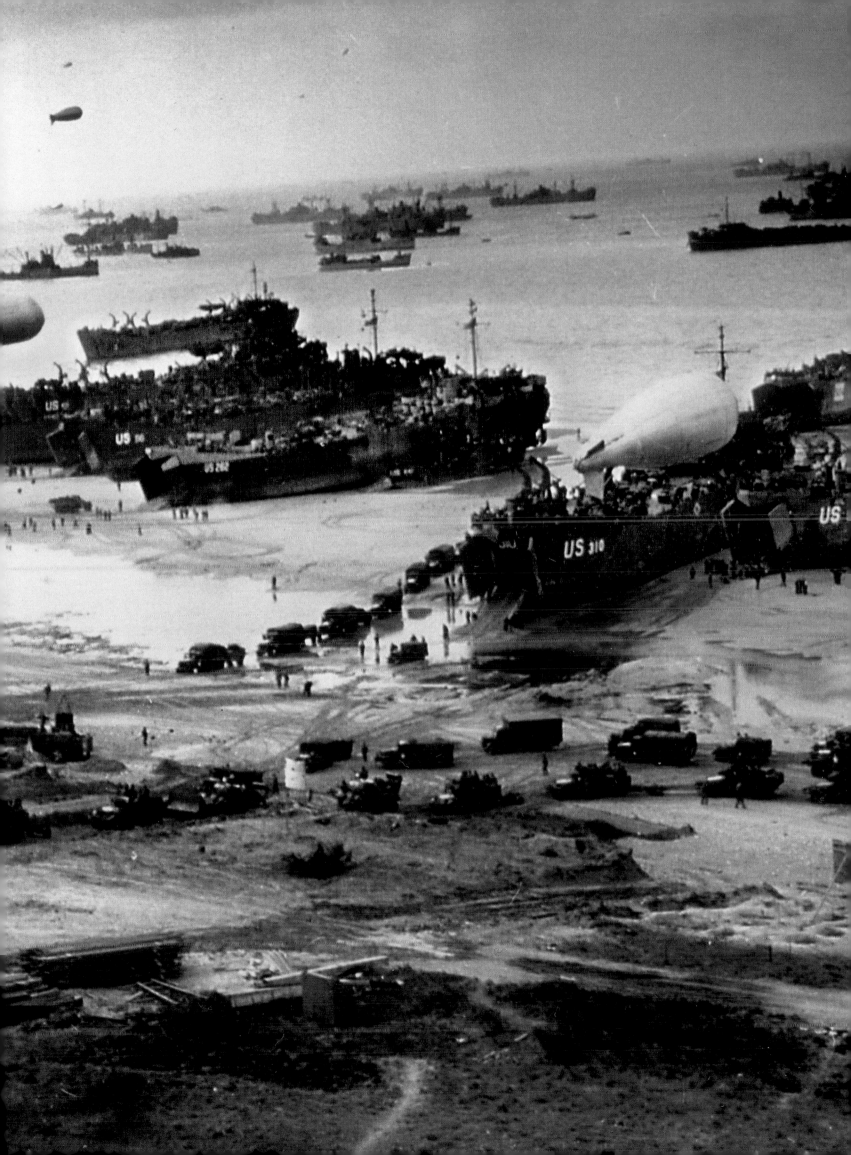

that made him look like a villain: boastful expression, half-closed eyes and malevolent smile. It was obvious that *Time* had chosen him because he was an important man in the news, although it disagreed with his views. Stalin had been designated because, by making a pact with Hitler, he had allowed Hitler to launch his marathon war. *Time* reported:

"... The actual signers were German Foreign Minister Joachim von Ribbentrop and Soviet Premier Foreign Commissar Molotov but Comrade Stalin was there in person to give it his smiling benediction, and no one doubted that it was primarily his doing. By it Germany broke through British-French "encirclement," freed herself from the necessity of fighting on two fronts at the same time. Without the Russian pact, German generals would certainly have been loath to go into military action. With it, World War II began."

In 1942, *Time* again named Joseph Stalin "Man of the Year," this time as a United States ally in the war, with these words:

"The year 1942 was a year of blood and strength. The man whose name means steel in Russian, whose few words of English include the American expression "tough guy," was the man of 1942. Only Joseph Stalin fully knew how close Russia stood to defeat in 1942 and only Joseph Stalin fully knew how he brought Russia through ... Had German legions swept past steel-stubborn Stalingrad and liquidated Russia's power of attack, Hitler would have been undisputed master of Europe, looking for other continents to conquer ... But Joseph Stalin stopped him. Stalin had done it before, in 1941,

First victim. Melville Jacoby was the first *Time* correspondent to die during WW II. He was killed in 1942 on an airfield when a plane crashed into him and a group of people that were en route to cover the American's defensive air bases on the Australian front. The photo, above, of Jacoby working by candlelight was taken by *Time* war photographer Carl Mydans.

when he started with all of Russia intact. But Stalin's achievement of 1942 was far greater. All that Hitler could give he took, for the second time."

The 1943 cover illustration also reflected *Time*'s current attitude towards Stalin. The arrogance and spiteful smile of 1939 gave way to the magnificent face of a hero, serene, with grayish hair, wrinkles and a good-natured expression. The artist was also a Russian, Boris Artzybasheff. The cover was published on January 4, 1943, during Gottfried's tenure. Manfred Gottfried was a defender of the neutral position that the magazine should espouse, and had more than one run-in with Luce over the issue. He argued:

"*Time* is non partisan ... seeks to serve no interest which is not wholly consistent with the interests of the nation and of humanity. Thus, *Time* does not think of its function as being to get things done—that is the prerogative of the sovereign people— Our function is to assist in getting things understood."

In August 1941, Gottfried informed Luce to start looking for his successor, although he thought he still had three or four years left in the position. But since he also knew that Luce took a long time to make such decisions, he gave him plenty of advance notice. Gottfried's prediction came true: Luce first proposed Thomas Stanley

D-Day. This picture, taken on June 7, 1944, shows the powerful Allied air, sea and land forces in Normandy. Allied troops, landing by air and amphibious vehicles, took the Omaha beachhead with the support of massive air attacks and naval bombardments. (Previous spread)

Matthews as a potential candidate for the position, but recommended that he should first work as executive editor under Gottfried. The arrangement didn't work because Gottfried and Matthews had frequent arguments. Luce then proposed to Matthews that he take over the London correspondent position for three months, in his words, "so you can broaden your editorial outlook," and that he would replace Gottfried upon his return to New York. At last, Luce named Matthews executive editor. He took over in January 1943.

In 1941, before the United States joined the war, *Time* already had a circulation of close to a million. The following year, sales doubled. But the company itself had to tackle several problems. The first had to do with its staff, since by September 1942, 167 Time Inc. employees had left their jobs to join the military. Another difficulty was the rationing of paper, which, starting in 1943, forced *Time* to reduce its size to 104 folios, limiting the number of its editorial pages. It was nevertheless able to launch Australian and British editions in an effort to take the news to the troops.

The two faces of Stalin. Joseph Stalin was "Man of the Year" in 1939 and 1942. These two different portraits reflect *Time*'s subjectivity during the war (below, left and right). In the first, he appears to be a villain after he agreed with Hitler that their countries nonaggression treaty would have a secret pact, dividing Poland between their two countries; in the second, he appears to be a hero, after he joined the Allied powers when Hitler betrayed him by invading Russia.

The Bomb

Almost four years after the attack on Pearl Harbor, the United States dropped two atomic bombs over Japan. The first one fell on the city of Hiroshima on August 6, 1945. It was called "Little Boy." It was ten-feet long and weighed 9,700 pounds. It was loaded with uranium. Its casualties: 135,000 people.

The second one was dropped over Nagasaki on August 9. It was called "Fat Man." It weighed 9,900 pounds and was loaded with plutonium. It caused 36,000 casualties.

The first one, with all the horror it conveyed, exploded the day *Time* went to press, so that issue only partially covered the news. The newsroom wrote using "background" information in its files about how it had been assembled. The day after the second bomb was dropped on Nagasaki and five days after Japan's surrender, *Time* featured on the cover an image of a black cross over an orange sun. Included inside was a section titled "Victory," with an article simply titled "The Bomb." It read:

> "The greatest and most terrible of wars ended, this week, in the echoes of an enormous event—an event so much more enormous that, relative to it, the war itself shrank to minor significance. The knowledge of victory was as charged with sorrow and doubt as with joy and gratitude. More fearful responsibilities, more crucial liabilities rests on the victors even than on the vanquished.
>
> In what they said and did, men were still, as in the aftershock of a great wound, bemused and only semi-articulate, whether they were soldiers or scientists, or great statesmen, or the simplest of men. But in the dark depths of their minds and hearts, huge forms moved and silently arrayed themselves: Titans, arranging out of the chaos an

age in which victory was already only the shout of a child in the street. With the controlled splitting of the atom, humanity, already profoundly perplexed and disunified, was brought inescapably into a new age in which all thoughts and things were split and far from controlled. As most men realized, the first atomic bomb was a merely pregnant threat, a mere infinitesimal promise.

All thoughts and things were split. The sudden achievement of victory was a mercy, to the Japanese no less than to the United Nations; but mercy born of a ruthless force beyond anything in human chronicle. The race had been won, the weapon had been used by those on whom civilization could best hope to depend; but the demonstration of power against living creatures instead of dead matter created a bottomless wound in the living conscience of the race. The rational mind had won the most Promethean of its conquests over nature, and had put into the hands of common man the FIRE and force of the sun itself.

Was man equal to the challenge? In an instant and without warning, the present had become the unthinkable future. Was there hope in that future, and if so, where did hope lie?

Even as men saluted the greatest and most grimly Pyrrhic of victories in all the gratitude and good spirit they could muster, they recognized that the discovery which had done most to end the worst of wars might also, quite conceivably, end all wars—if only man could learn its control and use.

The promise of good and of evil bordered alike on the infinite—with this further, terrible split in the Fact: that upon a people already so nearly drowned in materialism even in peacetime, the good uses of this

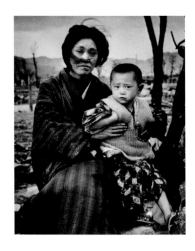

Destruction. The atomic bomb was detonated over Hiroshima on August 6, 1945. Three days later a second bomb was detonated over Nagasaki. Over 150,000 casualties occurred due to the bombings; many people were lethally affected by radiation. This picture of a desolate mother and child, sitting among the ruins in Hiroshima, was taken four months after the atomic bomb dropped (left). *Time* crossed out Japan's rising sun on its August 20 cover (opposite), just as it had crossed out an image of Hitler to symbolize his death a few weeks earlier.

TIME

THE WEEKLY NEWSMAGAZINE

95

power might easily bring disaster as prodigious as the evil. The bomb rendered all decisions made so far, at Yalta and Potsdam, mere trivial dams across tributary rivulets. When the bomb split open the universe and revealed the prospect of the infinitely extraordinarily, it also revealed the oldest, simplest, commonest, most neglected and most important of facts: that each man is eternally and above all else responsible for his own soul, and, in the terrible words of the Psalmist, that no man may deliver his brother, nor make agreement unto God for him.

Man's fate has forever been shaped between the hands of reason and spirit, now in collaboration, again in conflict. Now reason and spirit meet on final ground. If either or anything is to survive, they must find a way to create an indissoluble partnership."

The story was written by James Agee, one of *Time*'s most gifted writers, who was on staff for more than sixteen years. Agee began at *Fortune* magazine after graduating from Harvard in 1932 and was hired by Ralph Ingersoll, following Luce's dictum that it was easier to transform poets into business journalists than bookkeepers into writers. At *Time*, Agee wrote book and film reviews with such brilliance that his work transcended the anonymity that cloaked most *Time* staffers and won for him a reputation that led him to a full-time career in Hollywood, where, among other achievements, he is remembered for his excellent screenplay for John Huston's *The African Queen*. His posthumously published autobiographical novel, *A Death in the Family,* won a Pulitzer Prize in 1957.

In the story on "The Bomb," Agee conveyed the thoughts of Luce, who always believed that it was a big mistake to require the enemy's unconditional surrender to win the war. Luce was convinced that it was not necessary to drop the atomic bomb to force Japan to capitulate. In 1948, during a speech in Milwaukee, the *Time* founder said:

"If instead of our doctrine of 'unconditional surrender' we had all along made our conditions clear, I have little doubt that the war with Japan would have ended soon—without the bomb explosion which so barred the Christian conscience ... The U.S. must never again fight a war for 'unconditional surrender.'"

It was in the September 10 issue, under the headline "Victory's Grim Visage," that *Time*'s correspondent Theodore White, who witnessed the rendition on the deck of the American ship *Missouri*, wrote:

"Complete silence greeted the Japanese as they ascended the deck. The American generals watched them with varying degrees of emotion. Stilwell bristled like a dog at the sight of an enemy. Spaatz' chiseled face lines were sharp in contempt. Kenney curled his lips in a visible sneer."

Nevertheless, after the bombs, after World War II, a new era started in the world. Other wars started, continued and ended. Walls went up, missiles were readied and new nuclear experiments made humanity tremble. At the same time, there were countless breakthroughs in medicine and science, and the technological revolution produced an avalanche of new devices that radically changed the quality and way of life. They were the two faces of a reality that, face to face, week after week, continued to be reflected in the pages of *Time*.

Surrender. Days after the Hiroshima and Nagasaki atomic explosions, Japan surrendered. The surrender ceremony took place on September 2, 1945, on board the American battleship *Missouri*. Officials from the Japanese government sign the Japanese Instrument of Surrender—the official end of World War II (right).

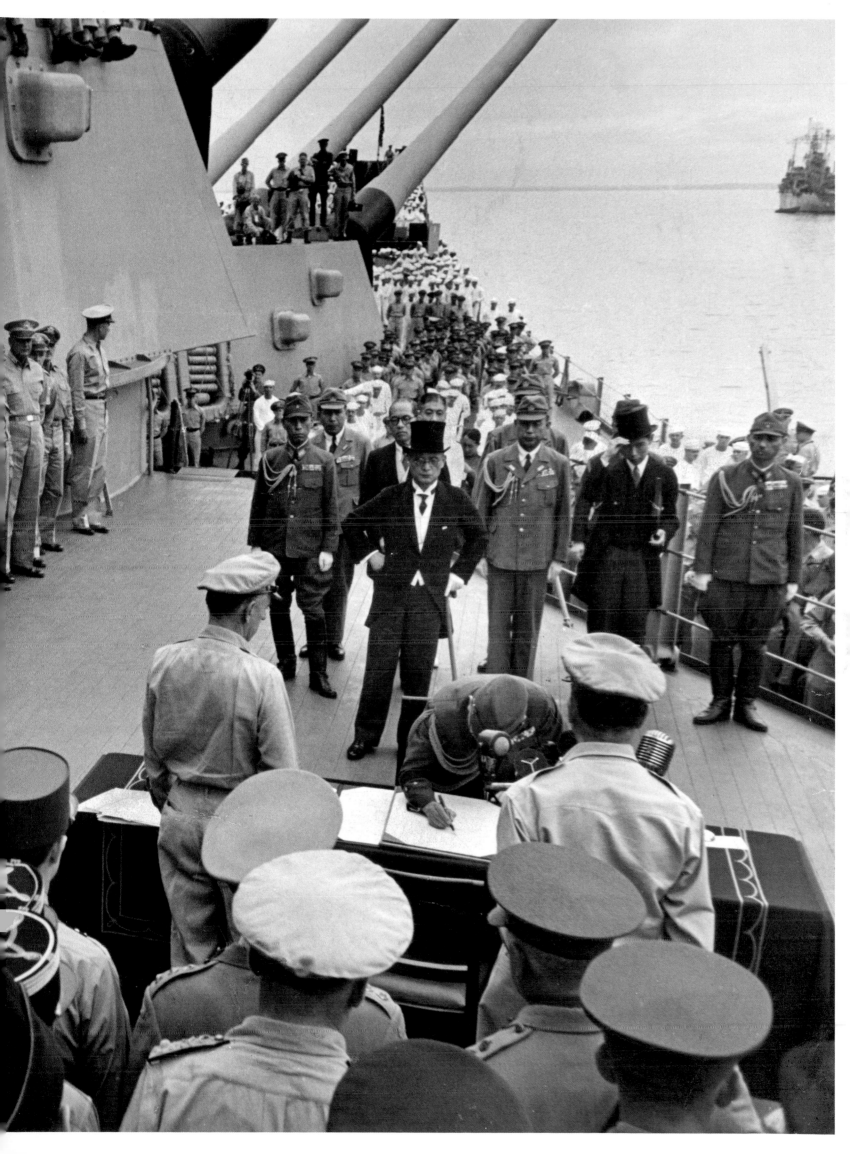

3

Growth, Discontent and the Great Cultural Opening

Magazines are not an independent facet of culture, nor are they at the top of a lighthouse, from which they only watch. They are protagonists as well as witnesses and, as living creatures, they are born, grow, evolve and change along with the society to which they belong. Often, a magazine's success and permanence depends on how it reflects that evolution, as well as its editors' ability to forecast, adapt to and become part of those changes. In the period after World War II, *Time* reflected and engaged with the new realities of a world that had been shaken by two atomic bombs but was prepared to grow with new technologies, and would be transformed by new behavior, new horizons and new conflicts.

Once the war was over, the United States emerged as a world economic superpower. With its cities left untouched, its fields and industry at full production and its people eager to turn to peacetime consumption, the nation contrasted markedly with the European countries, which had been devastated by the conflict. Moreover, Americans, forced to avoid spending during the war, had by the end of the 1940s saved an estimated $135 billion, their coffers enriched by military payments and war bond investments.

Peacetime security and optimism about the future prompted a sharp increase in the birthrate. Between 1946 and 1964, an estimated 76 million babies would be born in the United States, a development that came to be known as the "Baby Boom," a term first used by *New York Post* columnist Sylvia Porter in May 1951. At the same time, women, who had found jobs in the nation's factories and offices while men were away at war, enjoyed a new economic

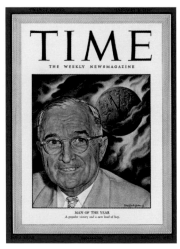

1948. Harry Truman

"Man of the Year" and unexpected victory. *Time* named Truman "Man of the Year" for 1948 (left). During his presidency, the country experienced one of the most significant periods of growth in its history. Even the *Chicago Daily Tribune* jumped the gun giving the winning title to Thomas Dewey over Harry Truman. But the Missouri farmer and haberdasher won by a slim margin to become the 33rd president of the United States (opposite).

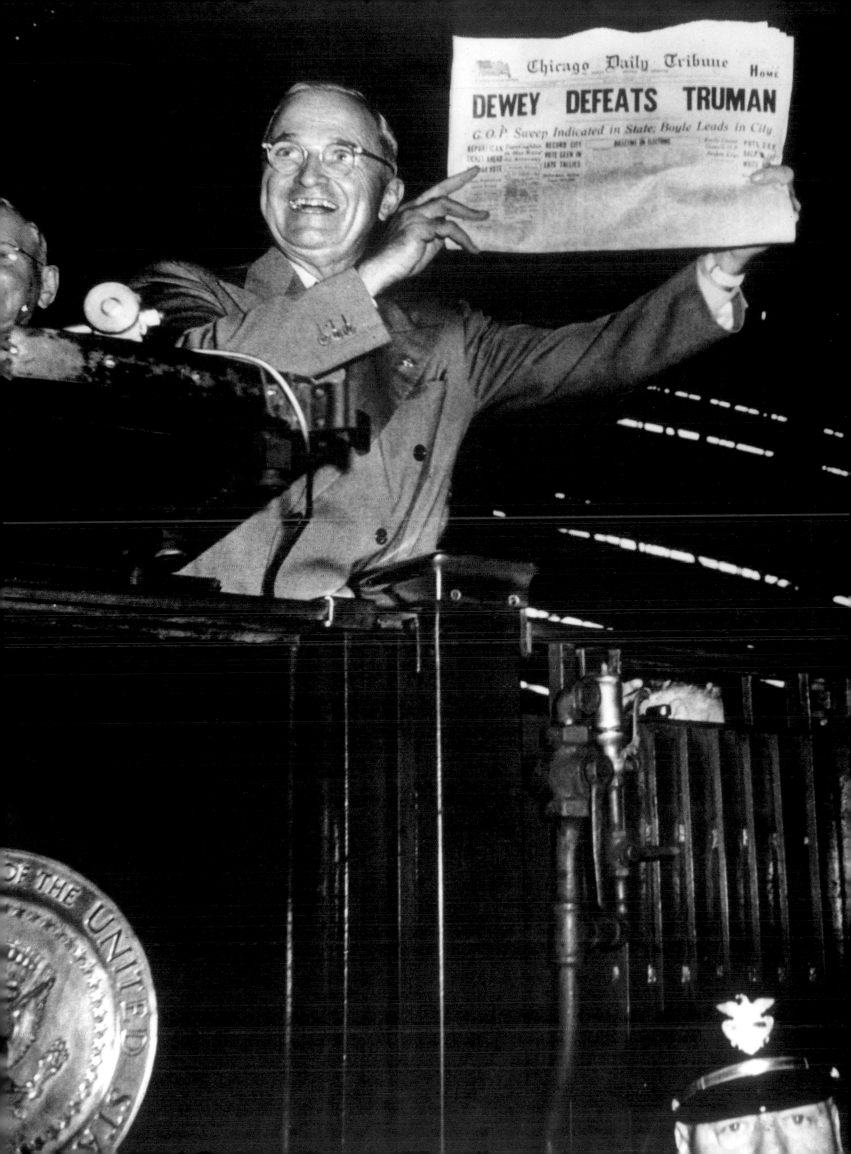

Baby boom. In the United States, an estimated 76 million babies were born between 1946 and 1964.

At full speed. Between 1945 and 1955, the number of automobiles doubled, reaching 52 million units. Throughout the country, highways were built with motels, restaurants and drive-in banks springing up around them. Drive-in theaters, giant outdoor screens in parking lots, became a popular family attraction; by the end of the 1950s, there were 4,000. On the following spread, an image of Charlton Heston as Moses in the 1958 film *The Ten Commandments* is on a drive-in screen.

independence and increasing opportunities to fill roles other than as wives or mothers.

A true spending spree took place, encompassing cars, houses, electronics and new-fangled gadgets of all kinds. The prestigious economist John Kenneth Galbraith dubbed the newly buoyant America "the affluent society." In addition to letting people save, the economy, thanks to high defense spending spurred by fears of Soviet expansion, kept everyone employed. The implementation of the Marshall Plan, geared to help Western Europe recover from the war, contributed not only to the high employment level but also to the opening of new export markets.

The nation prospered, and *Time* prospered along with it. By now, the magazine was an established institution, growing steadily in confidence and influence, and its journalism took on a new substance and authority.

Truman's victory

On the political front, 1948 brought a stunning surprise: Harry Truman's upset victory over New York Governor Thomas E. Dewey in the presidential race. Truman—who had taken over after Franklin D. Roosevelt's death in 1945—had been widely criticized during his three years in office. For Republicans, and for a segment of his own Democratic Party, he represented the old, discredited political machine and was soft on Communism. "To err is Truman," was the slogan invoked throughout the campaign. Regardless, Truman made it to the White House again and served until 1953. It was during his two terms that America's prosperity and dominance surged.

Time and its sister magazine, *Life*, reflecting the Republican leanings of Henry Luce, had joined in the criticism of Truman and had favored his adversary

Dewey. Yet after Truman's victory, *Time* chose him as the 1948 "Man of the Year." In the story published in its January 3, 1949, issue, the magazine sketched a vivid panorama of what the country was experiencing at the time:

"... In 1948's troubled world, the U.S. had reason to be thankful. In the midst of hunger and want it knew unequaled prosperity. The year's harvest was the biggest in history. With few exceptions, everyone who wanted a job had one. Labor got a third round of wage increases, and strikes were at a postwar low. Prices inched upward and everyone worried, complained, and talked about them. But the U.S. citizen was earning more actual buying power than ever before. He also managed to save some money (personal savings were up $4.9 billion over 1947). The year's crop of babies pushed the population to 147,280,000—up 15,500,000 since 1940 ... Bebop, a frantic, disorganized musical cult whose high priest was quid-cheeked Dizzy Gillespie, replaced swing ... Babe Ruth died ... a coal miner's daughter nicknamed "Bobo" married into the Rockefeller clan; Manhattan's nickel subway fare went to a dime; the year's most popular book on human behavior was by a zoologist named Kinsey ... women took the family wash and their gossip to "Launderettes," which became a modern urban equivalent to the village well; they flocked to quiz programs where prizes reached a frenetic peak of absurdity. The world learned officially that man had flown faster than sound. In sport, the athlete of the year was a horse; Citation won everything worth winning, was probably the greatest horse of all time. Television became an accepted part of U.S. life...

His election was a personal victory almost without historical parallel; a victory of the fighting spirit ... He had humbled the confident, discomfited the savants and the pollsters, and given a new luster to the old-fashioned virtues of work and dogged courage. The year 1948 was Harry Truman's year ... Anybody but Truman was the cry. Through it all, the man from Missouri kept his own counsel, and laid his plans. When he was asked to withdraw, he retorted grimly: 'I was not brought up to run from a fight.'

When Harry Truman, brisk and smiling in a gleaming white linen suit, walked into the steamy Philadelphia convention hall, he faced a sullen, demoralized Democratic Party. The delegates had kept him waiting for four hours while the South staged a last fight against his nomination. Mississippi's and half of Alabama's delegation had walked out. It was 2 a.m., delegates were sweaty, rumpled and tired.

Minutes later, the bedraggled delegates were on their feet, yelling, applauding and cheering the man nobody had wanted...

He set out to 'tell the people the facts.' He was no orator. He stumbled over big words, made mistakes in grammar, got tangled up in his sentences. A man without pose or side, he was incapable of dramatizing an issue ... His irresponsible implication that a vote for Thomas Dewey was a vote for fascism horrified his soberer followers. But Harry Truman succeeded in dramatizing himself; to millions of voters he seemed a simple, sincere man fighting against overwhelming odds—fighting a little recklessly perhaps, but always with courage and a high heart.

Few men have been able to communicate their personality so completely. He never talked down

WALL STREET
Bull Market
(See Cover)

It was getting to be a regular customer couldn't be sure of a place to sit; eager-eyed newcomers were beginning to crowd the nation's 4,200-plus brokerage offices. The public was not doing much buying yet—not was still a professional's market—but moving ticker tape was once again a sight to see, and dreams of quick killings were again dreams to dream. Wall Street was nursing a baby bull, and a lot of cow-eyed mother love was suddenly loose in the land.

Rosy Glow. The bull was still scraggly, unsteady on his feet, not quite sure whether he was going to bellow or belch. Though still young enough to be scared by any wisp of bad news that came floating along, he was learning slowly—and, most important of all, putting on a little weight every week. Almost everyone admitted he was a pretty cute trick.

On the New York Stock Exchange, the Dow-Jones industrial averages last week edged up to a high of 191.27, best since Aug. 16, 1946. Then they worried off a shade or two. After such a fast climb as they made in May (180.28 to 191.26), a spell of hacking & filling was to be expect-

ed. Many Dow theorists even expected a substantial "correction."

In some respects, the Dow-Jones averages—which record the rise & fall of 65 (out of 1,558) stocks on the Big Board—did not show the true strength of the baby bull market. Day after day last week, scores of stocks hit new highs for 1947-48 and stayed there. The booming oils had even passed their 1929 peak.

The U.S. economy seemed to warrant the rise. Overall profits were well up from last year's record peak. U.S. industrial production, which had slipped a bit during the spring, was climbing again. Backlogs of orders were building up in some industries faster than production could consume them. And U.S. employment, now nosing above 58,000,000, was expected to be greater than ever by midsummer.

Most of Wall Street's 1,200 market depositors and crystal ballers felt a rosy glow. Some expected a rise of 20 points more or less, which would put the industrial average even with the peak of the 1946 bull market. Others, like Shields & Co.'s Edmund W. Tabell, were more optimistic, held to: "My ultimate objective [for the average] is ... 230 to 260."

Grey Chill. A few even imagined 1929 all over again (without the hangover).

But no one put much stock in such notions. The giddy '20s were gone forever. Now there are 73% margins; a speculator has to put up more than three times as much money to buy the same amount of stock as he did in '29. Moreover, greatly increased taxes have slashed the amount of cash available for speculation; and, in addition, the 25% capital gains tax eats deeply into any profits.

In the face of these checks and dangers, Stock Exchange President Emil Schram, a onetime New Dealer with a deep-seated fear of wild speculation, was "not so sure this is anything more than a flurry." The diehards who were clinging to their bearish positions hoped he was right. Broker John H. Lewis, who had been one of the first to see the 1946 bear trend, was still seeing the market in a cold grey light. But he confessed that he was lonely. "Until a few weeks ago I had a lot of company," he said. "Now, I'm about the only one left. The others have all jumped on the bull wagon."

Confidence in the Future. What the bull wagon needed, if it was going to go rolling, was a public push. The "little fellow," who traditionally gets in the market just in time to get cleaned out, was not taking any big chances yet. Said Francis Adams Truslow, president of the New York Curb Exchange: "Investors have been hesitating for the past several years. They are just beginning to exhibit their confidence in the future."

The public doesn't come in, according to an old Wall Street saw, "until its avarice grows stronger than its fear." Even though the U.S. economy is bigger and richer than ever before, the investing-speculating public is dogged by fears of international crises, labor-management strife and lower profits.

As a barometer, the stock market has proved none too accurate, notably in the last two years. Back in 1937, the market was far worse than the drop in production; since 1942, the market has been much lower—in comparison with the gross national product—than it was even in the dark days of 1932 (see chart). The Dow-Jones industrials, now earning even more ($20 a share) than they did in 1929, are selling for only half as much.

In the inflated U.S. economy, Wall Streeters consider stocks generally deflated, feel that the Big Board is selling the U.S. short. Item: Standard Oil (N.J.), with indicated 1948 earnings of $16 a share, is now selling at $84—only a bit more than five times earnings. Many another stock, with years of steady dividends behind it, is paying anywhere from 7% to 11% a year in dividends (most bonds are paying only 3 to 4%). Samples: Westinghouse Air Brake, Standard Brands, Underwood Corp., American Safety Razor Corp., Cluett, Peabody & Co.

Such tasty bait as this, Wall Streeters hoped, would sooner or later lure in the public. They had some pious arguments in

favor of it: a big bull market, for one thing, would not only fatten brokers' commissions, but would permit industry to raise some of the capital, through stock issues, that it badly needs for expansion. One simple recipe, favored by both Schram and Truslow to attract more investors: cut margins to 50%.

Coffee House Compact. The New York Stock Exchange was built on speculation, in early days it often seemed jerrybuilt. Wall Street (so-called because of the log wall that peg-legged Peter Stuyvesant had built) was a natural site for trading; near the docks at its foot, there had long been a slave market. There, in 1790, when the first U.S. Congress voted "public stock" to redeem the Continental scrip which had financed the Revolution, a lively trade in the U.S. "stock" sprang up.

Wall Street's merchants and insurance brokers then did their trading under a buttonwood tree. Soon, 24 of the most active traders signed a compact: to favor each other and not charge less than 1/4% commission. They held a daily "call" of stocks in the Tontine Coffee House, which was "in an eternal buzz with gamblers."

The buzz persisted through the years—years in which the New York Stock Exchange was plagued both by fire (which, in 1835, destroyed its building and 647 others) and the continual forays of a ruthless crew of freebooters. There was grim-faced Daniel ("Uncle Dan'l") Drew, who originated the term of "salted & watered stock" (while driving cattle to New York, Drew used to feed them salt, then increase their weight by letting them drink enormous quantities of water); and the coldly scheming Jay Gould ("whose name, built upon ruins, carries with it a certain whisper of ruin"), whose attempt to corner gold brought on the "Black Friday" of 1869 and disrupted the nation's whole credit structure.

There was also hairy Jim Fisk, Gould's co-raider of the Erie ("harlot of the rails"), who was shot to death by a rival in love; Cornelius Vanderbilt, who used

"salt & water" to good advantage in putting together the New York Central; Jay Cooke ("parson & fox"), whose crash brought on the panic of 1873 and closed the Stock Exchange for ten days. And, too, there were hundreds of hard-working, little-publicized brokers who helped finance the incredible expansion of plants and railroads across the continent which put Wall Street at the front of the world's money marts.

Bloody Struggle. At the corner of Wall and Broad Streets, opposite the fortress-like House of Morgan, stands the $13 million, Corinthian-columned temple that now houses the Exchange.[*] The trading


EMIL SCHRAM
The "little fellow" was hesitant.

"floor," six stories high, is almost as cavernous as Grand Central Station. On weekdays, between 10 and 3, as many as 600 Exchange members (out of a total membership of 1,375) scurry among the 18 horseshoe-shaped "trading posts," where the stocks are listed, some 70 to a post.

Around noon, the floor crowd thins as members dart out for a quick, nervous lunch. For those who take the elevator to the members' luncheon club above the high ceiling there is a bronze reminder of the daily battle: a bear & bull locked in bloody struggle.[*] Lunches are usually bolted, before the battle can take an unprofitable turn.

The basic operation of the market for the ordinary investor (who is usually optimistic and thus a bull) is as simple as was the trading under the buttonwood tree. Example: when an order is placed at an Omaha brokerage office to buy 100 shares of General Motors, it is wired to the broker's New York office and phoned to the firm's "floor partner" at the Exchange. He goes to the post where the stock is listed, finds another broker with G.M. stock to sell. He makes a deal, and sends a notation of the purchase back to his office by a telephone clerk. The number of shares bought and the price is then recorded on the ticker tape, which is teletyped to 1,922 brokerages, banks and other offices in 310 cities. The actual stock certificate changes hands later.

For professionals, the market has another side (the short position), in which many of the biggest killings are made. Usually only professionals sell short, chiefly because the ordinary investor is vaguely suspicious of the process. Shorts (bears) sell stock which they do not own, hoping that the market will go down and that they can buy the stock

[* There are stock exchanges in 12 other U.S. cities, where trading is principally in stocks of local companies. Among the biggest: Chicago, Boston, San Francisco, Los Angeles, Philadelphia, Detroit, Cleveland.]

[* The use of "bear" to describe a short-seller stems from an old saying about "selling a bearskin before the bear is caught." The use of "bull" to describe a speculator on the long (or up) side is believed to have come from the upward toss which a bull gives to his horns.]

STOCK MARKET BAROMETER

DOW-JONES INDUSTRIAL AVERAGES — GROSS NATIONAL PRODUCT (in billions of dollars)

EARNINGS OF DOW-JONES INDUSTRIALS (in dollars per share)

houses. In his building year ending next March he will have put up about 1,900 houses, 1,500 in Levittown and the rest in another Long Island project.

Ranch v. Cape Cod. The influence of Levitt & Sons on housing goes much further than the thresholds of its own houses. Its methods of mass production are being copied by many of the merchant builders in the U.S., who are putting up four of every five houses built today. It is such mass production on one huge site which is enabling U.S. builders to meet the postwar demand and to create the biggest housing boom in U.S. history.

In the record year of 1949, when 1,025,-100 dwelling units were started, builders thought they had reached their peak by starting about 104,000 units in one month. Yet in May this year, 140,000 units were started—and June was probably even better. This year the U.S. will probably build 1,170,000 units; there is scarcely a city without some big new development. Though some of the houses are ugly and some projects poorly planned, most had one thing in common: the houses are nearly all "ranch houses," a loose term for any house whose rooms are concentrated on the first floor.

On a 320-acre farm near Lexington, Mass., Boston's Builder Joseph F. Kelly, who in three years has sold about 3,000 Cape Cod houses, is starting work on 400 ranch-type houses to sell for less than $10,000. In Portland, Ore., Builder Franklin T. White is frankly copying many features of Levitt's ranch-type house, adding some of his own—and selling it at a higher price ($8,500). In Philadelphia, Matthew McCloskey Jr. is at work building 522 Levitt-type houses, though they do not contain all the Levitt equipment.

Outside Los Angeles, on what was once a huge beet farm, Aetna Construction, Inc. and Biltmore Homes, Inc. are building 17,130 one-story houses, all monotonously arranged on a 3,500-acre gridiron, just about eight feet apart. The prices: $7,825 to $9,600.

In Richmond, Calif., Builder Paul Trousdale (TIME, Dec. 2, 1946) has

START & FINISH
For Jack, a record he couldn't match.

teamed up with ex-Prizefighter Joe Louis and plans to build 4,000 houses for Negroes. In San Francisco, Builder Henry Doelger has put up so many rows of his five-room, white stucco houses (one story above a garage on a 25-ft. lot) that local wags call the southwest corner of the city the "White Cliffs of Doelger." Just outside Chicago, Builder Nathan Manilow, whose well-planned Park Forest development on a 2,400-acre plot makes a complete city of 3,000 rental houses, is getting ready to build another 2,800 houses to sell for $8,500 to $14,500.

The Great Change. Yet the demand for low-priced houses is still above the supply, notably in cities like Chicago, hampered by antiquated building codes and tight union restrictions. Furthermore, those who had hoped prices would drop are sadly disappointed. The prices of lumber, plumbing and heating equipment, etc, are all on the rise again. Some builders are

also beginning to jack up their prices. When they do, many find that it is just as easy to sell their houses as before.

To a man, Bill Levitt and all the other builders know exactly whom to thank for the boom and the steadily expanding market. Said one San Francisco Builder last week: "If it weren't for the Government, the boom would end overnight."

At war's end, when the U.S. desperately needed 5,000,000 houses, the nation had two choices: the Federal Government could try to build the houses itself, or it could pave the way for private industry to do the job, by making available billions in credit. The U.S. wisely handed the job to private industry, got 4,000,000 new units built since the war, probably faster and cheaper than could have been done any other way.

The Government has actually spent little cash itself, But by insuring loans up to 95% of the value of a house, the Federal Housing Administration made it easy for a builder to borrow the money with which to build low-cost houses. The Government made it just as easy for the buyer by liberally insuring his mortgage. Under a new housing act signed three months ago, the purchase terms on low-cost houses with Government-guaranteed mortgages were so liberalized that in many cases buying a house is now as easy as renting it. The new terms: 5% down (nothing down for veterans) and 25 years to pay. Thus an ex-G.I. could buy a Levitt house with no down payment and installments of only $46 a month.

Fountain of Youth. Like its counterparts across the land, Levittown is an entirely new kind of community. Despite its

INDOORS & OUT
For the Joneses, a move a year.

size, it is not incorporated, thus has no mayor, no police force, nor any of the other traditional city officers of its own. It has no movies, no nightclubs and only three bars (all in the community shopping centers).

And Levittown has very few old people. Few of its more than 40,000 residents are past 35; of some 8,000 children, scarcely 900 are more than seven years old. In front of almost every house along Levittown's 100 miles of winding streets sits a tricycle or a baby carriage. In Levittown, all activity stops from 1 to 2 in the afternoon; that is nap time. Said one Levittowner last week, "Everyone is so young that sometimes it's hard to remember how to get along with older people."

The community has an almost antiseptic air. Levittown streets, which have fanciful names as Satellite, Horizon, Haymaker, are bare and flat as hospital corridors. Like a hospital, Levittown has rules all its own. Fences are not allowed (though here & there a home-owner has broken the rule). The plot of grass around each house must be cut at least once a week; if not, Bill Levitt's men mow the grass and send the bill. Wash cannot be hung out to dry on an ordinary clothesline; it must be arranged on rotary, removable drying racks and then not on weekends or holidays.

There are perquisites as well as rules. For the young children there are parks and countless playgrounds. For the old folks (the 5- to 35-year-olds) there are baseball diamonds, handball courts, six huge 75-by-125-ft. swimming pools, plus 25-by-75-ft. kiddy pools, shopping centers and 60-odd fraternal clubs and veterans' organizations.

"The Old Freeze." Actually, Levittown's uniformity is more apparent than real. Though most of their incomes are about the same (average: about $3,800), Levittowners come from all classes, all walks of life. Eighty percent of the men commute to their jobs in Manhattan, many sharing their transportation costs through car pools. Their jobs, in any other big community, range from banking, to teaching to preaching.

Levittown has also developed its own unique way of keeping up with the Joneses. Some Levittowners buy a new house every year, as soon as the new model is on the market.

Levittowners' isolation is more real than apparent. Said one housewife last week: "It's not a community that thinks much about what's going on outside." The members of Long Island's horsy set, who have watched aghast as the Levitt houses have marched toward their sacrosanct land of polo, privet and croquet, also tend to think of Levittowners as a class apart. One elderly dowager regularly takes her friends through Levittown in her chauffeur-driven limousine to show "what Levitt has done for the poor people." Levittown housewives encounter even more galling snobbery. Says one: "Whenever I tell people outside where I live I get the same old freeze. Some of them think that everyone who lives in Levittown is on

relief. But the only people who criticize the place are the ones who don't live here."

Future Slums? The most frequent criticism of Levittown, and of other projects like it, is that it is the "slum of the future." Says Bill Levitt: "Nonsense." Many city planners agree with him, because they approve of Levittown's unscattered plan and its plentiful recreational facilities. Nevertheless, in helping to solve the housing problem, Levittown has created other problems: new schools, hospitals, and sewage facilities will soon be needed; its transportation is woefully inadequate, even by Long Island standards.

But most Levittowners think the disadvantages are far outweighed by the advantages. Said ex-G.I. Wilbur Schantal, who lived with his wife and a relative in a one-room apartment before he moved to Levittown: "That was so awful I'd rather not talk about it. Getting into this house was like being emancipated." Bill

ALFRED & ABRAHAM LEVITT
For father, grass seed.

THE BILL LEVITTS AT HOME
For friends, A Message to Garcia.

to his audience. He showed no shadow of pompousness. He introduced his wife as 'my boss' ... 'I would rather have peace than be President,' he cried. He never had to remind his audience that he had been a Missouri farmer..."

A time for superheroes

Ten years before Truman's election, at a moment when the smell of gunfire was already in the air, a simple but powerful myth was born in the United States. It was the superhero phenomenon, starring comic book characters with extraordinary physical capabilities and a moral fervor to match. These characters devoted themselves to the battle for law and order, justice, authority, equality and tolerance. Undoubtedly, during the waning days of the Great Depression, and even more so during the anxieties of wartime, the superheroes reassuringly represented good against evil, fairness and kindness against injustice and malevolence. Around these characters a whole culture evolved, embodying the values and ideals of American society and conveying to the citizenry that no effort should be spared in a fight when the cause was worthy. As *Time* noted in its lively coverage of the rise of superheroes, they became a symbol of power, equity and justice.

The first superhero was Superman, who made his debut in 1938 by graphic artist Joseph Shuster and scriptwriter Jerry Siegel. A year later came Batman, created by Bob Kane. Captain America by Joe Simon and Jack Kirby made his debut in 1941, punching Hitler in the face in the first issue. A year later came an attractive young lady, Wonder Woman, who fought the Nazis and Japanese wearing the colors of the American flag. All of them were fantastic physical specimens, with tight outfits emphasizing their fit musculature.

During the expansive post war period, the superheroes became an expression of American prowess, invincibility and growth—a manifestation that anything was possible. *Time* continually published articles on Superman and other leading characters throughout the superhero phenomenon. On March 14, 1988, to commemorate the Man of Steel's fiftieth birthday, it even devoted its cover to him, with the headline "Happy Birthday, Superman!" and a subheading that read: "Still invincible, America's number one hero turns 50."

The automobile as a symbol of status and adventure

In addition to the fictional Superman and other superheroes, reality offered another giant as a symbol of power, strength, energy, freshness, new technology, growth, expansion and wealth: the automobile. America's cars weren't just plain old vehicles. What rolled off Detroit's assembly lines were long, wide and showy chariots that for decades would exemplify the thriving automobile industry and by extension the thriving American economy. The United States was at "an all-time crest of prosperity, heralded around the world," *Time* proclaimed in its January 2, 1956, cover story about its "Man of the Year," General Motors president Harlow H. Curtice. The article continued, "Much of this prosperity was directly attributable to the manufacture and sale of that quintessential American product, the automobile."

The trademark of the period was tail fins, stylized flourishes on the rear fenders that were copied in every model that aimed for state-of-the-art design. Car fins were introduced by General Motors on the 1948 Cadillac, copied by its design team from a secret U.S. Air Force airplane, the Lockheed P-38. The 1949 model was a best seller, which led to fins in just about all new models of all makes: Buicks, Chryslers and even Fords by 1957. They became wider and taller with time, until

they reached three feet above the ground in the 1959 Cadillac Eldorado.

Other new features and technological advances joined fins. In 1940, Oldsmobile launched the first fully automatic transmission; in 1941, Packard offered the first true air-conditioned vehicle; in 1946, Chevrolet was the first carmaker to advertise on television; in 1946, Goodyear invented the tubeless tire; in 1951, Kaiser introduced the first pop-out windshield; soon after, Packard offered air brakes; and in 1956, Ford became the first company to feature seatbelts as an option, but the public wasn't interested—most argued that since cars didn't go that fast, they were unnecessary.

Three-fourths of all existing vehicles in the world were in the United States. Such was Americans' passion for cars—and the aura of personal success that the machines conveyed—that, between 1945 and 1955, their numbers doubled from 26 million to 52 million units. In 1957, the average car cost $2,700, the equivalent of around $20,500 today.

The car boom, along with the highway construction that fed it, led to the emergence of other new phenomena. With greater mobility came drive-in movie theaters, drive-through restaurants and banks and roadside motels (Holiday Inn was born in 1952). In 1955, McDonald's introduced a revolutionary concept defining the quick service restaurant industry. The automobile was lucky for Las Vegas: on weekends, some 20,000 people arrived by car on Highway 91. Society as a whole changed: distant suburbs sprouted, linked to downtowns by highways and vehicles. Technological innovations that contributed to comfort, such as air-conditioning, prompted people to move to states once considered too hot, such as Florida and others in the Sun Belt.

Bulls and housing. *Time*'s pages witnessed the postwar economic boom. The June 14, 1948 postwar cover story was devoted to a prospering Wall Street, symbolized by the image of a young bull. The article included an "info-chart" by Robert Chapin (above, top). Two years later, the July 3, 1950, issue reported on the boom in home building with builder William J. Levitt on the cover. The story featured the mass-produced homes in the Levittown community he built on Long Island, under the headline "Up from the Potato Fields" (above, bottom).

The Art of Writing for *Time*

In the meantime, the magazine carried on with its routine of condensing the news and weighing its importance. Common sights were reporters' desks covered with piles of paper and wire stories they had to analyze and reread before writing a story. And that took time—often, a lot of time.

> "I can think of only three jobs that are important enough to work such an exhausting amount of hours: an obstetrician in an understaffed hospital or town; the President of any country; a general in time of war. I think it is ridiculous to go at such a killing pace just to get out a weekly newsmagazine, even though a good one."

Those were the complaints that the writer A. T. Baker's wife mailed to Editor Matthews. With them, she depicted how hard reporters toiled at *Time*, where they spent hours and hours on end before their workday was over. As it did in the magazine's early days, the work week started on Thursdays. It was the calmest day. As closing time, Sunday, approached, days turned long, exhausting and without set hours.

The magazine's structure, however, remained unchanged. In times of war or peace, depression or reactivation, *Time* chronicled the world in single-column stories, and no event, no matter how important, altered the standard heading size: one column, 14 points, bold Vogue. The magazine always opened with "National News," which in turn always began with "President's Week," followed by "News from Overseas" and then by regular sections. Writing the articles was still very exacting, and though the magazine's prose during this period was on the whole finely wrought and polished, not everyone could easily adapt to the *Timestyle*.

In his autobiography *One Man's America: A Journalist's Search for the Heart of His Country*, Henry Grunwald reflected on his first few years at the magazine in the mid-1940s:

> "New *Time* writers, myself included, took pains to master 'tycoon' and 'pundit' and the use of professional appellations, as in ... merely 'Busdriver Smith.' We gleefully pounced on contractions like cinemogul. The pages were still populated by newshounds (or hens), moppets and socialites. The magazine still liked its characters to be dynamic; they strode rather than walked, plumped for rather than chose, whacked rather than merely beat, made whopping rather than just big profits. We worshiped words, played with them, laughed over them, made fools of ourselves with them. *Time* liked unusual headings, for instance, 'Peripatetics' for stories about the international movements of diplomats.... I struggled endlessly with my leads, trying to be especially clever and arresting; this could take days, and I realized that it was just an excuse to avoid the real, painful business of writing. I confess that I can still recite some of my favorites ('The Democrats have nothing to cheer but fear itself.') But the essence of *Time* writing was not words but structure. One of the simplest reasons for the success of the newsmagazine formula is that it avoids the deadly 'inverted pyramid' form of daily newspaper articles (most important fact first, additional facts in descending order of significance) and instead tells events as far as possible in chronological sequence. But that is only a general principle; it does not tell you just how to put a story together. I struggled

How to make a buck. The picture on the left is of Whittaker Chambers, one of *Time*'s most critical editors. "How to Make a Buck" was published in the July 29, 1957, issue on Disneyland's second anniversary. The Disney theme park brought in the most dividends since Walt's creation of Mickey Mouse in 1928. The photo on the opposite page, taken in 1953 in the Walt Disney Studios, shows Walt with three of his most famous characters: Mickey Mouse, Donald Duck and Goofy.

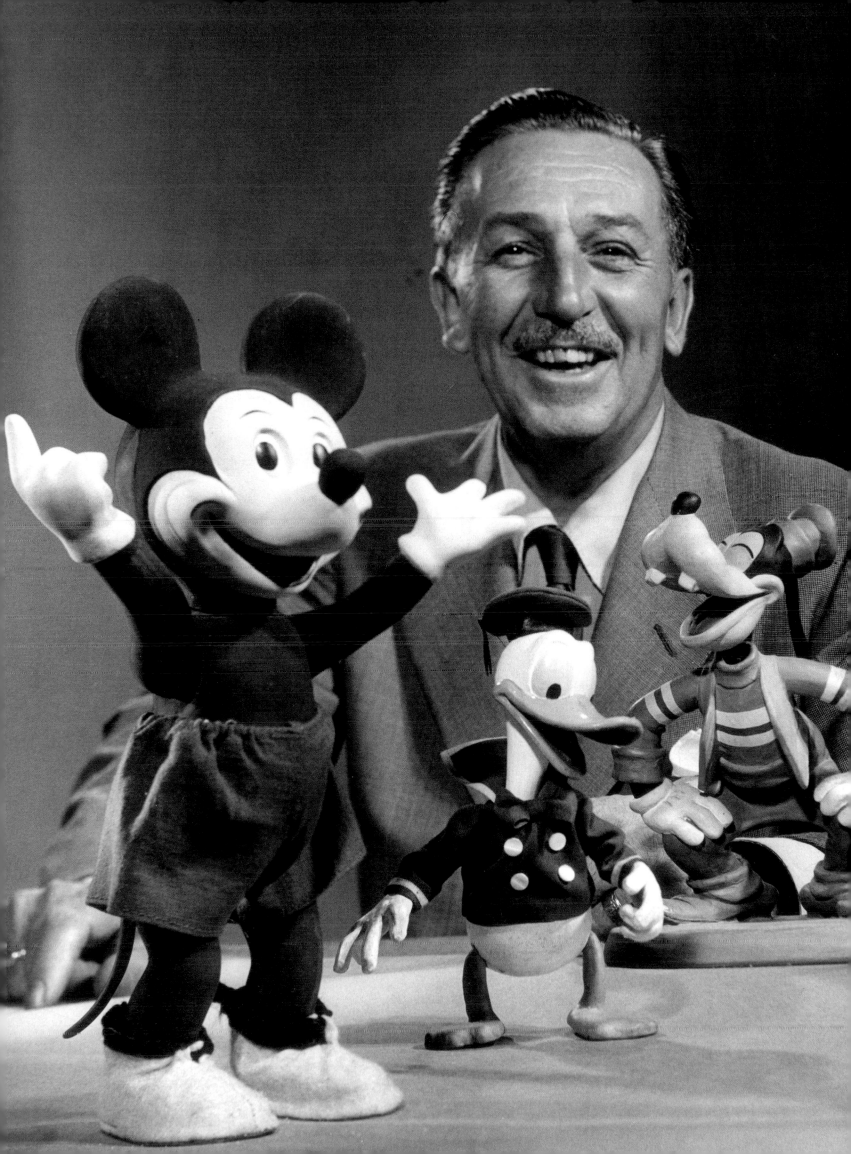

week after week with the problems of organization—for instance, avoiding clunky transitions and devices like 'to repeat' or 'as already stated above.' It sounds simple, but it isn't. Sometimes, when I went to bed near dawn in the midst of an especially difficult cover story, its pieces would assume almost physical shape in my mind, and between waking and sleeping, I feverishly moved them about in endless combinations."

For a sense of the "suffering" of the writers and how they wracked their brains to creatively summarize a news item in a few lines—and how skillfully they often succeeded—it's worth citing examples from articles from the 1950s and 1960s. Some passages seem like short literary pieces masquerading as journalism.

Walt Disney

Under the heading, "How to Make a Buck," the July 29, 1957, issue reported on the second anniversary of the creation of the celebrated theme park Disneyland.

"Once upon a time, in the magic realm of California, there was a grown-up heady boy named Walt Disney who set out to create the happiest place on earth. So he went into his countinghouses and to his moneylenders, and he collected millions of dollars. Then he ordered his royal artists and carpenters to build a whimsical wonderland of spaceships to the moon and Mark Twain river boats, of mechanical monkeys and bobbing hippos, of moated castles, wilderness forts and make-believe jungles. All the children, young and old, came to visit this happy place, called Disneyland. And Walt and his friends made millions happily ever after.

Last week, as Disneyland celebrated its second birthday, Walt Disney was indeed the world's biggest boy with the world's biggest toy.... Even adults can lose themselves in Disneyland, where the past they have not seen melts into the future they will never know."

Ernest Hemingway

The suicide of writer Ernest Hemingway and the reasons that drove him to it were described on July 14, 1961 by literary critic T. E. Kalem in an article titled, "The Hero of the Code":

"There was no hope of heaven or sustaining faith in God. In the short story *A Clean, Well-Lighted Place*, there is a parody of the Lord's Prayer built on the Spanish word 'nada,' meaning nothingness ('Our nada who art in nada, nada be thy name'). In *The Gambler, the Nun, and the Radio*, the hero narrator decides that 'bread is the opium of the people' ... but even Hemingway could not sustain himself on nada, or on bread alone. If life was a short day's journey from nothingness to nothingness, there still had to be some meaning to the

Hemingway and Nabokov. Ernest Hemingway (below, left) made *Time*'s cover twice. The first on October 18, 1937, and the second on December 13, 1954, the year he won the Nobel Prize for Literature. Vladimir Nabokov (below, right) wrote his famous novel, *Lolita*, while traveling during the summers on butterfly collection trips. He appeared once on the cover on May 23, 1969.

'performance en route.' In Hemingway's view, the universal moral standard was nonexistent, but there were the clique moralities of the sportsman or the soldier, or, in his own case, the writer. So he invented the Code Hero, the code being 'what we have instead of God' ...

The Code Hero is both a little snobbish and a little vague, but the test of the code is courage, and the essence of the code is conduct. Conduct, in Hemingway, is sometimes a question of how one behaves honorably toward another man or woman. More often, it is a question of how the good professional behaves within the rules of a game or the limits of a craft...."

Vladimir Nabokov and *Lolita*

Under the heading "Prospero's Progress," the magazine described writer Vladimir Nabokov in its May 23, 1969 edition:

"Nabokov's literary province is a bizarre, aristocratic, occasionally maddening amusement park in part devoted to literary instruction. It has many sideshows but only one magician. The general public, which chose to read *Lolita* as a prurient tale of pedophilia, enters through the main gate, hoping to meet the creator of that doomed and delectable child. A more sophisticated clientele moves beyond the midway to seek out and applaud Dr. Nabokov, the butterfly chaser, dealer in anagrammatical gimcracks, triple-tongued punster, animator of Doppelganger, shuffler of similes. Prolonged exposure to Nabokov reveals much more. What he calls his 'ever-ever' land of artifice opens on intriguing distances. There words transform the world into metaphor and time is held exquisitely at bay by memory..."

Jackie Gleason by John McPhee

John McPhee, a fabulous *Time* writer, described actor Jackie Gleason's enormous obesity in an article published on September 29, 1961:

"As for his eating, most horses would be embarrassed. Gleason orders pizzas by the stack, has put down five stuffed lobsters at a sitting. He says he has 'pica,' which *Webster's New Collegiate Dictionary* describes as 'craving for unnatural food, as chalk, ashes, etc.'; but what Gleason really has is merely an unnatural craving. Often—and with great willpower—he diets, cutting down his intake to 1,200 calories a day. He once took off 100 lbs. He is 6 ft tall, and his mature weight has generally varied from 220, which he calls 'slim,' to an ultimate high of 284 ... Gleason orders about a dozen suits a year to his tailor ... and he has to keep a triple wardrobe. Each 'medium weight' suit (designed to cover approximately 250 lbs, his present weight), has a larger and smaller counterpart."

The role of fact-checkers

Vital to the work flow and the completion of the magazine's stories was the role of researchers, or fact-checkers. They were all women, a pattern that continued for decades. In the postwar period, they didn't have private offices but worked together in open areas known as bullpens. Their boss was Content Peckham, who insisted that they wear gloves and stockings, even during summer "and even if you have good legs."

The work of these women was crucial, since they became the writers' underwriters, and they made sure information was accurate. Thanks to the fact-checkers, writers could deliver their copy without the need to stop and look up facts, by using two magic words in their stories: "To come" or the abbreviation "TK." For example, if a writer didn't know the year of an event or the name of a place, he could write: "In TK, Hitler met with Chamberlain and minister TK, on the shore of lake TK." The fact-checkers' task was to supply the missing information. They also verified facts, penciling a dot over each and every word to certify that it was accurate.

According to Grunwald:

"... The researchers included some memorable types. There was Blanche Finn, who came out of the labor movement and talked like a longshoreman.... There was Manon Gaulin, a Frenchwoman who kept a horse in New Jersey and, it was said, rode people just as hard.... There was Lili Lesin, a German with a Dietrich-like voice and very large bosoms of which she was rather proud; once, in the elevator, she found an editor of another magazine staring at them fixedly and she growled: 'That's right, I've got three.' There was Judith Friedberg, formidable and fearless, who once was assigned to cover Winston Churchill's arrival in New York and had herself hoisted by rope up the side of the Queen Mary to get a better look (her report began: 'First came the puff of smoke, then the cigar, then the Prime Minister').

Although researchers did some local reporting, they were barred for years from becoming full-fledged correspondents or writers, to their fury and frustration. Yet they were important to *Time* as guardians of its cult of facts; they bore the ultimate responsibility for accuracy, and every time a mistake was detected in print an orange-colored 'errors report' was circulated by Content Peckham, with a clear statement as to who was to blame. The researchers were, Luce once said, 'veritable vestal

virgins whom levitous writers cajole in vain, and managing editors learn humbly to appease.'"

Alexander replaces Matthews

In 1949, T. S. Matthews ended his tenure at the helm of *Time* headquarters as managing editor. Over six years, he had carried out important improvements at the magazine, not only by purging the excesses of its irreverent and eccentric style, but also by giving the whole publication a tone of greater editorial and visual maturity. Among other things, Matthews altered the organizational chart by delegating part of his role to two assistant managing editors, Dana Tasker and Roy Alexander. Alexander replaced him as managing editor. As would be the case with future editors, Matthews's stepping down was not entirely smooth. Luce, feeling it was time for a change in leadership, persuaded Matthews to go to London to explore the possibility of a British version of *Time*. Matthews had expected to lead the magazine for another two years, but at Luce's insistence, he accepted the change and went off on his new mission. When months later he heard that Luce had decided against the London project, Matthews sent him a telegram: "Why did you keep me standing on tiptoe so long when you weren't going to kiss me?"

Matthews remained in the London offices until his retirement from the company, and Alexander took over the magazine he had joined in 1939. Alexander came from the *St. Louis Post-Dispatch*, was a former pilot and specialized in aviation and military affairs—experience and knowledge that were key for the magazine during World War II. He was a calm and religious man. He began his day with Mass and Communion, which put him in the office much earlier than his staff. Matthews's deputy, Assistant Managing Editor Otto Fuerbringer, with whom he had worked at the *Post-Dispatch*, would in

turn be Matthews's replacement. Among Alexander's senior editors were the men who in the future would occupy executive editorial jobs in the company, among them Louis Banks, Tom Griffith and Henry Grunwald. Others in the ranks were James Keogh, who later joined President Nixon's White House staff; Robert J. Manning, who went on to become editor of *Atlantic Monthly;* and Osborn Elliott, a future editor of *Newsweek* and chairman of its board. During Alexander's eleven-year tenure, the magazine underwent significant changes, particularly in its subject matter.

Churchill, "The Man of the Half-Century"

Alexander took over the managing editor's job—Luce continued to hold the position of editor in chief—the year *Time* came out with a surprising selection: instead of its customary "Man of the Year," it named a "Man of the Half-Century." The choice was Winston Churchill, who was featured on the January 2, 1950, cover. The British World War II hero had been on its cover six times since the founding of *Time*, the first on April 14, 1923. This time it was an even greater distinction. The story was an update of geopolitical events during the previous fifty years, but focusing on Churchill because, according to Publisher James A. Linen in his letter to readers, he was "the man whose story comes closest to summing up those years." Inside, the reasons were explained further:

"One of the half-century's greater politicians was Winston Churchill. Sometimes wrong, often right, he fought his way toward the heart of every storm. In 1900, Churchill, like his contemporaries, looked forward in pleasant years. Like his contemporaries, Churchill was to struggle through depths and rise to heights unimaginable to 1900. No man's history can sum

up the dreadful, wonderful years 1900–1950. Churchill's story comes closest."

The G.I.: "Man of the Year"

Under Alexander, the magazine put the headline "The Ugly War" on its August 21, 1950, article about the Korean War, one of the first times that the United States faced off militarily with a Communist country. It was a conflict that, in a way, cast a shadow over the extraordinary growth the country was enjoying and foreshadowed the string of hostilities over the next few decades in which Americans squared off with the Communists in various latitudes—above all, in Vietnam.

After this article, in which *Time* gave voice to the resentment of many Americans of the Truman administration for entangling them in a war they didn't quite understand, it was no surprise that the magazine chose the American G.I. as its 1950 "Man of the Year." Illustrated by Ernest Hamlin Baker, the January 1, 1951, issue marked the first time in the history of the famous designation that *Time* named an abstraction rather than an actual person. *Time* explained its choice:

"The man of 1950 was not a statesman ... Nor was 1950's man a general ... Nor a scientist ... Nor an industrialist ... Nor a scholar ... As the year ended, 1950's man seemed to be an American in the bitterly unwelcome role of the fighting-man. It was not a role the American had sought, either as an individual or as a nation. The U.S. fighting-man was not civilization's crusader, but destiny's draftee.... Most of the men in U.S. uniform around the world had enlisted voluntarily, but few had taken to themselves the old, proud label of 'regular,' few had thought they would fight, and fewer still had foreseen the incredibly dirty and desperate war that waited for them. They

Half-century. Winston Churchill appeared as the "Man of the Half-Century" in the January 2, 1950, issue (opposite). The illustration was by Ernest Hamlin Baker. The magazine explained the reason for its selection: "No man's history can sum up the dreadful, wonderful years 1900–1950. Churchill's story comes closest."

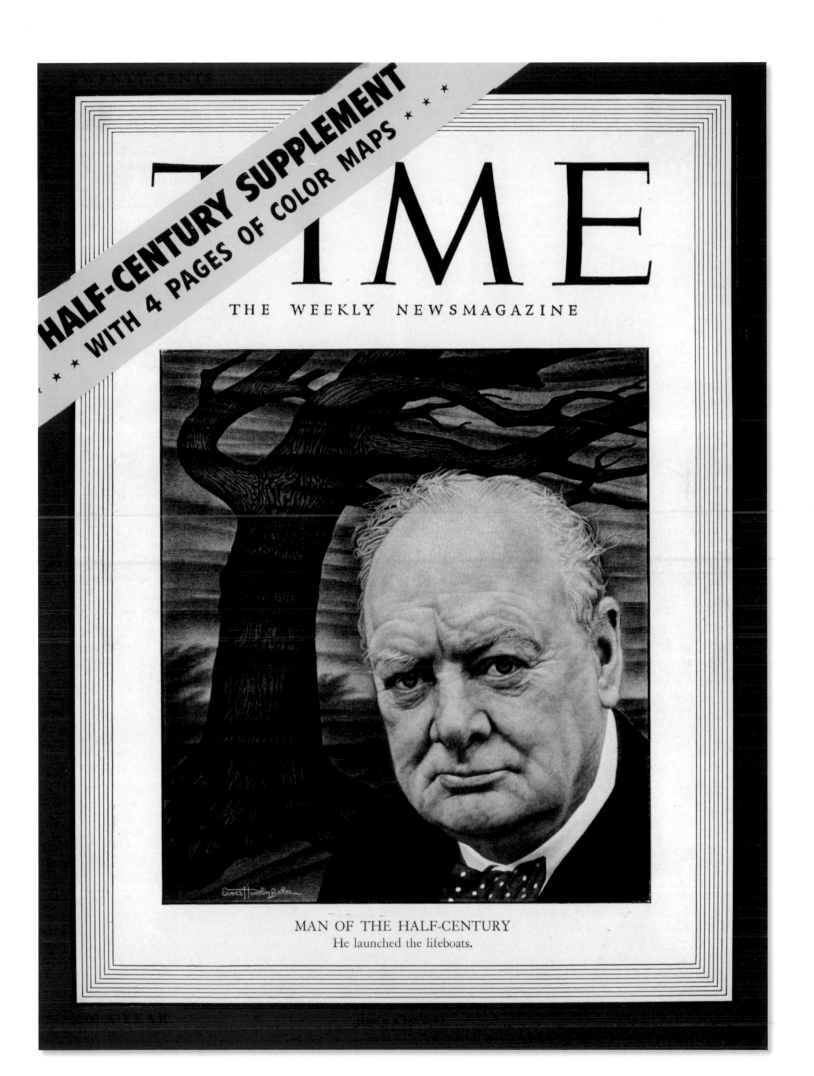

TIME

THE WEEKLY NEWSMAGAZINE

MAN OF THE HALF-CENTURY
He launched the lifeboats.

hated it, as soldiers in all lands and times have hated wars, but the American had some special reasons for hating it. He was the most comfort-loving creature who had ever walked the earth—and he much preferred riding to walking. As well as comfort, he loved and expected order; he yearned, like other men, for a predictable world, and the fantastic fog and gamble of war struck him as a terrifying affront.... No matter how the issue was defined, whether he was said to be fighting for progress or freedom or faith or survival, the American's heritage and character were deeply bound up in the struggle."

McCarthy's dark shadow
Alexander's magazine was witness to one of the most harrowing periods that American intellectuals have ever had to live through. Government employees and union members were hounded as well. This was the era of McCarthyism, a term that refers to the aura of fear and suspicion fomented primarily by Wisconsin Senator Joseph Raymond McCarthy. From his position as chairman of the Permanent Investigations Subcommittee of the Senate Committee on Government Operations, McCarthy was the self-appointed scourge of Communists and Communist sympathizers wherever he saw them, though he rarely backed up his accusations.

McCarthyism was bolstered by the long-established House Un-American Activities Committee (HUAC), which relentlessly investigated people suspected of sympathizing with Communism or cooperating with the Soviet regime.

Although to question McCarthy's methods or motives was to invite not only his withering scorn but also his genuinely threatening investigative zeal, *Time* boldly took his measure in a cover story on

October 22, 1951. McCarthy had denounced a Communist conspiracy in the Department of State in February 1950, claiming, "I hold in my hand" the names of 205 Communists who worked there. "[McCarthy] did not give the names of 205," *Time* pointed out in its story, titled "Demagogue McCarthy."

"He did not give the names of 57, numbers that he kept changing in press stories or public speeches when more specifics were requested. He did not produce the name of even one Communist in the State Department ... That it was a beginning, not an end, is partly explained by McCarthy's personality. Another man, humiliated by failure to produce evidence he said he held, would have retreated and wiped a bloody nose. McCarthy, who was a boxer in college, says: 'I learned in the ring that the moment you draw back and start defending yourself, you're licked. You've got to keep boring in.' This is not necessarily true of either boxing or politics—but Joe McCarthy thinks it is true."

Luce and many other editors and writers were fervent anti-Communists, but opposed McCarthy and his aggressive and irresponsible behavior. They thought his accusations were so rash that they might discredit even moderate opponents and critics of Communism. *Time* was of the opinion—and it was criticized more than once for it—that the press shouldn't pay so much attention to McCarthy and his attacks, since that encouraged him, made him feel important and gave him more power.

The senator accused the magazine of limiting itself to casting "stones" at Communism while it "rendered a practically unlimited service to the Communist cause." More than once, McCarthy exhorted advertisers to boycott the magazine.

Among the most prominent victims of McCarthyism in its various permutations were renowned writers—Bertolt Brecht, for instance, fled to Europe after testifying before HUAC—as well as movie and TV scriptwriters, such as Dalton Trumbo, Paddy Chayefsky and Rod Sterling, and directors and well-known Hollywood producers. Charlie Chaplin left the country to avoid being a target of investigation. An estimated 250 artists and film professionals were "blacklisted"—frozen out of work because of their alleged leftist affiliations—in addition to some 600 college professors who lost their jobs.

In 1954, a reckless McCarthy accused the army and the Department of Defense of covering up espionage activities. It was the last straw and provoked the ire of the Pentagon and President Dwight Eisenhower, who called for a Senate investigation, during which McCarthy as well as the army came under scrutiny. The hearings were covered by radio, TV, newspapers and magazines. McCarthy's closest collaborators were called to testify. Finally, his fellow Republicans in the Senate joined to censure McCarthy by a vote of 67–22, accusing him of "conduct inappropriate of a member of the Senate" for the way he had led his subcommittee. It was the beginning of the end. McCarthy was senator for another two years, albeit shunned by most of his colleagues.

McCarthy's persecutions and political witch hunts, his titanic fall and the furious criticism that rained down on him affected his state of mind and health so much so that on May 2, 1957, he died in Bethesda, Maryland, at age 48, due to cirrhosis and hepatitis caused by his chronic alcoholism. *Time* had pointedly noted from the beginning that he was "a two-fisted drinker."

McCarthy in action. This 1953 photograph (opposite) shows Senator Joseph Raymond McCarthy, the self-appointed scourge of Communism, administering the oath to writer Dashiell Hammett testifying before the House Un-American Activities Committee. *Time*, long critical of the senator, called him "Demagogue McCarthy" on the October 22, 1951, cover, adding the subhead, "Does he deserve well of the republic?"

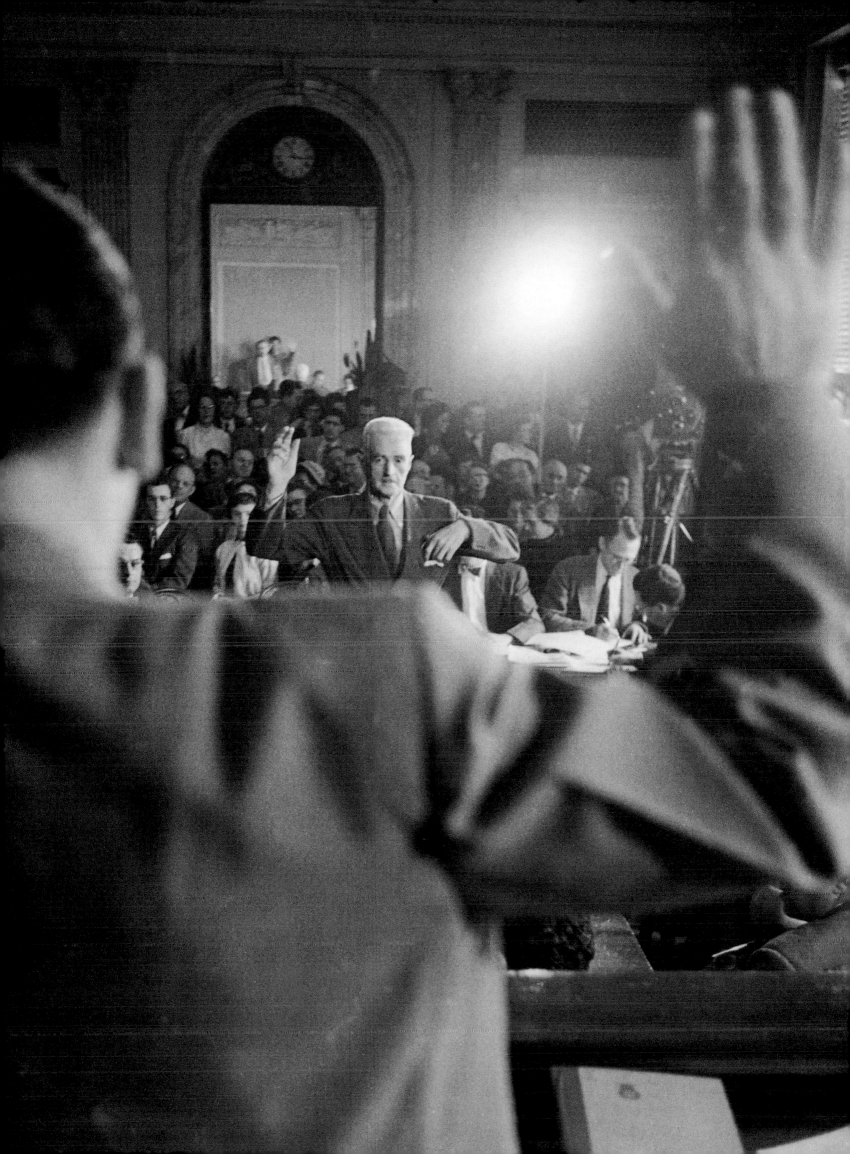

Roy Alexander: "Don't Forget the Doughnut"

Extracted from Time *Archives interview notes that Jim Bell, from the New York bureau, wrote for the "*Time *Special Oral History" section after interviewing Roy Alexander on March 1, 1967*

When I came to *Time* in 1939, Harry Luce was amazingly active. He was on our floor two or three times a week to see not only the managing editor but even guys like me.

I used to get up early and on Sundays I was at the office by 7:30 in the morning. Nearly every Sunday at 8 o'clock Harry would stick his head in my door and say "Hello, Roy. Where is everybody?" One day I asked him how come he wasn't in church. He said he went to the 11:30 service. He always dropped in the office for a few hours before church.

Throughout the '40s Luce sat in for the managing editors fairly frequently. Sometimes he'd edit for a month, sometimes for a couple of weeks. When we knew he was going to edit we'd take elaborate care to make sure he understood how to run the managing editor's signal equipment. We'd explain it all to him and put big signs on buttons for the copy boys and such. It was generally assumed that he was hopelessly incompetent on anything mechanical. But I never remember his having any trouble with the communications. Maybe the big labels helped.

During the Matthews' era (1943–49) both the managing and assistant managing editors were forever finding mysterious changes in copy. Investigation would disclose that Luce had called the writer directly, had the change made and had forgotten to notify anyone higher up.... The changes were usually minor...

He was an easier editor than either Gott (Manfred Gottfried) or me and he always went out of his way to be kind to writers.

He'd write them "well done" or call them up and say "gee, that's a fine piece." But he could be rough. I remember once the Fed raised or lowered the discount rate and he ordered a 60 line NA lede. Dunc Taylor (Duncan Norton-Taylor) must have written five versions after five discussions with him. He still didn't like it and it was press night. Finally he said to me "I guess we'd better give this up." I said let me have a try. I took it down the hall, wrote a new version, which was almost exactly like the last one Dunc had done, in 45 minutes. He looked at it and said "that's the damndest feat I ever saw—in just 45 minutes!" I figured he was tired of arguing about it.

Luce always knew which writer was writing the major pieces. If he was interested in it, he'd call the writer, invite him to the drug store in the RCA building for a coffee. He often made several trips to the drug store each morning each time with a different guest.

He always ordered a doughnut with his coffee. I've heard him ask the waitress when she was going to bring the doughnut and she'd protest he'd already eaten it.... I remember one night he took several writers to the Berkley Hotel for dinner. He announced that there would be only one drink because he wanted to talk business. Bob Sherrod, just back from Tarawa, said to the waiter "I'll have a Manhattan—two of them." Everyone else, including Luce, ordered two times one drink....

...

Over the years, people came and people went. Harry didn't like to see anyone fired. If you were planning to drop a writer, you made sure you talked to him first. He would usually try to find the fellow a new job. To the detriment of Time Inc.'s capital, he kept all sorts of people around, some of them in his own stable. To my knowledge he only fired one man—and he gave that fellow a salary for the rest of his life.

Luce's routine. This photo (left) shows Henry Luce posing in front of posters of *Life* and *Fortune*. *Time*'s founder had a few set habits: at times he made changes in the text and forgot to inform the editors; on Sundays he would arrive at the office early before attending 11:30 Mass; and several times each morning he would have coffee and doughnuts with different writers to discuss their stories.

Staff. Writers from *Time*, 1948: front row (left to right): Carl Solberg, Walter Stockly, Duncan Norton-Taylor, T. S. Matthews, Paul O'Neil; second row: Richard Oulahan, George Burns, Harry Lennon, Marshall Smith, Henry Grunwald, John Tibby; third row: Robert Hagy, Paul Scalera, Gilbert Cant, Mark Vishniak, Craig Thompson, Alexander Eliot, Max Gissen, Robert McLaughlin; fourth row: Chandler Thomas, Jonathan Leonard, William Miller, A. T. Baker, Irving Howe, William Rappleye, John Weeks, Hart Preston; fifth row (standing): Bruce Barton, Edward Cerf, Herbert Merrillat, Gilbert Millstein, Robert Cantwell, Roland Gask, Robert Fitzgerald, Ted Robinson; back row: Douglas Auchincloss, James Agee, Ben Williamson, Allan Ecker, Richard William, Robert Lubar, Thomas Dozier, Henry Bradford Darrach.

How did he go about picking his managing editors? Well, I can only tell you how my successor was picked. He called me up to his apartment in 1960 and asked me if I didn't think it was time for me to give the job up. I said I certainly did. I was ready. He said fine, he'd make me editor and that I should take four or five months and look around for a successor. I said "Look, we both know there's only one man to be my successor and that's Otto [Fuerbringer]." He grinned and said sure, he knew that. I told him I wanted to be relieved next week, not stay around as a lame duck. He grinned again and said "Then can I call Otto and tell him?" I said sure and we were both happy.

Time in Hollywood

When World War II ended, Hollywood was at the pinnacle of its glory, and as foreign markets opened up for movies the future looked even more auspicious. The five big movie studios, as well as the three smaller ones, had good reason to feel invincible. After wartime austerity, the domestic audience was booming: it rose to 90 million in 1946, a record. The baby boomers were emerging with new attitudes toward leisure time, which was divided among bowling, mini golf and the movies. Hollywood promoted the birth of drive-ins, giant outdoor screens in enormous parking lots, where families were able to see movies in their cars without the added expense of babysitters. In 1948, there were 820 drive-ins in the United States; a decade later, there were over 4,000.

Time captured the exuberant spirit of postwar Hollywood in its August 22, 1949, cover story devoted to one of Hollywood's freshest and most beguiling new stars: Elizabeth Taylor, who was barely seventeen. The cover image, illustrated by Boris Chaliapin, showed her flanked by the moon and a shooting star, and carried the striking heading: "Cinema sapphires from common clay." The story read: "At 17, 5 ft. 4½ in., 112 lbs., Elizabeth Taylor is a great beauty.... Her complexion has been described by an ecstatic publicity man as 'a bowl of cream with a rose floating in it.' Cameraman have paid her Hollywood's ultimate compliment to beauty: 'She doesn't have a bad angle.'"

In the following post war decade, however, those "sapphires" began to dim. The House Un-American Activities Committee began its hearings into alleged political subversion in the movie industry, harassing and persecuting moviemakers, screenwriters and stars, many of whom relocated to other cities or interrupted or completely halted their careers for fear of being prosecuted or even jailed. Moguls, who had ruled movies like kings for decades, such as Louis B. Mayer, Harry Cohn, Darryl F. Zanuck and Samuel Goldwyn, either retired or were fired. Ownership and control of the studios was taken over by conglomerates whose managers had no loyalty to peers or experience in moviemaking, and who were under orders to cut budgets and lower costs, no matter the repercussions.

Perhaps superseding all these factors was the rise of a new medium that at least partially eclipsed the movies. On May 28, 1951, after a poll indicated that movie audiences had decreased by thirty percent and more than 134 movie houses had closed down during the previous two years in Burbank, Warner Bros. negotiated the sale of thirty acres to NBC for a television studio. "TV has become the star of a new Hollywood, and the movies merely a supporting player," reported *Time* in the May 13, 1957, issue. At the beginning of 1951, there were 3 million TV sets in the country, but eleven months later, more than 10 million families in America's most important cities had at least one set at home. And for the first time in the history of the U.S., there were many more Americans watching television than listening to the radio. The result: the movie audience continued its decline, losing up to forty percent of its 1946 record audience.

Time was quick to chart the ascent of TV's new superstars. In its May 26, 1952, issue, it ran a cover story on Lucille Ball under the title "Prescription for TV: A Clown with Glamour." Ball's situation comedy, *I Love Lucy*, in which she starred with her Cuban husband, Desi Arnaz, reigned as the nation's number one show. On October 17, 1955, *Time*'s cover story profiled Ed Sullivan, the emcee of the *The Ed Sullivan Show*, TV's most successful variety program, on which the Beatles would make

1949. Elizabeth Taylor

1954. Marlon Brando

A star is born. At the tender age of seventeen, Elizabeth Taylor appeared on *Time*'s cover (left, top) with the headline, "Cinema sapphires from common clay." Boris Chaliapin portrayed her as the brightest star in the heavens. Marlon Brando made the cover on October 11, 1954 (left, bottom), the year his role in *On the Waterfront* won him an Oscar for Best Actor. The photograph on the right of Taylor was taken the following year in Paramount Studios while she filmed *A Place in the Sun*.

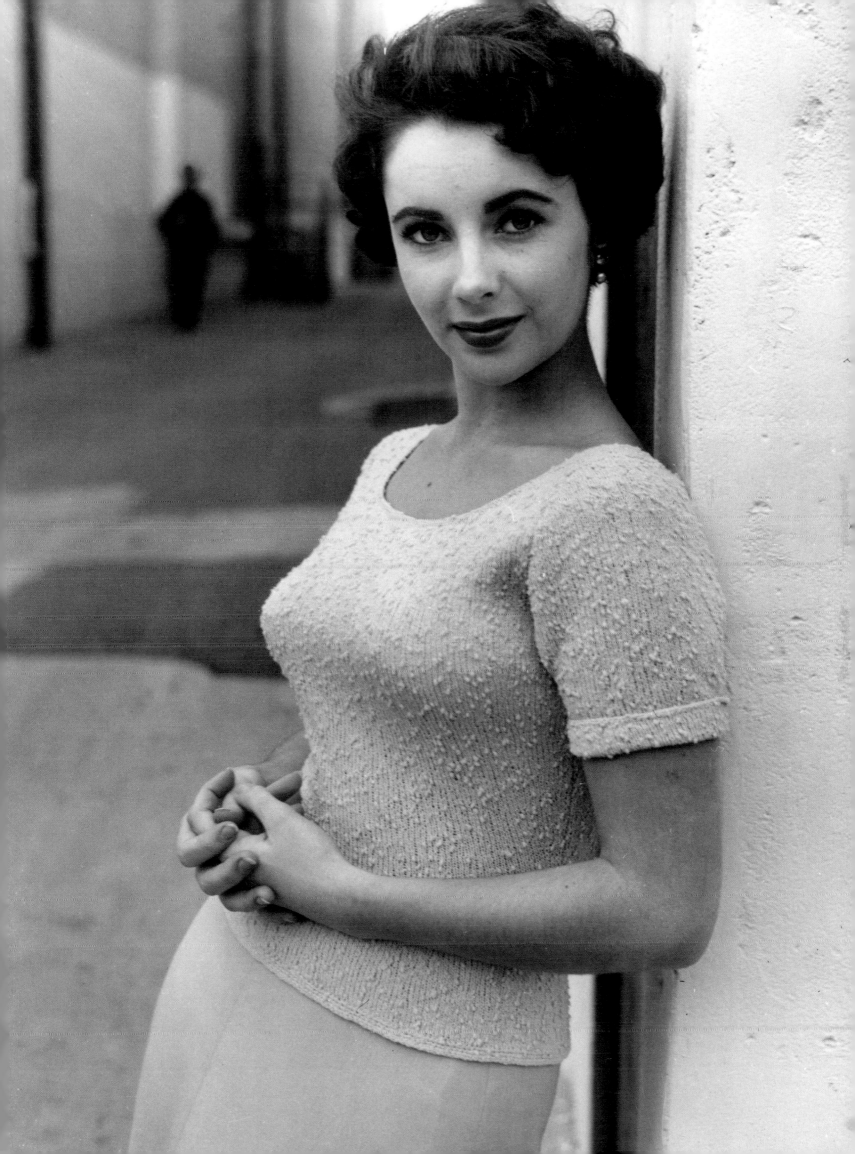

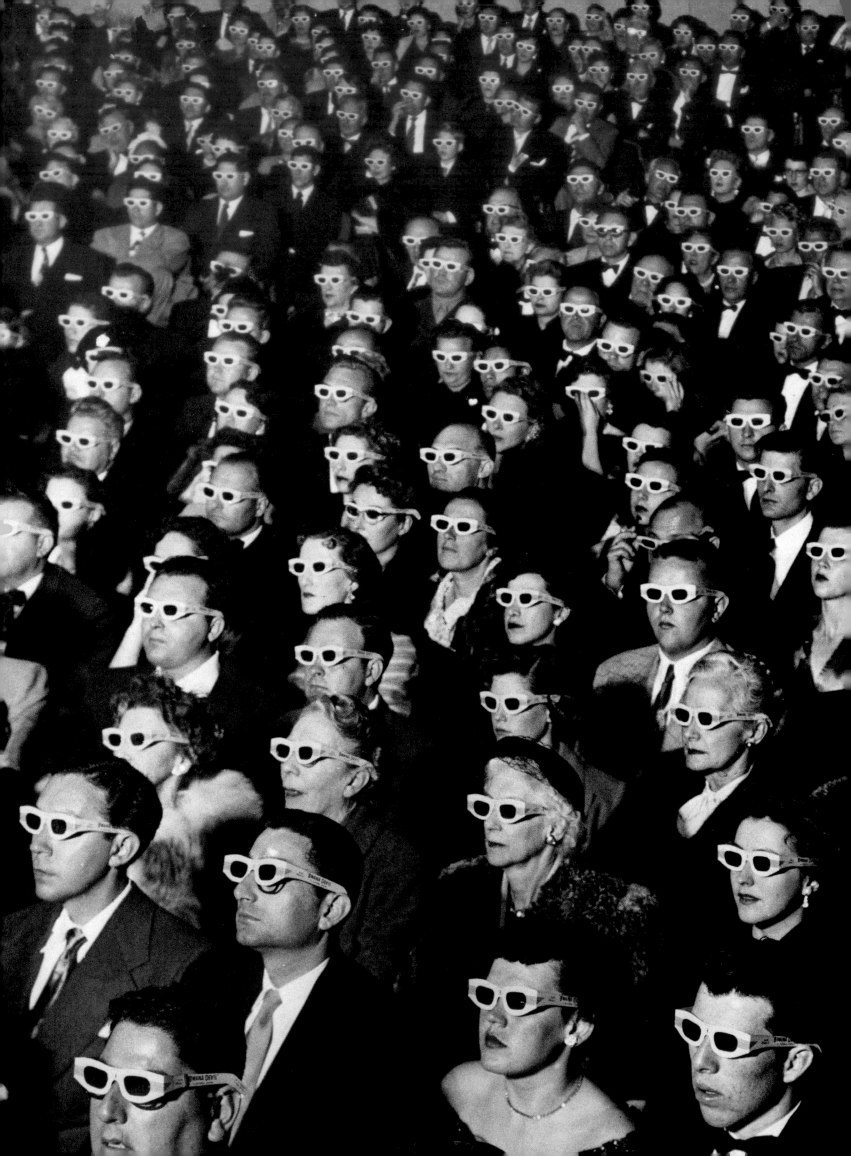

their U.S. debut in 1964. When Jack Paar, as host of *The Tonight Show*, established the late-night talk show as a major new format for the medium, *Time*'s August 18, 1958, cover story lauded Paar as a winningly natural, unpredictable conversationalist, "one of a whole new class of TV-age entertainers—the just-talkers."

Hollywood first ignored the TV threat, and then tried to fight it with such innovations as Technicolor, CinemaScope, stereophonic sound, Cinerama and 3-D movies. *Time* dubiously noted these innovations in its October 13, 1952, edition, with a cover story under the headline "3D movies and Chlorophyl," which described audiences donning special 3-D glasses and movie houses wafting fragrance into the theaters to enhance key scenes. The impact of such measures was short-lived: in 1953, RCA introduced its first color television set.

Finally, Hollywood concluded that its best ammunition against the television boom was to revive the attraction, seduction and box office appeal of its greatest stars. Agents started to bid up the price of top talent, and new stars slowly regained the clout their predecessors had lost with the studios three decades earlier. In its August 22, 1949, edition, *Time* wrote:

"Hollywood's taste buds, like those of any industry, are necessarily conditioned by earnings & profits. For these, the cinemoguls insist, glamour in the well-known shapes of male & female stars is basic, fundamental, utterly essential and sometimes colossal.

The trouble is: sex appeal has a way of being repealed by the passing years. Joan Crawford, for instance, who is reportedly 41, has a gem-hard glamour that has worn pretty well for 20 years ... the well-preserved charm of Claudette

Colbert, Barbara Stanwyck, Bette Davis or Marlene Dietrich, causing the box-office stampedes that it could set off ten, or even five years ago.

It is the same with the male animal—even with such solid 40-plus examples as Clark Gable (a big star since 1932), Humphrey Bogart, Spencer Tracy, Jimmy Cagney, Gary Cooper. These veterans are still expert performers, but their days as high-voltage box-office attractions are numbered.

Finding replacements for [the older] generation of stars is, Hollywood thinks, its top-priority problem. In other days, that might have meant turning loose an army of assistant producers (and relatives) to scout the nation's soda fountains for blondes. Today's need is great enough to warrant a more elaborate approach.

The public—though still attentive to such screen personalities as Robert Taylor, Hedy Lamarr, Errol Flynn, Irene Dunne, Greer Garson, Myrna Loy, Walter Pidgeon, Mickey Rooney, Loretta Young—no longer rushes by the millions to see a picture merely because one of them is in it."

The faces that photographers and Hollywood agents were now chasing were Kirk Douglas, Burt Lancaster, Montgomery Clift, Farley Granger, Robert Ryan and Richard Widmark, and on the distaff side Jane Greer, Ruth Roman, Linda Darnell, Virginia Mayo, Shelley Winters and Susan Hayward. *Time* welcomed some of these arrivals in a long article published in the September 3, 1951, issue.

The magazine made sure to intermix coverage of Hollywood's breakthrough newcomers with its stories about long-standing stars. On September 7, 1953, *Time* crowned twenty-four-year-old Audrey Hepburn as a "Princess Apparent," extolling

her in a cover story for "exquisitely blending queenly dignity and bubbling mischief" and for possessing "like all great actresses ... the magic ability to ... make her innermost feelings instantly known and shared." The following year *Time* assessed the meteoric early successes of thirty-year-old Marlon Brando. The October 11, 1954, cover story applauded Brando for the "deep-burning focus" and "almost magical lifelikeness" of his acting, but presciently predicted that with his surly, bad boy ways and contempt for commercialism, he faced a difficult career ahead. His talent was "getting too big for his blue jeans," *Time* wrote. "But the question arises: What else is he to wear? From Brando's precocious eminence, the future may well look less like a land of dreams than a highly promising nightmare."

In these stories, and in others by such writers as Brad Darrach and John McPhee, *Time* brought the celebrity profile to a high level of polish and vivacity. Stylishly written, the pieces were reported and researched with a keenness and exhaustiveness unsurpassed by *Time*'s earlier coverage—and indeed, with the same amount of effort as for virtually any mainstream publication. Ezra Goodman, who was a *Time* correspondent in the film capital in the 1950s, described the magazine's requirements for reporting on stars in general, and Marilyn Monroe in particular, in his book *The Fifty-Year Decline and Fall of Hollywood*.

"... In its Hollywood cover stories, as in all its reporting, *Time* insisted on only the best and most exhaustive. It was not enough to note that Frank Sinatra had a titanic collection of cuff links. The magazine wanted to know exactly how many, what kind, how much they cost and how they were housed ... it was part of my job to assemble the material for the Hollywood covers. *Time*'s policy was

A new look. In the 1950s, several innovations to enhance the movie experience were introduced. One of these was 3-D. Pictured (opposite) is the audience in the Paramount Theatre in Hollywood wearing 3-D glasses to watch the 1952 film *Bwana Devil* (the first U.S. color 3-D film). The movie initiated the 3-D boom in the American filmmaking industry.

to run approximately two Hollywood covers a year in order to step up newsstand circulation. The magazine preferred a glamour girl for decorative cover purposes ... During the course of my tenure in *Time*'s Beverly Hills bureau (known as Bevedit), I worked on cover stories about Audrey Hepburn, Humphrey Bogart, Kim Novak, Walt Disney, Frank Sinatra, Gwen Verdon, William Holden and others. The most interesting and strenuous assignment was Marilyn Monroe [May 14, 1956, cover] ... [this] ran over a two-month period of intensive, almost detective-style research. I interviewed more than a hundred of Monroe's friends and

enemies and spent a good deal of time with her.... It was a couple of days after we had arrived in Sun Valley, [Idaho] that I finally got to the elusive Monroe. It was evening ... This was our first meeting for interview purposes. Wearing a white terrycloth robe, she curled up on a sofa, sipped a glass of sherry and talked while I took notes. It was a rather movingly delivered story, but also a confusing, extraordinarily involved and often contradictory one.... In previous years, Monroe had declared that both her parents were dead and that she had been raised in foster homes as an orphan. Over a period of time it had come to light (from other sources) that

Monroe was born out of wedlock, that her mother was alive and that her father probably was too ... At Sun Valley, Monroe told me that she was born Norma Jeane Baker on June 1, 1926, in Los Angeles General Hospital, the daughter of Gladys Baker, who was listed on the birth certificate as 'Mexican' but was not. Monroe now averred that her mother was living ... Monroe also told me that she was 'illegitimate.' She admitted that her father might still be alive ... She added mysteriously: 'I can't tell you who he is.' (It turned out that Monroe knows who her father is, that he is very much alive and residing in Southern California...)"

Box-office appeal. On January, 31, 1955, Grace Kelly appeared on the cover with the headline, "Gentlemen prefer ladies" (below, left). The article was titled, "The Girl in White Gloves" and *Time* called her "a young (25) beauty who can act." Francis Albert Sinatra first appeared on a *Time* cover on August 29, 1955, the year before he won an Oscar for Best Supporting Actor in *From Here to Eternity* (below, right).

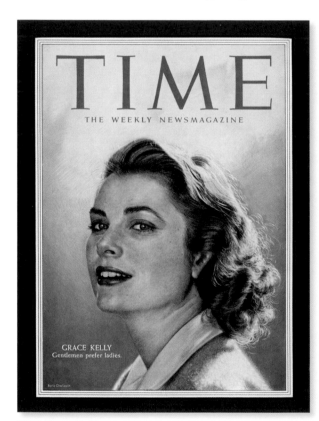

1955. Grace Kelly

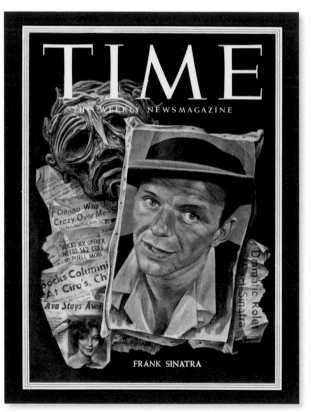

1955. Frank Sinatra

Marilyn in-depth. The research for the May 14, 1956, cover story (opposite) took more than two months. Interviews with her family, friends and colleagues filled more than sixty-five notebooks. When the issue hit the newsstands, her romance with playwright Arthur Miller was already public. Marilyn married Miller, her third husband, on June 29, 1956.

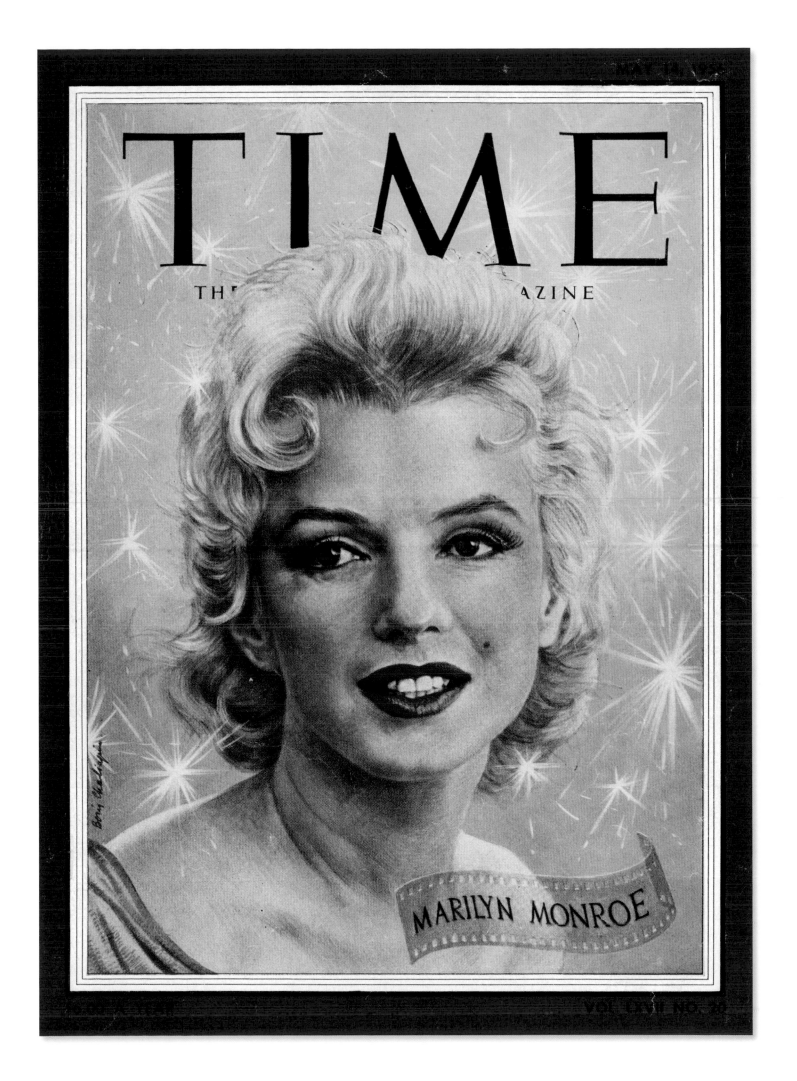

From Civil Rights to the Space Race

Although free from McCarthyism, the United States barely had a break. The country was soon in the midst of a complex internal transformation: the African-American struggle for civil rights as well as a thorny international challenge: the contest with the Soviet Union, both on Earth and in space.

In 1955, racial segregation still prevailed in most of the Southern states, banning African-Americans from, among other things, sitting next to whites on buses or using the same swimming pools, schools, restaurants, restrooms and many other public facilities. On public buses, whites generally sat in the front and African-Americans in the back. Whites that were standing were entitled to ask an African-American to give up their seat. But on December 1 in Montgomery, Alabama, an event changed the history of the fight for racial equality. Rosa Parks, an African-American seamstress, refused that day to give her seat on the bus to a white passenger. The driver called the police, and Parks was arrested and forced to pay a fourteen dollar fine.

The incident provoked the indignation of the African-American community, which created the Montgomery Improvement Association to defend its rights. The group was led by a then unknown Baptist minister named Martin Luther King, Jr. The association's first action was to boycott the city's buses. In its February 18, 1957, issue, *Time* noted the event:

> "Overnight the word flashed throughout the various Negro neighborhoods: support Rosa Parks; don't ride the buses Monday. Within 48 hours mimeographed leaflets (authorship unknown) were out, calling for a one-day bus boycott. A white woman saw one of the leaflets and called the *Montgomery Advertiser*, demanding that it print the story 'to show what the niggers are up to.' The *Advertiser* did—and publicized the boycott plan among Negroes in a way that they themselves never could have achieved. The results were astonishing: on Monday Montgomery Negroes walked, rode mules, drove horse-drawn buggies, traveled to work in private cars."

The boycott was an outright success: it lasted 381 days and helped to make the Montgomery African-American's cause known throughout the world. Parks's case reverberated all the way to the Supreme Court, which abolished segregation on public transportation by declaring it unconstitutional.

Rosa Parks thus became an icon of the civil rights movement, and her refusal to give up her seat provoked a widespread rebellion against segregation. On September 4, 1957, another case garnered international attention: Elizabeth Eckford and eight other African-American youngsters tried to walk into Little Rock Central High School, where they had registered, only to be rejected. In its September 16 issue, under the heading "Crisis in Arkansas," *Time* marked the event:

> "Most of the Negro children came in a group, accompanied by adults, and left quietly when told by a National Guardsman that 'Governor Faubus has placed this school off limits to Negroes.' But little Elizabeth Eckford, 15, stepped alone from a bus ... In a neat cotton dress, bobby-sox and ballet slippers, she walked straight to the National Guard line on the sidewalk. The Guardsmen raised their rifles, keeping her out. Elizabeth, clutching tight at her notebook, began a long, slow walk down the two blocks fronting the school."

The case reached such magnitude that it provoked a face-off between the

1957. Paratroopers at Little Rock

Against all odds. President Eisenshower dispatched the National Guard to Little Rock, Arkansas, to uphold the Supreme Court's decision that segregated schools were unconstitutional. *Time* devoted the October 7 cover to the issue (left). This photograph (opposite) shows Elizabeth Eckford attempting in 1957 to enter Little Rock Central High School, despite the protests of white students. Residents attempted to deny admission to nine black students.

Rosa Parks's seat. In 1955, Rosa Parks (pictured with the dark hat) refused to obey the Alabama law to give her seat on the bus to a white person. She was arrested and fined. Parks's action sparked the Montgomery bus boycott, which lasted over a year, and drew attention to the issue of segregation on public transportation. (Following spread)

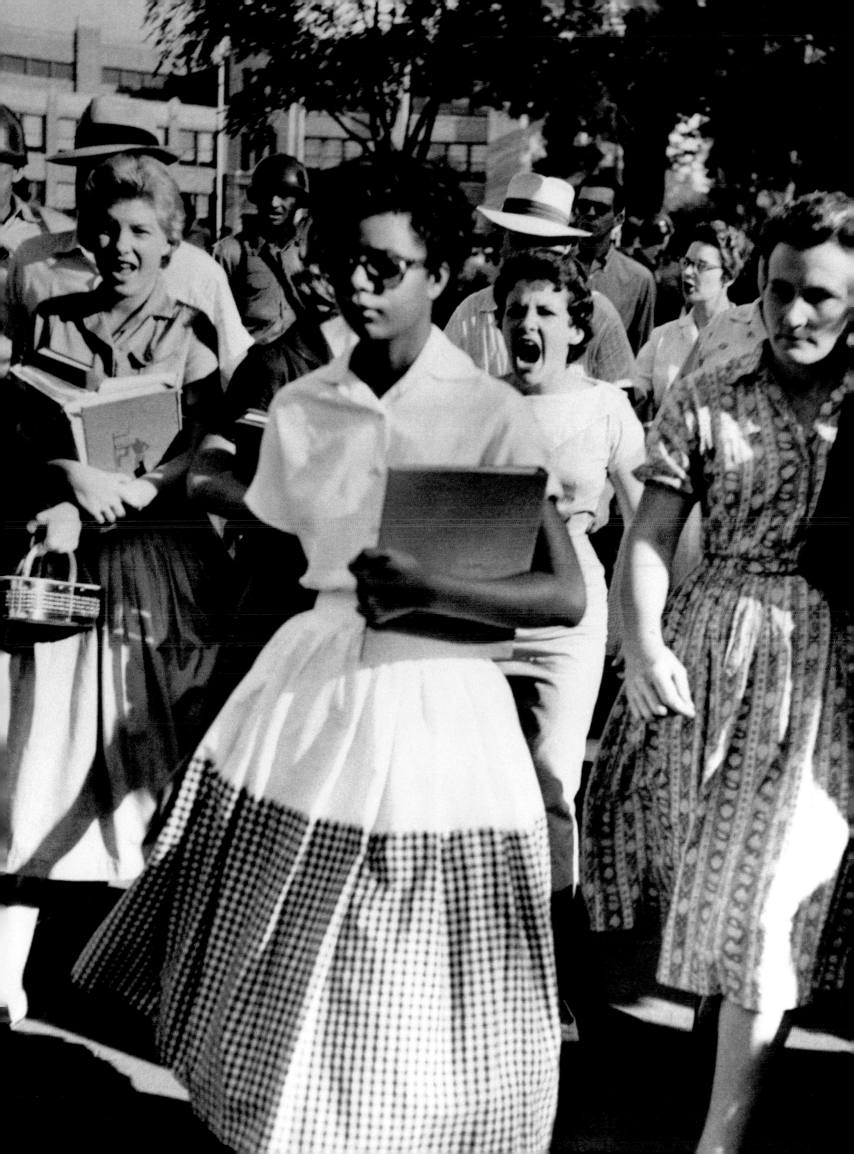

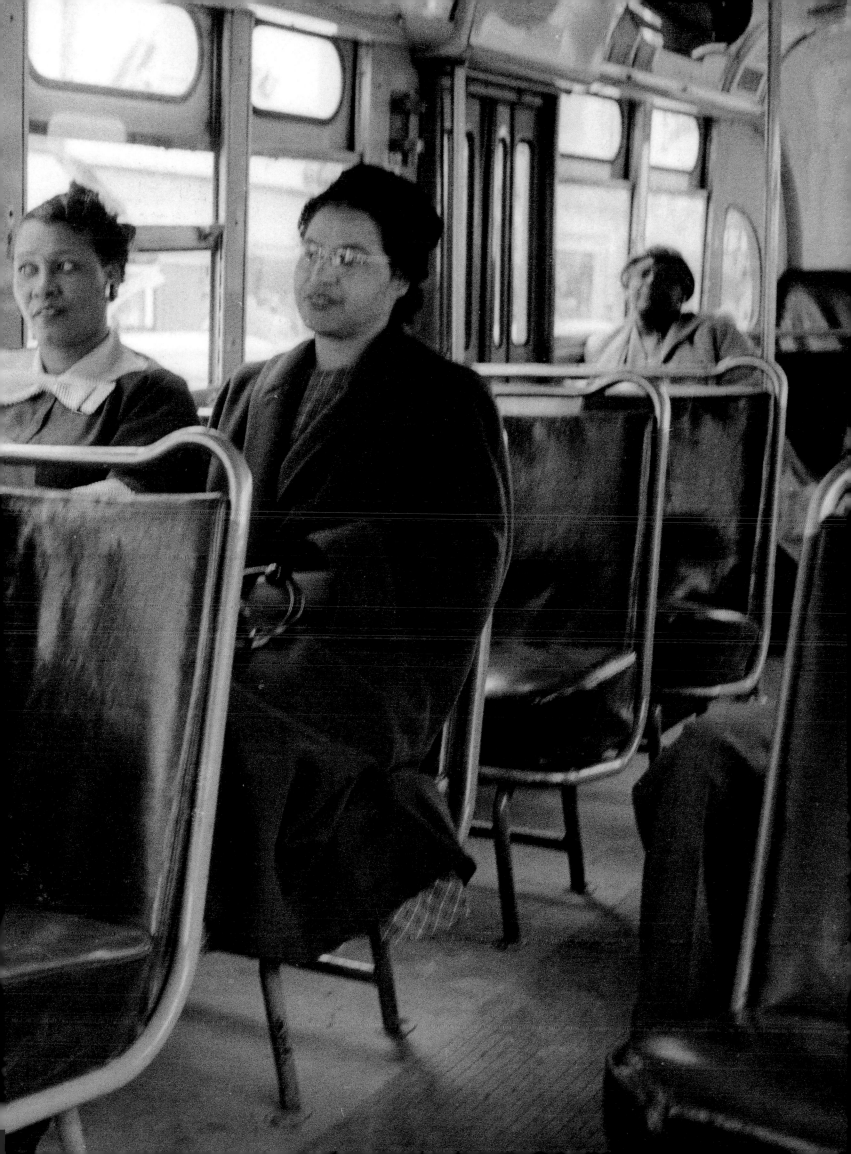

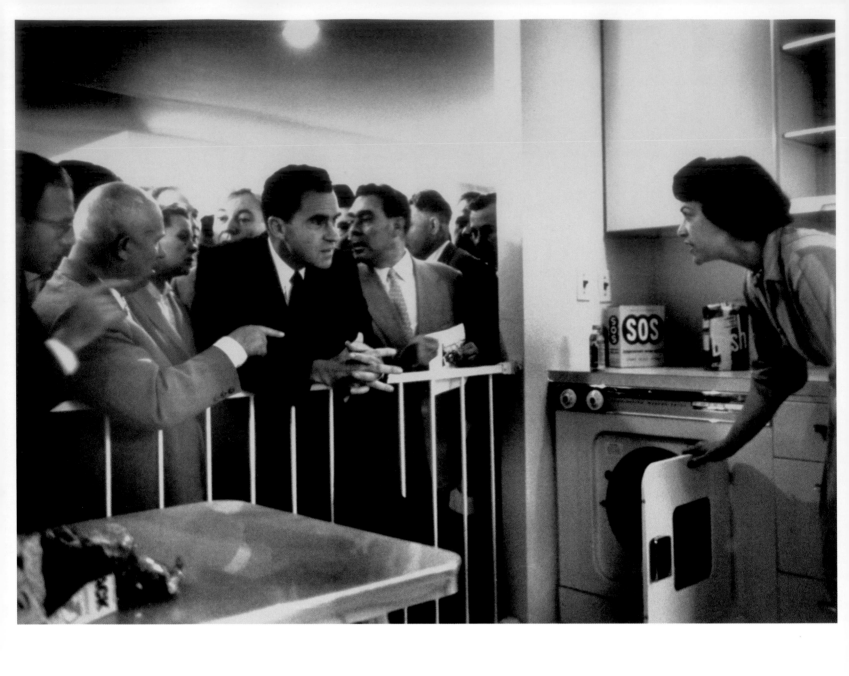

The kitchen debates. In 1959, during the American National Exhibition in Moscow, Vice President Richard Nixon boasted to Soviet Premier Nikita Khrushchev about the technological advances in the American kitchen (above). Khrushchev was not impressed—homes in the USSR were well equipped. The debate over appliances soon escalated to the other areas of competition between the two superpowers.

federal and state governments. To solve the problem regarding the students, on September 24, President Eisenhower sent federal troops to ensure the "Little Rock Nine" were admitted into the school. The photograph of young Elizabeth, wearing glasses and holding a notebook in her left arm while a white girl behind shouted at her, went around the world and became a symbol of the campaign for civil rights, which was beginning to win more and more battles throughout the United States.

At the same time, in another latitude, Americans found a new reason to be uneasy: the launching by the Soviet Union of *Sputnik I* and *II*, the first man-built satellites to orbit the Earth. This scientific achievement gave the United States's great rival a head start in what would become "the space race." The late 1950s were a time when the Cold War between the United States and the USSR was at its most intense. Any accomplishment by one country was viewed as a defeat by the other. In the space race, the launching of satellites into orbit was taken as another example of the Soviets' technological supremacy. Americans' faith in their own scientists and engineers, as well as the quality of the country's scientific education, was jarred.

In its November 11, 1957, issue, under the heading "A Time of Danger," *Time* published the news with a fear-inspiring tone:

"Somewhere out of the desolate steppes of the Soviet Union a giant rocket roared off into space last week, putting the second Soviet satellite, which carried an experimental dog named Little Curly, into orbit more than 1,000 miles above earth. *Sputnik II* weighed 1,120.8 lbs., six times the weight of *Sputnik I*, heavier than many types of nuclear warheads. The Soviet rocket generated a total thrust more

than enough to power an atomic bomb to the moon, more than enough to power a missile around the earth."

The launching of the *Sputniks* was undoubtedly the international news item of the year; *Time* could not dodge the issue in choosing the newsmaker who would be 1957's "Man of the Year." So, the cover was awarded to Soviet Prime Minister Nikita Khrushchev to recognize his accomplishments in space, as well as in agriculture and diplomacy with China. But, remembering what had happened in 1938 with the choice of Hitler, *Time* worried that its selection might anger readers. To avoid this pitfall, the magazine opted for a strategy of ridicule. In its January 6, 1958, cover story on Khrushchev, *Time* gave his alcoholism equal weight with his other qualities:

"With the Sputniks [wrote *Time*], Russia took man into a new era of space, and with its advances in the art of missilery,

posed the U.S. with the most dramatic military threat it had ever faced ... In 1957, under the orbits of a horned sphere and a half-ton bomb for a dead dog, the world's balance of power lurched and swung toward the free world's enemies ... Unquestionably, in the deadly give and take of the cold war, the high score for the year belongs to Russia. And unquestionably the Man of the Year was Russia's stubby and bold, garrulous and brilliant ruler: Nikita Khrushchev ... [He] was as extraordinary a dictator as the world has ever seen. Not since Alexander the Great had mankind seen a despot so willingly, so frequently, and so publicly drunk ... Drunk or sober, he never seemed to worry about what he said, who was listening, how it might diverge from the current line. A man in motion, he had the air of a man who never looked nervously over his shoulder in his life ... Within the party there may be younger men who will overtake him when he slows or stumbles. But in 1957,

Cold war, ironic cover. The magazine named Nikita Khrushchev "Man of the Year" in 1957, after the Soviets launched the first satellite to orbit the Earth. The event was the news of the year and a hard blow to the U.S. in the space race. In the midst of the Cold War hostilities, *Time* ran the cover. Boris Artzybasheff depicted Khrushchev wearing the Kremlin as a crown and spinning a *Sputnik* as if it were a toy (below).

1958. Nikita Khrushchev

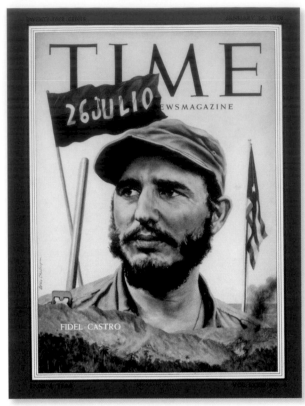

1959. Fidel Castro

"The 'barbudos.'" The word means "the bearded ones." The January 26, 1959, cover, after Fidel Castro and his troops overthrew the dictator Batista and executed over 200 people— who were accused of being torturers and mass murderers—in Havana (above). *Time*'s headline: "Cuba: Democracy or Dictatorship?" The cover story was titled "The Vengeful Visionary."

Nikita Khrushchev outran, outfoxed, outbragged, outworked and out-drank them all."

The description was matched by the image published on the cover. The artist was Boris Artzybasheff, who at the magazine's request had produced a cartoon like illustration depicting the Soviet leader sporting a crown that looked like the Kremlin and grinning as he held a *Sputnik* aloft in his chubby hands. Thus, *Time* was able to acknowledge Khrushchev's impact, while at the same time, expressing its own mordant attitude towards him.

Meanwhile, another Communist leader was emerging much closer to home—in Cuba, only ninety miles from American shores. In 1956, Fidel Castro led an invading rebel army in an uprising against Cuba's corrupt dictator, Fulgencio Batista. *Time* closely followed the advance of Castro's troops, which after early fighting holed up in the Sierra Maestra Mountains. A month after the invasion, *Time* reported, "Batista's troops sent to kill the rebels lacked the heart or the ability to do so." In November 1957, a correspondent interviewed Batista in Havana, and the following day met up with one of the revolutionary leaders in Santiago. Then,

Time climbed the Cuban mountains to see Castro and to witness a battle with Batista forces behind rebel lines. At that time, the magazine reported that Castro was acting "like a king" and "may become the brilliant liberator that his young followers see, or only, as one older rebel worried last week, 'a man on horseback.'"

However, in its January 26, 1959, issue, which offered an account of Batista's defeat and the march of Castro and his "barbudos"("the bearded ones") into Havana, the magazine harshly criticized the new regime. Beneath Boris Chaliapin's cover illustration of Castro, flanked by the Cuban flag on one side and a banner of his "26 de Julio" movement on the other, a headline asked: "Cuba, Democracy or Dictatorship?" Inside, under the title "The Vengeful Visionary," the story reported:

"The men who had just won a popular revolution for old ideals—for democracy, justice and honest government— themselves picked up the arrogant tools of dictatorship. As its public urged them on, the Cuban rebel army shot more than 200 men, summarily convicted in drumhead courts, as torturers and mass murderers for the fallen Batista dictatorship. The constitution, a humanitarian document forbidding capital punishment, was overridden...."

The story also quoted a defiant Castro: "If the Americans do not like what is happening, they can send in the Marines; then there will be 200,000 gringos dead...."

All of which added up to a grim prophecy. In the decade ahead, the deteriorating relationships among the United States, Cuba and the Soviet Union would end up placing the security of the entire world, the barbudos, at risk.

My days at *Time*

Thomas Griffith: Nixon and Kennedy with Salt and Pepper

Extracted from the book How True: A Skeptic's Guide to Believing the News *by Thomas Griffith, published in 1974 by Little Brown and Company*

It fell to me unexpectedly to edit *Time* magazine in the next presidential election year, 1960. In August 1960 the managing editor suffered a serious cerebral incident (though within four months he made a complete recovery). As the newly appointed assistant managing editor of *Time*, I sat in instead. The magazine had begun to show troubling signs of election year Republican partisanship; I was determined that our coverage was going to be as fair to both sides as I could make it ... Time Incorporated did proclaim itself for Nixon in 1960, but, properly, on the editorial page of *Life*. The endorsement was somewhat lukewarm, for Luce had always liked Old Joe Kennedy ... and admired his son Jack, whom he thought was anything but a liberal, and never did cotton too much to "Dick." I was for Kennedy, though not passionately, and certainly not for Nixon, but what mattered most to me was *Time*'s good name in an election year, and in this concern I knew I would have the support of a man I was just beginning to know, Hedley Donovan of *Fortune*, whom Luce was grooming as his successor...

The first week of my editorship all the stories came to me bland and salt-free, with Nixon and Kennedy getting equal space (as on many newspapers) whether or not each had equally made news. Louis Banks, the national affairs editor, and I agreed that this seemed too namby-pamby for *Time*. People would expect us to declare whether Nixon or Kennedy had won each televised debate. We would have to let the flow of the news take us where it would, even if this in some weeks led to a big advantage for one candidate. But since *Time* also had to overcome its past reputation, I decided that our fairness had to be explicit, and so made it my own business to see that in each week's issue the magazine touched four bases. In its coverage it had to record the best thing that might be said about the performance of either Nixon and Kennedy, and also the worst about each one, to assure the reader that we were not shading the news. I remember once when Nixon in one of his poor-cloth-coat moods was contrasting his humble origins with Kennedy's wealth; I added a footnote indicating that the vice-president of the United States was not exactly on relief, listing his salary, his expenses, his limousines and other perks of office.

Time's coverage created a happy stir in the Kennedy camp, for Kennedy considered *Time* important because, it went to "the kind of Republicans who could be reached by argument." Historian Arthur Schlesinger, Jr., working for Kennedy, was quoted: "This is the best *Time* political coverage since 1936, the best and the fairest...."

As for Luce, he would drop by my office to talk over the campaign with all the delight he always got from politics, but he never made suggestions or wanted to see stories in advance, and only after the last issue before the election went to press did he call me to say how pleased he had been, and ordered me to send a message to the staff saying that the real winner of the election was *Time*.

Visit. Presidential candidate Senator Kennedy accompanied by Luce during a visit at *Time* (below). Despite the friendship between the magazine's founder and Joe Kennedy, father of the young Jack, *Time*, loyal to its Republican tradition, supported Nixon.

A New Way of Looking at Art and Culture

American magazines in the 1940s and 1950s reaped the full benefits of what became known as the "Russian-European landing." The movement was composed of artists and intellectuals who emigrated to the United States as victims of the Nazi persecution of Jews or for the excellent earning potential and professional growth that the American magazine industry offered. Most of them were sculptors, photographers, painters or writers who brought new concepts and fresh artistic vision to American magazines. These imports gave the magazines a different, more intellectual and less isolated perspective. They were more disposed to and open to avant-garde trends and philosophies, which set them apart from the characteristic American pragmatism.

One of the most celebrated, creative and influential of the new figures was Alexander Liberman, a Russian painter, sculptor and photographer. Liberman was hired in 1941 at Condé Nast, where he was promoted to art director at *Vogue* and then to editorial director at the company. He made important artistic and editorial innovations to the publications during his command. Others who significantly influenced magazines were Russian artists Erté (the pseudonym of Roman Petrov de Tyrtov) and Alexey Brodovitch at *Harper's Bazaar* (a Hearst publication) and Iva Sergei Voidto-Patcèvitch, whom Nast, before his death, named as incoming president.

The "landing" also arrived at *Time* when Russians Boris Artzybasheff and Boris Chaliapin joined the staff to illustrate covers. No European émigré, however, had a more memorable and distinguished career at *Time* than Henry Grunwald, whose Jewish family had arrived from Austria in 1940, when Grunwald was seventeen. Young Henry started at *Time* as an intern and by age twenty-two was promoted to a writer. In 1947, when he was only twenty-

four, Grunwald wrote his first cover piece on musical comedy librettist, Oscar Hammerstein II. In 1951, he was appointed senior editor at twenty-eight, making him the youngest editorial manager in *Time*'s history.

Grunwald's background and credentials aptly suited him for the job of opening *Time*'s doors more widely to culture, art and science—a job that the magazine implicitly gave him when he became senior editor, and later, assistant managing editor. He came from a cultured family (his father wrote librettos for Viennese operettas), possessed a solid education and, although young, had a cosmopolitan outlook (he lived and studied in Austria, Czechoslovakia, Paris, Biarritz and Lisbon before arriving in the United States).

In these years, Grunwald's primary sphere of influence was the so-called "Back of the Book." The "BOB" customarily took up between fifty and sixty percent of the magazine's editorial content, and started with the "People" section, which focused on the week's catchy celebrity news item. Next came, through the end of the magazine, "Art," "Sports," "Theater," "Education," "Science," "Music," "Religion," "Media," "Milestones" (births, deaths, divorces, weddings, etc.), "Medicine," "Radio," "Cinema" and "Books." The same journalism standards applied to the Back of the Book as to the Front of the Book. The premise was still to inform and educate readers, albeit emphasizing the cultural aspect and making the sections fun to read.

Starting in 1951, when Grunwald took over these sections, he gave them a new dimension, running longer and more in-depth articles on culture and science and giving play to writers, artists and movies from foreign countries. *Time*'s readers were increasingly well educated

1950. Pablo Picasso

1958. Van Cliburn

Art and music. During the 1950s, the magazine increased the pages in the Back of the Book. Several covers illustrated articles from the "Art" section, like this one dedicated to Pablo Picasso on June 26, 1950 (left, top). The American pianist Van Cliburn occupied the cover on May 19, 1958 (left, bottom), when, in the middle of the Cold War, he won the First International Tchaikovsky contest in Moscow. This photograph (opposite) shows painter Pablo Picasso drawing in the air with a flashlight in a dark room.

and well informed, he believed, and would be open to an increase in the magazine's intellectual content.

By the end of the 1950s, *Time* reached a weekly circulation of 2.35 million. Many within the company credited this success to its last few pages. "Luce was often told that people read *Time* from back to front," Grunwald remembered, "because they thought that the cultural departments were less politically opinionated and offered more information not easily found elsewhere. He was partly annoyed by such comments and partly flattered."

In the decade between 1950 and 1961, nothing in the scientific or cultural panorama of events escaped Grunwald's attentive editorial eye. The "Medicine" section ran a cover story in 1954 on Jonas Salk for discovering the polio vaccine. The "Science" section devoted covers to assessing how Swiss psychologist Carl Jung in 1955 and Austrian psychoanalyst Sigmund Freud in 1956 had changed "forever the landscape and future of psychology." In 1960, in another cover story, the "Science" section celebrated French oceanographer Jacques Yves Cousteau for revolutionizing underwater scientific exploration.

Grunwald, an opera buff who attended performances regularly with illustrator Boris Chaliapin (son of a great Russian basso), brought more opera into the magazine, including covers devoted to Maria Callas in 1956, Renata Tebaldi in 1958 and Leontyne Price in 1961, after her Metropolitan Opera debut. Grunwald also put more content in the "Music" section, running profiles and stories about trends in classical as well as popular music and jazz. There were cover stories on jazzman Dave Brubeck (1954) as well as classical pianist Van Cliburn (1958), on singer-actor Frank Sinatra (1955) and composer-bandleader Duke Ellington

(1956) as well as conductor-composer Leonard Bernstein (1957).

For Grunwald, culture emphatically included pop culture. His "Back of the Book" closely followed the mushrooming growth of television in the 1950s, significantly changing the name of a traditional section from "Radio" to "Radio and Television," and then to "Television and Radio." During what is now called the medium's "Golden Age," executives programmed hours of live drama. Advertisers flocked to sponsor the productions, which in turn provided hefty budgets for producers to attract top-notch actors, writers and directors. Audiences discovered new talents such as Susan Strasberg, Paul Newman and Steve McQueen, followed by outstanding writers such as Rod Sterling, Paddy Chayefsky and Gore Vidal, who claimed that, along with the best American actors, they often found more opportunities in television than on Broadway or in Hollywood. Directors such as John Frankenheimer, Robert Mulligan and Delbert Mann, who directed many of the TV dramas, often claimed the same.

Ever alert to what was attracting audiences, the "Back of the Book" also traced the rise of popular genres. Later in the decade, for example, in a March 30, 1959, cover story titled "TV's Western Heroes," *Time* rounded up the spate of "rough ridin'," "fast shootin'" cowboy shows that were then entrancing the country. By that time, studies indicated that the average American family spent forty-two hours a week in front of a TV set.

Grunwald used the "Art" section in the Back of the Book to introduce or highlight leading American and international artists, and to showcase their work through the increasing use of high-quality color reproductions. In the February 20, 1956, issue, for example, under the heading "The Wild Ones," a six-page spread introduced and displayed the art of eight young

The television boom. According to 1959 studies, American families spent forty-two hours a week glued to their screens. Ed Sullivan, featured on the October 17, 1955, cover, became one of the popular celebrities of the time with his weekly variety show. Sullivan is pictured here (left) with the ninety-seven cakes he received from the public on his program's eighth birthday.

133

American painters, loosely grouped under the "Abstract Expressionist" label—most notably "the bright young proconsuls of the advance guard," Willem de Kooning and Jackson Pollock.

The "Art" section also used color pages to display some of the world's art and architecture masterpieces, such as the Roman Forum and the Piazza della Signoria in Italy, the Place de la Concorde and Place des Vosges in France and the Grand Palace in Brussels. In addition to portraying architect Eero Saarinen on the cover in 1956, the section published, in the 1960 Christmas issue, five color pages on the refined architecture of new American churches, followed by other covers in 1961

devoted to French architect Le Corbusier and to the booming art market in great paintings that were starting to command seven-digit prices, such as Rembrandt's *Aristotle Contemplating the Bust of Homer*, which sold that year for $2.3 million.

In the "Books" section, the magazine continued throughout the decade the tradition of covering American writers who had won the Nobel Prize for Literature (like Sinclair Lewis, Eugene O'Neill, Pearl Buck, T. S. Eliot and William Faulkner in the past). It also paid tribute to literary giant Ernest Hemingway with the cover and six inside pages in the December 13, 1954, issue, when he won the Nobel for *The Old Man and the Sea*:

"As an artist, he broke the bounds of American writing, enriched U.S. literature with the century's hardest-hitting prose, and showed new ways to a new generation of writers," *Time* reported:

"He consumes books, newspapers and random printed matter the way a big fish gulps plankton. One of the few top American writers alive who did not go to college, Hemingway read Darwin when he was ten, later taught himself Spanish so he could read *Don Quixote* and the bullfight journals."

After spending a week with Hemingway in Cuba, going out to fish with him on

Popular and classic. In 1952, *I love Lucy* was the number one TV program in America, and Lucille Ball ran on *Time*'s May 26 cover (below, left). Leonard Bernstein, the conductor, made the February 4, 1957, cover (below, right). Classical music stories, although less frequently than television ones, always occupied space on the cover of the magazine: the first instance was the 1926 cover with Arturo Toscanini.

1952. Lucille Ball

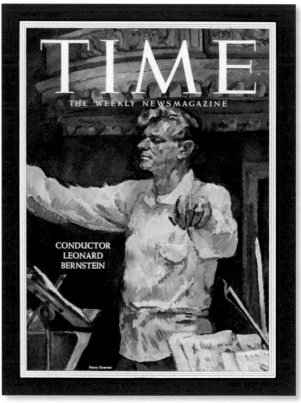

1957. Leonard Bernstein

The new jazz era. In the fifties, jazz held a predominant place in the pages of the "Music" section. Louis Armstrong (opposite) was on the cover in 1949, Dave Brubeck in 1954, Duke Ellington in 1956 and "The U.S. Music Boom" in 1957. In addition, there were articles on Garry Mulligan and Benny Goodman.

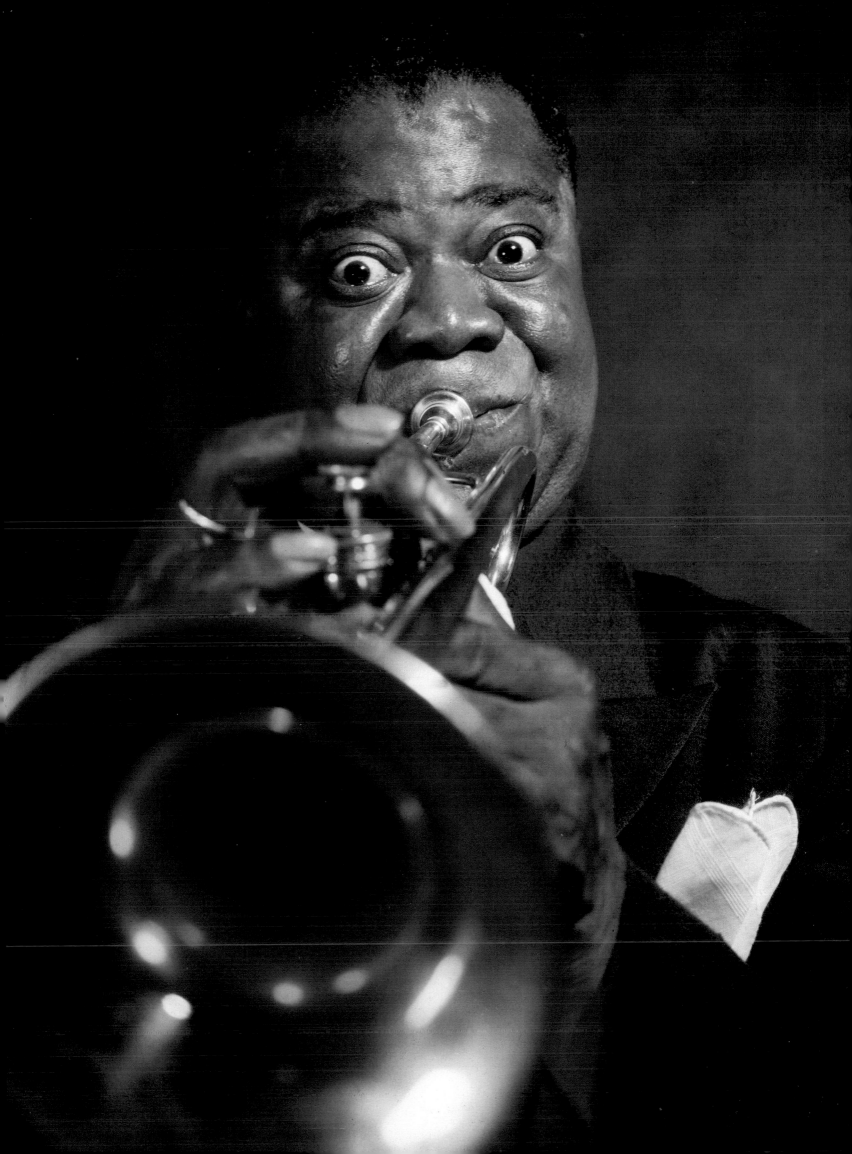

his yacht and watching how he lived and worked ("he writes standing up at the mantelpiece, using pencil for narrative and description and a typewriter for dialogue in order to keep up, always carrying a canteen of vermouth on one hip, and a canteen of gin or tequila on the other," wrote *Time*), the correspondent titled his article "An American Storyteller" and recounted Hemingway's adventures with bulls, alcohol, fishing and his all-night parties at his Cuban mansion, with celebrity guests, such as Ava Gardner and Gary Cooper, soldiers, sailors, boxers, bartenders and even young authors.

Time also devoted cover stories to such eminent international figures such as Thornton Wilder in 1953, Herman Wouk and Frenchman André Malraux in 1955 and Boris Pasternak in 1958.

Another great writer that *Time* hailed in this era was J. D. Salinger, featuring a cover story in the September 15, 1961, issue written by Jack Skow and illustrated by Russell Hoban, a Salinger fan who named his daughters after the author's last novel, *Franny and Zooey*. Robert Vickrey illustrated the cover. *Time* described Salinger as "the most private of public authors," a man who had gone off to live in the country as a hermit to avoid being besieged by interviews and autographs. "When I launched a cover story about him," Grunwald remembered:

"... He proved harder to report on than the Pope or the head of the KGB. He lived like a hermit in Cornish, New Hampshire. To find information about him we deployed a dragnet of correspondents, which was supplemented by an enterprising researcher, Martha Murphy ... She drove to New Hampshire to stake out Salinger and almost literally ran into him on a dirt road, driving in the other direction. She followed him to the nearby post office, where she confronted him and asked if they could talk. He stared at her in shock, ran back wordlessly to his Jeep, swung the vehicle around and took off. We nevertheless pieced together a fairly good story. When it appeared, Salinger went to the local paper store and bought up all the copies of *Time*, explaining that he did not want his neighbors reading about him. The shop's owner immediately reordered a lot more copies and sold all of them."

Nothing in the Back of the Book, however, stood out more at the time—or bore more of Grunwald's stamp—than an article published on June 11, 1956, to mark the wary reconciliation of the United States with its intellectuals. *Time* chose thirteen American thinkers—among them, playwright Thornton Wilder, historian Jacques Barzun (who was on the cover), nuclear physicist Robert Oppenheimer, and architect Frank Lloyd Wright—who were photographed by famous German photographer Alfred Eisenstaedt (another artist who left Europe due to Nazism). The article highlighted a thorny subject: why the United States and its intellectuals had historically developed such mutual scorn and antipathy, while in Europe intellectuals had generally been venerated for their wisdom and insight.

"The young nation had little appetite for theory and the intellectuals had little desire to furnish it," wrote *Time*. "By elevating the Common Man, the United States sowed the seeds of its own anti-intellectualism. Through much of American history, the nation's thinkers 'have been merely cultivating their own garden. Instead of one mission, they have many: they live both a part of society and apart from it.' Starting in the 1930s, though, intellectuals have begun to feel more at home with America's ideals and its role in the world. They have assumed their original function as 'the critical but sympathetic—and wholly indispensable—bearer of America's message.' Barzun, *Time* concluded, with his faith in a new American civilization, a civilization of diverse multitudes bound by 'the ethics of equality,' stood as an examplar of 'a growing host of men of ideas who not only have the respect of the nation, but who return the compliment.'"

Medicine and science. These were two very prominent sections in the Back of the Book, whose subject matter generated several cover stories in a decade in which there was an avidity for news about space exploration, atomic research and medical advances. Dr. Jonas Salk, creator of the first safe and effective polio vaccine, was on the March 29, 1954, cover (opposite).

TWENTY CENTS

MARCH 29, 1954

TIME

THE WEEKLY NEWSMAGAZINE

ARTZYBASHEFF

POLIO FIGHTER SALK

Is this the year?

VOL. LXIII NO. 13

4

Time's Cover Artists Create a Portrait of History

Jim Kelly, *Time*'s managing editor from 2000 to 2006, wrote, in the Time Inc. publication, *Time Covers History: 80 Years of Covers*:

"People sometimes ask me what part of my job is the most fun, and the answer is easy: picking the cover art every week. They also sometimes ask me what the most difficult part is, and the answer, alas, is the same: picking the cover art every week. In selecting each cover, the managing editor of *Time* must not only keep in mind what every editor must think of—clarity of message, elegance of presentation, that dash of attitude that makes the issue stand out on the newsstand or coffee table—but he must also be aware that history is looking over his shoulder ... And so when *Time* captures a person, an event or a trend within its iconic red borders, the magazine is adding that extra dose of significance that no other publication can quite match."

Kelly was not exaggerating, *Time*'s covers have, during the magazine's almost eight decades, formed a portrait of history. First within the cover's black-and-white filigrees, and then inside its noted red border, great men and women, wars and epic subjects from this century and last century have been spotlighted. The cover has featured Churchill as well as Stalin and Hitler; Einstein, Freud and James Joyce; Vladimir Horowitz, the Beatles and Picasso. On *Time*'s cover, the *Challenger* blew up, two planes attacked and destroyed the Twin Towers, World War II began and ended, the Berlin Wall went up and came down, and from the cover, Mother Teresa of Calcutta looked out kindly toward readers.

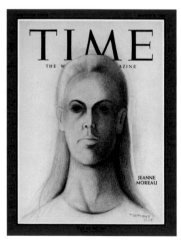

1965. Jeanne Moreau

Art and journalism. Although joined by several top artists, the ABC trio continued to play a significant role during the 1960s, using art to illustrate the news. Mexican artist Rufino Tamayo painted a portrait of actress Jeanne Moreau for the March 5, 1965, cover (left). Boris Chaliapin's painting of jazz pianist and composer Thelonius Monk was featured on the February 28, 1964, cover (opposite).

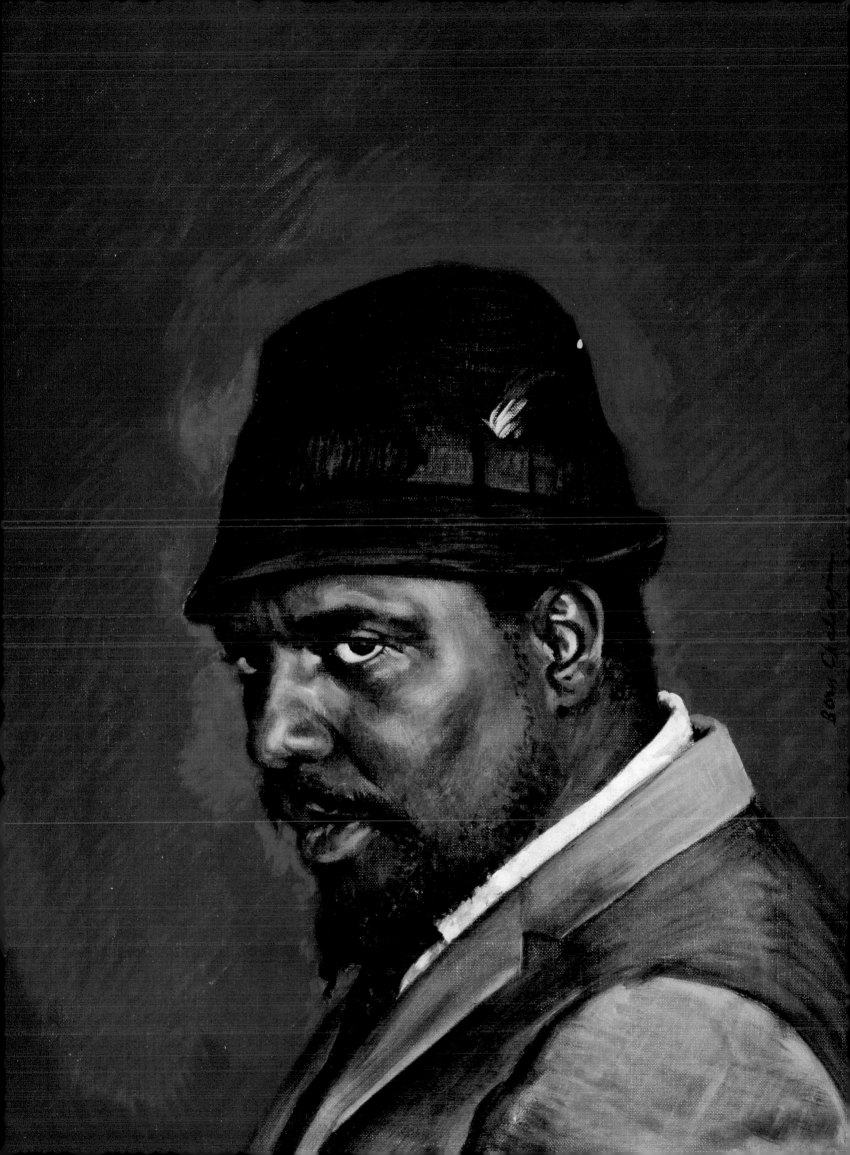

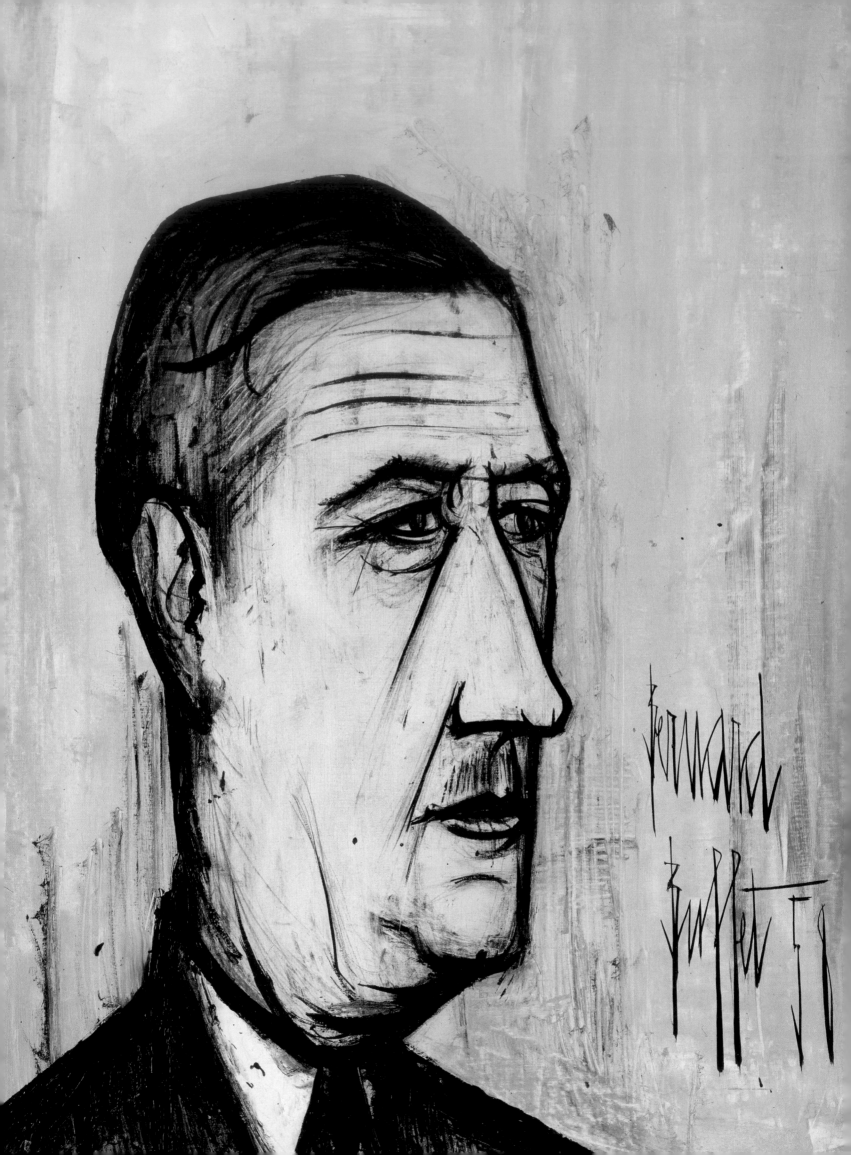

From the very beginning of *Time*, history had a human face. Henry Luce and Briton Hadden created the magazine based on the principle that the forces of history were better understood through individuals. They had the chance of changing the course of events. For many years, the cover, always with a newsmaker's portrait or photograph, reflected this philosophy.

Kelly noted:

"*Time* did not invent the idea of telling the news through people—as Henry Luce once quipped, the Bible got there first—but it went about it in pioneering and refreshing ways. From the very first issue in 1923, which featured a charcoal cover drawing of Speaker of the House Joseph Cannon, *Time* has specialized in pithy, sharply observed detail about the lives and backgrounds of the people it profiles. And almost every cover for the first few decades portrayed a newsmaker, whether it was a president, king, business tycoon, sportsman or Hollywood star. The charcoal drawings soon gave way to black-and-white photographs, then to color photographs and paintings."

Monitoring the various artistic trends, seeing how they adapted to the news and expressing them in images, provided a unique confluence of art and journalism. The influence of these cover illustrations lasted long after the week in which they were published. Many became iconic of what would become known as the *Time* School of Covers.

The cover illustrations mirrored technological and conceptual advances: covers were first drawn in charcoal, however, later in the decade, the magic of Photoshop made almost anything possible.

The charcoal era was characterized by black-and-white drawings. At the time, photography and printing had not yet reached optimal display levels. The filigrees on the sides of the front cover framed and highlighted the newsmaker's image. This era was followed by another that was fundamental for the magazine's future and identity: the red frame, an innovation that, beginning in 1927, gave *Time* character and became a trademark in the publishing world. During this period, the head-and-shoulders portrait became popular. The greatest proponent of this style was S. J. Woolf.

During the 1940s and 1950s, *Time* specialized in portraits appearing in front of backgrounds that provided context, informing readers of the reason these portraits were featured on the cover. Three different artists—Boris Artzybasheff, Ernest Hamlin Baker and Boris Chaliapin—

Politicians and celebrities. In the '50s and '60s, almost all of the covers featured newsmakers—scientists, politicians, religious leaders or entertainment celebrities—rather than issues. Ernesto "Che" Guevara appeared on the cover on August 8, 1960, illustrated by Bernard Satran, Sophia Loren was illustrated by J. Bouche for the April 6, 1962, cover and Rudolf Nureyev, by Sidney Nolan, for the April 16, 1965, cover (below, from left to right).

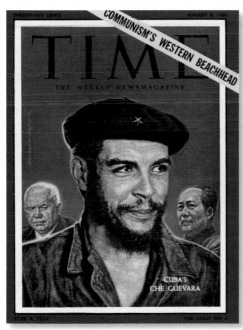
1960. Che Guevara

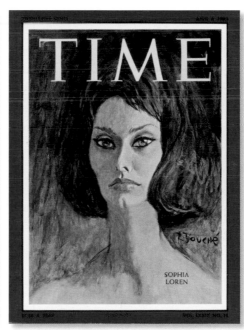
1962. Sophia Loren

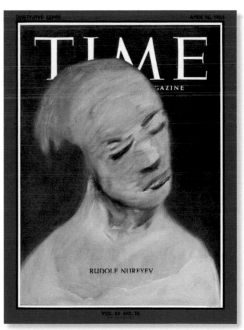
1965. Rudolf Nureyev

Expressionistic de Gaulle. Bernard Buffet, a French painter and graduate of the National School of Fine Arts in Paris, was among the artists that Cover Editor Dana Tasker brought to *Time*. Buffet painted Charles de Gaulle, the magazine's 1958 "Man of the Year," in a linear expressionist style (opposite).

produced most of these covers. From the initials of their last names, they were referred to as the ABC trio.

By the end of the 1950s and during the 1960s, well-known artists were summoned to create more conceptually advanced cover images. The participation of renowned painters, sculptors and illustrators continued throughout the 1970s and sporadically during the 1980s. In the mid-1960s, *Time* started to experiment with cover ideas that at times replaced newsmakers. In 1966, *Time* published a cover with three red words over a black background: "Is God Dead?" This was also the period when artists who were culturally identified with the subject they were assigned were brought on board to create covers.

The type of photography that the magazine is known for, which interprets the event and conveys the article's purpose, appeared in the 1980s, from the hands of great masters, such as Neil Leifer and William Coupon, and continued throughout the following decades with Matt Mahurin, Gregory Heisler, James Nachtwey and Albert Watson.

Starting in the early 1990s, dozens of covers were designed by Arthur Hochstein, the magazine's art director, who was a journalist before he began studying design. Hochstein was responsible for a new conceptual approach that utilized Photoshop to capture an issue's editorial focus in powerful photomontages.

In 1953, a major stylistic development for the *Time* covers began when Dana Tasker, the executive editor responsible for creating "the news illustration," retired from the magazine. Otto Fuerbringer, who was at the time Roy Alexander's assistant managing editor, began to oversee the cover illustrations. At the time, the cover's structure was divided into three segments: the logo was on top; the middle, as if in a frame, contained the illustration of the newsmaker; and the bottom section contained the headline. Under Fuerbringer, these elements were unified, with the illustration's background also serving as the background for the logo and headline.

Fuerbringer's most significant contribution, however, would go well beyond form. When Fuerbringer took over, the ABC trio was still in its heyday, and their illustrations dominated the magazine's covers. But the new editor thought that progressive stylistic changes were needed so that the cover art matched the magazine's new editorial direction.

Fuerbringer recruited great artists who, with their various distinctive styles, contributed to *Time*'s new interpretation of the news. Although the ABC trio continued on for several years, the magazine hired Aaron Bohrod, who in 1955 produced a great portrait of Frank Sinatra; Ben Shahn, who in July of that year, in his signature style, portrayed French writer André Malraux; Henry Koerner, who in 1956 depicted opera singer Maria Callas and the following year, musician Leonard Bernstein; Bernard Buffet, who illustrated Charles de Gaulle in 1959, the same year Andrew Wyeth created a noted tempura illustration of President Dwight Eisenhower. In 1957, Robert Vickrey and Bernard Safran also joined the staff and the ABC trio. Vickrey produced seventy-seven cover portraits for *Time* in egg tempura. Vickrey made his cover debut with an illustration of designer Christian Dior in March 1957, and in July of that year, he captured the image of movie actress Kim Novak. Safran also worked at the magazine for eleven years and produced scores of images for the cover. He distinguished himself by creating multi dimensional illustrations, and was responsible for images of both newsmakers and celebrities, such as

Capricious Callas. The October 29, 1956, cover illustration of soprano Maria Callas (left), by Henry Koerner, created a few obstacles. Callas was known to be a diva. To draw her from life, Koerner first traveled to Venice, then to Milan for several sessions, in part, because Callas claimed to quickly tire.

Richard Burton, Tennessee Williams, Fidel Castro, Lyndon Johnson, Richard Nixon and Ernesto "Che" Guevara.

In his book, *Faces of Time: 75 Years of Time Magazine Cover Portraits,* Frederick S. Voss, explained how the cover art evolved during Fuerbringer's tenure:

"In addition to being open to broader stylistic variety in covers, Fuerbringer also took an interest in recruiting artists wanting to do their newsmaker portraits from live sittings.

Going to the trouble of arranging for sittings did not necessarily guarantee a superior likeness. Nevertheless, being able to say that a portrait was drawn from life gave it a cachet of authenticity, and beginning in the mid-1950s, cover likenesses from life sittings became fairly common."

One of the new problems editors had to face with this modality—a political or Hollywood celebrity, portrayed by an artist—arose from the fact that they now had to meet the demands of both artist and subject. Henry Koerner, for instance, was a *Time* artist who didn't accept cover assignments unless the magazine guaranteed a face-to-face session with the subject. Obviously, this produced many complications and expenses, particularly when the cover production involved a complicated or difficult character. Often remembered is the story behind Koerner's 1956 session to make a painting from life of Maria Callas. Callas, known for her temper and whims, was going to grace the magazine's cover before an October performance at New York's Metropolitan

Opera. Koerner first went to Venice, where the diva was resting and refused to see him. She rescheduled the meeting for Milan for the week after her vacation. Koerner was forced to wait there until she agreed to several sessions. But noise made her nervous, and the work had to be postponed. She even refused to let him go into her house, saying the illustrator exasperated her. Finally, several weeks and incidents later, Koerner was able to finish his work, which was published on October 29.

Robert Vickrey was another artist who expected at least one sitting with his subject. Vickrey was always accompanied by a photographer, who took several shots while he made sketches. But these shots didn't always ensure an accurate representation of the subject of the portrait. As Vickrey writes in his book, *Robert Vickrey, Artist at Work,* that is what happened when he called on Majority Leader of the Senate Lyndon Johnson in 1958 for a cover session:

"He kept the *Time* photographer and me waiting in his office all day while he shook hands with a seemingly endless stream of constituents. We were finally admitted to his office just after sundown. It was quite dark, and we had to set up a photo flood to see him. After lecturing us for several minutes on the unfairness of all previously published portraits, he went into the next room where we could hear him shaving with an electric razor. He then announced we could have ten minutes of posing. Since we had been led to expect this sort of thing, we went into action. The photographer hopped about the room,

taking as many pictures as possible while I attempted to sketch. When we got the photos back from the lab, we noticed that LBJ was coming out green. We guessed that the harsh lights and the after-shave lotion he must have used made him seem like something out of the *Wizard of Oz*. Still, when the cover appeared, he asked to have it."

The saga of cover artists continued during the following decade, with other exceptional artists illustrating news and newsmakers, such as Rufino Tamayo, who in 1965, with pencil and crayons, drew French actress Jeanne Moreau's face; and Sidney Nolan, who, also that year, executed a ghostly image of Russian dancer Rudolf Nureyev. A cover on noted artist Marc Chagall was illustrated with a drawing the painter had done of himself. Vickrey remembered:

"Working for *Time* was rather a bracing experience. Most people are surprised to hear that the magazine known for its prose editorializing never tried to influence the style or content of its covers. In fact, Otto Fuerbringer, known to the writers in those days as 'The Iron Chancellor,' was always very relaxed and friendly to the artists. He once told me to go ahead and be as unflattering as I wanted with Republican subjects, 'because everyone knows we're a Republican magazine.' Delineating the defects of the Democrats seemed to bring in the only criticism."

Vickrey's record. Robert Vickrey portrayed Egyptian President Gamal Abdel Nasser for the March 29, 1963, cover (opposite). Vickrey, with the magazine from 1957 to 1988, illustrated more than seventy cover portraits. He sketched his subjects from life using the ancient technique of egg tempera.

More Internal Changes

Otto Fuerbringer took over as managing editor early in 1960, replacing Roy Alexander, who was named emeritus editor. In his book, *One Man's America: A Journalist's Search for the Heart of His Country*, Henry Grunwald wrote of Fuerbringer's editorial style:

"In America and the world it was the Kennedy-Johnson era. In the small universe of *Time* it was the Fuerbringer era.

In some quarters Fuerbringer was known as 'the Iron Chancellor' for his Germanic ancestry and autocratic manner. One researcher, Clare Mead, who had been a nun for ten years but reentered the world because she had found church discipline too severe, observed after one week's exposure to Fuerbringer: 'For this I left the convent?'

What he was most often enthusiastic about was politics; he took a passionate interest in the maneuvers, ploys and counterploys from Capitol Hill to statehouses...

Fuerbringer was proud of his Harvard degree and proud of his heritage. His grandfather had been a founder of the Missouri Synod of the Lutheran Church, his father president of the church-sponsored Concordia College in St. Louis. He loathed the term 'Bible Belt' and banned it from the magazine. He saw himself as independent of the boss, but on many issues he was more Lucean than Luce. Like Luce, he strongly backed an active American role in the world."

Fuerbringer would be the last of the six managing editors directly appointed by Luce after Hadden's death. The others were John S. Martin (1929–33 and 1936–37); John Shaw Billings (1933–36); Manfred Gottfried (1937–43); T. S. Matthews (1943–49); and Roy Alexander (1949–60). Fuerbringer was assisted by Assistant Managing Editors Thomas Griffith and James Keogh.

Except for a few small changes, the publication that Fuerbringer took over was, after almost forty years, still mainly a weekly version of a newspaper that selected important current events according to a set method, arranged them by sections and completely organized the news for the reader. According to Fuerbringer, this contract with the reader would remain in force. But he also maintained that *Time* should evolve and improve. In his opinion, "it had gone a little flat." To liven it up, he proposed making changes both in the selection of the stories and in how they were written. He meant to start slowly, but in May 1960, change came with stunning swiftness. Forty hours before the issue's closing, the news arrived that an American spy plane had been shot down over the Soviet Union and its pilot, Francis Gary Powers, detained. The information caused a stir and a scandal around the world. *Time* rushed to publish a story based on Powers, cancelled the cover that had been printed for May 16 and substituted a black-and-white photo of the pilot. This change to cover a late-breaking news event made readers feel the magazine was alive and ready to respond immediately to their needs.

During the magazine's first forty years, the sections originally created by Hadden and Luce went through only minor modifications. But with Fuerbringer's arrival, the magazine began to modify its thematic sections in an attempt to keep up with the times.

In March 1961, *Time*'s two main sections were renamed. "National Affairs" became "The Nation," and "Foreign News" was now called "The World." In May, a new section debuted. Its name clearly sent the message

Last-minute covers. *Time* substituted its May 16, 1960, cover with a photo of pilot Francis Powers, detained by the Soviets after his U.S. spy plane was shot down (opposite). This was the first time the magazine changed a planned cover that featured a photograph at the last minute. The following years saw frequent last-minute cover changes to accommodate late breaking news.

TWENTY-FIVE CENTS

MAY 16, 1960

THE COLD WAR GETS HOTTER
The High-Flying U-2 & the Cloudy Summit

TIME

THE WEEKLY NEWSMAGAZINE

PILOT
FRANCIS POWERS

ASSOCIATED PRESS

$7.00 A YEAR

VOL. LXXV NO. 20

of up-to-the-minute-ness that the magazine wanted to offer its readers.

The section was "Modern Living"—later called simply "Living." As its editors remarked at the time, it was intended to cover "every aspect of how people, and Americans in particular, live—their cars, homes, travel, play, food, fads, fashions, customs, manners." At first, the section generated suspicion, even from Luce, who considered it a bit "bland" and "frivolous" for the informative format the magazine should have. Nonetheless, three years later, in January 1964, "Modern Living" produced one of the most controversial cover stories of the decade. "Sex in the Sixties" positioned *Time* as a magazine capable of tackling issues that were of profound social import.

Another section *Time* created during the 1960s was "World Business." Its goal was to report on Europe, with its increasingly important Common Market, as well as the emerging economies of Asia and elsewhere. It came out in 1962, and five years later was taken over by the existing "Business" section.

When Fuerbringer took over, *Time*, in addition to its fans and ever-increasing readership—in 1960 the magazine's worldwide circulation surpassed 3 million—also had its critics.

Time was accused of being politically slanted, of being superficial or making the facts fit its vision and of being arrogant or attempting to impose opinions. The criticisms, whether warranted or not, were definitely unavoidable for a magazine whose articles were not only reports but also offered opinions.

One of the main complaints against *Time*, and an issue that worried editors, was the shallowness of its stories. This was often the subject of chats over coffee, dinners and office meetings, so much so, that Grunwald, looking back at that time, wrote:

"Nevertheless the magazine was still held in contempt by most intellectuals— and by people who wanted to pass for intellectuals ... Scandal sheets and women's magazines need not be taken seriously. But magazines like *Time*

had intellectual pretensions and were therefore threatening ... Thus *Time*, in its much advertised effort to be 'curt, clear, concise was accused of oversimplifying complex situations. True enough—but compared to what? Certainly compared to the better literary or scholarly journals but not compared to most of the press ... Especially in the coverage of the arts, religion, education, science, *Time* took up stories most newspapers and popular magazines never touched. No other publication approaching a mass circulation (*Time* sold some 1.5 million copies a year in the late 1940s) would have carried the equivalent of *Time*'s cover stories about Arnold Toynbee or Reinhold Niebuhr or C. S. Lewis or T. S. Eliot ... When critics complained that such stories were middlebrow, they forgot that for most of American newspaper readers, middlebrow was a step up."

In an attempt to provide deeper coverage of subjects that required more

Modern living. Managing Editor Otto Fuerbringer proposed several changes to the magazine's editorial content. In May 1961, he introduced a new section, "Modern Living" (below). The purpose of this section, later called "Living," was to cover how Americans, in particular, lived, worked and played and what they thought. Henry Luce considered the new section "frivolous."

1961. "Modern Living"

editorial time and pages, Fuerbringer's team offered a new section, "Essay." It's debut on April 2, 1965, was a change to the magazine's typical approach to news.

Contrary to *Time*'s usual style, "Essay" broke the traditional scheme of covering, in its various sections, headline-making subjects as they occurred, but instead was an in-depth follow-up to the coverage. For its debut, the publisher's letter described the reasons for the new section:

"Like the other sections of the magazine, Essay will treat topics in the news, but (except for the cover story) in greater detail and length. Essay will take a problem under current discussion and lay it bare. The new department will not treat a story or an issue when it is making the biggest headlines. That will be done in the appropriate section. Essay will come in later, when the problem is still far from settled but when second thoughts and greater reflection can be of particular benefit."

The section also allowed the experts consulted by the author to be quoted more extensively than in regular sections. "Essay"—to Fuerbringer the title seemed "a nice old-fashioned (word) to bring back"—was published that first time on two facing pages under the headline: "The U.N.: Prospects Beyond Paralysis." Subsequent issues would cover more controversial topics that hit closer to home, such as "Viet Nam: The Right War at the Right Time," "The New American Jew" or "The Pleasures and Pitfalls of Being in Debt."

In April 1964, a fundamental change took place in the company's editorial pyramid: the replacement of Henry Luce as editor in chief. His successor was Hedley Donovan, who, from then on, as editorial director, was in charge of editorial for all Time Inc. magazines. As with every important decision made by Luce, it had been considered well in advance, carefully planned and privately carried out. The change had been in the works for five years, when during a dinner party at his home, Luce offered the job to Donovan. "He wants me to be him," a surprised Donovan later told his wife. Luce's health, which had deteriorated since 1958, when he had a heart attack at his winter home in Phoenix, Arizona, had a lot to do with the decision. Luce had been editor in chief since 1942, and ever since the United States joined the war, he had given up all other positions at the company. In 1961, in a TV interview to commemorate *Life*'s twenty-fifth anniversary, he said: "The reason for remaining editor-in-chief, of course, is because I like it."

Enlightenment. The "Essay" section started in 1965 and is still part of *Time* today. It usually took up a double page spread (below). Its purpose was to analyze a current topic that the magazine had previously covered. The section was meant to enlighten readers not be a forum for the author's opinion—not all of its writers could meet the challenge.

1965. "Essay"

A Smile, Mr. President

On November 8, 1960, Americans went to the polls to elect a new president. Late that evening in front of television cameas, Republican Party candidate Richard Nixon conceded his defeat to John Fitzgerald Kennedy, who at age forty-three became the president elect of the United States.

With the new leader came a breath of fresh air in politics and an administration that made people believe that the American Dream was attainable. Kennedy broke all molds. He was the first Catholic president, the youngest president ever elected, the first born in the twentieth century and the first, after Theodore Roosevelt in 1901, to live with children in the White House. For 1,036 days, John and his wife, Jacqueline, along with their children, Caroline and John, Jr., were the quintessential American family.

The first member of the dynasty, Patrick Joseph had arrived in 1849 from Ireland—like so many others, escaping a country that was decimated by a potato famine—to make his way, with great effort, as an electrician in Boston. His son, Joseph Patrick Kennedy, married the mayor's daughter, Rose Fitzgerald, had nine children and became U.S. ambassador to Great Britain. The zenith of such a fast and brilliant family ascent culminated in 1961, when over the course of one year, three members of the Kennedy clan—three of Joseph's nine children—reached high positions in the country's political echelon: John Fitzgerald, 43, as president; Robert Francis, 35, as attorney general; and Edward Moore, 28, as senator.

From the start, the Kennedy name was ever present in the pages of *Time*. Joseph Patrick was on the cover in 1935 and 1939, while Massachusetts Democratic Senator John Fitzgerald appeared on the cover for the first time in December 1957, when he set out on the path toward the Democratic presidential nomination, and again in 1958 and 1960. In the July 11, 1960, issue, the magazine devoted the cover to

the clan, titling it "The Kennedy Family," and Robert was featured by himself in October. There existed a special, very friendly relationship between Joseph Kennedy and Henry Luce—in 1940, the founder of *Time* went along with the senior Kennedy's request and wrote the prologue to the book *Why England Slept*, written by young, twenty-three-year-old John. In it, Luce wrote presciently: "If John Kennedy is characteristic of the younger generation—and I believe he is—many of us would be happy to have the destinies of this Republic handed over to his generation at once." The day of John F. Kennedy's presidential nomination at the Los Angeles Democratic convention, his father Joseph was in New York and was invited by Luce to dinner in Luce's apartment to watch the presidential candidate's speech on TV.

Given this background, there was speculation, with reason, that the Time Inc. magazines, as they had done in every election, would endorse one candidate and that it would be Kennedy. Such was not the case. Although he was not totally convinced, Luce gave in to the arguments presented by Larsen, Donovan and Alexander, and supported Nixon. Only Tom Griffith—who at the time was in charge of *Time* while Fuerbringer was sick—decidedly favored Kennedy. But the other editors, staunch Republicans, tipped the balance with the argument that there wasn't much difference between the two candidates and that they should therefore continue supporting the more conservative ticket. Following tradition, Time Inc. communicated its position in *Life*, in an editorial published in mid-October 1960. The election was decided by a narrow 120,000 margin on behalf of Kennedy (a 0.17% difference), that is, for less than two votes between candidates at each polling place.

The election marked a milestone in the media coverage of the presidential

1962. John F. Kennedy

Kennedy's other face. Italian illustrator Pietro Annigoni painted Kennedy for the 1961 "Man of the Year" cover. Unlike his usual smiling image, the president appeared pensive, aged and with his tie askew (left). This July 1960 photo presaged the difficult decisions in the years ahead. John F. Kennedy is pictured with his brother Bobby (opposite).

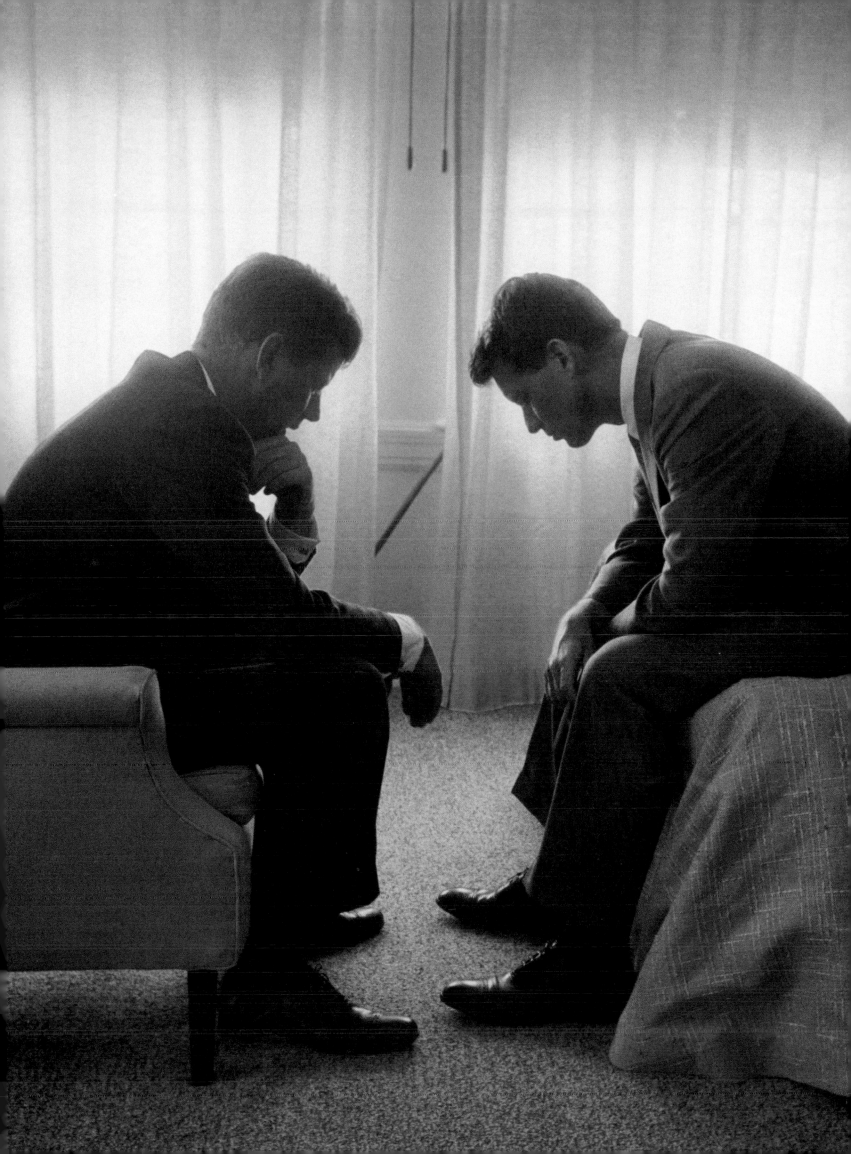

The joy of children. Jackie and John Kennedy with their children, John, Jr., and Caroline, and numerous dogs (above). Since Teddy Roosevelt's presidency at the beginning of the century, no other family had lived in the White House with children. The seemingly idyllic happiness of the Kennedy White House led to it being referred to as "Camelot."

election and changed how the president was portrayed in the media. Nixon-Kennedy was the first televised debate between two candidates before an election. Kennedy emerged victorious from this contest, and with that, the media candidate was born. Young, attractive, rich, enterprising, healthy looking and photogenic, Kennedy was the image of the "American way of life," a lifestyle that average citizens were fascinated with and watched on their TV sets. Thanks to this new appliance, which held a privileged spot in the American home, Kennedy defeated Nixon and gave way to a new communication style in which television would play a fundamental role. In 1961, *Time* featured a cover photograph of John F. Kennedy taking the oath of office as the nation's 35th president. It was the first time the magazine placed a presidential inauguration on its cover.

However, Kennedy had to deal with many truly frenetic episodes during his short time as president, as the ghost of the Cold War played a part in every decision he made and as he handled one incident after another. Barely three months after he took the oath of office, Kennedy made one of his worst political decisions: the failed invasion of Cuba at the Bay of Pigs, which sealed the alliance between Castro and the Kremlin. The plan of sending American-trained forces made up of anti-Castro Cuban exiles originated in the Eisenhower administration. The result: a disastrous defeat, for which Kennedy took full responsibility. That position was well received by the public, which acknowledged the merit of him taking all the blame. On August 13, 1961, the Soviets took yet another step in its clash with the West started to raise the Berlin Wall, which divided Germany in two. The United States initiated a move on the international scene when it sent 3,200 military "advisors" to Vietnam. All of that took place during Kennedy's first year in office.

Such conflicts landed Kennedy a *Time* designation as "Man of the Year" for 1961—*Time* wrote in the story published on the selection:

"... Seldom, perhaps never, has any President had such thorough exposure in so short a time ... But Cuba made the first dent in John Kennedy's self confidence ... Aides in the White House agree that August and September were the most critical months so far in the personal and political life of John Kennedy. The first thing that Kennedy did when he got back to the White House was to call for an estimate of the number of Americans who might die in an atomic war; it was 70 million. Kennedy and those close to him felt that war was a very real possibility. The president became moody, withdrawn, often fell into deep thought in the midst of festive occasions ... 'We do not want to fight,' he told the U.S., 'but we have fought before. We cannot and will not permit the Communists to drive us out of Berlin, whether gradually or by force.' ... It was to demonstrate that determination is the only language that Communism can understand."

The article had plenty of praise for the president, his personality and decisions. However, all that was overshadowed by the illustration published on the cover, which was criticized by Democrats, the president and his sympathizers, who preferred an image of Kennedy smiling—more like the type of image that had been promulgated by the White House.

This cover image created several problems. The first one arose from Kennedy's relationship with the press, and particularly, *Time*, which he considered the most influential magazine, and even occasionally more influential than newspapers. According to correspondent

Hugh Sidey, who covered the electoral campaign for the magazine, the hierarchy at Time Inc. had always fascinated the president. He knew the editors by name. Kennedy claimed he could detect differences in *Time*'s tone from one issue to another, according to who was editing the political stories in New York that week. For this reason, when Kennedy found out that he had been chosen as the 1961 "Man of the Year," he immediately accepted a proposal made by *Time*: to be portrayed on the cover through a different kind of image, and putting protocol aside, to be illustrated by Italian Pietro Annigoni, one of Europe's most prestigious portrait artists.

There was another side to the story. Annigoni, a staunch bohemian, showed up at the White House without a tie and badly dressed, with old, worn-out clothes. The president, who was fastidious about his personal appearance, didn't like the informality of the person who was to draw his image for all the country to see in the most circulated cover of the year. His wife, Jacqueline, had to intervene to convince him to pose for Annigoni.

Under the agreement with *Time*, the artist had access to Kennedy over three days. Instead of posing, the president allowed Annigoni to watch him and sketch him for a few hours every day, while he worked on government business. So Annigoni had the privilege of seeing another side of the president, the side that wasn't shown in the smiling official photos or the friendly televised images. The artist watched him during moments of reflection, decision-making and pondering issues.

Annigoni grasped that his cover image of the president couldn't be cheerful. After seeing the art, Managing Editor Otto Fuerbringer also agreed and did not hesitate to publish the portrait. President Kennedy, sensitive to any type of portrayal of him by the press, reacted furiously to

the image *Time* published. It showed Kennedy with an expression of great concern, serious looking and wearing an untidy tie, as if it had carelessly been placed under his shirt collar. This controversial image went down in history as a symbol of Kennedy's tough times during his presidency and spurred accusations that the magazine had been biased. It was the last time the leader, who was killed on November 22, 1963, in Dallas, was featured on the cover of *Time*.

The Kennedy White House is popularly referred to as "Camelot," which was the court associated with King Arthur. The word has come to more generally mean a period of idyllic happiness. A strong factor in creating that image was the personality of Jacqueline Lee Bouvier, the president's wife. Beautiful, smart, elegant and cultivated, Jackie reinvented the role of the first lady. While she created a new style in which a taste for art and sophistication were masterfully combined with a relaxed and American middle-class ambiance, her husband struggled with Nikita Khrushchev, the USSR leader who challenged him time and again to prove who had greater influence.

During his tenure, Kennedy had two serious clashes with the Soviets that made the international security situation extremely tense. The first was the construction of the Berlin Wall, which became one of the most stark symbols of the Iron Curtain. The wall was erected along ninety-six miles, dividing Germany into a western and an eastern sector. According to the Soviet Union, the wall was an anti-Fascist palisade to prevent Western aggression. Since Soviet military forces greatly surpassed American ones, Kennedy immediately sent Vice President Lyndon Johnson and military adviser Lucius Clay to Germany, along with brigades, which at the time were called "pentatomic" because they were equipped with tactical nuclear weapons. The American president told Khrushchev that any attempt by the Soviet Union to invade or take West Berlin by force would lead to a nuclear war. He preferred that option to having to give up the United States's basic rights in the area: free access to West Berlin, the presence of American troops in the city and the survival of the free economy there.

In its August 31, 1962, edition, *Time* devoted its cover story to the subject, under the heading "Wall of Shame," as a

In front of the wall. The Berlin Wall, the most graphic symbol of the Iron Curtain, was erected in Berlin in August 1961. This picture (below), taken in November 1961, shows a West Berlin couple with their child watching as Soviet guards set up barbed wire on top of the wall erected to keep people from fleeing East Berlin.

Western protest of sorts to mark the first anniversary of the construction of the wall. In the article, *Time* opined:

"Seldom in history have blocks and mortar been so malevolently employed or so richly hated in return ... like Berlin's war-scarred face, like an unhealed wound; its hideousness offends the eye as its inhumanity hurts the heart. For 27 miles it coils through the city, amputating proud squares and busy thoroughfares, marching insolently across graveyards and gardens, dividing family and friends, transforming whole street-fronts into bricked-up blankness."

The article also reported *Time*'s reaction to the construction by the Soviets in June 1962 of a second parallel 100-yard wall in East Berlin to make the escape of eastern dissidents even more difficult. *Time* would later call the area between the two parallel walls "the boulevard of death," after finding out that the Soviets had killed more than 200 people while they attempted to defect to West Berlin.

Kennedy's second clash with the Soviets, which almost unleashed a nuclear war and became known as the Cuban Missile Crisis, kept the world in suspense for thirteen days. It started on Sunday, October 14, 1962, when a U.S. Air Force aircraft, under the aegis of the C.I.A., photographed Soviet ballistic missile launch pads in the area of San Cristobal, seventy-five miles southwest of Havana. Kennedy immediately ordered a maritime blockade of the island. On Monday, October 22, the ships surrounded Cuba with a 500-mile radius to prevent the

arrival of ships. Kennedy also addressed the country and sent an ultimatum to Moscow to withdraw the missiles. Four days later, after frantic negotiations between the Soviet Union and the United States, the threat of a nuclear war dissipated when Khrushchev announced that the USSR was willing to withdraw the missiles with United Nations oversight, as long as Kennedy committed to abandon plans to invade Cuba. Months later, in

1963, Kennedy defended democratic freedom in front of the Berlin Wall—"Ich bin ein Berliner" ("I am a Berliner!") he said—and signed a treaty limiting nuclear testing. Thus, the two superpowers reached an atomic weapons agreement and reestablished the terms of their complicated relationship.

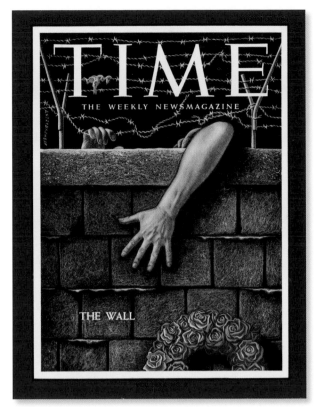

1962. Berlin Wall

Shameful anniversary. This cover image and story, "Wall of Shame," was published on the first anniversary of the construction of the Berlin Wall (above). The cover visually dramatized the sometimes fatal attempts by East Berliners to scale the hated "blocks and mortar." The continued attempts to flee led the Soviets to construct another parallel wall. During his visit to the wall, President Kennedy won the approval of the Germans, declaring, "I am a Berliner!"

Why Kennedy's Death Didn't Make the Cover

On May 6, 1963, the Waldorf Astoria was the scene of a lavish celebration: *Time* magazine's fortieth anniversary. In attendance, were a total of 1,668 people, 284 of whom had been on the cover of *Time*. The event brought together a variety of celebrities, from Italian actress Gina Lollobrigida to Walter Reuther, Casey Stengel, Jonas Salk, Common Market pioneer Jean Monnet, General Douglas MacArthur, Francis Joseph Cardinal Spellman, Pope John XXIII's special envoy, Vice President Lyndon Johnson and theologian Paul Tillich, the keynote speaker. Luce himself offered a toast and actor Bob Hope was emcee.

The only Kennedy to attend was Ted. The president was invited but offered an excuse. The truth was that he had been upset with Luce about certain criticisms published by the magazine. He sent a letter of congratulations, without missing the chance to slip in, albeit sarcastically, his displeasure with some of *Time*'s articles:

"Every great magazine is the lengthened shadow of its editor, and this is particularly the case with *Time* ... *Time*, in its effort to embrace the totality of human experience, has instructed, entertained, confused and infuriated its readers for nearly half a century. Like most Americans, I do not always agree with *Time*, but I nearly always read it."

A mere six months later, a terrible event shook the nation on November 22, 1963: President Kennedy's assassination.

The assassination had a tremendous impact on the whole country. Television, which had carried his smiling and hopeful image hundreds of times, broadcast non-stop the shots fired on the car he rode in, the impact on his head and a blood-smeared Jackie trying to help him. The public was anxious, saddened and dazed.

If one browses through the *Time* collection today and discovers that the event didn't make the cover of the corresponding edition or the following, or the edition after that, one would immediately think it's a mistake, that an issue may be missing, or that all of the copies had sold out and none were left for the archives. But such was not the case. *Time* intentionally did not give the cover to Kennedy's assassination due to a decision made by Editor Otto Fuerbringer.

Since the magazine's founding, *Time*'s protocol was to not publish an image of a dead person on the cover. Although not a formal rule (because undocumented), it was a protocol that had been orally transmitted and that held for many years. Those who objected to the rule when it came time to decide whether Kennedy would occupy the most important spot in the magazine argued that the publication had itself violated the rule several times. They mentioned the May 2, 1932, cover, with Charles Lindbergh, Jr., the son of the noted aviator, who was kidnapped and missing; the May 7, 1945, cover with Adolph Hitler, with his face crossed out as a symbol that his days were over after word of his suicide; and the February 23, 1948, cover, with Karl Marx on the one-hundredth anniversary of the Communist Manifesto, as well as the March 16, 1953, cover with the death of Joseph Stalin.

The evidence did not convince Fuerbringer. He argued that when the Lindbergh baby and Hitler covers came out, their deaths were mere speculation, since they hadn't been confirmed, and that Marx had been dead for a long time and that the cover lacked news timeliness. Instead, Fuerbringer presented several arguments for following through with his idea. First, was his desire to continue to honor *Time*'s protocol. Second, Fuerbringer believed that there would

"Soldier's" salute. Three days after his father's assassination in Dallas, three-year-old John, Jr., who was born when his father was president elect, salutes the passing funeral procession (opposite). In this photo, John, Jr., is accompanied by his sister, Caroline, his mother, Jackie, his grandmother, Rose, and his uncles Edward and Robert.

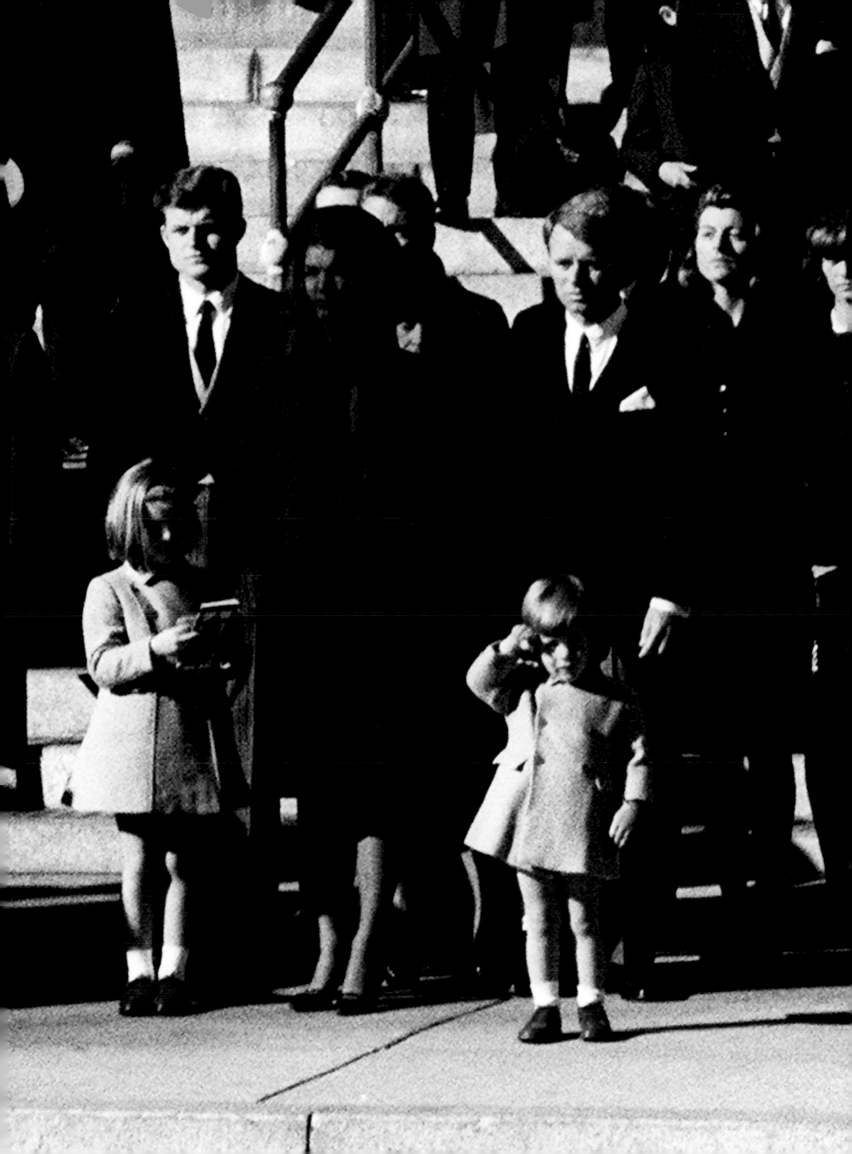

My days at *Time*

Henry Grunwald: "Gentlemen, the President is on His Way Out"

Extracted from One Man's America: A Journalist's Search for the Heart of His Country *by Henry Grunwald, published by Doubleday in 1997*

On November 22, 1963, Henry Luce was presiding over one of his regular lunches with editors of his magazines in a private dining room on the forty-seventh floor of the Time-Life Building. The topic was the U.S. economy, and my mind was wandering when, about halfway through the meal, we were jolted by a ringing telephone in the corner. Otto Fuerbringer went to answer it and came back looking grim and disbelieving "The president," he said, "has been shot."

Luce was literally in midsentence; as usual he was a hard man to interrupt, and he continued saying a few more words on the economy before he ran down. It was impossible for any of us to take in the news immediately. Then there was the desperate hope that the shooting was not fatal. But after a few minutes the headwaiter came in and said in one of those odd phrases that stay forever in the memory: "Gentlemen, the president is on his way out." Kennedy's death was confirmed at 2:00 p.m. EST.

I hastily finished the martini I had been nursing and joined the silent exodus from the dining room. No matter how we felt, we had magazines to put out—and now quite different magazines. Back in my office I found comfort by getting down to work: tearing up the existing layouts of my World section, sending queries to correspondents in the field for foreign reaction. Behind everyone's professional "the show must go on" demeanor, there was real grief...

A poll among *Time* staffers and readers undoubtedly would have chosen John Kennedy as the cover. Surely this was one of those rare occasions when the *Time* tradition of not putting dead people on the cover might be broken. But, unhesitatingly, Fuerbringer ruled that the week's cover would be the next president, Lyndon Johnson, as a symbol of the nation's continuity. To colleagues who pleaded for Kennedy, he said firmly, "The king is dead, long live the king."

Controversial cover. The decision to place the new President Johnson on the cover (below), instead of the assassinated president, fueled arguments among the editorial staff. But Managing Editor Fuerbringer would not budge from his decision to follow *Time*'s protocol of not putting the image of a dead person on the cover.

1963. President Johnson

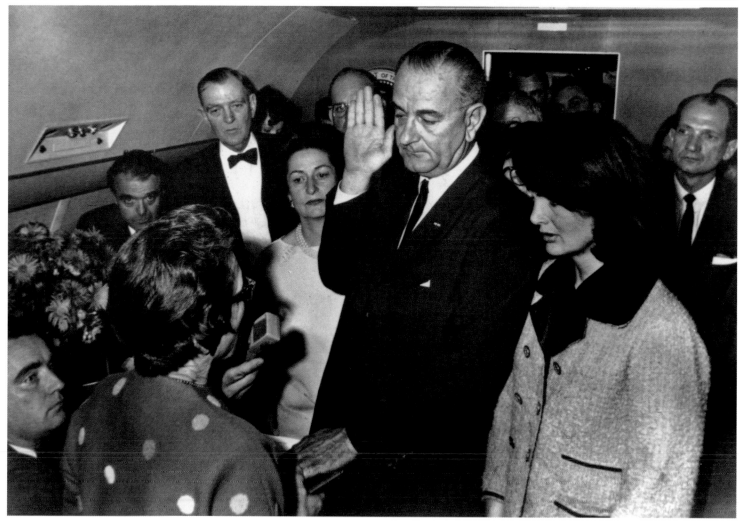

Oath. On board Air Force One at Dallas Love Field Airport, Lyndon B. Johnson was sworn in as the thirty-sixth president of the United States on November 22, 1963. Jacqueline Kennedy, wife of the president assassinated just hours before, bore witness to the pain of the moment and to the necessity of continuing the presidential leadership (above).

be talk of conspiracy and that placing Johnson on the cover would clearly convey the message that the country was committed to the continuity of the presidential leadership. Third, Fuerbringer recalled that in a similar case, the death of President Roosevelt, *Time* published a cover featuring an image of his successor, Harry Truman.

The image of Johnson published in the November 29, 1963, edition wasn't the most appropriate: his face, placed in front of the U.S.seal with the heraldic eagle, showed a certain air of self-sufficiency and satisfaction, while his lips insinuated a smile. The image spurred even more criticism. *Time*'s rule forbidding the photo of a deceased person on the cover seems to

have eroded during the 1960s, when *Time* published post mortem covers of Lenin (April 24, 1964), William Faulkner (July 17, 1964), Lee Harvey Oswald (October 2, 1964), Henry Luce (March 10, 1967) and Robert Kennedy (June 14, 1968).

1963: Martin Luther King, Jr. "Man of the Year"

Starting in its first edition in 1923, in which it made reference to the start of the 25th Negro National Educational Congress, *Time* devoted great effort to examine and report to its readers about the African-American fight for equality. Between 1953 and 1965, *Time* devoted fourteen covers to civil rights issues, including the noted 1954 U.S. Supreme Court decision that unanimously declared school segregation unconstitutional. Martin Luther King, Jr., was featured on three of those covers (February 18, 1957, January 3, 1964 and March 19, 1965). It was not by chance that *Time* assigned the illustration of the last cover to Ben Shahn, a well-known social-realist painter and dissident, who was also the artist for several of the magazine's covers: those of André Malraux, Sigmund Freud, Alec Guinness, Adlai Stevenson and Lenin.

Time reported on the civil rights movement in the United States from various angles, through different personalities and diverse points of view. Among those who expressed their points of view in the magazine were Supreme Court Chief Justice Earl Warren in 1953, noted African-American Judge Thurgood Marshall (1955), Attorney General Herbert Brownell (1957), Arkansas Governor Orval Faubus (1957), Alabama Governor John Patterson (1961) and African-American author James Baldwin (1963). In 1963, the magazine featured George Wallace and praised him for his political performance but criticized him for his segregationist preferences. Also in that year, the publication's cover went to African-American leader Roy Wilkins and "The Negro Revolution to Date," and the following year to African-American jazzman Thelonious Monk; Harlem, the densely populated New York neighborhood; and the great novelist and Nobel Prize laureate in literature William Faulkner, who focused on the American South and its characters in his works.

However, the most significant event of the year in terms of civil rights, which provided the reason for *Time* to designate him the 1963 "Man of the Year," took place on August 28 in Washington, D.C. At the Lincoln Memorial, and before a crowd of 250,000, King delivered a speech that made history with his use of the phrase: "I have a dream." He used the phrase as a tag throughout the speech:

"... I still have a dream. It is a dream deeply rooted in the American dream.

... I have a dream that one day on the red hills of Georgia the sons of former slaves and the sons of former slave owners will be able to sit down together at the table of brotherhood.

I have a dream that one day even the state of Mississippi, a state sweltering with the heat of injustice, sweltering with the heat of oppression, will be transformed into an oasis of freedom and justice.

I have a dream that my four little children will one day live in a nation where they will not be judged by the color of their skin but by the content of their character."

When the magazine chose him as "Man of the Year"—with a cover illustrated by Robert Vickrey—the designation became a double milestone in *Time*'s history. First, King was the first African-American so honored, and second, the cover generated 2,500 letters, more than half of which criticized the magazine's decision, although most of the letters expressed readers' interest in the subject of racial relations.

Born and raised by a minister's family in Atlanta, which was in the vanguard of the African-American protest for equal rights, King had experienced, since childhood, discriminatory practices that were demoralizing. King never forgot the drapes

1961. Martin Luther King Jr.

Distinction. Martin Luther King, Jr., was named "Man of the Year" in 1963 (left). He was the first African-American to receive the honor. That same year, his famous March on Washington drew 250,000 people, and President Lyndon Johnson received him in the White House to discuss civil rights (opposite).

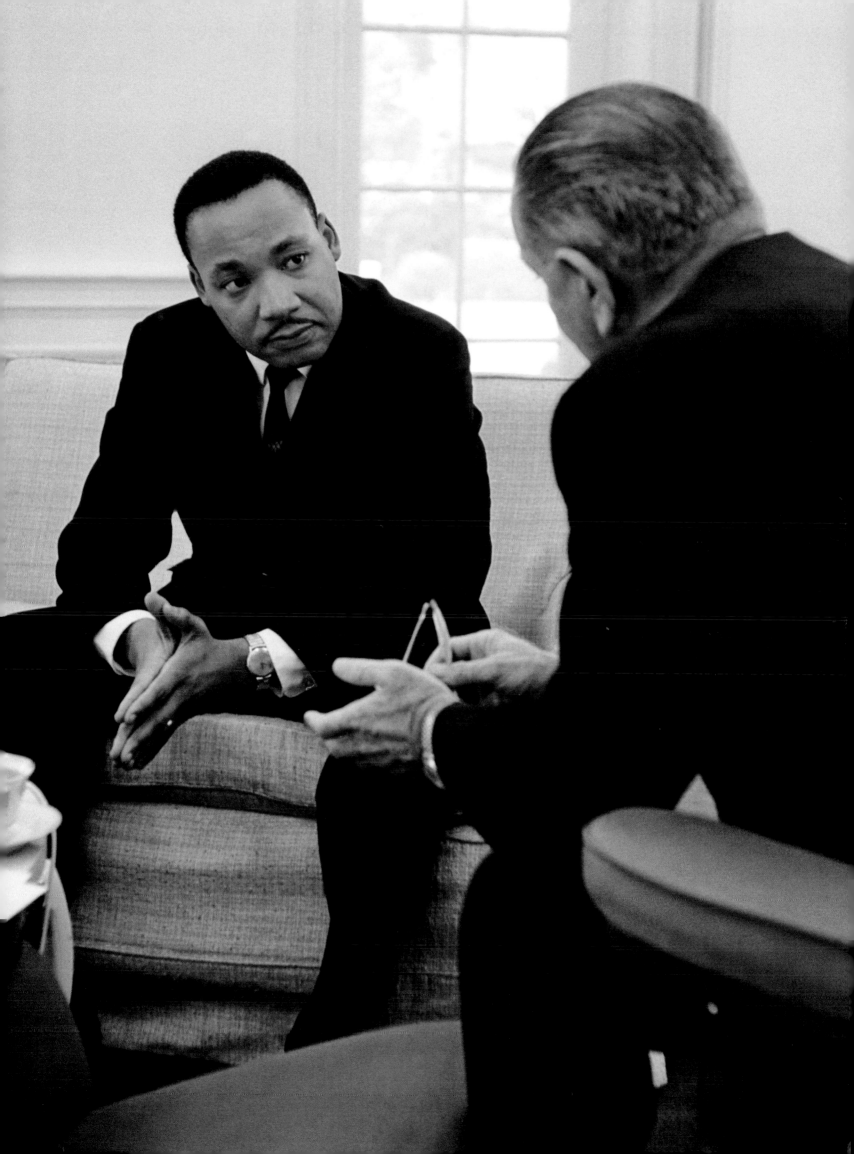

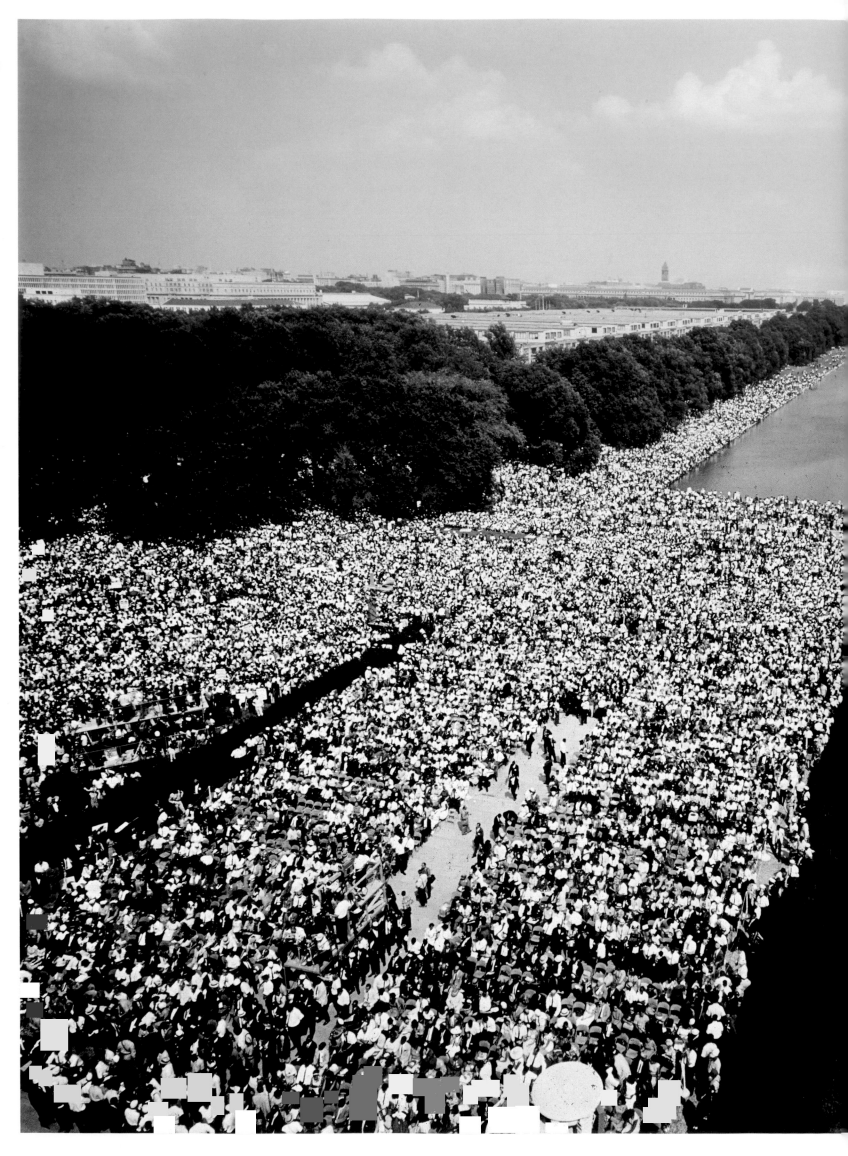

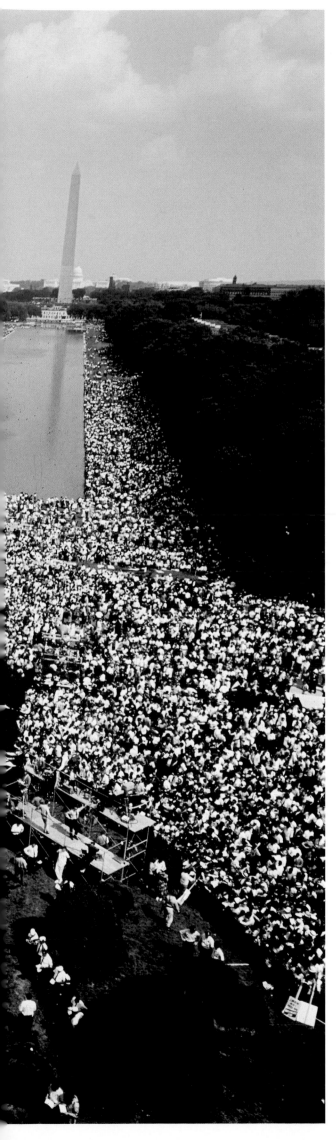

used in the train dining cars to separate whites from African-Americans, or the bus ride between Macon and Atlanta, during which he and his elementary school teacher had to stand up because the driver insulted them into giving their seats to two white passengers. *Time* quoted King as saying, "So we got up and stood in the aisle the whole 90 miles ... It was a night I'll never forget. I don't think I have ever been so deeply angry in my life." Those and other experiences developed in King, what *Time* called a "raw-nerved sensitivity." *Time* also noted that he attempted suicide twice when he was thirteen. The first time was when his brother unwittingly slid down a banister, knocking his grandmother unconscious. King thought she was dead from his brother's blow and jumped from a second-floor window. The second time King threw himself from the same second-floor window after learning of his grandmother's death while he was attending a parade without permission—he was lucky enough to land on a canvas awning that broke his fall and saved his life. It was due to this sensitivity that King, as a young man, decided to study medicine and law instead of theology, like his father and grandfather had. *Time* quoted King as saying, "I revolted against the emotionalism of Negro religion, the shouting and the stamping. I didn't understand it and it embarrassed me."

But in college, after reading Thoreau's essay, "Civil Disobedience," over and over, King concluded that the only possible framework for his ideas about nonviolent antiracial protest was religion. As a student at the Crozer Theological Seminary in Chester, Pennsylvania, the ideas of Hegel and Kant contributed to King's thinking, and after hearing a lecture on Gandhi, King set out to devour all of his books. According to *Time*, King summed up his education: "From my background ... I gained my regulating Christian ideals. From Gandhi I learned my operational technique." King combined these civil disobedience and nonviolence premises and set out, along with his followers, to attack segregationist practices in Birmingham, Alabama, and Selma, Mississippi, and other states with large African-American populations, paving the way for equality, the right to vote and the end of the waves of discriminatory and racist actions against African-Americans. The "King method," as *Time* called his philosophy of nonviolence, proved to have lasting signifigance.

With its "Man of the Year" coverage, *Time* not only paid tribute to King, the man, but also to the civil rights movement in the United States, devoting eighteen pages of the issue to report on the African-American visionary's life and highlight the contributions to American society by celebrities, such as singers Lena Horne and Harry Belafonte, musician Miles Davis, soprano Leontyne Price, athletes Rafer Johnson, Willie Mays and Jim Brown, as well as several unknown and professional African-Americans that, in their own way, made daily contributions to the country and its well being. The article ended with: "After 1963, with the help of Martin Luther King, Jr., the Negro will never again be where or what he was."

Protest and speech. A multitude convened on August 28, 1963, for the March on Washington (left). At the historic march from the Washington Monument to the Lincoln Memorial, Martin Luther King, Jr., delivered his speech, repeating the phrase that would go down in history—"I have a dream."

Luce's Last Days

Curtis Prendergast, in his book, *The World of Time Inc.: The Intimate History of a Changing Enterprise: 1960–1980*, wrote extensively about Henry Luce's last days. He related a conversation from 1963, in which Clare Boothe Luce asked her husband, "People don't celebrate anniversaries except the 25th or 50th—why the 40th, Harry?" Henry Luce is said to have replied: "Because I won't be here for the 50th." Luce's warning came true. He died in Phoenix on February 28, 1967, five weeks after turning sixty-nine and a few days after the forty-fourth anniversary of the magazine he created with Briton Hadden.

There was concern over Luce's health as early as January 1958, two months after his sixtieth birthday. While he was on vacation at his Biltmore Estates home in Phoenix, Arizona, Luce felt strong chest pains. His doctor played it down but ordered him to sleep alone. Weeks earlier, on February 5 at noon, as his wife was taking a bowl of soup to him in bed, Luce's words shook her: "I'm dying." She called the doctor and an ambulance, and Luce was immediately hospitalized and hooked up to an artificial respirator. "Don't pay attention to what I said. This is not IT," Luce told his wife later. And it was not to be then. Luce had had a pulmonary embolism followed by a coronary occlusion, which forced him to take anticoagulants for the rest of his life. But the attack had been relatively mild.

Luce recovered quickly, and by April, he was back at work in New York as the company's editor in chief. Although he began to have hearing problems, he refused to wear hearing aids. He continued to smoke as many cigarettes as he could. When his wife, Clare, or his physician, Dr. Caldwell, criticized him for smoking so much, he usually told them: "My father never drank and never smoked and died of a heart attack the night of Pearl Harbor at age 73. I am

taking off six years for the abuse that I give myself, but I am adding three or four years for what modern science now knows." He also continued drinking moderately, but following doctor's orders, he spent more time in Phoenix, due to its dry and warm climate. However, he exercised more, since his house was next to a golf course, and swam every day in the indoor pool.

When he was in New York, Luce followed his usual six-hour workdays and hosted weekly luncheons with the magazines' top editors. He didn't let up either on his frantic schedule and his devotion to memos, article suggestions, complaints about the magazines comments on the world and Time Inc.'s activities. Since Luce never typed, they were always handwritten in yellow marker and then typed up by his secretary.

In 1964, Luce gave up the editor in chief position and delegated its tasks to Hedley Donovan. But instead of slowing down, Luce kept a full agenda in which he mixed travel, conferences and speeches with routine stops at the Time-Life Building and days of work in Phoenix on his memoirs, the first book he would write in his half century as a journalist. It was, in part, an autobiography about his relationship with people and to historical events and, in part, an attempt, he said, "to trace in broad but hopefully accurate terms, the rise and the uses of power of the United States and ... to assay to what degree and in what ways [it] achieved greatness and in what ways it fell short." By July 1966, Luce had already written twelve of the fifteen chapters in the index of his draft manuscript. The story started when the United States joined World War II, and ended with the Kennedy administration. It was one of the few pieces of journalism he left unfinished.

Luce continued to work actively at the company after retirement. He kept up with the magazines' and the company's book

1967. Twenty-five and Under

Mr. and Mrs. Henry Luce. *Time* started 1967 with a cover devoted to men and women twenty-five and under, designating the generation the 1966 "Man of the Year" (left). Nine weeks after celebrating youth, the cover was devoted to Henry Luce's death. In 1963, Luce celebrated *Time*'s fortieth anniversary with a grand party. When his wife, Clare Boothe Luce (opposite), asked him why not wait until the fiftieth anniversary, his response was, "Because I won't be here for the 50th." *Time* was forty-four when Luce died.

projects, sending memos with suggestions, criticisms and observations. He continued traveling throughout the United States and abroad, always stopping by *Time* bureaus to meet with correspondents and talk about current events and work routines. He continued speaking publicly, at least once a month, addressing professional, academic and church groups, discussing his favorite subjects: the American destiny, man's purpose, rule of law, journalists' responsibilities and one of his great concerns, the interaction between East and West.

In May 1966, an event deeply touched him—the town of Oskaloosa, with 11,053 inhabitants and located in Iowa's corn country, adopted him as a native son. The origin of the designation stemmed from Luce's comment, made several

years earlier at a Time Inc. meeting, in reference to the question frequently asked by Americans, "Where are you from?" Instead of explaining that he was born in China, Luce commented: "I would give anything if I could say simply and casually: Oskaloosa, Iowa," words whose sound he really liked. The comment was later quoted in a *Saturday Evening Post* article on Luce. Soon after, Oskaloosa voted to give Luce the American birthplace he lacked.

Months later, in October 1966, Luce made his last trip overseas, with twenty-six other American corporate executives on a press tour that *Time* organized throughout Europe. Over the course of two weeks, the group went to Vienna, and, crossed the Iron Curtain's barbed wire to Hungary, went on to Budapest and Bucharest, Warsaw, Prague and Belgrade, where they met

with various heads of state. In November, continuing his busy schedule, Luce addressed Syracuse University's School of Journalism on the problems the industry faced in adapting to a time of radical changes. The speech was published in the January 1967 issue of *Fortune* magazine and was often quoted.

In February 1967, the month of his death, Luce was as busy as ever. Early in the month, he gave his last speech to the Student Association at the University of California-Santa Barbara. The subject: the differences between East and West. He then went to Los Angeles and met with the bureau chief, Marshal Berges, to whom he suggested a story about Hawaii's ethnic makeup, a subject, he said, that *Time* had long postponed. Had the residents of the fiftieth state become American, Luce wondered.

Fortieth anniversary. The party was held in the Grand Ballroom of the Waldorf Astoria in New York. The event made history by bringing together important figures from all over the world—many of whom had appeared on *Time*'s covers. This photo (below) shows Italian actress Gina Lollobrigida, who was featured on the August 16, 1954, cover, conversing with *Time*'s co-founder Henry Luce.

What did George Washington or Lyndon Johnson mean to them?

Back in Phoenix, he wrote his last article. It was the introduction to a new project by the Time-Life Books division, a series of books titled *Time Capsules*. Each book would be devoted to a year's worth of news as it was presented in the pages of *Time*. The series began in 1923, and in its introduction, Luce reminisced about the magazine's launch:

"At last, after a year of preparations and frustrations, the first issue of *Time*, dated March 3, 1923, was going to press. Soon after midnight, with Briton Hadden in command, almost the entire editorial staff was transported in three taxis from East 40th Street to the Williams Press at 36th Street and 11th Avenue, New York. There, until dawn, we stood around the 'stones' (tables) of the composing room..."

In mid-February, Luce was in New York for a Time Inc. board meeting and also to participate in the editors' luncheon in which the company hosted Prince Bernhard of Holland. As those in attendance have remembered, Luce acted as he did in the good old times, exuberant, asking questions, criticizing, making suggestions, putting speakers on the spot. He returned to Phoenix, and then accompanied Mrs. Luce to San Francisco where she addressed the Commonwealth Club. Luce had contributed to the speech, adding an optimistic final paragraph. It was his last public appearance.

The Luce's flew back to Phoenix the evening of Friday, February 24. On Sunday morning, Luce requested breakfast in bed. Uncharacteristically, when the cook arrived, he was still in bed and hadn't dressed. Ten minutes later he called her again to take away the untouched tray: "It isn't that the food isn't good. I just don't feel well," he told her. Since he stayed in bed all morning, his wife called the doctor. He had a low-grade temperature and was coughing, but his blood pressure and pulse were normal. On Monday, Mrs. Luce and the doctor insisted on having him hospitalized for tests. That night, when Mrs. Luce called—he had convinced her to go to a dinner party to which they both had been invited—he said he was feeling better, that he would watch *Perry Mason* (his favorite TV show, which they usually watched together) and go to bed. That night, he didn't sleep well. The nurses heard him get up and walk around the room several times. At 3 a.m., he got up and went to the bathroom. "Oh, God," he was heard saying. They were his last few words. His death, due to a coronary occlusion, took place a few minutes later at 3:15.

Briton Hadden died on February 27, 1929, barely six years after the first issue of *Time* was printed. Luce died on February 28, 1967, forty-four years almost to the date that he picked up a printed copy of that first thin issue and leafed through its pages.

The funeral was held at the Madison Avenue Presbyterian Church, where he had worshiped for almost forty-three years. Among those gathered were Governor Nelson Rockefeller and his wife, the Nixons, diplomats, editors, academicians and theologians. Through private closed circuit TV, the overflowing gathering was watched from two locations at the Time-Life Building. The Scottish pastor, the Reverend David Read was in charge of saying goodbye: "... there was no lingering, no slow decay. He went into the world unseen with a promptness—one might almost say a punctuality—that marked his mortal life. *We* were not ready for this departure, but we can believe *he* was." Years earlier, Luce had chosen his burial place. It was land that had once been part of his winter estate at the Mepkin plantation in the oak forest along the Cooper River, north of Charleston, in South Carolina.

In 1923, Hadden and Luce embarked on their adventure with $85,975 in capital. When he died, Luce had 1,012,575 shares, that is, almost fifteen percent of *Time*'s outstanding stock, with a value of just over $109 million and annual dividends of some $2.4 million. He left Mrs. Luce 180,000 shares, worth about $19 million; she also received their Fifth Avenue apartment, their house in Phoenix and a property in Hawaii. An additional 143,000 shares, with a value of $15 million, were placed in a trust for Luce's sons, Henry Luce III, *Time*'s bureau chief in London, and Peter Paul Luce, a New York management consultant. Approximately half of Luce's stock had been set aside in 1961 for the Henry Luce Foundation Inc., created in 1936 to honor Luce's father and devoted to promoting Christian education and the intellectual exchange among Far Eastern countries and the United States. Luce's will also left an additional 149,465 shares to the foundation, which in addition to the 191,029 it already had, turned it into the largest holder of Time Inc. stock, with 12.7 percent of votes. The foundation's president was Henry Luce III and other members were Luce's sister, Elisabeth, and her husband Maurice T. Moore, Peter Paul Luce, Roy Larsen and Charles Stillman.

Time bid him farewell by placing his image, drawn by Robert Vickrey, on the March 10, 1967, cover. The article spread over ten pages and was titled "Henry R. Luce: End of a Pilgrimage." In *Timestyle*, it started out: "'As a journalist,' he once said, 'I am—in command of a small sector in the very front trenches of this battle for freedom.' For Henry Robinson Luce, the battle ended last week. On the 44th anniversary of *Time*'s first issue, America's greatest maker of magazines died in Phoenix of a coronary occlusion. He was 68."

It was the 2,295 issue of *Time*. Luce's last closing.

Walter Isaacson: Henry Luce's Legacy

In this essay, commissioned in 2009 for this book, Walter Isaacson (left), Time's *editor in chief in the 1990s, examines Henry Luce's legacy.*

When Henry Luce founded *Time* magazine with his friend Briton Hadden, he described a paradox: folks were being bombarded with information but were nevertheless woefully underinformed. He set out to create a magazine that would sift through the clutter, synthesize what was important and preach his cheeky prejudices.

Sound familiar? By the time of Luce's death in 1967, television news had been added to the barrage of information hitting us each day, and our world today is far more info-saturated than even Luce could have imagined: cable shows and talk radio, blogs and websites, RSS feeds and Twitter, all brimming with headlines and hype, news and sleaze, smart analysis and kooky opining.

Through it all, however, the basic mission and strategy that Luce developed has endured. *Time* remains a way to help people cope with the clutter and sort out what's important and interesting. Although *Time* gradually moved away from providing a digest of the previous week's news, it still tries to put events into context, anticipate trends, add new insights and facts, tell the behind-the-scene tales and explore the questions others forgot to ask.

It does this not only in print, but now also on the web and in an ever-evolving variety of other electronic forms. I'm absolutely convinced that if Luce were alive today, he would love launching new websites.

One aspect of Luce's original mission has been strengthened. The proliferation of magazines, channels, blogs, websites and services means that much of the media has become narrowly focused on special interests and niches. *Time* continues to hold to the faith that intelligent people are curious about what's new in all sorts of fields, from politics to art, religion to technology. What *Time* tries to do, on its pages and websites and blogs, is what Luce taught us to do: expose you to topics that expand your interests rather than narrow them, and confront you with ideas and opinions that challenge your prejudices rather than merely reinforce them.

Each week *Time* still tries to follow Luce's injunction to bring together a mix of stories that conveys the excitement of our times in all its diversity.

We also offer, or at least try to, a philosophical common ground that has become all the more relevant given the yearning for post-partisanship that President Obama has sought to nurture. His election reflected a desire for a new era in which common sense would play a greater role than knee-jerk ideological faiths. Although our stories often have a strong point of view, we try to make sure they are informed by open-minded reporting rather than partisan biases.

Yes, that represents something of a change from the days when Luce's global agendas infused these pages. The son of a Presbyterian missionary in China, Luce inherited a zeal to spread American values and Christianize the Communist world. He was very up front about his approach.

As *Time* matured, it began to place more emphasis on reporting than on these prejudices. Nevertheless, there are certain prejudices—perhaps it's best to call them values—in the original prospectus that still inform *Time*'s journalism.

The foremost of these is the one Luce listed first: "A belief that the world is round." Luce was allergic to isolationism. In his famous 1941 essay, "The American Century," he urged the nation to engage in a global struggle on behalf of its values.

The challenges of the 21st century require us to uphold Luce's love of both freedom and of international cooperation.

Our challenges are global, ranging from pandemic flu to financial flu, climate change to nuclear proliferation. The digital revolution along with the spread of democracy means that individuals will inevitably have more control of their destinies.

When America has been willing to stand firm for its values, that willingness has proved to be, even more than its military might, the true source of its power in the world. *Time* thus remains rather prejudiced toward the values of free minds, free markets, free speech and a reverence for human dignity. This reflects our faith that people are generally smart and sensible; the more choices and information they have, the better off things will be. To the extent that America remains an avatar of freedom, the Global Century we are now in will turn out also to be, in Luce's terminology, another American Century.

In a world that is not only round but also flat—wired and networked—we remain committed to another prejudice in the original prospectus: "an interest in the new." The digital revolution, in particular, has already begun to change our world like nothing else since the invention of Gutenberg's moveable-type printing press more than half a millenium ago.

Because we believe in the value of information, we have celebrated the explosion of sources that is the hallmark of the digital age. It is not only healthy for the public, it is also healthy for us. In a world of a thousand voices, people will gravitate to those they trust. That encourages us to stick to a formula that is clear yet demanding: good reporting, good writing, authoritative and fair analysis. We wouldn't be in this business if we didn't believe that more information will eventually lead to more truth. That is why we were among the first journalists to go online and on the web, and why we plan to be at the forefront of each new technological opportunity. Luce would have it no other way.

Even as we pioneer these new technologies, *Time* has continued to emphasize narrative storytelling as a way to put events into context. We try to be the storyteller who comes to your front porch with the color and insights that turn facts into coherent narratives. Part of the process is telling the news through the people who make it.

Through narrative and personality, analysis and synthesis, we try to make a complex world more coherent. The ultimate goal is to help make sure that the chaotic tumble of progress does not outpace our moral processing power.

This new era will have challenges that *Time*, as Luce would have us do, will try to wrestle into moral and historical context. Digital technology, for example, had brought not only the excitement of more democratic forms of media but also the specter of invasions of our privacy and the spread of false information and poisonous ideas to every nook of a networked world. The impending biotech age promises not only the ability to engineer an end to diseases but also the weird prospects of cloning our bodies and tinkering with the genes of our children.

Nevertheless, the prejudice that we most firmly share with Luce is a fundamental optimism. For him, optimism—a faith in progress—was not just a creed, it was a tactic for making things better. Reporters must always be questioning, even skeptical. But we must avoid the journalistic cynicism—as a pose, as a sophomoric attitude—that reigns in other parts of the media, including the blogosphere. Intelligent skepticism must be compatible with a basic belief in progress and a faith in humanity's capacity for common sense. The magazine's goal is to be a touchstone for this common sense.

Above all, we continue to share his belief that journalism can be, at its best, a noble endeavor. It can make people think—and make them think differently. It can be empowering and liberating. And, of course, it can be fun and exciting. That's what Luce sought to impart in his new magazine, and what we still seek to impart in our pages, print and electronic, every day.

Cover and farewell. The portrait of Henry Luce, illustrated by Robert Vickrey, ran on *Time*'s cover on March 10, 1967, after his death (below). It was the magazine's tribute to its co-founder. A man of strong principles, Luce passed on a rich journalistic legacy to his successors.

1967. Henry R. Luce

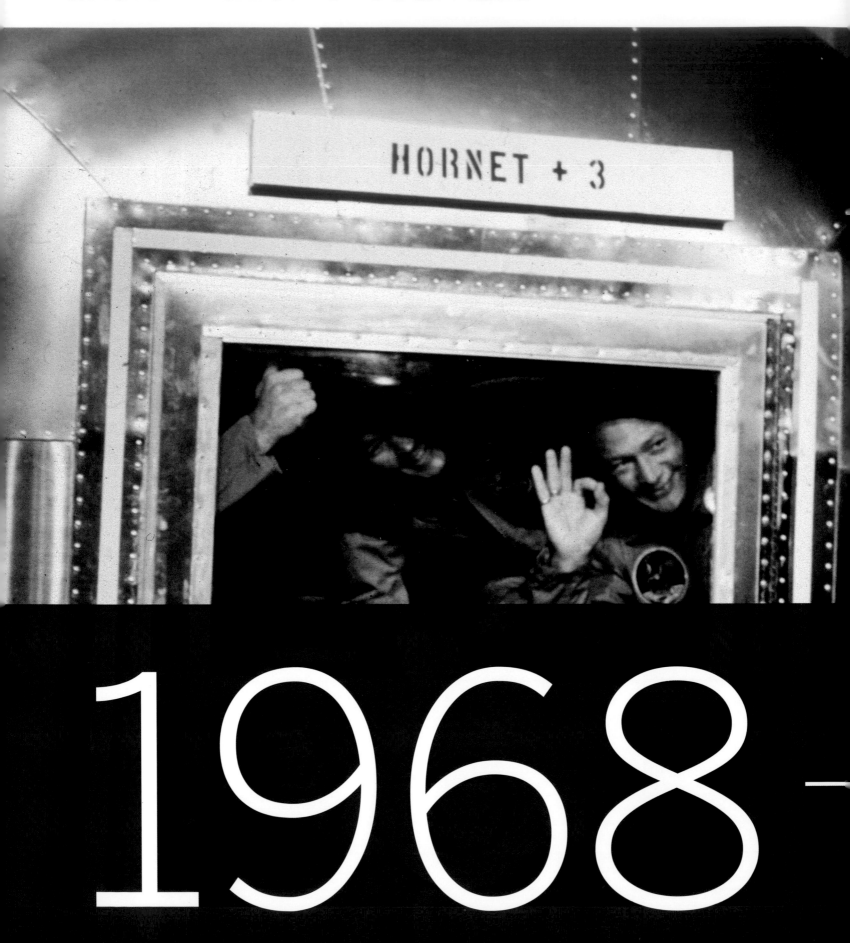

HORNET + 3

1968

1995

5

From Newsmakers to Big Issues

Some sociologists called them the "Swinging Sixties." Diana Vreeland, the tempestuous *Vogue* editor at the time described the era as the "youthquake." The decade of the 1960s ushered in political, social and cultural changes that included excesses, protests, drug use, libertine attitudes and radical changes in beliefs, outlooks and behaviors—all of which left historic marks on society, as well as on journalism. Young people started to rebel against traditional conservative norms and began to move away from and condemn the materialism of most Americans. Protests against military intervention in Vietnam went hand in hand with the birth of the hippie movement, and both trends became part of a general turn toward liberation that included the sexual revolution, the questioning of authority and government, as well as demands for greater freedom of expression and more participation in society by women and other minorities.

Two symbolic events during the decade—the so-called 1967 "Summer of Love" in San Francisco, in which exotically garbed hippies smoked marijuana and touted the slogan "make love, not war," and the 1969 Woodstock Festival in upstate New York.

The year 1968 became emblematic of the most notable manifestations of counterculture, in all its aspects, both bright and dark. Not only did pop artist Andy Warhol shock the world with his unconventional work, created in his Manhattan studio, The Factory, but also with how he merged art and life. The Factory was known for it's permissive atmosphere, but that changed when, on June 3, 1968, Valerie Solanas, a Factory hanger-on, attempted to murder him. Warhol was rushed to the emergency room and miraculously

1969. Vietnam Moratorium

Mission accomplished. In 1969, President Richard Nixon welcomed three astronauts from the *Apollo 11* mission, Neil Armstrong, Michael Collins and Edwin Aldrin, Jr. The feat defined an era, as Armstrong, the first man to walk on the moon, said, "A small step for man, one giant leap for mankind." (Previous spread)

The rebellion of the youth. The October 17, 1969, cover uses the peace symbol to portray the year's single biggest act of protest, the October 15 Vietnam moratorium (left). In the sixties, youth rebelled against America's materialistic lifestyle and conservative traditions, as this demonstration shows (opposite).

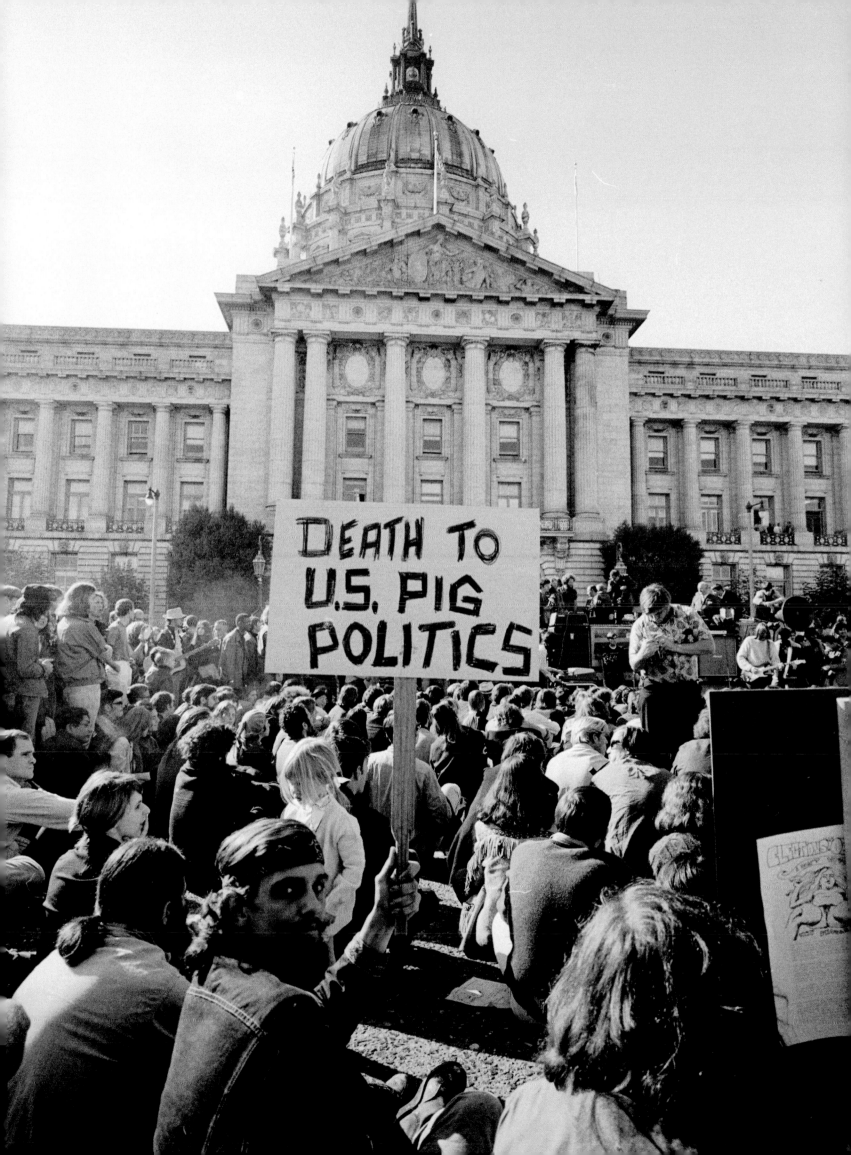

survived the gunshot wound although never fully recovered. In the same period, the psychedelic graphic art of Peter Max was all the rage. His cosmic drawings and posters were described by some as "printed hallucinations."

In the theater world, a history-making play hit Broadway on April 29, 1968—*Hair*, a musical that shocked the public with its nudity, exaltation of drugs and relentless criticism of the American lifestyle. The musical also contributed three songs that came to symbolize the era: *Aquarius/Let the Sunshine In*, *Hair* and *Good Morning Starshine*. In terms of music, the year was particularly prolific. Soul singer Aretha Franklin, Jim Morrison—The Doors leader and lead singer—Jimi Hendrix and Janis Joplin achieved fame. The last three died, basically at the height of their careers, due to drug overdoses: Hendrix and Joplin in 1970 and Morrison in 1971. Also in 1968, the British band Led Zeppelin and the American singer-songwriter Bob Dylan emerged with their innovative acoustics. Later that year, on December 3, Elvis Presley was featured on NBC with a comeback special "Elvis." It was his first live concert in seven years.

In film, youth's rebellion and discontent with the adult world were portrayed in *The Graduate*, in which Dustin Hoffman played a lost college graduate who has an affair with the wife (Anne Bancroft) of one of his father's friends. He also started dating her daughter (Katharine Ross), and snatched her from the altar away from the man chosen by her parents. It was the year's biggest box-office hit followed by *Guess Who's Coming to Dinner?* a 1967 film that addressed the controversial subject of interracial marriage, with a plot in which a young white girl introduces her black fiancée, played by Sidney Poitier, to her parents (Spencer Tracy and Katharine Hepburn).

What historians call the "Counterculture Revolution" took almost twenty years to develop and reach its climax. *Time* was forced to make editorial changes to reflect and accompany the "Revolution." Henry Grunwald wrote in his book, *One Man's America: A Journalist's Search for the Heart of His Country*, that editors had to make a great effort to keep up with the new trends:

"The Time-Life Building sometimes struck me as an embattled tower assaulted by howling winds of disturbing new forces. As journalists—the average age of the editorial staff was probably around forty—we tried manfully, if not desperately, to keep track of what was going on in America, like weathermen dutifully taking notes on a storm in progress."

The noise of that storm's initial thunder shook up *Time* from its inside pages to its cover. Before the "Revolution," personality covers so predominated that covers on subjects, trends and ideas averaged only two or three a year. However, in the late 1960s, editors began to feel that the news and events of the era were more appropriately represented on the cover by subjects, trends and ideas rather than by newsmakers. An average of seven covers per year portrayed subjects other than newsmakers by the end of the 1960s, a figure that increased to an average of nine in the late 1970s.

Some of these cover stories became milestones. "Sex in the U.S: Mores and Morality." The story was published in the January 24, 1964, issue and led to a series of covers addressing the issues of the era. In his letter for that issue, publisher Bernard Auer wrote:

"All *Time* bureaus in the U.S., as well as many part-time correspondents and the Paris and London staffs, were called on to contribute to the story.

They interviewed hundreds of people—sociologists, psychologists, historians, educators, clergymen, judges, law-enforcement officers, physicians, grandparents, parents and teenagers ... The correspondents' reports, plus a wealth of existing research, provided an imposing collection of material for the story. The researcher in charge is a mother, the writer a father, and the editor a grandfather. Their greatest task, they felt, was extracting general conclusions that would be fair to all."

The letter also explained that after an extensive search of contemporary art to illustrate the cover of such a taboo and controversial subject, *Siesta*, a 1962 painting by American realist artist John Koch, was chosen. He had also painted Princess Margaret of Great Britain for a previous *Time* cover on November 7, 1955. Koch was selected, according to the letter, because he "dealt sensitively and often with what he calls the 'man-woman theme.'"

In the May 21, 1965, issue, rock 'n' roll made its debut on the cover. The Shindig Dancers, the Beach Boys, Petula Clark, Trini Lopez, Herman of Herman's Hermits, the Righteous Brothers and the Supremes were featured in a photomontage, designed by Charles P. Jackson, on that cover. The artists had been selected because they all had top-selling records, but the magazine did not have many kind words for the music. The publisher's letter began, "The ears of nearly every *Time* reader everywhere surely have been haunted, horrified or, at least, reached by that pervasive, durable phenomenon known as rock 'n' roll."

Inside, the story mentioned that more than 5,000 discotheques had sprouted up in the United States that year—twenty-one in Manhattan—where young and old, professionals and blue-collar workers pulsed to the beat of the new music. Also dancing

Hair shock. On April 29, 1968, the history-making musical *Hair* made its Broadway debut (opposite). A product of the hippie counterculture and the sexual revolution, the musical especially shocked the public with its display of nudity—in one scene, the entire cast shed their clothes. *Hair* defined the new genre of the "rock musical."

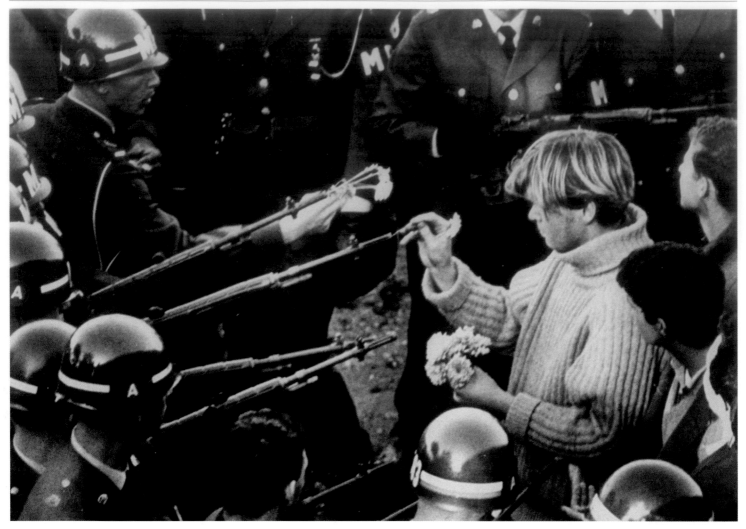

Make love, not war. The famous hippie slogan is exemplified by this image of George Harris, Jr., placing carnations into the rifles of the National Guard during the anti-Vietnam War march on the Pentagon in Washington, D.C., on October 21, 1967 (above).

to it and praising it: celebrities Rudolf Nureyev and Margot Fonteyn, writer Truman Capote, actress Carol Channing and actor Peter Lawford, playwright Tennessee Williams, designer Oleg Cassini and even Jackie Kennedy and composer Leonard Bernstein. To give some recognition to the majority of readers who viewed the new dancing style as disrespectful and incomprehensible, *Time* quoted the great musician Pablo Casals, who defined the new music as "poison put to sound" and Frank

Sinatra, who described it as "rancid-smelling aphrodisiac." At a time when few records of noted rock 'n' roll celebrities sold less than ten million copies, the pacesetters were the Rolling Stones and the Beatles, whose U.S. debut in February 1964 on the *Ed Sullivan Show* attracted an audience of 68 million. *Time* sarcastically quoted the Stones's manager, "The Stones are the group that parents love to hate."

Time's attitude toward the "youthquake" as reflected in the May 21, 1965, rock 'n' roll

cover story, was not well received by some of the more liberal-minded readers, who were open to the new youth phenomena. But no cover story from this era would generate more controversy than the one published on April 8, 1966, under the title "Is God Dead?"

"In *Time*'s forty-three years of publication, no story has been approached with more deliberation than this week's cover treatment of the contemporary concepts of God," began that issue's

The first cover without an image. After months of searching for images suitable to illustrate this controversial subject, Managing Editor Otto Fuerbringer suggested using the three words in red type with a black background for the April 8, 1966, cover (opposite)—it was the first typographic cover in the magazine's history. The subject, however, resulted in subscription cancellations and over 3,500 angry letters.

APRIL 8, 1966

TIME

THE WEEKLY NEWSMAGAZINE

Is God Dead?

VOL. 87 NO. 14

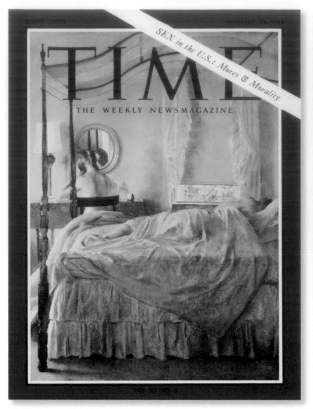

1964. Sex in the U.S.

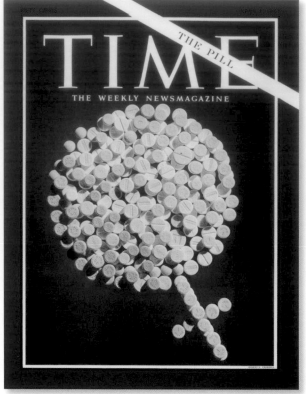

1967. The Pill

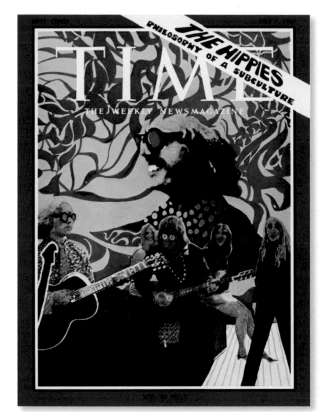

1967. The Hippies

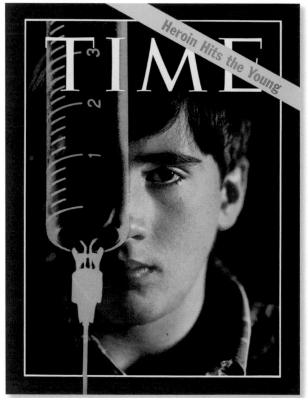

1970. Heroin Hits the Young

Trends on the cover. Since it was difficult to illustrate trends with the image of a single newsmaker, the magazine used generic images for cover stories about them. *Siesta*, a painting by American artist John Koch, was used on the cover for an article on sex in the United States (top, left). A photomontage of contraceptives in the shape of the scientific symbol for female, illustrated the cover on birth control pills (top, right). A group of New York City hippies called Group Image illustrated the psychedelic cover on hippie culture (bottom, left). The "Heroin Hits the Young" cover featured a photograph of a middle-class youth overprinted with an image of a syringe (bottom, right).

publisher's letter—in which Auer also explained that the story had been researched for more than a year. The writer was John T. Elson, author of several stories on religion for the magazine. Given the thorny and difficult task of writing a coherent news report to go along with the cover question, Elson is said to have tackled the job with prayer. "It would have been easier to do in the Middle Ages in a magazine perhaps called Tempus," he said at the time. "Easier because they had a God then that was consistent."

He was assisted by Monica Dowdall, who researched the concepts of God in all religions and philosophies, from Xenophanes on. For the more current portions of the story, Elson and Senior Editor William Forbis compiled more than 300 interviews and comments sent in by *Time* correspondents throughout the world, who spoke with theologians, philosophers, scientists, artists, teachers and students, among others, to showcase notions of God that went from pop atheism to faithful tradition.

In short, the story analyzed the crisis of religious faith, the spread of atheism, including a new form, Christian atheists, "who think it pointless to talk about God," and the effect that doubt could have in stimulating new beliefs. After reading the article, the logical response to the cover question was: "No, not really." But the title's premise made countless readers indignant.

The cover image was also a challenge for *Time* editors, and the solution was a visual milestone for the magazine. After searching for months for a work of art that would convey a contemporary notion of God, the editors concluded that there was no appropriate representation. Managing Editor Otto Fuerbringer suggested placing three words—"Is God Dead?"—in red type over a black background. It was the first cover in the history of *Time* "without an image." As a consequence, the magazine received more than 3,500 letters of complaint on the subject and its treatment, and many readers immediately canceled their subscription. However, the same design would later be used for the cover "Is God Coming Back to Life?" (1969), "The Shape of Peace" (1972) and the "Birthday Issue" (1976), devoted to celebrating the bicentennial of the United States under the heading "The Promised Land."

Following the concept of giving more importance to trends, ideas and phenomena over newsmakers, *Time* chose as the 1966 "Man of the Year" the "Twenty-Five and Under" generation. The cover portrait highlighted some of the many faces that comprised the generation—male and female, Caucasian, African-American, Asian. The cover showed a young white man, clean shaven, who wore a shirt and tie and had well-kept short hair. Behind him was a white girl in profile, with rosy lips and hair neatly-brushed from her face. Behind her, an African-American man and then an Asian one leading a sea of twenty-something. The story enumerated the qualities of the generation and the reasons for their success. *Time* described the twenty-five-and-under generation as being "... the man who will land on the moon, cure cancer and the common cold, lay out blight-proof, smog-free cities, enrich the underdeveloped world and, no doubt, write finis to poverty and war." The article described the generation's self-importance and self-confidence in changing a world that older generations had damaged—their common slogans: "Don't trust anyone over 30" and "Tell it like it is." *Time* added, "No adult can or will tell them what earlier generations were told: this is God, this is Good, this is Art, that is Not Done."

Such issues made *Time* a living magazine that adapted to change and new generations. At least, that is what the magazine sought to do. However, the magazine didn't always accomplish that goal, because, given its style and editorial policy, *Time* lost some of its attempted freshness by treating light subjects, such as pop culture, too seriously and solemnly, almost as if they were transcendental. In addition, opinions were sometimes contorted or exaggerated to the extent that either younger or more traditional readers did not share them—even some editors. Grunwald did not share all of the editor's opinions in the "Twenty-five and Under" article. In his book, he recalled:

"... it took a remarkably innocent view, including some howlers, such as the statement that despite the pill, the mating habits of the young hadn't changed much and that the new no-touch dancing was asexual. The story also gave a rather bizarre description of the American soldier in Vietnam: 'From the moment he arrives (usually aboard a comfortable troop ship), he is swiftly moved into and out of combat in planes, helicopters or trucks. He has a camera, transistor, hot meals and regular mail. If he is hit, he can be hospitalized in 20 minutes; if he gets nervous, there are chaplains and psychiatrists on call. It is little wonder that he fights so well.'"

Barely four months after the story on young people, the magazine made mention of another phenomenon of the decade: the birth control pill.

"'The pill' is a miraculous tablet that contains as little as one thirty-thousandth of an ounce of chemical. It costs 11¢ to manufacture; a month's supply now sells for $2.00 retail ... Yet in a mere six years it has changed and liberated the sex and family life of a large and still growing segment

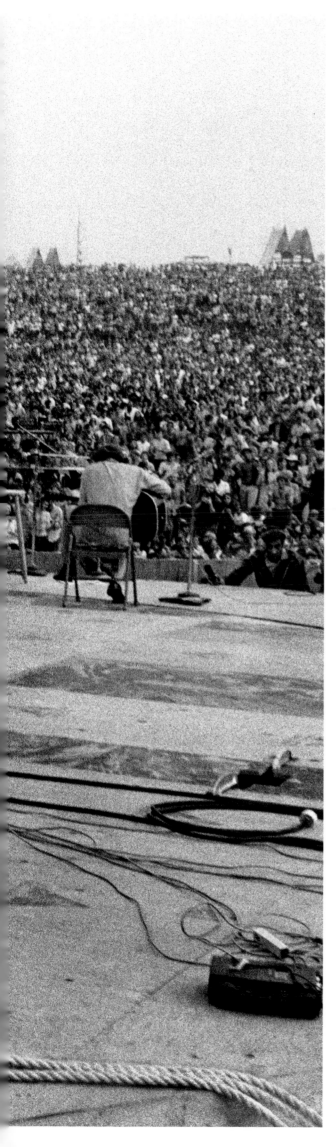

of the U.S. population: eventually, it promises to do the same for much of the world."

The above was the start of the story about The Pill, the April 7, 1967, cover, written by eighteen-year veteran "Medicine" section writer Gilbert Cant, edited by Peter Bird Martin and researched by Jean Bergerud, with the help of many correspondents. Photographer, Robert Crandall created the cover. For the image, he gathered all of the types of birth control pills on the market and arranged them in the shape of the scientific symbol for female. The pills' soothing pastel colors were in perfect accord with the article's title: "Contraception: Freedom from Fear."

To write the story on the hippies and produce its cover image for the July 7, 1967, issue, *Time* broke its traditional writing and reporting routine. Although most staff members considered themselves rather hip—according to publisher James Shepley's editorial letter—writing and reporting on the subject posed several problems. One of them was clothing. To get street interviews, researcher Katie Kelly decided to dress as a hippie, wearing different outfits that included an unwashed raincoat, a red minidress and worn jeans.

The article quoted historian Arnold Toynbee as saying that the hippies were "a red warning light for the American way of life." *Time* reported hippies had a strong touch of idealism: "[It] could be argued that in their independence of material possessions and their emphasis on peacefulness and honesty, hippies lead considerably more virtuous lives than the great majority of their fellow citizens." The article also set out to offer readers a thorough guide on the movement. It included descriptions of hippie philosophy, lingo and drug preferences. The article explained that the name of the phenomenon came from the slang word "hep," meaning, "to be up to date." The article also explained some of the new terms used by the members of the movement in Haight Ashbury, San Francisco's hippie mecca, such as "crash," "crash pad," "rapping" and "spaced out."

The editors turned to hippie artists to create a representation of that subculture, commissioning the work an artist co-op of sorts, called Group Image, which brought together about thirty Manhattan artists who painted, made posters and played music at several New York cafés, in addition to publishing a magazine called *Innerspace*. The result was a very psychedelic image of the hippie culture— longhaired figures with guitars, mirrored glasses and love beads.

Peace, love and music. The three-day Woodstock Festival, which took place from August 15 to August 19, 1969, on a farm in the rural town of Bethel, New York, was attended by nearly half a million people. Janis Joplin, Jimi Hendrix, Richie Havens (left) and Joe Cocker were among the performers.

New Covers
for New Subjects

Little by little, the increase in articles that reflected trends and phenomena also led to a new way of representing such subjects on the cover. While illustrators painted portraits based on photos and sittings for newsmaker covers, "… nonportrait cover images entailed the challenge to put a face to a faceless event, movement or trend," wrote Frederick Voss. At times, the search ended with a historic painting that was touched up to adapt it to the subject of the cover.

But early in 1966, Rosemary Frank, who Fuerbringer had put in charge of *Time*'s cover production process, introduced a new philosophy about the selection process of the magazine's covers. The idea was to try, whenever possible, to find an illustrator that had an emotional, cultural, social or political connection to the subject *Time* would place on its cover. That was the thinking behind the selection of Group Image, a co-op of New York City hippie artists, to render the 1967 cover on hippies, and others that followed.

One of the most noted among the covers was by British artist Gerald Scarfe to illustrate the Beatles, for the September 22, 1967, issue. Rosemary Frank selected Scarfe because: first, the editors wanted to do something very different than what had already been done with the Beatles; second, they wanted a British artist; and third, because Scarfe was considered a fabulous satirical cartoonist, capable of always coming up with something different. Scarfe lived up to the editors' expectations. He took the assignment so seriously that instead of an illustration, he produced a sculptural structure of each Beatle, then clad them in Eastern-style clothing to reflect their interest in that philosophy and finally, photographed the sculptures for the cover. The editor's letter for that issue explained Scarfe's work in detail:

"For *Time*, Scarfe went beyond his usual two-dimensional pen and chose special weapons: papier-mâché, paste, wire, sticks and watercolors. Scarfe started by sketching Ringo at the drummer's London suburban home, raced back to his Thames-side studio to construct a likeness on a wire frame with papier-mâché, made of old newspapers soaked in paste. He followed the same process for all four. The figures are life-sized head-and-torso, with paper-and-glue eyeballs inserted from the rear of the framework, hair made of scissors-fringed strips of the *London Daily Mail*, and a final facial of thin paste and watercolor. Each unclad figure took two days to build. To clothe his paste-paper gallery, Scarfe borrowed from London's elegantly In Savita shop … [where he got its owner's] gold-and-silver threaded theater coat for John's rainment. Ringo wears silk tweed, with a jute-thread-embroidered collar and wooden prayer beads. George sports a peasant-woven, hand-washable cotton from India. Paul's jacket is made of $98-a-yard pure-gold threaded fabric originally woven for the ceremonial robes of Tibet's Dalai Lama, who had to flee his throne before he could take delivery. The background rug, Persian but of Indian design, was borrowed from Liberty's of Regent Street, where it was priced at $2,800. Scarfe, who admires the creativity and force of the Beatles' music and is similarly admired by them, says that he 'was trying to catch them as they are at present. They have moved on since Sgt. Pepper—the drug thing—to the meditation scene.'"

Scarfe was not the only one to produce a sculptural structure to represent the week's image. Venezuelan sculptor Marisol used the same process in 1967 to produce an unique wooden sculpture to portray Hugh Hefner, the founder of *Playboy* magazine.

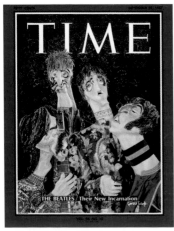

1965. The World According to Peanuts

1967. The Beatles

Drawings and papier-mâché. Charles Schulz drew the characters from his brilliant "Peanuts" comic strip for the April 9, 1965, cover (left, above). Featured on the September 22, 1967, cover, British artist Gerald Scarfe's sculptural portrait of the Beatles—made of wire and papier-mâché—used Eastern garb to symbolize the band's interest in transcendental meditation (left, below). Peter Max depicted Prince Charles as an "Aquarian Prince" in his cosmic cover art published on June 27, 1969, which used the colors, shapes and symbols of the "Age of Aquarius" (opposite).

She created the piece from a hollow wooden box. The red, white and blue colors Marisol used to paint Hefner onto the box suggested he was "the All-American boy." Hefner's head was painted onto a separate block of wood resembling a jet engine. His two pipes, one in his hand and the other in his mouth, were symbolic of the excesses of his playboy lifestyle.

Frederick S. Voss, in *Faces of Time: 75 Years of* Time *Magazine Cover Portraits*, elaborated on *Time*'s new cover philosophy in regard to the 1969 cover of Raquel Welch:

"Since the unabashedly sensual Rita Hayworth cover by George Petty in 1941, *Time* seemed to have consciously shied away from newsmaker likenesses that trafficked heavily in sex appeal. Even Marilyn Monroe's cover image of 1956 had made her out to be little more than an unusually attractive example of the girl next door. The new sexual openness of the late 1960s, however, loosened the constraints on cover sexuality, and in the summer of 1969, when *Time* looked ahead to an upcoming feature story on

Welch, it was assumed from the start that her sexual attraction would be the focus of her cover image. The magazine called upon a master in capturing female physical allure, sculptor Frank Gallo. His Welch produced the desired effect and then some. Certainly there was no confusing this bikini-clad siren with the girl next door."

Gallo used a series of photos to create the epoxy resin sculpture of Raquel Welch. It took Gallo three weeks to complete the cover while he was teaching a workshop in Illinois. Many readers did not approve of the scantily clad, mannequin like image of Raquel on the November 28, 1969, cover. According to Rosemary Frank, in a letter that is now in *Time*'s archives:

"... He [Gallo] finished her, in three-quarter, and brought her East in a seat beside him on a plane. When they got off the hostess informed her passengers that they'd had Raquel Welch aboard that morning. This one brought on an avalanche of mail

and many readers tore off the cover and sent it back. It seemed not enough for them to simply write and say that they didn't approve. It's the only dimensional piece I know of that elicited that kind of physical response. There were those who liked it, also."

The combination of more traditional cover illustrations and nontraditional illustrations allowed for an unprecedented mix of styles and forms to portray the weekly newsmakers, subjects, ideas and trends. More statuelike, superhero-style and hyper-realistic illustrations appeared, alternating with the work of the ABC trio. Eclecticism became the *Time* cover style, and prestigious artists such as Roy Lichtenstein and Peter Max began to contribute covers. These artists created high-level interpretative covers, well remembered for the way they brought together art and journalism to enhance the editorial impact of the story.

Lichtenstein, a pop artist, who was well known for his comic-strip-influenced paintings, reflected Robert Kennedy's

***Playboy* and Raquel Welch.** Venezuelan artist Marisol produced the image on the March 3, 1967, cover (below, left) using a painted wood box to depict Hugh Hefner, founder of *Playboy* magazine. His jet-shaped head and two pipes suggested his playboy lifestyle. Sculptor Frank Gallo, who specialized in capturing feminine beauty, cast sex symbol Raquel Welch as a bikini-clad sculpture for the November 29, 1969, cover (below, right).

1967. Hugh Hefner

1969. Raquel Welch

1965, Today's Teenagers

1970. Jane, Henry and Peter Fonda

1985. Lee Iacocca

1986. John Gotti

Four by Warhol. Above, are four of the five covers pop artist Andy Warhol created for *Time*. The "Today's Teenagers" cover was published in January 29, 1965. Warhol used the pictures the teenagers took at a coin-operated camera booth to produce the screen-printed illustration. In 1970, he portrayed Jane, Henry and Peter Fonda in their most famous roles. In 1985, car impresario Lee Iacocca appeared with his signature glasses and in 1986, Warhol illustrated New York Mafia godfather John Gotti in a dapper double-breasted jacket.

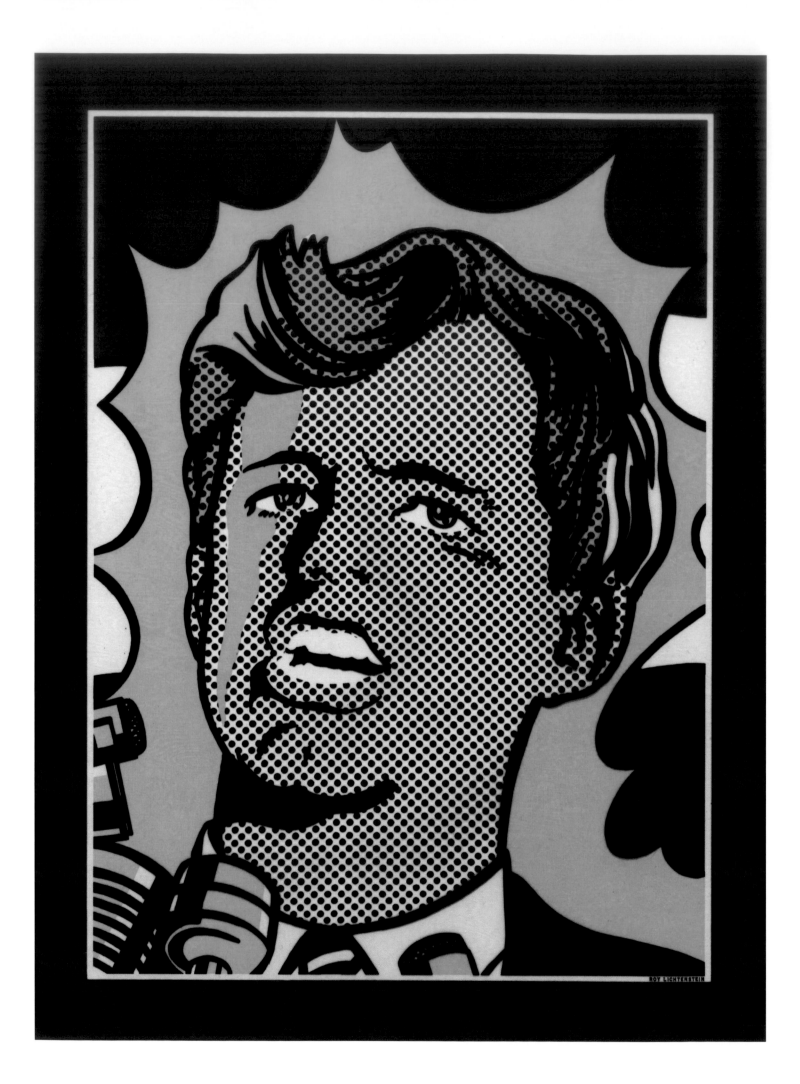

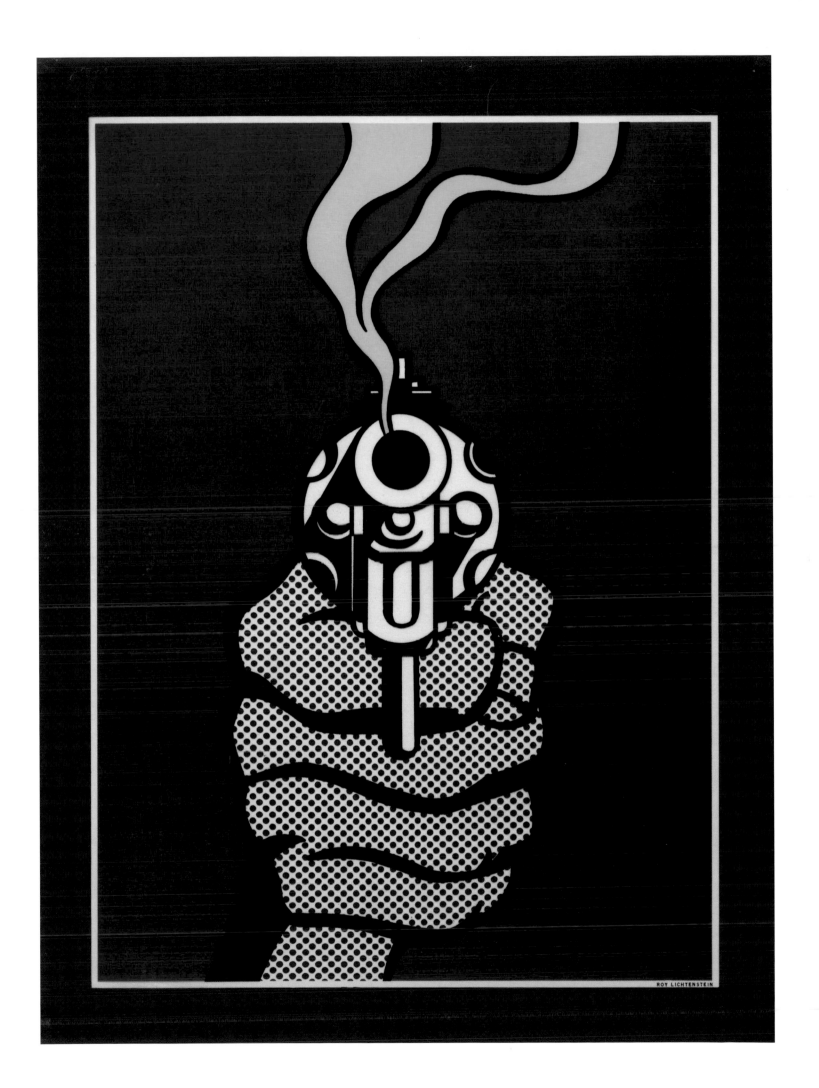

1967. Bonnie and Clyde

1976. The Joy of Art

Rauschenberg's brush. Although, like Warhol and Lichtenstein, he was criticized for turning art into commerce, Robert Rauschenberg was another pop artist who painted memorable covers for the magazine—seven in total. The first of his covers, on December 8, 1967, was a montage of the movie gangsters Bonnie and Clyde (above, left). His self-portrait occupied the cover on November 29, 1976 (above, right).

personality and energy as a politician with a painting of him that looked like a comics superhero. It was published on the May 24, 1968, cover, weeks before his assassination. A year later, for the June 27 issue, Peter Max produced a psychedelic illustration of Prince Charles. Other notable artists who left their mark during this period were: Stanley Glaubach, Andrew and Jamie Wyeth, Brad Holland, Romare Bearden and Alice Neel.

In addition to the innovative art, a design innovation that became popular during the 1960s was the gatefold cover. It was usually reserved for a special occasion, anniversary or presentation. The gatefold cover made its debut in the December 28, 1959, issue. To symbolize the spirit of Christmas, *Time* pictured an eighteenth-century crèche on the cover.

The social, technological and artistic advances of the mid-1950s to the early 1980s were reflected in *Time*'s covers. These covers transcended the week in which they were published and, in time, became true icons of pop culture.

Two by Lichtenstein. Famous for his comic-book-influenced pop art, Roy Lichtenstein depicted Robert Kennedy for the May 24, 1968, cover. Lichtenstein showed the character and energy of the Democratic senator by painting him like a comic-book superhero. Three weeks later, Bobby Kennedy was assassinated, and Lichtenstein painted a smoking gun to illustrate the cover of a story devoted to firearms crimes. It was the only cover the magazine repeated, on July 6, 1998, with the title "The Gun in America 1998." (Previous spread, shown without coverlines)

My days at *Time*
George Church: Ten Cover Story Commandments

Extracted from the internal magazine FYI, June 3, 1994. George Church was one of the most prolific writers of cover stories for Time, *second only to Nancy Gibbs. Although he wrote about a variety of topics during his twenty-five years at* Time, *his specialty was articles on business and the economy.*

1. At some point you have to stop reading and start writing, or else you won't start till Sunday night.

2. Don't get overwhelmed. Look at a cover story as just any other story—except longer.

3. Take a minute before you start to write and think of what your essential theme is. I draw up a short list of the things I have to say, and another of things I'd like to get in if I have room.

4. When you write the lead, make sure it's going to take you somewhere. Even if it's flat and pedestrian, it's better than winding down some side road into fascinating nooks and crannies.

5. If you can't think of a way to start, begin by writing another part of the story. Whatever you do, get your fingers going.

6. I'm much in favor of humor where it's appropriate. The 'sneer at this and then pay attention to it' approach can work. Or offer some assumption and then knock it down.

7. Unlike a newspaper story, the *Time* story is a literary composition that will supposedly be read all the way through. Endings are hard. Just make them work.

8. If it's a matter of ear, I don't argue with editors because that's a personal judgment. But if it's a matter of accuracy—factual or tone—I'll talk it out with them.

9. If a word or a phrase is catchy, but not accurate, take it out.

10. Don't get too opinionated.

Church's creed. Below are two of his cover stories: one on insurance published on March 24, 1986, and the other on November 2, 1987, on the October Wall Street crash.

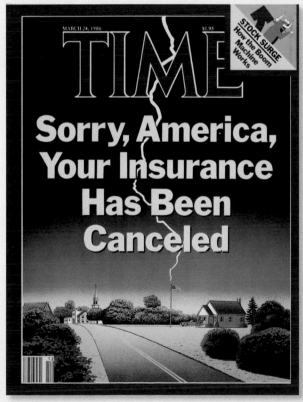

1986. Insurance

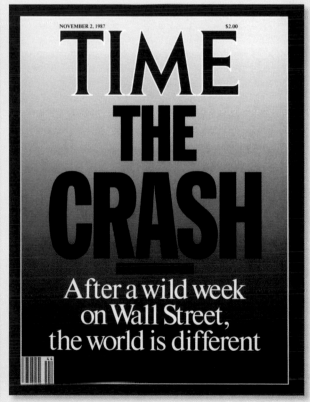

1987. The Stock Market Crash

Times of Great Violence

In April 1968, Martin Luther King, Jr. was in Memphis, rallying in support of a strike by the African-American sanitation workers, when James Earl Ray, a fugitive convict, fired the bullet that killed him, from a motel window across the street from where the civil rights leader was staying. An hour later, while King lay dying in an emergency room at the city's St. Joseph Hospital, the cries of sorrow for the loss of a leader turned to anger, as riots broke out in more than 100 cities throughout the country—it was an almost apocalyptic atmosphere. The flames and waves of acrid smoke from the Washington, D.C., riots first reached the White House, and then the Lincoln Memorial, where five years earlier, King had delivered his resounding speech, "I Have a Dream." More than 25,000 soldiers were sent to Washington D.C., to protect the White House. *Time* observed in its April 12, 1968, issue:

> "Once again a reiterative killing like that of John Kennedy … once again the crackle of gunfire … Once again the blood and the desperate fight to save a failing life, once again the dark assassin whose sole insignificance seemed offensive, once again the funeral in front of the whole nation…"

As with the assassination of John Fitzgerald Kennedy, *Time* didn't display the victim on the cover, according to the company's editorial tradition and Managing Editor Otto Fuerbringer demands. Instead, *Time* placed President Lyndon B. Johnson, illustrated by Italian artist Pietro Annigoni, on the April 12 cover for facing, as the publisher's letter explained, "the challenge and the opportunity to resolve the racial crisis … and at the same time to heal the agony of Vietnam." But under the heading "An Hour of Need," *Time* devoted nine pages to the assassination, four of them

photo displays, which served as a mirror that reflected the legacy of Martin Luther King, Jr. The magazine described his death as "a tragic finale to an American drama fraught with classic hints of inevitability."

Fatefully, one of the first politicians to call the victim's family to express his condolences was Robert Kennedy, who had previously come to King's aid by getting him out of jail in 1960 for leading African-American protests without a permit in Atlanta.

Unfortunately, it turned out to be a foreboding. On June 5, at the Ambassador Hotel in Los Angeles, a young Jordanian immigrant, Sirhan Sirhan, surreptitiously managed to get about six feet from Robert Kennedy and fire two fatal shots with a 22-caliber revolver. One of the bullets went in through Kennedy's right armpit and lodged in his neck, the other hit him in the head, spreading lead and bone fragments throughout his brain. Robert Kennedy underwent surgery for three hours and forty minutes at the hands of the best neurosurgeons available, but within twenty-five hours and twenty-seven minutes, he was dead. The country and world mourned his death, particularly his admirers—African-Americans, young people and the poor—and wondered about the reasons behind the hatred and violence in a country where a weapon could be purchased by mail as easily as fruit juice at the store. Another Kennedy was mourned with sorrow and tears, and 100,000 people, gathered in Washington, D.C., and stood in line for more than seven hours to bid a final farewell to their revered idol.

Three weeks before the episode, a fundamental change had taken place in *Time*'s editorial leadership. After eight years at the helm, Otto Fuerbringer was replaced by Henry Grunwald as the magazine's editor. Grunwald's debut coincided with a cover devoted to Robert

Farewell to Martin Luther King, Jr. He was assassinated in Memphis, Tennessee, April 4, 1968. Five days later in Atlanta, Georgia, the city of his birth, a memorial was held at the Ebenezer Baptist Church. In the photo, Coretta Scott King, wife of the assassinated leader, comforts their five-year-old daughter Bernice (opposite).

Days of violence. Immediately after the assassination, there were riots, looting and vandalism throughout the country. When smoke from the fires reached the White House, the government dispatched more than 25,000 soldiers to Washington, D.C., to protect government buildings. This photo (following spread) shows the National Guard on watch over a Baltimore residential area.

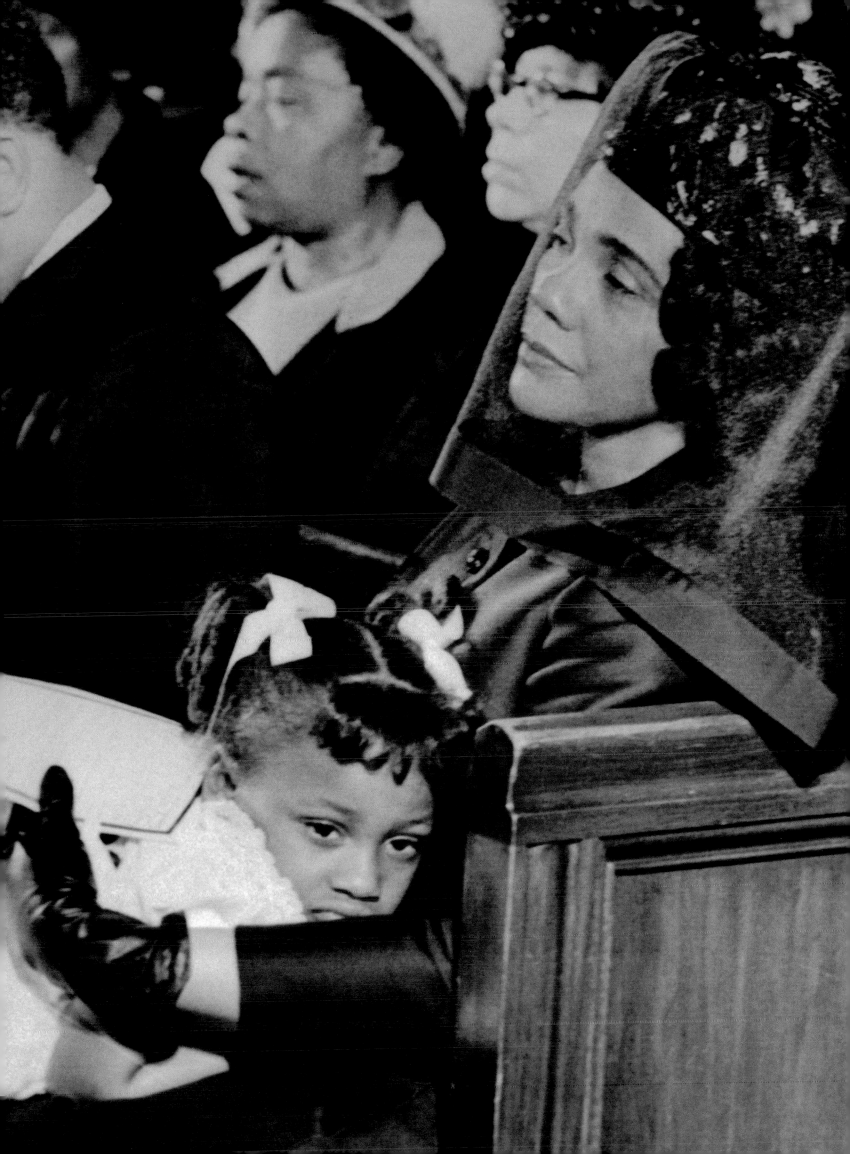

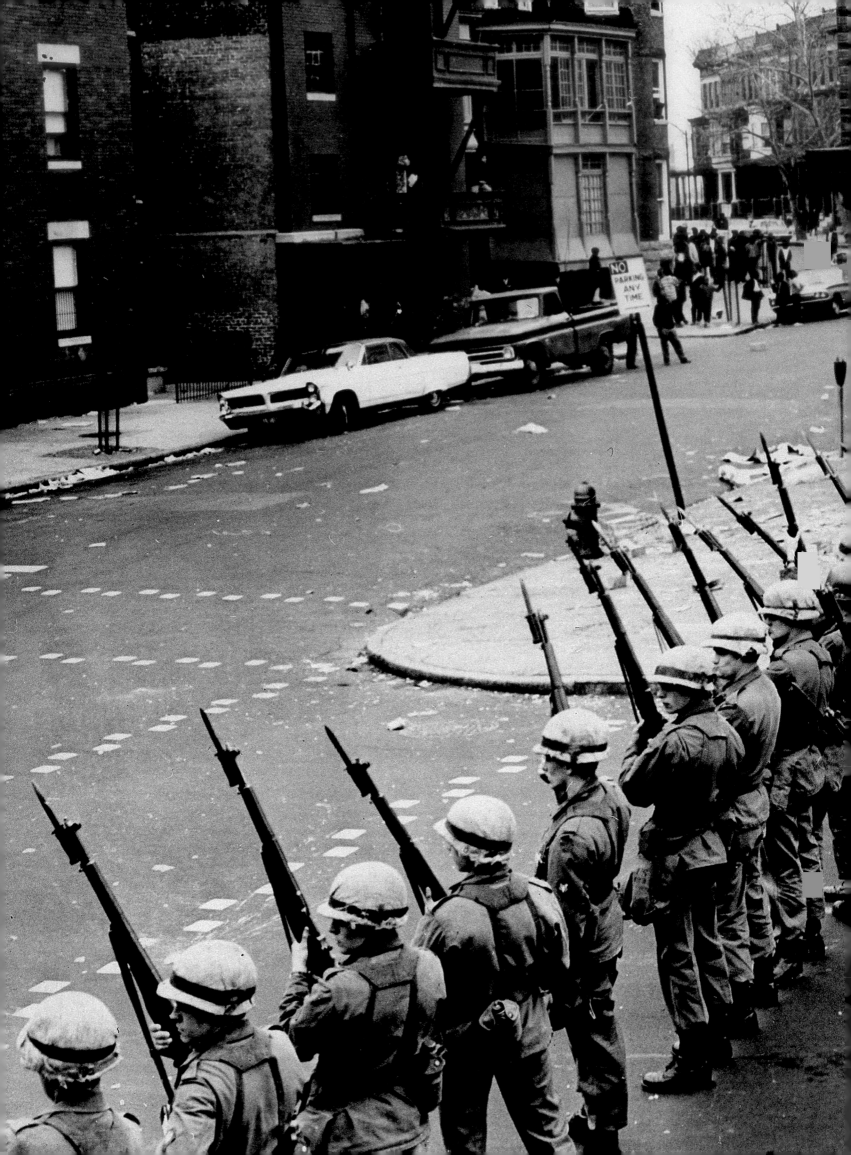

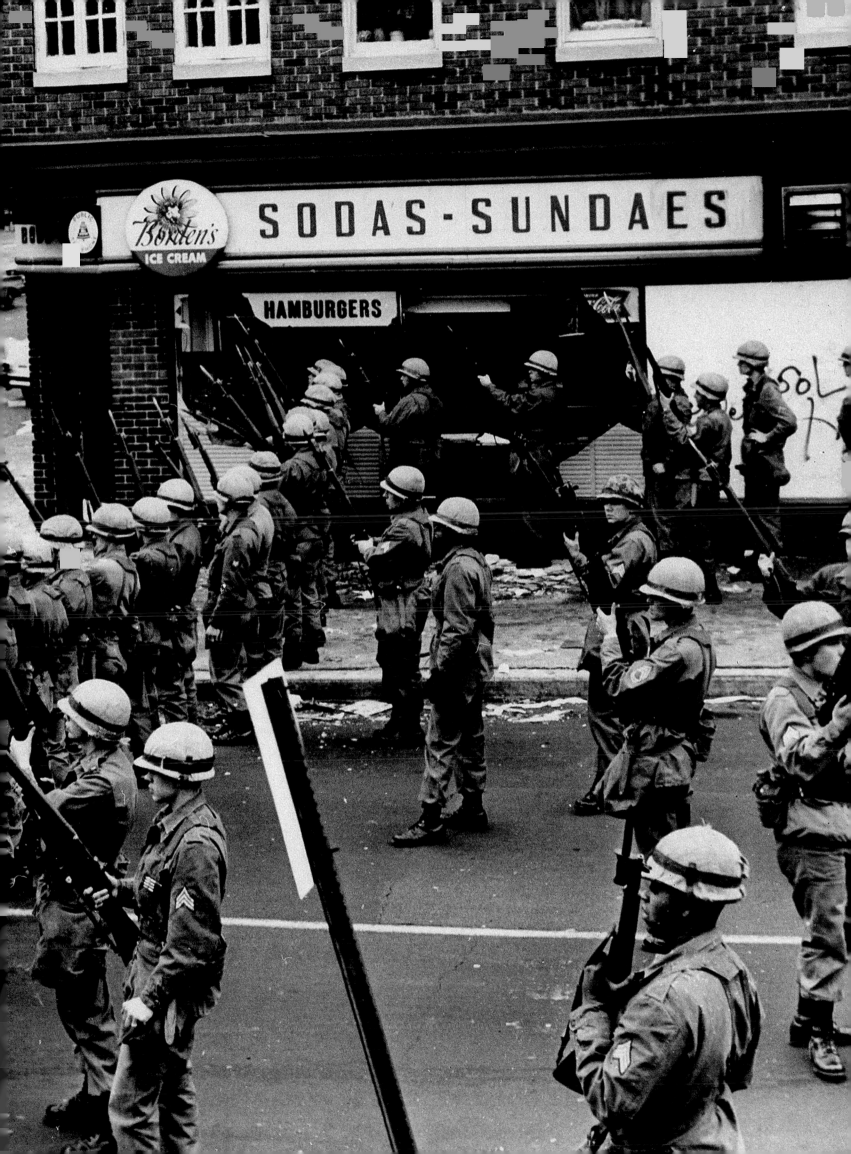

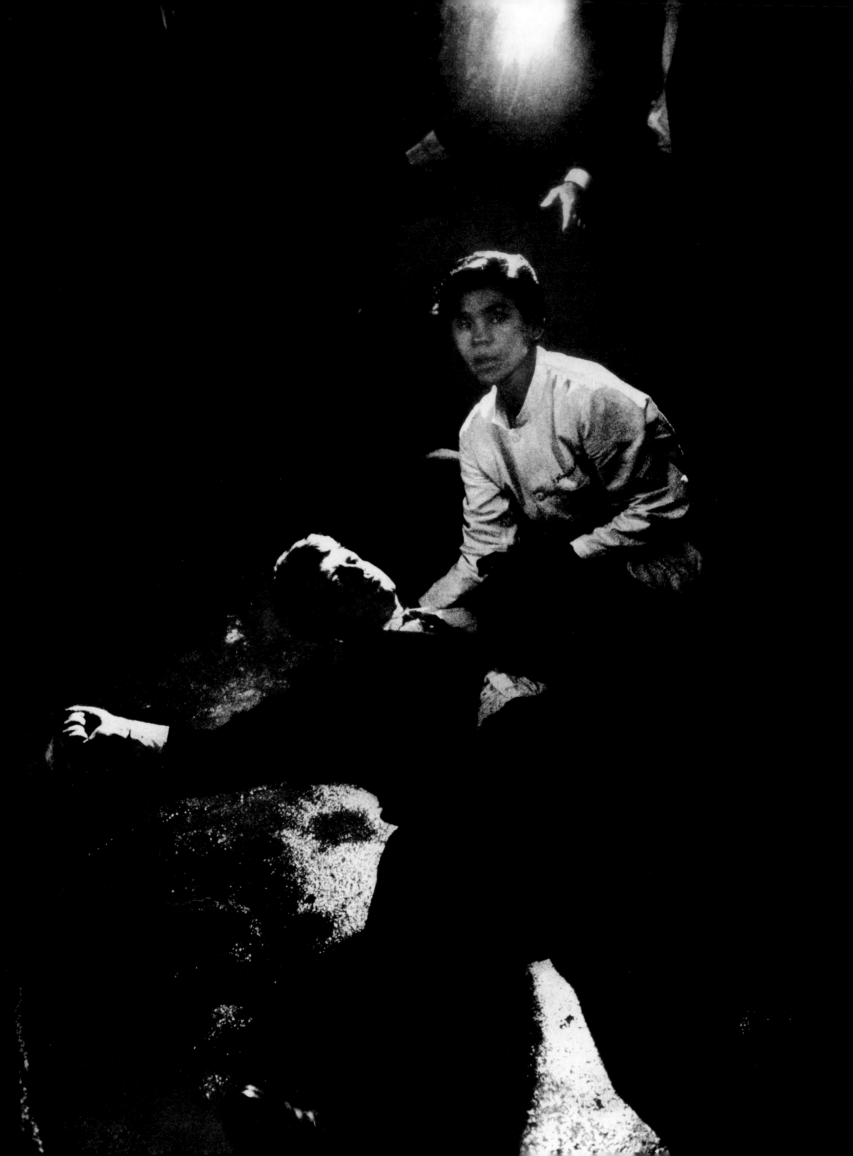

Kennedy, in which Roy Lichtenstein depicted the Democratic leader as a comic book superhero. Now, once again with the assassination of Robert Kennedy, it was time for a crucial decision in the history of the magazine: whether to portray a dead person on the cover. "Without hesitation I ignored the tradition that had kept John Kennedy and Martin Luther King off *Time*'s cover," Henry Grunwald wrote in his memoirs years later. Painting Bobby's cover portrait was a very painful experience for the artist Louis Glanzman, who was forced to finish it within eight hours. "I was glad to have the chance to do it," Glanzman was quoted as saying in the publisher's letter for the issue. "I had to get it out of my system."

Time had already devoted six other covers to Robert Kennedy over a decade. Grunwald attempted to find Sirhan's motive in his roots (he was born in Jerusalem as a Palestinian Christian). Grunwald called the Middle East a place "where political assassinations are commonplace and violence as accepted as the desert wind," and described the assassin as a "virulent Arab nationalist whose hatred stems from the land where he spent the early part of his life" and who looked at Kennedy "as a champion of the despised state of Israel." In the issue immediately after Kennedy's assassination, Grunwald decided to publish an article devoted to the lack of gun control in the United States, under the heading "The Gun in America." In this way, the magazine reflected the complaints and concerns of many who believed the United States had become a bloody place where children played with weapons, housewives kept them in their dressers and citizens, incapable of controlling their

1968. Robert F. Kennedy

Collectible cover. Henry Grunwald, the new managing editor, broke with the tradition of not portraying a dead person on the cover. The June 14, 1968, cover illustration of Robert Kennedy was painted by Louis Glanzman (above). The issue quickly sold out, but to satisfy readers' requests, *Time* republished millions of copies of the picture of "Bobby," with its $1.00 fee donated to the charities he sponsored.

anger, could kill their victims, because weapons were within everyone's reach. And so, *Time* tackled the issue, exploring both its causes and effects. In the comics-influenced style of his previous superhero-esque portrait of Robert Kennedy, Roy Lichtenstein created the powerful cover illustration—a smoking gun seemingly pointing at readers between the eyes.

At the end of the story, *Time* proposed rebuilding the country, claiming that King and Kennedy had died preaching the same message and demanding that grief over both be accompanied by a desire for reconciliation.

For that reason, after receiving hundreds of thousands of letters requesting the latest cover on Robert Kennedy, *Time* decided to reprint millions of copies, which it sold for one dollar each, rather than the usual per-issue price of fifty cents. All funds raised were donated to the same charities that Kennedy had supported.

Another tragedy. On June 14, 1968, five days after the assassination of Robert Kennedy in the Ambassador Hotel in Washington, D.C. (opposite), *Time* wrote, "The circumstances were cruel enough: son of a house already in tragedy's grip, father of ten with the eleventh expected, symbol of the youth and toughness, the wealth and idealism of the nation he sought to lead—this protean figure cut down by a small gun in a small cause. Crueler still, perhaps, was the absence of real surprise."

The Formula is Bent, But Not Broken

The decision to replace Fuerbringer with Grunwald had been made several months ahead. In January, during a private dinner at the Time-Life Building dining room, Hedley Donovan, the editor in chief, informed Grunwald of the news with these words:

> "I wanted to talk about the future of *Time*. I have felt for quite a while that along about now we should move Otto and persuade him to pursue newspaper acquisitions—although he is not eager to do that. I would like you to be the next managing editor ... I hope you will accept."

Grunwald was forty-five at the time, and he had been at the magazine since age twenty-two, when he had joined the ranks as a copy boy. Even though he had been assistant managing editor since 1966, he never thought the managing editor title was within his reach. He knew that Fuerbringer had recommended as his successor James Keogh, who was as conservative as he was and also had the position of assistant managing editor. But what also raised Grunwald's doubt about his ascent were comments by his wife, Beverly. During family chats, she maintained that it was very unlikely that an Austrian Jew with a European cultural background would be put in charge of the company's lead publication. That is why, as Grunwald mentioned in his memoirs, as soon as he received the offer that night, he informed his wife before anyone else. He remembered it this way:

> "Hedley then excused himself to go to the bathroom, and I rushed to the telephone—once again—to give Beverly the news. Later he said that he thought the usual term for a *Time* managing editor should be the equivalent of two presidential terms, give or take a year.

At the end of that period, he observed, I would still be a relatively young man and there would be any number of interesting things for me to do—writing a column, perhaps—but he could not hold out any particular position that might follow. It was his way of saying that I should not count on eventually succeeding him as editor in chief. Later in the evening Beverly, the kids and I celebrated with champagne. The bottle was flat, and I hoped this would not be an omen."

Sometime later Grunwald remembered the unusual year in which he became *Time*'s editor—the same month as the student protests that were known as "May 1968" threatened Charles de Gaulle's government in France and unleashed waves of complaints from the young and the left throughout the world.

> "I felt ready for the task. But I am not sure that I was ready for history. In January 1968 came the Tet offensive in Vietnam. In March Lyndon Johnson announced that he would not seek reelection. In April Martin Luther King, Jr. was assassinated. In June, Robert Kennedy. In August the Russians invaded Czechoslovakia. Also in August the Democrats held their chaotic convention in Chicago. All in all it was a tragic year, but it was also, in cold-blooded hindsight, a perfect year to become the editor of a newsmagazine."

When Grunwald took over, he was well aware of the impact of those important events and the coverage challenge they represented. He also knew that journalism had changed and that the *Time* formula needed to be updated. At a staff dinner to honor and bid farewell to Otto Fuerbringer, Grunwald noted:

1968. Russian Invasion of Czechoslovakia

Invasion. Henry Grunwald began his nine-year reign as managing editor of the magazine in 1968, a turbulent year in international politics. On August 30, *Time* devoted its cover to the Warsaw Pact invasion of Czechoslovakia, whose leaders had started to challenge Soviet policies (left). In an effort to end the civil unrest, 200,000 Soviet-led soldiers and 2,000 tanks invaded Czechoslovakia (opposite).

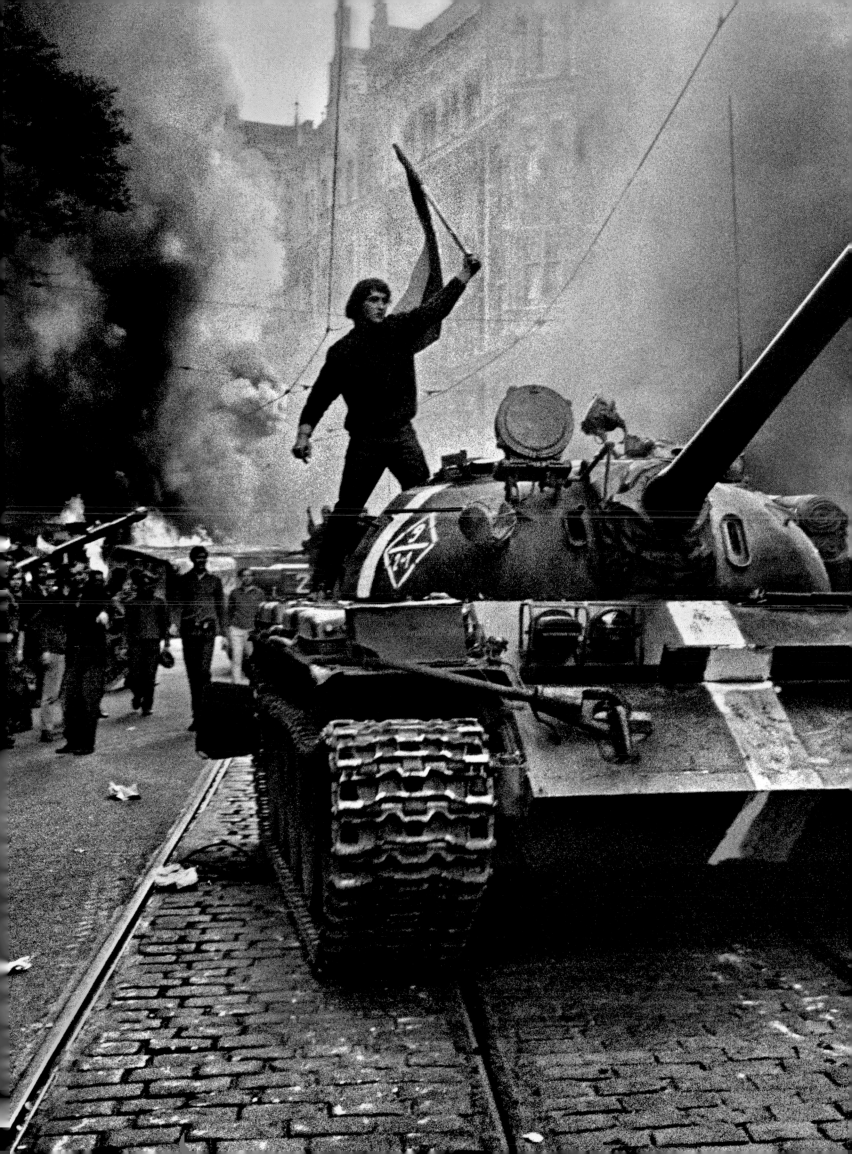

"I sometimes have an almost palpable sense of the world refusing to fit into our departments and sections ... of events trying to burst out of our neat organization, to burst out of the orderly measure of our columns. What is to be done about that? My notion is to let it happen ... Let people and events and ideas struggle and push into new forms and new shapes in our pages, both physically and intellectually."

During Grunwald's leadership, the *Time* formula was significantly changed, in Grunwald's words, "We have had to revise the definition of what makes a newsmagazine." During the nine years he was at the helm, a little more than the two presidential terms, as Donovan had anticipated, he devoted himself to reconfiguring the magazine to come up with a new product that better fit the times.

As soon as he took over as editor, Grunwald set up a work meeting in Bermuda with the magazine's writers and reporters: "I did not take the senior editors along because I wanted the writers to be able to speak—and rant—freely without the inhibiting presence of the 'colonels.'" Grunwald's purpose was to listen to their complaints, and at the same time, to introduce his own proposals for change and the new editorial approach he wanted for the publication. Grunwald's speech outlined his ideas:

"We must not break the formula, but bend the formula ... [T]he magazine must become more intelligent and, although I hate to use the word, more intellectual. By that I simply mean that we can make greater demands on the reader ... greater demands on ourselves. [We] must really avoid oversimplifying complicated situations. We should never shy away from history, philosophy, or

theory; at present we do shy away from these things quite a bit ... And above all, we must do much more to develop expertise in many fields ... This is ... particularly true and urgent in the front-of-the-book sections, which I think are often quite shallow."

Grunwald prefaced his speech with these words:

"TV has completely changed the conditions in which you sit down at a typewriter. There used to be a notion that people didn't really know about an event until they read about it in *Time*. I'm not sure that this was ever right, ever justified, but it certainly isn't now ... [t]he kind of *Time* item that says little more than a radio or TV news bulletin ... that merely pieces together a mosaic, no matter how orderly or attractive, of already reasonably familiar facts is no longer justified ... [w]here we must truly succeed is in what we add to the familiar event."

On that basis, he proposed turning *Time* into a "more intelligent, more intellectual" magazine. *Time* had to place itself behind the scenes and go deeper than the nightly news. TV emphasized "appearance." *Time*, on the other hand, had to become strong regarding "the facts." What Grunwald set forth with this new editorial perspective was a battle between the "images" on TV versus the "substance" that should characterize the magazine. If it was going to take longer articles to win that battle, then the magazine's set structure ought to be changed to give the articles more space. Rather than breaking the formula, it should be bent.

The editorial format changes proposed by Grunwald started immediately. A month into the job, in an item on the reopening

of the historic Belmont Park racetrack, he ran a poem on the scene there. And early in 1969, another oddity: the first fiction story in the "World" section. The story was titled "The Easter Procession," an account of religious persecution in the Soviet Union, written by Alexander Solzhenitsyn. The *Time* item helped the author become famous in the West before his novel *The Gulag Archipelago* was published in 1974. With the introduction of a new section, "Behavior," in January 1969, the number of end-of-the-book sections increased. "Behavior" dealt with all matters related to human behavior, and placed emphasis on psychological issues, in which the public was more and more interested.

"Behavior" was one of six sections introduced to *Time*'s table of contents during Grunwald's tenure. The others were: "Dance," which ran in April 1969 and was published whenever warranted; "Environment," in August 1969; "Economy," derived from the "Business" section, in September 1971; "Sexes," which *Time* introduced as "the oldest topic in the world and in some respects the newest," in January 1973; and "Energy," in November of the same year with the first oil crisis. Also, the "Show Business" and "Nation" sections were redesigned. In 1969, a new journalism option that is now a media staple was first used in *Time*: the public opinion poll. That same year, *Time* started using an innovation for publishing companies: it created the magazine's board of economists, a group of experts that met quarterly and gave editors insight into issues that were becoming more relevant to readers, such as inflation and unemployment. The board was made up of eight top-notch experts, many of whom became presidential advisors on the subject, and one of their roles was to keep editors ahead of the economic issues of interest. The early members included a young man named Alan Greenspan.

Antiwar Fonda. *Time* had proposed "To Heal a Nation" (on its January 24, 1969, cover), but by the early 1970s, the country was divided between those who supported and those who were against the Vietnam War. The protests intensified. Actress Jane Fonda led many of the protests (opposite). After her broadcast from North Vietnam, she was dubbed "Hanoi Jane." Many Americans boycotted Fonda's movies and demanded she be severely punished—she even received death threats.

Special issues

When Nixon became the country's President in 1969, one of the most noted changes in the history of *Time* took place: the arrival of a special supplement that treated a single subject more in depth than even the cover story. Under the heading "To Heal a Nation," this first installment spread over twenty pages in the magazine and included an analysis of the issues dividing the American people at the start of the Nixon administration: student protests, the Vietnam War, urban problems, as well as those related to law and order. Robert Crandall created the cover, a photomontage that combined in a circle the issues the thirty-seventh president would face, overlapped with a depiction of the brand new Nixon-approved medallion, which artist Ralph Menconi sculpted.

From then on, more special stories bypassed what up until then had been strict rules on section and column order. This made the magazine livelier and, every once in a while, surprised readers with a less rigid offering. Another special section was published in July, "To the Moon," with fourteen inside pages and a cover done by Dennis Wheeler, who envisioned the moon as a target to which a space capsule, the dart, metaphorically headed. In December, fifteen pages were devoted to the issue titled "From the 60's to the 70's: Dissent and Discovery," which was meant to "appraise the character of one decade as it sought clues to the next."

In April 1970, *Time* took yet another step and dedicated practically its entire issue to a single subject: "Black America." The editor's letter said that the racial problem "has become so crucial to American survival that it demands unusual efforts of analysis and understanding."

The advent of bylines

Time writing style had always been based on teamwork, and so all those involved joined efforts with a single goal: achieving a good written product, that is, an excellent news article. This work style, known as group journalism, had intrinsic pros and cons, as well as defenders and detractors.

That was the problem faced by Grunwald, who set out to find a solution. First, he started with the correspondents' issue. In December 1968, two months after the Bermuda gathering, Grunwald met with *Time*'s overseas reporters in Paris. There he granted the request the reporters had longed awaited: from then on, the stories written with information provided from their bureaus would be sent back to them for comments and corrections, with their facts unaltered. Although open to arguments from the reporter, the writer and editor in New York would ultimately determine the story's point of view.

The issue of writers and their anonymity had also been raised and debated for many years. Writers complained that when their stories went into the newsroom's hierarchical pyramid, senior editors habitually mutilated their stories. Paul O'Neil, a legendary writer at the magazine, even wrote that senior editors:

"... are just riding around on the writer's back, shooting at parakeets, waving

Length and depth. Grunwald perceived that *Time* should face the competition from TV with deeper and more intelligent stories. He adapted the structure of the magazine to publish longer articles to give them more "substance and meaning." Two examples of the new editorial concept were the coverage in the October 31, 1969, issue dedicated to "The Homosexual in America" (below, left) and the April 6, 1970, issue which contained a special section on "Black America 1970" (below, right).

1969. The Homosexual

1970. Jessie Jackson

to their friends and plucking fruit from overhanging branches while (the writer) churns unsteadily through the swamps of fact and rumor with his big, dirty feet sinking into the knee at every step."

Grunwald, aware of how upset the writers were over this matter, decided to resolve it quickly. In July 1970, the first bylines were published in "Essay" as well as the critique sections in the back of the magazine. But the first portion of the magazine went without bylines until 1980.

Design changes

Grunwald also quickly moved to change the magazine's visual appearance, making greater use of color, publishing more photos and refreshing the type, both inside and on the cover. The goal was to find a new look for an editorial proposition in which articles took up more space because of their in-depth content. To update the magazine's image, Grunwald had the backing and drive of Time, Inc. Editor in Chief Hedley Donovan, who was constantly concerned about the look of the publication.

The most significant design change during Grunwald's era occurred in the January 3, 1972, issue, when Art Director Louis Glessmann introduced his new magazine prototype. During the two years he worked on the prototype, Glessmann tested twenty-five variations of the existing logo and thirty-three typefaces for the interior. The goal, Glessmann said, was

"to keep the basic look and feel of *Time* (so that we can keep our readers) but at the same time to add an orderliness and a little more legibility to the mix … We are an information vehicle, and we must use our space with words and pictures to give our readers as much as possible."

Glessmann, who came from *Parents* magazine, focused his modifications on type more than any other feature. His changes—which at one point he described as a redesign, but in hindsight were not of the extent to be considered such—began with the word "Time" on the cover. The magazine's characteristic red border was slightly reduced to emphasize the cover illustration. Reflecting the longer stories and the larger images inside, *Time*'s heading type also became more intense. Space between columns was also altered, becoming wider, while section names were placed in white type over a red or gray background, in horizontal strips across the different areas.

Donavan thought that these changes were too conservative for the era and felt that a more radical and impactful magazine redesign would soon be necessary. However, it would take five more years for that change to occur.

Trends, news and newsmakers. To carry out its new editorial policy, *Time* offered more in-depth coverage of news stories and newsmakers. *Time* also more closely followed and examined the country's social issues and movements. The caption "everything you always wanted to know about" on the Woody Allen cover of July 3, 1972, and the August 21, 1972, cover on the sexual activities and attitudes of the American teenager are noteworthy examples (bottom, left and right).

1972. Woody Allen

1972. Sex and the Teenager

The Moon in *Time*

From the Earth to the Moon, one of Jules Verne's classic science fiction novels, published in 1865, ended up being a description that was very close to the real space missions that would take place in the twentieth century. The space projectile envisioned by the great writer was shot from a giant cannon in Florida, reached a speed of almost 25,000 miles per hour and turned burning red when, propelled by rockets, it went beyond the atmosphere and then around the moon.

Verne's prediction stopped being fiction in July 1969, when man first landed on the moon, an event to which *Time* devoted multiple covers. The first one was December 6, 1968, with the heading "Race for the Moon." A tempera painting by artist Robert Grossman showed two astronauts, a Soviet one and an American one, competing to be the first to reach the coveted goal. The cover story's title was "Poised for the Leap" and, throughout five pages, it showed how Americans were preparing their astronauts and equipment for the great historic adventure, despite acknowledging that the race against the Soviets would be difficult because of Russia's great power advantage with booster rockets.

> "In September 1959, only two years after they successfully orbited Sputnik 1, the Soviets hit the moon with Luna 2. That was 2 ½ years before the U.S. matched the feat with Ranger 4. One month after Luna's 2's flight, Luna 3 passed around the moon to shoot the first pictures of the hidden lunar backside. Not until more than six years later did Lunar Orbiter 1 televise similar shots to the U.S."

Russia also had an advantage with piloted flights. Yuri Gagarin had orbited the Earth in *Vostok 1* for more than a month before President John Kennedy predicted in 1961 that the United States would be the first to land on the moon before the decade's end, and ten months before the U.S. sent John Glenn into orbit in *Mercury 6*. Also, Russian cosmonauts were obviously leading the race by setting other space records: first woman in orbit, the first two- and three-person crew and the first space walk.

Time acknowledged that America was in second place with the Russians in the space race, but it reflected hope in the country's technology to be able to compete and eventually win it. In its May 12, 1961, issue, featuring astronaut Alan Shepard, Jr., on the cover, the text emphatically showed that American pride and hope were still untouchable:

> "For an endless, heart-stopping moment, the tall, slim rocket hung motionless—incredibly balanced above its incandescent tail. Slowly it climbed the sky, outracing the racket of its engine as it screamed toward space. In the returning silence, the amplified thump of an electronic timer beat like a pulse across the sands of Florida's Cape Canaveral. The pulse of the nation beat with it ... Riding that long white missile as it soared aloft last week was Navy Commander Alan B. Shepard Jr., first U.S. astronaut ever fired into space. And riding with him was his country's pride, the prestige of his country's science, the promise of his country's future on the expanding frontiers of the universe..."

Throughout the 1960s, with a revitalized space program, astronauts broke the record in orbital endurance. Followed by the successful *Ranger*, *Lunar Orbiter* and *Surveyor* unmanned missions not only landed on the moon, but also transmitted

1969. Neil Armstrong

Epic space voyage. "Man on the Moon" was the title of the cover of the July 25, 1969, issue in which the magazine depicted the great achievement of man reaching Earth's satellite (left). Moments after landing on the moon's surface in the lunar module *Apollo 11*, Neil Armstrong (opposite) pronounced the eagerly awaited words, "The Eagle has landed"—a metaphorical play on words, conflating the emblem of the United States with the name of the lunar module.

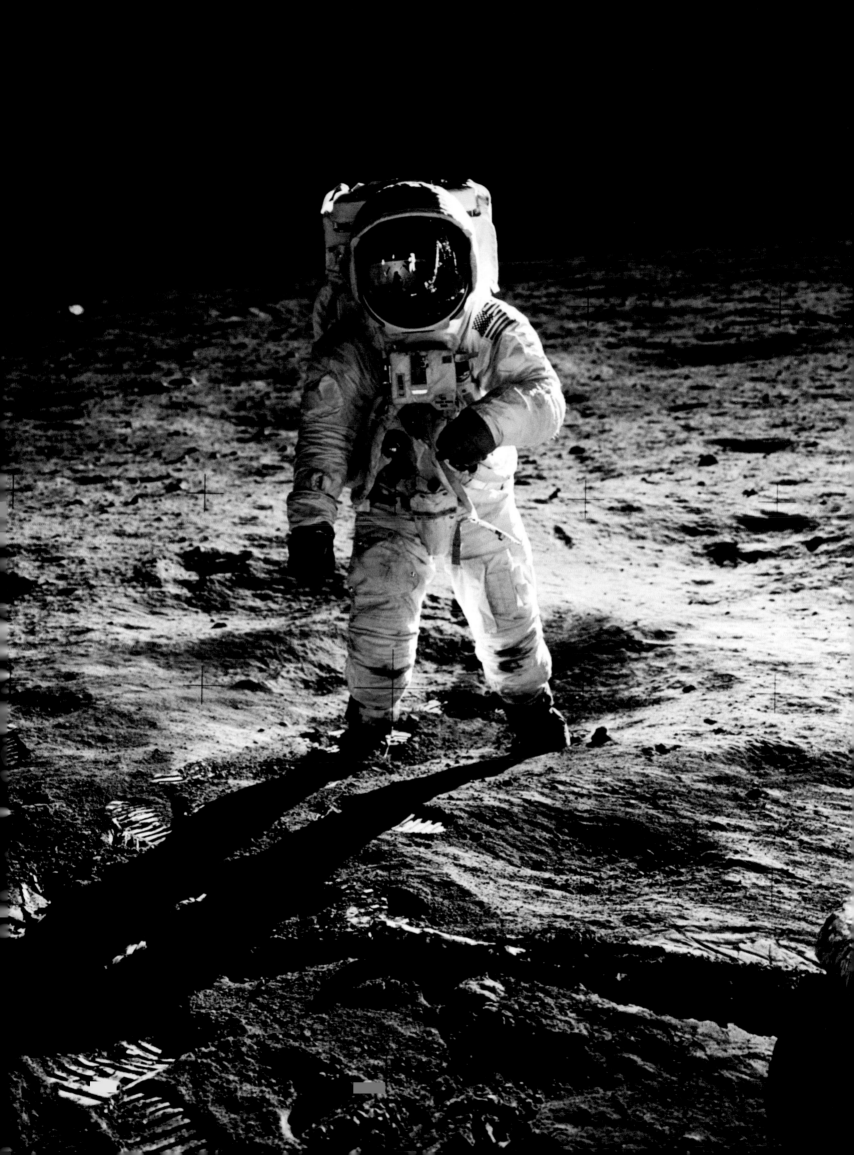

historic images of its surface. Also, the creation of the gigantic *Saturn 5* rocket in 1967, two-and-one-half times more powerful than the Russian *Proton*, was the most convincing piece of evidence that the American's odds for success were almost unsurpassable.

Defying warnings by British astronomer Sir Bernard Lovell, who held that a piloted mission had more to lose than to gain than an unmanned mission, the United States decided to cast doubt aside and not look back. The *Time* article summed it up: "It all comes down to this: man long ago picked the moon as a goal, and there is no turning back."

The twenty-page special supplement, "To the Moon," was used as an advance of sorts on the *Apollo 11* mission the following week. In the publisher's letter, *Time* compared this mission to several other historic journeys (real and fictional), including Christopher Columbus's arrival in the New World:

"The vehicles that will take Astronauts Neil Armstrong, Edwin Aldrin and Michael Collins on their epic journey have been aptly named. The lunar module that will land on the moon's surface has been christened Eagle because, Armstrong said, it is 'representative of the flight and the nation's hope.' The command module that will carry the astronauts back to earth has been dubbed Columbia, a close approximation of Columbiad, the name that Jules Verne gave to his lunar craft in his 1865 novel ... Prophetically, Verne launched Columbiad from a site in Florida and brought it down in the Pacific ocean, where it was picked up by a U.S. naval vessel."

In the meantime, the Soviets, who hoped to show the world that socialism was a better launch platform than

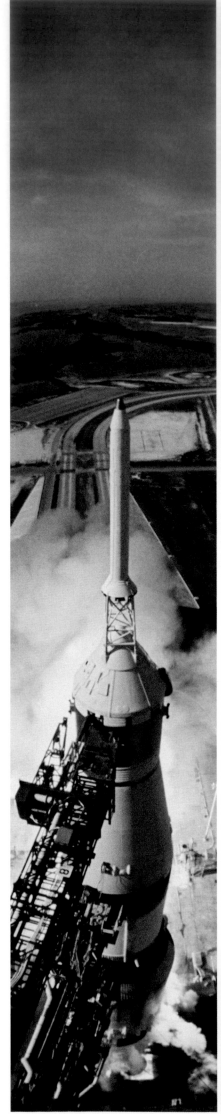
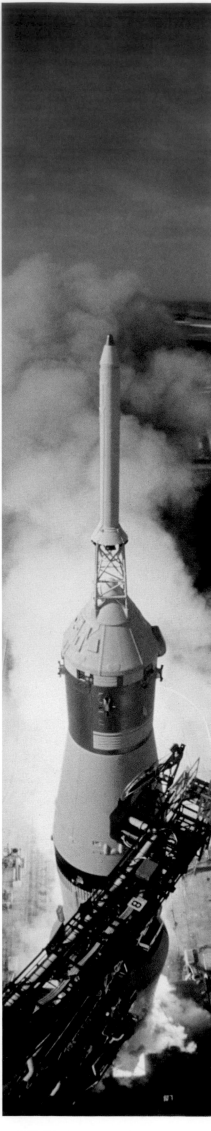

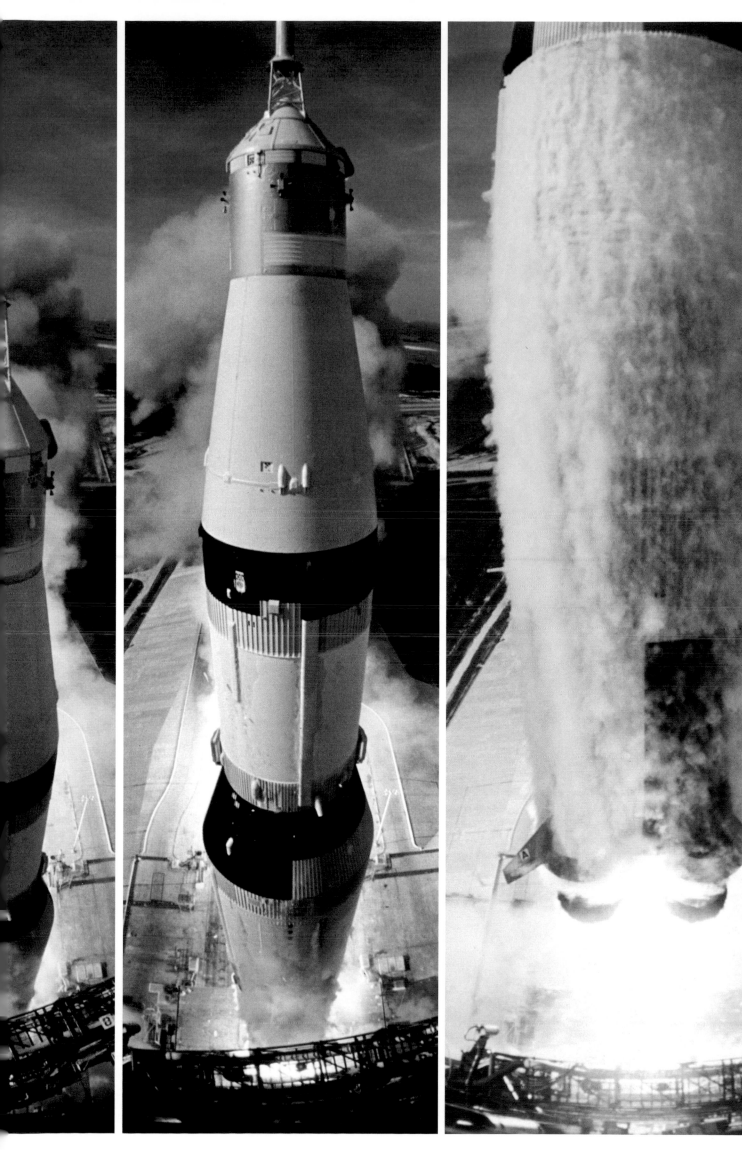

capitalism, seemed to have conceded the victory in the space race to the U.S., particularly after astronaut Frank Borman was applauded after his successful mission in *Apollo 8*. In the eyes of *Time*, the victory didn't justify disregarding or failing to recognize other accomplishments. And so, a long sidebar, "The Pioneers," was devoted to Konstantin Tsiolkovsky, the Russian who had been the first to work in space rocket dynamics, to Hermann Oberth, the German who made the dream of space travel a reality with his creations, and to Robert Hutchings Goddard, the American who implemented the first liquid fuel to propel rockets in 1926, later patenting 214 devices and parts, many of which were essential to the operation of modern space engines. The supplement ended with a page devoted to a human-interest and professional portrait of the three American astronauts in the mission, and a special one-page column authored by British science fiction writer Arthur C. Clarke, who penned the famous best seller *2001: A Space Odyssey*. Under the head "Beyond the Moon: No End," Clarke wrote that the moon was barely the first milestone in the long road toward the stars:

"... in the long run, those who go out to the stars will leave behind the barriers of nation and race that divide them now. There is a hopeful symbolism in the fact that flags will not wave in a vacuum; our present tribal conflicts cannot be sustained in the hostile environment of space ... The Frontier, which only a generation ago seemed lost forever, is open again. And this time it will never close."

On July 25, 1969, the story of man's first moon landing, in which four of the fourteen pages were photo spreads,

was published. Associate Editor Leon Jaroff, Senior Editor Ronald Kriss and the other reporters, correspondents and researchers were forced to work around the clock for two consecutive weeks to write and edit the issue covering the historic feat. Although *Time* usually went to press on Saturday night, that week it was forced to keep some pages open until Monday to cover the climax of man's first landing on the moon. In the meantime, in Houston, *Time* set up a mini office in a motel across the street from the Manned Space Center, where a team of telex operators took turns sending to New York the flood of information from throughout the country, particularly from Cape Kennedy. Louis Glanzman's cover, his thirtieth cover portrait for *Time*, showed astronaut Neil Armstrong taking his first step on the moon. The inside heading, "A Giant Leap for Mankind," was the second part of Armstrong's historic utterance, said when he set foot on the moon: "A small step for man, a giant leap for mankind." The phrase symbolized the incredible scientific and intellectual achievement. In the article, *Time* wrote:

"After centuries of dreams and prophecies the moment had come. Man had broken his terrestrial shackles for the first time and set foot on another world ... The spectacular view might well help him place his problems, as well as his world, in a new perspective."

After planting the American flag on the moon and taking their legendary walk, which technology allowed the whole world to witness live via television, the astronauts received a call from President Nixon, who told them: "This certainly has to be the most historic phone call ever made ... All the people on this earth are truly one in their pride of what you have

done, and one in their prayers that you will return safely."

Before embarking on their return to Earth, the astronauts left behind a one-and-one-half-inch silicone disk etched with messages in miniscule script from Presidents Eisenhower, Kennedy, Johnson and Nixon, as well as from the leaders of seventy-two nations and a missive from Pope Paul VI, quoting a hymn from the Eighth Psalm. One of the lunar module landing legs, which would also remain there, had a plaque signed by the three astronauts that read, "We came in peace." Other articles left behind on the lunar surface were medals honoring Yuri Gagarin, Vladimir Komarov, Virgil Grissom, Roger Chaffee and Edward White, the five Soviets and Americans who had died during space missions. From Cape Kennedy and the surrounding areas, more than 1 million tourists followed the lunar mission step-by-step, which was covered by 1,782 journalists from throughout the world. Also in attendance were special guests, such as Charles Lindbergh, comedians and TV hosts Johnny Carson and Jack Benny, General William Westmoreland, journalist Walter Cronkite and Cardinal Terence Cooke. Joining them were two hundred five congressmen, thirty senators, nineteen governors, fifty mayors and sixty-nine ambassadors, in addition to Lyndon and Lady Bird Johnson.

Closing the article was an essay on courage, which Ernest Hemingway had defined as "grace under pressure." *Time* ended it with these words: "In the balloon-shaped, ungainly suits, the Apollo 11 astronauts have demonstrated that man, despite his murderous and chaotic past, can still achieve a state of grace."

The takeoff, second by second. Over a million people gathered in Cape Kennedy and the surrounding area on July 16, 1969, to witness the takeoff of *Apollo 11* to the moon. *Time* illustrated its coverage with photographs provided by NASA and by photographer David Burnett. The magazine hired Burnett, although he was only twenty-two, to cover the "behind the scenes" event. Many onlookers camped out in the area for days before. (Previous spread)

Arnold H. Drapkin: Failure Was Not An Option

In this essay, commissioned in 2009 for this book, Arnold Drapkin, Time's *photo editor in 1967, recalls a last-minute cover change.*

It was the last week of January 1967. I was sitting in for my vacationing boss running Color Projects, the section responsible for producing the color pages and covers for *Time*. Due to *Time*'s production system, the big news for us was the snowstorm in Chicago. It was their snowstorm of the century. Earlier that week I had a call from freelance photographer J. Alex Langley. There was a photo-op of the three astronauts who were testing *Apollo* capsules at the Cape. I hesitated, but decided to give him the assignment and told him to ship the film.

By Friday afternoon the astronaut photo-op film had arrived, was processed and on my light table. It was then the direct line intercom buzzed. It was the Assistant Managing Editor, Henry Grunwald, who told me there had been an accident at the Cape, three astronauts were killed and we were changing the cover. I said a prayer and told him I had some pictures in hand that we could use. Viewing them on the light table he selected one. "That's it, that's the cover. Get it out to Chicago," he ordered. "Everything's closed up, it's the snowstorm, there are no flights," I replied. He patted me on the head and said, "Arnold, I know you. You'll find a way," and left for the evening.

The original color slide had to get to the R. R. Donnelley & Sons Chicago printing plant, and quickly. Failure was not an option. Because Meigs, O'Hare and Midway were still closed, there was no way to get to Chicago but to fly to St. Louis. I opened the office safe and took out the several thousand dollars in petty cash we had stashed for an emergency.

I arrived in St. Louis on Saturday morning and ran into the *Life* magazine courier stuck in the airport trying to get their editorial material, which was in a large, red canvas mailbag, to Chicago. I took custody of the mailbag. I chartered a small plane and as we

neared Chicago air traffic informed us that Meigs Field was opening up. The pilot agreed to land and drop me off and we became the second plane in the landing pattern.

Of course, there was no transportation of any kind. I had to walk over a mile through the deep snow in my loafers and light raincoat to the printing plant dragging the large canvas mailbag behind me. In fact, my moustache and goatee did freeze. At the plant they made the cover engravings in record time. I approved the proofs and we had our new cover. Now Chicago Production needed to get the vinyl molds from which the press plates were made to the printing plant in Old Saybrook, Connecticut.

Flights were going out of Meigs Field to Detroit, but there was a 3-day backup of stranded passengers. Time Inc.'s traffic expediters pulled all their strings and I was able to board a Detroit flight Sunday night out of Meigs. Monday morning I would connect with a flight to JFK where a messenger would meet me to take the molds to the Old Saybrook printing plant.

At the Detroit airport Sunday night everything was closed. I hadn't eaten since Friday and I couldn't even get a sandwich. I decided to freshen up in the men's room where I took off my shirt and started to shave. I guess I looked suspicious—the police came and wanted to arrest me, but bless her, the Time Inc. NY switchboard operator vouched for me. I took the 6:00 am flight to New York's JFK on Monday morning. There were only peanuts and coffee on board. We landed at JFK where I handed over that large, red canvas mailbag to the messenger from Old Saybrook and got something to eat.

It had been one of the toughest assignments of my career. It was a while before people learned to appreciate what I went through to get the job done.

From my earliest days as a copy boy at *Time* I had absorbed its culture. One of its tenets was "failure is not an option."

1967. Astronauts Grissom, White & Chaffee

A stormy close. The February 3, 1967, cover featured astronauts Grissom, White and Chaffee, the first NASA fatalities, who died on duty while testing *Apollo* capsules at Cape Kennedy (left). It took Arnold Drapkin, *Time* photo editor in 1967, more than two days to get the the cover photo to the snowbound printing plant in Chicago to make the last-minute cover change.

6

Vietnam, Watergate and Women's Liberation in *Time*

With Fuerbringer, and later with Grunwald as the magazine's managing editor, the war in Vietnam became a major topic. Just as the subject would divide the country, it divided *Time*'s editorial offices.

Vietnam was the longest war in American history, spanning over eleven years and the terms of three presidents: John Kennedy, Lyndon Johnson and Richard Nixon. Hundreds of journalists and photographers covered it, some were World War II and Korean War veterans, for others, Southeast Asia was their first assignment. The *Time-Life* news service, one of the most prominent international news networks at the time, had a bureau in Hong Kong which, starting in 1963, was headed by Frank McCulloch. Its coverage area encompassed not only Vietnam, but all of Southeast Asia, including Indonesia and the Philippines. The bureau was also charged with keeping up with events in continental China.

John Shaw, James Wilde, Charles Mohr, Don Sider, Jonathan Larsen, Donald Neff, William McWhirter, Bruce Nelan, Marsh Clark, David DeVoss, Robert Sam Anson and James Willwerth were among the correspondents who covered the war for Time Inc. from Hong Kong or Saigon. Among photographers, John Dominis, Paul Schutzer, Terry Spencer, John Loengard, Richard Swanson, Carl Mydans, Le Minh, David Burnett, Dirck Halstead and Ted Thai stood out. Halstead won the Robert Capa Gold Medal in 1975 for his coverage of the fall of Saigon. Larry Burrows's horrifying combat images for *Time-Life* outshined them all. He worked for the magazines from the war front for nine years until his death in 1971, when the helicopter in which he was flying over Laos was shot down.

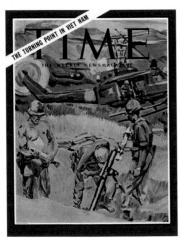

1965. Vietnam War

War and controversy. American soldier in December 1971, near Xuan Loc, north of Saigon by approximately 80 miles (opposite).

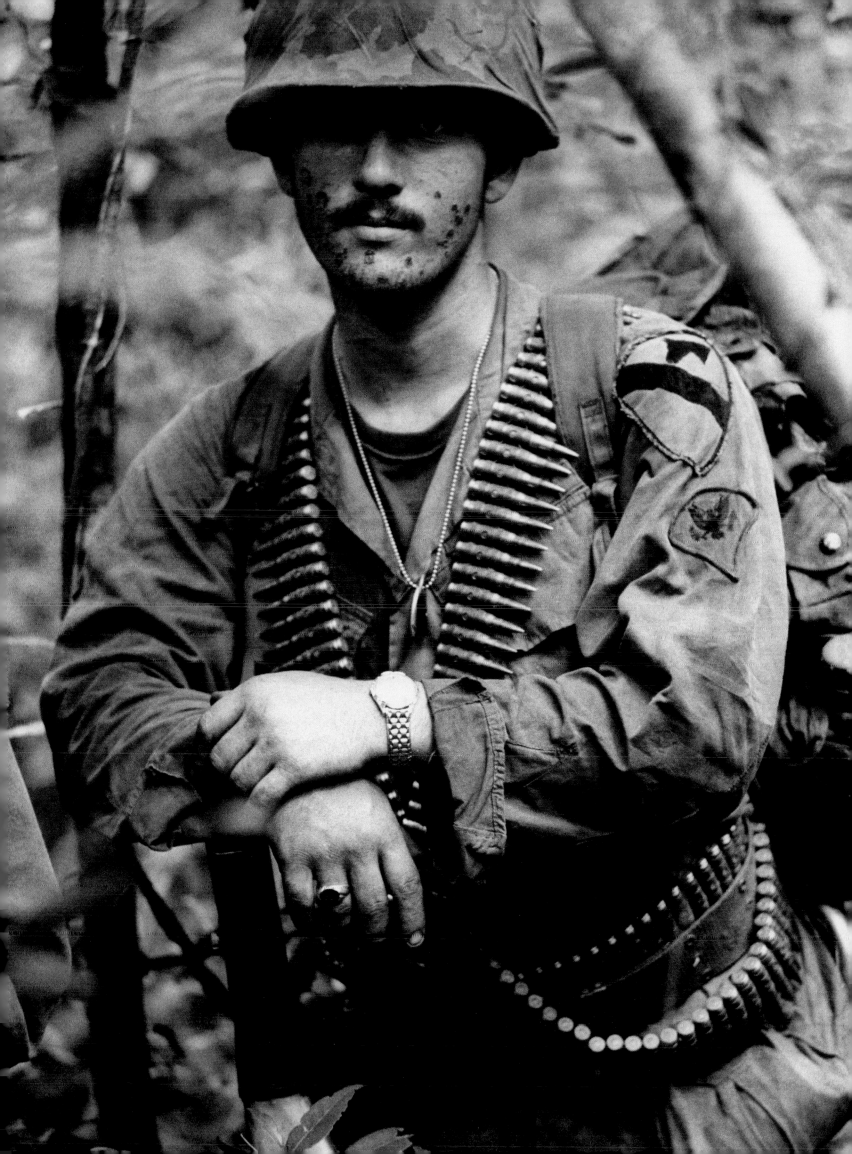

Time's editorial opinion on the war changed as the conflict escalated. Initially, *Time* supported the anti-Communist leader, Ngo Dinh Diem, who was elected president of the newly created nation of South Vietnam in 1956. However, *Time*'s correspondents, for the most part, did not support Diem, which led to controversy.

The start of the internal war
The first major controversy related to the conflict in Vietnam began when *Time* placed Madame Ngo Dinh Nhu, Diem's chief advisor, on its cover on August 9, 1963. The story was based on a file sent by Charles Mohr, a Southeast Asia correspondent, that began: "Vietnam is a graveyard of lost hopes, destroyed vanity, glib promises and good intentions." That line wasn't included in the published story, which infuriated Mohr. He sent a letter to his editors in which he complained that the article was too soft and didn't reflect the calamitous situation of Diem's government, which was about to fall, mainly due to internal failures rather than Communist persecution from North Vietnam. Mohr didn't mince words, saying that the New York editors were devoted to Diem and disregarded the information that Mohr sent in. He quit his job at the magazine after a story published in the "Press" section criticized American correspondents covering the war. Mohr felt that the story unfairly denigrated his colleagues, and he feared they might suspect the story was based on his dispatches. The story, which was rewritten by Fuerbringer, reads:

"... Such uncommon pressures unite the newsmen to an uncommon degree. They work hard ... But when they meet and unwind—in the field, in their homes or in the camaraderie of the Hotel Caravelle's eighth-floor bar (a popular press rendezvous in Saigon)—they pool their

convictions, information, misinformation and grievances ... But the balm of such companionship has not been conducive to independent thought...

The Saigon-based press corps is so confident of its own convictions that any other version of the Viet Nam story is quickly dismissed ... Many of the correspondents seem reluctant to give splash treatment to anything that smacks of military victory in the ugly war against the Communists, since this ... weakens the argument that defeat is inevitable so long as Diem is in power."

"The right war at the right time"
In the fall of 1963, Fuerbringer's defense of Diem was shattered when Diem was overthrown in a coup, which proved that the information from the *Time* correspondents in Saigon was on the mark. A military government took over leadership of South Vietnam. This new government was backed by the United States, and was opposed by both the National Liberation Front—dubbed, by the United States, as the "Vietcong," short for Vietnamese Communists—and by the Communist government of the North, which was headed by Ho Chi Minh. In the United States, Lyndon Johnson was elected president in 1964, defeating Barry Goldwater. When Johnson had replaced Kennedy after Kennedy's assassination, in 1963, there were 16,300 American military "advisors" in Vietnam. By the end of 1964, the number increased to 23,000, and in February 1965, U.S. air attacks against North Vietnam started. In March 1965, two marine battalions reached Danang—and were, in effect, the first U.S. combat troops in Vietnam.

Time made its position known right away. In an essay published on page thirty of the May 14, 1965, edition, under the title "Vietnam: The Right War at the Right Time," *Time* wrote:

"By and large, U.S. public opinion seems strongly behind Lyndon Johnson's unyielding strategy of bombing the North and stepped-up ground action in the South. At the same time, an insistent—if by no means unanimous—chorus of criticism is heard, particularly on college campuses, from faculty as well as students....

The pragmatic reasons add up to the notion that the U.S. cannot win or need not win in order to safeguard its interests. The moral objections are often weakened by the fact that, while the critics condemn the use of force against North Viet Nam, they either condone or ignore it in other situations, such as Sukarno's guerrilla war against Malaysia, Red China's conquest of Tibet or, most important, the Viet Cong's own terror against South Vietnamese peasants...

Despite all its excruciating difficulties, the Vietnamese struggle is absolutely inescapable for the U.S. in the mid-60's, and in that sense, it is the right war in the right place at the right time."

Correspondents versus writers-editors
Throughout the conflict, there was always sharp contrast between correspondents' views and the New York editors' outlook. Frank McCulloch, Hong Kong bureau chief, always complained of a tendency toward excessive optimism at the magazine. For instance, in the October 22, 1965, edition, under the heading "A New Kind of War," the following was published:

Everywhere today South Viet Nam bustles with the U.S. presence ... Wave upon wave of combat-booted Americans—lean, laconic and looking for a fight—pour ashore from armadas of troopships. Day and night, screaming jets and prowling helicopters seek out the enemy from

Leading the charge. *Time* photographer David Burnett captured the photo (preceding spread) of a soldier charging into battle.

their swampy strongholds ... The Viet Cong's once-cocky hunters have become the cowering hunted as the cutting edge of U.S. fire power slashes into the thickets of Communist strength. If the U.S. has not yet won guaranteed certain victory in South Viet Nam, it has nonetheless undeniably averted certain defeat. As one top-ranking U.S. officer put it: 'We've stemmed the tide.'"

In general, information coming from Vietnam was confirmed by other sources in Washington, where *Time* had an excellent relationship with the J ohnson administration. It's difficult not to blame that close relationship with the government for *Time*'s decisive support of the war in its initial years. Years later, when asked about the subject, Fuerbringer rejected such an interpretation: "Our fault was not so much that we believed what our Washington correspondents were telling us—from Pentagon sources and from Uncle Lyndon—as that we couldn't conceive that America couldn't get its act together and win."

Time believes in success

Fuerbringer, who along with other *Time* and *Life* executives, was obsessed with the less-than-triumphant information submitted by correspondents, decided to visit Vietnam in November 1965. He was welcomed by General William Westmoreland, who lead the troops, and briefed by other military leaders. They also took him to an enormous deep-water port that American engineers were building in the Cam Ranh Bay. Those installations greatly impressed Fuerbringer, who half-jokingly suggested that to start winning the psychological war, the facilities be shown to enemy commandants, as noted in Curtis Prendergast's book, *The World of Time Inc.: The Intimate History of a Changing Enterprise: 1960–1980*. "When I saw Cam Ranh Bay with McCulloch, it was hard not to think that as soon as all this power was applied with the military skill we had shown in the past, we would win ... Despite Korea, we believed in the ultimate can-do."

Hedley Donovan, who replaced Luce as the company's editor in chief, also decided to see for himself the ground forces and gauge America's actual chances in Vietnam. He went to Vietnam in November 1965. Donovan spent ten days visiting a dozen of the country's forty-three provinces, and was aboard a bombing mission along the route to Ho Chi Minh. Upon his return, Donovan wrote a story published in *Life*'s February 25, 1966, issue

The agony of "victory." By 1966, images like the one taken below, by *Time-Life* photographer Larry Burrows, of a soldier being led off the field by his comrades after a fierce firefight were common. The heavy toll on U.S. troops belied the magazine's optimistic forecast on the outcome of the war.

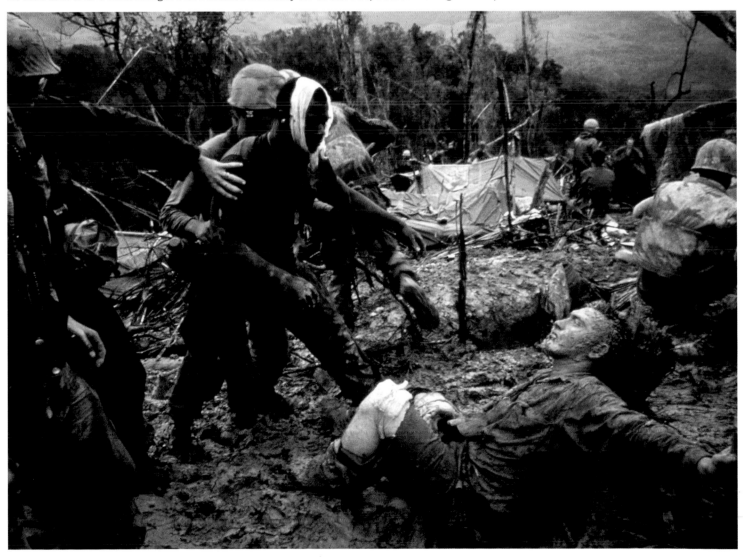

as a preface to a thirty-one paged section with the title "Vietnam: The War Is Worth Winning." The article read in part: "The war in Vietnam is not primarily a war about Vietnam, nor even entirely a war about China. It is a war about the future of Asia. It is very possibly as important as any of the previous American wars of this century."

Time understands difficulties

In May 1967, Donovan made his second trip to Vietnam, at a time when the deployment of American troops surpassed 400,000 soldiers. He met there with the military, *Time* journalists and various advisers. Donovan's goal was to closely monitor the developments of a war that military advocates—who favored the triumphant information that came out of Washington—claimed was about to be won, while those against the war—who gave greater weight to the reports sent by correspondents—claimed was headed towards disaster. During the trip, Donovan also joined his son Peter, who was serving with the International Voluntary Services in the Mekong Delta. His son's impressions, as he later remembered, had an impact on him and influenced his future position: "Peter had been enthusiastic about the war, a strong believer. [But] by the spring of 1967 he was discouraged by the corruption and the situation in the delta. He thought it was insoluble."

Time questions success

In the August 4 issue of that year, *Time* gave the first warning of a change in editorial opinion regarding the war. The warning was published in the "The World" section with an article that reached this conclusion on South Vietnam's fighting ability:

"The South Vietnamese Army has a long way to go to measure up to its potential...." The Vietnamese have been fighting for 20 years, in successive generations of young men, and the whole military fabric is frayed by the invisible cumulative fatigue of what seems like endless war.... Along with spotty leadership, the soldier in the ranks suffers from other liabilities. He is fighting an ethnic brother, and sometimes a brother in fact. Unlike the U.S. soldier in Viet Nam who knows he will not have to fight a day longer than one year, draftees in the ARVN ranks face a three-year tour in combat..."

The Tet Offensive. While Time Inc.'s magazines proposed a negotiated withdrawal from Vietnam, during a cease-fire in January 1968, North Vietnamese and Vietcong forces began launching attacks on South Vietnam. These strikes are known as the Tet Offensive. This famous photograph (below), taken at the start of the attacks, shows the South Vietnam national police chief, General Nguyen Ngoc Loan, executing a suspected Vietcong guerrilla.

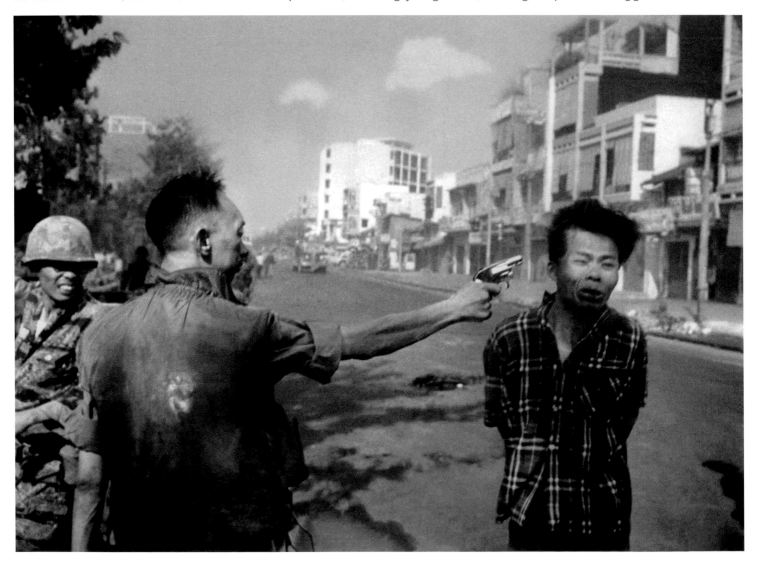

The story was penned by journalist Jason McManus, who received direct orders from Donovan to write it: "It was a conscious decision to raise doubts about the war ... Characteristically, Hedley insisted that it be not a lede (Time-ese for the lead-off story in a section) but a three-column story inside." At the same time, Donovan sent Fuerbringer—who still sympathized with the war—a confidential memo in which he requested "a note of wariness" in all stories that dealt with war developments.

Life opens fire

In the October 20, 1967, issue, Life published an editorial that explicitly expressed the company's new position toward the war. It took more than two weeks to write, and it was discussed at a luncheon attended by fifteen magazine top editors. "The Case for Bombing Pause Number 7" was considered so important that it was rewritten several times, and its publication was even postponed a week, as it was originally planned for the October 13 issue. That level of concern within the company led to a leak of the information and, days before the story was published, The Washington Post noted that Life was about to make "[a]n important shift of policy for the publication, generally associated with a hawkish position on the Vietnam conflict." The Washington Post further commented "there is a special irony in Life's change of heart in that the Far East was Luce's lifelong interest and the place in which his hard-line anti-Communism found its greatest expression."

The editorial admitted to the failure of the six previous American bombing pauses, but proposed a seventh as a sign to North Vietnam of good will and a willingness to negotiate.

The Tet Offensive

The conflicting parties had declared a cease-fire during late January 1968, due to the Lunar New Year, when family reunions are held throughout Vietnam. The cease-fire encouraged Life to publish, in January 1968, two editorials that proposed seeking a peace agreement between the South and North. The magazine's initiative didn't sit well with the White House, and Lyndon Johnson summoned Donovan to complain, telling him that surely Luce would have handled the matter differently. A few days after the meeting, Johnson's words were justified when North Vietnamese and Vietcong forces attacked South Vietnam in what became known as the "Tet Offensive," violating the agreed-upon truce.

North Vietnam's surprise military operation was launched on January 30, when many South Vietnamese soldiers were on leave due to the cease-fire. Eighty-four thousand soldiers carried out the operation. They invaded Saigon and took the fight, that up until then had taken place in the jungle into the cities. Not even the U.S. embassy in Saigon was spared from the assault: a suicide squad of nineteen Vietcong tried to seize it, but only reached the grounds surrounding the building. The South Vietnamese and American forces, caught off guard, took a while to respond, but then did so with all their power.

By late February, the South Vietnamese forces had recaptured the invaded areas. With heavy casualties on all sides, any "victory" was hard to swallow. The Tet Offensive also increased U.S. pessimism about the war.

Life and a blow to the heart

On June 27, 1969, Life published one of the most shocking, graphic documents of the war. The photo essay was based on a news item produced by the Pentagon regarding American casualties "in connection with the conflict in Vietnam," as it was usually phrased, concerning the 242 men who had died the week of May 28 through June 3, 1969. Life, under the direction of Ralph Graves and the supervision of Deputy Executive Editor Loudon Wainwright, set out to find and publish photos of each of the men. Of the 242 casualties, Life was able to obtain photos of all but twenty-five, whose families could not be located or refused to provide photos. The photos of the 217 casualties were featured together in a gallery of passport-size portraits that spread over twelve pages of the magazine: five per row, twenty per page, each with a caption that included their name, age, rank and hometown.

No other text was included. The photos were the story. Most of the dead were around the age of twenty-one. Among them, twenty-five were black and two were featured in high school cap and gown. Their young faces, side by side, staring from the page, conjured images of their unfulfilled dreams. The impact of these photographs was dramatic and decisive in swaying public opinion. The June 27 piece is now considered one of the most powerful published items against the war.

The My Lai massacre

In November 1969, news of another event shook the American public and made them indignant. The event became known as the "My Lai Massacre." On March 16, 1968, U.S. Army troops—headed by 1st Lt. William Laws Calley, Jr., in an operation that was meant to locate the Vietcong—destroyed the village of My Lai and killed 100 to 500 people, including the elderly and women and children. In December 1969, Time ran the story. The issue's cover was illustrated with a heavily posterized color photo of Calley, with a heading running across it: "The Massacre, Where Does the Guilt Lie?" The article reported:

"The deed was not performed by patently demented men ... [these

men] were for the most part almost depressingly normal. They were Everymen, decent in their daily lives, who at home ... would regard it as unthinkable to maliciously strike a child, much less kill one. Yet men in American uniforms slaughtered the civilians at My Lai and in so doing humiliated the U.S. and called in question the U.S. mission in Viet Nam in a way that all the antiwar protesters could never have done."

Kent State: More fury, more violence
The most unexpected act by the Nixon administration was the invasion of Cambodia in 1970. That neutral country, with a border barely thirty-five miles from Saigon, had unwillingly long provided supply storage and sanctuary to the North Vietnamese and Vietcong forces. Since bombing the area was not effective, the U.S. government decided to send in land troops. The American public reacted strongly to this escalation of the war into other territories. Protests reached their climax in the United States on May 4, 1970, at Kent State University in Ohio. On that day, after

three days of disturbances, Governor James Rhodes, comparing the demonstrators to Nazi "brownshirts," called in the National Guard. When guardsmen arrived, some students who refused to leave threw stones. The troops, in response, fired a round of coordinated rifle fire. In just a few minutes, four students died and nine were injured. Public indignation was widespread and led to even more pressure from those who were opposed to continuing the Vietnam War.

"Vietnam: Time to Fix a Date"
During 1970 and 1971, in decidedly open opposition to the war, Time Inc. magazines started to exert constant pressure against the Nixon administration. They did so with editorials and essays, which were always signed by Hedley Donovan, who had decided to personally oversee the editorial treatment of the war. In an editorial titled "Winding down the war on our own," Donovan wrote:

"... derided Nixon's expressed fear of being the first American President to lose a war. He might, however, if he

and we are lucky, become the third President to settle for a tie. The others were James Madison (War of 1812) and Dwight Eisenhower (Korea), perfectly respectable company for any President to keep."

In July 1970, under the heading "Vietnam: Time to Fix a Date," Life exhorted a faster withdrawal of troops and demanded "all American participation in the war" to terminate "by no later than the end of 1971." This came after the South Vietnamese, backed by the United Sates, extended the scope of the war by invading Laos in February of that year, under the premise that the Vietcong was supplied logistically from Laos. In the meantime, at Time, in a June 1971 essay, Donovan was blunt: he conceded that American forces could not withdraw that year, but said all air, naval and land combat and support troops should do so by April or July 1972, not only from Vietnam, but also from Laos and Cambodia.

The withdrawal
Along with peace negotiations, the Nixon

Vietnam, yes. On May 14, 1965, Time referred to Vietnam as just "the right war at the right time." A few months later, in an October 22 cover story (below) with the title "A New Kind of War," the magazine noted the "remarkable turnabout in the war" due to U.S. military buildups. The article boasted "The Vietcong's once-cocky hunters have become the cowering hunted as the cutting edge of U.S. firepower slashes into the thickets of Communist strength."

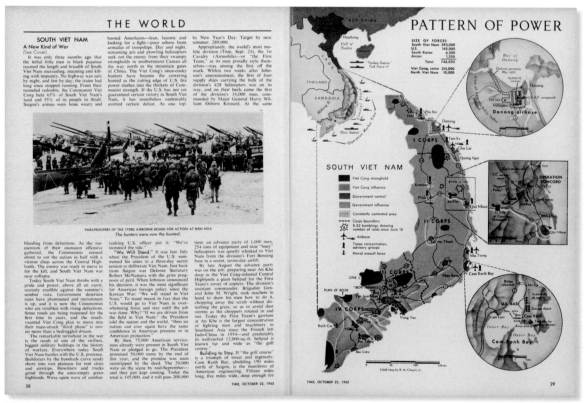

1965. "The World": South Viet Nam: A New Kind of War

administration took two paths: gradually withdrawing troops (by April 1972, combat forces were down to 95,000 soldiers), and carrying out fierce bombings of Hanoi and Haiphong, with the purpose of getting concessions from the North Vietnamese. In January 1973, the cease-fire was finally signed and, in March, with the departure of the last U.S. troops, the eleven-year American involvement in the conflict came to a close.

"Finally, the cease-fire," began *Time*'s twelve-page cover story on February 5, 1973:

> "At last, a truce. At last, after a season of false moves and false dawns, the papers were signed. At last, after years of death and destruction, the war that four U.S. Presidents had considered a necessary act of resistance against international communism was ending in an ambiguous stalemate ... [In Vietnam] there was no dancing in the streets, or anywhere else. There were no cheers, not even more smiles than usual ... The reaction in the U.S. was similarly subdued ... The ending of

the longest war in U.S. history, with its bitter sacrifice of lives and money, undoubtedly deserved more of a tribute. But the American public was obviously in no mood to celebrate...."

In terms of numbers, Vietnam's toll came to: 50,000 Americans killed in action and 300,000 wounded. Its economic cost was about $111 billion, much less than the $664 billion cost of World War II. However, the Vietnam War had a great psychological impact on Americans, particularly because it seemed senseless and unjustified. It was also a war leading to widespread protest and the death of students—441 colleges were affected; many of them shut down entirely.

Time devoted fifty-nine covers to the war during the official U.S. involvement. "Thumbing through 59 *Time* cover stories is another way to review the twists, shocks, hopes and frustrations of the strangest war in U.S. history," *Time* wrote in its February 5, 1973, "Letter from the Publisher." Stefan Kanfer stated in the essay of the special cease-fire supplement:

> "What is needed is a civilian DMZ, where the polarized Americans can gather, a place somewhere between the moral amnesia of those who would totally forget the war and those who proclaim a perpetual, self-lacerating *mea culpa* that would take the place of progress. Perhaps this war has broken the rules of history."

Vietnam no. The magazine asked, "The Massacre: Where Does the Guilt Lie?" on its December 5, 1969, cover of Lieutenant William Calley, Jr., responsible for the My Lai massacre (below, left). In the May 18, 1970, issue, *Time* published the cover story "At War with War" (below, right) in response to the nationwide student strike following the student demonstrations at Kent State University to protest the expansion of the war into Cambodia—four students were killed by National Guard bullets.

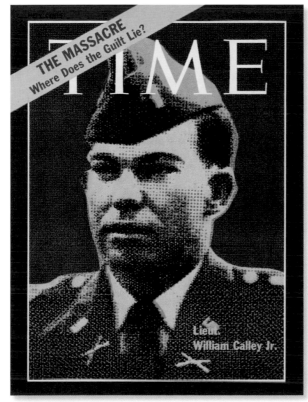

1969. Lt. William Calley, Jr.

1970. U.S. student protest

Nixon: The Record-Breaking President

Richard Milhous Nixon set several records at *Time*. He was on the cover more times than anyone else, and was the only president to twice be chosen "Man of the Year." He was the first leader to be satirized on the cover, and was the only president who pressed to be featured without any other officials on the cover. After the Watergate scandal, he was the target of the first editorial published by the magazine demanding a president's resignation.

As his frequency on *Time* covers reflects, Nixon was one of the most controversial presidents in American history. He ran for office the most times, as the presidential candidate or running mate, and he had a peculiar relationship with the press, to which his spokesmen more than once provided inaccurate information. Nixon, using hyperbole, made this prescient statement when he accepted the presidential nomination in 1968:

"As we look at America, we see cities enveloped in smoke and flame. We hear sirens in the night ... We see Americans hating each other; killing each other at home. And as we see and hear these things, millions of Americans cry out in anguish: Did we come all this way for this?"

Nixon was first featured on the magazine's cover in the August 25, 1952, issue, when he was chosen as the vice presidential candidate on a ticket headed by Dwight David Eisenhower. At the time, Nixon, thirty-nine, was a senator from California, who, between 1948 and 1949 as a congressman in the House of Representatives had a prominent role in the House Un-American Activities Committee. After the elections, Nixon made the cover for the second time on November 10, 1952, along with the victorious president. This was the start to the run that would place

him as the person most often featured on the cover of *Time*—sixty-one times.

The *Time* cover with the image of the president of the United States is a matter of tradition. Since *Time* was first published in 1923, only Herbert Hoover, who occupied the White House between 1929 and 1933, failed to make the cover during his presidency. Starting with Franklin Delano Roosevelt, every president was on the cover at least five times during their administration. An image of Richard Nixon, however, was featured on the cover thirty-six times during his one and one-half terms.

Presidents were also historically selected as "Man of the Year," since Roosevelt was chosen in 1932 when he was still president elect. The only exception was Gerald Ford, the vice president who became Nixon's successor and was at the helm of the White House from August 1974 to January 1977. Nixon also holds another record as the only person to be selected two consecutive years, in 1971 and 1972, as "Man of the Year." Interestingly, on both occasions, the cover artists created sculptures, rather than taking a photographic portrait. Nixon was not depicted smiling in either work, befitting the cover stories illustrated by the images.

Perhaps, there was no other U.S. president who was the subject of so many derisive and irreverent comments from the press. Nixon couldn't live down the Democrat's 1960 campaign slur, reused again in 1968, featuring Nixon's photo with the question "Would you buy a used car from this man?"

The press dubbed him "Tricky Dick," and was relentless about his constant reversals. Nixon's spokesmen often provided unofficial information adopting a particular position, only to then officially adopt the opposite one. It was not surprising that when Nixon was chosen "Man of the Year" in 1971, *Time* would

1952. Running Mate Nixon

Sixty-one for Nixon. Richard Milhous Nixon holds the record as the newsmaker that appeared most often on *Time*'s cover—sixty-one. His first cover was August 25, 1952 (left). Nixon also made cover history as the only newsmaker to be designated "Man of the Year" in two consecutive years—1971 (opposite) and 1972, when he shared the honor with Henry Kissinger.

depict him in profile with a very large nose (which has traditionally symbolized lying, though the cover story accompanying the image was quite positive). The artist, Stanley Glaubach, made a papier-mâché sculpture of Nixon's face, using clipped newspaper headlines, to convey the role Nixon played throughout 1971: after twenty-five years, he reopened dialogue with China, had marathon summits in Peking and Moscow, confirmed the withdrawal from Vietnam, imposed government controls on the economy and devaluated the dollar, producing an international financial crisis.

The magazine justified Nixon's image on its cover saying, "... If he still has a problem inspiring complete trust, it is no longer a simple matter of the old Tricky Dick image. He is still suspected of timing his major moves for political advantage, but perhaps not much more than most other presidents." Although the bulk of the article was positive, the fact remains that Nixon was the first U.S. president to be satirized on the "Man of the Year" cover.

Twelve months later, as the 1972 "Men of the Year," along with Henry Kissinger, Nixon was the subject of a sculpture by Marisol. On the cover, the men's faces were made of pink marble, as if sculpted in stone on Mount Rushmore, where presidents George Washington, Thomas Jefferson, Theodore Roosevelt and Abraham Lincoln are immortalized. In the cover story, Nixon and his administration are treated even-handedly:

"It was a year of visitations and bold ventures with Russia and China, of a uniquely personal triumph at the polls for the President, of hopes raised and lately dashed for peace in Viet Nam. Foreign policy reigned pre-eminent, and was in good part the base for the landslide election victory at home. And

U.S. foreign policy, for good or ill, was undeniably the handiwork of two people: Richard Milhous Nixon and Henry Alfred Kissinger, the President's Assistant for National Security Affairs...

They constitute in many ways an odd couple, an improbable partnership. There is Nixon, 60, champion of Middle American virtues, a secretive, aloof yet old-fashioned politician given to oversimplified rhetoric, who founded his career on gut-fighting anti-Communism but has become in his maturity a surprisingly flexible, even unpredictable statesman. At his side is Kissinger, 49, a Bavarian-born Harvard professor of urbane and subtle intelligence, a creature of Cambridge and Georgetown who cherishes a never entirely convincing reputation as an international bon vivant and superstar. Yet together in their unique symbiosis—Nixon supplying power and will, Kissinger an intellectual framework and negotiating skills— they have been changing the shape of the world, accomplishing the most profound rearrangement of the earth's political powers since the beginning of the cold war."

Nixon was upset at the prospect of sharing the cover with Kissinger. Henry Grunwald, *Time*'s editor during the elections, recounted this anecdote in his book, *One Man's America: A Journalist's Search for the Heart of His Country*:

"As we were preparing the cover story, Kissinger phoned me, asking to be left off the cover. 'Henry,' I said, 'people usually ask me to be put on the cover.' 'I know,' rumbled Kissinger. 'But the president is really upset....' When Kissinger described the president as really upset, he was not exaggerating. Nixon issued instructions, as Haldeman

later recalled, that Kissinger was not to see people from *Time* under any circumstances, 'that I'm to order him to do no interviews, social, return calls or anything to *Time*. And he told me to call the White House operators to turn those calls off to Henry, which, of course, I can't do.'"

The cover was published in the January 1, 1973, edition. The weekly, internal Times Letter Report, dated February 1 of that year and signed by María Luisa Cisneros, revealed the start of the public's growing discontent with Nixon: "The Richard Nixon Man-of-the-Year piece drew more mail than any other cover story in 1972. Over 1,300 readers sent letters, reflecting their displeasure about the selection of Nixon, during January to March 1973. Among those, ninety-one readers cancelled their subscriptions and seven said they would not renew it.

It was the first of fourteen covers devoted to Nixon that year, when the Watergate scandal broke and reached its heyday. It was an exceptional number of covers for a single person in one year, signaling, perhaps, another record the following year, also involving Nixon: in 1974, Nixon became the first president of the United States to resign and leave office before the end of his term.

My days at *Time*
Three White House Correspondents: At Home with the President

Extracted from the Time Inc. internal magazine FYI, *dated July 16, 1984.*

Hugh Sidey, Time's *emblematic Washington correspondent, recalled:*

... that Kennedy had an avid curiosity and insatiable appetite for the tasks of office. He came close to being a perpetual-motion machine of flesh and blood ... since I followed him on trips through most of the U.S. and diplomatic junkets from Bogota to Berlin. When you cover a president, you lead his life ... I was in a press bus 30 ft. behind the presidential limousine when Kennedy was assassinated.

Kennedy appeared to enjoy the give and take of dealing with the press and genuinely seemed to like reporters. If he hadn't become President, I think he would have been in the newspaper business ... Kennedy often granted informal interviews when his work load was light and occasionally revealed an impulsive side of himself. I remember going to the White House to interview him one day in 1961. We walked to the pool and talked about taking a swim. So we stripped down, jumped in and interviewed him on Berlin as we swam.

Bonnie Angelo, who joined Hugh Sidey as White House correspondent in 1966, during the Johnson administration, gave her impressions of the president:

Lyndon Johnson was Texas-sized. Everything about him was bigger than life. He was the best storyteller. [He] loved to show off on the dance floor. He loved to flirt with the women. Lyndon was also a real optimist by nature. He felt there was nothing he couldn't accomplish. Angelo feels this overconfidence led to Johnson's greatest failure: [the] war in Viet Nam. He just couldn't believe there was no face-saving way out.

Angelo says Johnson used a carrot and a stick to manipulate the press. He tried to reward reporters for favorable stories by giving them exclusives on other articles or inviting them to lavish parties at the White House while a less-than-favorable story would often result in a phone call from an angry Johnson press aide. No topic was too mundane. Angelo was once taken to task for criticizing the President's dancing.

He was also jealous of the press coverage Jack Kennedy had gotten. He once had press secretaries throughout the government measure every inch of type Kennedy had gotten on the front pages and compare the total to every inch he had gotten. Kennedy had more, and Johnson was furious. He told his aides, "I want as much as Kennedy had."

Dean Fischer, who began a stint at the White House just as Richard Nixon began his second term, recalled:

Nixon was not at all at ease with people. Particularly the press. I met him for the first time at a worship service in the White House. I spoke with him in the receiving line and he began to reminisce about previous White House correspondents from *Time*. Something peculiar happened. He sort of punched me in the chest with his index finger and said, "You *Time* correspondents. You come and go."

Next to the president. Hugh Sidey (left) was a White House correspondent for *Time* for forty-three years. His presidential coverage spanned from Dwight D. Eisenhower to Bill Clinton. According to Sidey's recollections, John F. Kennedy was the president that kept him hopping the most—Sidey called Kennedy a "perpetual-motion" machine.

Watergate and the History of the First Editorial

"I smell something very fishy in this Watergate business and I don't think you guys up here are taking it seriously enough. I've been talking to my people over at Justice and a lot of other places. Somebody is trying to keep the FBI from going after this. There have been calls from the CIA trying to wave them off. National security, they claim. It would take somebody with real clout to pull this."

With those words, Sandy Smith, one of the magazine's correspondents in Washington, complained, over the phone to Henry Grunwald, about how little space that *Time* was devoting to Watergate.

The Watergate case, the most shocking political and constitutional scandal in recent years, began June 17, 1972, in Washington, D.C. The Democratic Party had chosen Watergate, an apartment and office complex along the Potomac River, as campaign headquarters for the November presidential elections between Republican Richard Nixon and Democrat George McGovern. Five men informally known as "The White House Plumbers" planned to install microphones to wiretap the Democrats. Initially suspected to be burglars, they were arrested there. Among the five was James McCord, security director for the Committee to Re-elect the President. The other four—Bernard Baker, Virgilio González, Eugenio Martínez and Frank Sturgis—were members of the CIA.

As soon as the news was released, *Time*, along with members of the media, covered the issue shallowly and even dismissed it as a "caper." The magazine's information, as well, lagged behind other media. At the forefront was *The Washington Post*, led by Publisher Katharine Graham and Executive Editor Ben Bradlee. They backed the stories broken by Carl Bernstein and Bob Woodward, the reporters who had diligently followed the case since its outset and who became the leading journalists pursuing it. The reporters were assisted more than once by a confidential source they called "Deep Throat," whose identity, W. Mark Felt, was revealed in 2005 and who at the time of Watergate was the associate director of the FBI.

Not until August 12, 1972, two months after the fact, *Time* issued the following warning: "Now the Watergate affair," the magazine wrote, "promises to be the scandal of the year." In November, the Nixon-Agnew ticket overwhelmingly defeated the Democrats (47 million versus 29 million, with almost sixty-one percent of the total vote count) and began their second term in January 1973. That month, on January 8, at a court presided over by Judge John Sirica, the five who broke into the Watergate building, along with E. Howard Hunt, Jr., the former CIA agent and White House security consultant, and G. Gordon Liddy, counsel of the finance arm of the Committee to Re-elect the President, went to trial. The latter were accused of planning the espionage operation.

After the trial, and over the next eighteen months, a flood of charges, evidence, contradictions, verdicts, confessions, resignations and all sorts of exclusive reports shook public opinion. People were eager to hear the news, and the surprises were endless. *Time* launched its reporting counteroffensive, to not only catch up, but also to capture the lead with research and breaking news of its own. The magazine used its experience with what was known as "group journalism" to take advantage of several news-gathering elements to enhance reporting. *Time* set up a special Watergate team based in Washington. In charge of the team was Bureau Chief Hugh Sidey. The news editor was John Stacks. Dean Fischer covered the White House

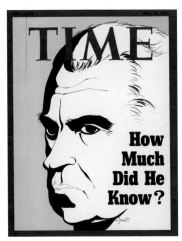

1973. President Nixon

Watergate's web. On the May 14, 1973, cover (left), artist George Giusti depicted the president cast in the shadow of doubt—should he confess his guilt or plead his innocence? This caricature—an illustration style seldom used by *Time*—by Jack Davis on the April 30, 1973, cover is considered one of the images that best represented how the Nixon administration was being caught in a complicated web (opposite).

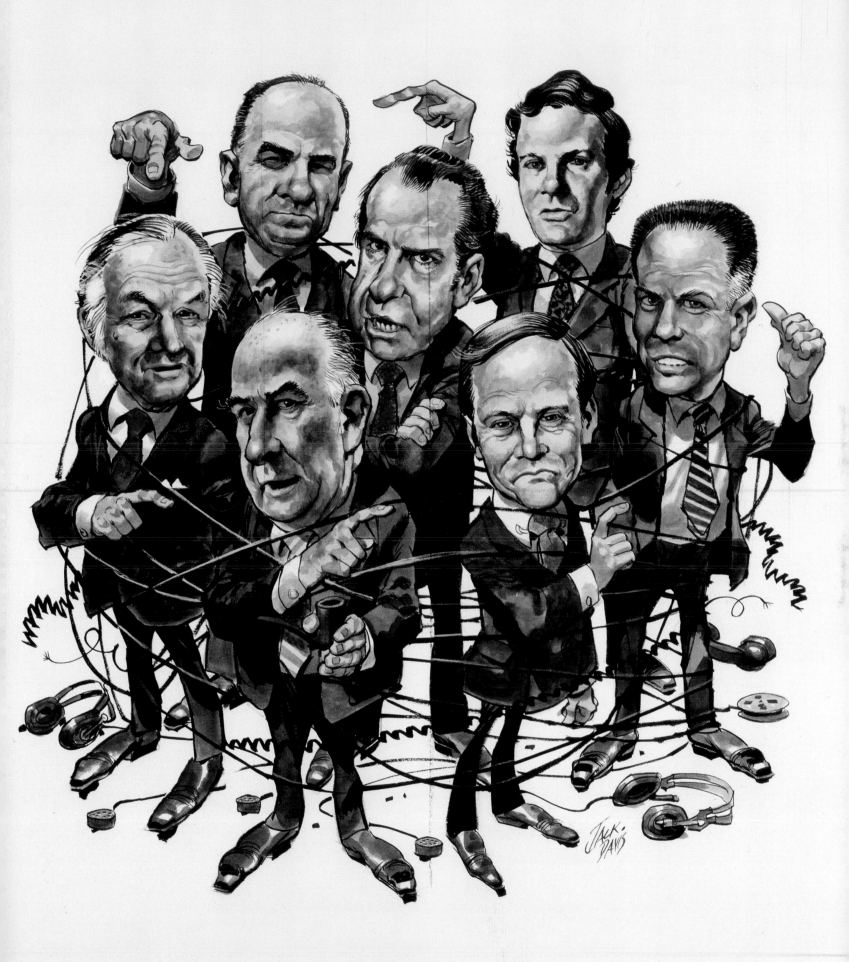

and Neil MacNeil reported on Congress. Also part of *Time*'s team was a special investigative unit featuring, among others, David Beckwith, Hays Gorey and Simmons Fentress. In New York, Grunwald set up a task force that included Senior Editor Jason McManus, in charge of organizing the material to be published, Editor Marshal Loeb, and Ed Magnuson, a pro at writing, who could weave the complicated and tangled facts into a cohesive story. During the eighteen months of the Watergate case, Magnuson wrote twenty cover stories on the subject, four of them back-to-back in May 1973.

"But no *Time* reporter," Curtis Prendergast in *The World of Time Inc.: The Intimate History of a Changing Enterprise: 1960–1980* wrote:

"produced more Watergate scoops and received less public credit for them than Sandy Smith—he wanted it that way. It was impossible to be specific about Smith's beat. He simply used his own sources, many never identified, many in the FBI.... Soon after Watergate broke Smith was on top of it, tracing the money found on the burglars, discovering where signals sent by the bugging devices were picked up, unearthing dozens of other significant details. But most weeks, Smith's explicit instruction to New York was: 'First and foremost, pls delete the byline. Thanks, but no thanks, on this one.'"

The first scoop to distinguish *Time* from the pack covering Watergate was an interview that David Beckwith landed in January 1973 with White House security consultant E. Howard Hunt, Jr. Hunt, with others, had plead guilty to planning the wiretapping of the Democrats' headquarters. The first cover that *Time* devoted to Watergate came out on March 26, 1973, with the image of L. Patrick Gray III under the heading "The FBI in Politics."

From March on, *Time* published thirty covers devoted to Watergate. The April 30, 1973, cover was a good depiction of this critical moment in the Nixon administration. The cover, by Jack Davis, was a caricature, an illustration style seldom used by *Time*. Davis's use of satire and humor had a powerful visual impact. According to Frederick S. Voss in his book, *Faces of Time: 75 Years of* Time *Magazine Cover Portraits*:

"the piece offered perhaps as good a summation as any single picture could of the recent string of events that were beginning to disclose Watergate's complicated web of wrongdoing. Without reading a word of the cover story itself, it was possible to understand its basic thrust by looking at Davis's image of Nixon's advisers implicated in Watergate, all pointing accusatory fingers at each other."

Another reporting coup that put *Time* ahead of the pack was an exclusive interview by journalist Hays Gorey with John Dean, Nixon's White House counsel. The interview was published in the June 4 issue, prior to Dean testifying before the Senate Watergate Committee (popularly called "The Ervin Committee" after committee chairman North Carolina Senator Sam Ervin), and served as a warning that Nixon's report on Watergate was far from accurate. Dean was the first to reveal that the president was personally involved in the case.

In *One Man's America: A Journalist's Search for the Heart of His Country* Henry Grunwald wrote, of *Time*'s efforts to keep up with Watergate:

"One of the functions of our Watergate stories was recapping events that grew so complicated that keeping track of them resembled trying to trace the pattern of an electronic circuit board. That became the specialty of Ed Magnuson, who was to write most of our Watergate stories. 'Mag' quietly, methodically prepared large wall charts of events and connections.

By far the most sensational revelation to appear on those charts was that Richard Nixon had taped every conversation in the White House for almost two years.

The revelation came from a witness before the Ervin committee, whose name had not yet even been mentioned. He was Alexander P. Butterfield, administrator of the Federal Aviation Administration and former aide to Haldeman ... As he later testified publicly, there was a recording system in the White House, and Nixon had automatically taped his conversations.

I believed that Nixon must have thought the tapes would somehow exonerate him—but then why did he fight so tenaciously against releasing them? There was never a satisfactory answer. After a long delay the U.S. Court of Appeals ruled that he must turn over the tapes to Judge John Sirica. He refused. Six days before, in October 1973, the Yom Kippur War had broken out. There was concern that the USSR would become involved. Nixon used that as an excuse; in times of international conflict, he argued, the United States must not be seen as weakened by a constitutional crisis. He proposed a 'compromise,' offering to supply summaries of the pertinent tapes, their accuracy to be verified by a single, trusted senator, John Stennis, who was seventy-two and hard of hearing. Nixon carefully explained that special listening devices would be provided. It was a bizarre, almost surreal scheme,

The beginning of the end. August 7, 1974: Richard Nixon embracing daughter Julie at the White House after he told his family that he would resign from the presidency the following day (opposite). Almost a year earlier, in the November 12, 1973, issue, *Time* published its first editorial in its half-century history in which it called for a president to resign.

suggesting a desperate if not unstable state of mind."

The events of October 1973, caused the case to pick up a frantic pace. Spiro Agnew, besieged by allegations of corruption, resigned as vice president. The special prosecutor named for the Watergate case, Archibald Cox, rejected Nixon's "compromise" for delivering the tapes. In response, Nixon decided to have Cox fired.

Nixon asked Attorney General Elliot Richardson to fire Cox, but instead Richardson resigned. Nixon then appealed to his second-in-command, William Ruckelshaus, who also refused. Solicitor General Robert Bork, third-in-command, who by law became acting attorney general, finally fired Cox and, also under Nixon's orders, shut down the Special Prosecutor's Office. Publicly, this series of events became known as the "Saturday Night Massacre."

After several months' debate throughout the company, *Time* made a drastic decision. On the first occasion in fifty years, *Time* published an editorial asking for the resignation of the president, as Nixon had been heavily implicated in the most noted political espionage case in United States history. The editorial was on the newsstands November 5, 1973, but, following the magazine's tradition to date the issue according to the last day of its weekly cycle, the issue was dated November 12.

The piece, written by Managing Editor Henry Grunwald under the heading "An Editorial: The President Should Resign," stated that Nixon:

"has irredeemably lost his moral authority, the confidence of most of the country and therefore his ability to govern effectively ... If he decides to fight to the end, he faces impeachment

by the House, for he has indeed failed his obligation under the Constitution to uphold the law ... But even if he were to be acquitted, the process would leave him and the country devastated ... [the] wise and patriotic course is for Richard Nixon to resign, sparing the country and himself this agony."

The editorial mentioned the support Time Inc. had given Nixon in the past but closed unequivocally:

"The nightmare of uncertainty must be ended. A fresh start must be made. Some at home and abroad might see in the President's resignation a sign of American weakness and failure. It would be a sign of the very opposite. It would show strength and health. It would show the ability of a badly infected political system to cleanse itself. It would show the true power of popular government under law in America."

The editorial coincided that Sunday with similar editorials by *The New York Times*, the *Detroit News* and the *Denver Post*. None of them, however, had as much impact as *Time*'s, perhaps because it was so unexpected.

In its November 19, 1973, edition, the company's internal publication, *FYI*, described the process of writing the editorial and the public's reaction:

"News broadcasts carrying this announcement on Sunday evening, November 4, surprised not only the general run of listeners in the U.S. and abroad but also most Time Incers and even most of the staff of *Time* itself ... The editorial was written and closed in an atmosphere of secrecy like that surrounding the selection of *Time*'s Man of the Year.

Grunwald let it be known that he was working on an essay while actually he was drafting the editorial in collaboration with Editor-in-Chief Hedley Donovan. Board Chairman Andrew Heiskell, President Jim Shepley and Publisher Ralph Davidson knew of the plan, and the consultations also included Chief of Correspondents Murray Gart; Washington Bureau Chief Hugh Sidey; Nation Editor Jason McManus, and Assistant Managing Editors Ed Jamieson and Dick Seamon...

As the release began to appear over the wires on Sunday afternoon, various Time Incers were busy spreading the news among the family. Chairman of the Board Andrew Heiskell called other Board members. Acting Editorial Director Jerry Korn notified the various managing editors. Grunwald called his senior editors, McManus notified his staff, Gart wired the news bureaus and Davidson telexed ad sales offices."

The news didn't sit well with many readers. The public relations office was inundated by calls, first from the press and then from the public. A week after its issue date, 1,744 letters had arrived, the strongest reaction that *Time* had ever seen. The final count objecting was over 5,600. The letter from Clare Booth Luce, the founder's widow, added to the uproar. The letter, sent from her home in Hawaii, began: "Fifty-year-old *Time* has written its first editorial. It demands the resignation of the President. The 70-year-old widow of Henry R. Luce, *Time*'s founder and its Editor-in Chief for 43 years, is now writing her first letter to *Time*. And it condemns that editorial." Grunwald had to intercede to convince her that it was not advisable to publish her letter, since it could be interpreted as a face-off between the founding family and its current leaders.

Despite criticism, *Time* didn't stop pressuring for Nixon's resignation. When Ford took over as Agnew's replacement, the magazine welcomed him with an unusual cover title: "The New No. 2." In December, after the editorial, *Time* featured Ford again on the cover, next to his wife and under the title: "The New Second Family." To wrap up the year, *Time* designated Judge John Sirica, who presided over the Watergate case, as "Man of the Year."

Finally, defeated by the evidence that implicated him, Nixon announced his resignation on Wednesday, August 8, 1974, and officially handed it in the following day. On August 19, *Time* published a special edition devoted almost in its entirety to the subject. Gerald Ford appeared on the cover under the heading "The Healing Begins." Newsstand sales reached 527,000 copies, slightly more copies than the issue on the end of World War II and more copies than *Time* or any other news magazine had ever sold on the street.

When everyone thought that the Watergate issue had come to an end, Ford announced a month later, in September, "a full, free and absolute pardon unto Richard Nixon for all offenses against the United States which he, Richard Nixon, has committed or may have committed or taken part in ..." *Time* then devoted two more covers to the subject: the first with a dejected and aging Nixon under the heading "The Pardon," and the second with a serious and circumspect Ford under the heading "Ford Under Fire."

Watergate raised the profile of the newsmagazine and of group journalism. Prendergast, in *The World of Time, Inc.: The Intimate History of a Changing Enterprise: 1960–1980,* wrote:

"Like no preceding peacetime event, Watergate showed newsweekly journalism's distinctive strength. Even if the whole complex of events—the intelligence operation set up by Nixon's Committee to Re-Elect the President, the actual Watergate burglary attempt, the tangled cover-up—had become fully known all at once, it would have been overwhelmingly difficult to sort out and fully understand. To follow the story daily, through newspaper and television accounts, was a task requiring hours— and it would have helped to be a lawyer. The lengthening cast of characters and their misdeeds, alleged or proved, threatened to become a hopeless jumble: Nixon, Haldeman, Ehrlichman, Dean, Mitchell, Mardian—now what was his job? And he told whom to do what? Did Nixon know? And if so, was that a crime?

The newsmagazines' contribution was coherent narrative. Additionally, they contributed no small amount of original reporting. A story demanding teamwork, Watergate displayed *Time*'s group journalism at its best."

The end. The August 19, 1974, cover with Gerald Ford and the headline "The Healing Begins" was a success: the special issue sold 527,000 copies on newsstands, even more than the issue on the end of World War II (below, left). But first impressions of the new president were tarnished when, a month after taking office, he granted Nixon a full pardon (below, right)—confirming for many the suspicion, of which there is no proof, that the pardon had been preconditioned.

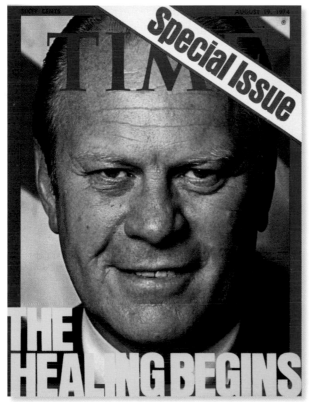

1974. Gerald Ford

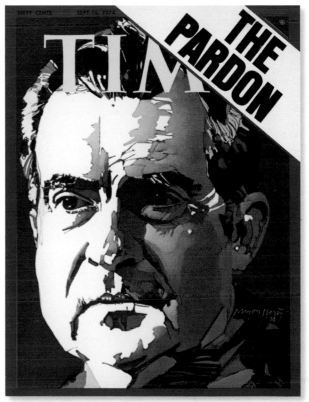

1974. Richard Nixon

Last Tango and Other Scandals

Following tradition, *Time* continued to reflect the week's news, but during Grunwald's tenure in the 1970s, *Time* also reported on topical social issues. Editorial's decision to cover social issues came about mostly as a response to readers' weariness of the negativity generated from Vietnam and Watergate. This type of issue, in journalism, has come to be known as "evergreen," or an issue that has a longer shelf life than the weekly news. At *Time*, this approach was characterized by the publication of covers and stories on psychological trends, new religious tendencies and other lighter, more entertaining subjects. To highlight these stories, *Time*'s covers were illustrated with symbolic or thematic images instead of those of newsmakers, since at times, there was no one face that represented the topic, but rather, several faces that were unknown to the general population. The goal of this trend in journalism, other than keeping the public informed about developments in society, was leisure and escapism. In addition, the magazine would have the possibility of opening up its pages to events that had never taken up much space in *Time*, such as the decade's feminist movement.

Trends and social issues

A cover story that really emphasized the tendency toward entertainment news was the November 9, 1970, issue on the emotional revolution among Americans. Joining the wave of what at the time was called "The Human Potential Movement," *Time* devoted ten pages to the subject, six of them photo spreads, to show how Americans were opening up to emotions and feelings, "... [a] wildly eclectic movement that is variously called sensitivity training, 'encounter therapy for normal's,' or the acidless trip ... to redefine and enrich the spirit of social man." The photos showed people unabashedly hugging and touching each other, participating in sensory awareness and nonverbal communication sessions, exteriorizing anger and practicing specific body movements to relieve stress, anger and to express moods and feelings. Many of these photos were taken at the Esalen Institute in California, where reporter Andrea Svedberg had participated in a ten-day course to get an inside look at the new psychological trend.

Another nontraditional story was "The Occult Revival," which *Time* published in its June 19, 1972, issue with the subheading "Satan Returns." It reflected the wave of fascination with the occult that began with the astrology boom and then extended to palm reading, reincarnation, astral projections, numerology, witchcraft and Satanism. The trend may have been popularized, in part, by NASA, which urged astronaut Edgar Mitchell to conduct extrasensory perception experiments aboard *Apollo 14*. With nine inside pages, four of them photo spreads, the article showed that many Americans had openly welcomed the occult phenomenon and the mysteries of the unknown, as well as parapsychology as a form of escape from the difficult social and political realities the country and the world were experiencing.

Other articles that examined new trends were published on March 5, 1973, when *Time* delved into the world of shamanism and mysticism by putting Carlos Castaneda on its cover, and later in the year on April 9, *Time* ran an illustration on the cover depicting a nationwide boycott, protesting the rising price of meat. In July, the magazine published "Monroe Meets Mailer," a cover story introducing the book *Marilyn*, written by the celebrated author Norman Mailer, on one of the most enigmatic and celebrated actresses of all time. The book focused on Mailer's lifelong fantasies about Marilyn, whom he had never met—encounters and

1970. Blue Collar Power

1978. Jonestown Deaths

Escape from reality. To help readers "escape" from the war and Watergate, *Time* covered "evergreen" topics," such as the "Blue Collar Power" issue published on November 9, 1970 (left, top). However, in the December 4, 1978, issue, *Time* couldn't escape reality—the massive cult suicide at Jonestown, Guyana, appeared on the cover (left, bottom). The June 19, 1972, cover, "The Occult Revival: Satan Returns," dealt with emerging interest in astrology, Satanism, witchcraft, palm reading, reincarnation, astral projection and numerology (opposite).

FIFTY CENTS

JUNE 19, 1972

TIME

THE OCCULT REVIVAL

**Satan
Returns**

Group sensitivity. In the November 9, 1970, issue, the magazine reported on "The Revolution in Feeling." The article included photographs taken at the Esalen Institute in California (above), one of the main centers of the growing phenomenon known as "the human potential movement." Eleven pages were devoted to the topic, showing scenes of sensitivity training and encounter therapy.

conversations with her that were a figment of his imagination or inspired by her actual answers in various interviews. The story ran under the heading "Two Myths Converge: NM Discovers MM," in the story's seven pages, illustrated with fourteen photos of Monroe with the cover by photographer Bert Stern. The subject was appropriate for the magazine given the difficult times the country was going through. *Time* again combined commercialism and escapism in its March 18, 1974, issue. The cover story was on the remake of the film version of F. Scott Fitzgerald's classic American novel, *The Great Gatsby.* Francis Ford Coppola wrote the screenplay and Jack Clayton directed the stars, Mia Farrow and Robert Redford, who appeared on the cover. Also

explored in the issue was the "streaking" trend, which led young and old to shed their clothes in what, according to the *Time* article, was "a form of escapism that doesn't seem sexual in nature. Students are working harder in school and this is letting off steam."

In addition to new trends, some fleeting and others more lasting, the magazine covered several subjects that shook the nation, among them, the shocking killing of Israeli athletes by a terrorist group at the Munich Olympics, which was covered in the September 18, 1972, issue, and, between February 1974 and May 1977, *Time* devoted three covers and twenty-four articles to the kidnapping of Patricia Campbell Hearst, daughter of media

magnate Randolph A. Hearst. After the ransom was paid, "Patty" remained with her kidnappers, participating with them in a bank robbery, and after her liberation, did not successfully prove in her trial that she had been psychologically tortured and brainwashed to commit the crime.

In 1973, just before *Time*'s discretely celebrated fiftieth anniversary, an event shocked and angered many readers. Interestingly, this time the news had nothing to do with the magazine's position regarding the war or the president's resignation. Unexpectedly, the scandal came from the film industry.

"Authentic moral and psychological Apocalypse," "Pornography with an overlay of philosophic angst," "The obscenity of scenes of carnal violence ... that go beyond artistic necessity," were among the negative comments voiced throughout the world regarding Italian producer, Bernardo Bertolucci's film *Last Tango in Paris,* starring Marlon Brando and young French actress Maria Schneider. The film's European debut led to outrage, public protest and censorship attempts as well as eight-hour waiting lines and sold-out showings. *Time* devoted its January 22, 1973, cover to *Last Tango in Paris*, with a watercolor and pastel portrait of Brando by Bob Peak, and a diagonal banner with the heading "Sex and Death in Paris."

Rather than following the usual practice of mentioning or explaining the subject of the issue's cover, the letter from the publisher, by Ralph P. Davidson, did not allude to the cover. Instead, Davidson mentioned another of the important changes made under Henry Grunwald's editorship—the new assignment for writer Hugh Sidey. Sidey, after a great career as Washington bureau chief, was to cover the presidency for the section "The Nation" as a permanent fixture at the White House. What surprised and shocked readers was

My days at *Time*
Henry Grunwald: "Text Tyrant"

Extracted from the book One Man's America: A Journalist's Search for the Heart of His Country *by Henry Grunwald, published by Doubleday, 1997.*

When I was a *Time* writer I had felt much the same way about the tyranny of the editors. And when I became an editor I was something of a tyrant myself. The jump from writer to editor is the most difficult move in the word game. Since *Time* editors were promoted from among the writers' ranks, they often confused the two crafts. So did I; I rewrote too much. Most of the writers suffered this with remarkable forbearance, or at least a show of it, but there were exceptions.

One was Brad Darrach, James Agee's successor as *Time*'s movie critic, whose boyish face looked perpetually puzzled when it was not contorted with the pain of writing. Once I heavily rewrote one of his pieces ... *Time* copy always carried the writer's name in the upper-left-hand corner; in those days without bylines it was the author's only mark of identification. Brad was so enraged by my interference that he blacked out his name on every one of the thirteen copies circulating in the office. On another occasion I sent a critical note requesting changes to Alexander Eliot,

the magazine's art critic. In a fury Alex sent back my message torn into small pieces with a terse covering memo: Your shameful note is entirely unacceptable.

In an interview with the authors, from 2009, Walter Isaacson—managing editor from 1996 to 2000—recalled:

... in 1978, after writing a story on President Jimmy Carter, Grunwald returned my copy with a big red circle on the opening sentence, "Prior to taking office, Jimmy Carter ..." and a side note saying: "Prior is a God-awful word." I didn't have it any better when I wrote my first cover text on the Colombian cocaine traffic: "I've read the cover on cocaine and it seems reasonably good. The only thing I'm missing is a justification for why we are doing it," commented Grunwald.

Grunwald knew he was tough on writers, he used to refer to himself a a "text tyrant." Both Grunwald and one of his mentors at Time—Senior Editor Whittaker Chambers, another obsessive editor who during that era was editing the Back of the Book—have gone down in Time's *history as "text tyrants."*

Demanding editors. Henry Grunwald (left), Hedley Donovan (seated) and Ralph Graves (right) were at the helm of Time Inc.'s editorial department in the late 1970s (below). Grunwald, who was then editor in chief of Time Inc.'s magazines, referred to himself as a "text tyrant."

The scandalous tango. The magazine's coverage of the Italian director Bernardo Bertolucci's film, *Last Tango in Paris*, was as unexpectedly daring as the film itself—especially the frontally nude photos of its two stars, Marlon Brando and Maria Schneider (above). In Paris, the scandalous film led to sold-out performances, and in Italy, to threats of censorship. Many readers complained and cancelled subscriptions over *Time*'s "scandalous" coverage.

what they found starting on page fifty-one in the "Show Business" section, under the title "Self-Portrait of an Angel and Monster." Particularly alarming to readers was a shot with partial frontal nudity of Brando and Schneider that, along with an image of the two stars dancing the tango, took up just under a third of the opening.

Although the text was informative and balanced, placing equal emphasis on criticizing the film as pornographic and praising the film as artistic, *Time* minced no words in the description of the carnal violence in the film's most scandalous scene:

"For Paul, 'happenis' as he calls it, is the brutal possession and degradation of a woman. The scenes in which he accomplishes this with Jeanne—who is excited, intrigued and masochistic enough to go along—are what might be called the hard core of the film. In one he asks her to insert her fingers in his anus, then exacts a vow from her that she would prove her devotion to him by, among other things having relations

with a pig. In another, the culmination of the subjugation process, he wrestles her to a prone position on the floor and sodomizes her while forcing her to recite a litany rejecting love, family, church and other values.

The sexual positions vary and so do the psychological ones, until it is difficult to say who is the victimizer and who is the victim. Jeanne, however humiliated, is merely having an adventure. Paul is warming himself against the chill of mortality."

But no explanation of the informational need or the interpretation of the film's positive message could contain the indignation and protestations of *Time*'s readers. An annual compilation by María Luisa Cisneros, who was in charge of the *Time* Letter Report, highlighted the readers' anger. Readers flooded *Time* by even more letters than the then-record-breaking 3,500 letters sent in over the articles "Is God Dead?" and "Sex in the U.S."

The complaints accused the magazine of fostering pornography. As the report read:

"It wasn't the pictures in the *Last Tango* cover story that caused all the commotion. What brought down the house, and gave indignant readers a field day with the editors, was the explicit way in which the movie's scenes were described and the fact that a 'respectable magazine' would feature such a film on the cover. The letters, which came from all parts of the U.S., were mostly from middle class American families who held *Time* responsible for exposing their teenage children to 'such garbage,' 'Sodom and Gomorrah in spades,' 'vulgar sex,' 'sexual pollution,' etc."

The story actually led 6,705 readers to cancel their subscription to the magazine.

Tête-à-tête. The January 22, 1973, cover story about *Last Tango in Paris* dealt with the "fearful ambiguities of sex and death" (below, left). Artist Bob Peak painted the cover portrait of Marlon Brando to mirror that ambiguity—light illuminates one half of his face, the other half is shadowed and he is depicted with the arched brow of a villain—to illustrate the article, titled "Self-Portrait of an Angel and Monster" (below, right).

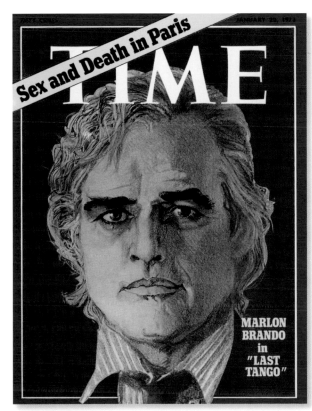

1973. Marlon Brando

Women's Liberation in *Time*

In 1968, New York members of the National Organization for Women (NOW) and other women's liberation activists picketed the Miss America pageant in Atlantic City, New Jersey. Most frequently mentioned in the press, to this day, is the "freedom trash can," into which some activists threw items to protest what Miss America represented, such as high heels, *Playboy* magazines and bras. On August 26, 1970, the fiftieth anniversary of women's suffrage, members of NOW organized a "Women's Strike for Equality," which included nationwide protests and rallies.

Several newspapers and magazines expressed solidarity with the movement, some urging that one of their issues be devoted totally to women. What followed were articles and debates on equal pay for equal work, breaking the corporate glass ceiling, abortion reform, creating permanent day care for children of working mothers and the eventual abolition of patriarchy. Although, for a long time these issues had been covered in the press infrequently, it was not until 1970, with Kate Millett's publication of *Sexual Politics*, that the movement found common ground and an ideologist. Millett had received her Ph.D. in English from Columbia University; her dissertation was the basis of her book. She became one of the leaders of the women's liberation movement.

Millett made *Time*'s cover in the August 31, 1970, issue. Across the top left of the oil portrait of Millett by Alice Neel was a banner that read "The Politics of Sex." It was an eight-page article for which, in a first for the magazine, fourteen women had researched and conducted interviews. Ruth Mehrten Galvin, *Time*'s correspondent in Boston, who specialized in the behavioral sciences, headed the team. The final version was written by B. J. Phillips, a woman, and Bob McCabe. The last two pages were devoted to an essay by Gloria Steinem, which was published with the headline "What it would be like if women win." In the introduction, Steinem wrote "Seldom do utopias pass from dream to reality, but it is often an illuminating exercise to predict what could happen if they did. The following are very personal and partisan speculations on how the world might be different if Women's Lib had its way ...":

Men's lib: "... Men in general [have] a shorter life span than women ... With women bearing half the financial responsibility, and with the idea of 'masculine' jobs gone, men might well feel freer and live longer."

Religion: "Organized religion will have to give up one of its great historical weapons: sexual repression ... in the future it will become an area of equal participation by women...."

Manners and fashion: "Dress will be more androgynous, with class symbols becoming more important than sexual ones ... Women with normal work identities will be less likely to attach their whole sense of self to youth and appearance ..."

"... In other words, the most radical goal of the movement is egalitarianism. If Women's Lib wins, perhaps we all do ..." she concluded.

"It did not hit me in the face but kept poking and prodding me," Grunwald wrote, describing his initial take on women's liberation:

"... The images of the long-legged goddess bestriding the world, and of the all-American bitch so dear to middlebrow literature, had faded. Instead there were the new feminist guerrillas manning the barricades— many of them pedantic enough to object to the use of 'manning.' In a

Right time, right place. In the late 1960s, coverage of the women's liberation movement was increasing, spurred, in part, by the 1968 picketing at the Miss America pageant in Atlantic City, New Jersey. Pictured are women's liberation activists marching on Wall Street in August 1970 (opposite).

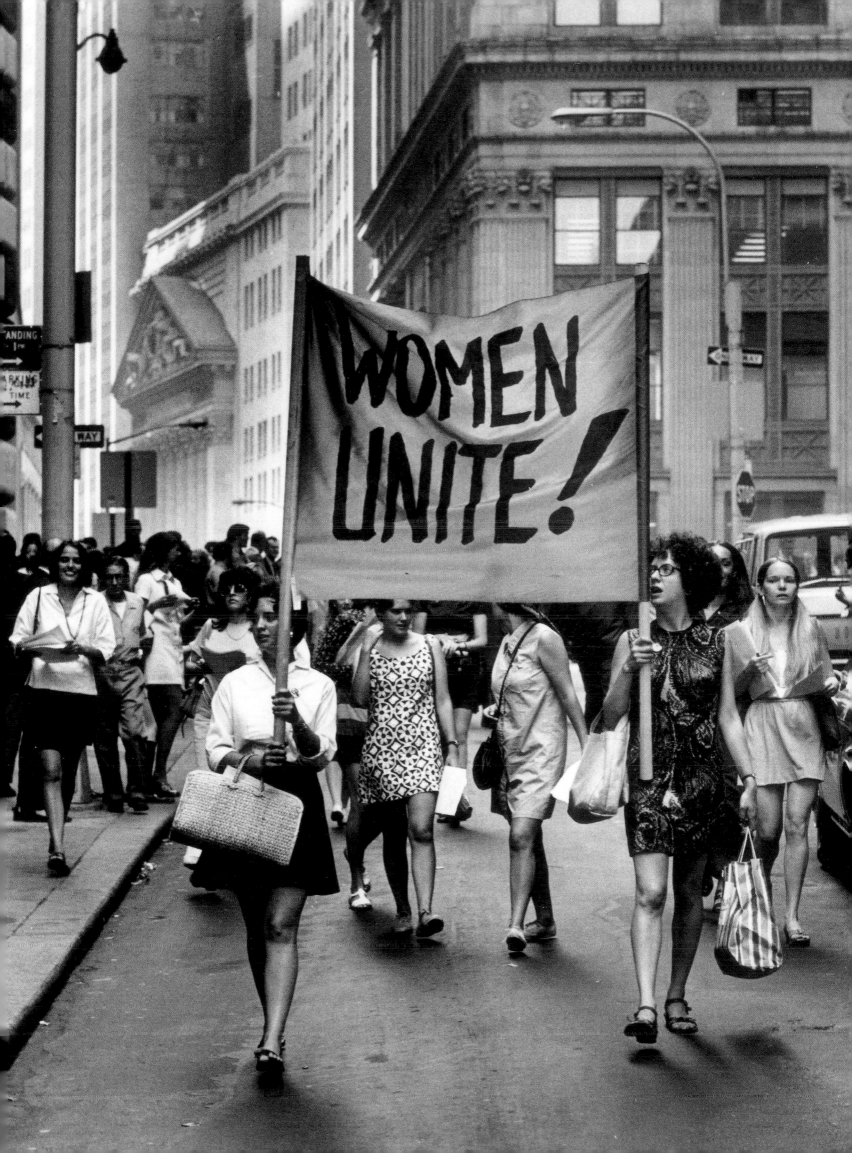

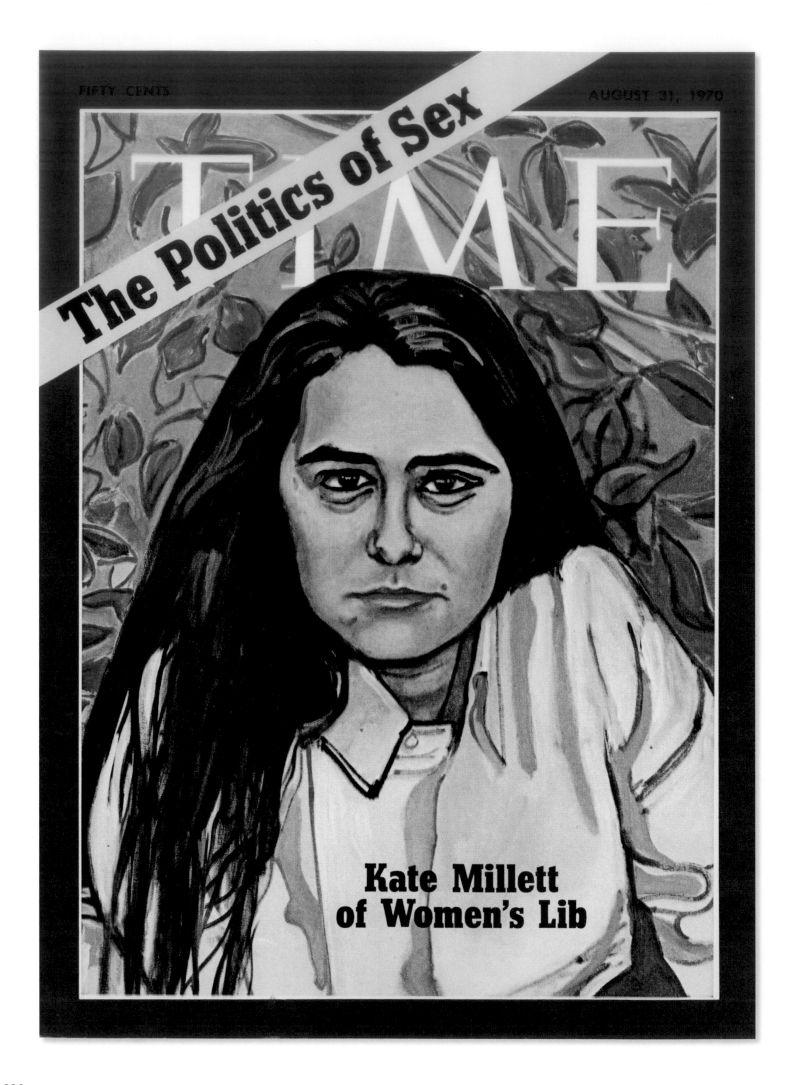

near fatal trend toward self-caricature, they advocated 'herstory' instead of history and 'girlcott' instead of boycott. Feminine endings were swept away—sculptor, not sculptress, for Louise Nevelson—but in *Time* I managed to hang on to actress and waitress. I also resisted chairperson and, especially, the idiocy of 'chair.'"

Among the fiercest of these militants was Millett ... Her former thesis adviser at Columbia University remarked: 'Reading *Sexual Politics* is like sitting with your testicles in a nutcracker.' In it she argued that 'patriarchy,' including the family, must be destroyed. She claimed that there was little biological difference between men and women with the exception of the specific genital characteristics. That, I thought, was quite an exception. We put her on *Time*'s cover, and she sternly looked out at the reader from under unruly dark hair. (Her mother, though a proud supporter of her daughter's views, complained that 'Kate's missing the boat if she appears ... without her hair washed')."

Despite its managing editor's reticence and personal objections on the subject, *Time* noticeably struck a balance in the story, which mentioned that the movement and women's efforts on behalf of equality were a century old and that they could no longer be dismissed or ignored:

"The status of women—America's numerical majority at 51% of the population—remains today as relentlessly second class as that of any minority. A third of the American work force is female: 42% of the women 16 and older work. Yet there is only one economic indicator in which women consistently lead men, and that is the number living in poverty ... Even when women enter more 'traditional' fields, they have trouble reaching the top. Nine out of ten elementary-school teachers are women, but eight out of

Sexual politics. The cover of the August 31, 1970, issue of *Time* was devoted to Kate Millett, whose portrait was painted in oil by Alice Neel (opposite). The article referred to her as "the Mao Tse Tung of Women's Liberation."

1970. "Nation": Who's Come a Long Way, Baby?

Women for women. *Time* devoted eight pages to the cover article on Millett (above)—it was the first time that women from the magazine's editorial staff—fourteen—were involved in the research, interviews, writing and editing. The subject of male-female dynamics had become so important that in the January 8, 1973, issue, "The Sexes" section made its debut.

ten principals of these schools are men. Harvard will have two tenured women professors in its arts and sciences faculty this year; there were none last year. Yet 15% of the graduate degrees awarded at Harvard in recent years have gone to women."

On March 20, 1972, *Time* once again highlighted women's progress: it devoted the cover and sixty of the issue's 104 pages to "The American Woman." Eighteen women headed by editor Ruth Brine, helped to produce, research and write the issue. Its one-page introduction, titled "The New Woman, 1972," read:

"... Another New Woman has emerged, but she is perhaps for the first time on a massive scale, very much the creation of her own, and not a masculine imagination ... The New Feminism ... is a much broader state of mind that has raised serious questions about the way people live—about their families, home, child rearing, jobs, governments and the nature of the sexes themselves."

The article explored the current status of women in America, and each section of the magazine was geared to the topic of women.

That same year, in a November 6 memo that he sent to Boston Bureau Editor Ruth Galvin, Henry Grunwald wrote:

"I would like to start a new section in *Time* to run occasionally—probably in alternate weeks with Behavior. It would be called 'The Sexes.' It would include those Behavior stories that deal with sexual behavior, but also with the relations between the sexes in a wider sense, as for instance, in the Women's Lib area. There is some risk that this would deplete the Behavior section, but I still think there would be enough left over to keep it entirely viable and it might generate some stories we might otherwise not do."

The following week, Galvin responded with a page and a half of proposals and editorial approaches. As a result, "The Sexes" section officially came out in

Time on January 8, 1973. The section's debut spread over two pages. One of the three stories was about British biologist, Alexander Comfort, who predicted unconventional sexual matches in the future and favored "open marriages."

But no *Time* homage to women's liberation or the advent of the new woman managed to surpass the one in the January 5, 1976, issue, when the magazine devoted the cover and fourteen pages inside to the "Women of the Year." The production, writing and editing team was made up of fourteen women and two men. Twelve women graced the cover, including First Lady Betty Ford, Governor Ella Grasso, author Susan Brownmiller and tennis player Billie Jean King—all female success symbols. The story and inside photos celebrated military women, mothers, professionals, scientists and homemakers who juggled family, work and sexual independence.

"They have arrived like a new immigrant wave in male America ... Across the broad range of American life, from

More coverage. *Time* started to provide more stories on women. In 1972, the magazine issued a special edition with sixty pages devoted to "The American Woman" (below, left). Popular performer Cher occupied the cover on March 17, 1975, when she won the Golden Globe Award for Best Actress (below, right). *Time* predicted that Cher might "Redefine that grand old American catchphrase 'family entertainment.'"

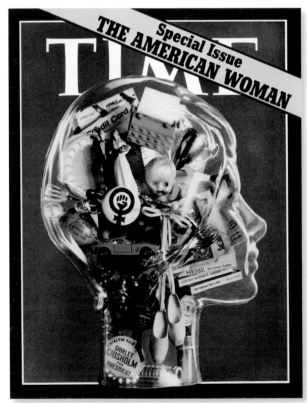

1972. The American Woman

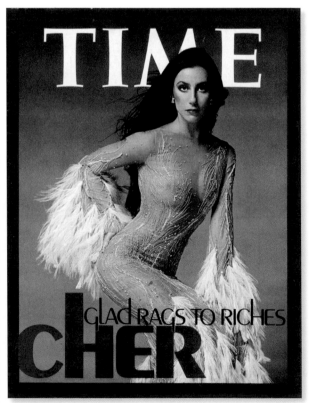

1975. Cher

suburban tract houses to state legislatures, from church pulpits to Army barracks, women's lives are profoundly changing and with them, the traditional relationships between the sexes."

Time devoted the last few pages of the long article to list the men who had been considered but eventually rejected as contenders for the "Man of the Year" distinction. The list included President Gerald Ford, Henry Kissinger, Senator Patrick Moynihan and leaders Anwar Sadat of Egypt and Teng Hsiao-Ping of China and also nuclear physicist, dissident and human rights activist Andrei Sakharov of Russia.

From then on, Time would continue to note women's accomplishments and their progress in American society. For instance, Time devoted the December 5, 1977, cover and seven inside pages to the National Women's Conference, held in Houston that year, and on June 16, published "Women in Sports," with the cover and seven inside pages celebrating not only women's access into mainstream

sports but also the changes they were making in American sports.

Despite its efforts, Time drew criticism from two communications professors at Trinity University of San Antonio, Dr. William Christ and Dr. Sammye Johnson. In their published study, Women Through "Time:" Who Gets Covered? the professors noted two significant points about Time's covers on women from 1923 to January 5, 1987. First, during the period studied, Time devoted 441 covers to women, an average of one every 7.5 issues. Second, the professors were greatly disappointed to note that the magazine had ignored "the great strides women have made in the work force in the past two decades." According to their research, only three CEOs or business executives had made the cover of Time: Helen Reid, Vice President of the New York Herald Tribune media group, in 1934; Elizabeth Arden, founder and CEO of Elizabeth Arden Cosmetics, in 1946, and Dorothy Chandler, President of the Times Mirror Co. communications group, in 1964. Most of the Time covers featuring women were devoted, according

to the researchers, to "entertainers, artists, spouses, or socialites."

The professors' conclusions are accurate: actress Eleanora Duse was the first woman to appear on the cover in 1923; followed by the Duchess of Windsor (Wallis Warfield Simpson), named "Woman of the Year" in 1936; and in 1977 (the year in which Grunwald stopped editing the magazine), a record of twelve covers with women was published, among them Amy Carter, Linda Rondstadt, Marabel Morgan, Lily Tomlin, Diane Keaton and a special December issue devoted to female politicians. "During the 1970s," the study concluded, "80 women were on Time covers, a number unlikely to be matched during the following decade, since there were only 32 from 1980–1986."

Leaders and heroines. In 1975, Time designated its traditional "Man of the Year" as "Women of the Year." Twelve women occupied the cover, among them politicians, journalists, educators and athletes (below, left). On December 5, 1977, the magazine devoted its entire issue to the National Women's Conference in Houston, concluding in its cover story, "it is a particularly exciting time to be a woman" (below, right).

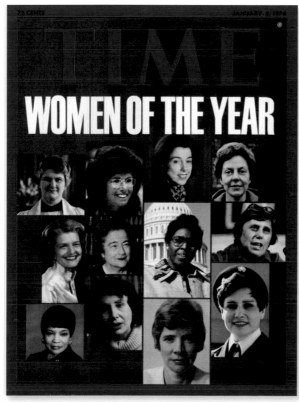

1976. American Women, "Women of the Year"

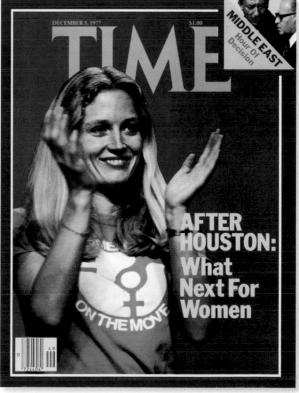

1977. Women's politics

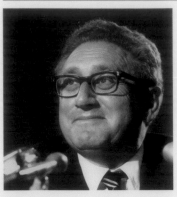

Henry Kissinger: The Magazine Was Always Fair with Me, But Not Always Flattering

In this essay, commissioned in 2009 for this book, Henry Kissinger recounts his history with Time.

To be on the cover of *Time* once is important enough. When you appear fourteen times, as I did in a relatively short period of about ten years, that makes you, to some extent, a celebrity. I never feared a *Time* cover. I knew former Managing Editor Henry Grunwald, and I was confident the cover would always be fair, even if not always flattering. The first time it happened it was quite unexpected, since I never expected to be on the cover of *Time*. I had just been appointed Security Advisor. I wasn't used to being a figure of public interest when I came into the Nixon Administration. I don't think that the heads of state or dignitaries with whom I was in contact at the beginning of my tenure in the government paid me much attention. But after several more covers, that changed. People forget today that I did not start out being a major public figure; in the first three years of being in office as Security Advisor, until around 1971, when I took the secret trip to China, I was only in the index of *The New York Times* five or six times a year.

I don't think I had met Henry Grunwald before I became Security Advisor but, after that, he invited me for meetings with the editors of *Time* every two months or so. Then we began to occasionally meet socially. Later on, he was very troubled about Watergate, and he ultimately made the decision—that I disagreed with strongly—to demand Richard Nixon's resignation. I wished Henry had handled it in some other way, even though that did not diminish my high regard for him. He was thoughtful, honorable and fair. Besides, I also had high regard for Hedley Donovan. Therefore, I never considered myself in moral or personal conflict with *Time*'s management.

Of all the *Time* covers on which I appeared, I did not like the one that *Time*

used for the publication of my memoirs in 1979. When *Time* published an excerpt of my memoirs, and they gave a party in my honor, I started my speech there with a joke: "Ladies and gentlemen, and the man who posed for my picture...." I like the one showing Ford's team.

For me, the "Man of the Year" experience was a nightmare. Other people would give their lives to be *Time*'s "Man of the Year," but when you are a presidential assistant, and they give you equal standing with the President, and when they are implying by this that the President who, after all made all or many of the big decisions, really did not make them by himself, it's a suicidal position. So I called Hedley Donovan many times and begged him to take me off the cover. I'm sure that this had never happened before: how can you call *Time* to beg them to take you off the cover as Man of the Year? And finally, after the tenth time, he said to me, "If you call one more time, we will make you the *sole* Man of the Year!" However, Nixon put no pressure on me, never complained to me. I really thought that this incident might lead to his firing me, but there was nothing I could do about it. Nixon behaved with great generosity.

I am often asked how I now see the two most difficult periods during the time I served—Watergate and Vietnam—in perspective, after so many years. I thought Watergate was a tragedy. I did say it then, and I do say it now that Nixon did a number of ill-advised things for which he should be severely criticized, but I did not think then, nor do I now, that it justified practically paralyzing the whole machinery of government for over two years. Nor did I want the resignation of the President; it could have been dealt with in a less drastic manner. That was my view then, and it is my view now.

Regarding Vietnam, I started out as a professor; my interest was European policy and strategy, and I was not involved in it

at all until 1965, during Lyndon Johnson's term. I was asked to go to Vietnam as consultant to Ambassador Lodge to give an outsider's view about conditions there. Then, when Nixon became President, and he appointed me as Security Advisor, the situation was that there were 550,000 Americans in place, and we were the country on which the defense of the free world depended. Russia was a major country and a major threat. So, for us, we could not just end the war like changing a television channel. We owed something to the people who, in reliance on our promises, had cast their lot with us. The heartbreaking thing to me was not that there was disagreement, because that was bound to happen, but that it took the form of an assault on the essence of government, which was described as a war-loving, bomb-happy Administration. Nobody could have wanted peace more than those who saw the daily casualty lists.

During the war, I attempted to be open to demonstrators and critics. When we had anti-war demonstrators in front of the White House, I would always send a staff member out to bring groups of them into my office and give them a chance to express their views. During the Cambodian crisis, I put aside two hours every afternoon for meetings with the demonstrators, whom we collected at random from protesters in front of the White House; some were students, others were professors. I respected the critics, but we also had a responsibility to those who depended on America.

It is well known that *Time* was at first in favor of Vietnam and then against it. When a highly influential magazine like *Time* goes against or in favor of one of your significant policies, that's a fact you cannot ignore. On the other hand, I still remained very friendly with the magazine and Grunwald, who did not ask my opinion before he decided to publish the editorial advocating Nixon's resignation. Had he consulted me, I would have done my utmost to dissuade him. Let's say I was disappointed but probably not surprised.

During my years of government service, there were three events that moved me most. The first was when the North Vietnamese accepted the proposal that Nixon had made four months earlier and had then been rejected. The second was when I was sitting in a room with Anwar Al Sadat in Aswan, and he got up, kissed me on both cheeks and said they had just received word that a disengagement agreement between Israel and Egypt would be signed that day. He was taking off his military uniform that day and would not wear it again, except on ceremonial occasions. The third was the first time I arrived in China. The worst was the day when we evacuated Vietnam.

As for my personal history, I was very unexpectedly given an opportunity to serve the country that saved me and my family in such a responsible post. I say "unexpectedly" because I had been a supporter of Nelson Rockefeller, who had opposed Nixon in three campaigns. So when Nixon was elected President, it never occurred to me that I would become his National Security Advisor. Before I took this position, I had never given a press conference and, suddenly, I was on a public stage with a lot of public attention. I looked at *Time* as a sort of a counterpoint for what I was doing, but also as a moral support in our effort for bringing the country together.

Protagonist of an Era. Henry Kissinger recalls his relationship with *Time* during his years in office—not always in agreement, such as *Time*'s view of Vietnam (below, left) and being chosen with Nixon as "Men of the Year" (below, right).

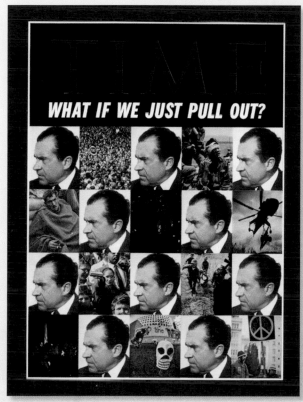

1969. Nixon and Vietnam

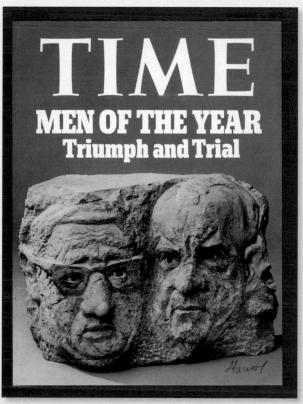

1973. Kissinger and Nixon, "Men of the Year"

7

The Color, Image and Design Revolution

In October 1977, *Time* underwent a substantial change. During his nine and a half years at the helm of *Time*, Henry Grunwald, the Austrian émigré who began working for the publication as a young man almost forty years earlier, had given the magazine a European touch, devoting more space in its pages to issues related to art, music, literature, sociology and the environment, and more depth and breadth to its stories. He was replaced as editor by Ray Cave, who became the first managing editor not to rise from the ranks of the publication. Cave was not a "*Time* man." He had joined the magazine as assistant managing editor in March 1976 from *Sports Illustrated (SI)*, the company's sports weekly. Most of his experience came from that magazine, which he had joined as a full-time writer in August 1959.

The appointment of Cave, in itself, was an important change. It meant a break in a tradition, since all former editors had come from the magazine's editorial echelons. Cave's appointment caused a stir among the staff at *Time*, considered by both insiders and outsiders to be a very rigidly structured institution where editors started out at the bottom as reporters and climbed up from there. The arrival of an outsider to the magazine's top post was unprecedented, but a risk that Donovan decided to take. "It's a gamble I wouldn't have taken," Cave said, in an interview with the authors.

Several years after having overcome that challenge and rumors predicting his failure as a manager, Cave summarized this early period:

"In about 1973, I wrote a long memo just for [Hedley Donovan] about how I thought *Time* might be improved. I did it because I love

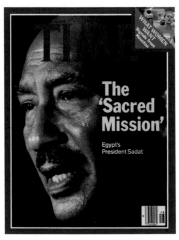

1977. Anwar Sadat

Inauguration. January 1977 saw the inauguration of the new president, Jimmy Carter (opposite), as well as the inauguration of a new color printing technology for *Time*. Using the "Fast Color Extended Program," the magazine was able to include four-color photos of events that happened on the very day the issue went to press. Four pages of color photos enhanced the November 2, 1977, cover story on Egyptian President Anwar Sadat's historic visit to Israel (left).

THE INAUGURATION

WALTZING INTO OFFICE

He has sounded forth the trumpet
that shall never call retreat;
He is sifting out the hearts of men
before His judgment seat;
Oh, be swift, my soul, to answer
Him! Be jubilant, my feet!

For some, the high point was Jimmy Carter's unexpected thank-you to Gerald Ford "for all he has done to heal our land." For others, it was Carter's unprecedented stroll down Pennsylvania Avenue from the Capitol to the White House after he was sworn in. But for many, the most memorable—and symbolic—moment came when a black choir sang the *Battle Hymn of the Republic* in honor of a Southern President.

A century of Southern estrangement from the nation was over. A remarkable political journey—one that led in only two years from the red clay fields of south Georgia to America's highest office—was at an end. Jimmy Carter, at 52, was the 39th President of the United States.

Few seemed less awed by the transformation than Carter himself. With Rosalynn and nine-year-old Amy in tow, he strolled like a tourist up the driveway to his new home. "Where do I live?" he asked White House Chief Usher Rex Scouten. Scouten promptly led the family upstairs to the presidential quarters that had only that morning been vacated by the Fords.

Someone had asked Carter the night before his swearing-in if he were nervous about becoming President. "No," he answered after a moment's reflection. "I'm sorry, but I'm not." He plunged immediately and vigorously into his work. Within a day he had issued his first Executive order, pardoning all Viet Nam-era draft evaders who were not involved in violent antiwar acts *(see story page 15)*. He also issued a statement urging Americans to save energy by turning down their thermostats to 65° F. in the daytime and even lower at night. Carter found time to select the desk he will use in the Oval Office: made of oak timbers from the British ship *Resolute*, and a present to President Rutherford Hayes from Queen Victoria, it was last used by John Kennedy.

This week Carter's Cabinet meets for the first time. The new President will probably also attend some of the first daily 8 a.m. staff meetings, to be presided over by White House Counsel Robert Lipshutz. High on the agenda: domestically, Carter's plans to reorganize the Executive Branch, reform welfare and stimulate the economy; in foreign affairs, a review of the negotiations over a new Panama Canal treaty and arms talks with the Soviets.

Carter's first acts as President came against the background of a notably subdued Inaugural Address. Even many of his supporters found it disappointing. It was more effective when read than when heard in Carter's singsong cadence. It contained no calls to glory, no "finest hour" rhetoric. Carter took a rather humble stance toward the American people and the rest of the world. His pledge to liberty ("We can never be indifferent to the fate of freedom elsewhere") provided a marked contrast to John Kennedy's ringing "We shall bear any burden" of another age. The speech offered some typical Carterian balances: warnings that we cannot do everything and exhortations that we must try to do nearly everything. Carter said he wants to be remembered as a President who furthered racial equality, helped provide jobs for everyone, and strengthened the American family. But he also said that "we can neither answer all questions nor solve all problems." He held out the startling vision of total nuclear disarma-

CARTER, AFTER THE INAUGURATION, ON HIS FIRST VISIT TO THE OVAL OFFICE
"I think I have a chance to be a great President."

ment, or at least a first step toward it. He was alluding to the signing of a new strategic arms limitation agreement with the U.S.S.R. Two days earlier, in a speech plainly aimed at the new American leader, Soviet Party Boss Leonid Brezhnev also gave top priority to a new pact before the SALT I treaty expires in October. Said Brezhnev: "Time will not wait."

But Carter also pledged to maintain military strength "so sufficient that it need not be proven in combat." These "yes, but" formulations can be irritating, suggesting as an attempt to have it both ways. But they may be closer to complex reality than simpler, more one-sided assertions. Typical of the Carter approach was his statement that he had no new American dream to offer, but wanted the old dream renewed, that Americans must adjust to changing times but cling to unchanging principles.

That last thought he attributed to his high school teacher in Plains, Julia Coleman, who encouraged his interest in literature, art and music and who died in 1973. Immediately after Miss Coleman in the speech came Micah (few other American politicians would hazard such a juxtaposition), an Old Testament prophet who lived during the Assyrian conquest of Israel in the 8th

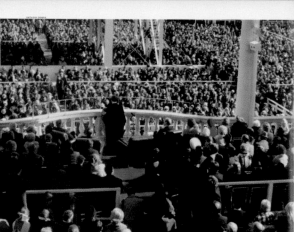

CLOCKWISE FROM LEFT: FORDS AND CARTERS LEAVE WHITE HOUSE EN ROUTE TO OATH-TAKING; CARTERS STROLL DOWN PENNSYLVANIA AVENUE AFTER INAUGURATION; NEW PRESIDENT SPEAKS IN FRONT OF CAPITOL; FIFE AND DRUM CORPS PASSES IN REVIEW; SPECTATORS ALONG PARADE ROUTE.

magazines and thought that there were things that *SI* knew that might benefit other in-house titles. *Time* had visual problems around 1977 or so. Its design was rugged, it was not consistent, it did not work.

My appointment at *Time* was a combination of things. *SI* was at the time the only magazine, probably the only one in the world, making extensive use of what we call 'fast color.' *SI* was used to working on tight deadlines using color photographs, and it developed the ability to do that by going to offset presses, by having numerous presses doing the job. Because when a football game ended on Sunday, and the magazine had to get the coverage out quickly, *SI* had the technical tools and knowledge to do that. And *SI* got better and better at doing it all the time. By the time I left *SI*, it was almost a four-color magazine. All this trained me in an aspect of magazine-making that turned out to be exactly what *Time* would need at that moment.

I think that top management wanted somebody from outside who could bring a little different visual sense to *Time* and certainly could bring more color photography to the magazine. On top of all this, they knew I would want to do it because of my memo from four years before. Hedley Donovan asked me to go to *Time* in March of '76, and I became managing editor in September 1977. There were so many other reasons I was asked. One was that *Time* was losing ground to *Newsweek* on newsstand sales, to the point that newsstand sales between the two magazines were almost equal, and that was causing discomfort since the previous difference had been substantial. The other reason was that *Time* was losing ground economically. (Cave's interview with the authors)

When Cave arrived at the magazine in 1976 as Grunwald's second-in-command, color was devoted, for the most part, to the "early forms," so called because they were the first to go to press, usually several weeks ahead of time. Black-and-white pages were closed just a few days before the issue came out. This was the practice since the 1950s in all of the company's publications. But in the mid-1960s, *Sports Illustrated*, forced to compete with color TV, left behind other Time Inc. publications and switched to the faster offset color printing method, which used film to prepare color plates. In 1972, *SI* started publishing thirty-two color pages every week. On the other hand, *Time*, continued to use typeset printing, with only two or three content pages in color out of the forty-eight to forty-nine editorial pages in each issue.

Donovan recognized that Cave was the man who could give *Time* the new look it needed with a change in technology. It was a change that would also modify the magazine's editorial structure.

With Cave at headquarters, it was decided to proceed with what was internally known at *Time* as the "Fast Color Extended Program." Grunwald put Cave in charge of the program, and fast color was first featured in the magazine's editorial pages in the January 31, 1977, issue, with the cover devoted to Jimmy Carter's inauguration as president. Twelve color pages were published, five of them with fresh photos of the events, taken the day the magazine closed.

Although this accomplishment placed *Time* several steps above its competition, it was obvious that another urgent need existed: to make a profound change in the magazine's graphics that would involve both inside pages and the cover—from typeface in particular to design in general. The responsibility of implementing this process fell on Cave.

"Shortly after I jumped on board, Henry and Hedley decided to advance the question of the redesign because it was actually the time to do it. Henry said he was starting to look for art directors to do the job, and asked me to have lunch with a man named Walter Bernard. By the way, Henry had a highly visual eye himself, but what mattered to him most at *Time* was not visual, it was text, words. Henry was a real intellectual and I was a huge admirer of him. He was a great man. He got intellectual weight into the magazine, something I could not have done. Walter's arrival was a major factor in what we were able to do with the magazine. Both he and his partner, Milton Glaser, were then considered the best designers in the business. I told Henry that I was highly impressed by him and he later decided to hire him. In my initial conversation with Walter, I said that I thought the magazine's design was choppy. He understood perfectly well what I meant by that. The prototype he brought had bigger pictures, it had column rules, the corner flap, etc., etc.... It was a success at *Time*."

Hard news in color. "Fast" color made its debut on January 31, 1977, with the coverage of President Jimmy Carter's inauguration. Thanks to the new color print process, one photo from the inaugural ball (opposite, top) and several color photos from the inauguration day events (opposite, bottom) were included in the twelve-page story. Although fast color gave *Time* the competitive advantage, the magazine soon realized the need of a redesign to make better use of images.

The First Major Redesign

"Whatever redesign is made, care must be taken to avoid a drastic change in character or personality, especially in a successful magazine. The editors want to make changes, but they also want them to pass unnoticed in order to avoid complaints. Their message is 'Help me, but don't hurt me,' or 'Change me, but don't touch me.' Whoever has subscribed to *Time* for twenty-five years believes that the product belongs to them and it is difficult to take the changes in stride."

This was the premise that Walter Bernard, of the New York design firm WBMG (from his initials and Milton Glaser's), used when *Time* called on him to redesign the magazine in 1977. Why did they choose him? Partly because of his experience: Bernard had studied graphic design at the School of Visual Arts, had catapulted in the mid-1970s to assistant art director at *Esquire* magazine and was soon art director at *New York* magazine under design director Milton Glaser, who became his partner; and partly because he was able to persuade the *Time* editors that his proposal would solve their concerns.

"A large part of my proposal, was simple and based on maintaining the organization and clarity of the publication. Neither the editors nor I wanted *Time* to be a new magazine, rather, that it continue to be *Time* but with a more modern and elegant look, with a visual and graphic style all its own ... Henry was on tour of some European bureaus, but he called me to tell me that he wanted the redesign in three months. 'Keep it secret and talk to Cave only,' he said. The proposal they sent stated that if they accepted the redesign I would be appointed as the new art director to execute it. If not, I would just get paid $25,000, which was

very good money at the time. I made a dummy, which I still have, and about fifteen different covers. I brought Rudy Hoglund in to help me, promising him that if I was appointed art director, I would also hire him as my assistant.

I had frequent meetings with Ray Cave, who gave me his impressions and answered my questions while I developed the redesign. Finally, when I finished the prototype, *Time* set up a meeting presided over by Henry Grunwald and also attended by Jason McManus, Cave, Ralph Davidson (from publishing) and Assistant Managing Editor Jamieson. Everybody loved the redesign, which was accepted in 1977 and was implemented in October of that year. However, Grunwald wanted the corner flap and the new logo in the magazine right away. Several meetings later, we agreed to slowly increase the color pages. At the beginning, we only had twelve, of which six had to close a week in advance. Ray brought all his color knowledge and experience from *Sports Illustrated* and since he had become managing editor, we started to include more and more color pages that could close at the last minute.

Cave revolutionized the use of color in *Time*. He was a visionary and we got along very well since he consulted all key editorial decisions with me. I stayed three years as art director, from July 1977 to July 1980, but my assistant Rudy stayed for fifteen years, and later he would be my successor in the job, hiring Arthur Hochstein (current *Time* art director) as his assistant.

It is important, not only to conceive and execute the new design, but also to make sure that the team understands the change, so that they can continue to apply the concept in the future—something that can take time and that in many cases requires individual

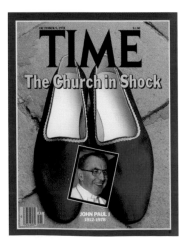

1977. Diane Keaton

1978. The Church in Shock

New covers. These three covers (left, top and bottom, and opposite) include Walter Bernard's cover changes: a larger red frame; a stylized, centered logo; Franklin Gothic type for headings; and the "cornerflap," now called the "*Time* flap," an ingenious innovation that gave the magazine the option to feature another story on the cover.

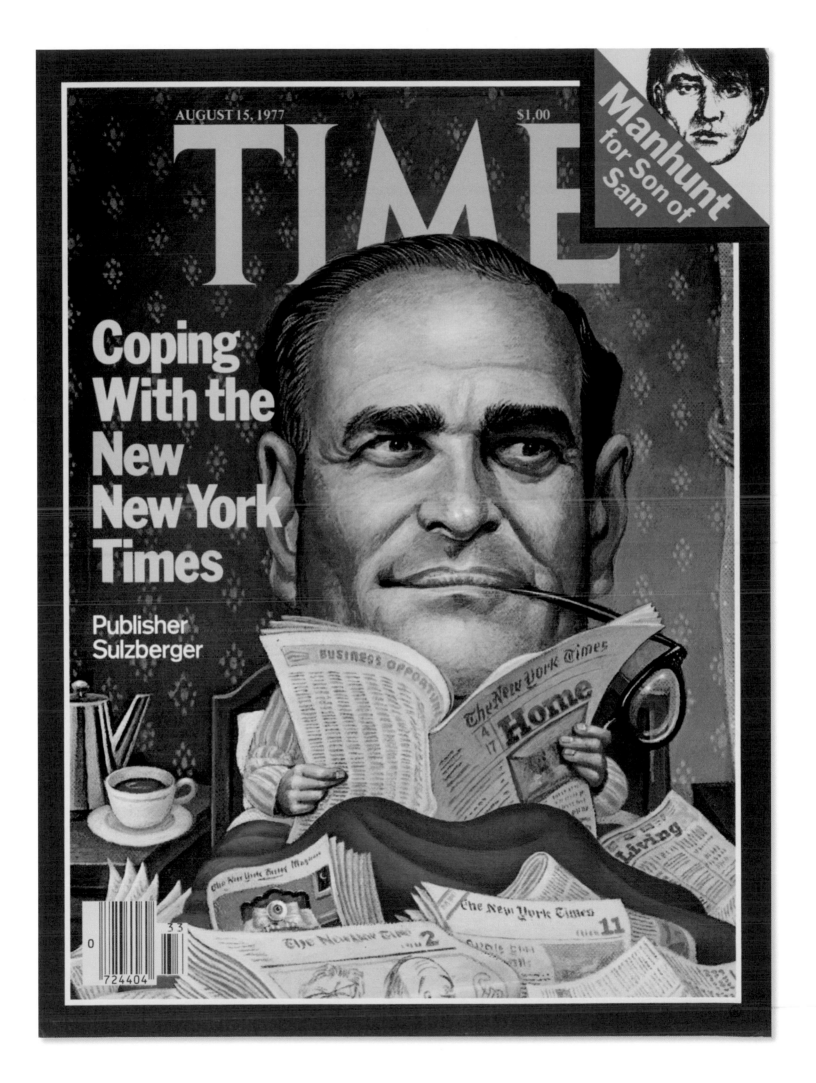

AUGUST 15, 1977 $1.00

TIME

Coping
With the
New
New York
Times

Publisher
Sulzberger

Manhunt
for Son of
Sam

0 724404 33

Anwar Sadat: Architect of a New Mideast

With one stunning stroke he designed a daring approach to peace

He called it "a sacred mission," and history may judge it so. By the trajectory of his 25-minute flight from a base in the Canal Zone to Tel Aviv's Ben Gurion Airport, Egyptian President Anwar Sadat changed the course of Middle Eastern events for generations to come. More emphatically than anything that has happened there since the birth of Israel in 1948, his extraordinary pilgrimage transformed the political realities of a region blackened and embittered by impermeable hatreds and chronic war. In one stroke, the old rules of the Arab-Israeli blood feud no longer applied. Many of the endless hurdles to negotiation seemed to dissolve like Saharan mirages. Not in three decades had the dream of a real peace seemed more probable. For his willingness to seize upon a fresh approach, for his display of personal and political courage, for his unshakable resolve to restore a momentum for peace in the Middle East, Anwar Sadat is TIME's Man of the Year.

"What I want from this visit," Sadat had told TIME Cairo Bureau Chief Wilton Wynn during the historic flight that took him to Jerusalem, "is that the wall created between us and Israel, the psychological wall, be knocked down." The wall fell. The astonishing spectacle was global theater—the images careened off television satellites to viewers around the world. In a wash of klieg lights, the Egyptian who had hurled his armies across the Suez Canal in 1973 stood at attention next to the old Irgun guerrilla whose name has been a dark legend to Palestinian Arabs for 30 years. An Israeli military band played first the Egyptian national anthem, *By God of Old, Who Is My Weapon*, and then the Israeli *Hatikvah*. In a hushed, deeply moving tableau, Sadat walked along the receiving line with Israeli Premier Menachem Begin to greet the old and resolute enemies: former Premiers Yitzhak Rabin and Golda Meir, Foreign Minister Moshe Dayan, Ariel Sharon, "Israel's Patton," who thrust Israeli armor deep into Egypt in the October War of 1973.

Next day, fulfilling a vow he had made to himself *(see interview)* Sadat prayed in Al Aqsa mosque in the Old City of Jerusalem, one of Islam's holiest places. Then the son of Ishmael stood before the sons of Isaac in the Israeli Knesset and formally declared that the deep, violent enmity between them had somehow passed.

Sadat's demands on Israel, in exchange for peace, were tough and familiar: the return to Arab sovereignty of all territory (including East Jerusalem) conquered during the 1967 Six-Day War; a homeland for Palestinians on the West Bank and in Gaza. Yet far more important were the generous words of acceptance that few Israelis ever expected to hear from an

Egyptian President Sadat standing before the Pyramids of Giza
The old rules of the Arab-Israeli blood feud no longer applied.

11

Music

COVER STORY

Linda Down the Wind

She is a superstar on the verge of becoming...a Big Superstar

Linda dancing to her music at photographer David Alexander's studio, and (right) "the way I really am."
She once kidded her Moonbeam McJune reputation by posing for an album cover in a barnyard with a couple of pigs.

Gleday is suing *Chicago Sun-Times* sports columnist Tom Fitzpatrick's 1973 contract had a 1974 delivery date. "Our letters were sent back as "undeliverable," so there's more to it than meets the eye," said James McGrath, Doubleday's general counsel.

There's at least one indication that pressure from publishers is leading to counterthreats from writers. One Doubleday author with a $1,000 outstanding unreturned advance and a sick wife responded to a damning letter by threatening to plant a bomb in the publisher's office. Doubleday hasn't pushed matters since then.

"Do these measures indicate that the good old days are gone forever? That publishing has now become as rigidly unaccommodating as any other business?" Before leaping to unwarranted conclusions, it is well to remember that there was similar talk when the philistine conglomerates invaded the gentlemanly world of bibliophiles. Hardnosed businessmen who couldn't tell the difference between delivering a book and delivering a ton of coal threatened to wrench the industry into theft-alien patterns. Simon & Schuster was absorbed into Gulf & Western; Putnam & Coward, McCann & Geoghegan clicked into their MCA slot; CBS swallowed Holt, Rinehart & Winston; RCA put its umbrella over Knopf and Random House. Publishing, however, is an incorrigibly individualistic business, and the conglomerates have behaved as distinctively as the houses they own.

RCA is considered benign, for instance. With the exception of sending in some of its own legal and financial people, RCA hasn't bothered anyone on the editorial side—and is not expected to, as long as its subsidiaries continue to earn money. Knopf, in particular, is a very easygoing house. At the opposite extreme is Putnam, headed by Walter Minton. Putnam is litigious, sending out streams of letters threatening to sue its wayward authors. At Simon & Schuster, an editor pronounced the house "much more generous 30 years ago." Richard Snyder, president of Simon & Schuster, is said to entertain himself at lunch with a list of people he is going to sue. One former client whose name has been mentioned in this connection is Jane O'Reilly. O'Reilly received three small sums over the years totaling

possible show, but we don't write out programs to suit the research department," Had Tinker ever seen any CBS research results? "I'm sure I must have. I want to say 'yes' but if you ask me for specifics the only thing I can think of is testing they did on the original "Mary" pilot seven years ago: they told us none of the characters worked—Mary was considered a loser, Rhoda was too aggressive and Phyllis got an equally negative response that I can't remember." If research discovered that Rhoda was more appealing as a married heroine, would that be communicated to MTM and encourage reconciliation? "Television executives are in a nervous business and audience research probably helps them make up their mind, but suppliers have to go with their own creative instincts."

Arnold Becker, director of TV network research at CBS, the man who had sent down word to test "Rhoda," wasn't letting on what he was finding out. The son of a former CBS radio network vice president and himself a veteran of the broadcasting wars since the 1950s, Becker is an amiably cagey man who talks pleasantly about his business while revealing as little as possible. "The testing of 'Rhoda' isn't specular, the discovery stage of the season it's difficult to know anything. The competition has been better than we expected. What are we learning about the public's reaction to her divorce? I suppose I could find out by walking into the next room, but I don't want to." As far as Becker was concerned, there was nothing special about the "Rhoda" tests—just ordinary on-the-air research to be entered into CBS's extensive data bank for future reference.

While the work that Becker's department was doing might not directly influence the outcome of Rhoda's marriage, it would certainly be a factor in determining whether she gets to play a fourth season. If CBS is counting on "Rhoda" to pull in women viewers at 8 P.M. Monday night, and if Becker's research finds that Rhoda's marital problems are turning off those same women viewers, it is a good bet the series will not be renewed. MTM's creative intentions are fine as long as they don't interfere with the true business of television—selling audiences to advertisers. "Our product," says Becker about his industry, "is people looking at programs and com-

analysis, story by story, article by article, case by case." (Bernard's interview with the authors)

Bernard not only redesigned *Time* in an ingenious, modern and thorough way, but his contributions also revolutionized magazine art and layout. The August 15, 1977, issue was the first to hit the streets with all the changes Bernard introduced. The cover was devoted to another great American press entity, *The New York Times*, and featured the newspaper's publisher Arthur Ochs Sulzberger. In it, Bernard's four great contributions to the magazine's design were evident:

The logo
Bernard retained the cover's red frame, which had become a magazine trademark, but made it larger and stylized the word "Time." He also centered the logo on the cover. The idea was that, as a whole, the cover should look more like a book than a magazine. Like a book, starting on the first page, visuals would be used to rank the content readers would find inside. Another goal was for the magazine to stand out more at newsstands.

The type
Bernard used Franklin Gothic, a font that had never before been used by a magazine in a cover headline. Franklin Gothic would become "the voice of *Time*," and would later be used by newspapers and other periodicals. Also, a new font, used for internal headings and decks—or subtitles—called attention to the subject of the stories.

The corner flap
To make room for another heading on the cover, Bernard included a dog-ear on the top right corner in which a photo and text could be placed. The wording within this

Decision. The new managing editor, Ray Cave, chooses a cover from several options. Helping him with the choice is Art Director Rudy Hoglund (front), Editor Irene Ramp and Executive Editor Jason McManus (above).

space was also placed diagonally. Milton Glaser used this ingenious invention in a 1972 redesign of *Paris Match* magazine. *Paris Match* used this invention only for a few weeks; in *Time* the invention became a milestone. When editors questioned the fact that the text in the flap wasn't positioned horizontally, Bernard responded: "Why don't you try something completely different, just once?" Bernard won the battle: the text was placed diagonally, setting a precedent in the design world—this innovation is now known as the "*Time* flap."

Visual impact
The new layout, through a better use of images and color, gave *Time* greater visual impact. Such emphasis on visuals

was unusual among magazines at the time, which largely favored text over image. For the January 2, 1978, "Man of the Year" issue, Bernard designed a powerful opening, with a photo of Anwar Sadat spread over one and one-half pages, the first time the magazine published such a large, color shot. Another innovation within the magazine was the use of a series of sequential action shots, which allowed readers to interact visually with newsmakers and lent a dynamism to static photos, two statesmen chatting at an official meeting, for instance. By showing a sequence of photos from the same event, Bernard created in *Time* a cinema-esque style through which to portray the news and newsmakers.

Visual innovations. This image, featuring Anwar Sadat standing between two Egyptian pyramids (opposite, top), is the first instance in which *Time* ran such a large color photo. The sequential, cinema-esque action shots of Linda Ronstadt (opposite, bottom) were another design innovation for *Time*.

CREDIT
Merchants of Debt

With a few rectangles of plastic…enter the world of Buy Now, Pay, Later

Past experience has shown that The Spanish opposition, which includes 200 or more separate parties and splinter groups, is not overly impressed with the constitutional reforms. For one thing, critics note that the equal powers of the authority to block any legislation proposed by the popularly elected assembly. For another, they wonder about how much power the opposition parties will really have while even anti-Communists believe that the communist Party —which might command only 10% of the votes—should be legalized, although the government argues that it is "too soon." "This 'constitutional reform' is nothing more than a cynical joke," says a madrid-based member of the 126-person Communist Central Committee. Joaquin Ruiz-Gimenez, a distinguished constitutional lawyer, complains that the government is simply handing down reforms without letting other parties participate in the process. Yet even this, he does admit, is a beginning.

The dyspepsia of the opposition, it is a fact that for the first time politicians not directly connected to the old Franco apparatus are out of the closet. The press is lively and aggressive. There are still depressing examples of repression in Spain (a claimed 700 political prisoners, 291 of them accused of terrorism). Basques, Catalans and striking workers carrying on illegal political demonstrations can expect head bashings from Spain's 65,000-man civil guard and 40,000 armed police, qho are under Fraga,s control. "If the opposition wants to make trouble in the streets," warns Fraga, "I will give it back to them." Generally, however, the police crackdown seems to be selective, and members of the so-called Bunker, a term Spaniards borrowed from English to denote Franco-era hard-liners, are clearly on the run.

As he presides over Spain's political emergence, the astute, engaging Juan Carlos steadily gains self-confidence. In Franco's waning days, the royal heir designate led a listless life sailing off Mallorca, skiing in Granada, trying with his Nikons and snipping ceremonial ribbons. Today he is at the center of the political vortex and shows a clear and subtle understanding of the conflicting currents. The stream of ministerial cars passing through the gates of Zarzuela Palace, his residence northwest of Madrid, indicates that the King has close it where it counts. Significantly, Juan Carlos is using that clout to receive not only ministers but opposition leaders like Ruia-Gimenez and 35-year-old Socialist Leader Felipe Gonzalez, who have been heard before.

wheguiling Blonde. At the outset of his reign, Juan Carlos' somewhat stiff public countenance led many Spaniards to think that he might not be the right man for t eir chief of state. But in three excursions to Catalonia, Andalusia and Asturias, he sparked rousing receptions and warmed to the affection of the crowds. Juan Carlos is helped immeasurably by beguiling blonde Queen Sofia, 37, who along with her royal demeanor has also shown surprising political skill. In the Catalan town of Manresa, Sofia dismissed the royal automobiles and led the King on a flesh-pressing 300-yard march up the town's main street. In Asturias, the royal couple put on miners' attire and spent 90 minutes inspecting a coal mine. Last week, in an extraordinary act for a Spanish Queen, Sofia smashed a 500 year old tradition by attending Jewish religious services in a Madrid synagogue.

Juan Carlos' public pronouncements have been few and bland. Nonetheless, there are encouraging signs that the King may be a good deal less cautious than either Fraga or Arias, a timid holdover from Franco's days who is probably too venerable and rigid to be the kind of Premier that Juan Carlos needs at such a critical time.

He presides over Spain's political emergence, the astute, engaging Juan Carlos workers carrying on illegal political demonstrations can expect head bashings from

The Spanish opposition, which includes 200 or more separate parties and splinter groups, is not overly impressed with the constitutional reforms. For one thing, The Spanish opposition, which includes 200 or more separate parties and splinter groups, is not overly impressed with the constitutional reforms. For one thing, critics note that the equal powers of the reactionary Upper House apparently rewolre the authority to block any legislation proposed byt he popularly elected assembly. For another, they wonder about how much power the opposition parties will really have while even anti-Communists believe that the communist Party —which might command only 10% of the votes—should be legalized, although the government argues that it is "too soon." "This 'constitutional reform' is nothing more than a cynical joke," says a madrid-based member of the 126-person Communist

Central Committee. Joaquin Ruiz-Gimenez, a distinguished constitutional lawyer, complains that the government is simply handing down reforms without letting other parties participate in the process. Yet even this, he does admit, is a beginning.

The dyspepsia of the opposition, it is a fact that for the first time politicians not directly connected to the old Franco apparatus are out of the closet. The press is lively and aggressive. There are still depressing examples of repression in Spain (a claimed 700 political prisoners, 291 of them accused of terrorism). Basques, Catalans and striking workers carrying on illegal political demonstrations can expect head bashings from Spain's 65,000-man civil guard and 40,000 armed police, who are under Fraga's control.

Teets," warns Fraga, "I will give it back to them." Generally, however, the police town seems to be selective, and members of the so-called Bunker, a term Spaniards borrowed from English to denote Franco-era hard-liners, are clearly on the run.

As he presides over Spain's political emergence, the astute, engaging Juan Carlos steadily gains self-confidence. In Franco's waning days, the royal heir designate led a listless life sailing off Mallorca, skiing in Granada, trying with his Nikons and snipping ceremonial ribbons. Today he is at the center of the political vortex and shows a clear and picked his ears.

The World's largest known assortment of credit cards belongs to Walter Cavanagh of Los Altos, California.

Revolution in the Theater

Paul Davis's beautiful posters for Joe Papp are radical —and sell tickets

Only the Shadow knows. The Spanish opposition, which includes 200 or more separate parties and splinter groups, is not overly impressed with the constitutional reforms. For one thing, critics note that the equal powers of the authority to block any legislation proposed by the popularly elected assembly. For another, they wonder about how much power the opposition parties will reall have while even anti-Communists believe that the communist Party —which might command only 10% of the votes—should be legalized, although the government argues that it is "too soon." "This constitutional reform is nothing more than a cynical joke," says a madrid-based member of the 126-person Communist Central Committee. Joaquis Ruiz-Gimenez, a distinguished constitutional lawyer, complains that the government is simply handing down reforms without letting other parties participate in the process. Yet even this, he does admit, is a beginning.

Paul Davis in his studio in Sag Harbor, Long Island

The dyspepsia of the opposition, it is a fact that for the first time politicians not directly connected to the old Franco apparatus are out of the closet. The press is lively and aggressive. There are still depressing examples of repression in Spain (a claimed 700 political prisoners, 291 of them accused of terrorism). Basques, Catalans and striking workers carrying on illegal political demonstrations can expect head bashings from Spain's 65,000-man civil guard and 40,000 armed police, qho are under Fraga,s control. "If the opposition wants to make trouble in the streets," warns Fraga, "I will give it back to them." Generally, however, the police crackdown seems to be selective, and members of the so-called Bunker, a term Spaniards borrowed from English to denote Franco-era hard-liners, are clearly me the run.

As he presides over Spain's political emergence, the astute, engaging Juan Carlos steadily gains self-confidence. In Franco's waning days, the royal heir designate led a listless life sailing off Mallorca, skiing in Granada, trying with his Nikons and snipping ceremonial ribbons. Today he is at the center of the political vortex and shows a clear and subtle understanding of the conflicting currents. The stream of ministerial cars passing through the gates of Zarzuela Palace, his residence northwest of Madrid, indicates that the King has close it where it counts. Significantly, Juan Carlos is using that clout to receive not only ministers but opposition leaders like

Ruia-Gimenez and 35-year-old Socialist Leader Felipe Gonzalez, who have been heard before.

wheguiling Blonde. At the outset of his reign, Juan Carlos' somewhat stiff public countenance led many Spaniards to think that he might not be the right man for t eir chief of state. But in three excursions to Catalonia, Andalusia and Asturias, he sparked rousing receptions and warmed to the affection of the crowds. Juan Carlos is helped immeasurably by beguiling blonde Queen Sofia, 37, who along with her royal demeanor has also shown surprising political skill. In the Catalan town of Manresa, Sofia dismissed the royal automobiles and led the King on a flesh-pressing 300-yard march up the town's main street. In Asturias, the royal couple put on miners' attire and spent 90 minutes inspecting a coal mine. Last week, in an extraordinary act for a Spanish Queen, Sofia smashed a 500 year old tradition by attending Jewish religious services in a Madrid synagogue.

Juan Carlos' public pronouncements have been few and bland. Nonetheless, there are encouraging signs that the King may be a good deal less cautious than either Fraga or Arias, a timid holdover from Franco's days who is probably too venerable and rigid to be the kind of Premier that Juan Carlos needs at such a critical time.

A Chorus Line was the only one rejected.

Three of Davis' pieces that set a new direction for theater advertising. The Three Penny Opera poster sells for $400; All of the others, including Colored Girls and Streamers are becoming collectors' items.

As part of the new design, Bernard also proposed a series of changes for the inside pages by instituting a new graphics style. The purpose of most of the changes was to give the magazine greater unity and personality. Statistical graphics had become popular in print media, but these graphics were used mainly to illustrate stories on the economy and, to a lesser degree, social issues. And the best use was not always made of them: at times, their graphic style differed from the magazine's, and at others, they were overly simplistic, monotonous and often limited to bar graphs. Another problem for *Time* was that the longer cover stories or essays appeared segmented because of the advertising interspersed among their pages. He suggested hiring an English designer named Nigel Holmes. It was an inspired choice.

Holmes not only solved some of *Time*'s internal design problems, but he also created a style of symbols, pictograms, drawings and illustrations, which earned him a reputation as the father of contemporary "infographics." Educated at the Royal College of Art in London, Holmes joined *Time* in 1978 as assistant art director, and soon made popular a unique pictorial style to convey statistical information.

The task Holmes initially undertook at *Time* was to organize for readers the kind of extensive coverage that not only ran for several pages, but also, in addition to the main article, involved other related stories. To accomplish this organization, Holmes used a small identifying symbol—later called a pictogram or dingbats by *Time* staff—to link the various articles to the main subject. "The idea of doing a pictorial symbol for this purpose appealed to me," Holmes recalls in his book *Designing Pictorial Symbols*, first published in 1985. "It was not to be used decoratively (that is, just to dress up a page, at an art director's whim) but it had a real job to do, which

was to let the reader see that a story had companion pieces related to it."

In addition to providing continuity, Holms incorporated into his symbols information for the purpose of interpreting the news. As Holmes recalled:

"I would speak with the editor and ask: What did he want to say with this element? Is it good or bad news? Later I sat down to think of the most appropriate way to express it in order to

reflect the information accurately and in a visually agreeable way." (Holmes's interview with the authors)

In October 1980, to illustrate a story on the Gulf War, Holmes used a pictogram of an oil barrel burst in half and surrounded by flames. In March 1982, to illustrate the threat of nuclear war, he used a pictogram of a vertical finger about to push a red button.

His first infographic pieces in *Time* appeared in the "Economy" section. Every

Falling ice. To help make the business-news articles more understandable, Nigel Holmes introduced illustrated statistics to charts and graphs. Below, the bar graph, illustrating the price of diamonds, is depicted by the curve and bend of the leg of this caricature of a voluptuous woman. The graphic is attention-getting and it also quickly conveys the information on the drop in the diamond market.

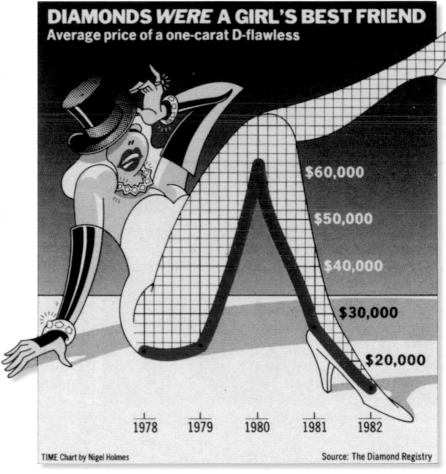

Visual identity. Bernard's redesign succeeded in giving *Time* a more modern and elegant look with a unique visual and graphic style for both the cover and inside pages. Pages from two different sections, "Theater" and "Economy & Business," which illustrate the graphic impact of his redesign (opposite). Bernard remained art director for three years. His legacy was to provide *Time* with a "visual identity that it never had before."

week Holmes made his editors shudder because they thought his illustrated statistics would interfere with the seriousness of their section. But almost 2,000 letters from readers applauded the graphics as useful in understanding the business news, and the new style spread quickly to other sections. To illustrate a graphic on the diamond market, for instance, Holmes drew a caricature of a voluptuous woman using her fishnet-stocking-clad legs to chart the price of a carat. To depict the decline of world prosperity, he used an illustration of a melting globe that contained bar graphs on inflation and growth rates. And in an eloquent display of the Senate's excessive spending, he drew a monster whose jagged teeth represented expenditures.

According to Holmes, this visual style, which combined information with photography or illustration, should meet three objectives:

"First, it should tell people what the idea is, what it is about. Then it should communicate the information, and lastly, it should tell people what that information means. When we proposed to do this type of work at *Time*, we assumed that it would be possible because the reader of a general-interest magazine isn't specifically interested in, for example, the price of crude oil. Readers are interested in how that price will affect them. That is why, in our graphics, the interpretation is as important as communicating the information."

The redesign garnered great response, not only among *Time* readers, but also within the publishing business. This is how Rudy Hoglund, who was later to be appointed art director at the magazine, summarized Bernard's redesign: "Most people liked it, but writers were shocked at discovering that the format called for fewer words ... We lost some readers, but gained many more within the year." And the redesign catapulted Bernard to the highest level of regard in the media industry. He would be called upon to redesign other important international publications, such as *The Washington Post*, Barcelona's *La Vanguardia* and Rio de Janeiro's *O Globo*.

With a more distant and academic perspective, Bernard has summarized what he considered to be his main visual contributions to *Time*:

"I would say it was a combination of elements. The corner flap, the Franklin Gothic type on the cover and providing the pages with a type that would make it different from *Newsweek*'s. But above all, I think that my greatest contribution was to educate the art department about the new visual trends and update the editors on the world design trends, since *Time*, apart from being highly conservative, had been isolated from them. Rudy, Cave and myself created a style book so that future designers could know what we did and set up the visual foundations of the magazine. I would say we provided *Time* with a visual identity that it never had before."

Symbols. Nigel Holmes introduced pictograms to provide visual continuity throughout the pages of long articles, and to aid readers in quickly interpreting the news. A finger about to push a red button illustrated a story on the proliferation of nuclear weapons; an exploding oil barrel symbolized the Gulf War; and a hand holding a gun appeared in a story about murders using firearms (below).

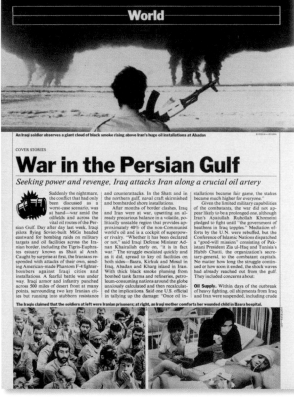

1980. World: War in the Persian Gulf

Graphic news. Nigel Holmes is considered the father of modern "infographics." Opposite are infographics used to add visual clarity to stories in the "Economy & Business" section. The top chart adds wit to the sobering deficit statistics; the bottom chart illustrates the rising costs of medical care. Infographics became a *Time* trademark.

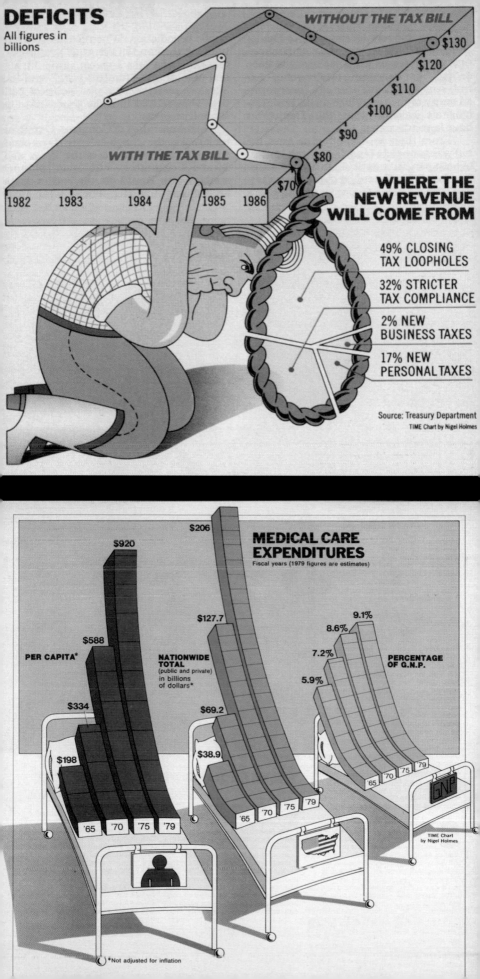

DEFICITS

All figures in billions

WITHOUT THE TAX BILL

$130
$120
$110
$100
$90
$80
$70

WITH THE TAX BILL

1982 1983 1984 1985 1986

WHERE THE NEW REVENUE WILL COME FROM

49% CLOSING TAX LOOPHOLES

32% STRICTER TAX COMPLIANCE

2% NEW BUSINESS TAXES

17% NEW PERSONAL TAXES

Source: Treasury Department
TIME Chart by Nigel Holmes

MEDICAL CARE EXPENDITURES

Fiscal years (1979 figures are estimates)

PER CAPITA*

$920
$588
$334
$198

NATIONWIDE TOTAL (public and private) in billions of dollars*

$206
$127.7
$69.2
$38.9

'65 '70 '75 '79

PERCENTAGE OF G.N.P.

9.1%
8.6%
7.2%
5.9%

'65 '70 '75 '79

GNP

TIME Chart by Nigel Holmes

*Not adjusted for inflation

A Fresh Editorial Style Meets a Bold, New Design

When Ray Cave joined the magazine's management, he was able to impose a new style, breaking with many of the traditions established by Grunwald, particularly Grunwald's obsession with writing intellectually demanding stories.

"I thought *Time*, with all its intellectual strength, was too hard to read. Henry was so intellectually demanding that a story had to have everything in it that he felt should be in it. He always wanted to make a point with a story. The problem was that it didn't allow you any breathing room."

At first, it wasn't easy for Cave to impose the bold, new style he was advocating. On one hand, there were the costs. After the issue on the beginning of Carter's presidency, Andrew Heiskell, then chairman of the board, had warned him that if the use of fast color and so many pages became habit, he would be $4 million over budget for the year.

There was also the issue of mistrust. The New York editors' uneasiness with the decision to hire Cave, since he had not risen from the ranks, peaked in late 1978, barely a year after he took over *Time*. A news item—the mass suicide of more than 900 members of a sect in Jonestown, Guyana—shook the world. The story had all the journalism ingredients to sell well: a strange cult, people hypnotized by a deranged leader and a ritualistic mass suicide. Cave balked at putting it on the cover. He thought that Jonestown was just a small incident with a dozen casualties—as initial accounts reported—and did not deserve the cover. Plus, to do so would delay deadlines during Thanksgiving week and greatly increase costs. Cave proposed coming out with a cover devoted to the Muppets, the puppet characters from the celebrated children's TV program *Sesame Street*. The editors

were beside themselves. Soon after, as the dozen of deaths became hundreds, the horror and grimness of the Guyana story grew. Cave was finally convinced, and gave the mass suicide story the cover on December 4. The *Time* story took up nine pages. Its competitor, *Newsweek*, led by Ed Kosner, devoted twenty-six pages to the story. Such a large difference in coverage was a journalistic shutout: an unwritten 1–0 for *Newsweek*.

Over time, Cave would have a chance to recover, earn the confidence of his staff and lead the competition. Under him were two executive editors—Jason McManus and Ed Jamieson—who soon became his right-hand men. Together, they produced a magazine that shows their pursuit of two distinctive editorial lines: hard news and soft news. Before this period, that division had never been so obvious.

Among the hard-news items featured by *Time* under Cave, of particular significance were the stories *Time* devoted, in 1978, to the Middle East: the Camp David accords and the peace negotiations, portrayed on the cover through images of Egyptian President Anwar Sadat (1977 "Man of the Year") and Israeli Prime Minister Menachem Begin. That same year, *Time* covered two problems the Catholic Church faced when, within a few months, the church was forced to choose its highest leader twice: first, John Paul I and, after his surprising death, John Paul II. The magazine devoted four covers and two cover flaps to the subject. In the April 9, 1979, issue, the magazine placed on the cover a subject that instilled fear among millions of Americans: the Three Mile Island nuclear power plant accident in Pennsylvania. But undoubtedly, the year's most surprising issue was the Iranian Revolution. Iran's monarchy was overthrown and a theocracy, led by revolutionary leader Ayatollah Ruhollah

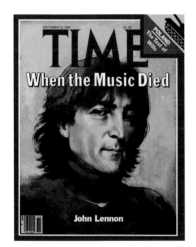

1980. John Lennon

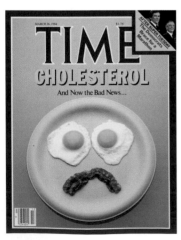

1984. Cholesterol

Collectibles. Two collectible issues were the December 22, 1980, issue on John Lennon, after his death (left, top) and the March 26, 1984, issue on cholesterol (left, bottom). The March 19, 1984, cover illustration of Michael Jackson by Andy Warhol (opposite)—with a story titled "Why He's a Thriller. Inside his World"—became an iconic image of the pop star. The issue was a best seller and one of the most sought after by collectors.

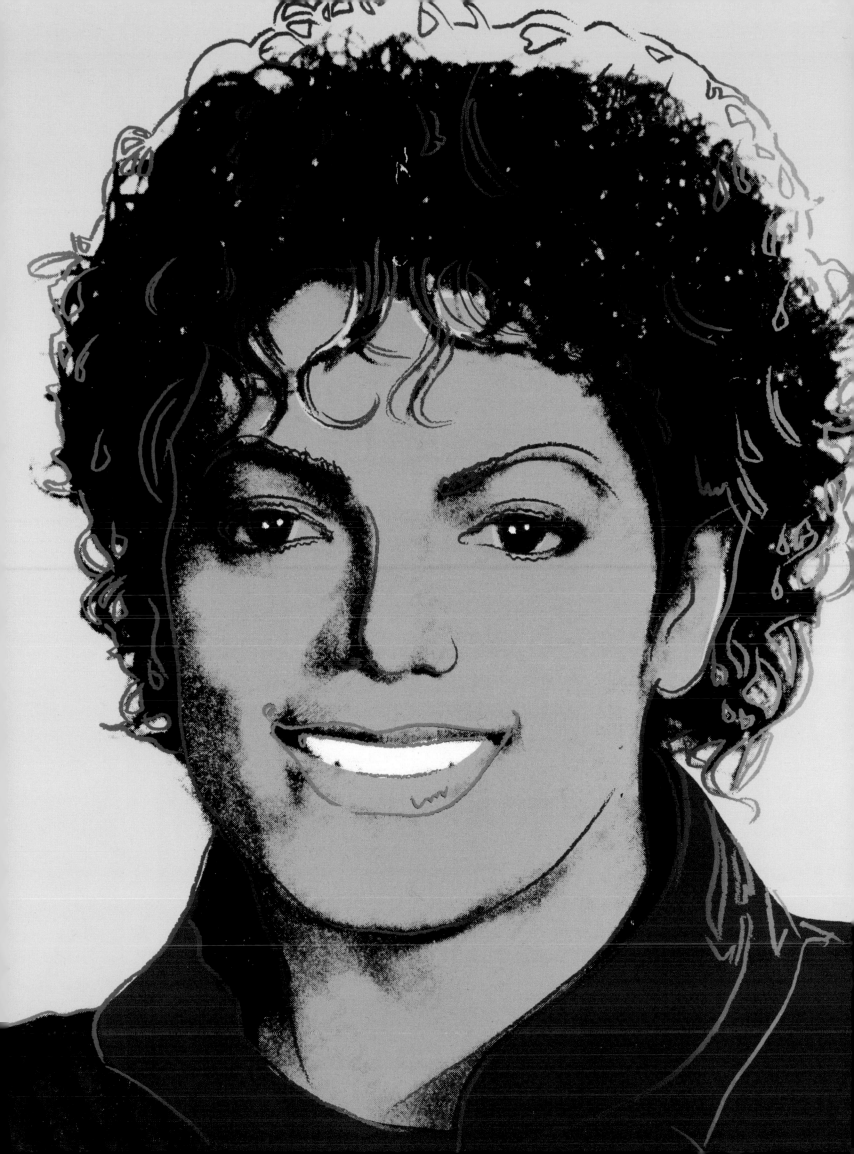

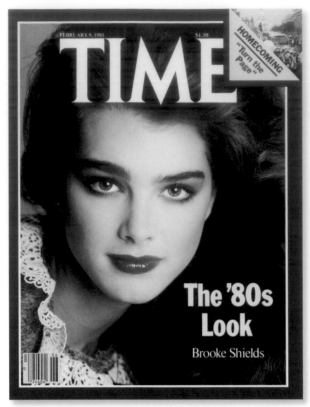

1981. Brooke Shields

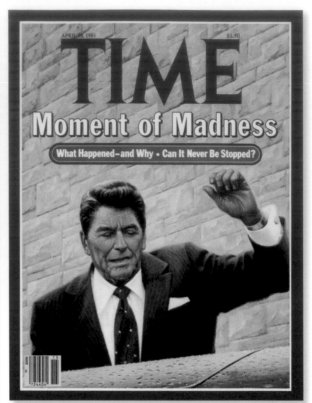

1981. Reagan Shot

1981. Cats

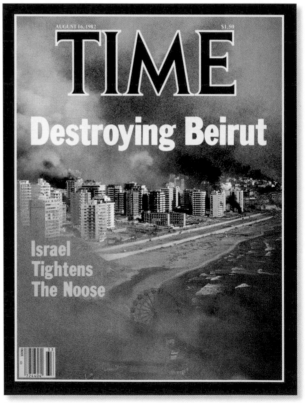

1982. Destroying Beirut

Soft news vs. hard news. During Cave's tenure, soft news coverage nearly equaled coverage of hard news. On the lighter side, Brooke Shields illustrated the February 9, 1981, cover (above, top left) and a photograph of a cat filled the December 7, 1981, cover (above, bottom left). *Time* devoted the April 13, 1981, issue to the assassination attempt on President Ronald Reagan (above, top right) and the August 16, 1982, issue to the war in Beirut (above, bottom right).

Khomeini was instated. Iran made the cover again with the hostage taking at the U.S. embassy in Tehran. *Time* devoted seven covers to Iran that year, four of them consecutively, and shocked its readers when Khomeini appeared on the January 7, 1980, cover as the 1979 "Man of the Year."

Nineteen eighty was an election year, and Jimmy Carter, besieged by inflation and the Tehran hostage diplomatic crisis, appeared on the cover seven times. It was also the year of the Mount St. Helen's volcano eruption, which was featured on the cover in June, and the onset of the Gulf War between Iran and Iraq. However, the most shocking event of the year took place late in 1980, with the assassination of the former Beatle John Lennon. *Time* featured the tragedy on its December 22 cover, and it became one of the most popular in history: with 531,340 single-issue copies sold.

In terms of soft news, Cave's tenure was one of the most prolific in history. In 1978, for instance, eight of the seventeen covers published between January and April—that is, almost fifty percent of the covers—were devoted to lighter subjects. Standing out among them: a January cover featuring Burt Reynolds and Clint Eastwood for a story on Hollywood; another devoted to the Computer Society; a cover on Muhammad Ali after he lost to Michael Spinks; and a cover on Cheryl Tiegs as the world's "Top Model." The last three covers were published consecutively, without any hard-breaking news covers in between.

The trend continued in the following months with a cover on John Travolta, and in articles about Jane Fonda and the aerobics boom and the premiere of the movie *E.T.* Some observers of Cave's choices opined, that although he didn't have a background in politics, the economy or general news at weeklies, Cave had a metropolitan journalist's touch and

intuition, which helped him to easily spot issues, other than weekly news, of interest to readers. In 1981, he published covers on model Brooke Shields ("The '80s Look"), future princess Diana Spencer ("The Prince's Charmer") and Meryl Streep ("Magic Meryl"). He also devoted covers to subjects that at one time would have been hard to imagine on a *Time* cover, such as cats (1981, "Crazy Over Cats") and ice cream (1981, "Ice Cream: They All Scream for It"). Covers were also given to Pop music stars: Michael Jackson (1984, "Why He's a Thriller: Inside His World") and Madonna (1985, "Why She's Hot").

As editor, Cave added sections such as "American Scene," "Computers," "Video" and "Design." In December 1980, *Time* published a cover with the heading "The Robot Revolution." In May 1982, the magazine explored young people's passion for computers in a cover titled "Computer Generation" and, breaking with tradition for the first time, *Time* replaced the "Man of the Year" with an object: the computer. In May 1983, *Time* gave the cover to George Lucas, the new movie special-effects genius for *Star Wars Three: The Return of the Jedi*, and in May 1984, to Bill Gates, under the heading, "Computer Software. The Magic Inside the Machine."

Also characteristic at the time was the production of special issues devoted almost entirely to a single subject, such as immigration, Japan or Hiroshima. In 1983, *Time* dedicated the entire issue to the magazine's sixtieth anniversary. It included special features, such as articles covering the most important events of the period, reproduced as they had been published, without changing words such as "Negro," used at the time to designate African-Americans. Also, starting in 1980, bylines, which until then had been limited to reviews, became the norm in the magazine, and also gave credit to

the contributing correspondents and researchers-reporters.

When asked if his tenure changed *Time*'s editorial focus and made it softer, Cave explained his philosophy with these words:

"Look, we could not have *Newsweek* at par with *Time*. So, I cared a lot about newsstand sales. But a cover on cats or bad backs, or ice cream, was the cover that would let me do two covers on the Middle East and one cover on Senator so-and-so. Therefore, I was using the soft covers to allow *Time* to do what was really *Time*'s show. Mind you that Henry had as many offbeat or soft covers as I did ... Of course they were different! Henry would do Rostropovich while I would do Michael Jackson ... but the use of soft covers was very deliberate. However, let me tell you that I had a basic disagreement with my staff on journalism: like all good journalists, they wanted the story first, while I wanted the story when the reader would read it. In other words, I would give the reader a cover on Michael Jackson when he/she knows who the person is, why he is interesting and you want to read it.

Bad backs was a best-selling cover in 1980. Babies was one of the best-selling covers we ever had. It all depends on how narrowly you choose to define news."

Richard Stengel: Writers and the Most Dreaded Words: "New Version"

Extracted from "Agony, Poetry and Baking a Soufflé," by Richard Stengel (who began working at Time *in the early 1980s), an introduction to* Time: 85 Years of Great Writing, *edited by Christopher Porterfield, published by* Time *in 2008.*

When I started at *Time* as a writer ... the attitude among writers in those days was that editors were the enemy and that writers needed to do their best to prevent them from cutting, flattening, rewriting or otherwise sucking the life out of a story. *Time* writers were a proud if slightly careworn species. We were craftsmen— craftsmen who could take a story and figure out a snappy opening, a smart "billboard" paragraph, a compelling narrative with unexpected twists, some clever turns of phrase and a memorable ending (or "kicker")—all in a limited number of words and in an amount of time that was always too short. We wore blue blazers and khaki pants. We smoked. We drank. And yes, a liquor cart was still wheeled down the corridors on Thursdays and Friday evenings.

We younger writers were in awe of the older writers. They seemed like giants— Nation writers Ed Magnuson and George Church, essayists Lance Morrow and Roger Rosenblatt, the art critic Bob Hughes, the drama critic Ted Kalem and the always versatile Otto Friedrich. During my first few years at *Time*, I sat next to an easygoing writer who could drink two six-packs of Budweiser on Friday while calmly tapping out a lucid cover story. Another one of my neighbors would bang the walls and yell and scream but turn out beautiful, lyrical copy. I had another colleague who stripped down to his boxer shorts to write. The idea was that you labored and struggled to make the prose seem effortless. We all believed it was agony to write, and that if it wasn't difficult, it wouldn't be good. Eccentricity was treasured. Great ledes, wonderful similes and clever puns were admired and read aloud. We debated the virtues of different ledes and kickers.

Time stories were a genre unto themselves. Newspaper writing, we felt, was straightforward, stolid and dull. Longer pieces in other magazines were lazy,

"The subway vigilante." Bernhard Goetz, a New York City resident who ran an electronics repair shop, defended himself by shooting members of a gang that tried to rob him on a Manhattan subway car. The event was highly controversial and divided public opinion. *Time* featured Goetz on the April 8, 1985, cover (below, left). Richard Stengel wrote the story (below, right).

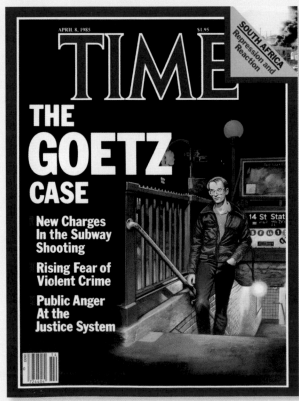

1985. Bernhard Goetz

1985. Nation: A Troubled and Troubling Life

Writing agony. Richard Stengel in 1986 (above), as a young writer, at his desk in the New York office, which was full of talented and eccentric characters. He described the young writers as being in awe of the older writers, believing that editors were the enemy and that it was agony to write the seemingly effortless prose.

indulgent and unstructured. A *Time* story was a poem by comparison. When I was hired, the editor who offered me a job said, "We can't teach journalists to be poets, but we can teach poets to be journalists."

I became a *Time* writer because of one man: John McPhee. He was my writing teacher in college and had been a staff writer at *Time* for seven years before becoming an icon at *The New Yorker*. He said that if you want to learn to write, there's no better place to learn than at *Time*. There, he said, you had to write several stories a week; all of them had to be models of concision, with clear prose and clear thinking; and the editors were tough but fair. I signed up. *Time* was a writer's boot camp in those days. The newest recruit usually spent a year writing

Milestones—the nimble little notes on deaths, births, marriages and the like—and A Letter from the Publisher, which the publisher never actually wrote. Every sentence was meticulously edited and checked and copy read and polished, and within six months I felt like a pro.

Editors rarely told you what you did right or wrong, but you learned in part through watching what they did. Your lede might be shortened and punched up, the billboard graph might be strengthened and made clearer, the paragraphs moved around to create a more transparent structure, the kicker tweaked to make it sing. Editors often had idiosyncratic ways of explaining what they wanted. I remember one of *Time*'s earliest women editors, Martha Duffy, who spoke so softly

that you had to lean across her desk to hear her, explaining the story she wanted me to write by saying: "Bake me a soufflé." I knew exactly what she meant.

The two most dreaded words to a *Time* writer were "new version." When a new version was ordered up, it meant that you had to go back to square one, that there was nothing salvageable from the story except "and" and "the," that you had to toss it all out, every last sentence, and start over. It was most dispiriting...

People in those days used to ask me, How can you write in that *Timestyle*? The dirty little secret is that there really was no such thing as *Timestyle*. Yes, there had been. In the early days, and up until World War II, there were the terse, choppy sentences; the brash mannerisms; the Homeric epithets; the clever coinages and labored neologism ("cinemactress, sexational"); and the famous backward-reeling sentences. And yes, in the 1950s and '60s, *Time*, under Henry Luce, was the voice of America's growing and prospering upper-middle class, and the writing often reflected that: a bit stiff, a little institutional, at times lofty and all-knowing. But by the late '60s, the writing loosened up and became more colloquial, more nuanced and open-minded. Today's magazine has more voice and a stronger point of view, but it has all evolved from the same DNA. What people still think of as *Timestyle* comes more from function than from form: the stories are characterized by brevity and concision, with a taut structure, a clear thematic line, precise details and a relentless forward flow with no dead spots.

... From the beginning we have not just reported the news but put it in context and perspective. We have offered clarity in a confusing world, explaining not just what happened by why it mattered. We don't just provide information, we convert it into knowledge and meaning ... and that's the writing we strive for every week.

Two "Man of the Year" Surprises: Khomeini and the Computer

The way in which hard and soft news were treated on *Time*'s covers during the Cave years, as well as the way news was featured within its pages, was also reflected in the much-anticipated selection of the "Man of the Year." Examples of both hard and soft selections are the 1979 and 1982 choices, although one of them was much more controversial than the other.

The first time Ayatollah Khomeini was featured on *Time*'s cover was in the February 12, 1979, issue, with the heading "Iran: Now the Power Play." Two weeks later, the country was again featured on the cover, with the title: "Iran: Anarchy and Exodus." No one could have imagined at the time that a few months later, between November and December, the magazine would devote four consecutive covers to Iran: on November 4, 1979, the U.S. embassy in Iran was attacked, its leaders overpowered and its occupants held as hostages—a move that was the equivalent to a declaration of war.

The image of the blindfolded, publicly exposed hostages incensed and humiliated the United States. The cover of *Time*'s November 19 issue was titled: "Blackmailing the U.S." The story read:

"It was an ugly, shocking image of innocence and impotence, of tyranny and terror, of madness and mob rule. Blindfolded and bound, employees of the U.S. embassy in Tehran were paraded last week before vengeful crowds while their youthful captors gloated and jeered. On a gray Sunday morning, students invoking the name of Iran's Ayatullah Ruhollah Khomeini invaded the embassy, overwhelmed its Marine Corps guards and took some 60 Americans as hostages. Their demand: surrender the deposed Shah of Iran ... as the price of the Americans' release. While flatly refusing to submit to such outrageous

blackmail, the U.S. was all but powerless to free the victims."

Surely, few *Time* readers imagined Khomeini was the person whom the magazine would choose to be 1979 "Man of the Year." When the cover was published, the entire country was anguished over the U.S. hostages still being held at the embassy by revolutionaries, supported by Khomeini. The Ayatollah's outrageous and unyielding demands for releasing the hostages, such as voters replacing President Jimmy Carter with a president more "suitable" to Khomeini, or the extradition to Iran of former Shah Reza Pahlavi so he could be brought to "justice" and executed, could not be met. Naturally readers were shocked and indignant when they received the January 7, 1980, issue with the face of Ayatollah Khomeini on the cover as "Man of the Year."

Time realized that this decision would be not only controversial but also offensive to many readers. To reduce the backlash, the publisher's letter in that issue took great lengths to remind readers that the "Man of the Year" designation simply meant an acknowledgment of someone's newsworthiness not a reward for good deeds.

Little did it help that painter Brad Holland had portrayed Khomeini with the evil expression of a bloodthirsty and vengeful man, or that the story described him in this way:

"The dour old man of 79 shuffles in his heel-less slippers to the rooftop and waves apathetically to crowds that surround his modest home in the holy city of Qum. The hooded eyes that glare out so balefully from beneath his black turban are often turned upward, as if seeking inspiration from on high, which, as a religious mystic, he indeed

1979. Ayatollah Khomeini

1979. Hostages in Iran

Outrage. Ayatollah Khomeini first appeared on *Time*'s cover on February 12, 1979, to accompany a story about his return to Iran after fifteen years of exile (left, above). Brad Holland illustrated the 1979 "Man of the Year" cover (opposite) depicting Khomeini. Many readers were enraged, some calling the decision "treason"—at the time, a group of Iranian revolutionaries were holding personnel from the U.S. embassy in Tehran hostage (left, bottom).

is. To Iran's Shi'ite Muslim laity, he is the Imam, an ascetic spiritual leader whose teachings are unquestioned. To hundreds of millions of others, he is a fanatic whose judgments are harsh, reasoning bizarre and conclusions surreal. He is learned in the ways of Shari'a (Islamic Law) and Platonic philosophy, yet astonishingly ignorant of and indifferent to non-Muslim culture. Rarely has so improbable a leader shaken the world. Yet in 1979 the lean figure of the Ayatullah Ruhollah Khomeini towered malignly over the globe. As the leader of Iran's revolution he gave the 20th century world a frightening lesson in the shattering power of irrationality, of the ease with which terrorism can be adopted as government policy."

None of the above helped to quell many readers' fury. Out of the 4,923 letters received, 4,123 complained about the magazine's decision. Some called it "treason," "shocking and repugnant" and "a slap in the face of every American citizen."

The reaction to and controversy over the magazine's decision went on for months, and the vicious letters even continued after the failed April 24, 1980, rescue mission that President Carter dispatched to the Great Salt Desert in Iran. The mission was botched when a sandstorm crippled two helicopters. Eight rescuers died and four were severely burned when several aircraft caught fire from the exploding ammunition of a crashed C-130. Criticism finally diminished in January 1981, after an agreement negotiated in Algeria allowed the hostages to return home. But the Khomeini case would go into the "Man of the Year" annals as the one that caused the most clashes between the magazine and its readers, and was so shocking for *Time* that its consequences would last for several years.

Three years later, in 1982, *Time* caused another stir with its choice of "Man of the Year." Although this selection was not questioned to the same degree, the cover became a milestone: for the first time, an object, instead of a person or group, was picked, and also for the first time,

instead of being called the "Man of the Year," the designee was called the "Machine of the Year," with the heading "The Computer Moves In." The cover story justified the selection:

"Will someone please tell me, the bright red advertisement asks in mock irritation, what a personal computer can do? The ad provides not merely an answer, but 100 of them. A personal computer, it says, can send letters at the speed of light, diagnose a sick poodle, custom-tailor an insurance program in minutes, test recipes for beer. Testimonials abound. Michael Lamb of Tucson figured out how a personal computer could monitor anesthesia during surgery; the rock group Earth, Wind and Fire uses one to explode smoke bombs onstage during concerts; the Rev. Ron Jaenisch of Sunnyvale, Calif., programmed his machine so it can recite an entire wedding ceremony. In the cavernous Las Vegas Convention Center a month ago, more than 1,000 computer

Machine of the Year. An object took the "Man of the Year" spot for the first time in 1982: the computer. George Segal sculpted the cover figures, who were depicted on the fold-out cover, at work and at leisure with their personal computers (below)—the machine that was America's latest passion.

1983. The Computer, Machine of the Year

companies large and small were showing off their wares, their floppy disc drives, joy sticks and modems, to a mob of some 50,000 buyers ... As both the Apple computer advertisement and the Las Vegas circus indicate, the enduring American love affairs with the automobile and the television set are now being transformed into a giddy passion for the personal computer."

Only four times between 1927 and 1982 had an actual person failed to grace *Time*'s annual "Man of the Year" cover. In 1950, in a tribute to the young men fighting in Korea, the magazine used the image of a soldier in a helmet, identified on the cover as "Name: American. Occupation: Fighting-Man." It was a powerful symbol. In 1956, the "Hungarian Freedom Fighter" was recognized, while in 1966 and 1969, groups of people were honored: "Twenty-five and Under" and "The Middle Americans."

"There are some occasions when the most significant force in a year's news is not a single individual but a process, and a widespread recognition by the whole society that this process is changing the course of all processes. That is why, after weighing the ebb and flow of events around the world, *Time* has decided that 1982 is the year of the computer. It would have been possible to single out as Man of the Year one of the engineers or entrepreneurs who masterminded this technological revolution, but no one person has clearly dominated those turbulent events. More important, such a selection would obscure the main point. *Time*'s Man of the Year for 1982, the greatest influence for good or evil, is not a man at all. It is a machine: the computer."

The cover image, produced by noted sculptor George Segal, depicted a person sitting at a desk, absorbed in a computer. Art Director Rudy Hoglund had chosen Segal precisely because he was a pro with scenes in which objects had strong visual appeal. Ironically, when the story was published, computers were not yet used in the *Time* office.

The computer was selected exactly fifty-five years after the first "Man of the Year," Charles Lindbergh. But the 1982 choice was also a preview of the fundamental impact that computers would have on our lives as the century came to a close: our work, entertainment and daily life. Computers became irreplaceable in the first half of the new century. The computer has not only dominated the first half of the twenty-first century, but it also made everything possible, from the Internet to e-mail, from blogs to websites, such as MySpace, YouTube, Wikipedia and Facebook. An adventurous soul such as Lindbergh could have never imagined all of this digital paraphernalia, particularly as he crossed the Atlantic Ocean in a solo flight, with an Earth indicator compass as his only instrument of advanced technology.

Revolution in progress. The article accompanying the "Machine of the Year" issue (below) enumerated the ways that computers were moving into every aspect of life—from sending letters at lightening speed, to testing recipes, to producing special effects for concerts and video games—and even monitoring anesthesia during surgery. *Time* wrote that the computer was "the end result of a technological revolution that has been in the making for four decades and is now, quite literally, hitting home."

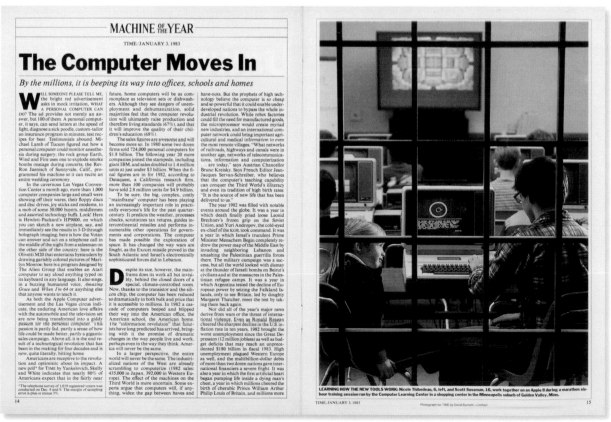

1983. Machine of the Year: The Computer Moves In

Writing for *Time*

With or without bylines, acknowledged or not, *Time* writers have always been part of an elite group. They were original, sometimes eccentric and often brilliant. Throughout the decades, *Time* writers have left their mark, on the magazine and beyond.

In the 1940s, one writer who stood out was Whittaker Chambers, a former Communist who joined *Time* in 1939 as a book reviewer and rose through the editorial ranks to become editor of the "Foreign News" section. Another noted author at the time was Theodore White, the war correspondent who started working for *Time* in 1939. One of *Time*'s most prestigious writers, James Agee, not only wrote film reviews for seven years, but also wrote memorable articles on a variety of subjects. Agee was known for his poetic writing: "The world, with one war still red under its nails and another beating in its belly..." Also prominent during the period was John Hersey, a Far East correspondent, who spent time in Pearl Harbor and joined *Life* in 1945.

Many of the writers went beyond the magazine's pages, and became noted book authors. John Hersey, for example, wrote twenty-five books between 1942 and 1991, and won the 1945 Pulitzer Prize for his first novel *A Bell for Adano*. Hugh Sidey, the veteran White House correspondent, authored books about presidents John Kennedy and Lyndon Johnson. Among many others, "Teddy" White wrote *The Making of the President 1960, 1964, 1968* and *1972*, which became well-known documentaries. These and other outstanding *Time* writers were paid tribute in the book, *Time: 85 Years of Great Writing*, published in 2008 in commemoration of the magazine's eighty-fifth anniversary. It was edited by Christopher Porterfield, who in 1963 began a diversified career that took him through almost every section of *Time* as a correspondent, writer and longtime editor, until he retired in 2003 as executive editor.

As in decades past, during the 1970s and 1980s, *Time*'s writers were passionate, and, on ocassion, were known for indulging in eccentric behavior, particularly drinking. In the 1960s, reportedly, so much alcohol was consumed as deadlines approached that Grunwald authorized the beverage cart to leave only a bottle of Scotch per section.

Although the magazine does not use the title "cover writer," the title would have been appropriate for at least ten writers at *Time*'s headquarters at any given point. Two writers penned more than 100 cover stories each: George Church, with 121 and Ed Magnuson with 128. Nancy Gibbs, who joined the staff in 1985 and since then has become the most prolific cover story writer at the magazine, holds the record with 162 stories through 2009.

Among those who stood out at the New York office who became prominent figures, within the magazine, there were Walter Isaacson and James Kelly (Stengel's predecessors as *Time* managing editors); Kurt Andersen (author of twelve cover stories); Otto Friedrich (who according to Porterfield was "the most complete *Time* writer: he could do it all—book reviews, essays, features, news, cover stories—at a consistently high level"); Claudia Wallis (author of eight covers, two of them about AIDS); Pico Iyer (who handwrote his stories and made carbon copies); and Evan Thomas (who held that to write a cover story, it was most important to be patient). There were also writers who moved on to other publications: Graydon Carter became editor of *Vanity Fair* and Maureen Dowd and Frank Rich became columnists for *The New York Times*. "*Time* continued to be the strongest lighthouse in the big

1982. Children of War

Iconic story. It took three months to research and write the January 11, 1982, cover story, "Children of War" (left and opposite). Roger Rosenblatt, the author, interviewed children in five war-torn areas of the world. The profoundly moving story won many awards—a year later it was published as a book.

CHILDREN OF WAR

All wars, it is said, are fought for the bene-fit of future generations. This is a story of how those generations are responding. The responses vary, as you would expect. The five war zones represented here are quite different from one another, and the children in each place have their differences as well. Nor do those within a single war zone necessarily react in the same ways to the terrors around them. What all these children do have in common is a fierce will to survive—a will that sometimes takes the form of revenge, and at other times, of an abiding serenity. But no matter how they assert themselves, there is an essential good-heartedness in almost all these children, a gen-erosity of nature that transcends and diminish-es anything they have suffered.

The question one asks is: When do these qualities disappear? Assume that the children of our modern wars are like those of any time. Why then does the institution of war continue to do so well? Here are some 30 children from five war-ring nations, most of them eager to make and keep the peace. If their nations were handed over to them right now, it would be pleasing to think that peace would follow. Of course, nothing will be handed over to them until they are ready, and by that time they will be grown up like us, and changed like us, who supposedly fight for their benefit. So they go about their business—riding bikes, playing ball, dreaming, doing what they are told, and watching with great care all that is being done for them.

ⓑBELFAST

Nothin's Worth Killing Someone

Our fathers and ourselves sowed dragon's teeth. Our children know and suffer the armed men.
 —Stephen Vincent Benét

If you want the full account of Frank Rowe's murder, it will not be provided by Paul. Paul is 13 now, was seven at the time, yet he can still only get so far into the story—to the point where "Daddy, he ran to the back, to the next house"—be-fore he starts crying. He has a woman's face, still dimpled, along with the absolutely blue eyes of most Belfast children, and brown hair parted carelessly down the middle: the sort of face the old masters sought. His school tie hangs cockeyed; it was knotted in a hurry.

"What do you feel about your father's death now?"

His friend Joseph answers for him. Joseph, also 13, has a small, tight head, a high, clear voice, and his ambition is to grow up and join the Provos. "Revenge. That's what you want. Isn't it, Paul?" Paul says nothing.

"I'd want revenge," says Joseph, looking again to Paul.

Paul eventually nods; then says faintly: "Aye. Revenge."

As if to make his case forever, Joseph thrusts his face toward the American stranger. "You. You'd take revenge too, wouldn't you, Mister?"

The two boys sit in low plastic chairs beside each other in a classroom of the Stella Maris Secondary School, a brick-and-stucco series of afterthoughts that could pass for a warehouse. Stella Maris is in an unusual position because it is a Roman Catholic school located in a Protestant area, and it holds a spe-cial place in modern Belfast history because Bobby Sands is an alumnus. Yet the Stella Maris students make no big thing of their connection to the hunger striker. A couple of boys were once caught playing a game called Bobby Sands, but that's about the extent of it. Ask Stephen and Malachy, both 15, what they think of Sands' decision, and they answer simultaneously. "Brave." "Foolish."

Joseph would undoubtedly say "Brave," and he would prob-

and allies. It refers to *"Technologie Israélienne"* and swears that Palestine *"est déterminée à continuer la marche vers la liberté."* Whether or not the baby has such determination at the moment, she will probably have it in four or five years. By then she may be an instrument of determination herself, her very name a beacon to other Palestinian children who are raised in this country to in-herit their parents' dreams and enemies.

The Institute of Tel Zaatar was founded to provide foster families and education for the 313 children who lost their par-ents in the Tel Zaatar massacre of 1976. A year before that, 27 Palestinian residents of the Tel Zaatar camp were slaughtered by Christian Phalangists as they returned by bus from a rally cel-ebrating a terrorist attack on Qiryat Shemona. In 1976 the Pha-langists used 75-mm and 155-mm howitzers for a seven-week siege of the camp in which 3,000 died. Tel Zaatar was demolished.

The orphanage is a large, serene house with a façade of bal-conies. There are 160 children in it now, not all of them victims of Tel Zaatar. Like children elsewhere, they have rebounded quickly from their tragedies. A small boy whose mother was killed while bringing him water from a well refused at first to take water from anyone, fearing that it augured death. But after a few weeks in the home he overcame his phobia. A boy of two, who was in his father's arms when the man was shot, made no sound during his first six months in the home; now he is prattling like his peers.

Jamila, Boutros and Mona have been at the home since it opened. Now 16, 16 and 17, respectively, they are considered el-ders, and have assumed the responsibilities of parents to the younger ones. They are sitting on a bed in a "family room"—all beds and dressers. Jamila, though an pigtails and sneakers, looks older than the other two. Her parents were killed in an Israeli

Armed with Soviet rifles, young Palestinians undergo military training in southern Lebanon; exploring a bombed-out building in Damur

shelling of Tyre. Boutros' father was killed when the Phalangists raided his poultry farm. Mona's father was killed after Tel Zaa-tar was destroyed.

"I was with my entire family, which divided into two groups, my mother taking shelter in one building, my father, my brother, my sister and I hiding in another. But the Phalangists found us and started to shoot again. I fainted. I did not know what was happening until I awoke the next day and found my father, and everyone, all dead in the room with me."

Jamila observes that by losing their parents they have lost their childhood as well. Like the girls in Belfast, these three have had to grow up quickly. Asked if they believe that they have gained anything by such experiences, Boutros replies, "Power." His face seems amiable for the answer. What he means by power is something specific. "To regain our homeland." At that all three talk at once. "First we were driven from Palestine in 1948"; "The Israelis tried to exterminate us." "It's not their land. It's *our* land," says Jamila. Her voice is urgent. As the questions con-tinue, she notices that her American visitor is sitting in an un-comfortable position. Without a word she rises and slips a pillow behind his back.

When do they most admire in the world? "Beside our great chairman, Arafat," says Boutros, "there are Ho Chi Minh and Castro." For Jamila it is Lenin. "Because he made a new world for his people. He made them like themselves and work togeth-er." The question of the future is raised, and the three of them talk of Palestine's certain glory. Jamila offers something more: "I would put an end to the use of all nuclear weapons."

"Do you all plan to marry and have children of your own?"

"You mean in the future?" They laugh. Mona blushes. Bou-tros jumps in: "When I was very young, my parents told me about their leaving Palestine. I will teach my children to be strong and to depend on themselves, as I depend on myself. I

Palestinian youngsters wander in the war rubble at Damur

Bare-shouldered Palestinian girl at the Chatila refugee camp in Beirut; little soldiers of both sexes go through their paces near Damur

will teach them to love all those who love the Palestinians."

Much of this nationalist fervor arises from what the chil-dren have seen firsthand as well as what they have been taught—as Nabil pointed out in the West Bank—so it is not fair to regard them solely as their elders' tools. Also their indoctrina-tion may be indirect. The normal conversation of parents will in-fluence children in any circumstance, and it would be a lot to ask of Palestinian parents that they display a political evenhanded-ness they do not feel. It may even be that for children like those in the Tel Zaatar home, this single-mindedness is not all that harmful. If there can be a benign side to indoctrination, it is that it offers a purpose; and when one's family is destroyed, any pur-pose, however limited, may be spiritually useful.

But the intensity of the indoctrination does not necessarily destroy one's charitable impulses either. At this stage, at least, the children are still gentler than their masters would prefer—even when their masters happen to be in the mili-tary. Samer's father is a lieutenant colonel in the P.L.O.; he con-trols the joint Palestinian-Lebanese forces in the region of Tyre. At the moment, Colonel Azmi controls his forces from a grass hut on stilts standing over an area bombed out by Israel last sum-mer. The hut is furnished with red leather chairs and a Swedish-modern desk, behind which Colonel Azmi, 40, smokes Winstons and makes pronouncements:

"We are ready. We will not stop our struggle. We are not fas-cists. Our power is our arms. Kissinger caused this trouble. We are not Communists. Begin is a Nazi. We never intend to kill children. Till the last child we will struggle to regain our home-land." The colonel looks up. "Ah, Samer."

His son enters the hut. Samer is four years old, about 3½ ft. high, and dressed in matching black-and-white checked shirt and pants and polished black laced shoes. He strides regimental-ly toward the Swedish-modern desk and stands before his father.

"They are so young," explains the colonel. "But they are so proud." Then to Samer: "Who is Sadat?"

"Sadat sold Palestine to Israel," says the boy, rapid-fire.

"Who is Jimmy Carter?"

"Carter supported Israel."

"Who are you?" asks his father with mock severity.

"I am from Palestine—from Hebron!"

"What is Israel?"

"The real name for Israel is Palestine."

The colonel invites his visitor to ask questions of his son. "Samer, have you thought of what you would like to do when you grow up?"

"I want to marry." The colonel's men who have been sitting solemnly around the hut explode with laughter. The boy blushes with shame and confusion. His father consoles him with a ges-ture of the hand. Asked if he would like to live in a world that does not need soldiers, Samer says, "Yes, I would love that." At his father's signal he exits.

"Colonel, would you send Samer into war?"

"I don't want him to suffer. But he would give his blood to regain his homeland. If I am killed, my son will carry my gun."

The legatee system in which guns are passed to the children may find its pinnacle in Ahmed, a leader in a P.L.O. youth group, the *ashbals*, and in the Boy Scouts. Just 15, he has already made speeches for the P.L.O. in Cyprus, Egypt, East Germany, Czechoslovakia, Bulgaria, Cuba and Moscow. The P.L.O. youth organization to which Ahmed belongs trains guerrillas from the ages of eight to 16, when they may graduate to the rank of full commando. The reason that Ahmed participates in both groups, explains Mahmoud Labadi, the head of P.L.O. press relations in Beirut, is that "he is so active, he doesn't want to let anything get past him." Labadi raises a hint of a smile to let Ahmed know

ocean of magazines and its writers were stars without knowing it," Kelly said, in an interview with the authors.

The superb Lance Morrow and Frank Trippet took turns at the "Essay" section, during and after the Grunwald years. In late 1979, after a notable career at *The Washington Post* and *The New Republic*, the talented Roger Rosenblatt joined them.

Rosenblatt, a world traveler, was renowned for his unsurpassable prose and versatility. Among his milestone articles and cover stories were "Children of War" (1982), "The Atomic Age" (1985), "A Letter to the Year 2086" (1986) and "A Day in the Life of the Soviet Union" (1987). Rosenblatt was promoted to senior writer six weeks after joining the magazine and remained in the post for eight years, when he left *Time* to become editor of the weekly *US News and World Report*.

Rosenblatt is one of *Time*'s top writers of the 1980s, and one of the most influential writers of the era. Rosenblatt was the first writer in the history of the "Man of the Year" to write the piece based on his own interview and not on the reports filed by correspondents.

"Until I did the Ronald Reagan 'Man of the Year' story no writer ever reported a story. I was the first one to do it. The reason was division of labor that came from the Luce era. Reporters did the reporting in the field and writers received the file and wrote the story in New York. I did not know about this. And even less than that there was a formula to write 'Man of the Year.' Ray had realized that it was a crazy system, particularly for a writer like me who was used to seeing things and putting them in the story. Within ten days I was at Pacific Palisades talking to the president." (Rosenblatt's intereview with the authors)

In general, writers became more involved in the reporting, but often they merely met the subject in order to gain firsthand impressions and then left the primary reporting to others. Though, when the subject was a foreign leader like Deng Xiaoping or Mikhail Gorbachev, the traditional pattern of the writer working from dispatches sent from the field continued to be the norm.

The "Man of the Year" story was published the first week of 1981. A year later, in January 1982, Rosenblatt accomplished a true feat in journalism: a twenty-three page cover story titled "Children of War," completely researched and written by him—within three months. The project was born when Rosenblatt saw a TV clip of a baby crying amidst the ruins of a Middle Eastern street. He proposed the project to Ray Cave who accepted the idea, even though it was a time-consuming undertaking.

Rosenblatt's trip focused on five areas of conflict: Northern Ireland; Israel; Lebanon; Thailand, where the refugees from years of Pol Pot terror in Cambodia had settled; and Hong Kong, where thousands of Vietnam refugees lived.

Upon his return, Rosenblatt wrote a 25,000-word article in three weeks. He

Tone poem. This opening photograph (below), which filled five out of the six columns available in a two-page spread, required a tone-setting introduction, as the introductory text could only occupy the one column not taken up by the image. The writing had to be concise—a style that became known as the "tone poem."

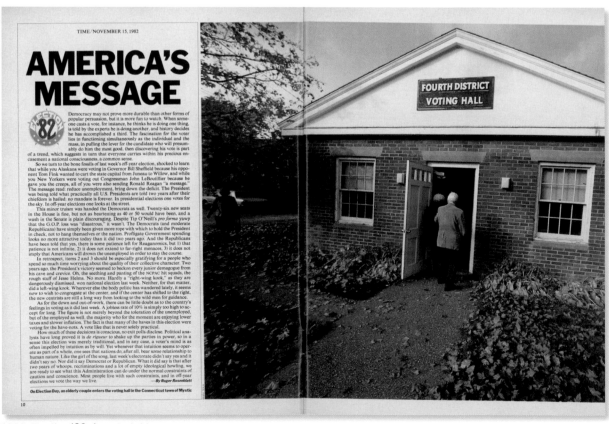

1982. Election '82: America's Message

made sure to change the children's names in several cases to protect them.

In the article, Rosenblatt explained:

"What all these children have in common is a fierce will to survive—a will that sometimes takes the form of revenge, and at other times, of abiding serenity. But no matter how they assert themselves, there is an essential good-heartedness in almost all these children, a generosity of nature that transcends and diminishes anything they have suffered..."

"Children of War" became a milestone of Cave's tenure and was one of the most moving stories ever published by *Time*. It is also among the articles that received the most awards. The year after its publication, the story was published as a book. According to McManus, Cave's deputy at the time, Rosenblatt turned a lot of heads with his twenty-three page story—this was the case of a superstar writer becoming a superstar reporter.

Another aspect of *Timestyle* upon which Rosenblatt had noticeable influence during the 1980s was the production of "symphonic" or "tone poems." These were a column of text placed in the opening of an article, next to a large photo and used to set the mood.

Larger images commanded shorter, more compelling stories. McManus described the new demands on *Time* writers:

"Against a five-column picture you just couldn't start the usual sort of *Time* story in that tiny space (the remaining single column of the two-page spread). You needed a tone poem. So this became a new form of address to the reader, a perceptible change in format, in the way stories were presented—a

generous picture setting the stage, then a tone poem setting the mood, and after that, the traditional *Time* story setting forth the facts." (McManus's interview with the authors)

Rosenblatt became an expert in writing these kinds of stories. This editorial tool set out to explain, from the start, the importance of the story and to serve as a harbinger of sorts to readers before fully delving into the subject matter. "It was a stage setter," Cave said in an interview with the authors. "It set the mood of the piece."

The tone poem formula was so successful that it continued to be used even after Cave's departure, and not only six times a year, but in almost every issue.

One of the most remembered tone poems is a story Rosenblatt wrote for the July 6, 1987, issue, titled "Words on Pieces of Paper." It was the opening of a long article celebrating the Bicentennial of the U.S. Constitution:

"The four sheets of parchment were vellum, the skin of a lamb or a calf, stretched, scraped and dried. The ink, a blend of oak galls and dyes. The lamp, an oil lamp. The instrument, a feather quill. All nature contributing to the assignment, human nature in the form of Jacob Shallus, ordinary American citizen, son of a German immigrant to Philadelphia, soldier, patriot, father of eight and, at the time of the Constitutional Convention, assistant clerk to the Pennsylvania General Assembly. The convention handed Shallus the documents for copying on September 15, 1787. He had forty hours to transfer to four sheets of parchment 4,400 words, for which payment was thirty dollars, good money for moonlighting."

After the mood was set with Rosenblatt's tone poem, the article continued:

"Two centuries later, Shallus becomes history's triviality ... But the words on paper are given Bicentennial parades. Amazing little artifact. What started out at one man's writing desk eventually journeyed the country from city to city as the nation's capital moved, went into hiding during the War of 1812, was transferred from federal department to department until it wound up in the National Archives in Washington, sanctified in helium and watched over by an electronic camera conceived at NASA. The quill age to the space age, and at every stage, a nation full of grateful believers making a constant noisy fuss over a piece of writing barely equivalent to a short story: much theme, no plot, and characters inferred.... The Constitution is more than literature, but as literature, it is primarily a work of the imagination. It imagined a country: fantastic. More fantastic still, it imagined a country full of people imagining themselves."

...

"Did Shallus read what he had copied when he finished? Would he have understood it if he had? How could he dream that all those words, thought out so meticulously, [by the best minds in the country], were conceived only for him? Citizen Shallus bent over his desk in his country, deliberately, exquisitely in the act of being born."

Photojournalism in *Time*

With the 1977 redesign, there was an average of twelve pages of fast color starting in 1979 and, beginning in the 1980s, there were six weekly articles that opened with photo spreads occupying almost two pages. With these changes, *Time* had the opportunity to make its mark in the world of photojournalism.

Cave set out to publish a magazine that was looked at, as well as read, in which images were as important as words. He appointed Arnold Drapkin as photo editor in July 1978. After taking design, sculpture and photo courses, Drapkin had joined *Time* in 1950 as a copy boy, and climbed the ranks through the years. Drapkin's career at *Time* was entwined with the advent of photojournalism at the magazine. "*Time* magazine was a word magazine," he recalled, in an interview with the authors, "words were primary and the pictures were decoration. In the early days, they came with a story and said, 'Go find some pictures.'" In fact, up to the beginning of the 1970s, photo credits did not appear on the masthead or in the magazine.

In 1971, Henry Grunwald was the first to break this mold. He established the magazine's visual foundations by hiring John Durniak as photo editor. Durniak set two precedents. The first was the hiring of staff photographers. After seventeen years of outstanding work for *Sports Illustrated* magazine, Neil Leifer joined *Time* in the 1970s. During and after the Cave era, *Time* made good use of Leifer's technical expertise and good eye for sports. Leifer traveled throughout the United States and the world to cover newsmakers, the Olympics and other sports events. His photos graced *Time*'s cover twenty-seven times. In addition to his memorable Olympic coverage, one of Leifer's best works was the cover and over fifteen inside pages for the story "The Inmate Nation: What Are Prisons For?" published on September 13, 1982.

"I took my cameras over a period of a year to six state prisons, including one for women and a federal penitentiary. I carried the lights myself to all of them," explained Leifer, in an inteview with the authors. One of his most vivid portraits was of Charles Manson, convicted of the Tate-La Bianca murders in 1969, who was photographed by Leifer for the first time in his cell.

Drapkin and Cave selected thirty-five of Leifer's black-and-white images for the story, in addition to the color photo for the cover, to put together *Time*'s largest photo essay using the work of a single photographer. Leifer did a similar piece for the February 23, 1987, cover story on African wildlife, which started with his ten-page photo essay with the headline "An African Journey," followed by Lance Morrow's essay "Africa."

Ted Thai was another staff photographer who came on board during the Durniak era. Thai was born in Cambodia and learned to take pictures during the Vietnam War, alternating working for *Time*'s Saigon bureau and assisting noted portrait artist Richard Avedon. After joining *Time*'s art department as an assistant in the early 1970s, Thai distinguished himself through images ranging from portraits to documentary photographs.

Staff photographers, like writers traditionally did, contributed to stories collaboratively. Dirck Halstead, who did more than forty covers for *Time*, contributed photos, along with Ted Thai, to a special issue, published in August 1983, devoted to Japan. The Statue of Liberty cover story, which ran in the July 14, 1986, issue, ran with a combination of photographers to celebrate its centennial. The cover shot was taken by Neil Leifer, and inside there were a series of foldouts: a two-page one of the opening ceremony

Crucifixion. Photographer James Nachtwey covered more than fifteen conflicts for *Time*. His assignments took him from Central America to Africa, Asia, the Middle East and Northern Ireland. In 1984, Nachtwey ventured into the jungle of Nicaragua to follow the fighting between the ruling Sandinistas and the U.S.-backed Contra guerrillas (opposite).

Pure photojournalism. For the photo on the following spread, James Nachtwey traveled to Palestine in 2000 to cover the conflict between the Palestinians and the Israeli army. The up-close photo shows Palestinians near the West Bank armed with Molotov cocktails. It was published in the October 23, 2000, issue to illustrate the story "Fires of Hate."

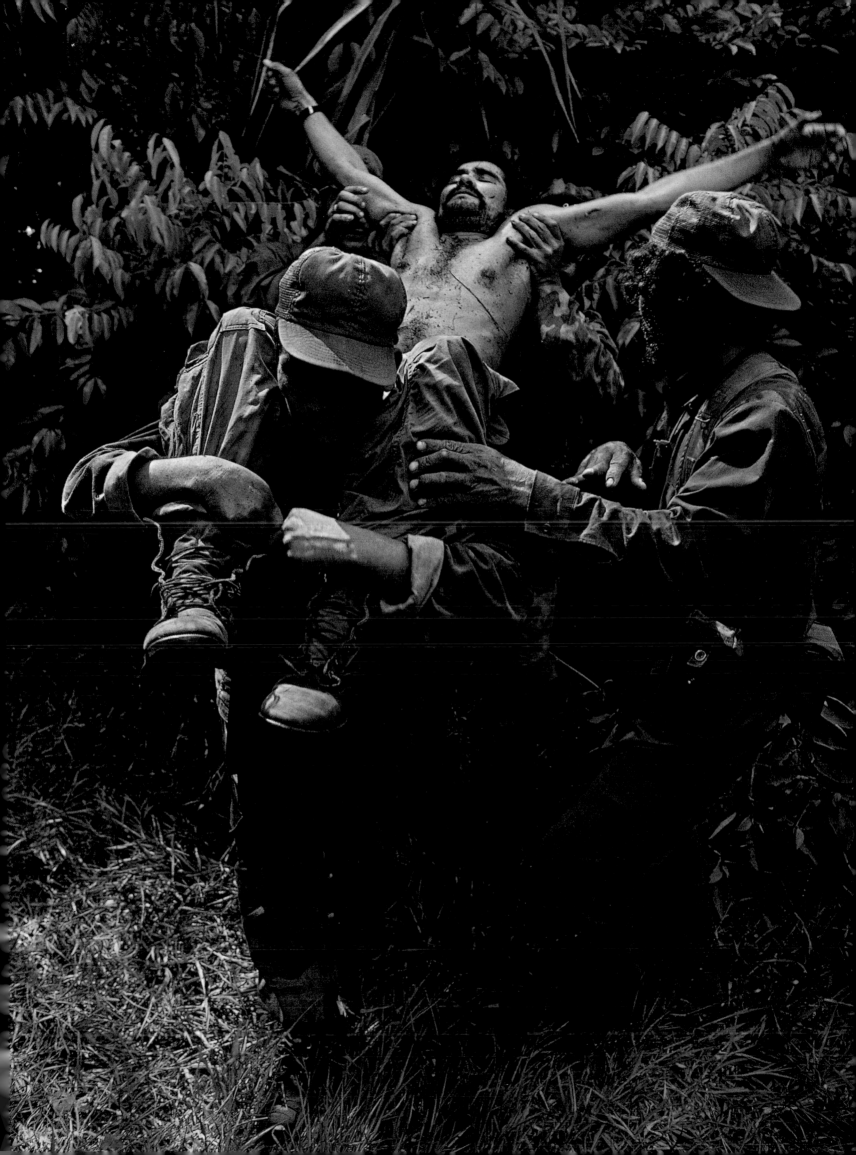

James Nachtwey: *Time* Became My Family

*In this essay, commissioned in 2009 for this book, James Nachtwey (*Time *photographer since 1981) remembers being on the front line for* Time.

Of the twenty-eight years I've worked for *Time*, the amount of time spent in the Time-Life Building could be counted in hours rather than days. El Salvador, Nicaragua, Lebanon, Bosnia, Kosovo, Chechnya, Rwanda, Afghanistan, Iraq, Gaza, the West Bank, Congo, Sudan, South Africa, Indonesia, Mindanao, South Korea, among many other locations are where relationships with my colleagues back at headquarters were forged, relationships that were geographically distant but strong as iron, because they were forged in fire.

Being a freelance photographer is hard enough. Mundane realities like coming up with the rent every month can be an adventure. Day-to-day survival is often a roll of the dice. But enduring extreme conditions, somehow getting the pictures, and then not knowing where they might be published, if ever, can ratchet anxiety to a level of pure fatalism. In principle, I've always been a freelancer, but *Time* became my family. I knew who I was working for, that they're the best at what they do, that chances were good the pictures would actually see the light of day, be given a chance to make a difference. Knowing

those things helped me through a lot of very unpromising circumstances. I came to understand that good photography without good editorship is like howling in the wind. Nicaragua, 1984—mountainous jungle, bone-chilling, torrential rain, mud, curled up at night in the bottom of a plastic garbage bag, back-to-back with Jon Lee Anderson, then a *Time* correspondent, reporting on the contra war—ambushed, machine-gun tracers screaming through the trees, running headlong in the blackness, fueled with high-octane adrenaline—in a jungle clearing, pick up the Beeb—President Reagan to address joint session of Congress about the war, news peg, time to go—late the following night walk into *Time* office wearing the same muddy clothes and a seven-day beard, hand deliver film to Picture Editor Arnold Drapkin—having lost my New York apartment, crash in the Chelsea Hotel—return to office in a few hours to help edit, Arnold up all night, Ray Cave tears up entire week's issue and starts over—cover story, right on deadline—begin looking for new apartment.

Everyone needs a champion. My champion, and my guardian angel was Michele Stephenson. She believed in me, and that made all the difference. When I was passionate about a story, she listened. Even if a "World" editor or the editor in

Nachtwey in action. The picture below is typical Nachtwey—from the front line. The photo shows him working in the line of fire in 1994 in South Africa. Nachtwey is considered to be the successor to combat photographer Robert Capa.

chief himself had doubts, she got the green light switched on. Stories that initially had no editorial consensus ended up running for pages. Pictures in which readers would theoretically not be interested ran double page—over and over again. She let my voice be heard. But it wasn't really my voice. It was the voices of the people in the pictures, and without Michele they would have remained silent.

Of course, she didn't do it alone either, and the support and encouragement of Robert Stevens, "World" picture editor, and MaryAnne Golon, deputy picture editor and later director of photography have to be recognized.

New York City, 2001—11:30 p.m. September 10, arrive a day earlier than scheduled from trip to France—next morning look out my window, south tower of World Trade Center hemorrhaging black smoke, think it's an accident, assemble camera gear—vibration rattles my windows, look again, north tower burning, we're at war—familiar feeling of running in direction from which people flee—witness south tower collapse, two blocks away, find shelter from flying debris, run to the spot—fire trucks burning, police cars smashed, standing below north tower shooting pictures—hear a rumble in the sky, north tower collapsing directly overhead, calculate four to five seconds left to live—defy the laws of physics and human capability, enter hyperspace and beam myself to shelter—utter blackness, might already be dead, except I'm alive because I'm suffocating, believe I'm buried under rubble—crawl, choke on dust and smoke, visibility zero, perceive tiny points of light in the blackness, realize they're car directional signals, know I'm not buried alive—head north, begin to see daylight— find loopholes through police checkpoints, make it to ground zero—science fiction, apocalypse—eyes burning, work until

nightfall—walk to Time-Life Building, jets roar in the night sky, soldiers on the streets—turn in film—I'm a ghost made of dust—walk to lower Manhattan, no electricity, no cars, no water, no phones, nowhere to find food, candles for light, I know it well, another war zone, only now I'm home.

As editor in chief, Jim Kelly rose to the occasion and produced a special issue of *Time*, the trademark red border replaced with black. It came out Friday that same week and thanks to MaryAnne Golon, the driving force behind the imagery, it was composed of all double page photographs— visual testimony that the unbelievable had happened. We all knew that anything any of us could possibly do was dwarfed by the event itself, but we tried to do what we knew how, refusing to give in to shock and despair.

Jim was a wise and compassionate editor, a newsman at heart. He genuinely cared about what happens under the sun and had the courage of his convictions. A story I had suggested about AIDS in Africa had been languishing for months. It was one of those stories Michele had green lighted despite the ambivalence of a powerful editor who was concerned about how the advertisers might react. When Jim got hold of it, he ran it for twenty pages, ten for the photographs, all double-trucks, and ten for a brilliant text by Senior Editor Johanna McGeary (who had been robbed at gunpoint and almost shot while reporting from South Africa), plus a bold cover design. In a transcendent breach of orthodoxy, a portrait of AIDS sufferers all but effaced the *Time* logo itself. Reporters and photographers in the field learn very quickly that the stories we work on are far bigger than we are. With the publication of the AIDS cover, an editor in chief at *Time* asserted that the story was bigger than the magazine and bigger than the advertisers.

It was a triumph of journalistic responsibility over marketing, and the story had a substantial impact on the conversation in America about AIDS in Africa.

During the invasion of Iraq in 2003, I was covering the bombardment, not embedded with American forces, but from inside Baghdad. At a critical moment, the Defense Department issued a warning to American news organizations to evacuate their people immediately. There was a mass exodus by the U.S. press, with only a small handful hanging in. Many correspondents were reluctant to leave, but had been given direct orders from their home offices. Jim, on the other hand, phoned me personally to tell me it was my decision. He expressed his deep concern, recommended that I play it safe, but if I was committed to staying, it was my call. Either way he would back me up 100 percent. Of course, nothing was going to make me leave, but the respect he showed by allowing me to decide an issue with such serious consequences for both myself and the magazine was extraordinary.

I survived, and later that year, documented the life of a platoon for *Time's* "Person of the Year" issue along with Correspondent Mike Weisskopf, whose right hand was vaporized when he made a move to toss away a grenade that was thrown into our Humvee. Two soldiers and myself were wounded, but Mike's courage and sacrifice saved the lives of everyone in the vehicle.

A couple of years later, I was offered an assignment by another magazine to do a story in Iraq. I felt uneasy about it, but Jim established the high ground. He called to wish me well and offer his help.

In jail. The photo on the following spread is one of thirty-five published in the September 13, 1982, issue for the photo essay "Inside Looking Out" on life inside high-security prisons. Neil Leifer shot the photo at the San Quentin State Prison in California, one of the six state prisons he visited. He also shot the color photo that ran on the cover. At the time, it was the magazine's largest photo essay by a single photographer.

Candid camera. Diana Walker took this photo on March 3, 1983, at the de Young Memorial Museum in San Francisco, during a dinner honoring Queen Elizabeth (above). In her speech, the queen made light of the nonstop rain during her visit, pointing out that the rainy weather was part of the British legacy.

at Governor's Island by Dennis Brack, a four-page one by Ted Thai of the fireworks display and a final three-pager by Neil Leifer of the tall ships in New York Harbor.

The second precedent established by Durniak was hiring "contract photographers," thus paving the way at *Time* for great photojournalists, such as Eddie Adams, who had worked for the Associated Press; Dirck Halstead and David Hume Kennerly, both from United Press International; and Ken Regan and

Bill Pierce. Several of them worked, earned accolades and reached records before, during and after the Drapkin era. Durniak left *Time* to join *Look* magazine, while Drapkin, the assistant editor, took over the department.

Drapkin followed the photojournalism policies of his predecessor, but added a new element. With the advent of fast color, the mission of the new photo editor was to assign or find hard-news color images that conveyed the impact and immediacy of

the stories. Consequently, Drapkin added to the already-strong list of *Time* photo stars—some of the best photojournalists of the time—including David Burnett, Michael Evans, Cynthia Johnson, James Nachtwey, Susan Meiselas and Diana Walker. They offered a series of memorable images for the magazine that documented the history of the world seven days at a time.

"We got an enviable integration between words and visuals and I got an

My days at *Time*
Michele Stephenson: A Smile and a Frown

From Michele Stephenson's interview with the authors.

The Reagan-Gorbachev Summit that took place in Reykjavik, Iceland, in October 1986 was a great example of using new technology with photojournalism.

When the summit was announced, we looked for ways to be able to electronically transmit color from Iceland.

We researched and found that the newspaper in Reykjavik had a color lab and a Scitex machine capable of scanning and transmitting color pictures. *Time* arranged to have exclusive access to this facility during the summit, which took place over a weekend.

But we also had a contingency plan. Sometimes we had more than one. That was the way we were trained to think at *Time*.

Therefore, Arnold Drapkin worked with our production people to ship a scanner to Reykjavik, a $750,000 monster of a machine that had to be transported via London to Iceland (it was the only way to get it there on time), just in case something went wrong with the other equipment on site. Should we need to use the scanner, we could always make the deadline if we had the picture. Besides, to minimize the risks, we also had early film couriered to New York.

The summit seemed to be a success and both *Time* and *Newsweek* went to press with pictures of Reagan and Gorbachev smiling on the cover.

However, on Sunday, when the two leaders reappeared at the end of the talks, our photographer, David Hume Kennerly, who was very familiar with the two, noted their expressions and their frosty demeanor in saying good-bye. As he photographed the downbeat farewell he alerted *Time* correspondents, then filing their stories in Reykjavik, that something had gone wrong. Soon confirmation came

that the summit had turned into a failure. Dirck Halstead, who was also covering the meeting, was the designated on-site photo editor. He called me at three o'clock on Sunday afternoon and said that Kennerley got the picture.

I went to Managing Editor Jason McManus and said, "Can we wait, can we hold until they can get the new picture to us?" Jason said, "If you can get it here by the time we finish changing the story, we can do it."

We had stopped the presses so it was a race against time. Dirck raced to the lab to get the film processed. Meanwhile, Art Director Rudy Hoglund designed the cover frame and added new cover lines; everything was ready to go. Jason, Rudy and I hurried down to our imaging center in the basement in New York, where the picture was coming in. At about one minute to 7 p.m., with the cover closing at seven, Rudy put the picture in place—they pressed the button and it was sent!

First editions of *Time* appeared on the newsstands the next morning (Monday, at the same time as *The New York Times*), with the new cover (left).

Newsweek had a smiling picture on their cover, although they later changed the cover line.

Returning to New York, *Newsweek*'s photographers sat with their undeveloped film in their camera bags very upset as they heard *Time*'s photographers celebrating their coup.

1986. Ronald Reagan and Mikhail Gorbachev

adequate budget to lead my department comfortably. Pictures, under Cave, were not a decoration, or a reiteration of a story point, but had to bring an additional dimension of understanding to the reader." (Drapkin's interview with the authors)

Except for Thai and Leifer, all the other photographers were on retainer, that is, the magazine guaranteed them a set number of stories a month or year for a set salary (which was increased if they went over the guaranteed minimum number of stories) and exclusivity until *Time* first published the photo. This meant that the photographers were allowed to resell their photos to other international magazines or work for other media, photo agencies, companies or even ad agencies,

as long as they didn't take with them ideas generated within *Time*. Each photographer contributed a specialty to the magazine: Ken Regan devoted himself to boxing and Hollywood personalities; Burnett first focused on wars and guerrilla clashes, and then became one of the favorite photographers to cover the Washington scene; and Kennerly took the best "behind the scenes" presidential shots, a form later perfected by Diana Walker. James Nachtwey emerged as the heir to the early combat photographer and photojournalist, Robert Capa, for his memorable photos of wars throughout the world.

During the almost ten years that Drapkin was at the helm as the magazine's photo director, *Time* received more than 200 awards for its visual coverage. David Burnett was the photographer at the

magazine to receive the most awards of that era, honored several times as "Best Photographer of the Year." During the 1980s, James Nachtwey became *Time*'s war photographer par excellence for his coverage of more than fifteen conflicts; he earned innumerable awards. Nachtwey followed these conflicts from Central America to Africa, Asia, the Middle East and Northern Ireland. "There is a job to be done—to record the truth. And I have a terrific personal compulsion to do it," Nachtwey said, in in an interview with the authors. In 1983, *Time* sent him to Central America for six months, where he was based in Nicaragua. He spent the rest of the year in Lebanon. In April 1984, he returned to Central America to photograph the contras, and in the following year, he covered the Beirut bombing as well as El

Courage. Christopher Morris, part of the photography team Photo Editor Arnold Drapkin built, took this photograph in December 1989, during the U.S. invasion of Panama (below).

Salvador's civil war and elections. In 1986, he was in the Philippines (February and March), in Afghanistan with the mujahedin (October) and then in Sri Lanka, covering, among other things, the Tamil rebels (December). For these and other stories, Nachtwey won the Robert Capa Gold Medal Award an unprecedented five times. Other photographers who won prizes for their coverage in Central America and the Middle East were Susan Meiselas and Kaveh Golestan. Anthony Suau (Pulitzer winner), Dennis Brack, Christopher Morris and Steve Liss were photojournalists who soon also became known for their images at the magazine.

During Ray Cave's editorship, Drapkin also brought more female photographers to *Time*, when it was hard for women to break into the field. Among them were Francoise Demulder, Cathy Leroy, Sahm Doherty, Cindy Karp, Susan Meiselas, Cynthia Johnson and Diana Walker. Johnson and Walker covered Washington and presidential travel. Susan Meiselas focused on Nicaragua and El Salvador. Demulder and Leroy worked in the Middle East, spending most of their time in Lebanon and Iran. Diana Walker made a career for herself as a *Time* contract photographer starting in 1979 and covered five presidents, from Gerald Ford to Bill Clinton, receiving several awards.

"I think my proudest contribution was the photography team I built. During my ten years as picture editor, we turned the magazine into a potent force in photojournalism." (Drapkin's interview with the authors)

Drapkin was at the magazine until 1987, when he was succeeded by Michele Stephenson, who during Drapkin's tenure had been promoted to deputy photo editor.

Stephenson took *Time*'s photojournalism to its apex in the 1990s, especially during Jim Kelly's stewardship. During her nineteen years as photo editor, *Time* won over 400 photo awards. During this time, James Nachtwey won more awards than any other photographer had previously.

Relief. David Burnett was another great photojournalist hired by Drapkin. This photo (below), shot at a refugee camp in Ethiopia is one of the outstanding pictures in the history of photojournalism. It was published in the November 26, 1984, article titled "The Land of the Dead."

Steven Spielberg: Everything Started with a Dream

In this essay, commissioned in 2009 for this book, Director Steven Spielberg recalls making the cover of Time *in 1982.*

In May of 1982, *Time* magazine put my movie *E.T. The Extra-Terrestrial* on its cover. (Well, to be more precise, on the upper-right-hand corner of its cover, where the squashy little guy was peering inquisitively at readers from behind the banner headline "D-Day In the Falklands.") The article included a bit of optimistic predicting about the box-office potential of the movie, although, back then, just days before *E.T.* opened, none of us imagined that it would go on to become the highest-grossing film in history at that time. But most of the story wasn't about money—it was about what inspired me to make the movie in the first place, including my fond memories of my own suburban childhood.

Reading the article again, I'm struck by how much the movie business has changed since *E.T.* came out—and by how much it hasn't. At the beginning of the story, *Time*'s writer warned that *E.T.* would face a good deal of competition for audiences that summer, and went on to list several of the other movies that would be opening. They included not only another film I'd worked on, *Poltergeist*, but two musicals, a *Star Trek* sequel, a remake of *The Thing*, mainstream America's first glimpse of Mel Gibson as *The Road Warrior*, Ridley Scott's *Blade Runner*, an adaptation of *The World According to Garp*, new movies from Woody Allen and Clint Eastwood, and *Tron*, which proved to be an important early step in computer-generated effects, something that would eventually become a more significant part of movies—and not just summer blockbusters—than most of us imagined.

That lineup of pictures, with something for everyone, full of strong directors pursuing their own visions, following the dreams that excited them and trying to communicate that excitement to moviegoers, seems amazingly varied from today's vantage point. Those weren't factory-made summer movies, they were personally crafted movies—and many of them (including mine, I'm happy to say!) still resonate with audiences. Back then, I told *Time*'s reporter that I was worried about a blockbuster mentality taking over the Hollywood studios. The problem, I said, is that "everybody is aiming for the right field stands." And I went on to express the hope that "if each studio would take $1 million profit per big movie and invest it in film schools and writing programs, we'd have the industry that David O. Selznick and Irving Thalberg created."

It's hard to argue that, since 1982, the blockbuster mentality hasn't gotten even more prevalent. And not only within the studios, but in the press—box-office grosses are now a blood sport, analyzed day by day in newspapers, on websites, and on blogs. But as we witness what sometimes looks like a growing gap between "big" movies and "small" movies, it's easy to forget that small movies can be big too. *E.T.* wasn't particularly expensive, it didn't feature movie stars, and much of it was set inside a single suburban home. It was a challenging and exciting movie for me to make, a kind of film that I hadn't had a chance to direct before, and in many ways a very quiet movie. In the article, I referred to it as "a whisper."

I hope, and I believe, that we still have room for whispers in today's ambitious universe. It's easy to assume that bigger is always better, but when I see a movie that I love—and many of them have ended up the subject of significant articles and *Time* covers over the years—I think about the size of the filmmaker's imagination, not of his or her budget. Great movies come large and small. They can be as epic as *Lawrence of Arabia* or as intimate as *Juno*. And sometimes, the littlest ones have more impact than even their creators could have dreamed.

Big dreams. Steven Spielberg is a legend in the film industry. His 1982 blockbuster, *E.T.* (opposite), was the highest-grossing film in history at the time. Spielberg considered the film a small, "quiet movie"—no big stars or splashy locations. He never dreamed it would be such a success. Dreams, whether big or small, are the industry's engine, according to Spielberg.

Salvador's civil war and elections. In 1986, he was in the Philippines (February and March), in Afghanistan with the mujahedin (October) and then in Sri Lanka, covering, among other things, the Tamil rebels (December). For these and other stories, Nachtwey won the Robert Capa Gold Medal Award an unprecedented five times. Other photographers who won prizes for their coverage in Central America and the Middle East were Susan Meiselas and Kaveh Golestan. Anthony Suau (Pulitzer winner), Dennis Brack, Christopher Morris and Steve Liss were photojournalists who soon also became known for their images at the magazine.

During Ray Cave's editorship, Drapkin also brought more female photographers to *Time*, when it was hard for women to break into the field. Among them were

Francoise Demulder, Cathy Leroy, Sahm Doherty, Cindy Karp, Susan Meiselas, Cynthia Johnson and Diana Walker. Johnson and Walker covered Washington and presidential travel. Susan Meiselas focused on Nicaragua and El Salvador. Demulder and Leroy worked in the Middle East, spending most of their time in Lebanon and Iran. Diana Walker made a career for herself as a *Time* contract photographer starting in 1979 and covered five presidents, from Gerald Ford to Bill Clinton, receiving several awards.

"I think my proudest contribution was the photography team I built. During my ten years as picture editor, we turned the magazine into a potent force in photojournalism." (Drapkin's interview with the authors)

Drapkin was at the magazine until 1987, when he was succeeded by Michele Stephenson, who during Drapkin's tenure had been promoted to deputy photo editor.

Stephenson took *Time*'s photojournalism to its apex in the 1990s, especially during Jim Kelly's stewardship. During her nineteen years as photo editor, *Time* won over 400 photo awards. During this time, James Nachtwey won more awards than any other photographer had previously.

Relief. David Burnett was another great photojournalist hired by Drapkin. This photo (below), shot at a refugee camp in Ethiopia is one of the outstanding pictures in the history of photojournalism. It was published in the November 26, 1984, article titled "The Land of the Dead."

Steven Spielberg: Everything Started with a Dream

In this essay, commissioned in 2009 for this book, Director Steven Spielberg recalls making the cover of Time *in 1982.*

In May of 1982, *Time* magazine put my movie *E.T. The Extra-Terrestrial* on its cover. (Well, to be more precise, on the upper-right-hand corner of its cover, where the squashy little guy was peering inquisitively at readers from behind the banner headline "D-Day In the Falklands.") The article included a bit of optimistic predicting about the box-office potential of the movie, although, back then, just days before *E.T.* opened, none of us imagined that it would go on to become the highest-grossing film in history at that time. But most of the story wasn't about money—it was about what inspired me to make the movie in the first place, including my fond memories of my own suburban childhood.

Reading the article again, I'm struck by how much the movie business has changed since *E.T.* came out—and by how much it hasn't. At the beginning of the story, *Time*'s writer warned that *E.T.* would face a good deal of competition for audiences that summer, and went on to list several of the other movies that would be opening. They included not only another film I'd worked on, *Poltergeist*, but two musicals, a *Star Trek* sequel, a remake of *The Thing*, mainstream America's first glimpse of Mel Gibson as *The Road Warrior*, Ridley Scott's *Blade Runner*, an adaptation of *The World According to Garp*, new movies from Woody Allen and Clint Eastwood, and *Tron*, which proved to be an important early step in computer-generated effects, something that would eventually become a more significant part of movies—and not just summer blockbusters—than most of us imagined.

That lineup of pictures, with something for everyone, full of strong directors pursuing their own visions, following the dreams that excited them and trying to communicate that excitement to moviegoers, seems amazingly varied from today's vantage point. Those weren't factory-made summer movies, they were personally crafted movies—and many of them (including mine, I'm happy to say!) still resonate with audiences. Back then, I told *Time*'s reporter that I was worried about a blockbuster mentality taking over the Hollywood studios. The problem, I said, is that "everybody is aiming for the right field stands." And I went on to express the hope that "if each studio would take $1 million profit per big movie and invest it in film schools and writing programs, we'd have the industry that David O. Selznick and Irving Thalberg created."

It's hard to argue that, since 1982, the blockbuster mentality hasn't gotten even more prevalent. And not only within the studios, but in the press—box-office grosses are now a blood sport, analyzed day by day in newspapers, on websites, and on blogs. But as we witness what sometimes looks like a growing gap between "big" movies and "small" movies, it's easy to forget that small movies can be big too. *E.T.* wasn't particularly expensive, it didn't feature movie stars, and much of it was set inside a single suburban home. It was a challenging and exciting movie for me to make, a kind of film that I hadn't had a chance to direct before, and in many ways a very quiet movie. In the article, I referred to it as "a whisper."

I hope, and I believe, that we still have room for whispers in today's ambitious universe. It's easy to assume that bigger is always better, but when I see a movie that I love—and many of them have ended up the subject of significant articles and *Time* covers over the years—I think about the size of the filmmaker's imagination, not of his or her budget. Great movies come large and small. They can be as epic as *Lawrence of Arabia* or as intimate as *Juno*. And sometimes, the littlest ones have more impact than even their creators could have dreamed.

Big dreams. Steven Spielberg is a legend in the film industry. His 1982 blockbuster, *E.T.* (opposite), was the highest-grossing film in history at the time. Spielberg considered the film a small, "quiet movie"—no big stars or splashy locations. He never dreamed it would be such a success. Dreams, whether big or small, are the industry's engine, according to Spielberg.

The explosion. Only seventy-three seconds after its takeoff, space shuttle *Challenger* exploded (above). Ralph Morse took the February 10, 1986, cover photograph of the disaster that killed all seven members of the crew. Morse, who photographed the launching of the first U.S. satellite, and almost every manned flight since 1958, knew from the start "they're in trouble up there."

book on the company's history, *The World of Time Inc.: The Intimate History of a Changing Enterprise: 1960–1980,*

"marked a sharp break with the past, perhaps the sharpest yet in nearly 60 years of Time Inc.'s corporate existence. Heiskell's 20 years as chairman—the last ten as chief executive—and Donovan's long tenure—five years as Luce's deputy, then 15 years on his own as editorial chief—had given great continuity to the previous management. Also, that management had been appointed by Luce, together with Larsen, and had worked intimately with both. Although Grunwald's editorial associations with

Luce were close, Davidson had dealt with him mainly overseas, in Europe, and Munro admitted frankly that while at *Time* and *Sports Illustrated* he had barely glimpsed Luce: 'I can't recall ever shaking his hand.'

Differences between the new generation and the old went beyond this, however, and were especially marked on the business side among the younger executives Munro brought into position after his own appointment. To make a somewhat facile distinction, the earlier generation had proved themselves first as publishers, while their successors came in more widely experienced, and probably better trained, as managers."

In 1980, Time Inc. was not only a publisher of magazines—it had seven that decade—but it had also diversified its business into other activities: books, videos, cable TV, a timber company and a newspaper. It was attempting to become strong in two areas: news and entertainment. Munro wrote, in a letter to stockholders, the goal was "a new Time Inc., turned solely toward the business of communications..."

This was the background in September 1985 when Jason McManus, who had joined *Time* in 1959, took over the magazine as managing editor. The new managing editor had first made a name for himself with his stories on Vietnam and the rest of Southeast Asia, then as the European correspondent, editor of the "Nation" section, assistant managing editor, starting in 1976, and executive editor in 1978. Soon after being named, McManus, promoting the new line among company executives, wrote in a staff memo:

"Before, editors never knew anything about money, didn't want to. The bad news I have for you is that every editor and department head now have to get their hands dirty because they will have to control their budgets. We have to cut expenses and from now on this will be our responsibility."

McManus was *Time*'s eleventh managing editor, but he held the position for only eighteen months. The short time he led the magazine was appropriate: brevity characterized his tenure. McManus shortened everything: headings, space for stories, the number of natural disasters featured on the cover every year (he resisted publishing more than one), the number of office meetings and decision-making time.

Shorter, more colloquial heads

McManus attempted to reach readers by using informal language, familiar terms and clear reasoning. In a story about the summit between Reagan and Gorbachev, published on November 18, 1985, the cover title was "The Summit: Let's Talk." Two weeks later, the same subject carried the heading "So Far, So Good." On March 10, 1986, when Corazon "Cory" Aquino was elected president of the Philippines, the magazine, using the new approach, marked the event with the heading: "Now for the Hard Part." And in April, for a story analyzing the dropping price of oil, the cover featured an illustration of the moon, with the hint of a smile, and the title above it: "Good News!: Cheap Oil!" Below the illustration, another title printed upside down read: "Bad News!: Cheap Oil!" "What all of these aim to do," McManus said, in an interview with the authors, "is invite the reader in by saying we know you know what this subject is about and we are not going to lecture you pedantically."

Special issues and new sections

Under McManus, new sections were born, such as "Ethics" and "American Profile," which alternated with "American Scene." The purpose of the latter two: doing more in-depth profiles of newsmakers.

Most notable during those nineteen months were special issues. The first, on July 8, 1985, was almost entirely devoted to immigrants. The second, published on June 16, 1986, was titled "American Best." The issue set out to profile the best the country had to offer in everything from the concept of freedom to sportswear and sandwiches. Four weeks later, a special issue commemorated the 100th anniversary of the Statue of Liberty, with a pullout cover. At year-end, a special issue took note of the most extraordinary events of 1986, with an original touch added by the cover title: "A Letter to the Year 2086." The issue, with its forward-looking letter, was included in a time capsule that was placed in the Statue of Liberty Museum, to be opened in 2086.

McManus believed the magazine should focus on two basic elements: information and entertainment. The February 23, 1987, issue, which devoted the cover to wildlife in Africa, is the best example of how he put his belief into practice. Of the story's twenty pages, ten featured photos (entertainment and context) and the other ten, an article by Lance Morrow (information).

The *Challenger* explosion and other disasters

"'Where in hell is the bird? Where is the bird?' shouted a space engineer at Cape Canaveral. 'Oh, my God!' cried a teacher from the viewing stands nearby. 'Don't let happen what I think just happened.' Nancy Reagan, watching television in the White House family quarters, gasped similar words, 'Oh, my God, no!' So too did William Graham, the acting administrator of NASA, who was watching in the office of a congressman. 'Oh, my God,' he said. 'Oh, my God.' … In one fiery instant, the nation's complacent attitude toward manned space flight had evaporated."

Wildlife in Africa. Information and entertainment were the main themes during McManus's tenure. Senior Writer Lance Morrow and Staff Photographer Neil Leifer spent seven weeks in East Africa to write the cover story and shoot the photos for the February 23, 1987, issue (below). A ten-page picture essay accompanied the ten-page story about wildlife in Africa, whether it would vanish and if so, what would be lost.

1987. African wildlife

JANUARY 4, 1988 $2.00

TIME

MAN
OF THE
YEAR

THE EDUCATION OF
MIKHAIL SERGEYEVICH GORBACHEV

The above excerpt is how *Time* began its February 10, 1986, report on the *Challenger* disaster. On January 28, 1986, the American space shuttle had exploded just seventy-three seconds after liftoff. Aboard were crew members Francis Scobee, Michael J. Smith, Ronald McNair, Ellison Onizuka, Gregory Jarvis, Judith Resnik and Christa McAuliffe. According to the investigations, the accident was the result of a failure of one of the rocket booster seals. The tragedy focused intense scrutiny on the shortcomings of the space program. The public was especially dismayed by the death of Christa McAuliffe, a teacher who joined the crew as the first member of the NASA Teacher in Space project.

A year earlier, *Time* had published on its cover two natural tragedies that also stirred international public opinion: the earthquake in Mexico and a volcano eruption in Colombia.

Although McManus had decided that the magazine would publish an image of no more than one catastrophe on the cover per year, events forced his hand. Weeks after the *Challenger* disaster, yet another disaster would appear on the cover of *Time*: the explosion in the Ukraine on April 26, 1986, of the Chernobyl reactor, the most serious nuclear accident in history.

Perestroika and Gorbachev, "The Man of the Year"

McManus's short tenure was marked by terrorist acts in the Middle East, hijackings of planes and ships, such as the *Achille Lauro*, and arms trafficking scandals, such as Irangate and the Iran-contra affair, involving the contras in Nicaragua. Perhaps overshadowing these disasters was a development that took place between 1985 and 1987 and would have serious, immediate consequences throughout the world. "Perestroika" (written in Russian as "Перестройка"), which means restructuring, was a term soon added to the Western Hemisphere's lexicon. Perestroika, based on innovations in the Socialist system aimed at freeing up the country's economy, was carried out by Mikhail Sergeyevich Gorbachev, who, in 1985, was elected Secretary General of the Communist Party and took over the reins of power in the Soviet Union.

Gorbachev was first featured on the cover of *Time* in the March 25, 1985, issue. The title was "Moscow's New Boss," and the subheading praised him as "Younger, Smoother and Probably Formidable." From 1985 to 1987, he appeared on the cover six more times, before he was crowned on the January 4, 1988, cover—made in the style of a Russian miniature—as the 1987 "Man of the Year."

The decision to select Gorbachev as "The Man of the Year" was made during two managing editors' administrations: Jason McManus's and Henry Muller's. In May 1987, McManus became the editorial director of Time Inc. and Muller replaced him as managing editor of the magazine. When McManus joined Time Inc.'s editorial ranks, Henry Grunwald was editor in chief and Ralph Graves was editorial director. Ray Cave also held a company-wide editorial post. McManus was promoted at the request of Grunwald, who wanted to groom him as his successor. Some consider that decision a bad one and think that the natural successor for the company's top editor job should have been Cave. According to Chris Porterfield, one of the closest witnesses to *Time*'s history over forty years—he began as a trainee in 1963 and retired as executive editor in 2003—McManus's direction of the magazine was a formality, part of Grunwald's strategy: "I think Grunwald wanted McManus by his side on the 34th floor," Porterfield told the authors, "and it would have looked weird to leap-frog

him without his being managing editor first. McManus's tenure was always viewed as a formality to win his stripes."

Be that as it may, McManus's short stint as *Time*'s managing editor started a new rhythm of short tenures for *Time*'s top editors over the next decade—McManus from 1985 to 1987; Henry Muller from 1987 to 1993; James R. Gaines only from 1993 to 1995, ceding the post in 1996 to Walter Isaacson. This quick succession was a marked contrast to the pattern of *Time*'s earlier decades. The last four editors before McManus had remained at the helm much longer: Roy Alexander for eleven years, Otto Fuerbringer for eight, Henry Grunwald for nine and Ray Cave for eight.

A new era was born, with less time to make decisions, less time to gain experience and less time to try out models or new editorial alternatives. Although *Time* always kept one eye on financial issues and the other on editorial ones, according to several editors and publishers who were interviewed, *Time*'s focus started to revolve around profits. Time Inc.'s general management started to lose faith in the magazine. It was often said that the magazine was at risk of losing readers' interest unless it transformed itself or at least made changes. The loss of faith gradually affected editors, whose attempts to fulfill their visions were hampered by greatly reduced budgets. Editorial goals were now subordinated to business-oriented ones. It's no wonder that once Jason McManus reached the thirty-fourth floor as editor in chief, he said: "This is a business, not a religion."

Russian art. Nikolai Soloninkin was commissioned to illustrate the 1987 "Man of the Year" cover of Mikhail Gorbachev (opposite). The artist created the portrait for the cover in the style of a Russian miniature; it took him days to make.

When Analysis Overtook the News

The decision to name Henry Muller *Time*'s managing editor was noteworthy for several reasons. Except for the founders, Muller, at forty, was the youngest managing editor to take over the publication. He was also the first one to reach that level from such deep roots in the Time-Life News Service, since he had spent more time as a foreign correspondent than in the home office. Also, after Grunwald, he was the second immigrant to lead *Time*. Muller was born in Germany and spent his early childhood in Switzerland before he and his family moved to San Francisco when he was six. Muller joined *Time* in 1971 as a correspondent in Canada, and held important jobs from a young age. At twenty-four, he was Vancouver bureau chief; at twenty-six, European economic correspondent in Brussels; at thirty, Paris bureau chief; and at thirty-five, senior editor of the "World" section in New York. Because he had spent most of his professional life overseas, his appointment generated misgivings among the "New York line" of editors, and because he spoke perfect French, English and German, as soon as he took over the magazine in 1987, the home office, following its tradition of using nicknames, started calling Muller "the editor from another planet."

From Switzerland, where he now lives, Muller recounted the reasons behind his nickname:

> "What was unusual was that I had come from the ranks of correspondents (the News Service) and thus represented a break with the tradition of managing editors being 'edit' people who had come up as writers and editors in New York ... My predecessors had been trying for some time to reduce, if not eliminate, the rigid division between News Service and edit, so I saw my appointment as an important step in that direction.

Time Inc.'s management was totally supportive of my appointment. The lower ranks, I think, were divided between those who found it refreshing to have a former correspondent in the corner office and those who feared I might not sufficiently appreciate colleagues who had made their careers in New York.

My 'foreignness' was probably a little exotic for the company, but it underscored *Time*'s position as a magazine with global reach, both in its news coverage and its readership. Nor was I the first: Henry Grunwald came to the U.S. in his teens, and the legendary *Sports Illustrated* managing editor, André Laguerre, was French-born. In any event, I wasn't all that foreign. I moved from Switzerland to the U.S. when I was six. I went to grade school and high school mostly in the U.S. and then college at Stanford, where as editor of the newspaper I had a front-row seat during the upheavals of the late '60s. I served in the U.S. Peace Corps; when I went abroad again it was for an American magazine. Before being named managing editor, I had been back in the U.S. for six years. I never felt any less capable than any other journalist of covering American politics, society or popular culture (except sports) just because I was born abroad and spoke foreign languages." (Muller's interview with the authors)

During Muller's tenure, significant journalistic shifts occurred: placing greater value on analysis over news and on investigative reports over current events; introducing the interview format as a means of presenting newsmakers; running correspondents' files directly as articles instead of using them as raw material for writers in New York, thus lessening clashes

1989. Student athletes and education

1991. Scientology exposed

Breaking tradition. During Muller's tenure, more subjects than newsmakers appeared on *Time*'s covers: "The College Trap" on April 3, 1989 (left, top), and "Scientology" on May 6, 1991 (left, bottom). The endangered Earth was selected as "Planet of the Year" in 1988, instead of the traditional "Man of the Year." To illustrate the cover, Christo, the Bulgarian environmental sculptor, wrapped a sixteen-inch globe in polyethylene and rag rope and photographed the "Wrapped Globe 1988" as if it had washed ashore on a Long Island beach (opposite).

PLANET OF THE YEAR TIME

What On EARTH Are We Doing?

TORCHING THE BRAZILIAN RAIN FOREST: Unprecedented profligacy in the name of progress

1989. Planet of the Year: What on Earth Are We Doing?

Environmental pioneer. *Time* was one of the first newsmagazines to wholeheartedly address the effects produced by climate change, biodiversity and overpopulation. In addition to the article about the Earth in danger (above), *Time* arranged a three-day conference in Boulder, Colorado, with scientists, administrators and political leaders from five continents to find solutions and produce an action plan. Senator Al Gore was among them.

between the field and the home office; and devoting the majority of covers to issues, rather than to newsmaker portraits.

The newsmaker covers—a *Time* trademark since its founding—began to lose their primacy. In 1989, for instance, thirty-three of the fifty-three covers were devoted to issues. The cover photos included a globe sculpture, the sun, an elephant, a baby, the hammer and sickle and various city or country landscapes. On August 28, an anniversary was featured on the cover: fifty years after World War II. Two months later, another anniversary, "150 Years of Photo Journalism" made it to the magazine's front page. The focus had undoubtedly changed.

Muller also sprang some surprises. Instead of following the custom of placing the newly elected president, George H. W. Bush, on *Time*'s first cover in 1989 as the 1988 "Man of the Year," Muller selected the Earth as the 1988 "Planet of the Year." The issue was significant for its journalism, the originality of its choice and its cover illustration. Christo, the noted Bulgarian environmental sculptor, created the cover. To depict the "Endangered Earth," Christo used one of his trademark techniques, wrapping, and covered a sixteen-inch globe in polyethylene and rag rope, then placed it on a Long Island beach at sunset.

Another of Muller's innovations was the creation of new sections, such as

"Profiles," "American Ideas," "Travel," "Grapevine" and, perhaps most notably, the "Interview" section.

Muller's strong point during his career had been reporting. He was the first *Time* managing editor who had worked mainly as a correspondent and as a reporter, and his background was apparent. According to Priscilla Painton, who joined the magazine as a reporter in 1989 and in 2000 became executive editor:

"Muller thought that reporting was key to distinguishing *Time*. For him it was extremely important that readers could find news in *Time*, news that you could not find anywhere else. *Time* was

always proud of its literary tradition as well as its reporting, but Henry realized that the long-term survival of the magazine was going to be in its ability to report."

Muller's tenure was also characterized by strengthening the role of women on the magazine's staff. Not only was Painton hired, but also Nancy Gibbs, who had joined the staff in 1985 as a fact-checker, was promoted. As of August 2009, Gibbs holds the record for producing more cover stories than any other *Time* writer (162).

Muller inherited a traditional *Time* magazine from McManus. It focused on the mass audience and tried to distill everything on the national and international scene, including the worlds of arts, fashion, sports and cinema, as well as business. But from the outset, Muller emphasized investigative journalism in his cover stories, which Grunwald had started with *Time*'s coverage of Watergate. Among Muller's investigative pieces: "You Bet Your Life: Pete Rose and the Great American Obsession," the coverage of the scandal revolving around Rose's betting on baseball games; "The College Trap," an in-depth analysis of colleges that promoted themselves through their student athletes; and "Scientology," a look at the controversial religion founded in the 1950s by science fiction writer L. Ron Hubbard, rumored by some to extract exorbitant amounts of money from its members.

This trend toward deep and analytical subjects on the cover veered the magazine from its usual focus on the latest news and current events. For example, in 1991, the week professional basketball star Magic Johnson announced that he had tested positive for HIV, Muller ran a cover story on the state

1992. The Agony of Africa

Out of touch. The tendency was for the latest-breaking news to give way to more analytical subjects on the cover. For example, when Hurricane Andrew thrashed the coast of Florida, leaving a disaster in its wake, the September 7, 1992, issue referenced the catastrophe on a band across the right-hand corner of the cover reading "After the Hurricane," yet the cover story was "The Agony of Africa" (above).

of California. In 1992, when Hurricane Andrew devastated South Florida, Muller published a cover photo of Africa, under the heading "The Agony of Africa," and barely referred to the hurricane inside the issue. The magazine became a mirror of subjects that, although important, were often removed from American society and its immediate concerns. In the last six issues of 1992, the cover of *Time* featured investigative pieces on "God and Women: A Second Reformation Sweeps Christianity"; the British monarchy; Russia; Somalia; and "What Does Science Tell Us About God?" To some, it seemed

that the magazine wanted to set and impose its own news agenda, one that on occasion was at odds with what appealed to readers.

From the Fall of the Wall to the Gulf War

Muller would institute, in 1992 a drastic redesign of the magazine that, apart from the diverse opinions it generated, was a traumatic event in *Time*'s history. It occurred in the fifth year of his 1987–1993 tenure, a period in which the world in general and journalism in particular underwent many transformations. These transformations affected not only the news but also the way news items were reported and published.

Barely two years after Muller took over as the magazine's managing editor, several events validated his penchant for placing international issues on the cover. In April 1989, the profound changes taking place within the Soviet Union were the subject of an investigative piece illustrated with a hammer and sickle on the cover. A few weeks later, in May, the magazine's cover reflected the first signs of protest against the Communist regime in China, with Tiananmen Square in Beijing as the setting. In June, the cover reflected the bloody repression of that protest's end. In the same year, novelist Salman Rushdie made the news when he was sentenced to death by the government of Iran for his novel *Satanic Verses*. The Ayatollah Khomeini, who died at eighty-nine, also appeared on the cover that year. Other notable events that made the cover included the San Francisco earthquake, the environmental disaster in Alaska caused by a spill from the Exxon *Valdes* oil tanker and the invasion of Panama by the United States.

The year's—and arguably the decade's—most important international political event occurred on November 20, 1989, when the Berlin Wall, which divided East and West Germany, was torn down. With it fell a symbol of oppression that had separated people of the same nationality and occasionally even people from the same family from one another for twenty-eight years. Many called it the "Wall of Shame." *Time* featured the event on its cover under the heading "Freedom!" The story, written by George Church, captured the wall's historic sweep:

"For 28 years it had stood as the symbol of the division of Europe and the world, of Communist suppression, of the xenophobia of a regime that had to lock its people in lest they be tempted by another, freer life—the Berlin Wall, that hideous, 28-mile-long scar through the heart of a once proud European capital, not to mention the soul of a people. And then—poof!—it was gone. Not physically, at least yet, but gone as an effective barrier between East and West, opened in one unthinkable, stunning stroke to people it had kept apart for more than a generation. It was one of those rare times when the tectonic plates of history shift beneath men's feet, and nothing after is quite the same."

Nineteen ninety was another prolific year for international news at *Time*. Of the magazine's fifty-four covers, twenty-two, or nearly forty percent, were devoted to news from overseas. The year's first issue was devoted to Mikhail Gorbachev as "Man of the Decade," the second was on the fall of tyrants in Romania and Panama and the third was on Antarctica. In addition, throughout the year, *Time* focused on four big events: the dissolution of the Soviet Union, the new Germany, the release of Nelson Mandela in South Africa and the Iraqi invasion of Kuwait. Because of the invasion, Saddam Hussein made his first appearance on the cover of *Time* on August 13, 1990—"A blood-drenched tyrant," in the words of the magazine. Beginning with that issue and through the end of the year, *Time* devoted seven covers to the invasion and then, nine more in just three months of 1991. In January, an international coalition of thirty-four countries led by the United

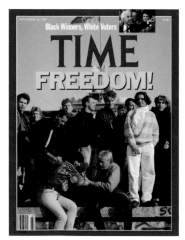

1989. Fall of the Berlin Wall

Hammers and champagne. After twenty-seven years of dividing West and East Germany, on November 9, 1989, the Berlin Wall fell. The event was one of the most emotional in history. On its November 20, 1989, cover (left) and story, "Freedom!" *Time* described it as a revolution and a celebration, a combination of "hammers and chisels" and "a champagne-spraying horn-honking bash." (Following spread)

The First. In 1990, *Time* selected Mikhail Gorbachev as the first "Man of the Decade" for the January 1, 1990, cover (opposite). According to the magazine, the designation was to acknowledge the person who had the most impact on the events of the 1980s, some of which would influence the next decade or even the next century.

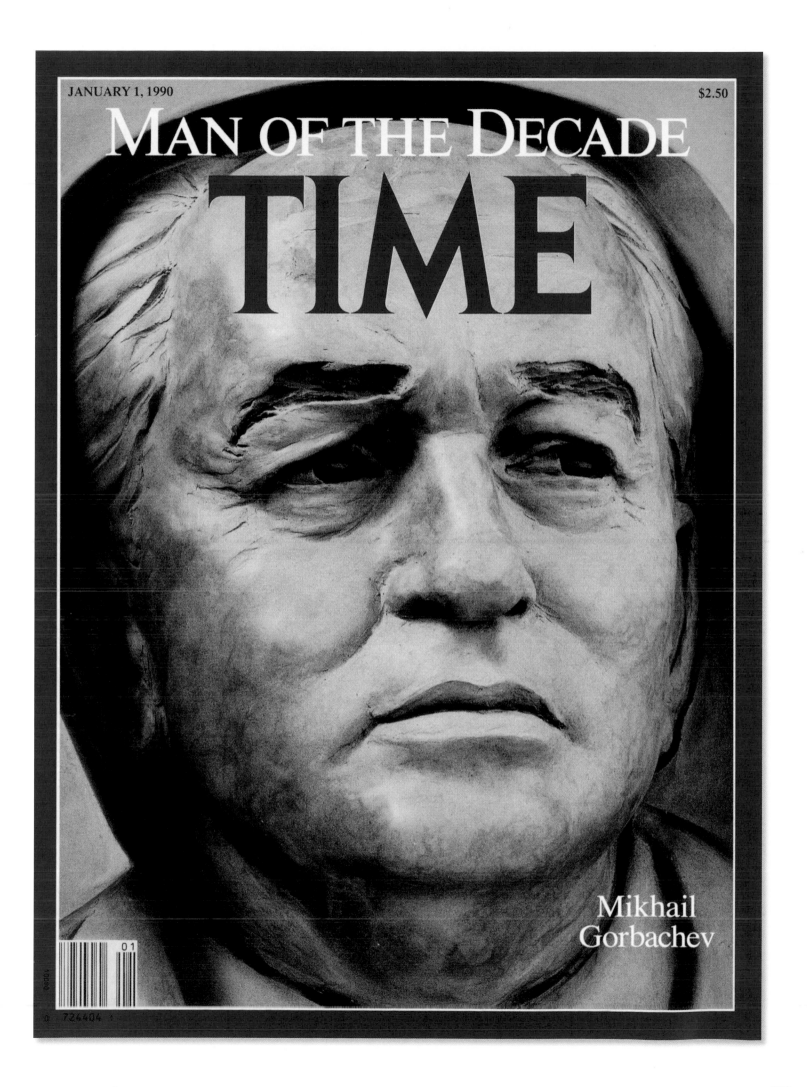

$2.50

MAN OF THE DECADE
TIME

Mikhail
Gorbachev

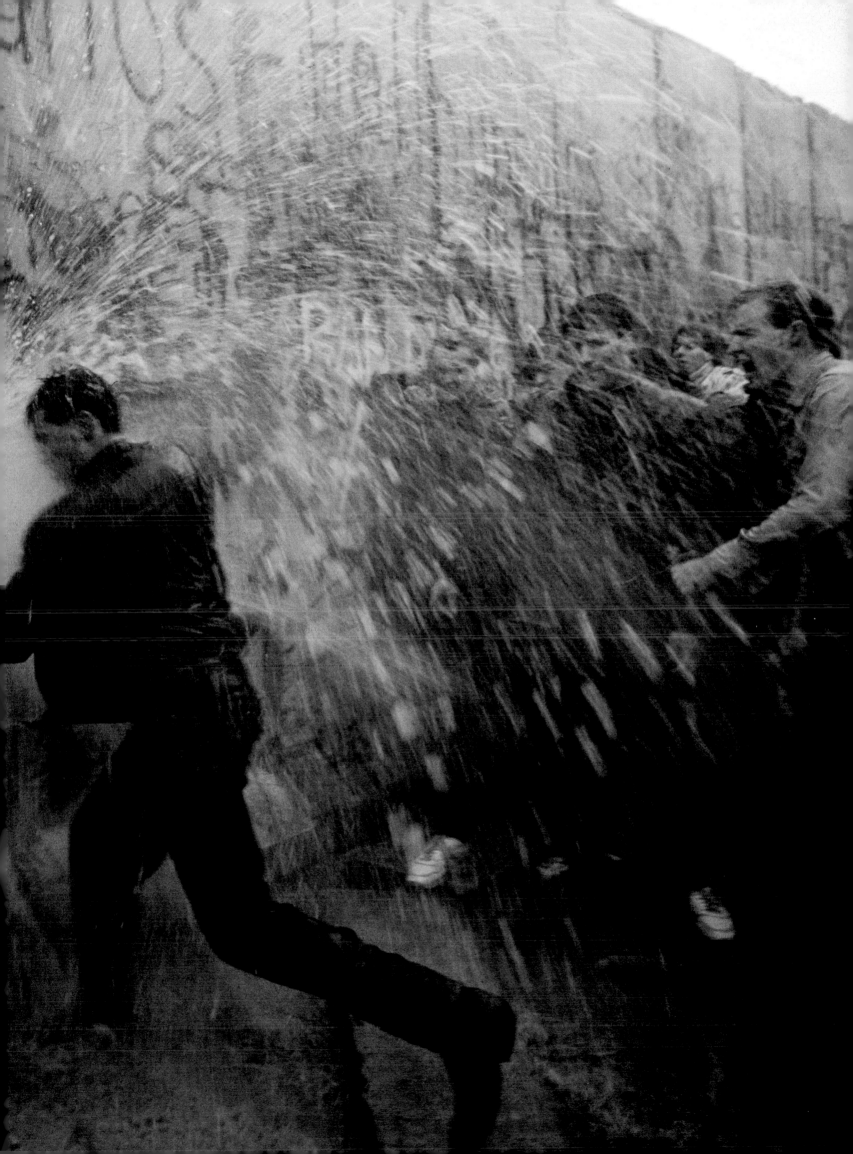

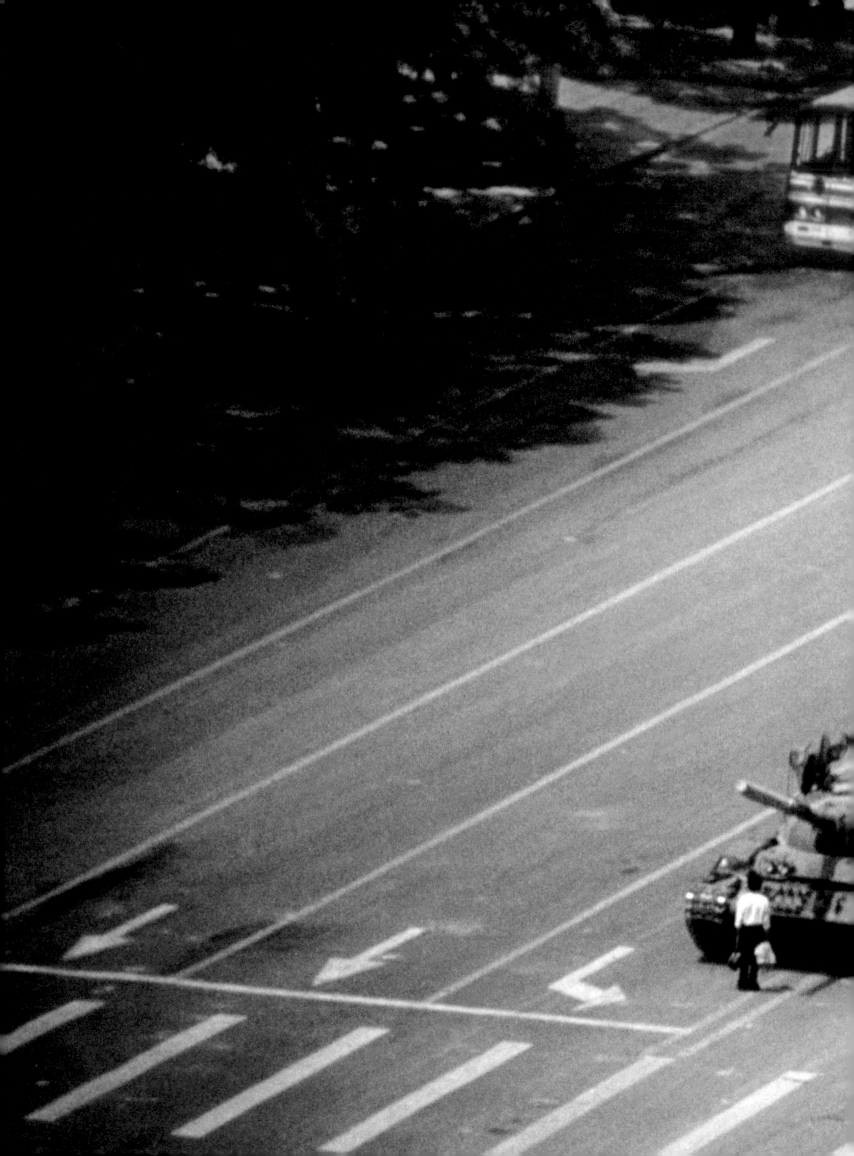

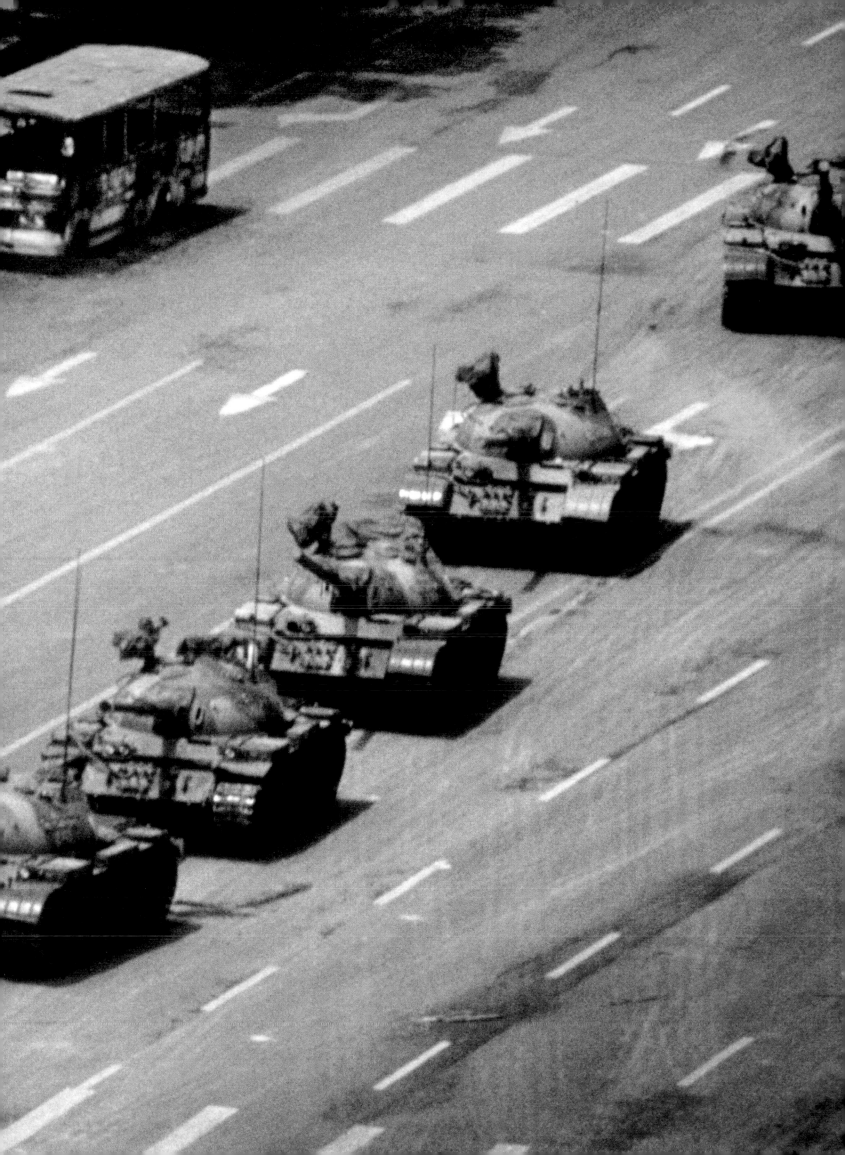

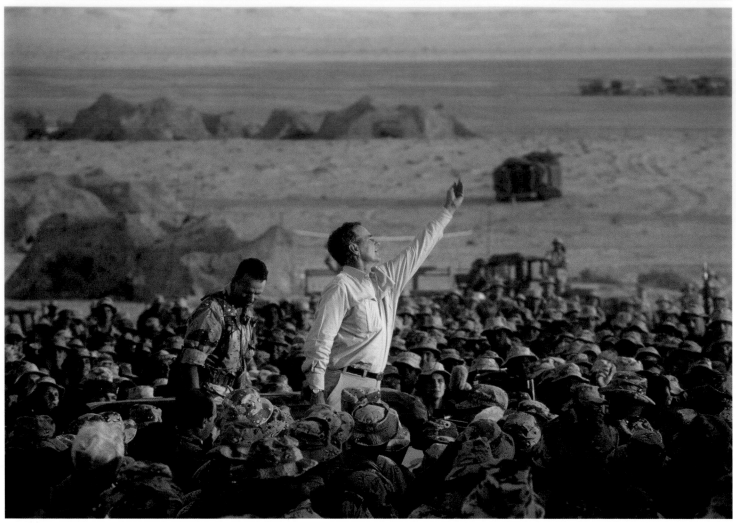

Presidential toss. In November 1990, photographer Diana Walker took this photo (above) of President George Bush tossing out tie clips on his Thanksgiving visit to the American troops in Saudi Arabia. The picture was published in the January 7, 1991, issue on "The Two George Bushes: Men of the Year." The photo also won Walker the "1990 1st Prize, People in the News" Award for the World Press photo contest.

States declared war on Iraq. Before the end of March, the Gulf War ended with the flight of the Iraqi troops from Kuwait and the victory of the allied troops commanded by General Norman Schwarzkopf.

The Gulf War also put CNN (Cable News Network) on the world journalistic map. The news service, founded by Robert Edward (Ted) Turner III in 1980, allowed the world to follow the war with unprecedented immediacy. "The very definition of news was rewritten—from something that 'has happened' to something that 'is happening' at the very moment you were hearing of it," wrote Roger Rosenblatt in the January 6, 1992, issue in which Turner was designated by *Time* as the 1991 "Man of the Year," "[f]or influencing the dynamic of events and turning viewers in 150 countries into instant witnesses of history..."

In 1992, the spotlight of the news shifted to domestic events. It was an election year and the Democratic Party once again had a chance at ruling the country. It succeeded when William Jefferson Clinton won the November election, defeating incumbent president George H. W. Bush. But before the election, racial violence shook the nation. It followed the April 29, 1992, not-guilty verdict by a predominantly white jury in the trial of four Los Angeles police officers who were caught on tape beating an African-American man they had apprehended

Face to face. This photograph (previous spread) of a demonstrator confronting a line of manned Chinese army tanks was taken on June 4, 1989, at Beijing's Tiananmen Square, where a few days earlier protests against the Communist Party took place.

after a high-speed pursuit. For a week, bloody confrontations between police and African-American and Latino youth arose throughout Los Angeles.

The 1990s also saw the development of the Internet, which profoundly changed the habits of the media and its consumers. The "network of networks" was developed by the Department of Defense as an interconnected computer system to allow the federal government to continue operating from any given place in case of nuclear attack. Academia, government institutions and corporations started to store and exchange information. Scientists, who had free access to the system, quickly discovered that the network's usefulness went beyond official business and started to exchange private messages and put up electronic bulletin boards with items of common interest. The Internet's evolution has overwhelmingly influenced the exchange of information.

Time recorded the technology that would change our lives with an April 12, 1993, cover story, "Take a Trip into the Future on the Electronic Superhighway." The following year, in the July 25, 1994, edition, the magazine not only noted the new technologies that were available to the general public, but also focused directly on the Internet and the promises and challenges it entailed. The story, titled "The Strange New World of the Internet: Battles on the Frontiers of Cyberspace," noted:

"Traditional journalism flows from the top down: the editor decides what to cover, the reporters gather the facts, and the news is packaged into a story and distributed to the masses. News on the Net, by contrast, is bottom up: it bubbles from newsgroups whenever anyone has anything to report. Much of it may be bogus, error-ridden or just plain wrong. But when writers report on their area of expertise—they often do—it carries information that is frequently closer to the source than what is found in newspapers. In this paradigm shift lie the seeds of revolutionary change. The Internet is a two-way medium. Although it is delivered on a glowing screen, it isn't at all like television. It's not one-to-many, like traditional media, but many-to-many."

War live. *Time* dedicated nine consecutive covers in just three months in 1991 to the Gulf War. The January 28 issue was a special edition on the war (below, left). The conflict established CNN as a news channel with its live coverage from the battlefield. *Time* named Ted Turner, CNN's founder and owner, as 1991 "Man of the Year" for the amazing power of CNN to bind the world into a truly global village" (below, right).

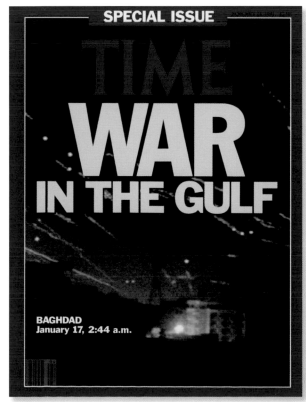

1991. War in the Gulf

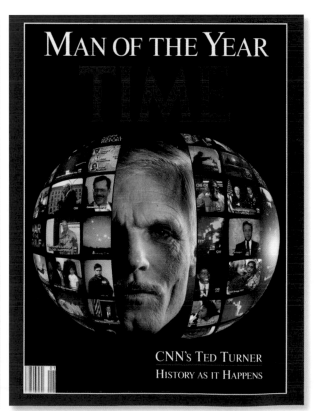

1992. Ted Turner

The Magazine Is Divided into Three Parts

Responding to criticism of *Time*'s direction in the 1980s, McManus had set up a commission to study the future of the magazine. Its task was to propose strategies to bring *Time* into the twenty-first century. Its members were: *Fortune* Managing Editor Walter Kiechel; *Life* and former *People* Managing Editor James R. Gaines; *Money* Executive Editor Caroline Donnelly; *Entertainment Weekly* Publisher Mike Klingensmith; *Time* writer Nancy Gibbs and *Time* political columnist Michael Kramer; and, from the finance department, Sheldon Czapnik. Muller rejected some of the commission's suggestions, such as printing author photos with every story. But more than that, he preempted the commission with a broad proposal that included not only a graphic redesign but also a profound editorial reconfiguration that intended to turn *Time* into a more upscale, relevant and analytical magazine. Muller believed society had been overtaken by what he called "the CNN effect" or the "information glut." In an interview with the authors, Muller said: "Given the circumstances, *Time* can't function any more like a traditional newsweekly, telling readers what they already know, we have to reinvent the newsweeklies."

The new design was spearheaded by Rudy Hoglund, *Time*'s art director, who had participated, along with Walter Bernard, in the previous revamping. So extensive was this redesign, changing everything from the magazine's logo to its structure, that it was referred to internally as "T2," as if it were a second iteration of *Time*. Many of the decisions the new scheme entailed were controversial.

The redesign began with high expectations. Although the project was secret—the initial work in April 1991 took place in a private home and later in a locked room in the Time-Life Building—rumors emerged in the industry that *Time* was plotting something big. According to some versions, *Time* would be lighter, more like *Life*, full of photos. Others speculated that it would be heavily loaded with intellectual analyses and lean on current affairs. In the meantime, Hoglund's team, which included redesign chief Arthur Hochstein and later cover designer Leah Purcell, freelance designer Jane Fray, *Time* International Art Director Mirko Ilic and graphic director Nigel Holmes, came up with the layout for the new *Time*, which made its debut on April 20, 1992.

The cover image was a photo of Bill Clinton printed as a negative. The changes, highlighted on a special card fastened to the cover for advertisers, started with the logo. Instead of the centered logo, used since its modification by Walter Bernard in 1977, the magazine's name was nearly flush with the top and sides of the frame. It had been redesigned by the prestigious designer Roger Black, who in 1985 had redesigned *Newsweek*. Rudy Hoglund told the authors, "Roger fiddled with it and tweaked it and came up with something everybody just loved," referring to Black's combination of Henry Luce's original logo and Bernard's 1977 version.

The most significant change, however, was inside the magazine, with a section structure that was very different from the one *Time* had since its inception It no longer opened with The Nation, followed by The World and the rest of the sections. The news was now organized into three broad sections:

The Week, the lead
A news summary of sorts that reported the most important events of the week in different areas: national, international, business, sports, society, health, arts and sciences. This section was geared to quickly update readers unfamiliar with the week's events.

Redesign and the first cover. On April 13, 1992, with this photograph of presidential candidate Bill Clinton printed as a negative, the new design, spearheaded by Muller, made its debut (opposite). Roger Black redesigned the logo by combining Luce's original design with Bernard's 1977 modification. The "Time" logo, now positioned on the top edge and running the width of the cover, became more prominent.

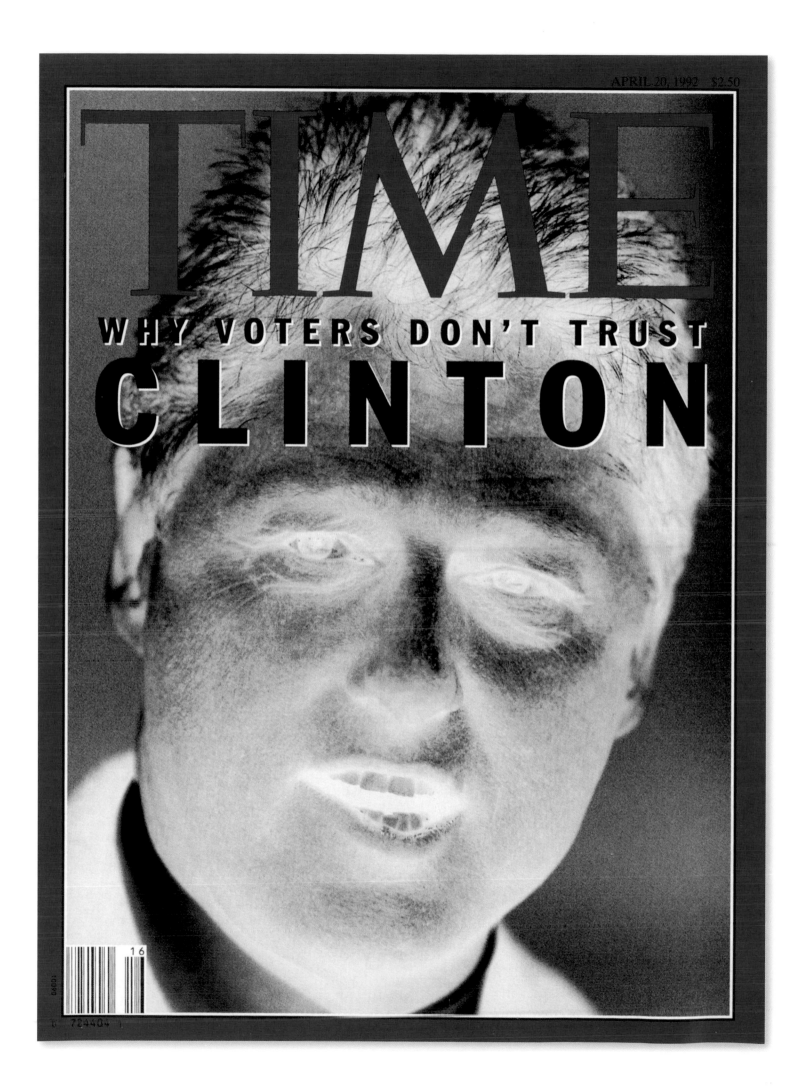

The Well, the middle
It included the issue's most important stories, such as the cover story, special reports, trend analysis, interviews, photo essays, society, culture, education and environmental issues, and the "Ideas" and "American Scene" sections. It was the magazine's news core, not necessarily with breaking news, but rather longer stories that enticed readers to analyze and ponder events.

Reviews, the end
A large section with movies, television, theater, music, arts and literature reviews as central themes. The magazine ended with the "People" and "Essay" sections, each a page long.

As opposed to the previous redesign, this one went beyond the strictly visual: it was more substantial and aimed at a comprehensive editorial reconfiguration. "This redesign is the result of an effort of teamwork between editors and designers, who jointly discussed the best way to improve the magazine," Hoglund concluded.

The issue Muller wanted to solve with the new design and news organization was what he perceived as the magazine's lack of editorial flexibility. Starting when he was named managing editor, Muller tried to steer the magazine away from summarizing the news from the previous week, but he felt his attempts were hampered by the design of the magazine. "In the old format there were a lot of little cubbyholes," Muller said. "There had to be a "World" section and a "Business" section and so many pages, no matter how good the stories were. They had guaranteed slots. In the new format, stories would run because they were original, not because they fit into a mandated space menu."

Because of the depth of the changes made to the magazine, "T2" was the subject of analysis by the national press, which offered various opinions on the weekly's redesign. *The New York Times* in its April 13, 1992, issue called the new look "the most radical redesign since [the magazine] began publication 69 years ago." *The Wall Street Journal* agreed that it was "the most fundamental change in the

newsweekly since its start in 1923." At the same time, several critics rang the alarm when they realized the magazine wasn't the same. According to *The Wall Street Journal* of May 12, 1993, "*Time* once was the voice of the country but the redesign was a great mistake. Today it's almost an anti-news magazine."

First and third. After almost seventy years, the sections gave way to parts. The magazine was now divided into three parts. The first, The Week, was a summary of the most important news events of the previous week (below, left). The second, The Well, contained the cover story and other analytical pieces. The third, Reviews, featured reviews on art, film, theater, television, music and books (below, right).

1992. The Week: "Nation"

1992. Reviews: "Art"

My days at *Time*
Priscilla Painton and Arthur Hochstein: Pros and Cons of the Redesign

Two members of Time's *editorial and design teams provided their opinions about the 1992 redesign under Henry Muller's tenure: Priscilla Painton, former assistant managing editor, who joined the magazine in 1989, noted:*

If you look back on the redesign, you can see that there were elements that have been kept. Muller made the magazine more open and less compartmentalized, and some of it looked as today's *Time* looks. A lot of that stayed, all that white space, a greater use of graphics and visuals. You're right that some of the original elements of the redesign were changed but if you look at the magazine today, it looks like Muller's redesign, it does not look like anything done before. Muller's redesign didn't give up the sections entirely, they were handled differently, that's all. This was an organic and evolutionary process rather than a failed redesign which was very consistent with several principles: first, to open the magazine visually; second, to make each story more accessible by introducing what we called entry points; and third, to open up the previously closed doors of each section. This was an up and down process.

Arthur Hochstein, art director, who joined the magazine in 1985 remembered:

Looking at it in perspective, I'd say we created a dream design based on what the magazine should be. But it did not reflect the magazine's current realities in terms of staff structure, how it gathered the news, etc.... It was as if the mind did not fit the body. The change in physical structure didn't reflect the organizational structure of the magazine, and the editors didn't really have a grasp of what the new design was trying to accomplish. There were also certain typographic mistakes we made. The visual branding was off. Since we broke open the sections, the separation between the ads and edit was not as strong as it should have been. There were a lot of unfortunate missteps. Maybe if we had more time and made more organic changes it would have been different, but we did not have enough time.

Team. Below are Arthur Hochstein, seated at the computer, next to (left to right) Betsy Brecht, Jane Fray and Leah Purcell, members of the team that worked on the 1992 redesign. The new layout and editorial structure drew both positive and negative feedback and changed the thematic concept of the magazine to deliver more analysis than news.

Turning the Page Again

In February 1993, just a year after he introduced the redesign that radically changed the magazine, Muller's time was up. The ongoing discussion over replacing him had been intensified by *Time*'s diminished credibility when a source for the April 27, 1992, cover story on the tragic December 21, 1988, explosion of Pan Am Flight 103 was confirmed to be unreliable. Also, during Muller's tenure, the magazine's circulation and ad revenue both decreased. Circulation was down 600,000 to 4 million, while the recession ate away at advertising revenue. Gerald R. Levin, who had become chairman and chief executive officer of Time Warner Inc. following *Time*'s merger with Warner Communications in 1989, agreed with the criticism from Publisher Robert Miller, who passed along complaints from advertisers and the focus group that analyzed the publication: "The main problem is that the magazine has sacrificed the news, it lacks energy and immediacy," Miller summed up in the April 20, 1992, issue of *FYI*, *Time*'s internal newsletter. The criticisms echoed those of the committee that McManus had set up to study *Time*'s present and future.

Among the study group members was James R. Gaines, who had worked his way up from writer to managing editor of *People* and for three years had filled the same post at *Life*.

Gaines became *Time*'s thirteenth managing editor. He was named in November 1992 but did not take over until January 1993. Henry Muller moved onto the thirty-fourth floor to work next to McManus, as the company's editorial director. In December 1992, a month before stepping into his new position, Gaines, during a dinner in Paris with correspondents and a few editors, succinctly summed up *Time*'s new editorial direction: "It's the news, stupid." He explained his use of the phrase:

"It was a take on Carville's phrase regarding Clinton's victory. I wanted that to be a memorable phrase because that was the direction I wanted the magazine to take. I wanted to return the magazine back to group journalism. I wanted the bureaus to know that reporting was extremely important and that the magazine was not going to be opinion and analysis or pontification. We were in the business to find out other things, things people don't know and not to reshape what they already do know. Therefore, I told reporters that their job was to report and provide details and precision, not to think aloud or pontificate or give opinions, and writers to use their best abilities with the files they got." (Gaines's interview with the authors)

Gaines conveyed his thoughts on the redesign that had divided the magazine into three large sections: "I'm trying to revert *Time* to its original concept: to keep busy people informed. In a way, both the redesign and our advertising campaign conspired to send the message that we were getting away from the news, forgetting that our main business is news."

It was expected that Gaines would go against the layout structure and news reconfiguration produced by Muller. But such was not the case. Only small changes took place, such as reducing page size, changing names and implementing different editorial styles. "When I told Editor-in-Chief Jason McManus that I wanted to change the redesign," Gaines recalled, "to bring back the original sections, he did not allow me to do it. 'It would give the appearance of disarray,' he said. Therefore, I could only make some minor changes." As a result, the first gossip and rumor column, "Grapevine," was changed to "Informed Sources," under the premise that a serious magazine had to publish

1992. Pan Am 103

Current events. *Time*'s loss of credibility by the misinformation and questionable sources in its April 27, 1992, coverage of the Pan Am Flight 103 tragedy (left), hastened Henry Muller's demise as managing editor. In February 1993, Gaines replaced Muller, and once again hard news became the magazine's center of attention. That month, with the Februrary 15 issue already closed, Gaines replaced an article with one covering the recent death of tennis star Arthur Ashe (opposite).

The face of tragedy. David Koresh, shown above, was on the March 15 and May 3 covers of *Time* in 1993. Between those two dates, the leader of the Davidian sect and its followers barricaded themselves in the Waco compound for fifty-one days, armed and responding to fire from the police that had them surrounded. When the FBI, using firing tanks, finally entered the building, they found the burnt bodies of Koresh and seventy-six of his followers.

We'll never know if 'T2,' as we code-named the new design, would have stood the test of time because one year later my successor, Jim Gaines, redesigned the magazine again. The Gaines design was attractive enough from an aesthetic standpoint, but it was a huge mistake for the company to introduce a new design after so short a period. Instead of looking like the steady ship it was, *Time* came across as confused and insecure, like a vessel with its sails flapping in every direction and its crew members not knowing which way to turn. This was exactly the wrong signal to send just as critics were discovering a new reason to question the newsmagazine's future viability: the Internet."

Gaines had an even stronger impact on the editorial content. He championed the news above all else and believed that *Time* should use every available resource to tell a story earlier and better than anyone else. Almost immediately after taking the job, Gaines had the opportunity to put his opinions into practice with the news of the death of tennis player Arthur Ashe on February 6, 1993, as he died late on a Saturday, closing day for *Time*. The magazine had already gone to bed, was about to be printed and Gaines was about to dine with his family. Instead, he set aside everything, headed to the office and asked two of his editors to join him. The three cancelled that week's final essay and, along with a few correspondents, managed to put together enough information to write a very eloquent tribute on the athlete's death. They didn't finish until early Sunday, but the result was a very "newsy" magazine Monday morning. A similar approach was used for writing other stories that were added practically at closing time, such as the article on the Waco, Texas, siege, the cover story of May

solid information and not chitchat. The "Week" became "Chronicles" and shrank from eight to five pages. The office dubbed this first section "The River," and, from the onset, considered it boring because its news items sounded like a weekly radio report. Gaines hired Kurt Andersen, *Spy* magazine's co-founder and a former *Time* writer, to redesign and edit the section. He made it livelier and easier to read, and even gave its stories a touch of humor. The back section, "Reviews," became "Arts and Media" to allow for the coverage of a wider variety of subjects instead of limiting itself to critiques.

Although the changes were mild, Muller did not welcome them. He disagrees with

them to this day, especially because they came so fast:

"It's never easy to know how to measure the results of a redesign. The publishing side hoped for an immediate uptake in reader surveys, but that did not happen. I wasn't surprised because as a general rule, readers get comfortable in the environment they know and therefore find redesigns disconcerting. That doesn't mean magazines should never redesign. But editors should go down that road only when they're convinced a redesign will make their magazine's content more attractive and easier to navigate over the long term.

My days at *Time*
Chris Porterfield: "Thanks for Batman"

Extracted from former Executive Editor Chris Porterfield's interview with the authors.

It was strange (the redesign). Conceptually it made sense. It was already clear that cable news and the Internet had created a new rhythm as to how people got the news. The general perception was that a weekly magazine was no longer bringing much that was new to the reader. Therefore, conceptually it made sense to move the magazine away from the news and build a magazine that assumed the reader already knew the headlines and what they wanted was more perspective and analysis. The curious thing was that when Muller moved the publication away from the news, the life went out of it, it became kind of dead. It lost life and vitality. I think Henry was edged out of the M.E. position because there was a perception that the redesign did not work. We should also remember that during the Muller tenure the magazine went through a lot of corporate changes that eventually would influence editorial. When *Time* was just Time Inc. it was an enlightened

company and it had the spirit of Henry Luce even after he died. The goal was to do something for the public good. But at the end of the '80s and beginnings of the '90s, it became just another big corporation, which basically cared about the bottom line. Inside the magazine, we thought that in the Warner merger we were eaten for breakfast! Right after that there was a wave of cost cutting and it was tough. I will never forget when I met Steve Ross, the former chairman of Warner Communications who became a co-CEO of the merged company. Warner Bros.'s *Batman* movie came out at that time and Richard Corliss, our reviewer, gave it a bad review. During a luncheon for *Time* editors presided over by Ross, I was in the reception line to meet him, and when whoever was doing the honors introduced me as the editor of the Back of the Book section, he shook my hand and said, "Thanks for Batman." I felt a chill. But truth to tell, we never did get much of that kind of editorial pressure from corporate.

Dangerous criticism. When the movie *Batman* made its debut in June 1989, the magazine's June 19 review, "Murk in the Myth," was not very generous (below). The reviewer, Richard Corliss, called the movie "the skeleton of a nifty film" and claimed that "it prowls—slowly, slowy—in search of grandeur but it often finds murk." The review didn't sit well with Warner Bros., Time Inc.'s new partner.

1989. "Show Business": The Caped Crusader Flies Again

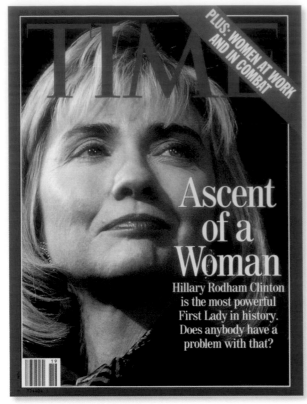

1993. Hillary Rodham Clinton

At the center of power. Hillary Clinton was on the cover of *Time* for the second time on May 19, 1993 (above), a few months after Gaines took control. To differentiate himself from the previous managing editor, Gaines approached all stories as news and was known for changing the cover topic at the last minute, almost at closing, as with the cover and story on Hillary, who redefined the role of first lady in her first 100 days.

19, 1993, on Hillary Clinton's first 100 days as first lady and earlier that year, the February 26 bombing of the World Trade Center.

This quick-response method of journalism, with constant cover changes and the assignment of many reporters to a single story, became the way of doing business at the magazine. "Jim's [Gaines] mandate was that the magazine had gotten away from the news. What he meant by that was reporting," Jim Kelly told the authors. Kelly was assistant managing editor and executive editor during the Gaines period. Kelly remembered:

"He was frustrated with the reporting. After attending an editorial meeting at *Time*, Gaines said that he felt like coming out from a meeting at the State Department talking about crises in the world. 'Let's get detail, let's get facts, let's get reporting, reporting, reporting ... God's in the details,' he used to say. Jim really felt that had slipped away from the magazine. When news happened he threw everything at it. So, when Waco took place, he threw everything he had at it and we got a package longer than we might have done otherwise. That was his big

plus, but that also put a lot of strain on the writers and reporters: when you change your *Time* cover two or three times in a week, given how much longer a story and how much more high-standard reporting you need to back it up compared, let's say, to *People* (where they dealt with these last-minute changes with a fix such as a 200-line story plus a few good pictures, including the cover), and given the fact that *Time* typically did not simply use news photographs or artwork or photography that's set up and established, he pressed the organization too much. The plus side with Jim was that he jumped on stories, which was good, but what frustrated some folks here was that he tended to jump three or four times during the same week." (Kelly's interview with the authors)

Some writers complained about what they called the "*People*-ization" of *Time*, by which they meant that oftentimes stories on more serious topics were replaced by lighter, shallower articles. "Lemon meringue pie" and "culinary journalism" were the terms used internally for stories that emphasized, for instance, the last meal of someone on death row.

Criticism about Gaines's tenure was not limited to the above. For a 1993 cover on prostitution, *Time* published images of young male prostitutes that appeared to be documentary photographs. Actually, the shots had been staged by a Russian photographer. It took *Time* three months to admit its mistake.

No controversy or criticism against the magazine during the Gaines years was as extensive and virulent as the one over the June 27, 1994, cover. The image on the cover was an altered version of the mug shot of Orenthal James ("O.J.") Simpson,

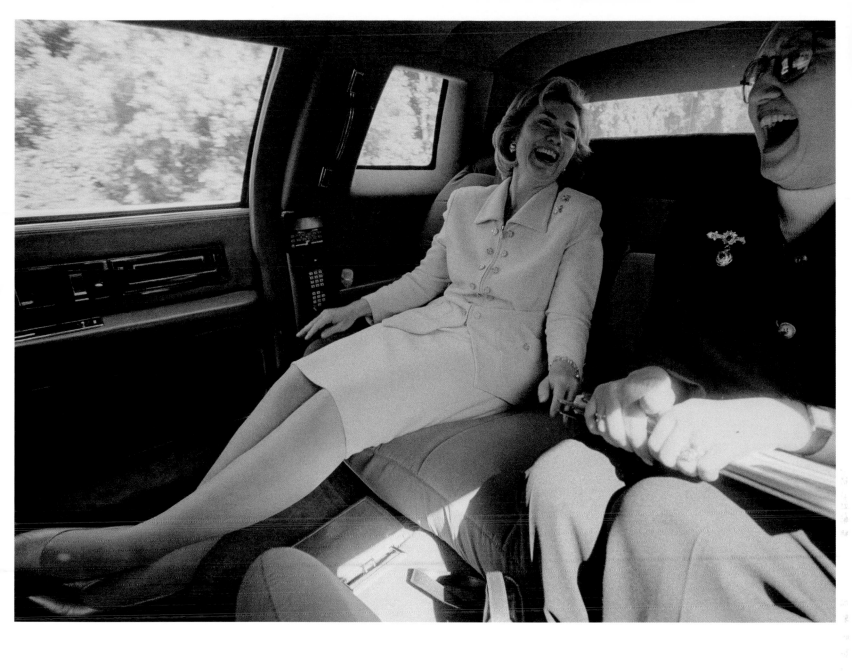

Role model. Hillary Clinton was the first lady of the United States from 1993 to 2001. A Yale graduate and a lawyer, she wanted to be an active participant in her husband's administration. This photograph (above) of Hillary with her chief of staff, Melanne Verveer, was taken in 1997. At the time, Hillary was promoting the State Children's Health Insurance Program.

accused of murdering his wife and her friend. *Time* commissioned illustrator Matt Mahurin to create it and make an image that would distinguish it from the widely distributed photograph. Mahurin, in his usual style, used Photoshop to create a portrait that was dark, brooding and soft focused. *Time*'s cover was noticeably different from the cover published by *Newsweek* the same day. Both magazines began with the same image, but *Newsweek* had not manipulated the image as much, and Simpson's complexion was not as dark. When the National Press Photographers Association and the Magazine Publishers' Association compared the two covers, they cried foul, accusing *Time* of being unethical. Civil rights organizations also complained, sparking widespread racial discrimination charges against the magazine. The following week, in the July 4 issue, James Gaines was forced to write a response in the Editor's Letter: "To the extent that this caused offense to anyone, I deeply regret it." Gaines also explained:

"Honestly, it was a problem of not having anybody at the office on Saturday to say: 'Hey, you've darkened his face!' There was not a conscious racial overtone of any kind there. It was an attempt to take a too brightly lit mug shot and make it more human, make it say something, but it was unfortunate."

The following year, in 1995, *Time* published three covers with Simpson's image, all of them with his natural skin tone unaltered.

But also that year, another internal event shook *Time*: after just three years at the helm of the magazine, Gaines left the job. Was it a surprise? A few events accelerated his departure, including the continuous refusal from editorial management to change the redesign led by Muller, who remained on the thirty-fourth floor. Although he did a redesign in 1994 that reinstituted much of the structure of the pre-T2 magazine, Gaines was not allowed to reinstitute formal sections. Also, breaking with the tradition of editors in chief coming from the ranks of *Time* editors, the company hired Norman Pearlstine, who had never worked at Time Inc., to replace McManus. Gaines, who logically aspired to that future position, was frustrated once again.

In just ten years, three managing editors led the magazine and two of them, McManus and Gaines, set records for the shortest stints. With Gaines, the page turned again. It was up to Walter Isaacson, his successor, to write the following pages. He became the fourteenth managing editor. "I learned something very important at *Time*," Gaines concluded:

"When I was at *People* I thought I was a genius at that but when I look back at my *People* years, I realized that I was delivered by the culture of a steady stream of great story ideas. But when I was at *Time* they stopped! There were a few good stories but when Walter took over he got Diana and then John John—Monica Lewinsky! It was so frustrating. I realized then that what makes a successful editor is a combination of instinct and great stories. O. J. was the exception. It was a hell of a story and we covered the hell out of it, despite the fact that I will be known forever as the person who darkened the face of O. J. Simpson. Our last story on him was spectacular, because I told the reporters from the very beginning: 'We are going to do something big when the verdict comes in and I want a lot of fresh reporting, therefore don't throw all your material on the weeks leading up to the verdict. Keep some powder dry.'

And we had Waco, and the Clinton budget and Newt Gingrich, but I wasn't as lucky as I had been at *People*."

My days at *Time*
Matt Mahurin: The O. J. Simpson Photo

Extracted from freelance photographer and visual artist Matt Mahurin's interview with the authors.

This was a fascinating, maddening, challenging and ultimately expanding experience. As an image-maker, I work in a dark palette. Whether it was my *Time* cover on domestic violence, nuclear terrorism—or a former football hero who is suspected of murder—much like a stage director would lower the lights on a somber scene, I used my long-established style to give the image a dramatic tone. Also, the raw image I was given was washed out—therefore from a pure design consideration, by making the image more graphic, I hoped to give it more visual impact to catch the reader's eye as they passed the newsstand.

For me, the controversy was as much about power as it is about racism. *Time* magazine had the circulation power to reach millions of readers—and I had the power to make the image that they would see. In hindsight, the misfortune was that there was not a person in a position of power or perception able to be sensitive as to how this image could be perceived by the various interests—each pushing their own agendas on race, power and the media. I also believe it was possible there was no one who could have anticipated the fallout. In the end, my career has been in pursuit of the power of the image—and it is through this power of the image that we become educated—and in the end, this is what we should hold on to; that we have been educated as to how images can be perceived.

As both a professional and personal experience, it is not one I would wish on anyone, nor would I have ever traded it away, because despite all the conflict that came from this controversy, it is yet one more testament that one image is worth a thousand words.

Two polemic faces. On the left, the police mug shot of O. J. Simpson on June 17, 1994, the night he was arrested for murdering his wife and her friend. On the right, *Time*'s June 27 cover showing O. J. Simpson with darkened skin. Mahurin created the portrait in his usual style—dark, brooding and in somewhat soft focus. The cover caused an uproar. The magazine was accused of racism, causing Gaines to make a public apology.

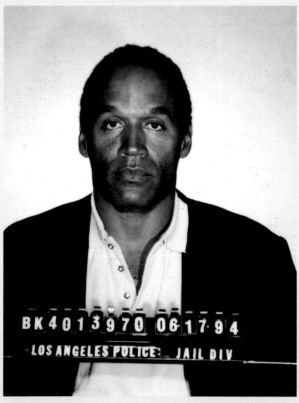

1994. O. J. Simpson

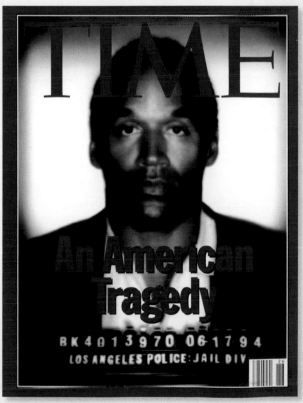

1994. O. J. Simpson

Photos:
The New Cover
Language

During the 1980s and the 1990s photographs played an important role in a new cover style proposed by *Time*. According to Arthur Hochstein, the art director, who joined the magazine in 1985 and participated in Muller's redesign:

> "At the beginning of the '80s, there was a perception that paintings looked old and dated, and as other media started to speed up on the delivery, the trend moved more to photographic covers, especially when the news cycle changed (with CNN and the Internet) and that made painted covers look old. Despite the fact that painted covers reflected more craftsmanship and separated *Time* from many other magazines, the pressure was to move away from them." (Hochsteins's interview with the authors)

At first, photojournalism shaped the cover image style. It called for the best photo, one that emerged from a high-impact and breaking-news event, nothing more. But the covers over this period changed with the emergence of three great photographers who joined the staff as freelancers in the 1980s: William Coupon, Matt Mahurin and Gregory Heisler. They produced memorable covers that define the *Time* style to this day. Coupon specialized in portraits, using distinct lighting; Heisler, in conceptual shots that reflected the article's tone; and Mahurin, in photo-based artistic illustrations.

William Coupon: Rembrandt-style subjects

Between 1982 and 2004, more than five United States presidents posed for Coupon. The first was George H. W. Bush, followed by Richard Nixon, Ronald Reagan, Bill Clinton and George W. Bush. All of them were photographed in Coupon's particular style. His style has been compared to the seventeenth-century Dutch artist Rembrandt, who used dramatic lighting to define and highlight the gestures of the kings and biblical prophets he portrayed. "From the start," Frederick S. Voss wrote of Coupon, in his book, *Faces of Time: 75 Years of* Time *Magazine Cover Portraits*, "his central interest was portraiture, and he adopted a style that bespoke a reverence for Rembrandt that was achieved largely through strong single-source lighting and spare, neutral backdrops. The result was dramatically shadowed likenesses having a distinctly painterly feel."

Voss also noted Coupon's defense of his format, "while it [the format] is 'respectful' of sitters, it also stands a better chance than other photographic styles of yielding 'a more revealing portrait.'" Although, Coupon's covers seem similar to each other, his work stands out because it conveys the character of the newsmakers. This trait gave *Time* its own style, distinct from its competitor, *Newsweek*, which had been publishing photos on its covers for years.

Matt Mahurin: The photographer who made the cover the most

Mahurin began freelancing for *Time* in 1982 at age twenty-three. He showed his portfolio to Irene Ramp, associate art director, who brought him on board for a story on family violence. The story touched on issues such as rape and abuse of women and children. "I remember the moment—still to this day, the most decisive of my entire career," he recalled and added:

> "I decided, that in addition to my two expected images, I would create as many images as I wanted and submit them all. There it was. The best work I had ever done laid out on the twenty-fourth floor of the magazine I had dreamed about working for. A few hours later Rudy

1990. David Lynch

1994. The Peacemakers: Yitzhak Rabin, Nelson Mandela, F. W. de Klerk, Yasser Arafat

Heisler style. Gregory Heisler illustrated more than seventy covers. In his work, Heisler didn't resort to darkroom tricks or digital retouching. He illuminated half of David Lynch's face with green light to illustrate Lynch's eccentricity—"Czar of Bizarre" (left, top). Lighting, as in the "The Peacemakers," plays a fundamental role in Heisler's work (left, bottom). This portrait of George Bush, for the January 7, 1991, "Men of the Year" cover, is among his most famous (opposite). It only took him fifteen minutes to photograph Bush, but it took twenty-five hours to prepare the scene.

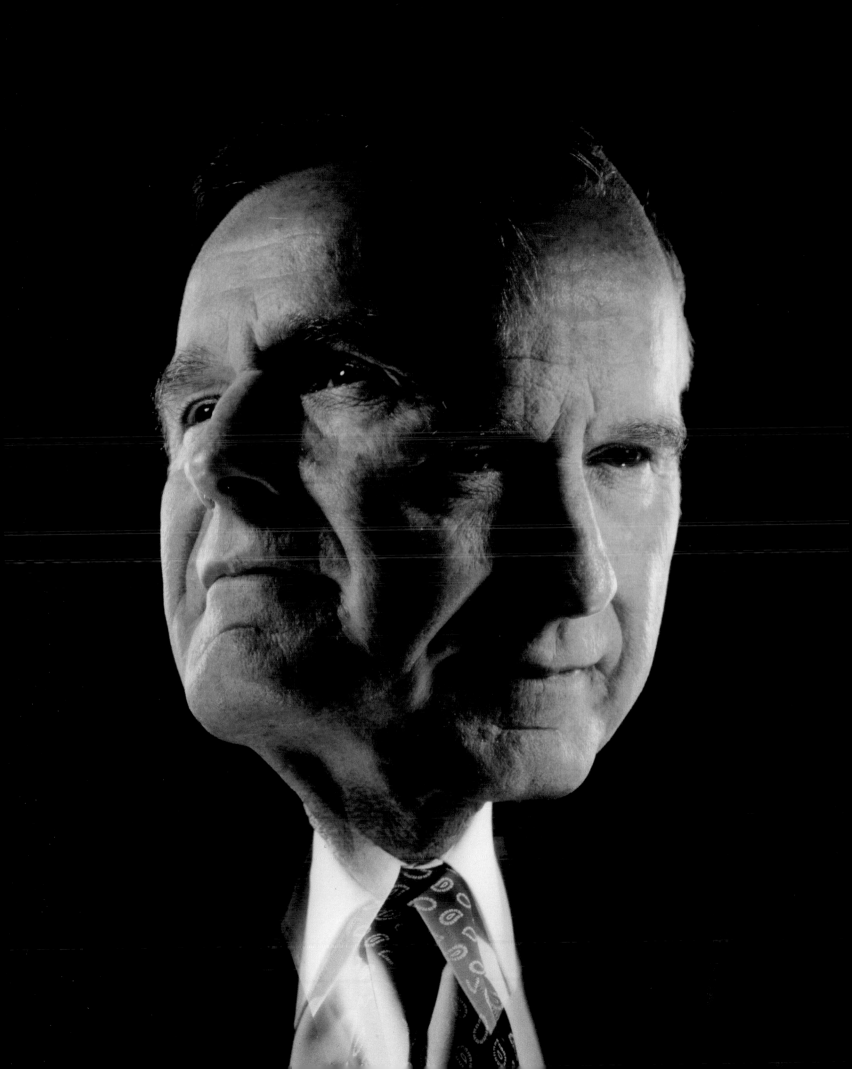

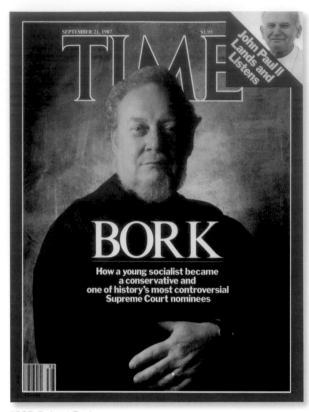

1987. Robert Bork

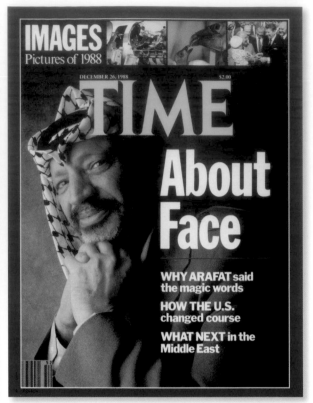

1988. Yasser Arafat

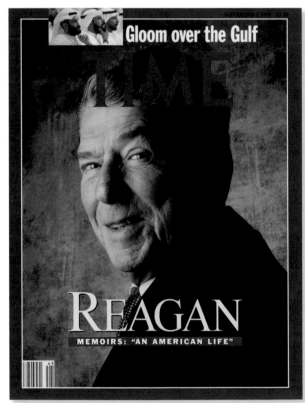

1990. Ronald Reagan

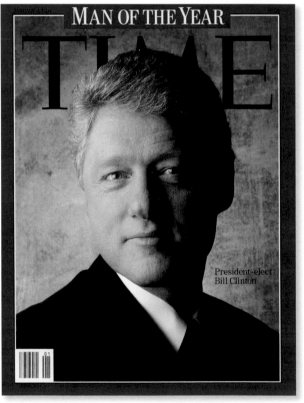

1993. Bill Clinton

Coupon style. William Coupon's style of photography has been compared to the "emotional canvases" of Rembrandt. He used single-source lighting, the same neutral backgrounds and his subjects always looked directly at the camera, as the four covers above exemplify. Coupon's photographs looked like paintings. He believed that his technique rendered a "more revealing portrait."

called 'They decided to kill the other art and run all your images.' Before I could dare utter the question, he continued, 'Yes, you got the cover.' The cover of *Time* and nine pieces printed inside. A few days later, I walked the streets of New York City, from corner newsstand to supermarket magazine rack, staring at my image. My *Time* cover." (Mahurin's interview with the authors)

Mahurin started his career at *Time* in the triple role of photographer, visual artist and model. The illustration featured on the September 5, 1983, cover, under the title "Private Violence," was based on a photo in which Mahurin posed rocking a doll in his arms. He then modified it several times until he achieved the sinister effect that he wanted to convey. Mahurin, an expert in combining different visual media, was his own model for the image on the cover several times. Among his most noted images are those of Sigmund Freud, *Homo erectus* and a nuclear terrorist. For the first image, published on November 29, 1993, under the heading "Is Freud Dead?" Mahurin colored his beard white and dressed up as the psychoanalyst. He digitally manipulated the image, removing the top of the figure's head, which is empty inside, the edges shaped like puzzle pieces. To the left, four of those pieces appear to be falling away. The visual metaphor matches the article's contention that the theories of the Vienna psychoanalyst were falling out of acceptance. He managed to produce a color image that greatly resembled Freud, even though there were no color images of him in that era.

Another of his self-portraits was the basis for a photo illustration published on the March 14, 1994, cover. This time, Mahurin played the role of *Homo erectus* for a cover titled "How Man Began." He took a picture of himself and added a protruding brow (for which he digitally collaged another photo of his knuckles onto the eyebrows in the photograph). His eyes are blue, but for the cover image he changed them to brown, he drew the ears and neck in the image by hand and, after applying a variety of digital effects, he had produced an image that resembled drawings of primitive man. Mahurin explained his process:

"I consider myself a visual journalist, meaning the content and opinion expressed by the image is the driving force of my intent—not the technique or tools I must use. I see my job as threefold: the first is in service of the magazine; making sure they receive an image that is both visually arresting and conceptually compelling, hopefully drawing the potential reader into wanting more. My second obligation is to help that reader to make an emotional, intellectual or philosophical connection to the subject of my illustration—enhancing their ability to reflect on the issue or event. My third duty is to myself by creating an image that enables me to refine my craft, pursue my passion and expand my understanding."

Gregory Heisler: The special-effects photographer

Heisler began to showcase his technique on the cover of *Time* in the late 1980s. The photographer managed to produce more than seventy pieces for the magazine's front page. Heisler's first big cover was published on October 1, 1990. It featured David Lynch, director of the successful TV series *Twin Peaks*. In an effort to convey in a single image the personality of a newsmaker known for being eccentric and creative, Heisler used a greenish-red light to illuminate Lynch's face, resulting in an almost surreal image.

What was unusual about this photo, and Heisler's other captivating photos, was that he produced them using only his camera, without manipulating the image in the darkroom or digitally. A few months after the photo of Lynch, he came up with an equally spectacular image: a photo of President George H. W. Bush for the January 7, 1991, "Men of the Year" issue. The cover featured a photo that, like the article, showed two faces of the leader: a negative one in terms of domestic policy and a positive one regarding foreign affairs. Heisler shot the photos in barely fifteen minutes. "The shot required two different cameras, two different lighting setups simultaneously. It was a 4-by-5 camera and the shoot was so complex that after taking each shot of President Bush in two different chairs I had to reshoot both with the same camera so that they looked together," Heisler told the authors. But to prepare the scene to achieve the final effect he was seeking, Heisler had spent twenty-five hours at a rented studio near the White House, rehearsing with a stand-in and preparing a floor plan that marked the exact spots to place the lights and the chair where the president would sit.

In the following years, Heisler continued to work only with film. His precision, originality and skillful camera techniques became evident once again when he photographed Bill Gates for the June 5, 1995, cover. In the first image, Gates is likened to Prometheus, and appears to hold a spark of energy. Actually what Gates held between his fingers was a piece of polyester plastic that, once lit and captured by Heisler's camera at a precise point, produced an original and high-impact special effect.

Now assisted by digital technology, Heisler continues to be one of *Time*'s most important photographers. Heisler looked back on the period in which he, Mahurin

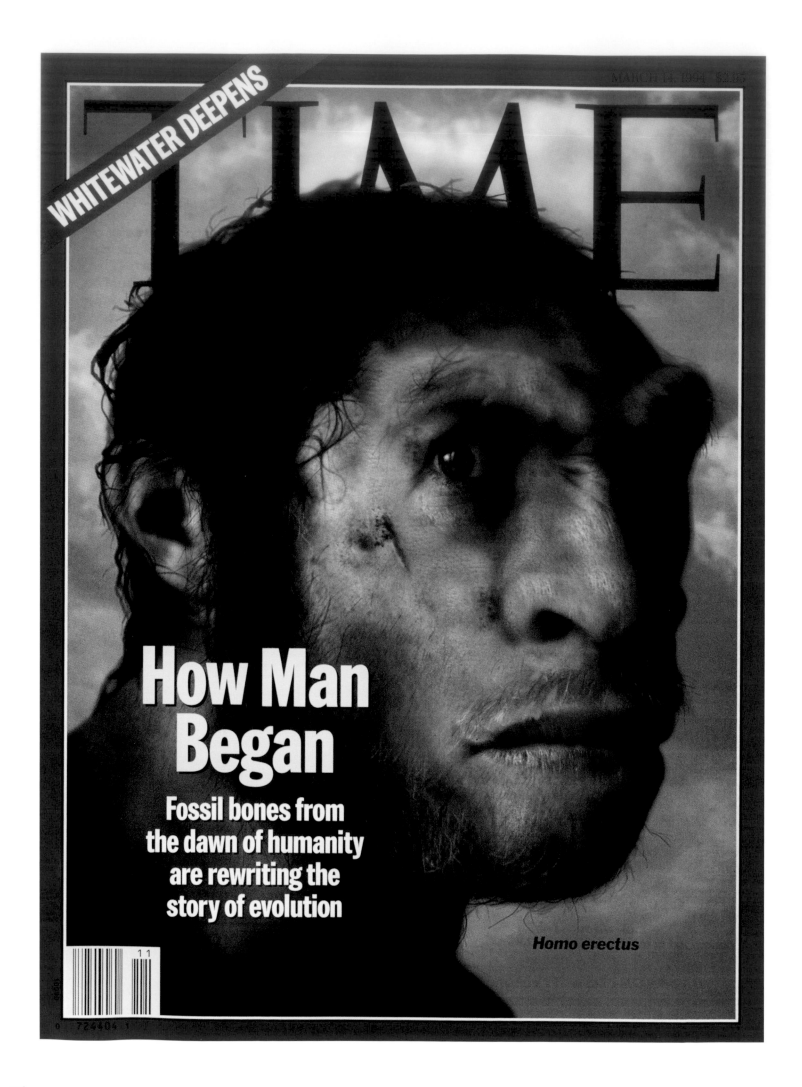

WHITEWATER DEEPENS

TIME

How Man Began

Fossil bones from the dawn of humanity are rewriting the story of evolution

Homo erectus

and Coupon displayed their styles on the magazine's most prominent page:

"William Coupon's pics were a look—all of his photographs are the same. Same backdrop, same lighting, same pose. He would do Obama and Britney Spears the same way. If there was any interpretation of the newsmaker it would be through the expression. On the other side, Matt's work is very conceptual and far more illustrative. Although his work is photographically based, I don't think that people look at his work as being photographic and neither does he. Photo is his raw material and then he uses it for illustration. He is very subjective and conceptual. And often-times he gives you a highly emotional response, one that you can really feel, rather than an intellectual one. My photographs, in turn, look like photographs. I feel the photograph is not about me but about the subject. They are not a statement about my style. For me, style is an approach like your fingerprints, unique to you, and maybe it's not even a conscious decision. It's the way you see things. It may manifest itself visually or more conceptually or in many ways. My goal is for the photo to be completely about the subject, but it's very specific. It is a pic of that particular subject for that specific assignment in that particular context at that moment in time. The same photo would not be the same if I did it, let's say, for *Fortune* or *Rolling Stone* or ten years later." (Heisler's interview with the authors)

Mahurin style. Matt Mahurin was the photographer who appeared the most on the cover of *Time*. Mahurin used a self-portrait that he modified manually and digitally. On the March 14, 1994, cover (opposite), he was *Homo erectus*; on the November 29, 1993, cover, he was Freud (below, left); and for the August 24, 1994, cover, he put a shower cap on his face, inhaled deeply, and then later, digitally rendered a monsterlike image of a nuclear terrorist (below, right).

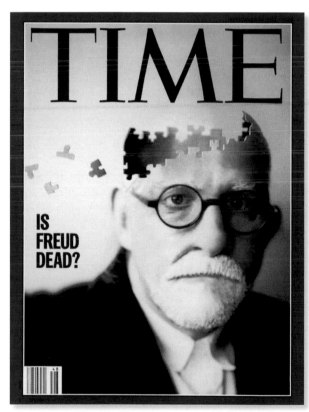

1993. Is Freud Dead?

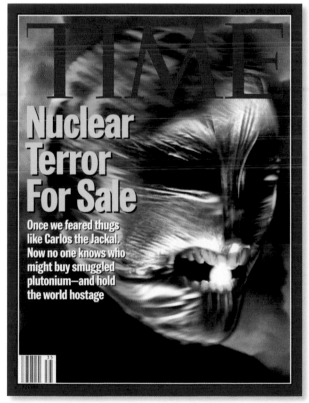

1994. Nuclear terrorists

Part III: The Magazine for
the New Century

1996-

9

The Digital Revolution at *Time*

When Walter Isaacson took over as managing editor in January 1996, considerable changes occurred at *Time*. It was a return to managing editors that rose through the magazine's ranks. Three of Isaacson's four predecessors had come from outside the magazine: Cave had come from *Sports Illustrated*, McManus from *Time*, Muller from the Time-Life News Service and Gaines from *Life* and *People*. James Kelly and Richard Stengel, the editors who succeeded Isaacson, worked for *Time* since they were young and knew what it meant to be a "*Time* man." They aspired to leave their mark on *Time* and on journalism. It was these editors who would lead *Time* to face the challenges of the new century, and as the year 2000 approached, it was up to Isaacson to come up with a new style for the magazine in a competitive environment that focused more and more on digital communications.

Walter Isaacson joined the magazine in 1978, when he was twenty-seven, as a staff writer for the "Nation" section. He became a political correspondent for the Washington bureau, the "Nation" senior editor and then *Time* assistant managing editor. In 1993, he was named editor of New Media at Time Inc., and oversaw the development of the company's online magazines and of the Time Warner Pathfinder Internet service. His prior experience at *Time* magazine would influence his decisions in his new job.

When Isaacson was named managing editor, he announced his goal: to return *Time* to the center of the national scene as a significant magazine, that not only witnessed but also actively participated in society's rapid advancement during the age of electronic communication. Isaacson's first order

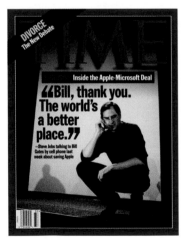

1997. Steve Jobs

September 11. Smoke billowed from the north tower of the World Trade Center after terrorists crashed American Airlines Flight 11 into the building at 8:46 a.m., September 11, 2001. Pictured is United Airlines Flight 175 just before it was flown into the south tower at 9:03 a.m. (Previous spread)

Digital revolutionaries. Apple co-founder Steve Jobs was on the August 18, 1997, cover (left). This photo is of a young Bill Gates who, at thirty-one, became a multimillionaire by taking Microsoft public in 1986 (opposite).

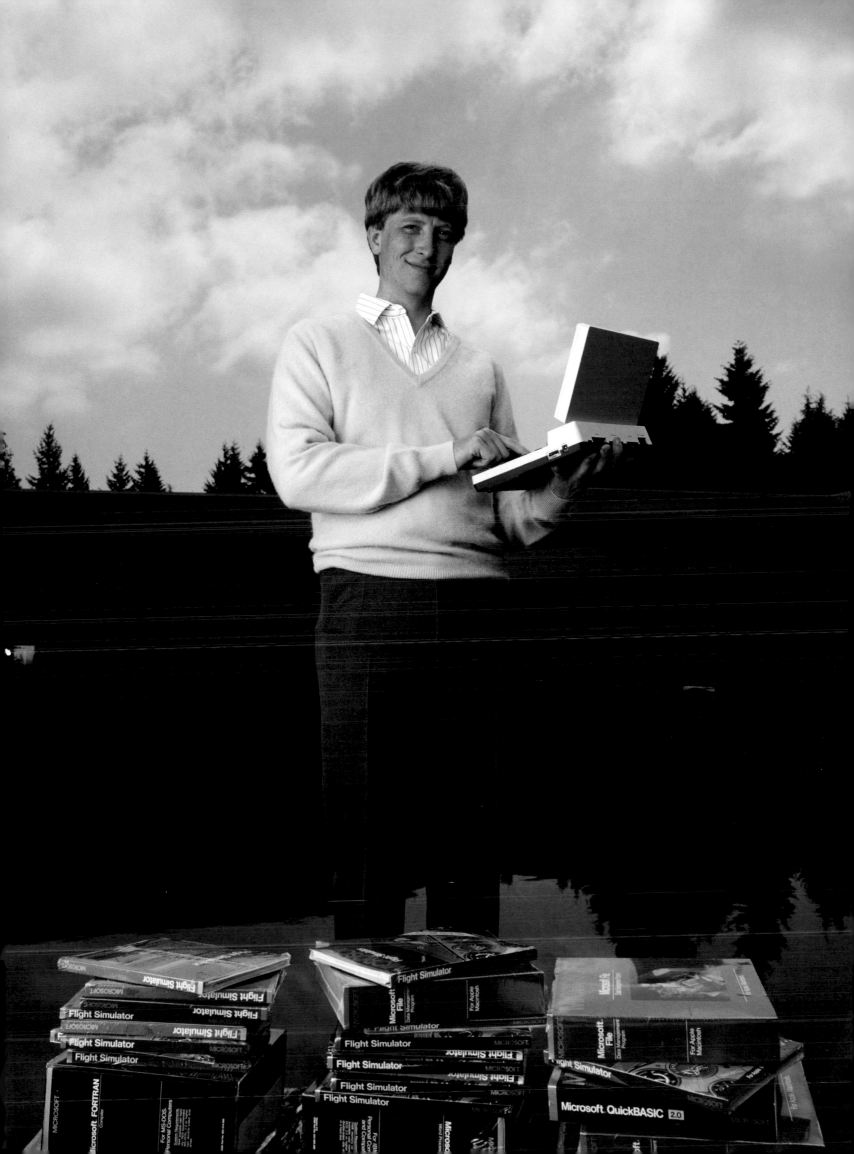

of business was to fight against an intangible internal enemy, which had grown steadily during his three predecessors' terms. Almost every editor after Grunwald fought against the view that *Time*'s days were numbered and that it would be unable to overcome the threat posed by CNN and the Internet. Muller and Gaines were more focused on the threats of the new media, while Isaacson was more focused on the opportunities that the new media offered a newsweekly.

According to Norman Pearlstine, editor in chief since January 1995:

"Walter began with a belief in the power of the *Time* name and brand. He infused the entire staff with a belief in itself. My sense of the magazine, even before I got to Time Inc., was that for a long period there had been a lot of self-doubt at the publication, that the redesign had reflected that self-doubt and that Walter came in believing that the *Time* brand carried weight, moral authority and he conveyed to the staff that spirit, making them believe what he believed in."
(Pearlstine's interview with the authors)

In addition to the spirit he conveyed to his co-workers, Isaacson developed a strong editorial team with James Kelly as deputy managing editor, and E. Bruce Hallett as the magazine's president, who supported and helped develop Isaacson's new philosophy.

The return of newsmakers

As soon as he became managing editor, Isaacson had the chance to lay out his cover philosophy: to once again place newsmakers, the faces that reflected history, on the cover, as Luce and Hadden had originally proposed. In the January 15, 1996, issue, for a story on the law enforcement war against urban crime, Isaacson gave the cover to New York Police Commissioner William Bratton, instead as the former editors might have done, to a symbolic image of violence. On April 1, 1996, the subject of prostate cancer was on the cover, represented by one of its victims, General Norman Schwarzkopf, commander of the allied forces during the 1990 Gulf War. Isaacson was convinced that portraits of interesting people were a good way to

make the world come to life. Isaacson was also passionate about politics, as evidenced in his treatment of the 1996 presidential election between Bill Clinton and Bob Dole. He turned the contest into a riveting adventure in which their wives, Hillary and Elizabeth, also played a part—they faced off on the cover on July 1, 1996.

Notable, was the presence on the covers and inside the magazine of newsmakers from the world of computers and the Internet, such as Jeff Bezos, Marc Andreessen, Steve Jobs, Jeff Braun, Doug Colbeth, Andy Grove and the ubiquitous Bill Gates. *Time*'s message conveyed that in this era, the big players were not only working in Washington, but also in Seattle, Boston, the Silicon Valley and other new cradles of technology. The focal point of news had changed. "Some events, like this one, can help define a magazine," Walter Isaacson said.

"I wanted to grab on to the digital revolution. What I wanted for *Time* was to have a more intellectual engagement with the reader and distinctive writing.

Digital newsmakers. *Time* considered the newsmakers of the digital era so important that several of them were named "Man of the Year." On December 29, 1997, *Time* selected Andrew Grove (below, left), founder of Intel, whose microchip spurred the growth of a new economy, and on December 27, 1999, *Time* selected Jeff Bezos (below, right), whose Amazon.com revolutionized e-commerce.

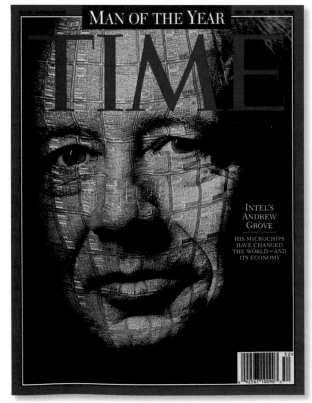

1997. Andrew Grove

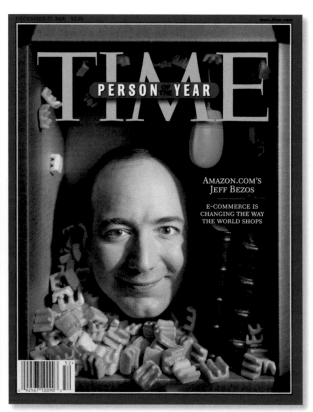

1999. Jeff Bezos

And the technological revolution attracted me because it had an intellectual component to it. By asking myself 'How does this revolution change our world?' I had a lot of ideas of what to put in the magazine."
(Isaacson's interview with the authors)

The return of the magazine's sections

Another change that was a throwback to *Time*'s original formula was the reorganization of news items in the magazine. This reconfiguration of sections was complete by the February 12, 1996, issue. The first section in the layout, the Front of the Book, was "Notebook," which featured short news items. Next came The Well, which included "Nation," "World" and "Business," just as Luce and Hadden had initially organized the magazine, with the longer news stories, including the cover story. And last, came the Back of the Book items, such as "Education," "Books" and "Theater." Despite the new section lineup, the magazine tacitly complied with Muller's redesign to divide the news into three general parts.

Discovering and learning, a new approach for the magazine

Before becoming *Time*'s managing editor, Isaacson, wrote, along with Evan Thomas, *The Wise Men: Six Friends and the World They Made*, a book on six policymakers of the Cold War. In 1992, he penned *Kissinger: A Biography*, a study of the life and politics of the former secretary of state, and after leaving *Time*, he published two highly acclaimed biographies on Benjamin Franklin and Albert Einstein. Throughout his career, Isaacson was known for proposing books and journalism pieces that would awaken readers' curiosity and whet their appetite for knowledge.

Often, he did so by asking questions. Just two weeks into his tenure, a cover

story on Steve Forbes was titled "Does a Flat Tax Make Sense?" The following week, featuring a photo of the Earth from space, the cover asked, "Is Anybody Out There?" In 1996, other titles that tried to hook readers with questions included: "Can Machines Think?" "Who Speaks for Kids?" "Can This Boy Save the Monarchy?" and "Whose Web Will It Be?" "How" and "Why" became common questions on the front cover. In Isaacson's opinion, they helped define the news and attracted more attention than the answers.

This philosophy was also the premise for such stories as the one in the October 12, 1998, issue under the title "A Week in the Life of a Hospital" and for "America— The Inside Story" in the July 7, 1997, issue. The goal of the series was to reveal the country's culture by exploring its different communities. Isaacson had a group of reporters travel U.S. Highway 50 by bus. Similarly, for a report on July 10, 2000, "Life Along the Mississippi," the journalists navigated the Mississippi River on a chartered boat, stopping at towns and cities along its banks. Isaacson recalled:

"I was putting out a magazine that I was interested in; I got intellectually excited about every story. That's why I took my journalists to trips around the country. My message to them was, 'We are not better than our readers. Let's get excited about what we do. The reader is interested in the same things we are.'"

New writers, new writing style

By 1996, the internal debate over whether stories should be written through group journalism or by the individual reporters had yet to be settled. The attempt to replace the old cooperative writing system often resulted in poorly written stories, which usually landed on the New York editors' desks for rewriting. Isaacson, who

had recognized the problem, solved it by hiring talented new writers who could interview, research and write their own stories. During his tenure, reporters wrote eighty percent of the articles, while only twenty percent were penned by New York writers from reporters' files—the reverse of the traditional ratio.

One of Isaacson's first steps was to set the tone for the magazine by offering his own writing as an example for staff writers, something no other managing editor had done. "So I wrote a cover story on Bill Gates trying to show a more personal, intimate narrative that *Time* covers could be," he explained to the authors. He used the same approach with other favorite topics, politics and diplomacy, when he interviewed and wrote the cover story about Secretary of State Madeleine Albright, published on May 17, 1999. He explained:

"I traveled with these people, I spent time with them, saw them move and act, examined how they dressed and what they ate and how they treated people around them. That was a way to show by example the type of writing I wanted."

Early in his tenure, Isaacson defined his style in the January 15, 1996, letter to the readers:

"In New Orleans, where I come from, folks are divided into two categories: preachers and storytellers. I'm a bit more in the storyteller camp. I believe that ever since we invented campfires, narrative tales have been the best way to capture people's attention, to convey ideas and moral beliefs. And as an occasional biographer, I believe that portraying interesting people is a good way to make the world come alive. '*Time* did not invent personality journalism,' Luce once said. 'The Bible did.'"

LIFE
ALONG
THE
MISSISSIPPI

Let us take you on a trip down America's great river, where we explore the troubles and triumphs of people trying to catch up with the new economy and all that goes with it, from charter schools to dotcom ventures. In a region once bogged down by history, the rising tempo of change is sparking dramatic stories of conflict and opportunity

TIME

PHOTOGRAPHS FOR TIME BY DIANA WALKER

BY NANCY GIBBS

UNLESS YOU ARE DRIVING ACROSS it or flying over it or floating down it, it is hard to see the actual Mississippi. Anyone who had anything to do with the river discovered long ago that it was too powerful to leave alone, this huge continental drainpipe, and so the great engineers engineered the levees and locks and dams that reduced the number of ships that sank and towns that vanished—but also had the effect of hiding the river behind its walls and leaving the rest to the imagination.

As luck would have it, since the great American writer wrote the great American novel about the river and where it goes and what it means, imagination may be the best guide for exploring it. Otherwise you need both a boat and a car, maybe a canoe and a bicycle too for the skinny inlets and alleys along the way, and a lot of time and patience. We could at best splash in it a little, to see what it felt like, and what we might learn—and unlearn—by stopping along the way. It was worth remembering Huck Finn's lesson: the river is the sanctuary; the shore is where you get into trouble.

This may be especially true in an election year, for all of us who have listened already to months of debate over how to help good schools and fix bad ones, and nurse the new economy, and save Social Security, and wondered whether, if we went out and talked to a bunch of voters, they would be concerned about the same things the candidates are talking about. In a country where travelers lament that every town looks the same—Where's Taco Bell? Where's Home Depot?—it's easy to assume that no region is really distinct anymore. We're all online now, and even in Baton Rouge, La., the local doyenne observes, the kids don't say y'all anymore. They say, "you guys," just like on TV.

SO WE WERE SURPRISED, EVERYWHERE WE WENT. THE MORE YOU explore the communities along the river, the farther south you travel down into the Mississippi Delta, the more apparent it becomes that this is still a land unto itself, defined by its colorful, bloody past and wrestling with a different experience of this present explosion of progress and prosperity. It is a land apart even from the region that cradles the early stretches of the river itself, the Midwestern states of Minnesota, Wisconsin and Iowa, which reinvented themselves three times in a half-century, moving from agriculture to industry to high technology. Wisconsin went from making milk to making Harley Davidsons to becoming headquarters for General Electric Medical Systems, the multibillion-dollar diagnostic imaging-equipment company.

But farther south is where the country's two wars were fought: the Civil War, and, a century later, the battle for civil rights. "Of course the war is not over," says our 87-year-old guide in Vicksburg, Miss. Now there is a quieter conflict raging, not on the broad political stage but in the particulars of individual lives. Along the river, people hear about the new economy, but they don't have a ticket to get there. Information superhighway? Progress here is a buck road, winding, scenic and personal, but slow by the standards of a country in a hurry into the future.

Thus everyone wants to talk about education, but many say the big problem is not more money or vouchers or class size; rather it is lazy or indifferent or overworked parents who can't

42

An emblematic cover story

Isaacson's story in the January 13, 1997, issue, "In Search of the Real Bill Gates," is considered one of the best pieces about the software genius in terms of reporting, research and writing. It was the first story that carried private images of Gates, his wife, Melinda, and their daughter, Jennifer—material to which the rest of the press had never before had access. The story was a milestone, not only because Isaacson had intimate access to the inaccessible and elusive genius who didn't often grant interviews, but also because Isaacson managed to interact with Gates, who was not interested in small talk. For the first time, Isaacson lifted the veil on Gates's private life.

Hard headed and extremely competitive
Isaacson began the article by recounting this incident from Gates's youth:

> "When Bill Gates was in the sixth grade, his parents decided he needed counseling. He was at war with his mother, Mary, an outgoing woman who harbored the belief that he should do what she told him. She would call him to dinner from his basement bedroom, which she had given up trying to make clean, and he wouldn't respond. 'What are you doing?' she once demanded over the intercom. 'I'm thinking,' he shouted back. 'You're thinking?' 'Yes, Mom. I'm thinking. Have you ever tried thinking?' ... After a year of sessions and a battery of tests, the counselor reached his conclusion. 'You're going to lose,' he told Mary. 'You had better just adjust to it because there's no use trying to beat him.' 'Mary was strong-willed and intelligent herself,' her husband recalls, 'but she came

around to accepting that it was futile trying to compete with him'"

Multitasker
This description paints Gates as the extremely busy man everyone assumed he was:

> "He can be so rigorous as he processes data that one can imagine his mind may indeed be digital: no sloppy emotions or analog fuzziness, just trillions of binary impulses coolly converting input into correct answers ... Even while eating he seems to be multitasking; ambidextrous, he switches his fork back and forth throughout the meal and uses whichever hand is free to gesture or scribble notes [in a notebook he always carries with him]. 'All the neurons in the brain that make up perceptions and emotions operate in a binary fashion,' he explains. 'We can someday replicate that on a machine. Earthly life is carbon based, and computers are silicon based,' he notes, 'but that is not a major distinction. Eventually we'll be able to sequence the human genome and replicate how nature did intelligence in a carbon-based system.'"

His passions and blunders
> "It's a rainy night and Gates is bombing around in his dark blue Lexus. He loves fast cars. When Microsoft was based in Albuquerque, New Mexico, in its early years, he bought a Porsche 911 and used to race it in the desert; Paul Allen [his partner and friend] had to bail him out of jail after one midnight escapade. He got three speeding tickets—two from the same cop who was trailing him—just on the drive

from Albuquerque the weekend he moved Microsoft to Seattle. Later, he bought a Porsche 930 Turbo he called the 'rocket,' then a Mercedes, a Jaguar XJ6, a $60,000 Carrera Cabriolet 964, a $380,000 Porsche 959 that ended up impounded in a customs shed because it couldn't meet emission standards, and a Ferrari 348 that became known as the 'dune buggy' after he spun it into the sand ... Despite this record, Gates is not wearing a seat belt. (A dilemma: is it too uncool to use mine?) He rarely looks at you when he talks, which is disconcerting, but he does so when he's driving, which is double disconcerting."

About children and religion
> "... I used to think I wouldn't be all that interested in the baby until she was two or so and could talk ... but I'm totally into it now. She's just started 'ba-ba' and to have a personality,' he says ... Analytically, I would say nature has done a good job making child raising more pleasure than pain, since that is necessary for a species to survive. But the experience goes beyond analytic description.... I believe that someday we will be able to replicate intelligence and emotions in a computer but I must admit that the joy of having and rearing my daughter Jennifer goes beyond analytical description ... Religion has come around to the view that even things that can be explained scientifically can have an underlying purpose that goes beyond the science. Even though I am not religious, the amazement and wonder I have about the human mind is closer to religious awe than dispassionate analysis."

Discovering America. Isaacson wanted his reporters to know and understand *Time*'s readers. For a July 7, 1997, cover, with the heading "America—The Inside Story," journalists traveled by bus along Highway 50. The article, a report on the different communities the reporters encountered, was called "The Backbone of America." The July 10, 2000, cover heading, "Life on the Mississippi," featured an article titled, "America's river of dreams," for which the journalists made an "eye-opening" boat trip along the Mississippi (opposite).

From Tragedies to the Lewinsky Shots Nobody Could Find

As opposed to the events that occurred during the tenure of James Gaines, his predecessor, Walter Isaacson's tenure was teeming with tragedy and scandal, which provided rich material for *Time*'s articles. Tragedies—from the Oklahoma City bombing in 1995, to the TWA Flight 800 explosion the following year, Versace's murder and the deaths of Princess Diana and Mother Teresa in 1997, as well as the Columbine High School massacre and the death of John F. (John-John) Kennedy, Jr., in 1999—sold issues. More positive events, such as Bill Clinton's reelection to the presidency in 1996, the landing of the Mars Pathfinder the following year, John Glenn's return to space at seventy-seven, Pope John Paul II's visit to Cuba in 1998, in addition to the new millennium, didn't quite balance out the dark side of this five-year period.

None of these events had more emotional resonance among readers than the deaths of Princess Diana and John F. Kennedy, Jr. *Time*'s coverage of Princess Diana began with the April 20, 1981, issue when she was featured for the first time on the cover under the heading "The Prince's Charmer." The letter from the publisher described her as "that rare phenomenon: a real-life embodiment of a Hollywood image of a princess." The princess captured the cover nine times—more than any queen, including Queen Elizabeth, who was selected "Woman of the Year" in 1952. Because of her popularity—she was described by *Time* as "Princess of the World"—the magazine published two consecutive issues on Diana after her death. The first issue on September 8, 1997, focused on her fatal car accident. It took *Time*'s staff barely sixteen hours to include twenty-pages on the tragedy that occurred on a Saturday, the magazine's closing day. The following issue, on September 15, was a "Commemorative Issue," a keepsake tribute that detailed her life and accomplishments with thirty-nine-plus pages under a black top border: "Princess Diana, 1961–1997."

Time covered the death of John F. Kennedy, Jr., similarly. When he and his wife and her sister tragically died in 1999 when the plane he was flying crashed, *Time* devoted two consecutive covers to John-John, as he was affectionately known. The first was the July 26, 1999, "Commemorative Issue," with only his name and the years of his birth and death on the cover. Inside, the magazine contained thirty-seven pages of coverage, with the first six as double photo spreads, and again, under a black top border, his name and years of birth and death. The following week, on August 2, *Time* devoted another cover, "In Memoriam," to him. On the cover was John-John saluting his father's passing coffin in 1963 with the cover caption "Ask Not...." Inside were twenty-seven pages on his legacy.

The first two issues on John-John, as well as the commemorative issue on Princess Diana, are still among the magazine's top-ten all-time best sellers. The July 26, 1999, commemorative issue on John F. Kennedy, Jr., sold 1,304,288 copies at newsstands, and the September 15, 1997, issue on Princess Diana sold 1,183,758 copies.

However, no event during the Isaacson years held the attention of readers as persistently as the scandal over the affair between intern Monica Lewinsky and President Bill Clinton. The magazine devoted twelve covers to the subject throughout 1998, culminating with the designation of Clinton and the prosecutor assigned to his case, Ken Starr, as "Men of the Year." The series started with the February 2, 1998, issue, under the heading "Monica and Bill, the Sordid Tale That Imperils the President." It included a special thirty-four-page report on the issue, with numerous articles unified

1999. John F. Kennedy, Jr.

Commemorative issues. In 1997 and 1999, *Time* devoted two consecutive covers to the tragic deaths of John F. Kennedy, Jr. and Princess Diana. The July 26, 1999, issue on John F. Kennedy, Jr., (left) and the September 15, 1997, commemorative issue on Princess Diana, photographed by Mario Testino (opposite) were two of the best-selling issues in the history of *Time*.

Exhale and go. Photographer Diana Walker captured the picture on the following spread of President Bill Clinton backstage before delivering his acceptance speech at the Democratic National Convention in Chicago on August 29, 1996. The photo illustrated the September 9 cover story "Convention 96: Sitting Pretty" on the overwhelming likelihood of Clinton's reelection to a second term.

SEPTEMBER 15, 1997 $2.95

TIME

COMMEMORATIVE ISSUE

by a blue border containing the presidential seal. The competition with *Newsweek* over coverage was intense. "Then Monica Lewinsky hits and we are stuck in a very competitive situation with *Newsweek*," Jim Kelly, the magazine's deputy managing editor at the time, remembers:

"They [*Newsweek*] had the best of both worlds. They discovered the story and got credit for holding it, and got a National Magazine Award for the M. Lewinsky coverage. But Walter played that very well, beating them on the photography front and then eventually beating them on the impeachment story. I remember when Walter wanted to make Clinton and Ken Starr the People of the Year, and Walter spent an afternoon with Ken trying to persuade him to cooperate and finally he did." (Kelly's interview with the authors)

It was not easy for *Time* to surpass *Newsweek* on the photo front, either. There were two problems. The first, finding a good photo of Monica and Bill together. The other one was ascertaining which of the women with whom Clinton had been seen and photographed with was actually Monica. At the beginning of the scandal, print media, as a whole, was in the dark in that regard. Eventually, the Pentagon released a photo of the intern in which she looked very different from how she looked at the time of the scandal. *Time* had to investigate the subject surreptitiously, without raising any suspicions that might allow its competitors to scoop the information. "Suddenly, one day we get a call from a guy who claims he is a Boston student and that he had pictures of Clinton and Lewinsky together that, according to him, were taken during one of the frequent benefit open events that took place at the White House lawn," Michele Stephenson, *Time*'s former director of photography, explained:

"One of our contact photographers was based in Boston, so I sent him over to see if it was a decent, publishable picture. He called and said, 'Yeah, it's a snapshot, but it's certainly publishable.' So we talked to the guy. By this time I had let Walter know and soon he was in my office pacing. And he got on the phone with this student, who was also talking to a lawyer. In the meantime, we didn't know if there were 400 other people out there with similar pictures because it had been taken during an open event. Why weren't professionals calling in with pictures? We had no idea if this young man had something or not, but if he did, you know he wanted big money for it! So Walter is talking to him and he's talking to his lawyer, and I'm talking to him and we finally convinced him to bring the pictures to New York, because he wasn't going to let go of them and he only had three frames—four, there was one with Al Gore and Monica that Clinton was not in. I think we actually sent someone to drive him down. He showed us the pictures. I took the picture to our two 'Nation' photo editors and said: 'Compare this to the Pentagon picture. Tell me if you think this is the same person.' And they studied it and said: 'Something is not right. Something's not matching. Her teeth aren't quite right. Her earlobe isn't quite right.' They determined that the Pentagon picture, which was released through the AP all over the world, was flopped, was backwards. It still is backwards when it is shown.

So we bought the picture from him and made a deal for a lot of money— more money than I have ever spent on a picture—and we signed an agreement not to divulge the amount of money or his identity. And we syndicated the pictures and were thereby able to make back our investment and make additional money for the photographer.

Anyway, we cropped Clinton out of the picture, and sent it to our L.A. bureau picture editor, Martha Bardach, who found two friends that had gone to school with Monica. Not knowing that Clinton was in the picture, they confirmed that it was her and said: 'Oh yeah, that's absolutely her.' Since we could not find anything else, we decided to run the picture both on the cover and the opening spread. Walter was a nervous wreck. He was still concerned it wasn't Monica. So we closed the issue on Friday night and he went on CNN Saturday afternoon, which was unusual in those days. Normally we wanted to keep the cover secret until Sunday night. But this time, Walter wanted to get it out there, to make sure that she was Lewinsky, and if it wasn't right, to correct it or to at least get a mea culpa out there, ahead of the news. The minute he went on the air, all of the TV networks went to their video files and found the footage of the same situation (because we released it to CNN with the date and place of the event). Several months later our photographer Dirck Halstead found his own picture of Lewinsky with Clinton. It was brilliant, a gorgeous picture, one of Dirck's best. It looked like a Rembrandt— the lighting was spectacular. It was so perfect that he didn't want us to crop it as a cover at first because it was a whole horizontal scene. But it made a terrific cover. The same thing happened with this second picture: the minute we made the date public, the networks found video of the same event, which verified it. To this day I have not seen any other still pictures from these two events. (Michele Stephenson's interview with the authors)

The millon dollar picture. The photograph on the previous spread was taken by Dirck Halstead. It shows Monica Lewinsky, with bright red lips and eyes closed, embracing President Clinton at an October 1996 Democratic fund raising benefit in Washington, D.C. With the heading "Why She Turned … What He Can Do," the picture was the August 10, 1998, cover story on the scandal.

My days at *Time*
Dirck Halstead: The Monica Lesson

Extracted from Dirck Halstead's electronic magazine, The Digital Journalist.

There have been lots of rumors running through the photo journalistic community about the picture that was the cover of *Time* magazine, showing Monica Lewinsky, her red lips glowing, her eyes closed in anticipation, being embraced by President Clinton at a fundraising event in October 1996.

Here, from the photographer's fingertips, is exactly what happened.

I have a theory that every time the shutter captures a frame, that image is recorded, at a very low threshold in the brain of the photographer. I have heard this over and over from photographers around the world. It doesn't matter if the photographer saw the processed image or not. These split seconds, as the mirror returns, are recorded as "photographic lint" on the mind of the photographer.

When the photographs of Monica Lewinsky, in her beret, on the lawn of the White House, emerged in February of this year, I KNEW I had seen that face with the president. I had no idea when, or where.

When I take photographs on assignment for *Time* covering the White House, which I do every third month (nobody could do it more), the pictures first go to the magazine. They have first-time rights on the photos. Once they have gone through the take, and pulled a few selects for the *Time-Life* picture collection, the take goes to my agent, Gamma-Liaison. They then comb the take a second time, and pull their selects. Eventually, the take comes back to me, and resides in my light room until I sort through it again, then I send everything to the University of Texas, which is where my archives reside. Because I am busy, I only get around to sending the pictures to Texas about every 18 months.

When the Lewinsky story broke, all these organizations started to go through their files, and found nothing.

I hired a researcher, and she started to go through the piles of slides in the light room. After four days, and more than 5,000 slides, she found ONE image, from a fund raising event in 1996.

By that time, the original "news break" was over. I told *Time* we had found an image, and sent it to New York. We all agreed that this was an important image, but the story had moved away from us.

So, we all sat on the picture for six months. When you think about it, that is incredible. Not only *Time*, but also Gamma-Liaison kept a secret for six months.

When Monica went to the prosecutors, and offered her testimony, the story went back to page one. At this point, *Time* and the agency went into action. The photo was run as a cover on *Time*, and is now in magazines and newspapers around the world.

So, what is the lesson from this episode? I wrote several months ago about David Rubinger talking about how important our archives are. I would rest the case on this example.

One of the things that become clear is that first, the wires could not find this photo, even after it was released in their files. That may be due to several problems. First, they have cut back on their support staff—who is going to go through their photos? The reality is that after several months, outtakes go into warehouses. If the photographers to the left and right of me on that stage, that night, were shooting digital, they probably erased the files (Monica who?). The networks, once *Time* released the photo, were able to go back into pool footage and find the picture. However, we have not seen anything from the other photographers who were there, other than an amateur photographer who was in the crowd, and whose photo was the cover of *Newsweek*.

I will make some money from this picture (not nearly as much as most people think), but if I did not own my photographs, if I did not go through them, the picture would never have emerged ...

Recall and records. Dirck Halstead (left) has said that his photographic memory and his diligence in archiving his pictures resulted in locating the picture of Monica Lewinsky hugging President Bill Clinton. After a researcher went through 5,000 negatives to find the picture, *Time* kept it secret for months until Monica's testimony made the story a page-one item again.

Power, Influence and the Man of the Century

Isaacson knew that fostering new writing styles, focusing more on history makers and connecting readers with new technology wasn't enough to reposition *Time* internally or externally. The ups and downs the magazine experienced in the previous decade had not only disconnected it from the news but also, on occasion, caused it to report exaggerated or erroneous information. *Time* lost the journalistic supremacy it had always enjoyed. As the new century approached, Isaacson realized that the magazine needed a shock that would revitalize its editorial image and place it, once again, at the center of power and influence. Isaacson's journalistic strategy is clear: he turned three focus points—*Time*'s seventy-fifth anniversary, the century's most important people and the beginning of the new millennium—into big news events for marketing purposes. These interconnected focus points were carefully thought out in hopes of improving the magazine's image.

The first event, the seventy-fifth anniversary celebration, took place on March 3, 1998, at Radio City Music Hall in New York. This was an extraordinary event that Isaacson initiated as a public demonstration of *Time*'s prowess: in addition to publishing headlines and news, the magazine had the ability to bring together, at one location, on one night, the most important newsmakers featured on its covers week after week. Hillary and Bill Clinton, Mikhail Gorbachev (who posed next to the cover the magazine had devoted to him in 1989 when it named him "The Man of the Decade") and his wife Raisa, Sharon Stone, Steven Spielberg, Henry Kissinger, Tom Hanks, John Glenn, Steve Jobs, Billy Graham and Toni Morrison. These were only a few of the nearly 1,200 personalities that *Time* gathered in a formidable display of power and influence.

The seventy-fifth anniversary party accomplished the first part of Isaacson's objective. His next step was to establish *Time* as the authoritative measure of public opinion. *Time* had the prestige and background necessary to be the magazine that could designate the 100 most influential people of the twentieth-century. The selection became an event: readers speculated about it, everyone talked about it and about *Time*.

This phase started a few weeks after the anniversary party. On April 13, 1998, the magazine published its first twenty selections in the first of five issues about the century's most influential newsmakers. Over the remainder of the decade, *Time* published four more special issues, with twenty personalities each, until reaching 100, as in a century. "*Time* 100" became a trademark until the turn of the century. The first issue was titled "Leaders and Revolutionaries," with a subhead reading "The first in a series of looks at the most influential people of our century." The next two issues, both in 1998, focused on "Artists and Entertainers" and "Builders and Titans." In 1999, the theme continued with "Scientists and Thinkers" and "Heroes and Inspirations." Each issue of "*Time* 100" profiled very different and influential people: Theodore Roosevelt, Mother Teresa, Pelé, Alexander Fleming, Adolf Hitler, Winston Churchill, Sigmund Freud, Nelson Mandela, Muhammad Ali, Pablo Picasso, Ronald Reagan, Rosa Parks, Marilyn Monroe, Che Guevara, Albert Einstein, Mohandas Gandhi, Coco Chanel, Walt Disney and Ayatollah Khomeini, among many others.

The first issue of "*Time* 100" contained another distinct feature that was repeated throughout the series: noted writers wrote the texts. British historian John Keegan, perhaps the greatest living military historian, wrote the profile on Winston Churchill; William F. Buckley, Jr., a leading conservative writer, undertook the one on Pope John

2000. U.S. voting system

Venerable history. The December 18, 2000, cover featured the preamble to the U.S. Constitution, symbolizing the questions that the disputed Bush-Gore election results posed to the American electoral system (left). For the last cover of the century, *Time* selected Albert Einstein (opposite) for his scientific discoveries and impact on technology.

1998. *Time* 100: Leaders & Revolutionaries

1998. *Time* 100: Artists & Entertainers

1998. *Time* 100: Builders & Titans

1999. *Time* 100: Scientists & Thinkers

The most influential. Beginning on April 13, 1998, as a precursor to the selection of "Person of the Century," *Time* published five issues dedicated to the 100 most influential people in the world, of which four of the covers are above. The first "*Time* 100" special report featured twenty "Leaders & Revolutionaries," followed by twenty "Artists & Entertainers" on June, 8 , 1998, "Builders & Titans" on December, 7, 1998, "The Centuries Greatest Minds" on March 29, 1999, and "Heroes & Icons of the 20th Century" on June 19, 1999. "*Time* 100" became a yearly feature in 2004.

Paul II; Elie Wiesel, a Nobel Peace Prize winner, crafted the piece on Adolf Hitler; and Anglo-Indian writer Salman Rushdie contributed the one on Mohandas Gandhi. The task of capturing the cover's importance and energy fell to Robert Rauschenberg, the influential American artist whose imaginative collages are cultural icons, often full of historical references. The work took him four days to make at his Captiva Island, Florida, studio. "There's no such thing as power and politics without personalities, and power and revolution do not exist with hands in pockets. I hoped to get that across in my cover," said Rauschenberg, as quoted in the April 13, 1998, letter to readers.

With the publication of the five issues of "*Time* 100," *Time* reclaimed its stature in public opinion, and the final stage of Isaacson's project started. It culminated on December 31, 1999, when *Time* devoted its cover to Albert Einstein, the figure the magazine designated as "Person of the Century." The cover omitted a subheading; it simply carried Einstein's name. The cover image was a classic Philippe Halsman photo of Einstein looking directly into the camera. The issue came out the week after Amazon creator Jeff Bezos was featured as "Person of the Year." Also in 1999, the historic "Man of the Year" became "Person of the Year" to be inclusive of future female selections.

The editor's letter, signed by Walter Isaacson, which was published in the Einstein issue, identified the three finalists for the "Person of the Century" selection, as well as the authors chosen to write their profiles. Einstein won because of his scientific breakthroughs and for his role as the genius who influenced some of the most influential technological innovations, such as nuclear arms, television, space travel, lasers and semiconductors. Stephen Hawking, also a top theoretical physicist, was charged with explaining Einstein at the end of the century. Franklin Roosevelt was selected as a finalist

for embodying "the triumph of freedom over fascism and communism." Noted historian and biographer Doris Kearns Goodwin and President Bill Clinton each wrote articles— Clinton's a fascinating essay titled "Captain Courageous" on what Roosevelt meant to the world at the time. Mohandas Gandhi was also selected as a finalist for his crusade for civil rights and individual freedoms. Nelson Mandela, in his essay on Gandhi, described how and why at times he strayed from Gandhi's philosophy of nonviolence. "By the end of our process, we felt strongly that Einstein best met our criteria: the person who, for better or worse, personified our times and will be recorded by history as having the most lasting significance," the managing editor wrote in "To Our Readers."

As for whether totalitarian leaders such as Hitler, Lenin and Stalin were considered for the title of "Person of the Century," Isaacson wrote:

"No. He [Hitler] lost. So did Lenin and Stalin. Along with the others in their evil pantheon, and the totalitarian ideologies they represented, they are destined for the ash heap of history. If you had

to describe the century's geopolitics in one sentence, it could be a short one: Freedom won. Free minds and free markets prevailed over fascism and communism."

A new century began in 2000. For Walter Isaacson, it was to be his last year as the magazine's managing editor. He had taken leadership of the magazine five years earlier, with the goal of reestablishing *Time*'s traditional identity by covering newsmakers and returning to the use of sections. He managed to do so but the odds were also in his favor: between 1995 and 1999, advertising income increased sixty-three percent and ad pages by thirty-five percent, reaching more than 3,000 a year. During the same period, revenues went from $404.5 million to $658.4 million. It was quite an accomplishment. In December, as George W. Bush and Al Gore were going through their presidential tug of war, *Time* changed leaders. Isaacson became editorial director of Time Inc., and James Kelly was promoted to managing editor. He was number fifteen and another "*Time* man."

Birthday. *Time* celebrated its 75th birthday with a party at Radio City Music Hall in New York. The attendance of almost 1,200 newsmakers who had graced *Time*'s covers attested to the magazine's power and influence. In this photograph, from left to right are E. Bruce Hallett, president of Time Inc., Walter Isaacson, managing editor, President Bill Clinton, his wife, Hillary, and Gerald Levin, Time Warner chairman and CEO (below).

September 11, 2001

Jim Kelly was forty-six when he became *Time*'s managing editor. He had joined the magazine in 1978 and, like many novices, started out in the "Milestones" section, writing short stories about births, weddings, deaths and the newsmakers involved in other life events. He soon became a writer for the "Nation" section, joining Walter Isaacson and Richard Stengel. In 1988, he was named editor of the "World" section. In 1991, Henry Muller named him assistant managing editor. In 1994, James Gaines promoted him to executive editor in charge of the first half of the magazine, and in 1996, he was promoted to deputy managing editor.

Isaacson held his title of editorial director at Time Inc. for barely six months. In July 2001, he was named president and executive director of the CNN News Group at AOL Time Warner. Meanwhile, Kelly's challenges began almost immediately. The complicated results of the contest for president between George W. Bush and Al Gore, with a 537 vote difference, required special coverage by the magazine, which devoted six consecutive covers to the subject. For the November 20 issue, the first after the election, writer Nancy Gibbs wrote three different stories: one with Gore as the winner, another with Bush and the third with ambiguous results. The year's last cover, December 25, 2000, was the "Person of the Year" issue. Bush, having finally been confirmed as president elect, was selected.

Kelly's tenure lasted five years, until 2006, in what perhaps was the period of greatest editorial turmoil since World War II. High-impact, overwhelming and tragic events challenged his management and the way news was reported and displayed. If there was one issue that put Kelly's leadership to the test, it was the special issue, produced on an extraordinary two-day deadline, which reported the attack on New York's World Trade Center on September 11, 2001. Not only was it a historic issue that people kept as a testament of that day's horror, but also it was *Time*'s highest-selling issue. Newsstands sold out of all 3,259,156 copies. It was also the first issue since 1927 to do away with the red frame, which was replaced by a symbolic black one.

The morning of Tuesday, September 11 was challenging for the magazine's photography department. Alerted of the attack, Photo Editor MaryAnne Golon was attempting to drive into Manhattan while most people fled the city. Meanwhile, photographer James Nachtwey, who was scheduled to fly to the Caribbean that day, called the airport and found out that all flights were cancelled. When he peeked out his apartment window, near the towers, he saw what was taking place and was one of the first photographers at the scene. He took incredible shots, and was almost trapped when the second tower toppled. When he arrived at *Time* to deliver his work, he was unrecognizable, due to the smoke and dust on his clothes and face. It was suggested that he be hospitalized due to fears that the foul air might have affected his lungs.

A special issue, edited by Jim Kelly, Arthur Hochstein, Deputy Managing Editor Stephen Koepp and MaryAnne Golon, came out on September 14, containing no ads, only news, in its fifty-two pages. The issue is a milestone: edited with sophistication and a powerful juxtaposition of photos and stories.

On the cover, a single photo showed the instant when the second airplane crashed into the north tower of the World Trade Center, causing an explosion of fire, smoke and debris. The cover did not carry a heading: words were unnecessary—just the *Time* logo and "September 11, 2001" as a small caption between the two towers.

2001. Special Edition: September 11

A witness to horror. On September 14, 2001, *Time* published a special fifty-two-page edition dedicated in its entirety to the terrorist attacks that destroyed the Twin Towers of the World Trade Center, as well as damaging the Pentagon and causing United Airlines Flight 93 to crash in a field near Shanksville, Pennsylvania. Thousands of people died; the nation was in the grip of fear and loss. For the first time since 1927, the cover's traditional red border was replaced by a black border (opposite). The issue ended with a photograph of the Statue of Liberty, partially shrouded in a cloud of smoke and dust, as a mute witness to the horror (left).

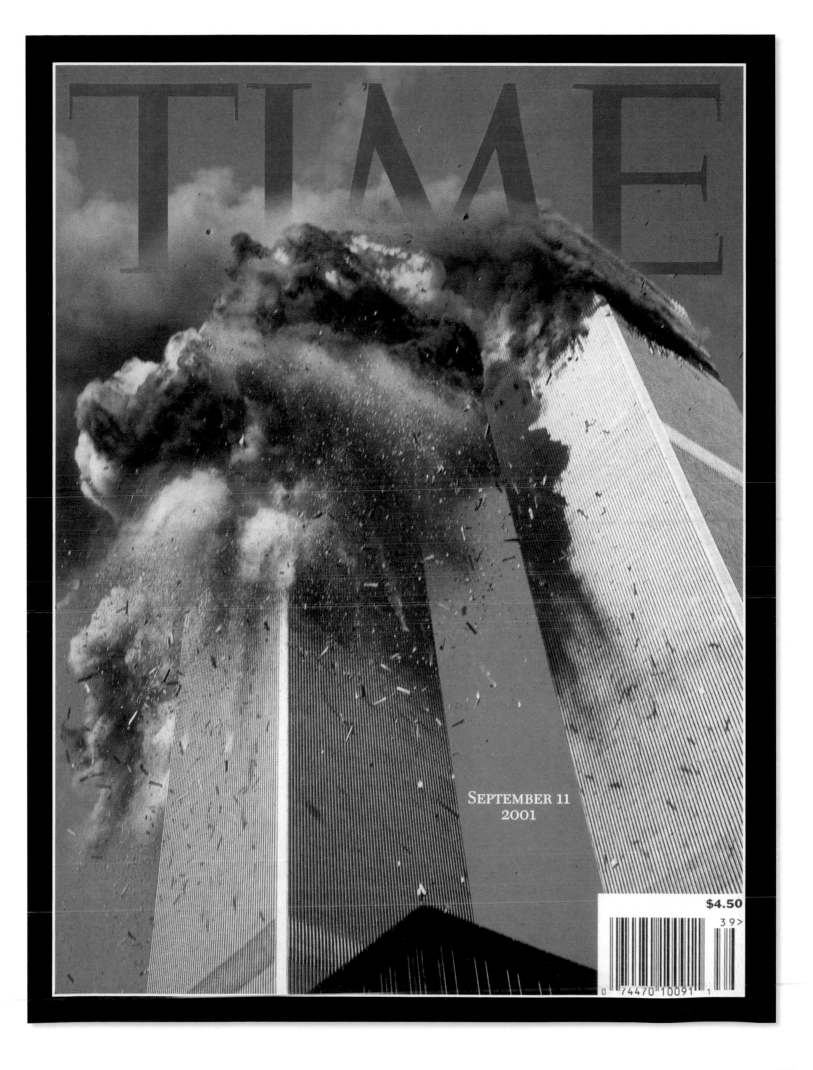

SEPTEMBER 11
2001

$4.50

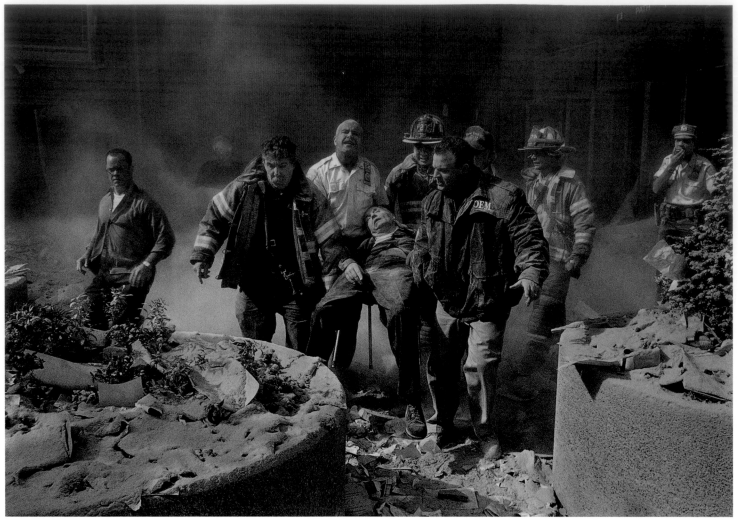

Rescue. This image (above) shows firefighters carrying Father Mychal Judge, Chaplain of the New York City fire department, who was killed heroically while ministering at Ground Zero, where the cloud of dust and smoke made rescue efforts nearly impossible.

Lyle Owerko, from the Gamma Agency, took the photo.

The first spread contained a black-and-white photo over a page and a half and a letter from the editor. The following, four half-page photos by Robert Clark, from the Aurora Agency, showed, step-by-step, the last few seconds of the second plane crashing against the south tower. The next double page spread carried a giant heading, "Day of Infamy," over a dramatic photo of the resulting fireball.

The following twenty-four pages skillfully combined images of explosions, fear, dust, destruction, solidarity and tears—all of it sequentially, with narrative rhythm, telling the story almost cinematically. Next, starting with a double page graphic, "Twin terrors," to balance the opening double spread, came a twenty-page text recounting what happened that day. The back cover featured a cinema-esque conclusion: a shot of the Statue of Liberty and, in the

background, covered by dense smoke, a few barely visible Wall Street buildings. Like the front cover, the photo said it all. No need for words. Kelly remembers:

"Everyone was clamoring 'Let's put out an issue right away!' I was slow to embrace the idea—and that means two hours later and not a day later. We rushed out there and my fear was that two or three days after we came out with an advance publication date

that we would be outdated by all other media. We ended up tiring all the staff out on Tuesday and Wednesday, and then on Thursday we were up to a new start for the coming week's edition. My question was 'How am I going to protect us from doing the same kind of issue twice in two days and from looking stupid on Friday if we are missing some important fact?' That's why I decided to do one story that chronicled the day of the attack. I wanted *Time* to produce a story that, if it was read fifteen years later, you'd say 'O.K., this is what it felt like that day, this is what it was like to be alive when this event happened.' And the model came from my past: I was 9 or 10 when JFK died and both the AP and UPI put out memorial hardcover books in the spring of '64, and I just pored over these things, filled with accounts of what happened to all sorts of people on that day of November 22, 1963. How this event was covered in these books six months after that fact was what I was trying to create in that issue. I hate to do this but if I had to pick two issues representative of my tenure, it would be the 9/11 issue and the Katrina issue. When you are facing big events like these two, you'd want to put out an issue that has bottom, so to speak, has the kind of approach that would make you want read it and save it."

Nancy Gibbs, the top cover-story writer at *Time*, was in charge of writing the single article, based on more than 950 files she received from all the correspondents and reporters who went out to cover the September 11 stories. Gibbs remembered:

"When Jim told me how to write this story, I thought he was crazy because he requested a single vivid narrative. Later, I realized it had been a very wise decision. When he called me the morning of the attack, we were all glued to the television, and he wasn't sure that we could put out a special issue right away in 24 hours. We had to close on Thursday (the attack was on a Tuesday) and we were unsure about the printing capacity and all kinds of other logistical complications. 'I just want you to tell the story of today. Just think of it as a time capsule. Just tell what happened today. You don't have to speculate about anything or write about what comes next.' This is such a testimony to his instincts as an editor. Any other traditional editor would separate the coverage in sections, dividing the piece. 'You write about New York, you write about Washington and you about the president's response,' etc., and then there would be ten writers working with ten editors as fast as possible.

But [Jim] said 'Only one writer and everyone else will be reporting.' We sent reporters and writers to hospitals, downtown; Jay Carney was onboard Air Force I with President Bush. Everybody was supposed to e-mail me what they saw and heard. Bob Hughes, our art critic, was on the roof of his building downtown describing what he saw, for example. At that point, I had something like 950 e-mails in my computer, and in the meantime, I had the TV on and was taking notes while I kept writing. I had neighbors who were in the towers —it was weird. As I was home on this beautiful Tuesday watching TV and writing, I was also on the phone with one friend of mine who watched the plane go into what looked like her husband's office and she didn't know for hours that he had made it out. My husband went to get the children from school.

At the same time that the events were unfolding for us and our friends, we were trying to capture not only what was happening here but also everywhere else. You know they closed down the National Parks, and that parents in Birmingham, Alabama, took their kids out of school. In the meantime, I was wondering, what's happening in Los Angeles, in Kansas City, in other cities ... There was literally too much for me to read, let alone to put in the story, and I told Howard Chua-Eoan, our information coordinator, to read all the material coming from outside New York and Washington, and to find the best way to highlight everything for me and put it in a miniature report or boil it down to what really resonated. We worked like a perfect machine. All these different parts were working simultaneously in a deadline that *Time* never had before in its history. We worked as if we were a daily. In perspective, it was a great example of what this magazine should give its readers." (Gibbs's interview with the authors)

Recovery. This photograph (following spread) by James Nachtwey, who was almost trapped in the collapse of the south tower of the World Trade Center, is a surreal image of a firefighter going through the twisted and smoldering heap of rubble in hopes of recovering bodies.

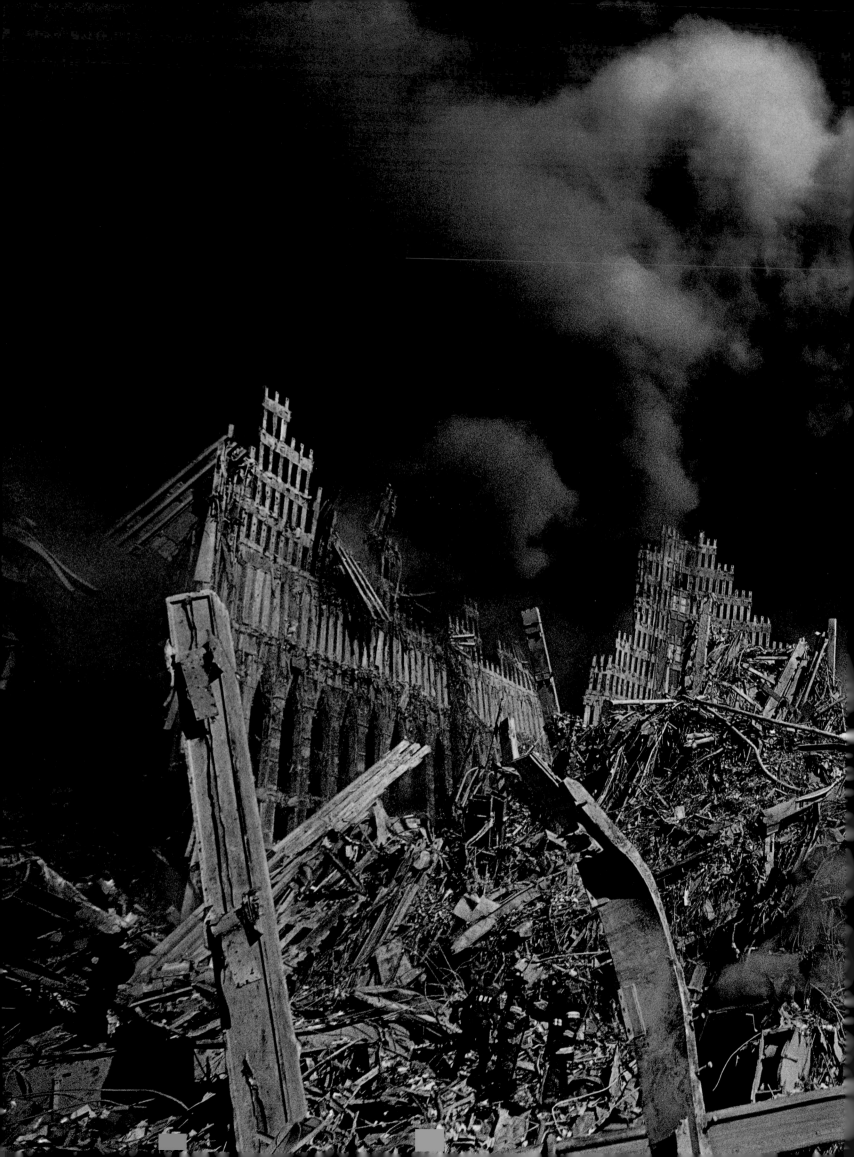

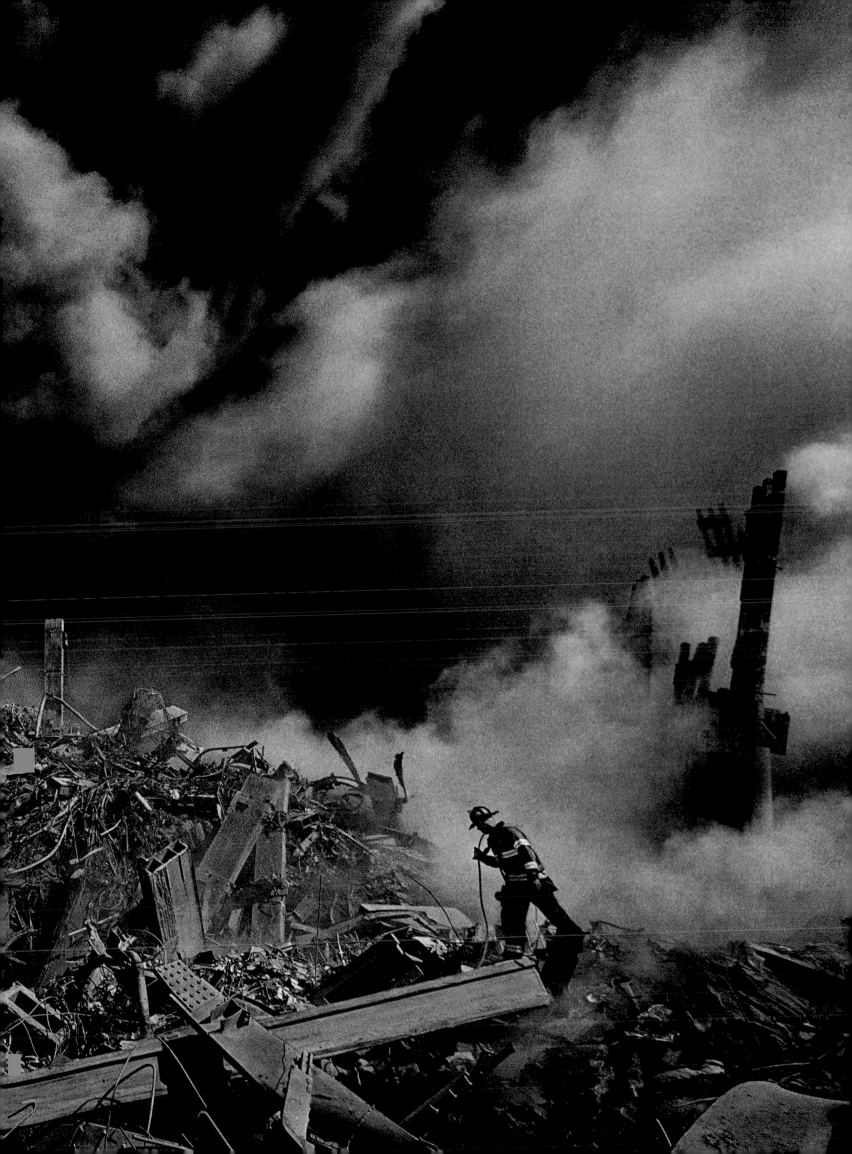

Giuliani, 2001 "Person of the Year"

Barely two months after the attack on the Twin Towers, the selection of the 2001 "Person of the Year" became a hotly contested subject. The question made *Time* confront its own identity, its history, its feelings, its commitment to journalism, its credibility and its duty to readers.

What should *Time*'s editors do now with Osama Bin Laden, the alleged protagonist of the single-most-important news event of the year? Their predecessors hadn't hesitated, despite facing harsh criticism, when they chose Adolf Hitler in 1938, and hadn't hesitated when they named Nikita Khrushchev in the middle of the Cold War, when the Soviet Union's *Sputnik* wounded American pride, and hadn't hesitated in 1979, when they named Ayatollah Khomeini while American diplomats were held hostage in Tehran.

None of those earlier figures, however, had attacked the United States homeland, destroyed two symbols of a major U.S. city and killed thousands in a terrorist attack. Managing Editor Jim Kelly reached the conclusion that putting Bin Laden on the most anticipated cover of the year would be a hard blow for most Americans, so on its January 7, 2002, cover, *Time* featured New York Mayor Rudolph Giuliani as the 2001 "Person of the Year."

After the controversy over the selection of Ayatollah Khomeini as "Man of the Year," *Time* added two new considerations to the selection process. One was that the candidate not be anti-U.S. or anti-American, and the other was that the candidate not be somebody who cast a negative light on the history of mankind. For that reason, *Time* had picked Einstein as "Person of the Century" instead of Hitler who, without a doubt, had been the person who left the most indelible impression during the last century. This new "Person of the Year" criterion was used to select Giuliani.

In retrospect, the January 7, 2002, cover story that exalted Giuliani and justified him as "Person of the Year" reads as hyperbole, but it is a true portrayal of the shock the city was going through after the destruction of the World Trade Center towers:

"There is a bright magic at work when one great leader reaches into the past and finds another waiting to guide him. From midmorning on Sept. 11, when Giuliani and fellow New Yorkers were fleeing for their lives, the mayor had been thinking of Churchill. 'I felt so proud of the people I saw on the street,' he says now. 'No chaos, but they were frightened and confused, and it seemed to me that they needed to hear from my heart where I thought we were going. I was trying to think, where can I go for some comparison to this, some lessons about how to handle it? So I started thinking about Churchill, started thinking that we're going to have to rebuild the spirit of the city, and what better example than Churchill and the people of London during the blitz in 1940, who had to keep up their spirit during this sustained bombing? It was a comforting thought.' With the President out of sight for most of that day, Giuliani became the voice of America. Every time he spoke, millions of people felt a little better. His words were full of grief and iron, inspiring New York to inspire the nation.

'Tomorrow New York is going to be here,' he said. 'And we're going to rebuild, and we're going to be stronger than we were before ... I want the people of New York to be an example to the rest of the country, and the rest of the world, that terrorism can't stop us...' Giuliani's performance ensures that he will be remembered as the greatest mayor in the city's history, eclipsing even his hero, Fiorello La Guardia, who

2001. Osama bin Laden

Controversial choice. Much of the media felt that Osama Bin Laden should have been named "Person of the Year" in 2001 (he had already been on four consecutive covers since September 11, one of which is on the left), but the distinction went to New York City Mayor Rudy Giuliani (opposite). *Time* chose, as Jim Kelly explained, the "light of the news" rather than the "darkness of Bin Laden's terrorism."

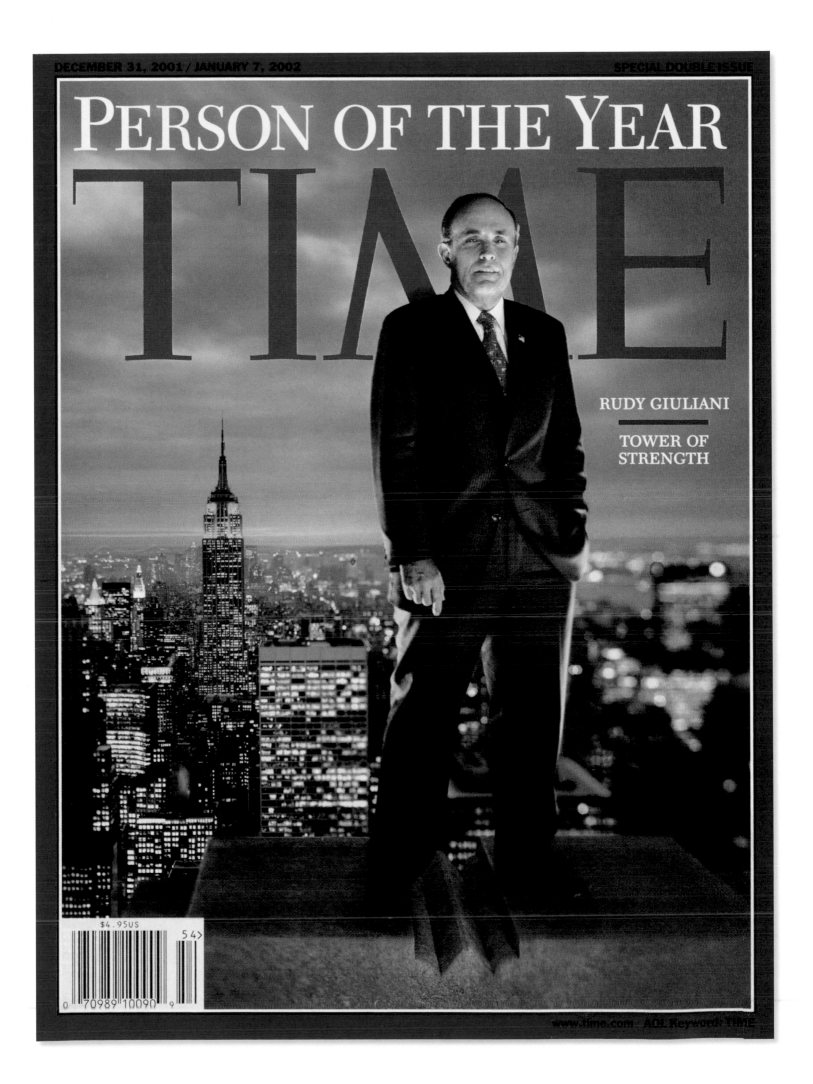

guided Gotham through the Great Depression...."

The decision to pick Giuliani provoked criticism from other media, some of which, particularly internationally, accused *Time* of being too accommodating and subjective in not selecting the leader of Al Qaeda, the mastermind behind the terror attack. Jim Kelly justified his and his staff's decision with these words: "On one hand, we had the light of the news in Giuliani and on the other the darkness of Bin Laden's terrorism. We decided in favor of the light."

The 2001 "Person of the Year" issue had one hundred fifty-six pages, with multiple stories on Giuliani. It also contained a photo essay on September 11, with eighteen pages of photos as reminders of that terrible day. On the cover, Giuliani was portrayed as a tough, strong, resilient man. The photo was taken from atop Rockefeller Center, as if New York City were at his feet. Credited with this imposing shot was Gregory Heisler, a master of grand cover productions and a superb newsmaker portrait photographer, who could faithfully interpret the message of the story:

"It was after 9/11, it was his shining moment. He was the voice. He was the face people associated with courage. The pics had to show him serious and powerful and also a dignified, strong symbol in the context of New York City. I scouted all of New York City and could not find the appropriate location. Besides, he decided he did not want to do it at Ground Zero. He thought it was sacred ground and it would be self-aggrandizing to pose right there. Then we thought of the Rainbow Room in Rockefeller Center, which allows you to be in the skyline rather than on top of it. I spent a good part of the week, especially at dusk, figuring out the lighting, the time of day, the angle, etc...

The tricky part was that Giuliani was supposed to stand on the parapet on the actual edge of the roof. I generally put myself in the position of the subject just to imagine how they would feel in that pose, and get a sense of how comfortable he would feel there, right by the edge of a 64-floor skyscraper. I am scared of heights and suspected that he would be too. So I had some set builders build a wooden platform where he would feel safe and secure. And it worked." (Heisler's interview with the authors)

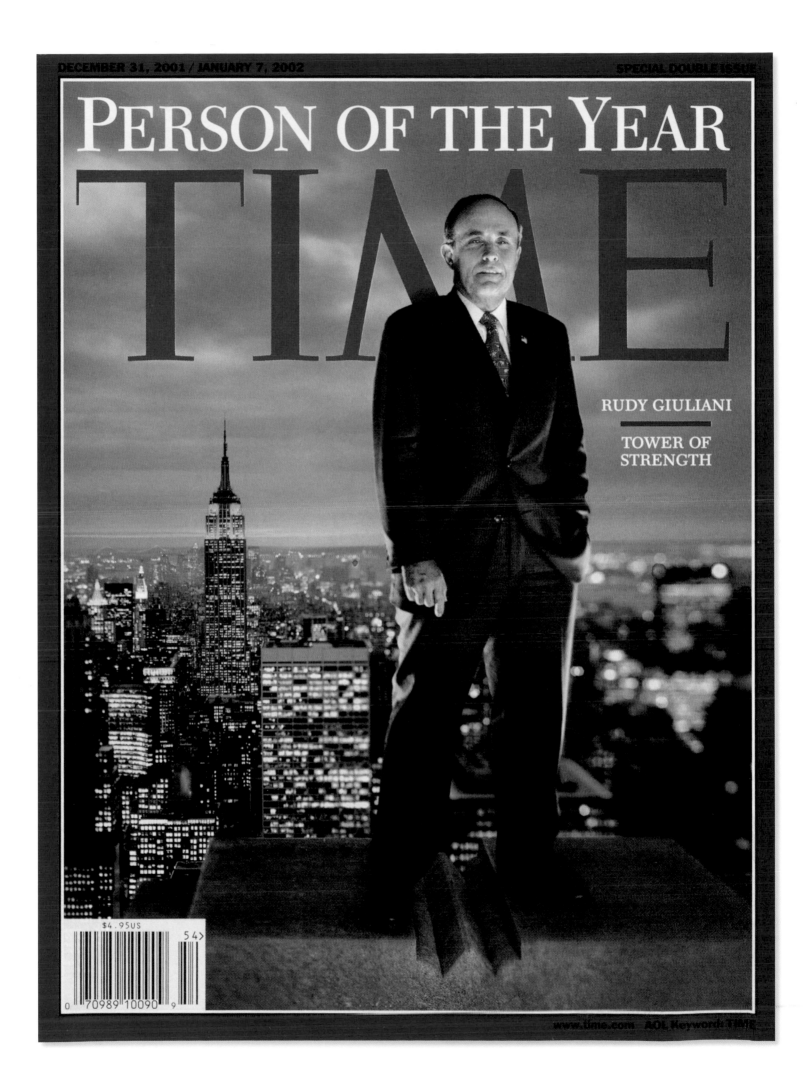

guided Gotham through the Great Depression...."

The decision to pick Giuliani provoked criticism from other media, some of which, particularly internationally, accused *Time* of being too accommodating and subjective in not selecting the leader of Al Qaeda, the mastermind behind the terror attack. Jim Kelly justified his and his staff's decision with these words: "On one hand, we had the light of the news in Giuliani and on the other the darkness of Bin Laden's terrorism. We decided in favor of the light."

The 2001 "Person of the Year" issue had one hundred fifty-six pages, with multiple stories on Giuliani. It also contained a photo essay on September 11, with eighteen pages of photos as reminders of that terrible day. On the cover, Giuliani was portrayed as a tough, strong, resilient man. The photo was taken from atop Rockefeller Center, as if New York City were at his feet. Credited with this imposing shot was Gregory Heisler, a master of grand cover productions and a superb newsmaker portrait photographer, who could faithfully interpret the message of the story:

"It was after 9/11, it was his shining moment. He was the voice. He was the face people associated with courage. The pics had to show him serious and powerful and also a dignified, strong symbol in the context of New York City. I scouted all of New York City and could not find the appropriate location. Besides, he decided he did not want to do it at Ground Zero. He thought it was sacred ground and it would be self-aggrandizing to pose right there. Then we thought of the Rainbow Room in Rockefeller Center, which allows you to be in the skyline rather than on top of it. I spent a good part of the week, especially at dusk, figuring out the lighting, the time of day, the angle, etc...

The tricky part was that Giuliani was supposed to stand on the parapet on the actual edge of the roof. I generally put myself in the position of the subject just to imagine how they would feel in that pose, and get a sense of how comfortable he would feel there, right by the edge of a 64-floor skyscraper. I am scared of heights and suspected that he would be too. So I had some set builders build a wooden platform where he would feel safe and secure. And it worked." (Heisler's interview with the authors)

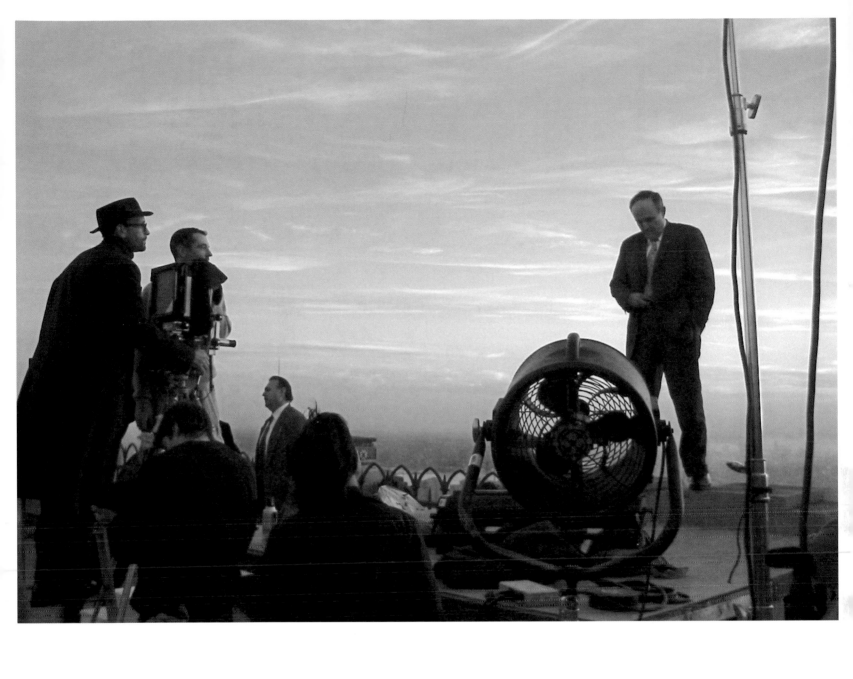

New York heights. This photograph (above) of Giuliani was taken on the sixty-fourth floor of the GE Building in Rockefeller Center by Gregory Heisler. He constructed a wooden platform at the edge of the roof to make the mayor feel safe during the dramatic pose. The mayor was portrayed as a "Tower of Strength," a symbol of recovery.

Topics to Get Away from the War

Although the Twin Towers attack and its aftermath, the wars in Afghanistan and Iraq, and the pursuit of Bin Laden and Saddam Hussein, set *Time*'s reporting agenda during the first five years of the new millennium, other subjects and editorial approaches also characterized Jim Kelly's tenure.

First, the magazine's look—which Isaacson had already reestablished by organizing the news in sections once again—underwent another update. Although not an actual redesign, earlier changes were intensified and the different parts of the magazine were more clearly demarked. *Time*'s news offerings were displayed throughout its pages as if they were "a restaurant menu," a phrase coined by Kelly. In his opinion, the first course in *Time*'s menu was an "appetizer," with short stories in the "Notebook" section, which took up three or four pages. Next came the "first course," made up of regular sections generally divided into two pages each, such as the "Nation," the "World," "Business" and "Education." The "main course" was the cover story plus the photo essay—the high-impact nucleus of the magazine. The service items, with very specific information particularly useful to readers, came after the core. These included "Health," "Money," "Technology" and the "Arts and Entertainment" sections. Kelly called this portion "the dessert." Finally, the "cup of coffee" or "liqueur" of the menu were two one-page sections, "People" and "Essay," which sometimes were alternated with "Comics," which approached a news item of the week with a slightly humorous tone.

In an attempt to visually grab the reader, Kelly gave headings a more dominant position on the page and increased them in size. Kelly also introduced another significant change in the magazine with an innovative section that was published once or twice a month. Called "*Time* in Depth," the section spanned six to eight pages and was defined by Kelly as "a piece of journalism written like an essay but researched in depth like a book." One of the "*Time* in Depth" articles with the widest repercussions was published in 2001 under the title "How Much Is a Life Worth?" The piece analyzed a system developed by the government that assigned a price to each of the Twin Tower casualties, according to their jobs.

It was difficult for Kelly and his staff to stay away from what they called the "Twin Towers effect" as a subject. In the fifteen remaining weeks of 2001 after the tragic event, fourteen of the magazine's covers were related to the war in Afghanistan, the Taliban or Al Qaeda. The only deviation was the December 10 issue on the death of one of the Beatles, George Harrison. "After such a big event like 9/11, as weeks go along, readers develop war and terrorism fatigue," Kelly said:

> "Then you have to keep that audience from going away. Therefore, sometime around November of 2001, I was supposed to find a way to get a little bit out of it, and then I did "The Women of Afghanistan: Life Behind the Veil." My intention was to look at Afghanistan in a different way than just the military point of view. And then George Harrison died. I thought, well this is terrible, but as sad as it is, this may be the cover that can help us move out of the post 9/11 coverage back into the broader world. And because of all that George Harrison stood for, we went for it. We had this beautiful picture of Harrison holding a flower, taken by Mark Seliger for *Rolling Stone*, and I thought: 'This is a great image, this was a wonderful man, and we ran it with the purpose of re-engaging our audience.'"

2003. Gulf War II

Exception. In 2003, the war in Iraq began and *Time* devoted the cover to the subject on March 31 (left). From September 14, 2001, through the end of the year, all but one cover referenced the terrorist attack on the Twin Towers or its aftermath. The death of George Harrison was the exception. *Time* featured the eye-catching photograph of Harrison on the December 10 cover (opposite).

BUSH'S CIVIL LIBERTIES　　THE INVENTION EVERYONE'S BUZZING ABOUT

GEORGE HARRISON

1943-2001

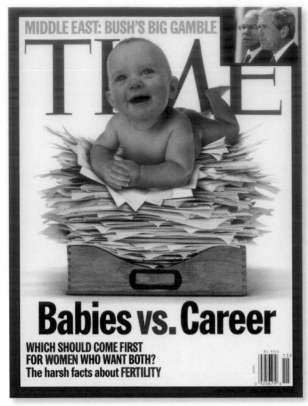

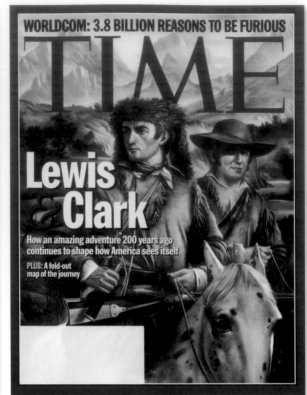

2002. Babies vs. Career

2002. Lewis & Clark

Different topics. To attract more readers and to move away from stories on the war, the magazine, under Kelly's leadership, introduced stories with lighter themes. The April 15, 2002, cover was titled "Babies vs. Career," and featured articles focusing on how timing and biology affected the decision to have children (above, left). In the July 2002 issue, *Time* introduced a new series, "Making of America," to be published annually in honor of Independence Day and featuring leaders that shaped American life and culture. Explorers Lewis and Clark were on the July 8 cover (above, right).

All in all, Kelly and his staff made great efforts to deal with the amount of harsh news that they faced between 2001 and 2005: Saddam Hussein's detention (December 22, 2003); proof that members of the U.S. armed forces tortured prisoners in the Iraq and Afghanistan military campaigns (May 17, 2004); the catastrophic tsunami that slammed across the Indian Ocean, striking eleven countries with its furious wave of water (January 10, 2005); and closer to home, Katrina, the hurricane that swept through the city of New Orleans, which *Time* called "An American Tragedy" (September 12, 2005).

Also during this time, the magazine had to deal with other events that could be characterized as unwelcome news. Such was the case with Iraq Special Correspondent Michael Weisskopf, who in December 2003 lost a hand when he attempted to toss out an enemy grenade thrown into the vehicle in which he was traveling with soldiers and other journalists. A less tragic but more controversial event was the case known as "Plamegate," in which reporter Matthew Cooper was involved. He published a story on *Time*'s website that mentioned that Valerie Plame, wife of American Ambassador Joseph Wilson, one of the

officials charged with looking for evidence of Saddam Hussein's alleged weapons of mass destruction, was a CIA agent.

Even after being subpoenaed, members of the editorial staff refused to reveal the sources of the information on Plame. Cooper was charged with "civil contempt" and sentenced to jail. In addition, Time Inc. faced a $1,000-a-day fine while the case lasted. Both decisions were suspended, however, during the appeal. The company's CEO, Dick Parsons, told Editor in Chief Norman Pearlstine what he had previously said to the board: "At the end of the day, the company will abide by the final determination of the courts." That is, that he wouldn't necessarily

support the position of Pearlstine and many other journalists at Time Inc., or the American press, who, in general, traditionally supported the protection of confidential sources.

At first, Pearlstine disagreed with Parsons' position, but later changed his mind and revealed the names of the sources to the court. His revelation made many enemies within and beyond Time Inc., but avoided Cooper's detention and the company's fines. The incident tarnished the magazine's image, especially because Judith Miller, a *New York Times* reporter who was also involved in the case and was backed by her paper, refused to turn in her sources and consequently was jailed.

One strategy *Time* used in order to offset these wearying subjects was to cover current medical and health issues. In 2002 alone, *Time* produced cover stories such as "The New Thinking on Breast Cancer," "Inside the World of Autism," "Understanding Anxiety," "The Truth About Hormones," "Preventing Headaches," "Inside the Womb" and "The Coming Epidemic of Arthritis."

The second strategy *Time* used was to cover issues regarding social evolution in the United States, with reports that took society's pulse, touched on people's daily lives and fostered discussion. That led to stories such as "Female Midlife Crisis" and "Will You Ever be Able to Retire?" Priscilla Painton, the first woman to be promoted to assistant managing editor at the magazine, was involved in the development of many of these reports, as well as the stories on medicine and health. At various times she had also headed sections, such as "Science," "Nation" and "Business," up until then edited by men.

The third editorial tactic was to focus on people. "*Time* 100," the successful series that Isaacson created in 1998, made a comeback on April 26, 2004, in a form that emphasized the subjects' influence on contemporary life instead of their historical significance. The 2004 version featured Vladimir Putin, Pope John Paul II, Osama Bin Laden, Bill Gates, Steve Jobs, Bill and Hillary Clinton, Nicole Kidman, Oprah Winfrey, Mel Gibson and Tiger Woods, among many others. Like its predecessor, the 2004 version was a

"Plamegate." Pictured in this photograph (below) are Ambassador Joseph Wilson, one of the officials involved in looking for Saddam Hussein's weapons of mass destruction, and behind him, his wife, Valerie Plame, whose status as an undercover CIA agent was publicly disclosed in an article by Matthew Cooper on *Time*'s website. The courts sentenced Cooper to jail and fined Time, Inc. To avoid both, the company ultimately made the controversial decision to reveal its sources.

success and has been repeated annually ever since, becoming one of the year's most anticipated features.

Kelly's team created another series that placed people at the center of the news. Called "Making of America," the series was published yearly around the Fourth of July to highlight leaders of courage, intellect, dreams and innovation who shaped America's life and character. The series began with the July 8, 2002, issue with a cover devoted to explorers Meriwether Lewis and William Clark, the military men who 200 years earlier had started a journey up the Missouri River in search of a navigable waterway that would connect the Pacific and Atlantic oceans. *Time* wrote:

"What Lewis and Clark and their party finally found was not a path between the oceans but a story whose power to challenge and absorb would bridge the more profound gap between their day and ours ... the young nation already had a Constitution, but it lacked an epic. It had a government but no real identity. Lewis and Clark helped invent one.... There are much better maps of the West than those that the Corps of Discovery created, but there are still no better stories ... [it was] the first and greatest American off-road trip."

In 2003, a story on Benjamin Franklin followed the one on Lewis and Clark. "Of all the founding fathers, he was early America's boldest intellectual adventurer, making history in every realm from science to business to statesmanship," Kelly wrote in the July 7 editor's letter. The year 2004 featured Thomas Jefferson, and in 2005, came Abraham Lincoln and

the series continues to the present. The issue on Franklin brought together *Time*'s Walter Isaacson, who wrote a biography on Franklin, and Pulitzer Prize-winning biographer Stacy Schiff. As part of his background research to edit the first story in the series, "Lewis and Clark," Deputy Managing Editor Steve Koepp relived the explorers' experience by traveling the Missouri with his eight-year-old son and two other reporters. Michael J. Deas was behind most of the covers. He enhanced the theme of "American Ideals" with eye-catching hyperrealistic illustrations.

Kelly transformed these articles, normally considered "soft" news, into more serious reports that fit the mood of the world after 2001—a world whose events *Time* continued to reflect on every seven days.

Health and medicine. In 2002, *Time*'s cover featured an article from the "Health" or "Medicine" section nearly once a month. Autistic fifth-grader Tommy Barrett was on the May 6 cover (below). The in-depth story, "The Secrets of Autism," dispelled many of the misconceptions of autism and related disorders that, at the time of the article, affected nearly 300,000 children in the U.S.

My days at *Time*

Priscilla Painton: Putting "How We Live" Stories on the Cover

Priscilla Painton, former deputy managing editor of Time *describes, in an interview with the authors, the imprint she left on the magazine's changing definition of news.*

I joined *Time* as a reporter in 1989 in the New York bureau, at the end of one era and the beginning of another. The era that seemed to be ending was the one in which women were mainly researchers, and the office was sometimes a playground for the men who ran the place. The liquor cart was on its way out, and if the tales of male misbehavior were dutifully passed on, they were done in a pedagogic spirit, as testaments to the past *Time* was leaving behind. The era that seemed to be dawning was one in which women had a chance to report and write cover stories on a routine basis, and even conquer management corners that until then had been off limits to them.

Four years into my stint at the magazine, I became pregnant with my second child, and I decided I had to get off the road as a reporter and develop a more structured life at home. So I asked to become an editor. I did it on a Monday; on Tuesday, Jim Gaines called me up to his office and gave me the job of filling in for every vacationing editor that summer. I got a crash course in crashing covers: I edited one on the Mayans, and another one on derivatives.

I was made business editor in the fall, and had a blast appropriating any story I thought was interesting and giving it a "business" angle. With that mercenary approach, I did a Hollywood cover on DreamWorks, the Spielberg-Geffen-Katzenberg studio, and another one called "Hip is Dead," about how mainstream culture had perfected the art of stealing the fringe overnight. Then Gaines named me "Nation" editor, responsible for politics and national news—the first time a woman held that position in the magazine's history. The

pressure to stay ahead of the competition is more intense in that job than any other; and the internal politics associated with it are too. But it was the center of action, and I loved it: in the many years when I had either a direct or indirect role running politics, I saw the rise and foibles of both Bill Clinton and Newt Gingrich, the cliffhanger election of George W. Bush, two Gulf Wars, and the attack of 9/11.

In between, there were also major transformations in the way Americans thought about their society and led their lives. Although I was forged in the experience of hard news, I was secretly passionate about the stories that fell between the cracks: how men and women in the U.S. were reinventing their relationships and their families, and the inventive ways they were coping with modern life.

So I climbed the ladder of *Time*, and ultimately became its deputy managing editor. I pushed hard to do what became known as the "How We Live" covers: "Is Feminism Dead?," "Too Much Homework?" and "The Female Mid-Life Crisis." I also pushed hard to bring a human element to the stories that had been traditionally run by men: if we were going to cover the troops at war, could we also describe how their absence was affecting the home front? Fewer tank graphics, please, and more stories about the families left behind.

I am uncomfortable saying that I helped "feminize" the content of *Time*—the men around me pushed hard for these stories too, and it was men, after all, who put them on the cover. But I was thrilled to be part of changing the definition of news.

1998. Is Feminism Dead?

Social themes. This June 29, 1998, cover (left), "Is Feminism Dead," featured an article on the crisis of feminism, "Feminism: It's All About Me!" Such socially themed articles were intended to offer readers a more in-depth perspective on modern life in America. Priscilla Painton, the magazine's first female deputy managing editor, was the driving force behind covering these kinds of topics. She also brought a more human element to hard news stories.

Visual Impact, the Imprint of Kelly's Tenure

Based on an issue-by-issue review, the Kelly years can be called the golden era of *Time* photo essays. That is, perhaps, the most outstanding aspect of his tenure. As Kelly explained:

"To begin with, one of my first issues as managing editor was about AIDS in Africa, which opened with 12–14 pages of photos taken by James Nachtwey, and then the story began. This was the message I was sending about how important photography was for *Time* and would be under my tenure. Then 9/11 happened and that became so much about the event and so much about the war in Afghanistan, and so much about the war in Iraq, which were particularly fit for photography. Remember we had a lot of pages then, and during some of those bloody weeks, some advertisers chose not to run their ads. That meant that I even had more pages than usual to display great photography. We had the good fortune of having at least 98 pages in those days.

Secondly, for a *Time* editor, the magazine is more shaped by the events that are going on than by your particular editorial views. Obviously, if 9/11 had not happened and the Bush presidency had not become a national security priority, I would have put out a much different magazine. The times that you live in put the biggest imprint on a magazine."

Internal and external factors contributed to the visual boom during the Kelly years. One of them, as mentioned by Kelly, was that the magazine had more editorial pages than at any other time in its history. The managing editor saw this as an opportunity to offer larger photo displays. Another factor was that, as opposed to his predecessor Walter Isaacson, Kelly believed that often, to tell a story, photography was just as powerful as, if not more powerful than, the written word. Also, Michele Stephenson, the photo editor, and MaryAnne Golon, the assistant photo editor, not only shared Kelly's passion for visuals, but also had come to be skilled graphic editors, with many contacts and wide influence in the field. This helped to attract and recruit the top photojournalists at the time, such as James Nachtwey, Christopher Morris, Anthony Suau, David Burnett, Diana Walker, Dennis Brack and Yuri Kozyrev.

During Kelly's tenure, the magazine alternated between two styles of visual coverage. One style was to open stories with four, six or more double-page photo layouts, and to start the text halfway through the piece. This style was regularly used for coverage of the wars in Iraq and Afghanistan, natural disasters, such as Hurricane Katrina or the 2004 tsunami, or stories about events directly or indirectly linked to terrorism. The second style was the unified photo essay, a series of photographs supplemented with text. The exemplar of this style was James Nachtwey, as in his sixteen-plus-page story titled "Snapshots of a Soldier's Life." The story, depicting the dangers, scarcities and hardships American troops faced daily in the war zone, appeared as a special section in the December 29, 2003, issue, with the "Man of the Year" cover devoted to "The American Soldier." Other outstanding examples, also by Nachtwey, were the seventeen-plus-page story on the Sudan famine for the October 4, 2004, issue and the twelve-page black-and-white coverage of the civil conflict in the Congo for the June 5, 2006, issue.

Time's coverage of Hurricane Katrina, which started with the September 12, 2005, issue under the heading "An American Tragedy" and continued for

2001. AIDS in Africa

2006. Congo: The Hidden Toll of the World's Deadliest War

Three by Nachtwey. James Natchwey opened and closed Jim Kelly's golden era of cover photo essays with his February 12, 2001, cover (left, top) on AIDS and his June 5, 2006, cover (left, bottom) on the Congo civil war. The October 4, 2004, issue, featuring Natchwey's cover photo evoking Michelangelo's *Pietà* (opposite), included a photo essay on the civil war-related devastation in Darfur. All three are considered among the best photo essays in the history of photojournalism.

Respect and dignity. Two iconic photos by Nachtwey: Iraqi women praying, published in the December 22, 2003, issue and a sick man walking out of the shower in a Harare hospital, which ran in the February 12, 2001, issue (following two spreads). "Dignity is one of AIDS first casualties," read the *Time* caption below the second photo.

OCTOBER 4, 2004

TIME

KERRY VS. BUSH
ON IRAQ'S FUTURE

The Tragedy of
Sudan

www.time.com AOL Keyword: TIME

My days at *Time*
Michael Weisskopf: The Battle After the War

As told to the authors by Michael Weisskopf, a Time *reporter who lost his hand after the grenade that he intended to throw out of the Humvee he was riding in exploded. His act of courage saved the lives of all the soldiers and journalists riding with him. After this personal tragedy, Weisskopf went through rehabilitation and resumed his work as a journalist, writing about his personal struggle and the incident for* Time *and in his book,* Blood Brothers, *published in 2006.*

[The night of December 10, 2003,] I was in Iraq to profile the American soldier as "Person of the Year" for *Time* magazine. It was a dream assignment, a chance to escape Washington and work in exotic environs on a big story. I had teamed up with another reporter, Romesh Ratnesar, and had set us up three weeks earlier to find a unit representative of the 120,000 U.S. troops then in Iraq. We had chosen a platoon of the First Armored Division that operated in a district of northwest Baghdad, considered crucial to any hope of securing Iraq. Al-Adhamiya was nestled in a bend of the Tigris River, a historic crossroads for the Sunni Muslims, who dominated political life in the days of Saddam Hussein. Sunnis actively fueled the anti-U.S. resistance after Hussein fled: insurgents launched rockets from its alleyways, hid weapons in houses, and seeded the roads with booby-trapped bombs, concealed in everything from trash to dead cats. I was scribbling notes from the wooden bench of my Humvee. Across from me,

Time photographer Jim Nachtwey was snapping pictures. We turned onto Market Street a few minutes before nine and got stuck in traffic. At first I thought it was a rock, a harmless shot against an armored Humvee. For me it was the sound of a projectile landing louder than any stone should have. It bounced off the steel blast wall behind me. I gazed down, then to the right, and spotted an object on the wooden bench two feet away. The dark oval was as shiny and smooth as a tortoiseshell, roughly six inches long and four inches wide. None of my fellow passengers seemed to notice. Something told me there was no time to consult the soldiers. I rose halfway, leaned to the right, and cupped the object. I might as well have plucked volcanic lava from a crater. I could feel the flesh of my palm liquefying. Pain bolted up my arm like an electric current. In one fluid motion, I raised my right arm and started to throw the mass over the side of the vehicle, a short backhand toss. Then everything went dark...

The price of peace. *Time*'s 2003 "Person of the Year" was the American Soldier "for uncommon skills and service, for the choices each one of them has made and the ones still ahead, for the challenge of defending not only our freedoms but those barely stirring half a world away." Washington reporter Michael Weisskopf, who was sent to Iraq to write the story, above, lost one of his hands after a grenade explosion.

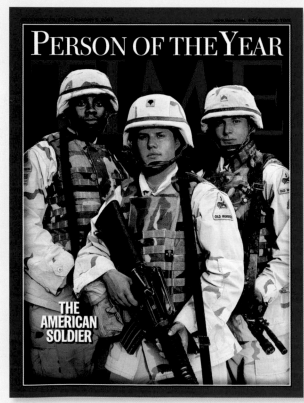

2003. Person of the Year: The American Soldier

2003. Portrait of A Platoon

Showdown at Crawford. This famous picture by Christopher Morris, shows former Vice President Dick Cheney (left), former President George W. Bush, and former Secretary of Defense Donald Rumsfeld (right) before facing reporters at Bush's ranch in Crawford, Texas. The picture was part of the December 17, 2004, story in which Rumsfeld's response to the question "How Safe Are Our Troops?" ignited a "firestorm."

two consecutive issues, was truly historic for its visual strength. It earned *Time* the 2006 National Magazine Award under the category "single-topic issue." The cover image by Kathleen Flynn of the *St. Petersburg Times*, as well as the excellent shots in the fifty-two-page special report did not come from *Time* photographers, but rather from agencies, such as Agence France-Presse and Getty Images, from Fort Worth newspapers, and from others,

such as Matt Rourke of the *Austin American Statesman* newspaper, Smiley Pool of the *Dallas Morning Star* and Vincent Laforet of *The New York Times*. The reason: the hurricane's strength and magnitude took the magazine by surprise, with the exception of Assistant Photo Editor MaryAnne Golon, who took it upon herself to buy photos and guarantee advances to several newspapers close to New Orleans without previous authorization from

Managing Editor Jim Kelly, who she updated after making the decision. Golon recalled:

"I called him at home on Sunday night and this is also highly unusual. I mean, unless somebody dies or somebody is hurt, you don't bother a managing editor at home on a Sunday night. I called him and I said, 'Jim, I'm really worried about the storm.' He said, 'What storm?' He hates weather stories. And I said, 'No,

Grim business. Freelance Russian photographer Yuri Kosyrev depicted the deadly war in Iraq in the April 14, 2003, issue, "Saddam's Last Stand," in a ten-page photo essay. It was among the best photo essays of Jim Kelly's tenure. This image (spread on pages 360–361) shows a cemetery worker taking a coffin to be reused after the funeral of a woman killed by a rocket blast south of Baghdad.

House clearing. Photographer Christopher Morris took this photo (spread on pages 362–363) of members of the army's 3rd Infantry Division clearing a building in Nasiriyah, in Southern Iraq. The photo was part of a ten-page photo essay, "At Close Range," that provided an intimate look at the real work of the ground forces. It was published in the March 31, 2003, issue on Gulf War II.

Jim, this is a category four hurricane and it's headed straight for New Orleans.' And I said, 'I've gone ahead and given the guarantee to one photographer, who has a truck, a generator, everything, and he's heading down there to get as close as he can, but I think I should buy out these little newspapers around there, just to have some coverage.' He said, 'Are you crazy?' And I said, 'Turn on the Weather Channel. Have a look at this. This is unheard of. It's a direct path to New Orleans. I'm telling you. This is the storm that's going to put New Orleans under water.'" (Golon's interview with the authors)

Kelly told this anecdote during the National Magazine Awards ceremony, concluding that he was so glad he trusted Golon.

Bill Gates: Leaders Like Me Read *Time*

In this essay, commissioned in 2009 for this book, Bill Gates writes about how the information technology revolution has changed the world and, more specifically, the news. According to Gates, there will always be a demand for good journalism no matter what the medium.

The 1990s was a period in which everything in the world seemed to accelerate. By the time Walter Isaacson became managing editor of *Time* in 1996, that globe you bought your kids back in 1990 was as obsolete as your VCR. We began the decade with the fall of the Berlin Wall and then in short order saw the start of wars in Iraq and Bosnia and Kosovo and the first World Trade Center bombing—so much for the post-Cold War era of peace. Even as malaria continued to kill millions of children a year, HIV/AIDS came out of seemingly nowhere to become another genuine global scourge. In an inspiring triumph of true democracy in 1994, Nelson Mandela was elected to lead South Africa. Around the time the European community created the Euro and the U.S. banned smoking on domestic airline flights, Pakistan tested its first atomic bombs and India responded by firing off six of its own.

Things moved even faster in the world of science. In 1996, Dolly the sheep was cloned and a year later, NASA scientists reported evidence of what appeared to be fossils of microbial life on Mars. In the meantime, the Human Genome Project had made tremendous progress toward mapping how our genes work and in 1998 other researchers isolated human stem cells for the first time.

As the decade wore on, it was digital information technology that seemed to move fastest of all, propelled by what we glibly call Moore's Law—which really is simply an observation that the semiconductor industry consistently has been able to double the number of transistors it can place on a given size of semiconductor chip roughly every two years. More transistors in a small space means better, faster computing power, and that in turn gives software developers more computing potential to work with. In the mid-and late 1990s this exponential growth in the power and capacity of semiconductors reached such a scale that it was as if the digital technology industry had strapped on a set of afterburners.

As a consequence, the PC revolution kicked into high gear and provided a sturdy foundation to redefine the economics of the entire information technology industry, and accordingly to alter how modern corporations organize and manage themselves. Meanwhile in Europe, a computer researcher named Tim Berners Lee triggered another breathtaking technological chain reaction when he invented a set of digital protocols that created what he dubbed the "World Wide Web," which operated over the Internet—then a little-known shared data infrastructure used mainly by scientists. By the turn of the twenty-first century that "Web," not yet ten years old, had already evolved into the next great electronic mass medium—one potentially more powerful than print, television, and radio combined.

So fast did the media landscape change that by 2000, the world literally seemed upside down when Time Warner, the media conglomerate parent of *Time* magazine, was acquired by Internet arriviste AOL in what is still considered one of the most controversial mergers of all time. Meanwhile, Steve Jobs, who had repolished his reputation as an innovator while helping Pixar reinvent the animated feature film, found himself back in charge of Apple and hoping to get that company's creative juices flowing again.

We had never seen the world change so dramatically and so quickly and in so many

Inadequate response. This picture (previous spread) was published in the September 19, 2005, issue, "System Failure: An investigation into what went so wrong in New Orleans." The photo was part of Magnum photographer Thomas Dworzak's photo essay "Ghost Town." The image of the body of an unidentified man floating down a flooded street of the Elysian Fields neighborhood, a week after Hurricane Katrina, exemplified the inadequate response to the tragedy.

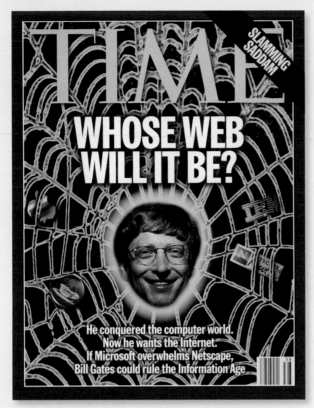

1996. Bill Gates

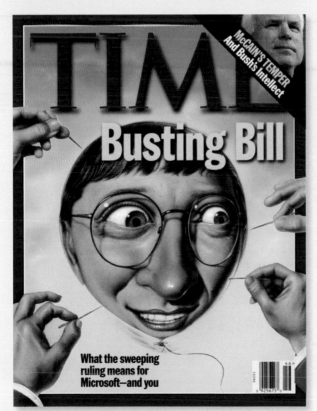

1999. Bill Gates

ways. Moreover, the growing ubiquity of communications made more of us aware of this cacophony of cultural, political, and commercial transformations, too. These tumultuous events and developments touched all of us in one way or another, and they cried out for sober, yet open-minded and informed analysis. And *Time*, under Walter Isaacson, rose to the challenge of making sense of a world that was more complex than ever.

Among the trends that *Time* explored on numerous occasions and with great insight was how much digital technology could disrupt the previous analog order. The poster child for this trend at first was the recorded music business, which is still reeling from the breakdown of its business model as music continues to be traded and downloaded illegally. To a lesser extent television and film and computer software face similar disruptions, but those industries seem to have forestalled such a fundamental upset.

The poignant irony of it all is that the industry that will be distorted the most by the magic of digital technology could well be *Time*'s own. The Internet is also an opportunity for traditional media, of course, and Time.com is an excellent example of delivering much of the magazine's fine work and much more in a digital form. But there is nothing quite like sitting back with a magazine in hand, and reading a penetrating, well-written and well-researched article such as *Time*'s 1998 "Man of the Year" profile of my colleague Andy Grove, then the CEO of Intel. I know him well, but I learned things from that article I never knew before, and came away with a deeper understanding of a remarkable and courageous man who contributed so much to the world. There will always be demand for journalism like that, no matter the medium used to deliver it.

Digital revolution. Since 1996, and during Isaacson's tenure, *Time* has been one of the major media sources for information on the digital revolution and its newsmakers. Bill Gates was featured on the cover several times, including the September 16, 1996, and November 15, 1999, issues (above).

10

News and Analysis with a Point of View

The year 2006 brought major changes to *Time*, starting at the top. In January, Norman Pearlstine, Time Inc. editor in chief, retired and was succeeded by the company's editorial director, John Huey. From the moment Huey's appointment was announced, in October 2005, he had focused on *Time*. The editorial accomplishments of Kelly's tenure had been solid. Under him, *Time* had published two of the best-selling issues in its history, both devoted to September 11. It had won four National Magazine Awards—the single-topic award for issues covering 9/11 and Hurricane Katrina (2005), the photography award for James Nachtwey's "Sudan" cover photo essay (2004) and the general excellence award in 2005. *Time* also received its first Emmy for its collaboration with ABC News on the 2003 series *Iraq: Where Things Stand*. The magazine had become stronger and its articles and photo essays had showcased some of the best photojournalists in the world.

The journalistic success, however, did not carry over to the business side. Between 1999 and 2005, the magazine's revenues fell considerably, reflecting the country's weakened economic performance after the attack on the Twin Towers. Struggling industries, notably Detroit's automakers, cut back on advertising. In September 2005, the decrease in earnings plus fears of a decline in readership led to the decision to lower *Time*'s annual subscription rate from $72 to $49. They also led Huey to conclude that a change in the magazine's leadership was in order. In December 2005, he had lunch with Kelly and informed him of his decision.

After a six-month search, Huey found *Time*'s sixteenth managing editor. He was Richard Stengel,

New management. In July 2006, Richard Stengel took over the helm at *Time*. He immediately proposed a redesign of the magazine. Most notable were the changes to the cover. This November 2006 cover of President George W. Bush (opposite) was typical of these changes, in the use of white space and clean lines.

TIME

ELECTION PREVIEW

THE LONE RANGER

**He's faltering in Iraq.
He's out of favor with his own party.
He's increasingly isolated.
Why this election is
all about George W. Bush
and the world he's created.**

fifty-one, another "*Time* man." Stengel had joined the magazine in 1981 and had become a senior writer and political correspondent. He covered the 1988 and 1996 presidential campaigns, and wrote more than two-dozen cover stories on everything from South African sanctions to Jay Leno. He later became the arts editor, then the managing editor of Time. com and, during Kelly's tenure, the editor of the "Nation" section. Along the way, Stengel, the author of several books, had thrice left the magazine for other pursuits—first to collaborate with Nelson Mandela on his autobiography, then to become a senior adviser and chief speechwriter for Democratic Senator and presidential candidate Bill Bradley and later to do speechwriting again. In 2004, he left for the fourth time to become president of the National Constitution Center in Philadelphia.

As he took over the magazine's top editorial job in 2006, Stengel immediately tackled the challenges facing weekly journalism in the new century. He addressed not only a loss of readers and influence but also fierce competition from the Internet as a free, unlimited media outlet with instant worldwide reach. His goal was to make the transition to the Internet era, expand the footprint of the *Time* brand and, in the process, make the magazine smarter, more serious and more important.

The news cycle that confronted Stengel had changed drastically in the decade or two leading up to his appointment. Where newspapers had traditionally worked on a daily rhythm and newsmagazines like *Time* on a weekly one, cable television and the Internet delivered round-the-clock news coverage. On the Internet, particularly, news was updated almost instantly—every few hours or minutes as necessary.

Numbers 15 and 16. Above, Richard Stengel (left) succeeded James Kelly (right) in 2006. He began his career at *Time* in 1981. Stengel presented his vision for the magazine to Editor in Chief John Huey before being chosen as the sixteenth managing editor.

Stengel, like all the other candidates for the managing editor's job, had written a memo for Huey, describing his vision for *Time*. His seven-page document zeroed in on what he called "The Over-Arching Question—And the Answer." The question: "Does *Time* still matter? Is there a place for the weekly newsmagazine in the 21st-century media scrum?" Stengel's answer clearly laid out the philosophy that would shape his tenure:

"I would argue that precisely because of the teeming media forest, the buzzing, blooming confusion of modern media, the dizzying array of information, there is a need, a hunger for a single iconic publication that makes sense of it all, that separates the wheat from the chaff, that explains it all for you in one compact readable place. This is more necessary, more vital than ever. In fact, it's not unlike the reason that Luce founded *Time* in the first place to be a kind of news handbook. In the next decade, *Time* can be the guide through the chaos, the one place that has everything you need to know. The one source you really need to make sense of everything ... Let's put it this way: everything else out there is undigested information; *Time* is knowledge."

With Huey's support, Stengel began to make over the magazine. The first issue un der his command was dated July 3, 2006. Within eight months, he introduced a new design, a new website

Knowledge. Stengel said, "We're not in the news business, we're in the knowledge business." He favored stories with in-depth analysis and opinions based on expertise, such as the January 29, 2007, cover story, "The Brain: A User's Guide" (opposite).

HOW THE Brain Rewires ITSELF

BY SHARON BEGLEY

Not only can the brain learn new tricks, but it can also change its structure and function—even in old age

IT WAS A FAIRLY MODEST EXPERIMENT, AS THESE things go, with volunteers trooping into the lab at Harvard Medical School to learn and practice a little five-finger piano exercise. Neuroscientist Alvaro Pascual-Leone instructed the members of one group to play as fluidly as they could, trying to keep to the metronome's 60 beats per minute. Every day for five days, the volunteers practiced for two hours. Then they took a test.

At the end of each day's practice session, they sat beneath a coil of wire that sent a brief magnetic pulse into the motor cortex of their brain, located in a strip running from the crown of the head toward each ear. The so-called transcranial-magnetic-stimulation (TMS) test allows scientists to infer the function of neurons just beneath the coil. In the piano players, the TMS mapped how much of the motor cortex controlled the finger movements needed for the piano exercise. What the scientists found was that after a week of practice, the stretch of motor cortex devoted to these finger movements took over surrounding areas like dandelions on a suburban lawn.

The finding was in line with a growing number of discoveries at the time showing that greater use of a particular muscle causes the brain to devote more cortical real estate to it. But Pascual-Leone did not stop there. He extended the experiment by having another group of volunteers merely think about practicing the piano exercise. They played the simple piece of music in their head, holding their hands still while imagining how they

Illustration for TIME
by David Plunkert

You exist, right? Prove it. How 100 billion jabbering neurons create the knowledge— or illusion—that you're here

THE MYSTERY OF Consciousness

BY STEVEN PINKER

THE YOUNG WOMAN HAD SURVIVED THE CAR CRASH, AFTER A FASHION. In the five months since parts of her brain had been crushed, she could open her eyes but didn't respond to sights, sounds or jabs. In the jargon of neurology, she was judged to be in a persistent vegetative state. In crueler everyday language, she was a vegetable.

So picture the astonishment of British and Belgian scientists as they scanned her brain using a kind of MRI that detects blood flow to active parts of the brain. When they recited sentences, the parts involved in language lit up. When they asked her to imagine visiting the rooms of her house, the parts involved in navigating space and recognizing places ramped up. And when they asked her to imagine playing tennis, the regions that trigger motion joined in. Indeed, her scans were barely different from those of

Illustrations for TIME by Istvan Orosz

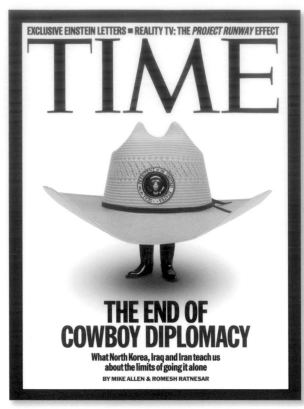

2006. The End of Cowboy Diplomacy

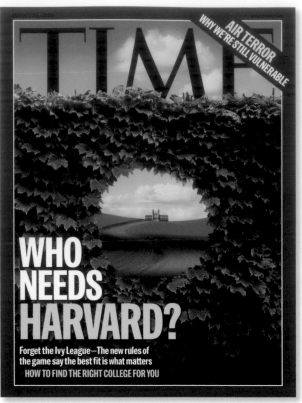

2006. Who Needs Harvard?

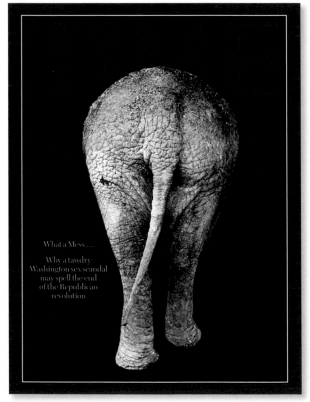

2006. What a Mess ...

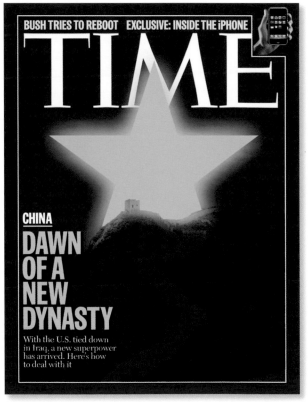

2007. China: Dawn of a New Dynasty

Hidden messages. From July to December 2006, the first six months of Stengel's tenure, issues dominated. Only four of the twenty-six covers were about newsmakers. This award-winning cover, depicting President Bush with an oversized hat bearing the presidential seal (above, left), referred to his "all talk" foreign policy.

and a new journalistic concept. Although the changes were implemented quickly, they were the result of a precise, carefully thought-out plan for editorial, circulation and advertising.

Increasing the price, reducing circulation

While working on the editorial changes— "I'm fixing the roof when the sun is shining"—the new managing editor made two business decisions. First, he reduced the circulation that *Time* guaranteed its advertisers from 4.3 million issues to 3.3 million, thus reducing advertising rates and cutting back on printing costs. Second, as of November 20, 2006, he increased the newsstand price from $3.95 to $4.95 per issue.

In January 2007, Stengel carried the new approach to circulation and advertising even further. He abandoned the "guaranteed circulation" or "rate base" system—the greater the number of guaranteed subscribers, the greater the advertising rate charged—that had become standard in the magazine industry. Instead, he pioneered a "total audience" system, which counted all the people who read an issue—subscribers and newsstand purchasers, plus "pass along" readers (those who read the issue within a family or office) and online readers. By this measure, *Time* reached approximately 19 million readers—a calculation intended to reassure advertisers of reaching a huge audience.

Stengel also addressed rising printing costs. These costs had been driven in recent years by the number of special editions. *Time* printed for medical associations, doctors' offices by region and other professionals. With all the different demographic editions, Stengel noted, "the ornaments had taken over the tree." It was important to get back to the core magazine—one clean edition for all readers.

From "the mirror" that reflects the news to "the light" that illuminates it

January 2007 saw another important change. After half a century of coming out on Monday, *Time* switched to the preweekend publication day of Friday. The change was both pragmatic and philosophical. For years, research had shown that *Time*'s readers did not know the precise day they received the magazine, and would almost always put it aside to read it on the weekend. Stengel's notion was, why not get them the magazine when they wanted it? "I don't understand why any magazine comes out on Monday," he often said. "In today's world, few people have time for a magazine at the beginning of the week."

Moreover, the switch implied a more forward orientation in relaying the news. Up until then, the magazine usually reported and analyzed events that happened during the previous week. Now that it would hit newsstands on Friday, *Time* could tell its readers what to look for in the week ahead, and how the previous week's events would have current and future consequences. "The important thing here," recalled Stengel,

> "is that by coming out on Mondays, the magazine had to look backwards. In other words, we were looking at the news traffic from the back mirror, while now we have a forward looking agenda, which makes us look at the news traffic through the windshield. If we editors have learned something in facing competition from the Internet and cable news, it is that the only way to prevent running behind the news is to run ahead of it." (Stengel's interview with the authors)

In gearing its stories to look more toward the future, the magazine also had to change its writing style, which favored a narrative structure and emphasized details, color and anecdotes. Stengel often said, "We

are no longer just the mirror of the news but also the light." Accordingly, he needed writers who could provide more analysis, opinion and points of view in their articles. He urged his staff writers not simply to summarize a story with a traditional on-the-one-hand and on-the-other straddle, but to offer an opinion based on knowledge and expertise. He needed diverse, well-known, strong voices to say "this is what happened and this is our interpretation of it" or "here is a way of thinking about this." As a result, commentators gained a new status on the staff. Stengel added Harvard history professor Niall Ferguson and liberal columnist Michael Kinsley to the sharp and prestigious analysts, such as Joe Klein, Charles Krauthammer and William Kristol, already in the mix. Stengel said that he came up with the metaphors of the mirror and the lamp from a 1971 literary study he read in college, *The Mirror and the Lamp: Romantic Theory and the Critical Tradition* by Meyer H. Abrams.

Subjects, knowledge and meaning

The first covers published in Stengel's tenure demonstrate a preponderance of issues over newsmakers. After the July 3, 2006, cover on Theodore Roosevelt, his debut cover, Stengel published only three additional covers on newsmakers that year: Hillary Clinton, Iranian President Mahmoud Ahmadinejad and Barack Obama. The remaining twenty-two covers were devoted to issues. Stengel's predilection extended to the coverage of the 2008 presidential election. "I'm trying to think of the other theme issues with the election," he remarked.

> "To me, that's where the battle was being played and how I felt we could help readers was to take some of these things that were being debated and were kind of in the national

Person of the Year. Art Director Arthur Hochstein designed the 2006 "Person of the Year" cover (following page). *Time* contracted nearly 7 million pieces of reflective Mylar to be used for the computer screen. An animated version of the cover, with a rotating display of user-submitted photos, appeared on Time.com.

the things you'll see that I wrote in that memo [for Huey] is that when there's a blizzard of information out there you not only have to curate it but you have to convert it into knowledge. What is the great task of a publication like *Time*? It's to take all that information and not only convert it into something useful but something valuable, which is knowledge, so that has always been my obsession and vision for *Time*."

Stengel set out to produce a magazine whose articles were appealing enough to make them current and at the same time interesting and deep enough to make them timeless, he explained:

"I feel like the whole magazine and almost every article have to be both timely and timeless. There has to be an urgency for why you would want to read it right now, as soon as you get it, but it should be substantial enough, thoughtful enough that you can read it a week later, or ten weeks later or a year later and get something out of it."

"You," Person of the Year

Stengel made a conscious effort to surprise readers during his first few months. He needed to startle them, make a difference, show that the magazine had a distinctive editorial focus that was useful and personal, and he made the reader the main actor in the news. He used the year's most eagerly anticipated issue—the "Person of the Year"—to underline the point. The cover of the December 25, 2006, issue displayed the image of a computer whose screen was a Mylar rectangle in which readers could see a reflection of themselves. The title was "You." This was addressed not so much to the average person as to the individual who was creating user-generated content on the web. The year 2006 had marked the moment when ordinary users and readers had essentially made the Internet their own. Information had become more democratized than ever. Individuals, not mainstream media, had increasingly shaped the public's perception of the world. The subhead responded to the question readers, holding the magazine

and seeing their own faces reflected on the cover, were surely asking themselves: "Yes, you. You control the Information Age. Welcome to your world." With this high-impact cover, the magazine achieved its goal: setting its own news agenda and making people talk about it.

Stengel began to stamp his imprint on *Time* through his business and editorial decisions. In March 2007, he deepened that imprint with a redesign that embodied his fundamental journalistic outlook.

"You." In his editor's letter, "Now It's Your Turn," Stengel defined "You" as the general public for being the innovators, creators and consumers of user-generated content (not traditional media) and being largely responsible for transforming the information age (below).

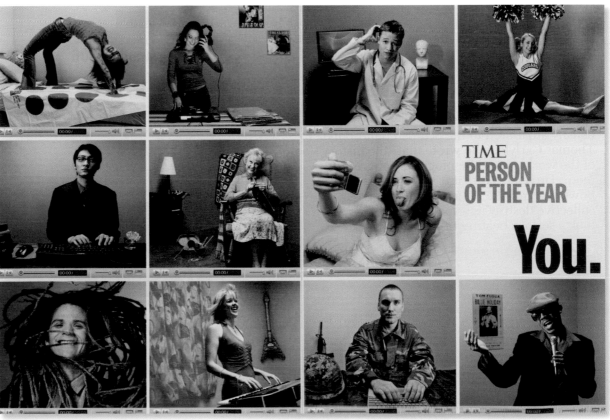

2006. Person of the Year: You

A Design in Tune with the New Content

Before taking over as managing editor, in his confidential memo to John Huey, Richard Stengel proposed the design changes he wanted to make. In his second bulleted point, "A *TIME* TO DO LIST," he wrote that Henry Muller's 1992 redesign had:

"... eroded what made *Time* special and unique and made it just like every other magazine. That is, it made it dispensable. And it disposed of reliability and consistency, which is what wins and retains readers. The old structure with specific sections where the reader always knows where she is, always knows where to find things, needs to be restored in a modern way. That TV-dinner structure is more necessary now than ever because it is both a symbolic and real guide through the media confusion. It embodies the idea that here is everything you need to know. If our mantra is that we explain the world for you, well, you better be able to find what you need to know."

Although the redesign of the Walter Isaacson days certainly incorporated some of those points by moving back toward the original structure of sections that Hadden and Luce had created, Stengel wanted to go further. He wanted a redesign that would be modern yet still connected with its origins, that is, still rooted in *Time*'s DNA. With that in mind, he ordered several design studies. He chose the proposal made by Luke Hayman and Paula Scher of Pentagram Design over the other competitors: Michael Grossman, who had previously been an occasional visual consultant for *Time*; John Korpics, creative director at Time Inc.'s *InStyle* magazine; and a team of designers led by Scott Mowbray, editor of Time Inc.'s Health.com. According to Hayman:

"The final version was very close to ours, with some tweaks. Changes could not be radical. Heritage plays a key role in *Time* as in many old magazines, and we did not want to mess with that. *Time* was highly organized because it was part of their language and we wanted to preserve that too. *Time* is a highly conservative magazine from a visual point of view. That's why we avoided big headlines and went more for sober ones. We don't think that the redesign made it lose some of its visual potency because, to begin with, the big photographic double spreads were no longer there for lack of space." (Hayman's interview with the authors)

Hayman, who in 2006 had culminated his tenure as design director at *New York* magazine with a National Magazine Award for excellence in magazine design, carried out the project along with Arthur Hochstein, *Time*'s art director, and his deputy art directors, Cynthia Hoffman and D. W. Pine.

The team took the stories published in the February 26, 2007, issue and laid them out in the new design. Feedback on the highly confidential new version was obtained from selected inside and outside sources, including some advertisers. The final redesign officially made its debut in the March 26, 2007, issue, with a cover image that showed Ronald Reagan shedding a single tear, under the heading "How the Right Went Wrong." In the "Letter to Our Readers," titled "A New Chapter," Stengel explained the concepts behind both the visual changes and the editorial reconfiguration:

This issue of *Time* marks a new chapter for us. The magazine has a new look and structure. Every issue of *Time* tells a larger story about the world we live

New design. *Time*'s new design made its debut on March 26, 2007, and included changes to the cover. The "TIME" logo, which had run across the full top of the cover, was now reduced and centered. To attract more readers, the space above the logo now contained three "teasers" of stories within the issue (opposite).

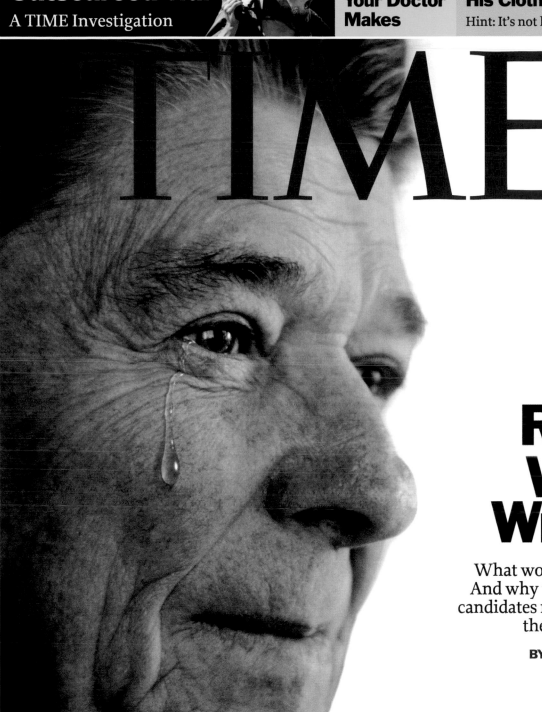

TIME

How The Right Went Wrong

What would Ronnie do? And why the Republican candidates need to reclaim the Reagan legacy

BY KAREN TUMULTY

www.time.com

379

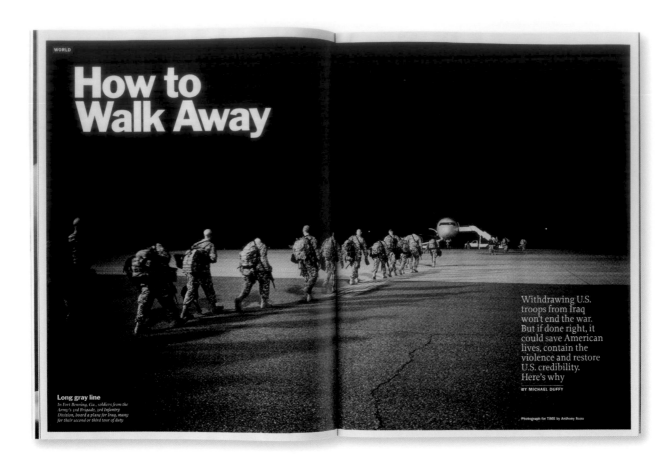

How to Walk Away

Withdrawing U.S. troops from Iraq won't end the war. But if done right, it could save American lives, contain the violence and restore U.S. credibility. Here's why

BY MICHAEL DUFFY

Long gray line
In Fort Benning, Ga., soldiers from the Army's 3rd Brigade, 3rd Infantry Division, board a plane for Iraq, many for their second or third tour of duty

Photograph for TIME by Anthony Suau

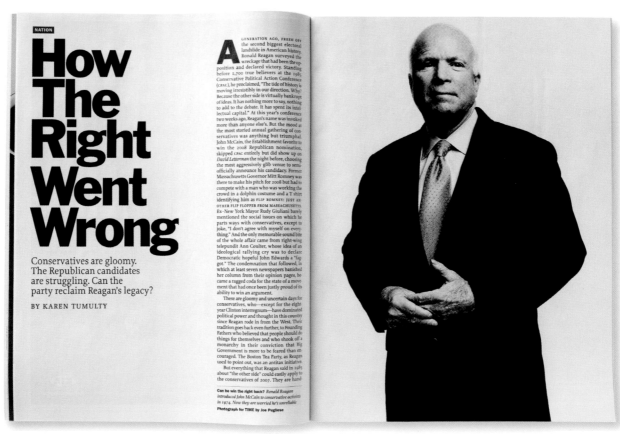

How The Right Went Wrong

Conservatives are gloomy. The Republican candidates are struggling. Can the party reclaim Reagan's legacy?

BY KAREN TUMULTY

A GENERATION AGO, FRESH OFF the second biggest electoral landslide in American history, Ronald Reagan surveyed the wreckage that had been the opposition and declared victory. Standing before 1,700 true believers at the 1985 Conservative Political Action Conference (CPAC), he proclaimed, "The tide of history is moving irresistibly in our direction. Why? Because the other side is virtually bankrupt of ideas. It has nothing more to say, nothing to add to the debate. It has spent its intellectual capital." At this year's conference two weeks ago, Reagan's name was invoked more than anyone else's. But the mood at the most storied annual gathering of conservatives was anything but triumphal. John McCain, the Establishment favorite to win the 2008 Republican nomination, skipped CPAC entirely but did show up on *David Letterman* the night before, choosing the most aggressively glib venue to semiofficially announce his candidacy. Former Massachusetts Governor Mitt Romney was there to make his pitch for 2008 but had to compete with a man who was working the crowd in a dolphin costume and a T shirt identifying him as FLIP ROMNEY: JUST AN OTHER FLIP FLOPPER FROM MASSACHUSETTS. Ex–New York Mayor Rudy Giuliani barely mentioned the social issues on which he parts ways with conservatives, except to joke, "I don't agree with myself on everything." And the only memorable sound bite of the whole affair came from right-wing telepundit Ann Coulter, whose idea of an ideological rallying cry was to declare Democratic hopeful John Edwards a "faggot." The condemnation that followed, in which at least seven newspapers banished her column from their opinion pages, became a ragged coda for the state of a movement that had once been justly proud of its ability to win an argument.

These are gloomy and uncertain days for conservatives, who—except for the eight-year Clinton interregnum—have dominated political power and thought in this country since Reagan rode in from the West. Their tradition goes back even further, to Founding Fathers who believed that people should do things for themselves and who shook off a monarchy in their conviction that Big Government is more to be feared than encouraged. The Boston Tea Party, as Reagan used to point out, was an antitax initiative.

But everything that Reagan said in 1985 about "the other side" could easily apply to the conservatives of 2007. They are hard-

Can he win the right back? *Ronald Reagan introduced John McCain to conservative activists in 1974. Now they are worried he's unreliable*

Photograph for TIME by Joe Pugliese

The Well. Following the "Briefing" section, The Well contains longer, in-depth main stories (the "light that illuminates the news"). The large headline, two-page opening spread, often with a full-page photo, sets The Well apart. A small red box with the word "World" or "Nation" identifies the section the story belongs to (above).

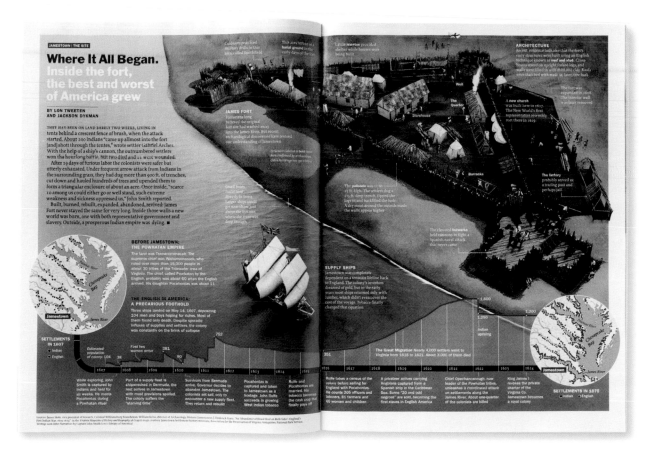

In-depth views. Above (top) is Aryn Baker's in-depth story on "Talibanistan," the home base for a new generation of terrorists. Above (bottom) is an illustrated view of the inside of the Jamestown colony for the May 7, 2007, cover story, "America at 400: How the Jamestown colony made us who we are." Online, this illustration became an interactive tour of the fort.

Structure. The magazine's first section was called "Briefing" (top, right) with short, lively coverage of the important national and global events of the week. "Life" (bottom, left) included topics such as "History," "Law," "Food" and the "Power of One." The final section was "Arts," which covered art and entertainment (bottom, right).

that would best present that story. It's part of a series of changes—beginning with the shift this past January of getting the magazine to you before the weekend—that we are making to create a *Time* that is more meaningful and more forward looking. Yet even as we modernize the design, we are also harking back to our roots.

In his 1941 essay 'The American Century' *Time* co-founder Henry Luce wrote that Americans 'are faced with great decisions.' As a nation and as a people, we are once again faced with consequential decisions. From the war in Iraq to the most wide-open presidential race in generations to how we educate our children for the 21st century, we will make decisions in the next few years that will affect all of us for many years to come. *Time*'s job is to outline the choices ahead and help you make those decisions. We do that every week in print and every day on Time.com by not just reporting the news but putting it in context and perspective. We offer clarity in a confusing world, explaining not only what happened but why it matters. To do that, we tap into our network of correspondents in the U.S. and elsewhere—we have more than 30 correspondents in foreign bureaus, as well as four international editions whose stories are all available on Time.com.

Week after week, we pledge to provide you with the best writing, the best reporting, the best thinking and the best pictures. And we will present it all in *Time*'s distintinctive way. 'Names make news,' said Luce, and we'll continue to explain the world to you through the people who make a difference. To paraphrase the poet Ezra Pound's definition of literature, we're in the business of news that stays news."

The Cover

One of the most noticeable changes on the cover was the logo, which was shrunk in size by twenty percent. Previously, the word "TIME" stretched almost entirely across the cover and was positioned high up, almost next to the red frame. The new reduced "TIME" was centered and moved down from the red frame to make room above for two or three story headings, some with photos. This top area, called "teasers" or the "roofline," showed readers, at a glance, stories from various sections within the edition. The idea was to attract more readers and to spur newsstand sales.

"Briefing"

The magazine was divided into several parts, of which the first was called "Briefing." A descendent of the "Chronicle" section, "Briefing" covered national and global events of the week with short, lively pieces. It now included "People" and "Milestones" along with "Numbers," "Verbatim" and "Moments." This part, according to Stengel's definition, was the magazine segment that fulfilled the function of "mirror of the news." Stengel jettisoned the eighty-year-old tradition in "Milestones" of the stylized miniobituaries that began with the word "DIED." He said, "Let's just write them as elegant and informative obituaries, with a beginning, middle and end."

The Well

Stories in The Well served as the light rather than the mirror of the news. The Well was the home of longer, deeply reported and illustrated stories that looked at the news in depth. The title "Well" did not appear in the layout. Rather, the double spread opener and the length of the leading article served to set apart the section and its stories. However, the

section to which a given story belonged, such as "Nation," "Time Investigation," "World" or "Business," appeared in a small red box at the beginning of the story. In addition to these longer, in-depth stories, bylined columns provided commentary and points of view. To distinguish them, the byline on the columns was larger than the title, on the theory that readers were mainly interested in the column writer and the opinions he had to offer. Hayman explained this feature of the redesign:

"For us, the names of the writers examining or interpreting the news are more important than what they are writing about. We know that the reader likes these writers and we want them to find their column right away in the book. When I read Maureen Dowd or Friedman in *The New York Times*, what I care about is what they have to say and how they say it and their point of view. Besides, the notion we got from Stengel was that these are "branded" names—maybe a lot of people just buy the magazine to read their opinions on a subject or a piece of news. What you expect from a magazine like *Time* is to give you their perspective or a way of thinking about something. The bold Franklin Gothic type builds up these characters and names."

"Life"

"Life" was a mix of news and analytical articles. There was talk of calling it "Ideas" instead of "Life." Its offerings included sections on "Medicine," "Science," "Crime," "Innovators" and new and revived sections, such as "History" and "Law." These were written by leading experts and academicians who added historical context in order to give readers greater perspective on current events. One new section was "Going Green," devoted to ecological and environmental

2007. Commentary: The Second Commandment Republicans by Joe Klein

Bylines. In providing more point-of-view stories, the magazine prominently displayed the author's name. This page (above) shows the new design—with the byline larger than the story's title. This style element was used to clearly identify "branded" authors, regardless of the topic.

innovations, challenges and advances. Also new was a section called the "Power of One," which dealt with opportunities for community service. Caroline Kennedy wrote the first story about a program called City Year Young Heroes, in which students could participate.

"Arts"

The magazine's last part was called "Arts." It started with a feature, usually based on an interview, and was followed by such subsections as the "Big Picture," "Books" and "Downtime," with reviews of art, music, books, films and theater—the entertainment world in general. Thus,

Time graphically closed the circle that Stengel had conceived for its content: the beginning and the end of the magazine were a mirror of the news. In the center, the heart of the magazine, were the articles offering analysis of and points of view on important current issues.

Hayman summed up the reasons behind the redesign:

"He [Stengel] felt that the magazine had taken a more entertaining direction and he wanted to turn information into knowledge, for which he needed a smarter look.

Both the Obama phenomenon and

the economic crisis had pushed the magazine away from the entertaining direction to focus more on serious issues, which should be covered with wit. I would say that the spirit of our redesign was to make *Time* look like a smarter magazine."

When asked whether the response to the magazine's new look was favorable or unfavorable, Hayman answered with a clear and simple example of its success:

"We understand that the renewal rate is up, which says a lot in this day and age. For us, that is a really good measure that the redesign worked. Jan V. White [author of books on magazine design] said it was one of the best magazine redesigns in history. We heard of no negative comments. Some designers mentioned that our redesign was a cross between *The Economist* and *The Atlantic*, but that's a compliment because both these magazines look very smart. In fact it was not a radical redesign. If you look back at what was there originally, it looks as if we just cleaned it up."

My days at *Time*

Karen Tumulty: My New Role as Architect of Information

In this essay, commissioned in 2009 for this book, Karen Tumulty, national political correspondent for Time *since 2001, recounts her transition from the print to the online world for* Time.

I joined *Time* in October 1994, and was assigned to cover Congress. That was just a few weeks before the mid-term elections that turned over control of Congress to Newt Gingrich and the Republicans. My big leap into the online world didn't come for another twelve years—until January 7, 2007, when we began our Swampland blog. It was another century, and it felt like one. Blogging was something I did with no small degree of trepidation, given what a raucous place the blogosphere can be. But after a few rocky months of getting acquainted with a whole new universe of readers (and vice versa), I began to realize that, to my surprise, I was starting to like blogging.

At first, it was a real adjustment. But ultimately, I found that I really loved the give-and-take that it demanded with our readers. Done right, the Internet can force you to take an almost Socratic approach to journalism that makes you better and sharper at what you do. In fact, the web gives you all kinds of opportunities to deliver information that you don't have with the traditional once-a-week format. For instance, in January 2008, I was invited to be the only reporter backstage with Ted Kennedy when he endorsed Barack Obama. It was a great opportunity, an exclusive chance to witness a huge political event. In the old scheme of things, the timing would have been a problem, given that it happened on a Monday—four days before the print edition of the magazine would hit the newsstand. Almost immediately, I was able to write stories for the web, posts for the blog and a podcast of my interviews with Ted and Caroline Kennedy and Barack Obama. Thanks to the exposure that work got on the web, I even was invited on *The Daily Show* that week—all before the magazine was even printed.

Are we "information architects?" That sounds better, I guess, than "content providers." But whatever you call us, it points to what has always been true: We journalists are only as good as the information we provide.

I'm surprised at how little overlap there really is between our two audiences. The online audience—especially the blog reader—expects to interact with you, and will challenge you on the spot. It is a much more intimate experience, and it requires a very different style of writing. You have to get to your point very quickly. The feedback comes pouring in, through the comments section, and in the number of hits and the number of links you get from other sites. By that measure, there is a satisfaction to being a digital journalist that we never got with the traditional format.

Information architect. Pictured below is National Political Correspondent Karen Tumulty, in an Iowa City hotel covering New York Senator Hillary Clinton's campaign to run as the Democratic candidate for president. Tumulty is both a print and digital content provider or, as she prefers, an "information architect." Beginning in January 2007, Tumulty became a writer for *Time*'s political blog, "Swampland."

Print and Web
Integration

Another fundamental goal of Stengel's tenure was to integrate the print and digital versions of the magazine. "We need to stop thinking of the web version of *Time* as a different species," he wrote in his memo to Huey before he was named managing editor.

> "It is the same product, the same brand, delivered and organized in different ways according to the medium. Online and print are extensions of each other, they help leverage each other, they don't fight or undermine each other. Print types tend to think of online as the backdoor to *Time*. More and more—and especially for young readers, it is the front door."

To build a bridge between the print and digital versions, Stengel tapped the talented young journalist Josh Tyrangiel. After starting at *Time* as a reporter/writer in 1999, Tyrangiel became a music critic in 2001, then served for two years as a traveling correspondent in Europe. Back in New York, Tyrangiel won praise as an intermediary between the editorial staff and the magazine's redesign team. In September 2006, Stengel, mindful that Tyrangiel had developed his career during the online era, put him in charge of Time.com. The portal had been born a decade earlier as a branch of Pathfinder, but lacked strategic vision and adequate financing. "We need one staff that writes for both things," Tyrangiel told his superiors, "and in order to do that I need to have a magazine title and credibility, because if I'm just to be 'the web guy' we don't have anything. The fact that I was a writer, and a very productive one for a long time gave me more credibility to say 'guys, this is where our future is and if you're not ready for the web you're not doing your job.'" Accordingly, Stengel named

Tyrangiel not only editor of Time.com but also assistant managing editor of *Time*.

Under Tyrangiel, the magazine and the website quickly introduced a new section called "10 Questions" to show how the integration of digital and print could go. In the section, newsmakers were interviewed each week—but the questions came not from the editorial staff but from Time.com readers, who were notified in advance of upcoming subjects. The readers whose questions were used were credited by name when the interview appeared in the magazine and online in a text or video format. Readers could copy and save the interview and send it to others. This created an interactive identity and loyal users, who felt they were the magazine's partners instead of passive readers.

Similar integrations followed in other areas. The traditional "Letters" section became the "Inbox," the term used in e-mail, the now preferred method for most readers to keep in touch with the magazine. Time.com introduced "Swampland," a political blog, with a constant flow of Washington news and comments that became a true chat room in which print-version writers, such as Joe Klein or Karen Tumulty, exchanged their points of view with web users. This followed Stengel's editorial premise of creating a multivoice spot in both the magazine and the website. Although "Swampland" was not part of the magazine, its contentious and colloquial spirit allowed *Time*'s writers to take the pulse of readers regarding current political affairs, and then deal with those opinions in the printed version's national political coverage.

The new interactivity also enabled readers to take a more active role in the annual selection of *Time*'s "Person of the Year." Through Time.com, they could vote online for the candidates of their choice.

Web identity. To identify with its print component, Time.com uses the same logo, same red frame and same font (opposite). Time.com also contains an archive of all the covers and articles published by the magazine since 1923. Besides its traditional analytical stories, the site posts the latest Associated Press headlines and offers additional lighter content. The writing style is more concise and more irreverent than the magazine.

Inside Time.com

Photos: The Wide World of Weird Sports

Ask Your Questions: Documentary Maker Ken Burns

The Fashion Week Blog: Marc Jacobs

Bank of America

ROLLOVER TO EXPAND

TIME

IN PARTNERSHIP WITH CNN

📰 NEWSLETTERS
📱 MOBILE APPS
📶 ADD TIME NEWS

Tuesday, September 15, 2009

SIEMENS

SEARCH TIME.COM 🔍

Must Reads

TUNED IN »
Jay Leno: Just Call It The Ten-ight Show
BY JAMES PONIEWOZIK

WORLD »
How Has Berlusconi Survived His Sex Scandal?
BY JEFF ISRAELY / BOLOGNA

U.S. »
Do You Have the Right to Flip Off a Cop?
BY SEAN SCULLY / PHILADELPHIA

THE CHEAPSKATE BLOG »
The Most Useless Baby Product of All
BY BRAD TUTTLE

THE CHINA BLOG »
Chinese Artist Recovering from Police Beating
BY AUSTIN RAMZY

ENTERTAINMENT »
Top 10 Outrageous Kanye West Moments

CHRIS HONDROS / GETTY

The Financial Crisis After One Year: Where Are They Now?

- Three Lessons of the Lehman Brothers Collapse
- Turning Point for the Global Recession?

Patrick Swayze: He Had the Looks, and the Moves
By RICHARD CORLISS
- 📷 Remembering Patrick Swayze

Somalia: Another U.S. Strike on

Latest Headlines
UPDATED: 10 minutes ago
- Officer: More Afghanistan Troops Needed
- 18 Pakistani Women Die in Stampede for Flour
- Probe Prompts 'Preventive' Terrorism Raid
- Car, Gas Sales Boost August Retail
- Indonesia's Aceh Passes Stoning Bill
- Iraqi Shoe Thrower Says He Was Tortured
- Police Seem to Be Closing In on Yale Killer
- CNNMoney: Family Health Costs Jump 5%
- CNN: Prince Harry: A Birthday Millionaire
- 📷 Remembering Patrick Swayze

TIME
Partners with CNN

Follow TIME on twitter

CLICK HERE

Politics

SEARCH TIME.COM 🔍

📰 NEWSLETTERS
🎙 PODCASTS
📶 ADD TIME NEWS

INSIDE: Main | Ted Kennedy 1932-2009 | The Page | Swampland | Videos | White House Photo Blog

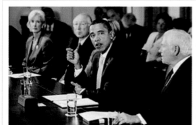
OLIVIER DOULIERY / GETTY

After Obama's Speech, It's Back to Wooing the Skeptics
By JAY NEWTON-SMALL / WASHINGTON

Obama's Health-Care Challenge: Keeping the Focus on the Larger Goals
By KAREN TUMULTY / WASHINGTON

Rep. Joe Wilson, Presidential Heckler
By RANDY JAMES

More Politics Articles »

SPECIAL REPORT: TIME's complete Ted Kennedy coverage »

Most Popular News
TIME | CNN | Real Clear Politics
1. 'You Lie!': Representative Wilson's Outburst
2. Rep. Joe Wilson, Presidential Heckler
3. After Obama's Speech, It's Back to Wooing the Skeptics

On the Blogs: Political Conversations

THE PAGE
Eight Years Later

2008. "10 Questions" 2008. "Inbox"

Interaction. The two sections published in the April 14, 2008, issue (above), have their roots in Time.com. The "10 Questions" section is an interview based on questions from online readers. "Letters" is now "Inbox" to correspond to e-mail, the current method in which readers submit their comments.

Once the votes were compiled, the major choices helped to guide the editors in making their final selection.

To preserve the magazine's DNA and reinforce the integration, Tyrangiel decided to retain in Time.com three familiar elements of the printed Time: the logo, the red frame and the typeface. And, in a sweeping move, the new Internet version included an archive section giving readers access to every cover image and every article from the magazine's founding in 1923 to the present. This put web users in instant touch with the vast and influential legacy of *Time*. In addition, the "Covers archive" section offered reasonably priced cover posters for purchase.

As the new website got under way, Tyrangiel and his staff were determined to learn more about their users. "The initial questions we were asking ourselves were, 'What does a web user want? What do they do, how do they behave, how do they interact with information and how do we deliver that?'" said Tyrangiel.

"When the results of the polls and focus groups started to arrive, we learned that a big chunk of our web users were college educated, mostly 35–45-year-olds, who visited Time.com from Monday through Friday between 11 a.m. and 2 p.m., which means that they are at their desks, when the phone is ringing

and the boss is at the door. Obviously, nobody's got time to read a 6,000-word cover story, and that means that the stories should be written differently. We understood that we needed 250-word leads rather than 600, with a headline that should be more clear than clever. That's why our current mission online is to make people smarter while saving them time." (Tyrangiel's interview with the authors)

The matter of the headline was crucial. For example, a title such as "A Long Good-Bye," with a photo of former President George W. Bush and Dick Cheney walking out the door, worked well for the magazine,

but was inadequate online. Titles not only needed to be short and clear, but they also had to contain keywords to enable search engines such as Google to link to them. The search engines, in turn, would lead new users to Time.com, generating more visits and interaction. For this reason, "A Long Good-Bye" was changed on the Internet to "Inside Bush and Cheney's Final Days." When a web user put any two of those words into the Google search engine, the article at Time.com would appear at the top of the results page. Another example: the magazine used the ironic title "Who Let the Blue Dogs Out?" for a story on Democrats' hurdles to the health care reform plan. The online version was more direct: "Why the Blue Dogs Are Slowing Health-Care Reform."

Having made a considerable investment of funds, forged a strategic, interactive vision and carried out the needed redesign, Time.com tripled its original writing, production and business staff to more than forty people. In addition, Stengel managed to get all print version writers, even senior ones who had limited or no digital experience, to write for the website, and also often to make video and podcast contributions. As a result, traffic surged from 500 million "visits per page" in 2006 to 1.2 billion in 2008, as measured by Omniture, an Internet marketing firm. In Tyrangiel's words, "We're not CNN.com, we are not MSNBC.com, we are not a wire service, we are a very large website now, but we're still a boutique operation compared to them."

The new Time.com featured a youthful and somewhat irreverent writing tone, as well as an editorial approach that alternated between information, knowledge and entertainment. The website could afford this expanded approach: while the printed version was a product with a limited number of pages and space, the Internet version was boundless. To direct

2007. Time.com advertisement

Ads. The magazine regularly promoted the connection between its print and online formats as seen above in its print ad for Time.com. It even changed its traditional "guaranteed circulation" advertising rate base to the new "total audience" rate base to include online readers. Stengel's goal was to integrate the print and digital versions of the magazine rather than consider the web version "a different species."

the reader, the main page was divided into three parts. On the left were the so-called "must-read" stories, which constantly changed according to news events and in which a strong point of view prevailed; the middle was devoted to the best analytical journalism and on the right were the latest headlines from other sources such as the Associated Press. Lighter content was most prominent in the top navigation bar featuring sections such as "Entertainment," "Videos," "People," "Photos" and "Best & Worst Lists." The last section, for example, provided lists on various subjects, such as "10 Personalities Who Gave Up the Gloves," or "The 10 Most Tasteless Ads"

or "5 Top Myths About Michael Jackson." The value of the information was perhaps questionable, but the main goal of the section was to amuse and entertain readers. "Time.com is *Time* magazine without the magazine, that is to say, a true digital version of the essence of what our editorial philosophy is," concluded Tyrangiel. To quote the Time.com ads that were published regularly in the magazine, "You trust us every week. Now, how about every minute?"

Vladimir Putin: the Seventh "Man of the Year" from Russia

In 1999, "The Man of the Year" became "The Person of the Year" to avoid sexist designations. Popes, kings, statesmen, presidents, dictators, women, demographics, machines, admirable and damnable people and even abstract concepts were chosen at one time or another for the most awaited of all *Time* covers, "The Person of the Year." One pattern that stands out is the number of times Russians were selected. Seven times—approximately ten percent of the annual cover choices since Joseph Stalin was featured in 1939. All of them top leaders: Stalin reappeared in 1942, Nikita Khrushchev in 1957, Yuri Andropov (next to Ronald Reagan) in 1983 and Mikhail Gorbachev in 1987. Gorbachev also boasts another honor: in 1989, he was chosen "Man of the Decade," the first person to be so designated by *Time*. His selection was influenced by the fall of the Berlin Wall that year. In 2007, Vladimir Putin was *Time*'s "Person of the Year." Putin was the first newsmaker that Richard Stengel and his staff chose for the spot, a decision that provoked a storm of criticism.

Controversy was nothing new for *Time*'s "Person of the Year" selections. In the years since the category was created in 1928, the criterion on which it was based had often been misunderstood. That criterion, as the editors of *Time* reminded readers annually, was defined by Henry Luce as: the individual who had most influenced the news during the year "for better or for worse." Nevertheless, many people mistakenly regarded the designation as a recognition of merit or good deeds. And indeed, it often was. But when a figure of baleful influence was chosen, such as Hitler (1939) or the Ayatollah Khomeini (1980), many readers reacted with outrage and complaints.

A similar controversy was generated by the Putin selection in 2007. *Time*'s title was "Tsar of the New Russia." Inside, Stengel led the coverage with an article titled "Choosing Order Before Freedom." In the last paragraph, he summed up the choice:

"At significant cost to the principles and ideas that free nations prize, he has performed an extraordinary feat of leadership in imposing stability on a nation that has rarely known it and brought Russia back to the table of world power. For that reason, Vladimir Putin is *Time*'s 2007 'Person of the Year.'"

Anticipating the designation would touch off disagreement and anger among readers, *Time* made a significant addition to the cover. In the band above the logo and next to the words "Person of the Year," it added between brackets, "And the Runners-Up Al Gore, J. K. Rowling, Hu Jintao & General David Petraeus." It was the first time that the magazine had published the names of other contenders on the cover—a gimmick to garner more attention, especially in the rollout of its announcement on television. Stengel explained:

"I had conversations with Jim Kelly, Walter Isaacson and others that maybe we should change the definition. Maybe the 'Person of the Year' is the person who did the most for the planet that year, because we almost always select people like that. At the same time, I wanted to test out somebody who isn't purely on the good side of the spectrum. Putin is somebody who is very powerful, who did affect the world, but he affected it for better and for worse. There was criticism, but it wasn't at the same level of the Ayatollah."

Polemic decision. The selection of Vladimir Putin as the 2007 "Person of the Year" (opposite) drew criticism. Stengel defended the "Tsar of the New Russia" as *Time*'s choice as a person of power who affected the world for better and for worse. It was also the first time the names of the other top four contenders were published on the cover.

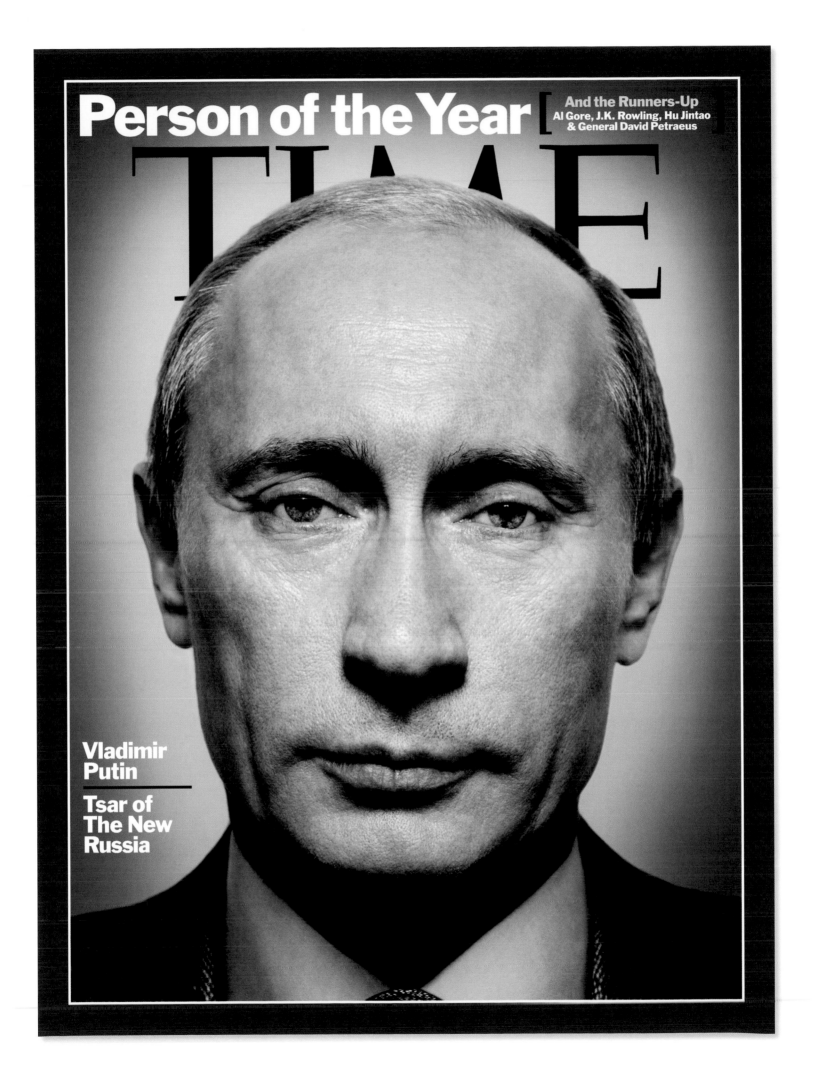

Person of the Year

[And the Runners-Up
Al Gore, J.K. Rowling, Hu Jintao
& General David Petraeus]

TIME

**Vladimir
Putin**

**Tsar of
The New
Russia**

Focus on Obama and the Economic Crisis

The Iraq and Afghanistan wars, the September 11 terrorist attacks, Hurricane Katrina—all were events that molded the editorial decisions during Jim Kelly's tenure. The emergence of African-American Barack Obama on the national political scene in the United States and the economic downturn in the country—which would eventually become the worst recession since the Great Depression—had a similar influence on Richard Stengel's stewardship. The editor explained:

> "Obama was such a transformative figure in American politics that you have to focus on such a newsmaker. He was the protagonist of this incredible narrative and this incredible story. In a weird way, even if McCain had won, the story would have been about Obama anyway, because it would be focused on why people were not voting for him. The fact of an African-American being nominated for the first time and the fact that he later became president of the U.S., are already reason enough to concentrate on him and the campaign issues."

Time started covering the Chicago senator early and presciently. It first devoted a cover to him on October 23, 2006, titled: "Why Barack Obama Could Be the Next President," more than two years before the presidential election. The cover story was written by Joe Klein, and ran alongside an exclusive excerpt from Obama's memoirs. From then on, Obama was the focus of endless inside stories and made the magazine's cover more than twenty times, alone on some of them. Three stand out: the one devoted to the "Most Influential People of the World" (May 14, 2007), the one naming him "Person of the Year" (December 29, 2008) and the February 2, 2009, commemorative edition, in which he is shown taking the oath of office next to his wife, Michelle. As Stengel noted:

> "My feeling about the election coverage was that we did not have to do the 'mirror' coverage of what was happening every week in the campaign. I wanted to do things that were more 'lamp' like, that could focus on the largest themes that were shaping the campaign, like the 'experience,' 'patriotism' and 'character' covers. Here is a way to understand what is going on, not on 'who's for or against nuclear energy or immigration,' but more about the spirit that drove the campaign."

At a time when Americans were deciding whether Obama's youth, with its implications of inexperience, would be a negative factor at the White House, *Time* ran a long cover story on March 10, 2008, under the heading, "How Much Does Experience Matter?" In it, David Von Drehle analyzed the significance of a long track record for a president. When, in July of that year, questions were raised during the campaign about the patriotism of a candidate with African roots, the magazine placed an American flag pin on the cover with the heading "The Real Meaning of Patriotism." It asked Republican John McCain to write an interpretative article on "Why service is our strength," and also asked Obama to offer his point of view under the title "Why we share the same destiny." In the issue's first article, "The New Patriotism," Stengel wrote:

> "That new patriotism, as Eric Liu and Nick Hanauer write in *The True Patriot*, means 'appreciating not only what is great about our country but also what it takes to create and sustain greatness.' That formulation is what this campaign should be about: defining America's course in the 21st century. The candidates may have different views on what makes

Poster. President elect Barack Obama was designated 2008 "Person of the Year." The cover was illustrated by American street artist Shepard Fairey, whose early "Hope" campaign poster of then Senator Obama became the populist image of the campaign. The cover image (opposite) expands on the poster and has been praised as "the most efficacious American political illustration since 'Uncle Sam Wants You.'"

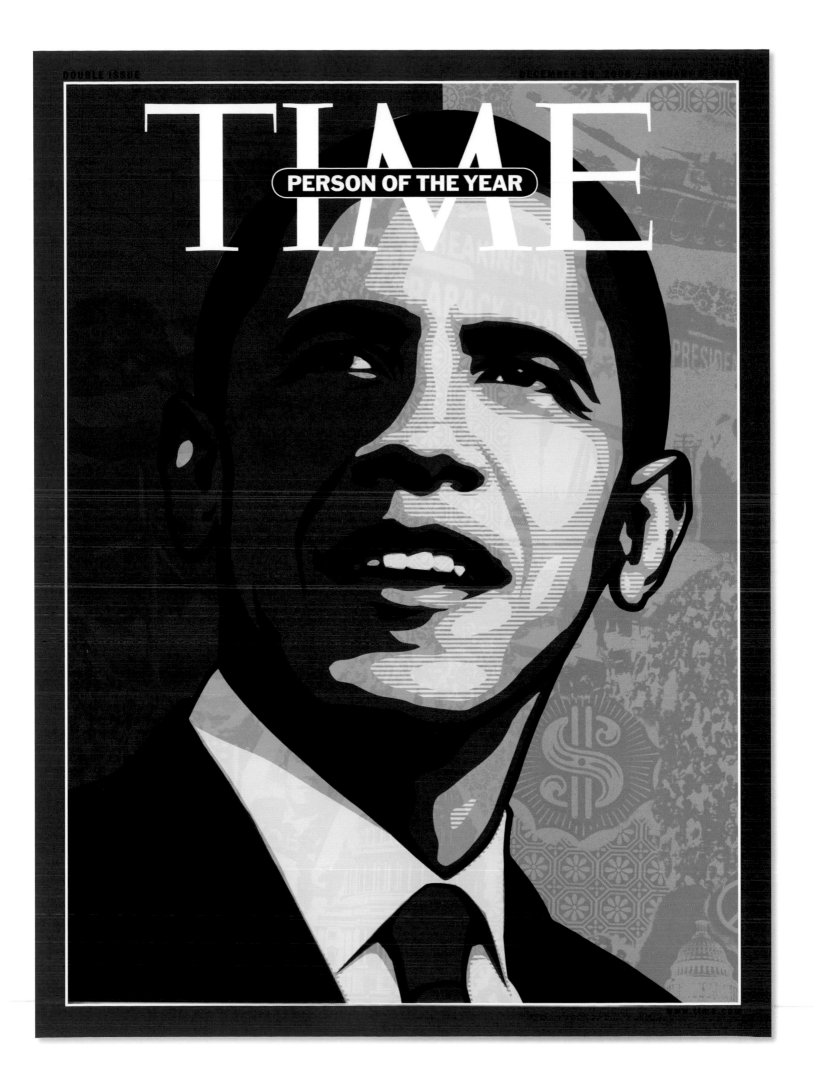

393

2008. How Much Does Experience Matter?

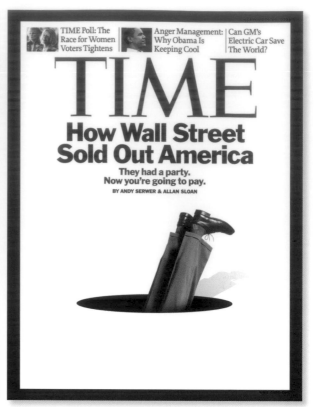

2008. How Wall Street Sold Out America

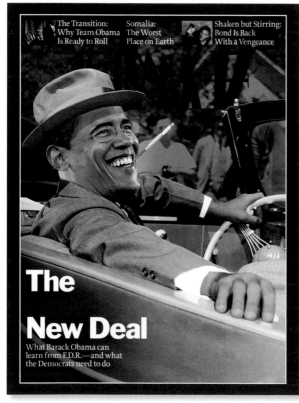

2008. The New New Deal

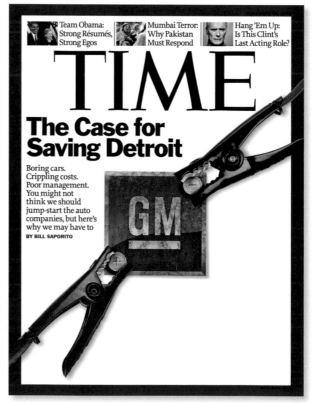

2008. The Case for Saving Detroit

Economy slump. The March 10, 2008, cover, with an image of the back of Obama's head, asked how important experience would be in tackling the problem of a stumbling economy (top, left). On the September 29 cover, the problem became a reality with the Wall Street meltdown (top, right). The November 24 cover humorously portrayed Obama as the Great Depression's New Deal President Franklin Delano Roosevelt (bottom, left). The December 15 cover tackled the question of salvaging America's Big Three automakers (bottom, right).

us proud to be Americans, but they share a belief in a modern American exceptionalism: that America has a greatness of purpose that no other nation does, and that for all our achievement, our greatest tasks remain before us."

When questions emerged during the campaign over whether Obama had the necessary character to face a terrorist attack or other crisis, *Time* used the same "spotlight" editorial premise, tackling the subject in the October 27 issue under the heading "Does Temperament Matter?" "... The most important attribute of a President is not intellect but something more familiar and less knowable—temperament," Stengel wrote in that issue's letter to readers. "The job of the modern presidency is so complex, so taxing, so intense that one's disposition even more than one's mental bandwidth may be the key to handling the job." Inside, the writer of the cover story, Nancy Gibbs, ranked several presidents: "Nixon, first-rate mind, second-rate temperament; Reagan, second-rate mind, first-rate temperament Perhaps only Lincoln tops the class in both categories."

For *Time*'s campaign coverage, Stengel gathered what, in his September 1, 2008, editor's letter, he called "A Super Political Team." It included Joe Klein, who not only covered a considerable portion of the presidential campaign but also always traveled on Obama's plane and was one of the first to exclusively interview him for the magazine. Other team members were writer Nancy Gibbs and National Political Correspondent Karen Tumulty. They constantly followed Obama from the beginning of the electoral contest through his inauguration as president, taking turns producing cover stories on his progress. Other frequent team members were reporter and editor David Von Drehle;

political consultant and columnist Mike Murphy; Mark Halperin, a frequent Time.com contributor; and essay writers Peter Beinart and Ta-Nehisi Coates.

Von Drehle wrote, among others, the noted article "The 5 Faces of Barack Obama" in the special issue devoted to the Democratic Convention (September 2008). Stengel noted in his letter to readers:

"More than any other modern candidate, Obama is a one-man Rorschach test, telling us about our own perceptions, biases, hopes and fears. David's five categories—the Black Man, the Healer, the Novice, the Radical, the Future—describe the prisms through which we see the Democratic nominee."

For the October 20 issue that year, Von Drehle made a 750-mile trek through Missouri, a state that over the past 100 years had supported the winning presidential candidate in every case but one. Von Drehle concluded that the economic downturn surpassed racial prejudice as a defining issue among voters

Stengel directed coverage of political and economic developments during the campaign not only through articles and essays, but also through intense, extensive visual essays. Most of these eight-to-ten-page photo spreads, usually accompanying the cover or main political stories, were produced by two outstanding photojournalists: Callie Shell in Obama's camp and Christopher Morris in McCain's camp.

"We want to show readers the images you won't see in the newspapers the next day," Shell said about her work. Her intimate, behind-the-scenes shots of Obama and, later, the new first family did that and more. Shell had worked for eight years as Vice President Al Gore's photographer, and then for Senator John Kerry's presidential

campaign. She joined *Time* as a staff photographer in 2001, going straight to the White House. Shell showcased spectacular photo essays on the Obamas before, during and after the presidential inauguration. In the May 4, 2009, issue, in a spread accompanying an analysis of his first 100 days in office, Obama is seen relaxing, tossing a football in his office between breaks in staff meetings, working in casual attire on a Sunday, in the privacy of the presidential plane and sitting in the Oval Office well into the night.

Christopher Morris, a *Time* contract photographer for twenty years, who distinguished himself with international war coverage, started taking political photos in 2001. "His clean, modern images have defined a new style of campaign coverage," Stengel wrote in the February 18, 2008, letter to readers. Morris followed Senator McCain's steps from the kickoff of his first campaign in 2000. He had unprecedented access to the candidate and the man—in McCain's hotel room, in whatever vehicle in which McCain was traveling or at his family ranch in Arizona. Morris also photographed Obama for the February 2, 2009, presidential inauguration cover.

Stengel rounded off the visual coverage of Obama with photos by Platon Antoniou and special illustrations, most notably by American artist Shepard Fairey's portrait of the president elect for the 2008 "Person of the Year" cover. Fairey got the assignment after *Time* editors saw the poster he had created for the Democratic candidate's campaign, under the slogan "Hope." It was praised by Peter Schjeldahl, *The New Yorker* art critic, as "the most efficacious American political illustration since 'Uncle Sam Wants You.'" Fairey's 2008 "Person of the Year" cover of Obama proved to be the best-selling "Person of the Year" issue in the history of *Time*.

Toward the end of 2008, the two

Making history. *Time* photographer Callie Shell, who had been covering Obama since 2006, took this January 20, 2009, photograph of Obama, waiting backstage before stepping onto the inauguration platform. Eyes closed, Obama savors the moment before he would make history as the first African-American president of the United States (following spread).

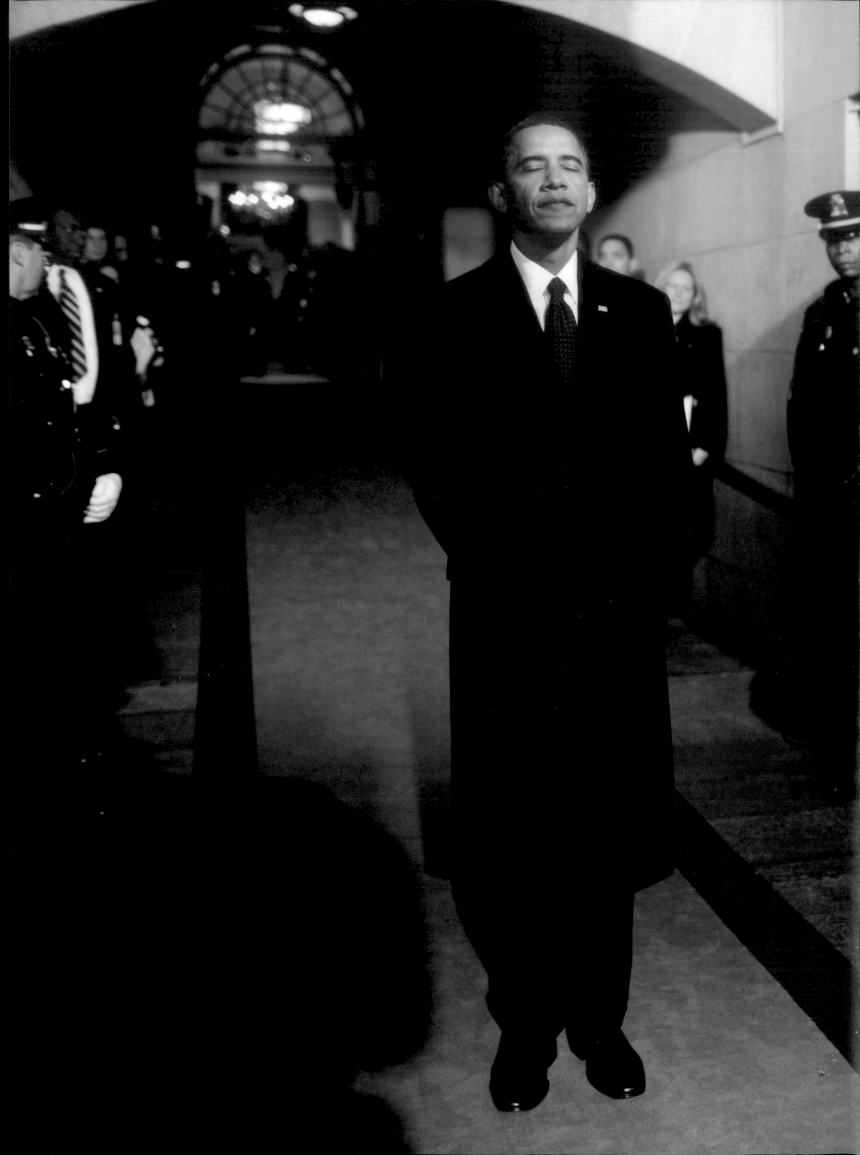

dominant stories of the day converged. One was the presidential campaign, of course, but with the fall of Lehman Brothers in September, the economy had also taken center stage. At the same time, the economic crisis had the effect of boosting Obama's candidacy. Stengel moved quickly to reckon with this convergence. The magazine pivoted from relentless election coverage to an equal focus on the economy—a subject readers said was even more important than the election. Three nearly back-to-back covers highlighted the shift: the September 29, 2008, issue on "How Wall Street Sold Out America," the October 6 issue, "Who Can Rescue the Economy? (Vote for One)," and the October 13 issue "The New Hard Times."

Stengel went back and forth between the mirror and lamp approaches during this period. Stories inside the magazine reported on high consumer debt and rising food prices, and one provided an etiquette guide for friends and relatives of those who lost Wall Street jobs or a chunk of their wealth during the recession. The cover on August 11, 2008, featured half-face portraits of Obama and McCain with the title "Job #1, The Economy" between them. This special report examined in detail the position of each on some of the fundamental issues of the economic crisis. Text by Bill Gates on what was needed for capitalism to work throughout the world complemented the mirror part of the report. His piece served as the lamp that illuminated the scene from a broader, almost theoretical viewpoint.

Later that year, the November 24 cover carried a humorous illustration by Art Director Arthur Hochstein and artist Lon Tweeten. Obama was portrayed as former President Franklin Delano Roosevelt, smiling in his convertible, wearing a hat and glasses, a cigarette holder clamped in his teeth at an angle. The title was "The New New Deal," with the subhead, "What Barack Obama can learn from F.D.R.—and what the Democrats need to do." This story served as a historical "lamp"—no president since Roosevelt had faced such formidable challenges in restoring the country's economy. Two other covers in 2009 continued the lamp approach: "The End of Excess, Why this crisis is good for America" in the April 6 edition and "The New Frugality" in the April 27 issue. "Those were amazingly interesting issues that we explored in the magazine," Stengel commented. "In a certain way, it was a philosophical point of view."

Worn-down shoes. The photo below was taken in March 2008, in Providence, Rhode Island. The focus on the holes in his worn-down shoes evidenced his marathon campaign for the presidency. According to Obama, he traveled to every corner of the U.S. and covered every state except Alaska and Hawaii.

Governor's dinner. President Obama and First Lady Michelle share a moment at the governor's dinner (above). The February 22 event was the first formal affair the president and first lady hosted at the White House. Earth, Wind and Fire, one of Obama's favorite groups, provided the music. The picture is from Callie Shell's photo essay "Obama's 100 Days: Behind-the-Scenes," published in the May 4, 2009, issue.

A Magazine in Constant Movement

"Every redesign is a beginning, not an end. We hope to evolve over the months and years as our world and your information needs evolve." Those were Stengel's words when he introduced the magazine's redesign on March 26, 2007. And he delivered. To match the evolution in the dissemination of information, the magazine moved forward, modifying sections, moving them elsewhere in the layout, eliminating some that were not working and adding others. *Time*, like a living entity, was in constant flux, with all its antennae working to keep pace with the increasingly fast changes in behavior, public preferences, trends and habits. In Stengel's first three years, the magazine came up with numerous innovations, both in content and design.

Sections come, sections go

Two new sections were inserted at the beginning of the magazine between the "10 Questions" section and "Briefing." One was "Business Books," launched in 2008, which took up a page and was published frequently but not weekly. Born as a consequence of the economic crisis, "Business Books" suggested three books on the economy that might provide readers with helpful information and advice. Its inclusion was also an attempt to resolve a problem from the 2007 redesign: where to place the "Business" section. It did not belong to "Life," "Arts" or The Well. The issue remained unsettled, however, since "Business" never found a fixed spot in the layout.

"Postcard," also a page-long section, was written by various correspondents and writers focusing on specific locations or scenes. Typical subjects were the impact of the national housing crisis on California residents, the discovery of a new butterfly that is saving New Mexico's ecosystem and the graffiti that Palestinian artists write on the wall that Israel built near Ramallah.

Stengel likened the section to "American Scene," created during Ray Cave's tenure, "but it's more international and one of the things I've seen among readers, and particularly young readers, is that they're interested in international news, but not necessarily international news about wars or something that's going on in a kind of current-events way. They're interested in the quality and texture of peoples' lives around the world. So that's what "Postcard" is, like a postcard. Here's something about life in Buenos Aires or Moscow or whatever and it's not pegged to something that's going on in the news."

From history to the weekend

With the decline in advertising, Stengel was faced with a decrease in the number of pages in the magazine. During his tenure, some issues contained only sixty-eight pages. The resulting space squeeze accelerated the demise of some sections that failed to catch on with readers. As part of the redesign, the "Law" and "History" sections made their debut in the "Life" part. Within months, "Law" ceased to exist, while "History" was reinvented on a smaller scale in "Briefing," under the name "A Brief History of..." This section dealt briskly with a variety of subjects ranging from priestly celibacy to nostalgic reminiscences of popular Broadway musicals.

"Briefing" also became the setting for a new feature called "Pop Chart," which ran photos and illustrations over short, humorous captions. Some old-line readers found "Pop Chart" too frivolous for a serious publication like *Time*, but the editors defended it as an attempt to capture the attention of younger readers. Deeper into the magazine was another newly created and frequently published section, the "Curious Capitalist," in which

2006. The Making of America— Theodore Roosevelt

2009. What Barack Obama Can Learn from FDR

Patriotism. Stengel's tenure began in 2006 with a cover dedicated to Teddy Roosevelt, as part of the series "The Making of America" (left, top). The series, which began in 2002 under Kelly, is published annually around the Fourth of July. Stengel believed that the series helped to explain what makes America a nation and a people, and that history can be used to help explain current challenges. In 2008, political wit and defender of racial equality, Mark Twain, was featured on the cover (opposite); in 2009 it was Franklin Delano Roosevelt (left, bottom).

Justin Fox commented on the economy, the market and business.

Numbers guide the way

In addition to reshaping the layout and creating new sections, Stengel introduced a number of new annual theme issues. His goal was for these issues to foster reader loyalty to the *Time* brand, just as such already-established issues as "Person of the Year," "Making of America" and "The Most Influential People in the World" did.

"America by the Numbers," which appeared on October 30, 2006, was the first of these new special reports. The entire issue was based on statistics, graphics and "infographics" by Jackson Dykman, *Time*'s graphic director. As Stengel explained, "it is an illustrated look at who we are as a nation—and where we're going." The idea came from a concept by the nineteenth-century French philosopher Auguste Comte, who said, "demography is destiny." Following Comte, Stengel developed the idea that

a nation's social, cultural and economic fabric derives in large part from the dynamics of its population. This first issue, titled "America at 300 million," traced the enormous growth among Hispanics in the country and showed how the traditional division between red (Republican) and blue (Democrat) states had given way to the purple United States. "I've long believed," Stengel wrote in his letter "To Our Readers,"

"that political polarization in America is much exaggerated and that the great mass of Americans are pragmatic moderates who tune out the high-decibel battles of the parties and the pundits. I agree with [Stanford] political scientist Morris Fiorina's thesis that as a nation, we are closely divided, not deeply divided, and the graphic shows it."

The second edition of "America by the Numbers" was published on November 26, 2007. On the cover, Norman Rockwell's familiar triple-image self-portrait was

digitally altered to show him painting a map of the United States. Four subheadings on the cover explained the contents: "How do we live?" "How happy are we?" "What do we do for fun?" and "A day in the life of the U.S. in statistics and photos."

The third special report, "The State of the American Woman," was published on October 14, 2009. Like its predecessors, the issue went far beyond facts and plain, cold numbers. The emphasis was on the reflection, analysis and knowledge that Stengel was committed to offering readers.

A stamp of patriotism, commitment and solidarity

Either by chance or coincidence, the first issue Stengel produced as managing editor in 2006 carried on the cover Teddy Roosevelt, who, along with other great figures of American history, was a protagonist in the magazine's "Making of America" series. One of the most prominent characteristics of Stengel's tenure was the publication of issues related to patriotism and civic values. Stengel, more than any editor since Luce, took these topics to the cover and stressed the cardinal importance of these values. He made something of a specialty of "national service stories," special issues devoted to "citizenship" and the propagation of philanthropic and community values.

The first such issue, whose cover story was written by Stengel himself, came out on September 10, 2007. The cover depicted an updated version of the classic World War II poster "Rosie the Riveter," with the title: "The Case for National Service." The subhead read: "Millions of Americans want to help their community, their country, their world. Here's a plan to put those ideals into action." Stengel's story proposed a ten-point plan that would cost some $20 billion a year—the equivalent of two months' expenditure on the war in Iraq and less than

Postcard. As the name suggests, this is a short, one-page section that provides snippets from real life. Stengel intended for "Postcard" to satisfy readers interest in the "quality and texture of peoples' lives around the world." The postcard written by Tim McGirk describes how the massive Israeli/Palestinian barrier, although an eyesore and insult to the Palestinians, has become "the world's biggest canvas" for graffiti artists (below).

2009. "World": Postcard from Ramallah

half the annual expenditure on the federal prison system. "A republic, to survive, needed not only the consent of the governed but also their active participation," Stengel wrote. "It was not a machine that would go of itself; free societies do not stay free without the involvement of their citizens."

The second story, "What We Can Do," was published on September 11, 2008. (Gearing the national services issues to the symbolic date of September 11 was a conscious choice.) This story, also written by Stengel, focused on how to carry out the plan described the previous year. To promote the cause, *Time* cosponsored a national service summit attended by Obama and McCain, among other community leaders. The summit's ninety-minute televised conversation with Obama and McCain on service, comoderated by Stengel and PBS's Judy Woodruff, was the only time the two candidates were in the same state during the campaign other than in the organized debates, and was one of the highest-rated evenings of television during the entire campaign.

Record holder

With the four covers that Stengel devoted to Hillary Rodham Clinton during his tenure—the first one on August 28, 2006—she became the most frequently featured woman on the cover of *Time*. Since first appearing on September 14, 1992, when her husband was running for president, Hillary Clinton had been on the cover sixteen times, ten of them alone. She thus surpassed the Virgin Mary (featured eleven times, two of them alone) and Princess Diana (featured twelve times, ten of them alone).

Entertainment celebrities, on the other hand, were scarce on the cover during Stengel's early years. Not until March 3, 2008, did an actor, George Clooney, show up on the cover. That same year, in August 2008, Stengel devoted a cover to the highest-paid basketball player, LeBron James, and in March 2009, to Oscar-winning actress Kate Winslet. On July 7, 2009, Stengel ran the first commemorative issue devoted to a show-business personality. It was a special tribute to Michael Jackson, the pop

superstar who had recently died. It sold an estimated 540,000 copies.

More changes

Starting on July 27, 2009, *Time* made new changes to its visual structure. Conceived by Cynthia Hoffman, the magazine's deputy art director, under Arthur Hochstein, and special consultant Luke Hayman, the changes took effect gradually and were mainly concerned with the magazine's shrinking news space. The "Life" and "Arts" segments changed names and joined the broader "Culture" section, as Hayman and Paula Scher had originally proposed in the 2007 redesign. Modifications were made to the story layout and the color of titles in the "Briefing" section. The controversial "Pop-Chart" disappeared, but Stengel emphasized that "Briefing" still targeted younger readers. Referring to 2008, Stengel said,

"I love the fact that we became the number-one magazine on college campuses last year. I think that had

National service and numbers. Stengel devoted special issues to the theme of citizenship or, as it was known internally, "national service stories." Stengel proposed a ten-point action plan for national service in the first issue, with a cover illustration inspired by WWII's Rosie the Riveter (below, left). To foster reader loyalty to the *Time* brand, Stengel introduced another annual series, "America by the Numbers." The series' second issue was published in November 2007, with the digitally altered image of Norman Rockwell's *Triple Self-Portrait* on the cover (below, right).

2007. The Case for National Service

2007. America by the Numbers

a lot to do with us being serious and covering the presidential campaign very closely, but I also think that we always need younger readers and I want people to feel that there's a sensibility in the magazine that's a little bit younger and 'Briefing' has that. And I think that is good for both younger and older readers because older readers kind of want to know what's au courant and what younger people are thinking and it's not really vice versa. Younger people are not interested in what baby boomers think."

Eighty-three years separate the magazine that Hadden and Luce created in 1923 and the one Stengel inherited in 2006. It took fifteen years for *Time* to make its first design change—modifying the inside heading type. Today, design changes are a constant. The idiosyncratic writing known as "*Timestyle*" is a thing of the past, along with the single, uniform voice of the magazine's prebyline era. Time has changed *Time*. The slogan coined to promote the magazine in 1924—"*Time* flies"—has special meaning today.

In his first three years at the helm, Stengel made his mark with a sober but innovative redesign; with a change in publication date, with more cover stories on issues than on newsmakers; and with stories offering more points of view to "illuminate" the news. At a time when digital technology was making interpersonal relationships more cold and distant, the magazine championed patriotism, citizenship and philanthropic and community values. Stengel helped *Time* to stand out from the global information glut by providing insight and meaning. Eight decades earlier, Hadden and Luce set out to distinguish their magazine with the same approach: "*Time* is interested, not in how much it includes between its covers—but in how much it gets off its pages into the minds of the readers." The philosophy and challenge remain, each week in print and each minute online.

Records. From 1992 through 2008, Hillary Clinton was featured on sixteen covers, the record for a women (below, left). Four of those covers were published under Stengel. The April 28, 2008, cover was also historic. To emphasize the importance of environmental issues, *Time* exchanged its traditional red border for a green one (below, right). In his letter to readers, Stengel urged that the balancing of environmentalism with economic growth should become a national priority.

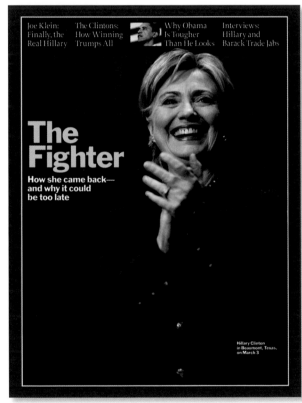

2008. The Fighter

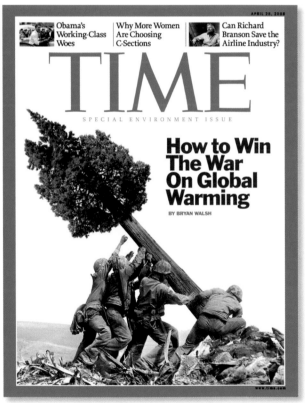

2008. How to Win the War on Global Warming

Commemorative edition. This special commemorative edition on Michael Jackson was published on July 7, 2009, shortly after his death. It sold an estimated 540,000 copies and stands among *Time*'s top-ten newsstand best sellers (opposite).

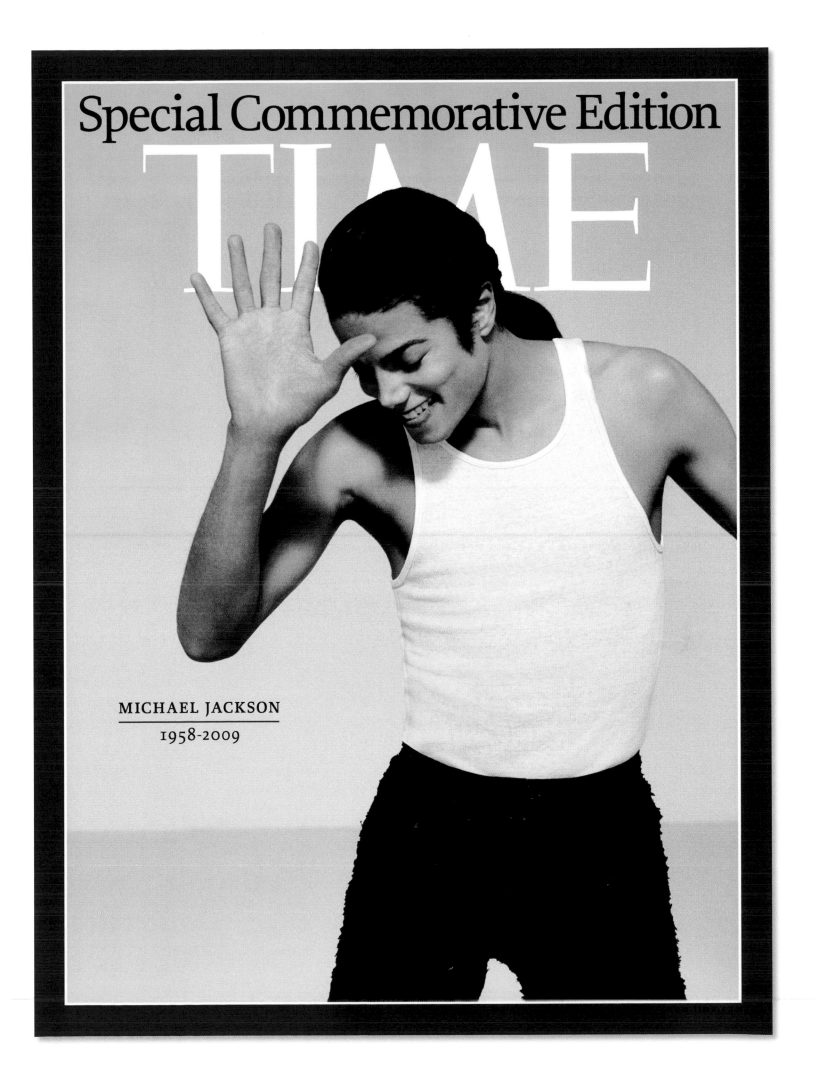

Special Commemorative Edition

TIME

MICHAEL JACKSON
1958-2009

Covers in the New Century's Magazine

Throughout *Time*'s history, its cover images were created by some of the nation's finest exponents of art, illustration and modern photography. Week after week, through the graphic elements on its cover, the magazine was an idea factory and also a mirror that reflected new concepts and forms of artistic interpretation.

During the last decade of the twentieth century and the first of the twenty-first century, *Time* developed three distinct cover styles: the informative and descriptive conceptual cover, the point-of-view conceptual cover and the photographic cover with extreme close-ups of newsmakers. These three forms were developed under the artistic leadership of Art Director Arthur Hochstein, who joined *Time* in 1985 and went on to work for six managing editors.

Hochstein, who studied journalism and gravitated towards design years earlier, recounted how conceptual covers emerged:

"I started doing some of the photo-illustrative stuff myself. I must have done between 50 and 100 of them. I started in the late '80s or early '90s, especially after Photoshop was starting to be used in the magazine industry. My first one was on the economy. We took an archival photo of a guy selling apples and we photographed one of our staffers in color and we sort of integrated both pics in black and white (the guy selling apples) and color, one giving the apples and the other one receiving them. I started to immerse myself in Photoshop and collaborated a lot with Matt Mahurin because his ideas are brilliant. I started to do it myself because editors prefer to deal with one person for the cover and they want more than one option to choose from. So, it turned out to be easier for me to do them myself. They were generally covers to illustrate ideas, I'd

say conceptual covers. Besides, at that moment the traditional conceptual illustration started to be a little dated and we had to take the cover one step beyond. We tried as much as we could to avoid stock pics for the cover because it was as if *Time* were running a wire story inside rather than writing our own text. If we use a stock pics on the cover, it devalues what we put within the red border." (Hochstein's interview with the authors)

Informative and descriptive conceptual covers

Conceptual covers could explain and convey everything that a photo alone, no matter how explicit, could not depict. Photos show only what is visible; the new technology, particularly Photoshop software, could create images of what people imagine and feel. Magazine covers could now "speak" through their cover images, depicting people's thoughts, emotions and reactions to events.

Two *Time* covers published in September and November 1998, during the Walter Isaacson years, mark the beginning and establishment of the conceptual stage. In both, several images came together to convey the subject in a single, striking news illustration. The September cover, titled "A Stinking Mess," was devoted to White House scandals. It was illustrated with a shot of a garbage can overflowing with photos of the scandals' protagonists and of landmark Washington buildings. The November cover, titled "The Herbal Medicine Boom," pictured a prescription bottle holding a bouquet of flowers and herbs, all listed on the bottle's label.

During Jim Kelly's tenure, conceptual covers became a means of avoiding the war fatigue of frequent covers on Iraq and other current events. For an article

Cover message. This July 30, 2007, cover is typical of the "white background covers," which carry a message, stimulate debate and offer a point of view. This cover suggests that a withdrawal from Iraq would leave the U.S. projects there incomplete (opposite).

Kids Who Beat Cancer

How new treatments keep them healthy when they grow up

The End of Easy Money: How Rates Will Squeeze You

Call Me Madam: Why Travolta Isn't A Drag

TIME

IRAQ

What will happen when we leave

BY MICHAEL DUFFY

www.time.com

407

on human cloning, a photo of a baby was copied, nose to nose, with the heading, "Human Cloning Is Closer Than You Think." To illustrate a story that asked why Osama Bin Laden could not be found, Bin Laden was shown in black and white on a white background, in which his face faded away, like a disappearing ghost. In August 2002, for a cover titled "How to Save the Earth," Hochstein photographed potted yellow flowers on his apartment terrace and a globe in his office; then, using Photoshop, he placed the planet in the center of the flower. The result was a dazzling image of a flower in bloom with Earth as its center—the seed that would sprout rebirth.

Aside from technique, these first conceptual covers could be characterized as more descriptive than analytical. They graphically transmitted the subject of the story but did not express an opinion. Sometimes they merely posed questions. Stengel preferred covers that didn't leave room for other interpretations, covers that took a position or held a point of view.

In his memo to Huey before taking over as managing editor, Stengel forcefully previewed his thinking on covers:

"The cover of *Time* magazine is still the single most important real estate in journalism. It is still an icon. It is still

the one thing that has a chance of breaking through in the media clutter. But it is a weakened icon, in part because the cover's authority has been squandered. In general, it needs to be a strong image and have a strong point of view. It has to have impact. Too many covers are of the 'inside story of something'—they are descriptive, not analytical; they are surveys, not judgments; they are about the 'what' of events, not the 'why.' Covers should answer a question, not pose one."

And so, as soon as Stengel took over, he and Hochstein started to develop a new

Covers with a point of view. The covers began to be intentionally more ironic and humorous. The April 6, 2009, cover on "The End of Excess" uses a reset button to symbolize the necessity of Americans to "reset" their values and beliefs and curb their excessive behavior (below, left). The May 25, 2009, cover shows a young man in both casual and business attire to graphically illustrate that the future of work will be a mix of new and traditional practices (below, right).

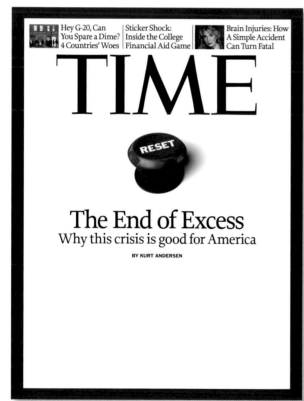

2009. The End of Excess

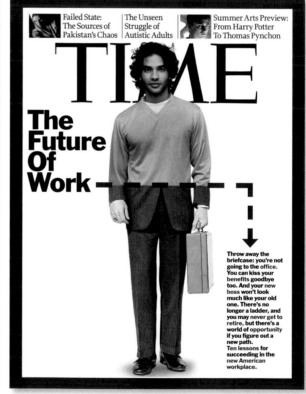

2009. The Future of Work

type of conceptual cover that followed Stengel's editorial thrust—that is, it was closer to the lamp that illuminates than the mirror that reflects. In strictly graphical terms, its main element was a clean white backdrop. Seventy-five percent of Stengel's early covers had that background. To Stengel, white was a much-defined color that separated the heading and the main image from other smaller ones. As Hochstein recalled:

"There was a bit of a tug of war for a while but what I discovered—and that was truly liberating creatively—was that the question I posed to myself was 'What do you do with that space, how do you use it?' Then I pared my thinking to using pictures more conceptually. Or, if you do use the Photoshop approach, to have to create one object that can fill or compensate all that white space. This was a totally different effect than previously. What I found really liberating was that we could create covers where the background became a graphic element that was beyond just visual, that it actually became part of the concept. It became a 'voice' for the visual presentation. We have been doing these white background covers pretty consistently, so much so that they are becoming a trend. It may last six months or a year, until we get tired of it. Nobody really knows how long it will last."

The new conceptual covers also took a fresh approach to the content they conveyed, that is, the way news was treated during this "Illumination Era." More than a point of view, they carried a message, seeking to stimulate debate and spur a national dialogue. The illustrations became more intentionally ironic and humorous. In journalism this is known as a "third idea" on the cover: the first idea comes from the interesting, ironic, suggestive image; the second derives from the relationship of the image with the title; and the third emerges from how the first two connect with the reader, who mixes them and interprets them, yielding the final message.

Two weeks after Stengel took charge, the first "Illumination" cover was published on July 17, 2006—a cover that won the American Society of Magazine Editor's Best Concept Cover Award for 2006. Over a white background, a huge Texan hat with the presidential seal hid the image of President Bush except for his boots. The heading read "The End of Cowboy Diplomacy." The image and heading evoked a well-known Texas jibe at people who boast. As Hochstein explained,

"The idea here is that between the headline and the Photoshop image we made a statement. Rick wants covers that make a statement, he wanted them to be noticed, not to be neutral. There's an expression in Texas, 'All hat and no cattle,' that applies to braggarts, which is really the statement we are putting through here. The image intends to make a serious subject funny. At that time I was learning to use the white space and any other foreign element here would be out of place."

Irony was also used to convey the message in another point-of-view and third-idea conceptual cover that was published on October 16, 2006. A huge elephant—the Republican symbol—was seen from behind. The article title was "The End of a Revolution." By linking the image of the elephant's behind with the title, the message or third idea Time transmitted was: "Republicans are making a mess of things." Hochstein explained, "It was the end of the Republican revolution, and the elephant is the symbol for the Republicans. The irony was showing the elepant's back and the implication of a mess." The same formula was later used to illustrate such events as the Wall Street debacle, Bush's retirement, the automotive crisis and the bank decline. "In this period," added the art director, "contrary to what we did with covers under Walter and Jim's tenures, photography is used both conceptually and ironically, something we would not have done in their periods. This is not a photo to convey information or a concept. It's about sensibility. It is a much more modern usage of photography."

"Extreme close-ups" of newsmakers

Under Stengel, photo covers were the exception at Time. Preference was given to reworked images that allow for interpretation, a point of view, a third idea. On the few occasions when newsmakers were photographed for the cover, the presentation needed to be original. The photo had to show the newsmaker from a different angle, as if the magazine had gone inside the subject's head to find his most private, revealing thoughts. The photographer who best exemplified this approach was British-born Platon Antoniou, who was raised in Greece and first studied graphic design, then devoted himself entirely to photography. His portraits were very close up, with no background and with perfect lighting. The newsmakers always had a blank expression, as if they were looking beyond, into the reader, as if to say, "You'll learn everything about me." Time had used this stark close-up approach periodically in the 1990s to good effect. During Stengel's tenure, Platon—who uses only his first name—employed this

"extreme close-up" style to photograph Vladimir Putin as *Time*'s 2007 "Person of the Year," Barack Obama on several occasions, his wife Michelle, John McCain and Ann Coulter, among others.

According to Hochstein:

"[Platon] takes wonderful portraits, very close up and generally uses a wide angle from a low point of view and he photographs the people either sitting or standing. His pics involve some degree of distortion—I think he is influenced by the artist Chuck Close. I would call his work modern photography, very clean and close up."

As the first decade of the new century drew to a close, Platon strived for penetrating interpretations of *Time*'s cover personalities just as S. J. Woolf had done in 1924 when he pioneered the "head and shoulders" style. Both Woolf's renderings through soft charcoal and Platon's through harsh photo lenses are the essence of the art and journalism that came together in the *Time* School of Covers—the prism that revealed newsmakers of the day, and history every seven days.

Close-up covers. These three portrait covers are examples of the photographer Platon's clean and penetrating style—close-up, dark background, perfectly illuminated. The Obama and McCain covers were published in 2008 on September 1 (below, left) and October 8 (below, right). This cover with Ted Kennedy's photo was published on September 7, 2009, shortly after his death (opposite).

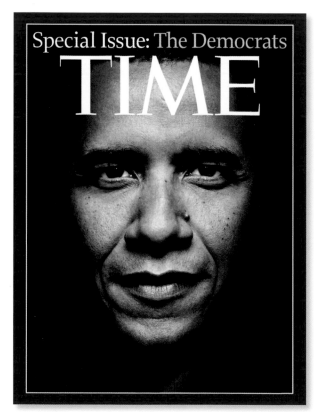

2008. The Democrats

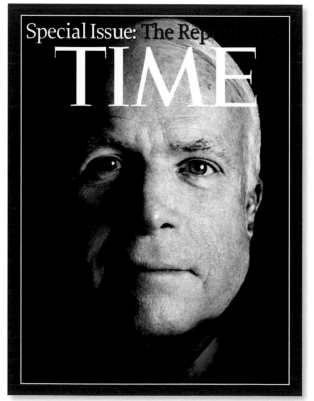

2008. The Republicans

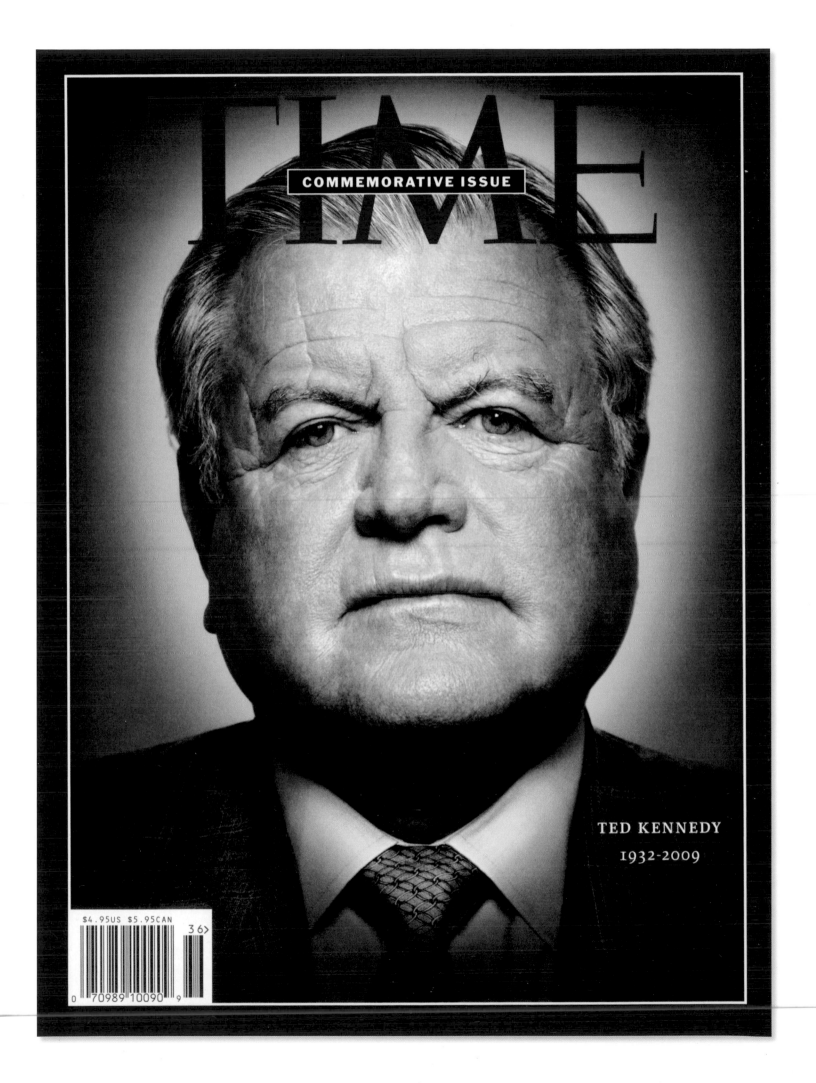

TIME

COMMEMORATIVE ISSUE

TED KENNEDY

1932-2009

$4.95US $5.95CAN

Time Today and Tomorrow

An interview with *Time*'s Managing Editor Richard Stengel about the magazine today, the challenges of the digital era and how he sees the future of *Time*:

What do you expect from column writers?
Frankly, what I am expecting from them is an idea that can get me excited. I want them to take the set of information that all other people have and give it what we call "a conceptual scoop," a different way of looking at the same things that we all look at. And I don't care if that's left, right or middle from a political point of view. It should be something that's really smart and I would want the reader to go, "Hey, I never thought about it that way" or "I didn't think of that..." That's the bar I have. I think there is a duality between left and right in our culture and I am a big believer in the Morris Fiorina theory that we are not deeply divided but narrowly divided. That being said, I also want some balance, and for example, a smart conservative who looks at something in a different way and a smart liberal who looks at things from another point of view, but I don't want them ever particularly having them labeled that way. For example, Joe Klein is such an independent thinker that he is as likely to attack the left as the right. And I would like to have a conservative attacking their own as well as those of the other side. The main thing is to approach things with this idea to get the so-called "conceptual scoop."

How does the mirror and the lamp premise really work in the magazine?
Even though I have never wanted to put it this way, the three parts of the magazine work like past, present and future, in a way. The "Briefing" stands for the past, as a sort of a mirror of what happened during the week, a recapitulation of the news. The middle of the magazine is a take on what is going on now but also pointing forward. And the last part of the magazine is kind of forward looking and conceptual. It doesn't necessarily work as past, present and future, but it does fall into this idea that the front of the magazine is a brief, with a direction of what happened; the middle is a deep dive into what is going on now and the back is much more conceptual and future-oriented, reviewing mostly things that are going to happen rather than had happened. I sort of think of it in that way. I'm not sure if the readers perceive it in the same way. The mirror and the lamp concept still applies, the "Briefing" being more of a mirror, The Well more of a lamp, even though the columns are, in a way, also a mirror of what is going on and the back as a sort of a mixture. I don't mean that one part is more superficial and the other deeper, but in a way that is also true. The front is definitely more superficial with bits and pieces of information; it isn't deeply reported. The middle is deeper. The back, especially in the evolutionary twist we have given it by naming it "Culture," is a texture of life, it's the ideas we are dealing with, it's not deep stuff.

What style of writing are you applying to the main stories, The Well?
The great change I want to introduce here is to write with a point of view. One of the things that make me uncomfortable is the kind of writing that says, "On the one hand..." and then, "On the other hand..." Journalists know, after reporting a story, both sides of the coin. But for decades, *Time* expected you not to give away what you thought about the subject or the event or the piece of news. You were expected to give this objective structure with both sides and the reader had to figure out his point of view. But I prefer a writer who's an expert, who can immerse himself or herself in the story, who uses different sources and reporting, and then I like him/her to explain things in a fair-minded way, but I want him/her to write "This person is truthful, the other not so much..." I want people with expertise

2009. Out of Work in America

and authority that, after doing all the journalistic homework, can also think and give me their point of view, what they think about what they are reporting or writing about. I don't want a writer to hide his or her views, I want to hear them but in a fair and transparent way. I'd say then that the new style is to have a point of view and be more transparent about how he/she came to their conclusions. Before, when we had the reporters reporting from the field and the writers in New York writing, we had two sets of brains in the same story, which should have been integrated into one. But whatever you do, the beginning, the middle and the end of a story should be somewhat present, because they are useful for any article. Good writers take the reader by the hand and they guide them. They tell the reader, "Look over there, pay attention to this or that, this is special for this or that reason," etc … The good writing I want is to take a complex idea and make it clear to the reader, so it's a

mixture of expository and persuasive prose, expository because writers are supposed to explain, and persuasive because they have to convince you not only that they have a credible point of view but also to persuade you to keep on reading. In The Well, the pieces should be more of what we call "reported analysis" but I think clear is the new clever.

What was a challenge at the beginning of your tenure and what is now?

The challenge at the beginning was reviving the magazine in terms of its importance, its significance, its intelligence and its design and turning it into one of the most important conversation subjects in our society. I had to make it smarter and more serious, both in print and online and in every other way. It was about taking *Time* seriously again. The challenge now is the wider challenge that everybody else in the media world has: how you adapt

yourself to this new environment and stay significant and important and get ready for the next stage. I spend a lot of my time thinking about what is going to be the *Time* magazine of the future, that is to say, when the Kindles and the cell phones and all these new devices prove successful in the market, what would *Time* magazine be in all these devices? It cannot just be a PDF of the magazine, and certainly not Time. com. It has to become a wholly new thing, a new design, a new way of storytelling with full-motion video, sound in addition to words. I think there will be three kinds of channels in the future: print, online and the devices, and the latter ones cannot be the same as the others. I think that Time.com will become a marketing or promotional tool. We might do it with cover stories, we are moving into a "pay for content world." If they're paying to download books and magazines on the Kindle, they should also pay for intelligent and well-reported content. What I am thinking about now is how to keep *Time*'s DNA in this new media. It's a worthy ambition.

Present and future. Although the September 21, 2009, cover was about unemployment (opposite), the issue also contained the third annual special report on service, a topic and practice Stengel strongly advocates. Another of Stengel's beliefs is that the *Time* of the future will continue to deliver intelligent and well-reported content in a mix of all channels—print, online and on handheld devices, such as the Kindle and iPhone below.

What proved adequate and inadequate for your earlier strategy and what do you think the magazine needs now?

I think that having a point of view has worked, as well as restoring *Time*'s smartness and significance. I wanted *Time* to stop asking questions on the cover, and start answering questions there, and we got that done, too. Writing with a stronger point of view has also worked, as well as the redesign and the switch from Monday to Friday publication dates. I think we should create more annual issues similar to the "Person of the Year" or "*Time* 100." A "Women's" issue and a "Photo" issue would be great, especially because it turns out that there's no better exposure in any platform for photos than magazines; it will differentiate them from newspapers and online channels.

Top-10 Best-Selling Issues

Since 1923, when *Time* magazine published its first issue, it has produced over 4,000 covers, featuring an incredible diversity of subjects. The issues that have been the highest sellers at the newsstand are those that pay homage to celebrities that have died, often too young, stories on terrorism and its repercussions and history-making political events.

The special commemorative issues for John F. Kennedy, Jr., John Lennon, Princess Diana and Michael Jackson, all of whom died tragically, were all best-selling issues. Of the top ten best-selling issues, the September 14, 2001, edition, devoted entirely to the September 11, 2001, terrorist attack on the Twin Towers of New York's World Trade Center was *Time*'s biggest seller, outselling the next best-selling issue, "One Nation Indivisible," by over a million copies. Shortly after the terrorist attack, *Time* published "Target Bin Laden," which also became one of the top ten best-selling issues.

Two top ten best-selling issues were devoted to political newsmakers: the commemorative election issue celebrating America's first African-American president, Barack Obama, and the special issue covering Richard Nixon's resignation in 1974.

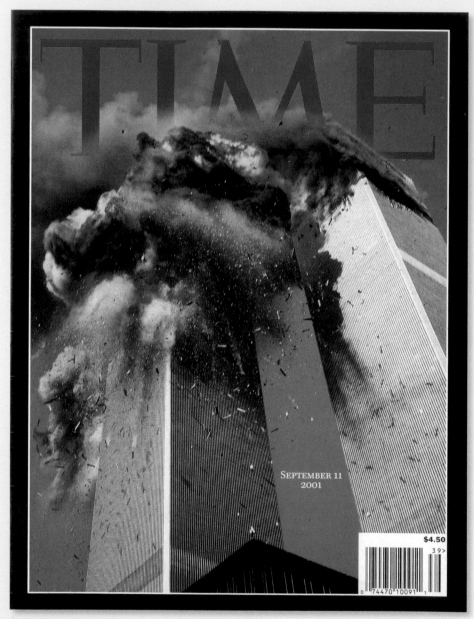

September 14, 2001
9/11 Memorial Special
3,259,156

September 24, 2001
One Nation, Indivisible
2,023,618

July 26, 1999
John F. Kennedy, Jr., Commemorative
1,304,288

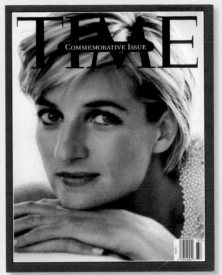

September 15, 1997
Diana Commemorative
1,183,758

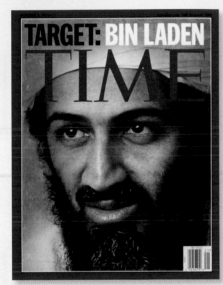

October 1, 2001
Target: Bin Laden
821,538

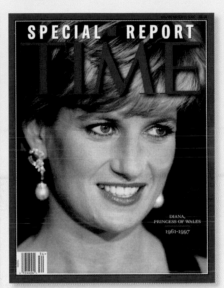

September 8, 1997
Diana, Princess of Wales
820,060

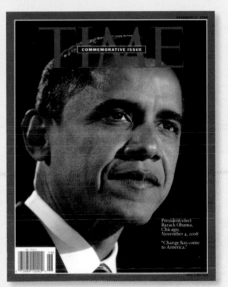

November 17, 2008
Election Commemorative
594,076

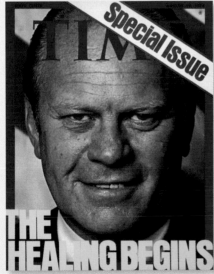

August 9, 1974
Nixon Resignation
564,723

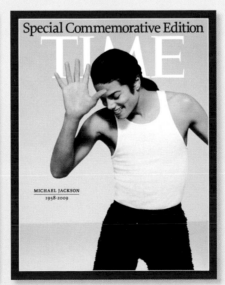

July 7, 2009
Michael Jackson Commemorative
540,000 (est.)

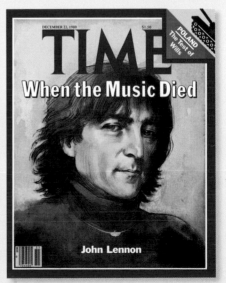

December 22, 1980
John Lennon
531,340

Person of the Year

The first "Man of the Year," Charles Lindbergh, was named in 1927. The cover featuring his portrait ran in January 1928. The title is always designated in December and the issue is printed in late December or early January. "Man of the Year" was changed to "Person of the Year" in 1999. On the opposite page, is every "Person of the Year" cover, from 1927 through 2009.

- Starting in 1927, every American president was named "Man of the Year," except for Calvin Coolidge, Herbert Hoover and Gerald Ford.

- The first president selected was Franklin Delano Roosevelt (1932), when he was president elect. He was chosen twice again, in 1934 and 1941, and he holds the record for being the American president who was most often on the cover.

- Mahatma Gandhi (1930) was the first foreigner selected, Haile Selassie (1935), the first monarch and Chiang Kai-Shek and his wife (1937), the first couple.

- Wallis Simpson was the first woman chosen, in 1936. In 1952, came Queen Elizabeth II, and in 1986, Corazon Aquino.

- In 1938, Adolf Hitler was selected. For the first time, the chosen newsmaker's face was not published. Instead, an allegorical illustration titled *Hymn of Hate* was used.

- Winston Churchill, who had already been selected in 1940, was designated "Man of the Half-Century" in 1949.

- The choice of "The American Fighting-Man" in 1950, during the Korean War, was the first time that a group was named. The same type of designation was made in 2003, "The American Soldier."

- In 1960, American scientists became the first career-related demographic to occupy the "Man of the Year" spot.

- Women were part of groups featured several times, including "The Hungarian Patriot" (1956), the "Twenty-five and Under" generation (1966), "The Middle Americans" (1969), "American Women" (1975) and "The Whistleblowers," who denounced corruption at companies such as Enron (2002). Melinda Gates was featured as one of "The Good Samaritans" in 2005, along with her husband Bill and singer Bono.

- The first pope chosen by *Time* was John XXIII in 1962.

- Martin Luther King, Jr., (1963) was the first African-American chosen as "Man of the Year."

- Richard Nixon (1971), who was also featured along with Henry Kissinger in 1972, was the only person selected in two consecutive years.

- In 1982, the computer was designated "Machine of the Year" and became the first object to appear instead of a person.

- In 1988, "The Endangered Earth" was chosen "Planet of the Year."

- In 1999, Albert Einstein was chosen as "Person of the Century."

- In 2006, the choice fell on another abstract concept, "You," the reader, who could see himself reflected in the Mylar computer screen affixed on the cover.

1927
Charles Lindbergh
Popular hero who made the first solo flight across the Atlantic in his plane the *Spirit of St. Louis*.

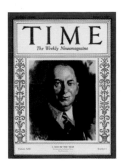

1928
Walter Chrysler
Shook up the auto industry in Detroit when he bought Dodge and launched a new line, the Plymouth.

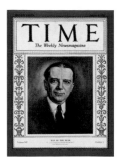

1929
Owen D. Young
Lawyer and RCA founder who served as a diplomat at the 1929 Second Reparations Conference.

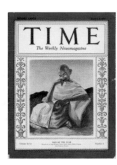

1930
Mahatma Gandhi
Mobilized the Indian independence movement through nonviolent civil disobedience.

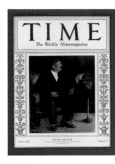

1931
Pierre Laval
With energy and vision, put France back at the center of world affairs.

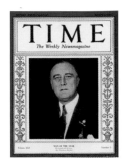

1932
Franklin D. Roosevelt
President elect of the United States at a time of unprecedented economic crisis.

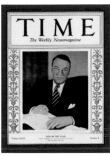

1933
Hugh Johnson
Director of the National Recovery Administration, the government agency confronting the Depression.

1934
Franklin D. Roosevelt
"Man of the Year" for having fervently battled the Depression.

1935
Haile Selassie
When invaded by Mussolini, the Emperor of Ethiopia eloquently appealed to the League of Nations to uphold its promise of collective security.

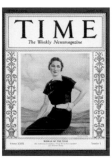

1936
Wallis Simpson
Divorcée who led Edward VIII to abdicate the throne and whose marriage rocked the British crown.

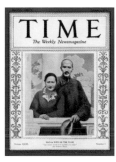

1937
General and Madame Chiang Kai-Shek
Refused to accept defeat after Japan's invasion of Imperial China.

1938
Adolf Hitler
Time called him "the greatest threatening force that the democratic, freedom-loving world faces today."

1939
Joseph Stalin
Instrumental in the Nazi-Soviet Non-Aggression Pact of 1939—soon after its signing, WW II began.

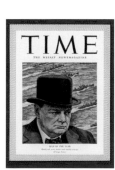

1940
Winston Churchill
Faced WW II with the words "Victory at all costs. Victory in spite of all terrors."

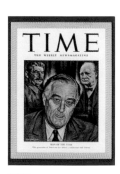

1941
Franklin D. Roosevelt
Prepared a reluctant United States to join the war.

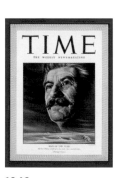

1942
Joseph Stalin
"Man of the Year" for joining the Allied powers after the Nazi invasion of Russia.

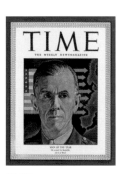

1943
George Marshall
Chief of staff during WW II, Marshall built and directed the largest army in history.

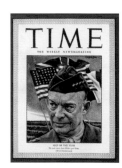

1944
Dwight D. Eisenhower
On D-Day, in 1944, Eisenhower commanded the Allied forces invading France.

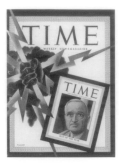

1945
Harry S. Truman
Rapidly asserted himself as Roosevelt's successor when few believed in him.

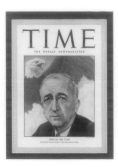

1946
James Byrnes
First U.S. Secretary of State to face the Cold War era.

1947
George Marshall
"Man of the Year" for his diplomacy in creating the Marshall Plan, a program offering economic and military aid to foreign nations.

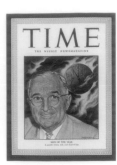

1948
Harry S. Truman
Reelected president by beating opponent Tom Dewey and inspiring the slogan "Give 'em hell, Harry!"

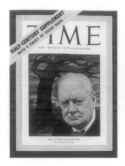

1949
Winston Churchill
To *Time*, a "man in a class of his own" and "Man of the Half-Century."

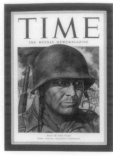

1950
The American Fighting-Man
Named in homage to the American troops fighting in the Korean War.

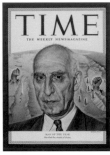

1951
Mohammed Mossadegh
Prime minister who briefly led Iran and nationalized the Iranian oil industry.

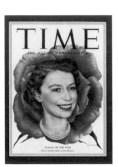

1952
Queen Elizabeth II
Newly crowned Queen, young and energetic, whose coronation ushered in a new era in Great Britain.

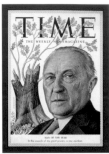

1953
Konrad Adenauer
Took the helm of a destroyed West Germany to lead the country toward the future.

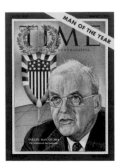

1954
John Foster Dulles
U.S. Secretary of State who introduced the term "brinkmanship"—the art of pushing confrontation to the brink—into the lexicon of the Cold War.

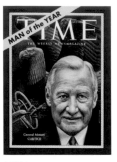

1955
Harlow H. Curtice
Head of General Motors and prime example of a businessman who brought the United States a new era of prosperity.

1956
The Hungarian Patriot
Emblematic participant in the first uprising against Soviet control behind the Iron Curtain.

1957
Nikita Khrushchev
Premier of the Soviet Union when it launched its first satellite, *Sputnik*, and gained a surprise lead over the U.S. in the space race.

1958
Charles De Gaulle
WW II hero returned to power in France by the Algerian crisis.

1959
Dwight D. Eisenhower
Gathered the support of all NATO allies to confront the Soviet Union.

1960
U.S. Scientists
Homage to the American men of science who made remarkable advances during the year.

1961
John F. Kennedy
Became president at 43, and during his first year in office, dealt with the Cold War, the Berlin Wall and the Cuban Missile Crisis.

1962
Pope John XXIII
"Opened the windows" of the ancient church, which reshaped the face of Catholicism.

1963
Martin Luther King, Jr.
Civil rights leader celebrated for embracing nonviolent strategies, such as those practiced by Gandhi.

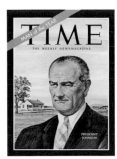

1964
Lyndon Johnson
Reelected as president of the U.S. following a sweeping victory over Barry Goldwater.

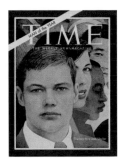

1965
General William Westmoreland
General in command of American military operations in Vietnam.

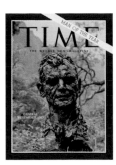

1966
Twenty-five and Under
This generation, then comprising half of the U.S. population, was singled out by *Time* for its determination to live according to new rules.

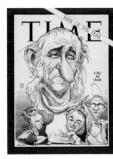

1967
Lyndon Johnson
The president who hoped to be the architect of social reform, but was haunted by the Vietnam War.

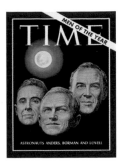

1968
The *Apollo* Astronauts
Astronauts Anders, Borman and Lovell who participated in the race to reach the moon.

1969
The Middle Americans
Asserted a new interpretation of patriotism and supported Richard Nixon in his successful bid for the White House.

1970
Willy Brandt
Chancellor under whom West Germany established the *Neue Ostpolitik*, a policy that aimed to ease tensions with East Berlin.

1971
Richard Nixon
President who, during a complicated term, opened the doors to China, devalued the dollar and stifled protest against the Vietnam War.

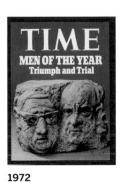

1972
Henry Kissinger and Richard Nixon
Masters of diplomacy who engaged in dialogue with the USSR to ease international tensions and visited China.

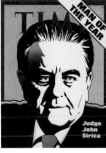

1973
Judge John Sirica
The judge who managed to untangle the Watergate case.

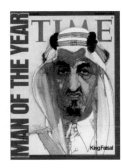

1974
King Faisal
The Saudi Arabian king and powerful OPEC member who supported raising oil prices, causing turbulence in the world market.

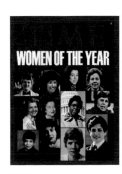

1975
American Women
In recognition that feminism ushered in substantial changes in all levels of U.S. society.

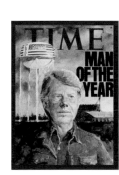

1976
Jimmy Carter
The "outsider" candidate who defeated Ford to reach the White House.

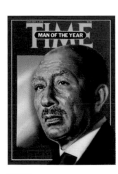

1977
Anwar Sadat
President of Egypt, Sadat was the first Arab leader to officially visit Israel to discuss a peaceful resolution to the Arab-Israeli conflict.

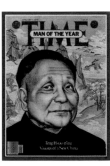

1978
Deng Xiaoping
Managed to govern a China plagued for many years by political instability.

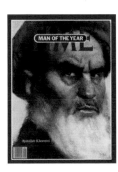

1979
Ayatollah Khomeini
When *Time* named him "Man of the Year" during the Iran hostage crisis, thousands of readers sent protest letters.

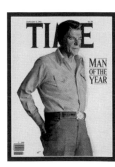

1980
Ronald Reagan
Won the White House as the American electorate swung to the right.

1981
Lech Walesa
Leader of Solidarity, the independent Polish labor union that inspired political action throughout the Communist bloc.

1982
The Computer
In anticipation of the personal computer revolution, the "Machine of the Year."

1983
Ronald Reagan and Yuri Andropov
Two world leaders deadlocked in negotiating the stockpiling of missiles.

1984
Peter Ueberroth
The executive who turned the Los Angeles Olympic Games into a huge business.

1985
Deng Xiaoping
Abandoned Mao's leftist cultural revolution and led the economic reform, which paved the way for China to become one of the fastest-growing world economies.

1986
Corazon Aquino
After her husband's assassination, Aquino came to power peacefully as president of the Philippines, replacing the authoritarian President Ferdinand Marcos.

1987
Mikhail Gorbachev
With "glasnost" and "perestroika," put an end to Soviet political and economic lethargy.

1988
The Endangered Earth
Time marked a new era of environmental activism, with its recognition of "Planet of the Year."

1989
Mikhail Gorbachev
The reformist Soviet leader—called "revolutionary" by himself and "visionary" by *Time*—was named "Man of the Decade."

1990
George Bush
Bush showed strength in confronting Saddam Hussein but backed away from confronting domestic economic issues.

1991
Ted Turner
The man who revolutionized television news broadcasting through his cable network CNN.

1992
Bill Clinton
Brought the White House back to the Democrats after twelve years of Republican government.

1993
The Peacemakers
Yitzhak Rabin, Nelson Mandela, F. W. de Klerk, Yasser Arafat. Four men in pursuit of a single goal: peace.

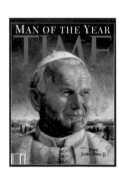

1994
Pope John Paul II
At 70, still traveled extensively to express his orthodox opinions.

1995
Newt Gingrich
The conservative Speaker of the House who led a sweeping Republican victory in the United States Congress.

1996
Dr. David Ho
Dr. Ho's pioneering research led to the development of protease-inhibitor "cocktails" and other antiviral drugs.

1997
Andrew S. Grove
Chairman of the microchip giant Intel who guided the digital revolution.

1998
Bill Clinton and Kenneth Starr
Special Prosecutor Starr's probing into the Clinton-Lewinsky scandal made as many headlines as the scandal itself.

1999
Jeff Bezos
Amazon.com creator who revolutionized the commercial world with his Internet bookstore sales.

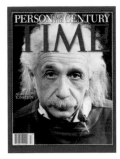

1999
Albert Einstein
Designated "Person of the Century" for his contributions to the evolution of modern technology.

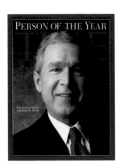

2000
George W. Bush
As the winner of the most controversial presidential election in American history.

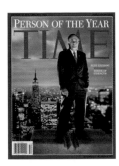

2001
Rudolph Giuliani
New York Mayor, who *Time* named the "Tower of Strength," Giuliani struggled to help Americans recover from the shock of the attack on the Twin Towers.

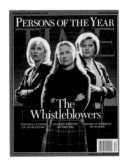

2002
The Whistleblowers
Cynthia Cooper, Coleen Rowley and Sherron Watkins were examples of courage and good citizenship. They exposed corruption at WorldCom, Enron, and the FBI.

2003
The American Soldier
Time followed a single platoon from the army's first armored division to "glimpse what the world's largest army can do while all the expectations for it are changing."

2004
George W. Bush
Time chose Bush for "reshaping the rules of politics to fit his ten-gallon hat leadership style."

2005
The Good Samaritans
Time designated Bill and Melinda Gates and Bono, "good samaritans" for their humanitarianism and philanthrophy.

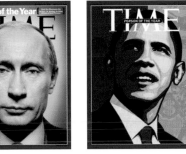

2006
You
The reader—reflected in the Mylar affixed to the computer screen printed on the cover—both witnesses and creates his or her own future in the digital age.

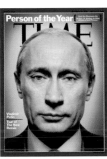

2007
Vladimir Putin
For *Time*, the "Tsar" of the new Russia, Putin succeeded in putting his country back on the world power map.

2008
Barack Obama
The first African-American president in the history of the U.S. took office during the worst economic crisis of the last fifty years.

2009
Ben Shalom Bernanke
His creative leadership prevented a catastrophic depression.

Bibliography

Abrams, Meyer H. *The Mirror and the Lamp: Romantic Theory and Critical Tradition.* New York: Galaxy Books, Oxford University Press, 1971.

Christ, William G. and Sammye Johnson. "Women Through *Time*: Who Gets Covered." *Journalism Quarterly* 55, no. 1 (Winter 1988): 887–897.

Elson, Robert T. *Time Inc.: The Intimate History of a Publishing Enterprise.* Edited by Duncan Norton-Taylor. New York: Atheneum, 1968–1986.

Fuerbringer, Otto. *On Time.* Self-published, 2007.

FYI, employee newsletter. Time Inc., 1940–2005.

Goodman, Ezra. *The Fifty-Year Decline and Fall of Hollywood.* New York: Simon and Schuster, 1961.

Griffith, Thomas. *How True: A Skeptic's Guide to Believing the News.* Boston: Little, Brown & Company, 1974.

Grunwald, Henry A. *One Man's America: A Journalist's Search for the Heart of His Country.* New York: Doubleday, 1997.

Hadden, Briton to Elizabeth Busch Hadden Pool, 7 February 1922. *Hadden Estate Papers.* Time Inc. Archives, New York.

Halstead, Dirck. "The Monica Lesson." *The Digital Journalist,* http://www.digitaljournalist.org/issue9807/editorial.htm.

Herzstein, Robert E. *Henry R. Luce: A Political Portrait of the Man Who Created the American Century.* New York: C. Scribner's Sons, 1994.

Holmes, Nigel. *Designer's Guide to Creating Charts and Diagrams.* New York: Watson-Guptill Publications, 1984.

——. *Designing Pictorial Symbols.* With Rose DeNeve. New York: Watson-Guptill Publications, 1985.

Hoopes, Roy. *Ralph Ingersoll: A Biography.* New York: Atheneum, 1985.

Janello, Amy and Brennon Jones. *The American Magazine.* New York: Harry N. Abrams, 1991.

Kerry, Patricia Frantz. *Great Magazine Covers of the World.* New York: Abbeville, 1993.

Knauer, Kelly, ed. *Time: 80 Days That Changed the World.* New York: Time Inc. Home Entertainment, 2003.

——. *Time: Goes to War; From World War II to the War on Terror: Stories of Americans in Battle and on the Home Front.* Picture ed. Patricia Cadley. New York: Time Books, 2002.

——. *Time: Great Images of the 20th Century; The Photographs That Define our Times.* New York: Time Books, 1999.

——. *Time: 1968; War Abroad, Riots at Home, Fallen Leaders and Lunar Dreams—The Year that Changed the World (40th Anniversary Special).* New York: Time Books, 2008.

——. *Time: 75 Years; 1923–1998: An Anniversary Celebration.* New York: Time Books, 1998.

——. *Time 100: Builders and Titans; Great Minds of the Century.* New York: Time Books, 1998.

——. *Time 100: Leaders and Revolutionaries, Artists and Entertainers.* New York: Time Books, 1998.

Lacayo, Richard and George Russell. *Eyewitness: 150 Years of Photojournalism.* New York: Time Books and Oxmoor House, 1990.

Lehnus, Donald J. *Who's on Time? A Study of Time's Covers from March 3, 1923 to January 3, 1977.* New York: Oceana Publications, 1980.

Luce, Henry to Henry Winters Luce, Luce Letter-351, 1922. *Luce Estate Papers.* Time Inc. Archives, New York.

Luce, Henry and Briton Hadden. "Prospectus," *Time,* 1922. Historical documents. Time Inc. Archives, New York.

Matthews, T. S. *Name and Address, An Autobiography.* New York: Simon and Schuster, 1960.

Morrow, Lance. "The Time of Our Lives."
In *Time 1923–1998, 75 Years: An Anniversary Celebration*, edited by Kelly Knauer. New York: Time Books, 1998.

Mott, Frank Luther. *A History of American Magazines.* Vol. 5, *Sketches of 21 Magazines.* Cambridge, MA: Harvard University Press, 1938–1968.

Pearlstine, Norman. *Off the Record: The Press, the Government, and the War Over Anonymous Sources.* New York: Farrar, Straus and Giroux, 2007.

Peterson, Bernard. *Magazines in the Twentieth Century.* 2nd ed. Urbana, IL: University of Illinois Press, 1964.

Porterfield, Christopher, ed. *85 Years of Great Writing in* Time. New York: Time Books, 2008.

Prendergast, Curtis and Geoffrey Colvin. *The World of Time Inc., 1960–1980.* Edited by Robert Lubar. Vol. 3 of *Time Inc.: The Intimate History of a Publishing Enterprise.* New York: Atheneum, 1968–1986.

——. *The World of Time Inc.: The Intimate History of a Changing Enterprise, 1960–1980.* New York: Simon & Schuster, 1986.

Prospectus, *Time.* Historical document, Time Inc. Archives, New York.

Reilly, Patrick M. "The Instant-News Age Leaves *Time* Magazine Searching for a Mission." *World Street Journal*, May 12, 1993.

Rosenblatt, Roger. *Children of War.* Garden City, NY: Anchor Press/Doubleday, 1983.

——. *The Man in the Water: Essays and Stories.* New York: Random House, 1994.

Tebbel, John and Mary Ellen Zuckerman. *The Magazine in America, 1741–1990.* New York: Oxford University Press, 1991.

Time: Great Events of the 20th Century. New York: Time Books, 1997.

Vickrey, Robert. *Artist at Work.* New York: Watson-Guptill Publications, 1979.

Voss, Frederick S. *Faces of Time: 75 Years of* Time *Magazine Cover Portraits.* Boston: Little, Brown & Company, 1998.

Weisskopf, Michael. *Blood Brothers: Among the Soldiers of Ward 57.* New York: H. Holt, 2006.

Wilner, Isaiah. *The Man Time Forgot: A Tale of Genius, Betrayal, and the Creation of* Time *Magazine.* New York: Harper-Collins, 2006.

Interviews
Unpublished interviews by the authors between 2008 and 2009 with:

Bernard, Walter
Cave, Ray
Drapkin, Arnold
Gaines, James
Gibbs, Nancy
Golon, MaryAnne
Hayman, Luke
Heisler, Gregory
Hochstein, Arthur
Hoffman, Cynthia
Hoglund, Rudy
Huey, John
Isaacson, Walter
Kelly, James
Mahurin, Matt
Muller, Henry
Nachtwey, James
Painton, Priscilla
Pearlstine, Norman
Rosenblatt, Roger
Scher, Paula
Stengel, Richard
Stephenson, Michele
Tyrangiel, Josh
Tumulty, Karen
Voss, Frederick
Wilner, Isaiah

Acknowledgments

The authors are deeply grateful to Managing Editor Richard Stengel for his encouragement and support and for opening *Time*'s doors to allow us to interview the people who produced and continue to produce the magazine every week. His unerring suggestions were inspirational and invaluable in the making of this book.

The authors are especially indebted to former *Time* managing editors Ray Cave, Henry Muller, James Gaines, Walter Isaacson and Jim Kelly for spending hours in several interviews with us to review their respective tenures. They provided us with a historical perspective on *Time*'s editorial and design blueprint and helped us to shape the structure and content of this book.

We are also indebted to Arthur Hochstein for his expert guidance on the magazine's evolving cover design; to Michele Stephenson, our photography consultant, who, together with MaryAnne Golon, Patricia Cadley, Hillary Raskin and Cornelis Verwaal, illuminated our way through thousands of pictures; to Christopher Porterfield for his insightful comments on reviewing the text; to Isaiah Wilner for his guidance on *Time*'s early writing style—especially on Briton Hadden's editorial contributions—and to Bill Hooper for his historical knowledge and his extraordinary efforts in finding unique, iconic archival material. Our thanks also go to photographers James Nachtwey, Gregory Heisler and Matt Mahurin for providing us with invaluable anecdotes, recollections and information about their careers at *Time*, and enhancing the scope and depth of this book. We much appreciate former and current writers-editors Nancy Gibbs, Priscilla Painton, Roger Rosenblatt and Karen Tumulty for being instrumental in guiding us in paying homage to the best writing from the history of *Time*.

John Huey, Norman Pearlstine, Josh Tyrangiel, Walter Bernard, Nigel Holmes, Arnold Drapkin, Joy Butts, Richard Fraiman, Regina Feilner, Rudy Hoglund, Dick Stolley, Dirck Halstead, Frederick S. Voss, Larry Cohen, Wendy Koska, Marvin Levy, Susana Cummings and Crystal Honores could not have been more gracious and generous. We also extend our warm thanks to D. W. Pine, Cynthia A. Hoffman and Skye Gurney Lewis from *Time*'s art department, as well as to Tosca Laboy and Anne King, assistants to Richard Stengel and Jim Kelly, who always managed to find time for our interviews with them despite their solidly packed agendas.

To Charles Miers of Rizzoli International Publications, our publisher, thank you for believing in this book from the very beginning and for providing us with a great team to make it become a reality: Anthony Petrillose, Kayleigh Jankowski, Maria Pia Gramaglia, Pam Sommers and Jennifer Pierson, as well as fact-checkers Ken Jacowitz and Sandra Jamison and copy editors Amoreen Armetta, JoAnn Mitchell and Rachel Selekman.

Finally, we extend our warmest thanks to the spectacular decisions made by designers Luke Hayman, Shigeto Akiyama and Emily Anton at Pentagram.

Index

Photo Credits